Joyce Wieland

A Life in Art

Joyce Wieland

A Life in Art

Iris Nowell

ECW PRESS

NATIONAL LIBRARY OF CANADA CATALOGUING IN PUBLICATION DATA

Iris Nowell
Joyce Wieland : a life in art

ISBN 1-55022-476-X

1. Wieland, Joyce, 1930–1998. 2. Artists — Canada — Biography. 3. Motion picture producers and directors — Canada. 1. Title.

N6549.W53N69 2001 709'.2 C2001-900818-X

Cover and text design by Tania Craan
Layout by Mary Bowness
Front photo: Courtesy George Whiteside
Back photo: Courtesy National Archives of Canada / Michel Lambeth
All images of Joyce Wieland's artwork have been reproduced with the permission of the Joyce Wieland Estate.

Printed by Transcontinental

Distributed in Canada by
General Distribution Services,
325 Humber College Blvd.,
Toronto, ON M9W 7C3

Published by ECW PRESS
2120 Queen Street East, Suite 200
Toronto, ON M4E 1E2
ecwpress.com

This book is set in Garamond, Bickham and Bodoni.

PRINTED AND BOUND IN CANADA

The publication of *Joyce Wieland, A Life in Art* has been generously supported by the Canada Council, the Ontario Arts Council and the Government of Canada through the Book Publishing Industry Development Program.

Canadä

Copyright page continued on page 519

Contents

Acknowledgements

I am deeply indebted to the many people who have contributed in their numerous ways to this book.

I am grateful to Joyce's nieces Alison (Stewart) McComb, Nadine (Stewart) Schwartz and Lois (Stewart) Taylor, and her nephews Keith Stewart and Michael Wieland, for the time they spent with me on family recollections. Of great importance was the family history loaned to me by Joyce's nieces, written by their mother, Joyce's sister, Joan (Stewart) Proud.

My thanks also to Doug MacPherson, executor of Joyce's estate, and the help of Linda Abrahams, whose early support of this book is greatly appreciated, as is her later assistance, along with Georgia Abrahams, with selections of photographs.

To Joyce's ex-husband Michael Snow I also extend my thanks and appreciation for sharing memories of his and Joyce's life together.
My thanks also to Joyce's art dealers, Av Isaacs of the Isaacs Gallery and Ron Moore of the Moore Gallery, for both their recollections and assistance with Joyce's exhibition history. With regard to Joyce's art history and filmography, I have relied heavily on the Art Gallery of Ontario/Key Porter catalogue of Joyce's retrospective exhibition at the AGO, as I have with other exhibition catalogues, and I am indebted to "The Films of Joyce Wieland," edited by Kathryn Elder.

Librarians and archivists have been very helpful to me and I appreciate their devoted searches. I thank Kent M. Haworth, University Archivist, Archives and Special Collections at the Scott Library, York University, Toronto, where Joyce's papers are held, as well as Suzanne Dubeau, Sean Smith and Fred Johnson, and several summer students over time. Also, at the National Gallery of Canada library Peter Trepanier, head, reader services and Cyndie Campbell, head, visual resources. My thanks also to Randall Spears, librarian at the Art Gallery of Ontario, and librarians at the Metropolitan Toronto Public Library Keith Alcock, Vaughan Thurman and Juta Upshall.

I also thank photo librarians at Jean Bradshaw, with special thanks to Donna Jean MacKinnon at *The Toronto Star*, Jillian Goddard at the Toronto *Sun*, and Francine Bellefeuille, the *Globe and Mail*. My thanks as well to Maia-Mari Sutnik, head of Collections at the Art Gallery of Ontario, and Faye Van Horne, Syvalya Elchen, Felicia Cukier, and Gloria Marsh in the photographic department. Also for photographs from the National Archives of Canada, I am grateful for the help of Jean Matheson, Mike McDonald and Andrew Rodger. My thanks also to photographers Warren Collins, Tess Taconis, Tom Moore, and John Reeves.

Film libraries and collectives have been very helpful with providing access to records and granting personal screenings of many of Joyce's films, Michael's films and Joyce's filmmaker colleagues in Toronto and New York. My thanks to the New York Anthology Film Archives, the New York Film Distribution Centre, headed by M.M. Serra, and the Canadian Film Distribution Centre.

I am grateful to the help I received from public art gallery curators and directors: Pierre Theberge, director of the National Gallery of Canada, Charles Hill, curator, Canadian Art, National Gallery, Brydon Smith, past curator, 20th Century Art, National Gallery, Phillip Monk, past director, Power Plant, Toronto, William Withrow, director emeritus, Art Gallery of Ontario, Dennis Reid, chief curator, AGO, Anna Hudson, assistant curator of drawings and prints, AGO, David Burnett, past curator of Canadian

contemporary art, AGO, and Joan Murray, past director, Robert McLaughlin Gallery, Oshawa, Ontario.

Thanks also to Greg Gatenby, artistic director of the International Readings at Harbourfont, and Karen Lackner.

I extend my warmest appreciation and thanks to Joyce's devoted friends and colleagues in Toronto, Ottawa, New York and San Francisco, who have been very helpful in sharing and shedding light on Joyce's professional and personal life: Steve Anker, Sara Bowser, Marilyn Brooks, Ken Carpenter, Warren Collins, Christine Conley, Robert Cowan, Kathryn Dain, Jamee Erfurdt, Betty Ferguson, Graeme Ferguson, Selma Lenchak-Frankel, Linda Gaylard, George Gingras, Gerald Gladstone, Pen Glasser, Marjorie Harris, Paul Haines, Jo Hayward-Haines, Flo Jacobs, Ken Jacobs, Chris Karch, Marg King, George Kuchar, Richard Leiterman, Les Levine, Janice Crystal Lipzen, Doris McCarthy, Sheila McCusker, Lynn McDonald, Jonas Mekas, Maureen Milne, George Montague and his late wife, Donna, Les Levine, Charles Pachter, John Porter, Gordon Rayner, John Rennie, Gerald Robinson, Diane Rotstein, Hanni Sager, David Silcox, George Shane, Judy Steed, Melita (Mel) Waterman and her late husband, Vic, Kay Wilson and Chris Yaneff. My thanks also to those few individuals who wished to remain anonymous.

Also, my thanks to Shelagh Cartwright for her research and industrious fact-finding. As well, I am very grateful to first readers of the manuscript, Bob and Jean Burgener, and editor Olive Koyama, for their most helpful comments.

Also, my very special thanks to Jack David, president of ECW Press, for his enthusiasm and unrelenting encouragement of my book. As well, I am extremely grateful to editors Jennifer Hale and Kit Thurling, for their keen eyes, beautiful nit-picking and wonderful grace notes they bestowed upon my text.

I would also like to thank the Ontario Arts Council for its assistance.

Special Thanks

I am deeply grateful to the supporters of this book, whose generosity was of great help to me during the early stages of my work, beginning four years ago. I appreciate that these benefactors, through their generosity, are supporting the documentation of a treasured contributor to Canadian art history, Joyce Wieland. My special thanks to philanthropist and art collector Irving Zucker, who first came on board, and whose support inspired others.

Founder:
Irving Zucker, C.M.

Patron:
The Laidlaw Foundation

Friends:
Books For Business
Diane Simard-Broadfoot
Moore Gallery
Rogers Communications Inc.
Standard Broadcasting Corporation Limited

Introduction

The soprano sings, the diva astonishes. This expression could also be adapted to Joyce Wieland. She painted, she astonished. What is more, she astonished not only as a painter but as a quiltmaker, collagist, printmaker, draftsman, and filmmaker.

"I had to," she stated, when asked about why she felt driven to attract attention to herself, to astonish the viewer and the art establishment. Early on, since her first exhibition in Toronto in 1959, both Joyce's artwork and her persona demanded, *"Look at me!"* By whatever means, she felt compelled to make her mark in the tough, male-dominated field of abstract expressionism and pop art.

Joyce Wieland created a body of art that stands alone. Environmental issues, historical passages, and Aboriginal rights appear in buoyant, satirical images. Her powerful erotic themes linger in the mind, just as her dark, troubling renderings of catastrophes and grotesque couplings will not vanish. To make her distinctive, highly personal art, Joyce used paper cut-outs, small toys, bits of wood, glass, film strips, and pieces of her panties, as boldly and felicitously as she used oils, coloured pencils, and embroidery.

At first, critics didn't know what to make of her. Some trivialized her work, calling it kitschy and clumsy, and others denounced her subject matter, be it patriotic or genital. Upon leaving an exhibition of Joyce's

that included drawings of penis wallpaper and a flower that metamorphosed into a penis, Alan Jarvis, then director of the National Gallery of Canada, dubbed the show "Phallus in Wonderland." Phalluses appeared in her underground films as animated wieners cavorting over a sleeping man, in step with a John Philip Sousa march.

By the early 1970s, Joyce's work was being exhibited across the country and was beginning to be purchased by the major public galleries, and by Canada's most distinguished corporate and private art collectors. She was the first living woman artist to be given a retrospective exhibition by the National Gallery, and for the first time she began hearing herself described as a visionary, the most important woman artist in Canada, second only to Emily Carr. Soon thereafter she would be hailed as a cultural icon and a passionate activist.

Joyce's struggle to achieve artistic acclaim is more than a *La Bohème* cliché. Suffering what she called "obscene poverty" as a nine-year-old, whose parents by then had both died, Joyce earned her first pocket money selling drawings at school. She drew pictures of costumed movie stars for the girls, and for the boys she drew naked ladies.

Nothing had been easy for Joyce. Her blighted childhood robbed her of an adolescence and stalled her maturity, and yet, mystically, paradoxically, she came to produce a mature, rich body of work. She accomplished this through her unflagging courage and heartfelt commitment to making feminine/political art, aided along the way by her humour; faith in her art angels; her lifelong adoration of animals; mythological creatures; Mozart, and Laura Secord chocolates; some psychiatric help; a little drug experimentation; a husband and lovers; her always dependable sister; and a loyal following of friends.

Joyce's pioneering successes as a woman artist, her daring to elevate quiltmaking to an art, the feminist issues she raised on canvas and in film, cost her negative criticism. In her passion and absolute belief in honouring her "female line" in art, she broke the ground for countless women artists to follow. She had persevered through the 1950s Dark Ages of Art in

Canada, endured the old boys' club that ran art in the 1960s, and her work and her efforts paid off. During the 1970s and 1980s, she achieved international success.

In 1956, Joyce married artist/jazz musician Michael Snow and in 1962 the couple moved to New York. For nine years they lived the grotty loft life typical of the city's artists, underground filmmakers, and musicians, and there Joyce discovered the joys of a glorious, wacky, hugely satisfying subculture — avant-garde film. During this period, she also suffered a brutal street attack, the callous exclusion from the major filmmakers' archive, and her husband's infidelities, while simultaneously creating some of her most esteemed films, paintings, assemblages, and works in cloth.

I met Joyce Wieland in 1962 at a fashion show in Toronto, and over the years would see her at art openings. She was a friend of a dear friend of mine, Wanda Phillips, who influenced Joyce's quest for spiritual fulfillment, and aroused Joyce's outrage over environmental waste and degradation.

Fashion and costume intrigued Joyce, I discovered, and in the course of writing this book I came to understand how fashion fit into her art, especially in sculpture. Throughout her life she held fashion and fashion designers in high regard — her first love was Coco Chanel, her last, Donna Karan. Her lifelong interest in fashion began as a child, with a coat she detested — a long, red, fox-collared coat that her mother had cut down from one of hers. It epitomized the family's poverty, Joyce's hand-me-down existence, a life stigmatized by having nothing new. In retaliation, Joyce wore beautiful, expensive clothes for most of her adult life.

Though as a youngster Joyce "was always drawing," she said, her dream of being an artist seemed far beyond her reach and she entered Central Technical High School to take up her second choice, fashion design.

Fortunately for us, Joyce veered away from fashion design when one of her teachers, painter Doris McCarthy, persuaded Joyce to join the art program. "She drew like an angel," recalled McCarthy. Joyce never stopped drawing.

Joyce Wieland incorporated art into her everyday life. Art would become the best, most dependable part of her life.

Along with having access to Joyce's personal papers, held at York University, Special Collections and Archives, I have relied on many people's memories — those of Joyce's nieces and nephews, her friends and colleagues, dealers, collectors, museum curators — to try to find answers to the essential question, *Who was Joyce Wieland?* In my search, I encountered every biographer's fundamental riddle: *What is the truth?*

Secondary-source materials often lack credence, for no particular reason other than that one source can be at disparity with another, the result of which is that errors are published in newspapers and magazines, and misleading assumptions are drawn. Dealing with primary sources — essentially people — presents another set of complications in that you must rely on an individual's recall, whose fragility naturally intensifies with the passage of time. Robert Cowan, a friend of Joyce's since 1958, who had moved to New York five years before Joyce and Michael, had been puzzling over his recollections of a particular incident of the early 1960s, and said, "If I'd known back then you would be writing this book, I would have remembered all that stuff."

I have attempted to tell Joyce's truth from as many perspectives as the search allowed, while balancing her integrity with my sense of propriety. Numerous viewpoints have been presented, many opinions asserted, and an enormous degree of love for Joyce has been expressed, from which I was left to tell this story.

Not uncommonly, I faced difficult decisions about what information to include and what to omit. Some of Joyce's friends are very protective and would prefer that her story concentrate solely on her courage, her indomitable spirit, her generous nature, and her artistic achievements. But when examining the fear and interior darkness that tormented her, I decided that if they unlocked for me essential truths about Joyce and the

sources of her brilliant work, they had to be included. Otherwise, they were not.

In one of her journals Joyce wrote to herself this single line: "Tell Joyce to be careful not to go where there are no angels."

After a four-year exploration of Joyce Wieland's art and life, I truly believe that the angels were on her side.

Chapter One

"Joyce helped me steal my car one night," said Selma Lemchak-Frankel, charging gleefully out of the gate of her reminiscences about Joyce.

Selma had been newly separated and her husband had locked her out of the house, preventing her from getting her personal things, and her car. Tearfully, she'd related the situation to Joyce. "I really wanted my car and Joyce said, 'Well, let's just go and get it.'"

In Selma's favour — she had a car key.

"Joyce figured it all out," she said admiringly.

Joyce drove Selma to her former matrimonial home at three o'clock in the morning, under a moonless cloak of stealth and cunning. "So we were sneaking around, trying to be quiet," Selma reported, "and the car was right there in the driveway. So I got in and discovered it was out of gas, or at least the thing was on E, but Joyce said, 'Never mind, drive it anyway. I'll be right behind you and we'll find a service station.'"

Selma was skeptical. "I said, 'Where are we going to find a service station at three o'clock in the morning?' and Joyce knew where there was an all-night station, at St. Clair and Bathurst, a dozen blocks away. She said, 'Just drive and if you run out of gas I'll push you.'"

They found the gas station, it was open, and they filled up.

Joyce told Selma to have a new key made right away because Selma's kids also had a key.

Marvelling, Selma said, "Joyce knew *exactly* what to do." She laughed. "So I got to keep the car but it was no good anyway." And with a comic's sense of a good closer, she paused and beamed. "That's how Joyce helped me steal my car."

This was in 1986. Selma and Joyce had met in 1956 and for thirty years had shared, as loving friends do, the highs and lows, the joy and pain of their lives. Selma was in a slump then, but Joyce was flying high.

Joyce treasured her friendships, and in this incident with Selma can be seen the essential Joyce — her unstinting generosity, the energy and humour that fired her, her commitment to righting wrongs, and her determination to overcome the odds, to challenge systems and institutions. She had learned through a lengthy, costly process to count on herself and her art as her best resources. It was now paying off. Having recovered from a depression, a hysterectomy, her divorce, the breakup of a love affair, an acrimonious litigation and a downturn in her career, she declared, "I healed myself" — by making a suite of drawings that would become her most acclaimed works to date. Pierre Théberge, then director of the Montreal Museum of Contemporary Art, said they were "the most beautiful drawings ever done in this country."

By this time, Joyce had begun easing herself out of her stranglehold of work. "You don't know what a workaholic I was," she said. "I practically drove myself into the grave with work." She splurged on a new wardrobe, got a chic hairdo, had a face makeover. "People didn't know it was me," she was pleased to announce. She had evolved from young French gamine in black, to bosomy sex siren, to flower child, to designer-silk doyenne and come full circle to the simplicity of Donna Karan. Completing her total new look, Joyce bought her most beautiful, exciting accessory — a car. The first car she had ever owned, a Volkswagen convertible. Joyce loved her little car, loved that it represented independence, derring-do — like pulling off a nocturnal car heist — but most significant, that it symbolized her new success. "When I drove around in it, it was one of the greatest feelings of my life," she exclaimed. "I drove with the top down and the radio blaring, like a person who missed being seventeen."

In many respects, Joyce had missed being seventeen altogether. Much as she had missed being a child.

Joyce described her childhood as Dickensian, by which she meant the poverty and bleakness of Dickens, not rosy-cheeked little children at the hearth with cocoa and cakes.

During the Great Depression in Toronto, when Joyce was born, countless families forfeited their pride and well-being to an existence cursed by pogey and hand-me-downs, contrasted with those who counted themselves lucky to be working in even the most demeaning jobs. For the better part of a decade, recovery was stubborn and cruel. Privation left its ugly stain on every threadbare child, every empty cupboard. And while it is true that the nation suffered collectively all through the Dirty Thirties, you could inevitably find one family on the street whose hardship outstripped everyone else's. Joyce considered hers to be such a family.

She recalled that as a small child she saw people standing in lines. "They are so ashamed of themselves. They do not want to show their face." This was in wintertime and she remembered people without gloves,

mitts or scarves. Describing the effect this image had on her, Joyce said, "It makes me mad. I am little but I am angry." She felt the ignominy of hardship in not having new things — unlike "people across the street that had money and jobs, really good jobs. When I got my stuff it was second-hand, fixed up nice, but I hated it. I wanted to have what the others had."

In 1939, at age nine, Joyce would be an orphan. Along with being orphaned, the meaning of which she horrifically understood, Joyce's wailing heart shattered anew at the dumbfounding realization that she had so little grasp of life's pre-eminent mystery: *Who am I?* Her English-born father and mother had revealed to her little of their family backgrounds. No stories had been passed along to a young Joyce bouncing on Grandpa's knee or baking cookies with Granny. In fact she had not given thought to her non-existent extended family until the death of her parents, when she and her two siblings found themselves on their own, without grandparents, uncles, aunts, or cousins. Joyce had managed to ignore other kids' discussions of their relatives until abruptly, after age nine, she would be tortured by such talk. *Where were her relatives? What had happened to them?*

Joyce was a highly imaginative child. From age three she drew on anything she could find — paper bags, her sister's books, the walls — and in the process she concocted grandiose tales to illustrate her drawings. A self-confessed "little chatterbox," she claims to have been always telling stories, "making stuff up" to amuse herself and — most importantly, she acknowledged — to attract the entire family's attention.

According to one of Joyce's psychiatrists (she had several over the years), the death of both parents is so traumatic that the surviving children's brains become disorganized. Often such children think they are to blame for the deaths, in one way or another. Case histories are replete with examples of the child who angrily lashes out at a parent, "I wish you would die!" and very shortly thereafter the parent is killed in a car crash, say, with the result that the child believes he or she willed the parent's death, leaving that youngster with feelings unspeakably demonic and confused. Joyce was involved in therapy for most of her adult life, trying

to unravel a monumental skein of guilt that entangled her as a result of her parents' deaths.

During the time Joyce spent seeking clues to her origins she retrieved some dusty ephemera from the family attic, but the problem was, once dusted off, these bits and pieces exposed more imponderables than they illuminated facts. Not until Joyce was nearly fifty years old and went to London, England, to do some genealogical research would she glean a notion of who she was.

Three generations of Joyce's paternal family were show people on the English stage.

Her father's ancestors, Hollanders who had come to England as tumblers and acrobats, played for the court of William III (William of Orange) in the seventeenth century. Succeeding generations continued the tradition by performing in circuses as bareback riders, trapeze artists and dancers, with some of them scattering into the music halls.

Joyce's great-grandfather, George Arthur Wieland, launched his theatrical career in 1825, at age fifteen, playing a monkey at the Drury Lane Theatre at a time when monkeys onstage were all the rage.

London's Drury Lane had been a street of fine Tudor residences until the area fell into disrepair, but it eventually rose to lasting fame through one edifice, the Drury Lane Theatre, built in 1663. Destroyed by fire in 1672 and rebuilt two years later, it is the oldest theatre in London still in use. The beautiful Nell Gwyn, whose status as an orange seller outside the theatre (audiences showed their disapproval by tossing orange peels at actors onstage) escalated sharply on her becoming mistress of Charles II and England's most celebrated lady of the stage, made her debut at the Drury Lane Theatre in 1665. Despite a period during the late seventeenth century of having to overcome its notoriety as a cockfighting pit, the Drury Lane Theatre is where England's finest performing artists gained their reputations over three centuries, playing vaudeville, Shakespeare, French farces, and dramas by Britain's "angry young men." The current fare is slightly more

eclectic, given the popularity of Neil Simon and American mega-musicals.

Members of the aristocracy avidly patronized the Drury Lane Theatre while the masses found more suitable entertainment in the music-hall tradition at the Pantomimes, affectionately called "the Pants," where other members of Joyce's family, including her father, would perform. The name itself provoked the ribaldry that is a staple of English humour. Whether the brow be high or low, the English loved their Pants, and the bawdy, bumptious English music halls were a place of engagement for three generations of Wielands.

Joyce's grandfather followed his father's monkey act with a career as a ventriloquist in Ballerina Burlesques, a vaudevillian spoof on classical dance, and acted there with Charlie Chaplin's father. He went by the name "Mr. Wieland," and what the name lacked in theatricality was compensated for in performance. His reputation was given historical significance by none other than Charles Dickens, who referred to Mr. Wieland as possessing a "grotesque humour of no ordinary kind."

Joyce's father, Sydney Arthur Wieland, born in 1879, was the youngest of an unknown number of children from his mother's first of two marriages. A premature baby, Sydney was so tiny he slept in a shoebox placed on the opened oven door. Arriving into circumstances endemically deprived, young Sydney managed to survive, though just barely. His formal education approximated grade three and at age eleven he was put out to work — not unusual for England's poor and orphaned children, who had been virtually enslaved in factories and mines since the onset of the Industrial Revolution.

Young Sydney's first job, as a blacksmith's helper, proved far too strenuous for the weak, undernourished lad; one day while pumping the bellows he suffered an immense strain on his heart, one that apparently caused permanent damage. Sydney's was the grim but familiar fate that countless children suffered for having been put to work to help support their destitute families. (Joyce's older sister Joan, too, would find herself at age fifteen sacrificed into paid work on the altar of family necessity.)

In the mid-1890s, when Sydney was about fifteen, he and four of his brothers followed their father's music-hall footsteps by putting together a song-and-dance act. Billing themselves The Five Wieland Brothers, they played in the hordes of travelling shows that toured all over England, and remained together as an act for about three years. Sydney, a skilled ventriloquist, seemed to be the most accomplished. One Clara Wieland, possibly a sister, sang and danced in the Pantomimes, according to a theatre program dated July 27, 1895.

The Five Wieland Brothers' stage career collapsed in tandem with the waning music halls' waning popularity, a situation that reduced the Wielands to working as agents for trapeze artists and clowns at the Westminster Aquarium. Not a stellar career, as Joyce learned. "Even people in the music halls looked down on the Aquarium," she said.

One of the Wieland women, whom Joyce called her Great-Aunt Zaeo and described as "a lower-class, chunky chick," performed at the Aquarium, an act in which she executed a backward somersault and a fall "from a great height to a net," according to one clipping. Joyce said, "She did a world tour and became notorious for her astonishing leap and dive." A review in *The Music Hall* dated August 16, 1890, carries the headline, "Zaeo triumphant!" She caused a scandal when a photograph of her in her scanty trapeze costume appeared in a newspaper. Later, Zaeo shared the bill with another young performer, a girl named Zaza, who was shot from a cannon. Zaeo ended her performing days in a fire-eating equestrian act, and at an age when she was unable to trapeze and ride horses she booked "acts" outside the Aquarium — that is, she rented stalls to hawkers selling food, drink, and souvenirs.

Joyce kept a poster in her studio that she'd had made from a blow-up of a photograph of Zaeo wearing the famed scandalous outfit, posed on a trapeze swing. "I was fascinated by her," Joyce admitted, and claimed her as an inspiration. She would also have empathized with the great-aunt after learning that Zaeo had been an orphan.

Sydney's most renowned family member was his great-uncle, Sir

Charles Hood, who had been knighted by Edward VII. His son, Captain Basil Hood, an army officer, songwriter, and playwright ("One of our most finished and poetical playwrights," according to *The Green Room Book*), collaborated with Gilbert and Sullivan. When Gilbert had his famed falling-out with Sullivan, Joyce's great-uncle, Basil Hood, replaced him as lyricist.

Dorothy Hood, Sydney's cousin, who had been described as a "typical English rose," was a ballerina, and her sister, Marion Hood, was a singer and actress. Joyce kept a photocopy of a playbill from the Gaiety Theatre, in which Marion played the lead in a play called *Dorothy*; she also sang in a "nautical comic opera," *Billee Taylor*.

The smell of greasepaint and the roar of the crowd made a lifetime imprint on Sydney's soul that persisted long after he had to forsake the theatre's insecurity for steady paid work in his twenties. Like many uneducated, resourceful young men lacking lineage, Sydney grabbed at whatever came his way — carpentry, paperhanging, and painting. Joyce's sister Joan recalled that their father could do "just about anything, even fix shoes," and that he loved gardening.

For a short period of time Sydney established a business as a pest exterminator. A recipe for flypaper was found among Joyce's papers, penned by her father in a flourishing style:

"Recipe for flypaper:
Formaldehyde 40% by vol.
Equal part water
With Lysol or [illegible]'
Signed *S. A. Wieland*

Another recipe was found: for rat poisoning, arsenic one part to ten [of water]; and for mice, one part to fifteen.

Eventually, Sydney settled into working as a waiter, beginning at

Simpson's in London, a luxury dining lounge. Such establishments gained popularity at the turn of the century as members of the nouveau riche emerged from commerce and industry, and retaliating against the nobs for excluding them from their private clubs, they founded their own clubs — that is, deluxe restaurants. Before long, the new money evolved into a highly visible new class: café society. Vivaciously, conspicuously, they stepped out in their new finery, flaunting their fast-growing success dining and dancing at The Ritz; and to serve the country's nouveau riche, more stylish restaurants opened, more waiters were required. When not working in top restaurants, Sydney signed on as a ship's steward. Which was not, as will be seen, entirely his preference.

Joyce's mother, Rosetta Amelia Watson, was born in 1902, one of the three girls and three boys of Mary Jane Cooper and Charles McKiller Watson.

Mary Jane was descended from the Coopers who owned a cotton mill in the Midlands, and was a wealthy heiress when she met the dashing Charles McKiller Watson, a Scot from the seaport town of Dundee on the Firth of Tay. Well dressed, tall, with gleaming black hair and a handlebar moustache, Charles was a charming, handsome man, and a bit of a rake and a bounder. He married Mary Jane, then promptly went through her money as quickly as he took up with other women. Charles was said to have had "itchy feet," a discreet euphemism for his predilection to relocate; he and his wife moved so frequently that no two of their six children were born in the same place.

Wherever they lived, though, Charles found work in his trade as a draper — then a respected cloth and dry goods trade — his specialty being draping funerals. Early in the twentieth century, the upper classes assigned extravagant pomp and ceremony to a death in the family. A deceased person was typically laid out in the family home so that friends and relatives might come and pay their respects, an occasion solemnized by the hanging of black curtains above the bed. People of wealth draped the entire room in which one of their dead lay, a practice that gave rise to

the expression "a crêpe hanger" or "hanging crepe," in describing a person who always expects the worst. Draping at its finest involved the most expensive silks and velvets sculpted into artful shapes and decoratively clumped and arranged around bedposts.

Charles travelled in northern England and Scotland, and when gold was discovered in South Africa in 1886, his itchy feet took him there, along with a pack of other adventurers, runaways, and dreamers who had previously swarmed to Australia's gold rush in 1823. Before setting sail to South Africa, Charles left his family a parting gift: a ton of coal. If this surprised Mary Jane, she had another surprise a month later when she received the bill.

The fortune Charles sought in gold resulted from softer goods: draped cloth. He achieved the crowning glory of supplying draping for the funeral of Paul Kruger, president of the South African Republic (Transvaal) from 1883 to 1900. From this huge state funeral in 1904 there remained so much leftover cloth that Charles sent the remnants home to Mary Jane. She and her children wore clothes made of purple and black velvet for years.

Joyce believed that Charles was in South Africa during the bloody Boer War of 1889 to 1902, which could have linked him to Kruger. She said, "After leaving on one of his lengthy trips he never returned." (He died at the age of eighty-five in 1925.)

Several pages of Joyce's handwritten notes, accruing from her sister Joan's writings and the trip Joyce took to London for genealogical research, sketch out her lineage, and whether Joyce fantasized it or knew it for certain, she believed that her mother, Rosetta, was Charles's favourite child. "She had a great fighting spirit. She would tell him off at a very young age." Rosetta inherited her father's black hair and Joyce noted that when the father came home he would ask, "'Where is the black bugger?' That was his intimate expression," although Joyce then added that he would try to put her over his knee "to whack her but he could [not] bend her."

Joan wrote that her mother was "a strong-willed, spunky one," who at

age sixteen ran away from home. "I think she couldn't identify with [the kind of] future her sisters had [as] women who were very mild-mannered and never married." Rosetta cut her long hair, stuffed her corset up the chimney and "got on a train to London," where she worked as a waitress.

In 1919, Rosetta journeyed to Liverpool and found a job in the bakery of the restaurant where Sydney Wieland worked as a waiter after returning from the war as an ambulance driver, Joyce believed. (Joan made no mention of this in her notes.) During that time, Rosetta earned extra money making and selling colourful red, white, and blue paper flowers at Victory celebrations marking the end of the First World War — flowers described by Joyce as so beautiful they looked real. She said her mother was always very good at making paper flowers, clothes, and shortbread.

Details are sparse and dates are missing, but the salient factor is that when Sydney met Rosetta he was already a married man with three children. His marriage came to a dead end in Liverpool when he met the sassy young girl from Lancashire. Rosetta was nineteen and Sydney, a worldly forty. Rosetta lived over the restaurant — restaurant owners commonly provided living accommodation for single female help — and Sydney would climb on the roof and into her room at night. He persuaded Rosetta to go with him to Brighton, where he had a better job offer. By Joan's account, he "charmed the pants off" their mother. "Literally."

Rosetta and Sydney could have entered into a mock marriage of some sort, to appease bosses or nosey neighbours. In those days living common-law was scandalous, and even the most daring couples would have disguised their living arrangements in a Sunday-best subterfuge. Soon, however, the wife discovered her estranged husband's whereabouts and began to hound him, forcing Sydney and Rosetta into her father's tradition of moving from place to place.

They went to London, where they could safely set up housekeeping while shielding their unmarried status. They had a daughter named Rosetta, who died at the age of one year. Two other children followed: Sydney (always called Sid), born in 1920, and Joan, the next year. Keep-

ing one step ahead of his legal wife, Sydney worked most of the time on steamships and was seldom home.

In 1924, when Sid was four years old and Joan three, their father, in a drastic and final attempt to shake off his wife, set sail again — this time for America. Using the alias "Sydney Spink," he landed in New York, safely evading any English law applying to bigamy and/or family desertion, crimes then punishable by imprisonment. He got a job as a railroad steward and Rosetta joined him a year later. She worked at an Automat for almost a year, until her illegal status was discovered and she was ordered deported. Canada, as a member nation of the British Commonwealth, was the couple's obvious choice of destination and the two of them journeyed to Toronto. Neither knew a soul there, or for that matter anywhere in Canada, but they must have determined that the large city would effectively conceal Sydney's double life. They arrived in about 1926.

Joan painfully recalled her unhappiness when her father left the family to go to America. She was only three years old and Sid four. A greater blow followed the next year when their mother departed.

The children's maternal grandmother, Mary Jane Watson, was a cold and stern woman — neither Joan nor Sid had ever been hugged or kissed by her. She wore long black dresses and white bib aprons, and pulled her grey hair into a bun apparently as tight as her heart.

It appears that the unfeeling grandmother refused to care for her two grandchildren when her daughter went to the United States, so Rosetta had arranged for the children to live with the family of their former nursemaid, Carrie Pepper. (A paid nursemaid was and still is a convention of upper-class English families: a young woman with nursing training comes into the house for a few weeks to help the new mother recover from childbirth. Working-class families emulated the practice by hiring an affordable local girl, whom they called a "nursemaid," to do household chores.)

"It was a miserable year we put in there," Joan wrote in her family history. The Peppers' teenaged son Tom, whom Joan described as a

mental case, tormented her and Sid with stories of witches and bogeymen who stole children from their beds at night. The boy was constantly leaping out of the dark at them, frightening them silly. He insisted that lightning would strike the youngsters blind, creating in Joan a fear of thunderstorms that rent her entire childhood. And he would horrify them by sticking a needle in and out of his palm. "God, what a nightmare for two small children!" Joan exclaimed.

She remembered "old man Pepper" as bald with a frizzy fringe around his ears, a drunk with "a terrible temper." Joan lived in fear of him and his son. She suspected she had been molested by either one or both of them, although she noted, "I have blocked it out."

Sid and Joan lived with the Pepper family until a friend of their father's, a man named Hart, paid a call on them — apparently after having received word from Sydney in the United States. Appalled by the children's undernourished, nervous state, the man took the youngsters home with him. Joan described the Harts as "lovely people. . . . Mrs. Hart prepared wonderful meals for us and bought us new clothes and a few weeks later put us on a ship bound for Canada." Joan's last sight of England seen through her tears was the Harts on the dock, waving good-bye. Mrs. Hart was crying, too.

Aboard the *Mauretania*, Joan said, "I cried my eyes out."

Who paid the children's passage, which would have been considerable even in steerage, is uncertain. Sydney and Rosetta both had been earning salaries in New York and may have pinched together the fares. The Harts may have contributed, as well.

Entrusted to the care of the ship's nurse, Joan and Sid were settled into a below-deck cabin in a tiny, dingy room that caused Joan nightmares and she often awoke screaming, fearful of the unfamiliar surroundings and the dark that Tom Pepper had manufactured into such an aversion for her.

When the ship docked at Quebec City, a woman engaged by their parents met the children and escorted them to Toronto by train. At Union Station a black-haired woman rushed toward them. Sid flew into her

arms, but it took the shy, confused Joan a moment to realize that this woman was their mother.

The child then spotted a man on the sidewalk watching them. The mother asked if they knew who he was. Sid knew. This man, their father, swung Sid up in his arms. But Joan recalled, "I didn't know him; after all, I had been only three when he had left us."

Sydney had found work as a hired hand on a small farm outside Maple, Ontario, about twenty miles north of Toronto. The place was "sheer heaven" for Joan. Having grown up in crowded, noisy London, she welcomed the quiet, the "wide-open spaces and fresh air." Spoiling her elation, however, was Joan's discovery that her father lacked real interest in her. He teased her "unmercifully" about her fear of the dark and her bed-wetting, although he tried alleviating her dread of thunderstorms by explaining that the noise of thunder was caused by angels bringing in coal for the winter. But Joan felt he made no attempt to understand her fears. "Sid, of course, was Daddy's boy and could do no wrong."

Within about a year, the family moved into the city so that Sid and Joan could attend school; they were enrolled in Ryerson Street Public Schol, a ten-minute walk from where they lived. Sydney got a job as caretaker in a movie house and the family lived in the flat above. Joan remembered starkly the afternoon she and her brother were watching a movie and a pedophile enticed Joan into the seat next to him by offering her a nickel; before she knew it, he had thrust his finger into her vagina. She shrieked in pain and the pervert ran out. Afraid at first to tell her mother, Joan eventually blurted out the story in order to explain the nickel.

Shortly afterwards movie-theatre owners were legislated into hiring matrons to keep an eye on children during Saturday matinées, and at Sydney's next workplace, the massive Orpheum Theatre at Queen and Bathurst streets, their mother worked part-time as the matron.

Living above a theatre on a busy main street, the Wielands found their only neighbours were shopkeepers, mostly Jewish, whose children, Joan recalled, kept to themselves. Joan and Sid had no friends. Without play

space and only the rush of Queen Street traffic out front, the two kids got on each other's nerves and spent much of their childhood fighting — physical fights that involved punching and hair pulling.

To make ends meet, Sydney Wieland augmented his low-paying care-taker's earnings with odd jobs. This kept him away from home once again and Joan felt increasingly distanced from her father. She reported, for example, trying to smoke one of her mother's cigarettes, which got her "the spanking of my young life," although no other reference to any form of parental discipline occurs.

Joan never felt loved by her father, but later in her life, when she became a mother of four, enduring her own share of financial, marital, and parenting troubles, she softened. In her sixties, Joan wrote, "Nothing ever seemed to go right for us, no matter how hard my father worked. . . . But looking back now, I know that there was very little money to spare and Dad did the best he could with what he had."

The family moved to Claremont Street in 1929 when the theatre that employed Sydney was converted to talkies and the owner remodelled the space taken up by the Wieland flat for extra seating. Their house on Claremont Street, halfway between Queen and Dundas streets, adjoined another one next door. Called a cottage, it had two rooms upstairs and two down. Joan and Sid shared a room with a stairway running right through the middle, providing space for only two small cots. A shed behind the kitchen housed their privy. There was no furnace, no bath-room; everyone took a bath on Saturday night in a tin tub on the floor in front of the fired-up stove.

Joan's and Sid's clothes were bought at church rummage sales, mended and fixed up through their mother's seamstress skills, and their furniture was acquired from the Salvation Army, then repaired, repainted, and refinished by their handyman father. A kitchen wood-and-coal stove was their sole source of heat; Joan remembered shivering in bed on cold winter nights, sleeping under piled-up coats.

Their neighbourhood was poor, characterized by immigrants of mixed nationality, and it remains much the same to this day except that the predominantly Jewish and Polish families have been replaced by Portuguese and Chinese. (Now the area is dotted with old brick houses painted in startling colours of cherry red, mint green, and yellow, and front yards ablaze with flowers.)

The few English families considered themselves superior to the European immigrants and there was little co-mingling; each group associated mostly with its own. Sydney Wieland denigrated his immigrant neighbours. The British, possessing historic entitlements to snobbery, could find, regardless of their social standing, someone ranked lower to condescend to, and Sydney, who had travelled three continents and had been in the English theatre, enjoyed the riches of a varied life — one vastly different from (and superior to, he thought) that of his factory worker/labourer European neighbours. Joan described her father as a person who kept his distance from most people. Sydney, who had left school while still a child to go to work, would have had no meaningful life experience as a student, of learning to get along with his peers, playing sports, having fun. Lack of everyday socialization — a prime breeder of distrust — surely soured Sydney's attitude toward a world that had been so hard on him as a youngster. His years onstage would have been his training ground in human relations and yet, because of its transience, this, too, would have inhibited his ability to create lasting relationships.

Sydney's stand-offishness has a more compelling explanation: he was in fact a wanted man who had deserted a legal wife and children — reason enough for him to be circumspect. He must have harboured the dark fear that one day there would be a knock on the door . . .

Joan's impressions of her father would remain stark. She accepted his two distinct characteristics: that he was difficult to understand, and that he was a snob. It puzzled her as to why her father felt that the neighbours didn't measure up, even the English neighbours — except for Joan's school friend Grace Blake, a girl as shy and withdrawn as Joan, who

played the piano and spoke softly. Grace introduced Joan to a rarefied new world. At the Blake home, Joan discovered that people had fine furniture, not cast-offs, full sets of matching china, a shiny electric stove, a basement furnace, and, most luxurious of all, music. Grace played the piano and Joan heard "the most beautiful music this side of heaven": Brahms, Beethoven, and Chopin. Joan's new friend also took her to the library and there she found her second love: books.

Children don't think about their home life while living it; adult memories fill in the blanks, do the aggrandizing, downplaying, and adjusting. The adult Joyce contradicted Joan's account of her parents' isolation from others, saying that their parents used to go out at night to play cards with friends. But both Joan and Joyce were in agreement on and spoke highly of their mother's cooking, despite the family's impecunious circumstances.

Joyce was born at home on June 30, 1930, during a summer storm that "shook the bed," she had been told. An omen of a child's troubled future? A heavenly clamorous welcome? Ancient myths assign supernatural powers to storms, none more potent than the lightning and thunderbolts in Greek mythology that symbolize phalluses, and the presence of liquids — rain — which personify female primacy. As it happened, phalluses and menstrual blood would appear powerfully in Joyce's art. Mythological creatures, too. Joyce's life could be defined as dominated by myths and riddles; many of the good ones she embraced, while the evil others — contemporary political, feminist and ecological myths — would engage her in a passionate, lifelong battle. Mythical or calamitous, the storm provides a dramatic backdrop to Joyce's entry into the world.

At her impending birth her father ran to a neighbour's to call the doctor (like all poor families, the Wielands had no phone), only to learn he was out of town. Sydney then dashed to the nearby police station and returned with the police surgeon. Presumably more accustomed to treating gunshot wounds than delivering babies, the surgeon hid his ineptitude behind an upside-down newspaper he pretended to read

during Rosetta's labour — an incident that remained a long-term family joke. Largely, the police doctor left Rosetta in Nature's hands and Joyce entered this world at 2:00 a.m. on that stormy last day of June.

"Joyce was the apple of Dad's eye from the moment she arrived," Joan said. "And I was thrust more and more into the background of family life."

Sydney, then working full-time as a waiter at the Royal York Hotel, mostly serving at banquets, also took on odd jobs doing house painting and carpentry. Yet he was "never too busy to spend time with Joyce," according to Joan. He must have fantasized about Joyce's little baby feet dancing on the musical stage, carrying on his family tradition, for he daily exercised her arms and legs and massaged them with oil, which "managed to spoil her altogether rotten." Sydney even entered Joyce in a baby contest and although she did not win, the proud father never stopped bragging about his adorable baby girl.

Joan thoroughly resented Joyce. She couldn't understand how her father afforded it — and she brooded over the fact — but Sydney hired a woman to come in and help with the newborn Joyce's care while Rosetta recuperated. Typically in those days, women spent a week in hospital after giving birth and if circumstances permitted, rested at home for another two or three weeks. Joan was assigned to look after her baby sister, about which Joan felt "really put upon," and as for Joyce's intrusive presence in the house, Joan added, "Usually she just howled."

Among Joan's chores was taking Joyce for walks in a big wicker pram, an image that conjures up pure Norman Rockwellian sisterly love, a notion which could not have been further from reality. Little Joyce was the cause of Joan's increasing sense of alienation from the family; she felt more "unloved and unwanted" than ever. Suffering partly from middle-child syndrome, partly from her shy, timid personality, Joan began retreating into her imagination. In time, she found solace in thinking of herself as a changeling, dreaming that her "real" parents would soon come and claim her.

In 1933 the family moved to a small cottage next door. No bigger than a two-car garage, it was the kind of housing that was snapped up by poor families, for whom doubling up was a given. At that time people routinely lost their homes, which was proclaimed for all to witness by large eviction notices pasted over doors of houses where the rent had gone into unacceptable arrears or mortgages had defaulted, leaving numerous streets defaced with home after home bearing the public stigma of the family's private misfortune. Occasionally, a British flag would be seen tacked to a door, signifying that any act committed to physically evict the occupants, even posting the notice, would result in the greater crime of defacing the national flag. A visit from the bailiff was ignominiously marked by a family's worldly possessions appearing on the street, the door to their former house padlocked. Hordes of people fled their indebtedness under the cloak of darkness and hunkered down in cramped, cheap flats as though weathering out a tornado. Whole families moved in with relatives who had managed to retain a roof over their heads. Many people took in a roomer for an extra dollar or two a week; with butter at twenty cents a pound in 1933, a dollar had considerable buying power. If money woes eased somewhat, crowding wrought another set of problems — inconvenience, anxiety, resentments, lack of privacy and bickering. For Depression-era children, the idea of a room of one's own was so far-fetched it was yet to be conceived.

Sydney immediately set to fixing up the tiny cottage. An innovative man, he created the home improvements for his family that money best bought through enormous personal effort. He cobbled together makeshift pieces of furniture — no mahogany dining-room sets or armoires having been inherited from Grandmother — and he painted the place. His green thumb working overtime, he planted a vegetable garden and flowers. He built a chicken coop and raised chickens — another curiosity by today's standards, but in those lean days backyard chicken coops were common for families hard-pressed to put food on the table.

Accepting that the British have long taken the lead in eccentricity, and

mindful that odd behaviour is eccentric in Mayfair but barmy down at the docks, the well-travelled, resourceful, clownish, music-hall performer, family deserter Sydney Wieland was certifiably eccentric.

Not a traditionally handsome man, a bit on the pudgy side and slightly balding — a condition that preoccupied him and had him trying endless hair-growing remedies — Sydney Wieland never went out of the house without his bowler hat tilted at a jaunty angle. His threadbare suit was always neatly pressed, his shoes polished. He manifested a rather intimidating presence with his erect posture, courtly demeanour, and his penetrating, amber eyes. Lacking pocket money but rich in resourcefulness, he made his own beer and wine, and when he got a few under his belt he would bring out his straw hat and cane, do a soft-shoe shuffle for the family, and sing his music-hall songs.

At times he entertained neighbourhood kids with a ventriloquist act, giving voices to flowers, chickens, and any stray cat that happened by — antics that had other youngsters slapping their knees and pleading for more, especially his bit about making his belly talk. Meanwhile the man's offspring cowered in embarrassment. Joyce said that this was where she first understood, at age five, the sensation of being mortified. "I would get embarrassed to my roots. I was a little person and I had total embarrassment." Sydney's specialty of giving voice to a little man in his potbelly flung the kids into fits of wonderment. Joyce recalled, "He would throw his voice and talk to him. 'How are you doing?' Sometimes the little voice would say, 'I am hungry.' He would say, 'What is it like in there?' The kids thought it was real. They just knew there was a little person who lived in Mr. Wieland's tummy. The young audience was completely fascinated with him, as they were aghast [at] the little man that lived inside him." But all of them wanted to know, "When can we see him?" Just as eagerly, they would ask when Mr. Wieland was coming back.

Forgetting for the moment her preceding comment about being embarrassed, Joyce added, "Father was so lovely. I can now see him as this great big warm person with all this love coming out. I have never seen it

before. It was love. He showed his love to the children."

Joyce's memories are quoted from a transcript of a therapy session conducted in 1987 with a psychiatrist in Yonkers, New York, who was a disciple of or had studied with Carl Jung. In this session, the doctor used some form of hypnosis, possibly combined with drugs and images, either real or suggested, of various body parts, in that his notes appear as, "Administered with EP 26, exposed brain," and "EP 28, hearts," for example. (This may have been a form of narcoanalysis, a psychiatric therapy in which drugs such as sodium pentothal, Ritalin, and even LSD are administered to a patient to induce a semi-wakeful state. The drugs act as a "truth serum" that releases suppressed feelings.) Prompted by the therapist, Joyce discussed various body images. Unless otherwise noted, her comments are taken from this transcript.

Although Joyce seemed to be touched by the love her father bestowed upon his street audience, she also recalled another reaction when she stated, "I feel gyped." This comes as a surprise. Joyce's comments directly contradict Joan's account of Joyce as the favoured child. Joyce, however, believed that her father loved only the neighbourhood children and her mother. "Between the two of them," Joyce told the therapist, "I did not get much. Their relationship was the most important. My sister said the same thing. She felt like a shadow on the edge of it." On another occasion, Joyce declared, "We were like wallpaper."

Had Joyce understood that her father was performing as opposed to expressing love for the local children — a distinction she would have been unable to make at age five — she might have thought differently about feeling gyped or being like wallpaper.

Joan was probably correct in considering Joyce her father's little darling, and yet, like Joan, Joyce also recalled his aloofness. When she was six, Joyce offered him a Christmas light she had found. "When I gave it to him, it was like I gave my whole heart and soul, like I was in love with him. It was like the primal scene. I was filled with love. I was madly in love with my father, but I could never get the response [I needed]. He

said, 'Oh, that is nice, thank you.' But it was cold. I could never get him to be with me. He was always with my mother. I was always starving around the edges."

Albeit, Joyce had explicit recall of an earlier, tenderer father. She was four then. "I go to my mother and father's room. I get into bed with my father. Mother gets tea. I have Father to myself. Mother brings tea to us and we have sliced oranges with it. . . . My father and I have tea and oranges and we have a little talk. I tell him a lot of stuff. I am talking away like I haven't seen him for years, but it is my time with him. I make up a lot of stuff that will really knock him off his feet. I tell great stories, where I am going, etc., and [with] a little exaggeration. It was really great lying beside him. He is being very nice about it. I want his attention and I think up really great things. He seems to find them charming."

The age-old, atavistic yearning of daughters to seek patriarchal approval is conspicuous in these remarks, as is Joyce's disappointment at being unsuccessful at it. Although her concerns were valid and serious, they became tempered over the next few years. She had happier recollections of when she was five or six and her father would clown around at home, singing and dancing, doing his music-hall shtick.

In fact, Joyce admitted to experiencing "bliss" as a youngster in the company of her father. Nothing suggests that Joan exaggerated stories of Joyce's preferential treatment; Joan likely observed this pampering when Joyce, its recipient, was too young to recall it. However, another explanation could be that when Joyce reached age five the Wieland family had begun its descent into an irreversible spiral of misfortune. From that point onward there would be few pleasant memories for any of the children to treasure.

During the above-mentioned therapy session Joyce was fifty-eight years old. Her feelings then were substantiated by a later session with a different psychiatrist. She told the second therapist that she had come to realize that her mother's relationship with her husband was "so important" that it diminished their offspring. "When [my father] came home

from work, the whole place came alive but when he went to work I would feel sad, feel this depression around." This was because, Joyce believed, her father made her mother's life "bright."

Clearly motivated by show-business potential, Sydney taught his children acrobatics, and the seasoned performer in the man emerged regularly in his corny old jokes and music-hall songs. "I'm Champagne Charlie and Champagne's My Game," was a favourite, along with anything by George Formby — England's cowpoke without a horse or ten-gallon hat, whose banjo-strumming ditties about washing windows and leaning against the lamppost thinking about "a certain little lady" held Brits in his thrall for decades. Sydney also fancied tongue twisters like "Peter Piper." Joan told of him making up one of his own: "'I slit the sheet/and the sheet slit me/ slitting was the sheet/that was slit by me.'" He goaded Joan into saying it, waiting for her to mess up so he could "laugh his fool head off."

Without money for medical care, and no medical insurance, Sydney assumed full paternal responsibility for his wife's and children's health with his own home remedies. He concocted a "particularly vile-tasting tonic" made of malt, beef marrow, and cod-liver oil that he forced on the children every day. He painted sore throats with iodine — although this ghastly business required a five-cent bribe — and any one of them showing the slightest sign of a head cold would be instantly gargling with salt water. Another odious habit was dosing his children with Epsom salts to keep them "regular."

There is no doubting Sydney's position as king of his small, bereft castle; and, "My mother, bless her heart," wrote Joan, "was his willing slave." She wondered what her mother saw in him, but the conjugal ties between her mother and father were never frayed by the rough grind of their circumstances. Joan considered her mother a feminist long before the word existed, exemplified by Rosetta's leaving home when "nice" girls did not, and holding a job and being independent. But Joan also concluded that her "lovely, spirited mother" was "putty in Dad's hands." Her father's "eyes would sparkle and his dimples flash when Mom was near."

Joyce recalled in sharp detail her father kissing her mother, placing his hand around the nape of her neck, and "then he hugs her." Asked by her therapist how she felt about this, Joyce replied, "It is beautiful. It makes my heart swell up with love."

Probably Joyce's earliest memories involve her father arriving home from work. "My greatest image was [of] that little cottage when we were waiting for Daddy to come. That should be the title, 'Waiting for Daddy to Come.' We would say, 'He is coming, he is coming.' That was the big moment we would all go crazy, when he would come home. Like he was the breadwinner and he was coming home and what surprises would he bring home."

Those "surprises"? Leftover foods he pilfered from Royal York Hotel banquets.

By Joyce's description, "He had special pockets sewn into his overcoat. He was magical. There would be French tarts and things on one side of the overcoat, and one side just for meats." She mentioned loaves of bread, "good bread." Sometimes the family would enjoy the filched treats in the middle of the night. As Joyce visualized it, "He brings a steak out of his top pocket and it is wrapped in paper towels. . . . Then he brings out little pastries that are small and he shows them to me like he is serving them to me, like in a hotel. It is marvellous. He puts a white towel over one arm like he does at work. Then he sits with the three of us." She added, "Father has a beer and it feels like we are having a party. To me it was always like a party to meet up with him."

The sisters' contrasting natures are evident here. Joan downplayed her father's peccadilloes and Joyce rationalized them, presupposing his pangs of conscience with, "He is saying that this is for my children."

Joyce's recollections of these late-night celebratory feasts (at the end of Sydney's shift) uncover essential elements of her father's jollity and the time-honoured means by which men express their love for their daughters differently than they do for their sons; sons get playfully punched, wrestled, and fished with, and daughters don't. As Joyce described it, "I would

be sitting on his knee and he would take things out [of his overcoat], you never knew what it would be. He would let me open the bag and take something out." She understood. "Father is playing and teasing with me. [He would say,] 'Oh, there is something there,' and then he would say, 'Oh, I found something. Whose is this?' Then he gives me the whole bag with everything in it. He is getting a kick out of me and I am crazy about him." She described the play-acting as, "Making it into something, rather than just giving a bag of stuff." Joyce, too, played and teased. "I go into his pockets and see what is there. I find a penny. I yell I want it. I tickle Father. I pull his nose. He pretends that it hurts, and he pretends that he is crying. He hides the stuff I put on the table. . . . I leap around. I am happy."

We don't know if the following account is actual or conjured as Joyce wished it to be, when she said, "He tells me I am his favourite." And she reported their play-acting: "He would sing, 'There's Something About a Soldier,' and he would keep time. I am marching and kicking up my legs." She had just turned six. Joyce said her father wanted to teach her a skill, "to develop my talents. I had to do this marching and look cute and perform. I can appreciate what he is doing. He is trying to protect me. . . . I needed a skill."

Later, Joyce's attitude was not nearly so benevolent. She said her father wished all his children to be performers "so he could make money off us."

If Joyce was being cynical, this only confirmed her vacillating feelings about her father. She felt loved and then "gyped." The flip-flop recurred in her feeling acutely embarrassed about his performances for the neighbourhood kids and then thinking him "magical." She described an image of herself nursing at her mother's breast when her father came in and put his arms around her mother: "He kisses my forehead, Mother too. We are happy, the three of us there. So happy together. They are happy that they have me. I am overwhelmed with bliss. There is so much bliss to be had."

And sadness. She imagined her father at age seven in England, on the street, performing, begging. He brought home a penny.

Joyce referred on several occasions to her father reading a magazine

and drinking a glass of his home-brewed beer. He did not overindulge, although in the following incident he came close.

The Royal York Hotel hosted an annual Christmas party for employees' children. Joan, at age fourteen, had thought herself too old for such kiddie events but at her father's insistence, she'd attended. She vividly remembered him being tipsy that night — not the worst part of the evening.

Arriving at the party, Joan tried her best not to be impressed by the hotel's massive crystal chandeliers and plush carpets, although she admitted to devouring party sandwiches, petits fours, and fancy ice creams, the likes of which she had never seen before. Her father was working a convention on a different floor and he would appear at the kids' party periodically to distribute a few extra treats he'd spirited away for them. Joan smelled wine on him. As the evening progressed he became louder and jollier, telling tales about the wild party on the other floor. One has to accept Joan's account, fantastical though it appears, but apparently the convention involved a zoological attraction featuring a live donkey prancing on the banquet table and a red rooster sitting on the guest of honour's head.

Somehow, Sydney managed to nab the rooster, which he hid in his locker.

Before they left for home, he brought Joan upstairs and she peeked into the banquet room. Food was stuck to the walls, splintered chairs were scattered around, and the long banquet table was strewn with broken dishes, spilled food and wine, and donkey dung. The maître d' was listing damages in a notebook and a busboy was scraping Baked Alaska off his tunic.

Joan and her father left the hotel — Sydney with the rooster tucked under his arm — and the two of them caught the streetcar home. With the rooster flapping and squawking, Sydney performed for the carful of passengers, regaling them with jokes and songs — all except one woman who was not amused when the rooster left his calling card on her shoe.

Joyce described this event to the therapist, implying that she was there, too. She recalled her father appearing at the kids' party with cake

from the banquet and that she, Joan, and their mother sat at the back of the streetcar pretending they didn't know the madman with a goose. (Not a rooster.) The inference drawn from Joan's version is that only she went to the party; perhaps Joyce imagined being there, based on Joan's picturesque retelling of events.

Once off the streetcar, Sydney did a soft-shoe shuffle down the street, and when a policeman observed the dancing man with the squawking rooster under his arm, Sydney bowed, tipped his bowler hat and burst into song: "A policeman's job is not happy one."

Memory's selectivity maddens. That horrifying events are stored and sear the brain until death is one of life's sorry perfidies; and that despite vigorous hosing down of the mind, the worst memories still smoulder. Fear and humiliation resist measurement when vying for the degree of anguish they cause, but Joan's embarrassment over the Christmas party remained for her a permanent, disfiguring scar.

In 1935, when Joyce was five, the family moved to Dovercourt Road, a better neighbourhood than the previous one, and this time they had indoor plumbing. But no hot water, which meant they still had to heat water on the stove for baths. They took in a roomer, one Mrs. Growson, whom Joan disliked intensely (and who returned the sentiment), but Joan was repeatedly warned not to annoy the woman because the family could not afford for her to leave.

Joyce was yet to start school, whereas Joan had finished her first year of high school, and Sid, who hated school, quit at age sixteen and got a job at the Orange Crush plant around the corner from their house.

Their neighbourhood was like many others, in that light manufacturing plants were located within heavily populated residential areas, for easy access to the labour pool. This mix of industry and housing had begun in the couple of decades prior to the First World War when immigration swept the nation in two distinct waves — those who were lured out west by government land grants, and the great numbers of unskilled Europeans

not attracted to horses, plows and wheat fields who crowded into Toronto's mid-city to find cheap housing and factory work. As public transportation developed in the city — the first electric streetcar rolled onto the tracks in 1892 and the system had greatly expanded by 1921 — large plants moved out of the downtown area. Sydney never had been part of the neighbourhood labour pool, which was another reason for him to feel superior as he boarded the streetcar wearing bowler hat and pressed suit to his downtown job at the city's finest luxury hotel. In her later years Joyce took a few sentimental journeys back to the old neighbourhood and was pleased to notice that the Orange Crush plant had been converted to studio space for artists, designers, and small dot-com companies.

Joyce's father began taking her, at about age five, to tap-dancing lessons every Saturday morning. She detested it. She cried on the streetcar all the way. Her father did not make a lot of money as a waiter and tap-dancing lessons would have been a sacrifice to the family budget. In vain, it proved. Apparently Sydney pinned his vaudevillian hopes on Joyce rather than on Joan or Sid, although when Joyce tearfully protested he would have seen in the child's tears his music-hall traditions washing away before him, particularly his most immediately treasured fantasy — little Joyce popping out of cakes at conventions at the Royal York Hotel.

Placed beside the bed that shook the day Joyce came into this world was her father's large leather trunk containing the props of his music-hall acts. Among them were dozens of silk flags from half the countries of the world. One imagines Joyce caressing them, arranging them, playing the colours against each other; but whatever her thoughts, they obviously did not include dreams of tap dancing and twirling the lovely flags, or any other items, onstage. As a child what she loved was to draw. She drew on paper bags, on the walls, in her sister's books, which infuriated Joan, and on any scrap of paper she could find.

Little is known of Joyce's parents' regard for her art. Obviously, they would have noticed her interest but they may not have assessed it as talent. During that time, families such as hers had scarcely taken one step

out of the Great Depression before being stopped in their tracks by the gathering storm clouds of the Second World War. Coping with the pervasive daily unrest may have been doubly worrisome for Sydney Wieland if he had anticipated wartime conditions such as being called up for reserve military duty or some other form of community service (at age sixty in 1937 he would have been too old for active military service), for which a routine background check might have risked uncovering his double life. Sydney and Rosetta's uncertain future undoubtedly eclipsed any contemplation of their starry-eyed little girl drawing pictures.

In adulthood Joyce frequently described herself as a happy person. And more than one friend reported Joyce talking about her memories of early childhood as being those of a carefree, contented little girl. Compulsory tap-dancing lessons would leave no lasting sting and the ten years separating Joyce and Joan — eleven between her and Sid — all but eliminated the usual sibling scraps that children born closer together engage in. It is reasonable to accept that Joan suffered from her father's favouritism of Joyce and that Sid seemed somewhat outside the orbit, which left Joyce as the centre of that family's universe. Largely free of childhood despair, she blossomed.

Many a family history is freeze-frozen in snapshots typically curated by mothers who have spent evenings arranging them on the black pages of a photograph album according to milestone birthdays and holidays, relatives and pets. As the family life unfolds on the pages, the viewer draws instant conclusions. Very few Wieland family photos have been found, however — quite likely because the Wielands did not have a camera. Items that could not be handmade and required the full retail purchase price were luxuries this family and others like them did without. Given that Rosetta and Sydney had fled England, they would have packed only enough possessions to fill Sydney's leather trunk and possibly a couple of suitcases. Joyce recalled that her mother brought with her from England a china figurine of a bird in a tree, and a teacup and saucer. "She loved those things. They reminded her of England." The few existing

Wieland photos may have resulted from Sydney borrowing a camera from a fellow waiter at the hotel, or from the Mundays, a kind family with whom they shared their house. Of the early snapshots, one shows Joyce as a sweet-looking child of about three or four years of age, sitting on steps with her mother in front of what could be their home. Joyce wears a fine little coat and a pleasant look. Her mother, too, wears a nice coat and expression. Four other pictures of Joyce taken at about the same age are equally ordinary. In fact, both Joyce and her mother are better dressed than one would have thought, given their circumstances. By the look of things, Rosetta created a few silk purses out of sow's ears.

The ordinariness of the lives captured in these photographs would, in another few years, be riven by the chaos that befell the Wieland family.

The force of Joyce's adult exuberance that scattered cascades of fireworks upon those around her must surely have flared in her preschool years and created a similar, endearing attraction. We can properly assume this. Her humour and high-spiritedness would have surfaced early, based on what is known of character and personality development before the age of three.

She made drawings as a very young child. But similar to the missing pieces from Joyce's early history, like cut-outs in the old-fashioned table-cloths she so admired, her childhood drawings disappeared. They are not to be found.

Had they been kept, it is safe to suppose that Joyce's drawings at about age five would have expressed her jollity. Suns and bright colours surely would have dominated. Art educator Viktor Lowenfeld says that a child's earliest impressions of self can be clearly interpreted in the first scribbles. A two-year-old scribbles with a crayon on paper with no creative purpose, apparently, but the results are highly indicative of the mind and emotional status of the little being holding the crayon. Random, disordered scribbles signify a child with little control over his or her emotions. A series of circular swirls indicates openness and a need for variety, whereas straight lines drawn up and down or from left to right in a

repeated pattern are clear signs that the child has control over his or her motor ability and, in addition, can be seen to be gaining self-confidence by mastering the task of repeating the images. But a warning sign is inherent in these line scribbles; if rigidly repeated, they could signify an emotional block. By age three or so, the child gives names to his or her images — cat, mommy, house, tree — and regardless of how representational these images are, often discernible only through a loving mother's eyes, they are an important developmental stage, leading in another year or thereabouts to the child's most uninhibited depiction of his or her feelings. However, just as a challenge confronts a theory before the ink is dry on its documentation, in this case the painter throws the gauntlet at the academician. While the educator cited earlier considered that roundness in drawings signified openness, painter George Grosz considered that a painter who painted in circles was close to madness. That Joyce readily used circles in her adult drawings and paintings might demolish Grosz's theory, but perhaps another interpretation can be made, that the "madness" referred to by the painter may be deemed a fine, well-developed aesthetic madness. Hokusai, the master Japanese draughtsman, said he was "mad on drawing."

Artists possess well-defined sensitivities; they feel, therefore they paint. In fact, a certain amount of competition over sensitivity exists among artists, quite like arguing over who has the better colour sense or who the finer handling of light. Super-rivals Jackson Pollock and Willem de Kooning carried this debate to a quaint absurdity when Pollock told de Kooning, "You know more, but I feel more."

The genetic sensitivities possessed by Joyce's forebears are a mystery. Apart from Rosetta's hard-hearted mother and Sydney's mother's two marriages, little can be determined from this emotional inheritance. In that Sydney and Rosetta seemingly loved one another more than they loved their children, they appear to have possessed average sensibilities, and it may be assumed that the heightened emotional makeup Joyce revealed at a very young age was a second- or third-generation patriarchal legacy. To be sure, at age six or seven Joyce exhibited social sensibilities.

Her parents noticed this in her reaction to newspaper stories about needy children.

While it seems clear that Joyce possessed joyfulness, when she was about six and reading quite well she developed an acute sensitivity to the misfortunes of others. The compassion Joyce expressed throughout her adult life may have originated as a six-year-old from stories she started reading in the *Toronto Daily Star*. During the summer months the *Toronto Daily Star* ran appeals for readers to contribute donations to the Star Fresh Air Fund, a charity established for sending poor children to summer camp. Stories recounted the impoverishment of first-name-only children who had never experienced the joys of lakes and trees, boating and campfires. Another column, titled "Today's Child," was an appeal to adopt the featured orphan or foster child. Stories highlighted the youngster's pluckiness in the face of heart-tugging circumstances and the child, photographed smiling bravely through neglected teeth, often had a rare illness.

These stories upset Joyce terribly. In her mind, she likely saw these youngsters as singled out and held up to pity, like some perverse "Wanted" poster. Joyce cried and fretted over the stories so much that her parents cut them out of the paper so she wouldn't see them.

Initially, one can interpret her anxiety as overwhelming sympathy toward the less fortunate, but this bears closer examination. Perhaps Joyce included herself in that category of inner-city youngsters unable to go to camp, or she believed that an orphaned child was the saddest thing on earth. She may well have given thought to herself becoming an orphan, as children do. Obviously the dark thoughts in her mind hurt Joyce, who upon reading the stories went from being "us" to being "them."

And then one day — the ominous words announcing bad news — Joan was walking home from school when her brother came racing after her on his bicycle, his face red and contorted. "He's taken sick," Sid blurted out. For a moment, Joan didn't know whom he was talking about. Their father, of course.

Sydney Wieland had suffered a heart attack. He was weak, close to death. The doctor feared that his condition would not improve. The family breadwinner incapacitated, no wages coming in, what were they to do?

It was then that Joan learned of her mother's estrangement from her family. Rosetta had been heartsick and bitterly disappointed that her sisters and especially her mother, the cold woman with the tight hair and starched apron, would not take in her two children when she left to join Sydney in New York. She had no family to turn to in Canada, no one in England, no friends to lean on.

Joan believed their mother regretted losing touch with her family. "Sometimes she would get homesick for England and would talk about her brothers and sisters, and I could sense her loneliness. My heart ached not only for her, but for all of us, for we were strangers in what seemed to be an alien land with no one to guide us."

Typical of that era's domestic makeup, the mother and children were dependants in the absolute definition of the word. The way Joan phrased it, "Dad had always been the strong, dominant one in our house and when he was laid low, Mom was really at a loss. Oh, she tried to put a brave face on it but I knew she was frightened."

Their desperate plight demanded the remedy of strong medicine: Joan and Sid would have to keep the family going.

Sid got a job as a busboy at the St. George's Golf and Country Club in Islington, a west-end bastion of old Toronto conservatism, a job prized more for its future opportunities than for the fullness of its pay envelope. Consequently, he could provide only a few dollars a month toward expenses — not nearly enough for the family of five to live on.

There was no alternative; fifteen-year-old Joan would have to quit school and go to work.

Joan dreamed of being a writer. She loved school and the thought of quitting sickened her, but the family's survival took precedence over any of her trifling little fears, ambitions or desires. She saw that her mother "was worn out and sick with worry."

"Joan," Rosetta said finally, "we have to eat and pay the rent. There has to be money coming in."

During the Great Depression, hundreds of thousands of professional men and women, teachers, office workers, university graduates, and skilled tradesmen could not find jobs, and Joan, who was able to type but had no high-school diploma, faced the prospect of only household work and office cleaning. Anyone in the high-end labour pool was grateful to land a job in a factory or department store that paid six, seven, or eight dollars a week. People had suffered hard times since 1929; casualties were mounting. Throngs of people formed in lineups outside factories and offices, hoping against hope that a job might become available — crowds that were rivalled in size only by those at soup kitchens. In this grim year, 1937, Joan too lined up.

Meanwhile Sydney had been moved to a bed in the living room and slowly, remarkably, he improved. Joan prayed he would fully recover so that she could finish school, but the doctor said Sydney's heart condition prevented him from ever working again.

Joyce was not yet six when her father took ill. Her outstanding memory of the time was of bleakness; a household of dark, hushed fear. "It was so barren, filled with the atmosphere of death," Joyce told the New York psychiatrist. "So it was all dead and dying and 'Don't make any noise.' There was very little happiness there." She spoke of bathing her sick father in his bed and subsequently asking her mother for a penny. "'There, that's the last one,' she said," Joyce recalled. "I don't remember whether I took it or not, but that's when I discovered what guilt was."

Guilt, and more. Her father's illness caused an irreparable setback in Joyce's childhood development. From the moment he became ill, the oppressive, fear-filled atmosphere of the house caused a sudden social/psychological meltdown in Joyce. It suspended the free, rambunctious expression of herself, which prevented her in those crucial childhood years from commencing the process of forming her identity. Endlessly cautioned to be quiet and not make noise imposed on Joyce an unrealis-

tic, gigantic sense of responsibility for her father's well-being, suspecting that if she made a noise he might die. These personal anxieties, combined with the blanket of fear and anxiety hanging over the family, trapped Joyce in an omnipresent dread that disaster could strike at any moment. And it would be her fault.

Of course Joyce could not know the grave psychological harm she was inflicting upon herself when, seeking an escape for her unhappiness, she blocked out her memory of it.

That the father's illness brought the family to its knees and stunted Joyce's personal development is true, but the time also established Joyce's first validation of her worth as an artist. She was "allowed" to visit her father in bed periodically — by her recollection, only once or twice a day — and on those occasions she presented him with drawings she had made. She remembered that they pleased him. Her father's approval of her drawings — and by extension his approval of her — enabled Joyce, for a few brief moments, to pierce the gloom.

Luck made a timely intervention on the strangulating grip that joblessness held on the family when one of Sydney's co-workers at the Royal York Hotel contacted him about a job opening that might suit his daughter. With that solid a connection — "pull" was the word then — the position was Joan's for the taking. This wonderful job prospect? Cigarette girl at the hotel.

Joan couldn't believe that her parents approved of her taking such a degrading job. She would have to wear a tarty costume and walk smiling among men, a tray of cigarettes and cigars hanging from her neck. Men terrified her. People terrified her. She protested that she didn't know anything about being a cigarette girl.

Joan recounted that her father "looked at me with fury in his eyes, and said, 'This man is doing me a favour by giving you this job and I expect you to make the best of it. I expect you to do me proud.'"

One wonders what discussions the mother and father had, coming to this. Contrasted with the toughness of her father, Joan saw anxiety in her

mother's eyes. Rosetta tried to be cheerful, saying that Joan could do the job, the money would be a godsend — she was a mother clutching at a sudden life-raft of fortune that would keep her sick husband and children afloat.

Though Sydney's words were harsh — if Joan has portrayed them accurately, and there is no reason to believe otherwise — he too would have lived in fear for his family, expecting he might never again be able to support them. Who knows what went through his mind, pondering such an eventuality? How did he reconcile his pride against the steely hard truth that destitute children were placed "in care" (the going term for orphanage)? Sydney was likely not concerned about the welfare of his son, a sixteen-year-old who already had a job. And should worse come to worst, Joan too was old enough to take care of herself. This left the people Sydney cared most about: his wife and six-year-old Joyce. These two must thrive. In view of his son's insufficient wages, Sydney would have had no compunction about sending Joan out to work. On his behalf, she could save his wife and baby daughter.

At the hotel, quaking with embarrassment, Joan donned the skimpy uniform and tried to be a smiling cigarette girl, but after an incident where men laughed at her for dropping her tray she went to the change room and shed her uniform. The man who had hired her — the only kind person she had encountered the entire day — understood. He asked to be remembered to her father.

Joan was warned that she would have to go into service — be a maid or housekeeper — if she could not find another job right away, and shortly afterwards, Rosetta heard that the Neilson's chocolate factory, a few blocks from their house, was hiring. That night Joan prayed for the job. A combination of answered prayers and a woman who felt sorry for Joan in her obvious, desperate need for employment got her a job packing cocoa in tiny sample-sized cartons for give-aways at the upcoming Canadian National Exhibition. Every Friday Joan handed over her unopened pay packet to her mother, who in turn gave Joan a dollar as spending money.

One evening in November of that year, 1937, after Joan had been

working for six months, she came home from work to find the living room where Sydney had been sleeping in darkness, her mother's eyes red-rimmed. She didn't have to be told that her father had died — ten months after he had taken ill. Sid was seventeen, Joan sixteen, and Joyce, six.

Within the framework of their family plight, there is a grim appropriateness to the stark comment Joan made immediately after she described sobbing at the funeral: "I went back to work the following day and life went on."

Throughout the years, Joyce confided to friends about the desolation she experienced over her father's death and she clearly remembered having been left destitute. With no such luxury as a pension or life insurance, the family would have gone hungry if Rosetta had not swallowed her pride and applied for welfare. In addition, she resorted to her sewing skills and made rugs at home, which Joyce called "sweatshop stuff."

Among Joyce's pure Dickensian memories of the period after her father died was a freezing house in wintertime.

One cold day when there was no coal for the furnace, Joyce's mother gave her some pennies and sent her to a coal yard on Queen Street, near Toronto's landmark Hospital for the Insane, its proper name then but known colloquially by its address on Queen Street: "999,"(pronounced "nine ninety-nine), the three numerals that connoted everyone's nightmare fear of madness.[1] Joyce would have heard bizarre tales of its residents and while hurrying past the grim institution, pulling her sled, she was surely terrorized by the common childhood nightmare of an escaped crazy man chasing her with a knife, naked — they were always naked. At the coal yard her frightful appearance must have tripped the owner's heart, for Joyce returned home with much more coal in the sack than her pennies warranted.

On other occasions she dragged her sled along the railway tracks in search of bits of coal that had scooted off the stoker's shovel. Of that time, Joyce said, "I had to face what economics were. And bill collectors."

Her mother had made Joyce a winter coat that she cut down from one

of her own, a red garment that touched Joyce's ankles and was collared in old-fashioned red fox fur — the kind of gauche, homemade coat at which schoolkids hurled their cruel, contemptuous barbs. Joyce hated the coat. It publicly epitomized her hand-me-down, low-class existence.

She defined this period of her life as "the most obscene poverty imaginable."

As she did with many a childhood injury, Joyce in her adulthood converted the fox-collared red coat into a therapeutic symbol. It helps explain Joyce's penchant for dress-up, as if those early taunts emboldened her later to wear daring, sensational clothes. Costumes, actually. Clothes as distanced from the basic black dress and pumps as are rhinestone-studded purple leather skirts and red cowboy boots. One can also read in Joyce's mature fashion style defiance delayed, her willful retaliation against the schoolkids' derision, the way the person who, after reaching stardom, returns to her small hometown sporting mink and diamonds — or the reverse, in up-yours disarray — to strut before those who mocked her as a kid and are now screaming for her autograph. One thinks of Janis Joplin.

Chapter Two

Joyce could recall with shimmering clarity her very first emotional response to pictures. Tears fell all over her Shirley Temple pyjamas as she looked at the picture book, *The Story of Doctor Dolittle*, with its charming illustrations by Hugh Lofting. Her next visual fascination was with Beatrix Potter's *Tale of Peter Rabbit*. Over and over, Joyce said, "I didn't think there was anything more beautiful than Beatrix Potter's drawings."

Joyce remembered a junk collector down their street. "He knew my older sister loved books, so he brought them over to our house," she said,

adding, "although we were very poor, we felt rich having these books." She and her sister would spend hours with them, "admiring the illustrations." She explained, "After these experiences, I wanted to create pictures myself."

Joan, whose love of books was acquired from her grade-school friend Grace, passed on the passion to Joyce. "It was absolutely fantastic" to be taken to the library by her sister, Joyce said, where she first encountered "these incredible books," particularly Beatrix Potter's. Joan "showed me everything" and "made me into her student," which was, Joyce noted, "quite an education."

A child quickly outgrows one infatuation in order to accommodate the next one steaming into the emotional reservoir, but Joyce never outgrew her adoration of Beatrix Potter's drawings of rabbits and ducks, squirrels, hedgehogs, and cats. They filled her with wonderment as a child and enchanted her all the more as an adult, if that is possible. Not only did the Beatrix Potter drawings thrill her, they awakened Joyce to the power and mysterious lure of art. Like anyone struck by art, she must have felt the jolt to the central nervous system that hits in a shower of glorious little mini-shocks, and from that moment, life is never the same again.

Second to animals, Joyce loved hearts. Throughout all periods of her life — before attending school, during grade school, in high school, in her first and last artworks, in letters to friends and in her diaries and date-books — Joyce painted, drew, crayoned, pencilled, doodled, cut out, and sewed hearts. Round, slim, puffy fat, elongated, coloured the full spectrum of red and pink — and the odd black one, for good reason, as will be seen — Joyce's art hearts were as close to her as was her biological heart. If a single symbol represented Joyce, unquestionably it would be a heart. Why would a heart, the immediate representation of love and romance, so captivate the young, preschool Joyce? Her confusion about her parents' love for her, feeling adored one minute and shut out the next by their devotion to each other, the tears she shed over children too poor to go to summer camp — all clearly indicate that as a very young child Joyce's heart experienced joy and pain in the extreme. An early Valentine

card found among her personal papers is cause for speculation and may offer an insight into her undying devotion to hearts. Probably received when she was in grade school, the cutesy little kiddies' card bears an elementary scrawl, "Will you please write to me?" One wonders, with sinking woe, if this was the only classroom Valentine Joyce received that year. Or, in the contest of popularity and yearning that is Valentine's Day for grade-school children, was this singular greeting so painful that Joyce refused to save any others she may have received? Or does this represent the mean hard reality — that she received so few?

Hearts and animals among the endless flurry of images in her mind, inspired Joyce to draw. For as long as she could remember, she drew. "I was always drawing. It was like an everyday thing," she said. A small child may be encouraged to draw when a crayon or pencil is placed in the hands but the youngster who becomes an artist does not need any encouragement to draw; you can't stop him or her. Compulsively, the child picks up a crayon because a new sensory space created by that first pleasurable shock wave of images craves to be filled. There is no doubt that Beatrix Potter was Joyce's prime artistic influence, but whether this single visual stimulus was capable of shaping her into an artist cannot be known. Certainly, one event can constitute a life-altering force, which may have been the case when Joyce first saw Doctor Dolittle and Peter Rabbit, but more conclusively the artistic impetus surges through exposure to numerous visual stimuli. If Joyce's artistic development was sparked by Beatrix Potter, it exploded when she discovered another visual medium: the movies.

The first movie she saw generated in her two irreversible sequences: an eternal torch she carried for the movies, and an unstoppable desire to draw the actors in them. This life-altering movie? *The Charge of the Light Brigade*, made in 1936, starring Errol Flynn and Olivia de Havilland. One of the early costume/action movies known as swashbucklers, the genre would become formulaic in its scenes of derring-do, fabulous sets, glamorous costumes, heroes falling in love with beautiful raven-haired maidens, for which Hollywood appropriated the word *colossal*. Joyce, among

millions, had been colossally smitten.

Joyce drew pictures of *The Charge of the Light Brigade* from the time she was eight years old until the age of twelve. The textures and colours of the period clothing imprinted on her a lasting attraction to fashion and design. As well, the movie generated in her an entrepreneurial streak. She made her first pocket money as an eight-year-old, drawing the stars of the movie in pretty costumes and selling them to the girls at school for five cents, and drawing naked ladies, which she sold to the boys for ten cents apiece. Very early on, she grasped the enhanced value of erotica.

The idea of making what she described as her "pin-up girls and erotic drawings" occurred to Joyce from having noticed the comics kids were buying. Comic books, that cornerstone of 1940s and 1950s kidlit, were pervasive — parental approval or not. Dog-eared, traded, filched, and fought over, they were also *read.* Scarcely a pre-television boy or girl was not influenced by *Archie, Spider Man, Dick Tracy,* and/or *Little Orphan Annie* for their deeds dastardly and funny. Joyce discovered, "You could buy comic books that were fairly filthy so I thought if they can buy those, then they'll buy my drawings."

She "developed a steady market" for her dime-priced naked ladies and with her earnings bought "stuff I wanted" — comic books, pencils and crayons, plus "lots of junk." Remember, this was a child who heretofore had received only second-hand things, no store-bought junk.

Joyce had learned something about survival. Her father was dead, she had become shamefully familiar with bill collectors and welfare; the pittance her mother brought in from sewing was never enough. Making and selling her drawings sharpened Joyce's survival instincts — and more. The junior entrepreneur had to identify her prime market — naughty boys with an allowance — and then advertise, make presentations, take orders, negotiate price, arrange for delivery, and administer her inventory and cash return. Word of mouth would have made her job easier but the initial push required just that — pushiness. Through this childhood venture Joyce developed the necessary skills of self-promotion, salesmanship and admin-

istration of her affairs, and with them, served an apprenticeship in tenacity of the kind that would characterize her life's work.

The Charge of the Light Brigade soon activated Joyce's drawings from static images to moving comic strips. She discovered that with a pencil she could create sequential happenings and control her characters' actions. One of the comic strips she drew featured a female spy named Agent x-9. "x-9 never got out much," Joyce said. "She was always worried about what she was going to wear. She was always looking in at her wardrobe, always playing with her hair." Autobiographical without a doubt, but for Joyce her most powerful recollection was: "The colours were fantastic in that comic strip."

Joyce's favourite place in the house was the kitchen table, where, she said, "I made all my things and drew." This common household spot is the starting point for many artists, where they discover that pencils and crayons can execute their make-believe schemes and, in Joyce's case, it was the place where she could dream her dreams and escape. She didn't know it then, but her art would become as integral a part of her everyday life as was the kitchen table.

In the 1940s little girls whose heads swirled in dreams, desires and far-fetched imaginings like Joyce's played with cut-outs. A book of cutouts slaked dozens of wishes at a time. These books featured cardboard figures of pretty girls and page after page of line drawings of fashionable outfits that the youngster typically coloured with crayons; then with scissors she would carefully cut out the girl figures and the coloured clothes. Next came the really exciting part, as wardrobe manager. She would lay the cut-out clothes on the cut-out girls, folding strategically placed tabs to hold each outfit on. This, of course, could be an endless occupation, what with dressing and undressing and redressing, mixing and matching skirts, blouses, jackets, coats, and accessories.

Joyce made beautiful cut-outs. By this time, prompted by her drawings from the movies, Joyce's fixation with cut-outs far exceeded a childhood caprice over clothes and fashion. Moving up from paper cut-

outs, she ventured closer to the real thing by making doll clothes, no doubt with the help of her mother, the expert seamstress.

Along with drawing, comics, movies, cut-outs, and making things on the kitchen table, Joyce's cultural development was enriched by her sister's introducing her to music. On Saturday afternoons Joan would call Joyce into the living room, saying, "It's time for you to come and hear this. This is opera." And Joyce would listen to the New York Metropolitan Opera broadcasts. Not only was it a musical education that would endure throughout her life, Joyce said she was flattered by her older sister's attention. "She really wants my company. I am her follower." This statement would be all the more apt, and more poignant, in a very few years.

Just before Joyce turned nine, she came home from school to find her mother in bed, bleeding, but Joan wouldn't tell Joyce what was wrong. Less than two years of widowhood and grappling with her children's survival, Rosetta had developed uterine cancer. In later years Joyce told friends about carrying out pans of her mother's blood, about the bloody sheets and cleaning up after her mother. A few days later Joyce returned from school and her mother wasn't there. She was in the hospital, explained Joan.

Joyce never saw her mother again. She said, "I went crazy. I was always looking for my mother and father."

Dispossessed of a watchful extended family of parents, grandparents, aunts, and uncles lavishing praises on the bright young artist, Joyce dwelled in a place alone with her talent from about the age of five or six. Receiving little external praise equated sparse self-praise. She didn't know her drawings were good because no one told her so. Her sick father had expressed his approval and quite likely her grades one and two teachers made favourable comments about her drawings, but at home all was imperilled by the father's illness. Out of the chaos resulting from his death and their mother's less than three years later, three orphaned children were

bequeathed nothing more than the grit to carry on and little inclination for fanciful contemplation of a sibling's drawings.

Apart from her movie drawings, Joyce spoke of drawing animals all the time. In interviews Joyce gave as a mature woman she referred frequently to incidents associated with her childhood artistic dowry. The emotional quotient marked them in her memory: the brown paper bags that contained delicious, illicitly-obtained treats from her father; her sister who got mad at her for drawing in her books; her sick father who apparently praised her drawings; the girls who paid for her costumed ladies from *The Charge of the Light Brigade*, and the boys who bought her bare-breasted ladies; and her comic strips that originated from the movies. Her drawings of animals were linked emotionally to her everlasting adoration of Beatrix Potter's animal portraits, and while emotions are attached to certain drawings, Joyce was like most burgeoning young artists — she drew because she was unable to stop the giddy obsession.

There is no account of how many or what kind of drawings Joyce did after her mother's death. One of two possibilities seems reasonable: that she found a safe haven in drawing, a hideaway where she could minister to her despondency with pencils, crayons, and paper, and she continued with her early childhood habit of drawing. Or, that her broken world over-powered creative expression and she did few drawings. Had she made some drawings, they may have gone missing during the peripatetic nine years following her mother's death. Years later, Joyce said that a lot of her draw-ings "got lost." Or Joyce may have destroyed them in a fit of bottomed-out worthlessness. The latter is not difficult to accept. In her fragile childhood state, Joyce would have equated trashing things with destroying feelings — the antithesis of her adult extreme of saving things, when having lost her childhood, she dared not let anything more slip away.

There is a two-year period following Rosetta's death that lacks details of Sid, Joan, and Joyce's living arrangements, but by accounts of Joyce's friends and her nieces and nephews, for the most part the three siblings

lived in cheap rooming-house flats. During those early years of the Second World War, Joan remained working at the chocolate factory and Sid got a job there, as well. With Sid and Joan earning about a dollar a day each (hamburger cost five cents a pound then; a couple of rooms could be rented for four or five dollars a week), the three of them scraped by.

Joyce's lifelong friend, Betty Ferguson, said, "Joyce spent a lot of time sleeping on people's couches."

Another friend, Linda Gaylard, recalled, "This was very difficult for Joyce to talk about. She never knew where she would be living."

Other than in miserable, one-sentence generalities, Joyce spoke little of the immediate aftermath of her mother's death, and left behind no coherent records among her personal papers.

Typically, when a family is struck by disaster other members of the family rally around, but without any relatives the orphaned Wieland children foundered. Even if friends or neighbours had come to their rescue, the results would not have been promising; poor people who take in poor orphaned children feel the strain before the first bowl of porridge is doled out. Financial pressures are compounded by dilapidated housing, pest infestation, leaky faucets, children doubling and tripling up in beds, babies crying, cold winters, sweaty hot summers; but these images cannot reflect the deprivation individuals feel when they are trapped and living without hope of respite from their lot.

At the chocolate factory Sid met Barbara Kerr, who soon became his girlfriend. Sid moved in with the Kerr family who lived in the Dovercourt–Bloor area, which was not much different from other working-class neighbourhoods the Wielands lived in except that it was largely WASP, not multicultural.

In 1942 Sid and Barbara got married. Shortly afterwards, Sid lost his job, joined the army, and was posted overseas. When he left, both Joan and Joyce moved in with the Kerrs. Joyce was eleven years old.

Joyce recapped those first years after her mother died by saying that overnight she went from being a "spoiled brat" to learning how to use a gas

stove and cook for her sister and brother. "The next thing I knew, my brother came home one day in uniform and that was the end! That was it!"

Feeling abandoned by both parents who had died, leaving her without a home, and then being abandoned by her big brother, Joyce experienced a sense of spiritual and psychological loss that could be compared with a physical deformity that struck her first at age nine, like polio crippling one leg, and recurred at age eleven, disabling the other leg. The pain of abandonment afflicted Joyce throughout her youth. Not until she was in her early twenties would she receive some relief. Still, the hurt never went away.

Putting aside for the moment Joyce's struggle to cope during her pre-puberty years, she felt conspicuous about her day-to-day life. "Everybody was different from me. Sober and hard-working," she said in one of her rare references to growing up. At the end of the 1930s and into the 1940s, a terrible conformity ruled. People lived alike, thought alike, and largely behaved uniformly. Having no parents made Joyce stigmatically different, and then when fathers started going away to war, Joyce felt this stigma doubly; now she didn't even have a father who might go off to war and die. Alone with her oddness and with so much to hide, she may even have concealed her artistic bent, believing that it further alienated her from otherwise-normal kids.

One close friend of Joyce's spoke of an occasion that led her to speculate that sexual abuse may have existed in Joyce's past. Joyce and the friend were travelling by train to Montreal and a girl of six or seven was sitting near them with an adult male, the presumptive father. Joyce commented on the girl's behaviour, the splayed-legged way she sat, the coy interaction between the man and the young girl, and Joyce became noticeably agitated observing them. "Look at that," she said. "You know what's going on there." Joyce's troubled reaction to the scene had the friend wondering what secrets lay hidden in Joyce's psyche.

Another friend related a story similar in both detail and speculation, except that there were two girls "with no underpants" on the train with a man.

Beginning around the 1970s, the issue of recovered memories surfaced when psychiatrists found that memories of childhood sexual abuse, long repressed, could be recovered by adults who underwent certain psychotherapies, such as hypnosis and dream analysis. Opponents denounced the theory, accusing therapists of manipulating people's recall by producing false memories, especially where suggestible young children were involved. Joyce's sister Joan suspected that she had been sexually abused as a child in England by "old man Pepper" and/or his demented son, and for a fact she had been molested in the Toronto movie theatre, but she had "blocked it out." Apart from her reaction to the train incidents, there is no sign or record of Joyce having been a victim of childhood sexual abuse. Her father and brother were the only males in her young life and there was no highly suspect "Uncle Charlie" or weird neighbour man around. In one of her psychiatric sessions as an adult, Joyce used quite loving terms to describe her father's penis and also talked about her mother's vagina and breasts, along with other organs of both parents, especially their hearts and brains. Though sexually explicit, this account contains no hint of sexual impropriety; and none is implied. During Joyce's years from nine, when her mother died, to age eleven, when she and Joan were moving from place to place, other male strangers may have entered Joyce's life whom she seemingly erased. Friends wondered about this, but no one heard specifics from Joyce. It is conceivable that she experienced impressionistic echoes of some vague past dread, which would serve to explain the acuity of her suffering. It is also possible that she had been abused — just as she possibly may have assimilated Joan's abusive experience as her own — and that Joyce may have adopted sexual abuse as the cause of the excruciating pain her childhood inflicted on her, as though thinking, "It's not enough that my father and mother died and we were left destitute, something else more horrific must have happened."

Now it is known that Joyce erased a whole range of memories of those years, partly because of, says one of her psychiatrists, the darkness that was falling over her.

Through experiencing tragedy of an annihilating dimension, a child hides in a world of darkness, the psychiatrist explained. "The impact of such a loss [of both parents] is that you defend against it. You become dissociative, you cease to remember, you wipe out the memory."

In which case, Joyce would have started blocking out memory at age six when her father first took sick, and after her mother died the process would have achieved greater success; she had dimmed her mind to annul her pain.

One of four known psychiatrists Joyce saw over the years explains that when a young child loses parents, the child also loses his or her personality.

First, a child's identity is shared solely with the mother, then with the family unit. "You don't really get a sense of self until mid-adolescence," whereas prior to that you are not an independent person. You have a composite identity. You are a little kid, a brother, a sister, a member of the Smith, Jones, Chan, Steinberg, or whatever family. Parents are the mirrors of identity and when you lose your parent/mirrors, you lose the ability to develop as a person. Confusion, turmoil, and emotional anarchy take over." An "extremely blighted childhood," such as Joyce's, derails personal development.

Therapists commonly treat patients who have done such a thorough job of wiping out traumatic childhood memory of their parents' death that they cannot attach a face to the deceased mother or father. For some, the memory is so injurious that there is little recourse for the child but to obliterate the loss.

Joyce's loss had a catastrophic lifelong result for her chiefly because, the psychiatrist believes, she was more vulnerable than Sid or Joan. A psychiatrist is able to detect childhood vulnerability in the adult patient from evidence of incomplete personal development. Associated with such cases of arrested development are the remnants of infantile behaviour in an adult, which reveals itself as the adult having developed into a needy, insecure person, distrustful and fearful of things being taken away from him or her. In childhood these things are toys; in adulthood they are people. The mature Joyce retained both childlike behaviour and manner-

isms, which were part of her charm. Keith Stewart — a nephew, Joan's son — said his first impression of his Aunt Joyce was that "she was like a kid, like us." Joyce's nieces adored her playfulness. Throughout her life she never lost her childlike enthusiasm and wonder of things, nor did she lose her girly giggle and little-girl voice.

Tragically, though, Joyce lost her parents, and for years she sought the mirrors that would replace those of her parents. For the sake of her sanity, she found some.

Joyce and Joan lived with the Kerrs for close to three years, during which time both Barbara Kerr, now Joyce's sister-in-law, and Joan acted as Joyce's dual surrogate mothers. Joyce ran errands and did housework for Mrs. Kerr and baby-sat the Kerr relatives' children — one Joyce identified as, "Pardon my lingo but she's a bugger" (at that time, about the worst word a non-swearer could use) — and she earned two dollars a month, probably paid by both Joan and the Kerrs.

As common as bobby socks and bobby pins in the 1940s were the diaries in which teenaged girls penned their gushy, boy-crazy secret feelings before going to sleep at night, locking them up safely with a key that fit into a little brass clasp. Diaries were not a boy thing; their testosterone-thumping feelings got unleashed on the football field, at the pool hall, in yo-yo contests and clandestine self-pleasurings. Joyce started a diary when she was thirteen. In it, she heaped high praise on Mrs. Kerr's cooking, descriptions of whose dinners and birthday cakes Joyce always closed with an exclamatory "yum yum!" Mr. Kerr's role is enigmatic. Her opinion of him appears on only one page of a day's nondescript happenings that abruptly ends with, "Mr. Kerr is full of shit."

Joyce's diary was actually a small datebook divided into three days per page, allowing four lines for each day. With few exceptions, Joyce filled in every line of every day, starting on June 30, 1943, her thirteenth birthday, and continued her entries until just before Christmas. She writes with the

angst of any thirteen-year-old girl about the trivia and boredom of her life and clothes — "I look terrible," and her jumper "looks awful" — except that girls then were social stone ages behind today's cigarettes-sex-drugs-pill-savvy thirteen-year-olds. Here is Joyce's first entry:

> Dear Diary. Today is my 13th birthday. I got lots of stuff. I'm
> the happiest girl in the world. Everything is swell.

The very next day, she wrote, "Started out lousy with an argument as usual. Went to a show and saw 'Assignment in Brittany.' It was OK." And the day after, she noted: "Today was swell."

Highlights for July were that she had dinner at Mary's [we don't know which Mary this is] and played checkers — "It was fun" — and saw the movie *Random Harvest*. Someone named Butch worked with her on her Victory garden that "looks swell," Mary came over again and the two of them sewed. In these early years of the war, half the country was "knitting for Britain" and saving for salvage drives, and bandannaed Rosie the Rivetters assembled Bren guns at the Inglis washing-machine plant not far from Joyce's house. The effect of rationing and food shortages on Joyce can be seen in her noting that "soon I will be in 'Paradise' (Alton) to have fun and eat all I want again." (The Kerrs had a summer place in this small scenic town, less than an hour's drive northwest of Toronto.) On July 16 Joyce recorded that she arrived in the country safely. There are no entries for July 18 and 19; presumably she was having too swell a time in Paradise, although her next few entries are confused. It could be that Paradise got somewhat lost. And on July 30, she wrote, "Tomorrow I go back to TO. Hurray. Then on to civilization. Wow that's something."

In the month of August, Joyce went to eleven movies — she always called them "shows"— one with Mrs. Kerr and the remainder with Joan or Barb. She started August 3 with, "Prayed to go to a show and I did." After one show with Barb, "We had fish and chips yum yum." About the movie

So Proudly We Hail, she noted, "It was a swell picture all should see."

Also in August there was a great round of social activity — a shower for Barb, lunch with Betty and Ernie, and a supper with Betty and Ernie that ended with, "All I can say is yum yum." There was Pat's birthday. And one day she worked hard polishing furniture "and etc. and went on a spree and bought lots of junk."

Two entries stand out as emotional beyond others. On August 16, she wrote, "Today I went to Jeanette and Elizabeth's. They are a couple of dirty dames now. They smoke and put lipstick on too." And six days later: "I sewed Bill's pocket for him to-night and I sewed it good. I think Bill would be a swell brother."

Two days prior to returning to school she complained that she had nothing to wear on the first day of school and ended with, "Shit on Alma for — — —" Which apparently was something regarding a new skirt. Then on September 21 she stated, "Everybody hates me. Nobody loves me at all. They hate me like poison," and the next day she stayed home and "did work," but also, "I got my skirt today. Gee it's cute." Writing again in a few days about the skirt: "Everybody swoons in my path. Gee."

October 17 she recorded that she "painted some masterpieces today." On October 21 she went to the circus. "It was grand and thrilling. I am mad at Gloria too."

There are a number of entries in October about Joan and a boy named Bill breaking up, making up, *finally* breaking up, and then going to the show.

October 27 she noted that Gerald said hello. "Gosh was I thrilled. Sigh, sigh, oh golly." On October 30: "Today I stayed home. I am bored to death. I didn't go to any party. Isn't that a gyp. People don't care, do they?" (One supposes she was referring to a Halloween party.)

November 5 she wrote about going to a party that was "awful dirty. Lights went out and then mush began. It's awful. Some of them went to [the] cellar." And on November 10: "Tomorrow is parents night at Brock. [She stretches out the word *parents* to fill the whole line.] Golly wogs."

And a week later: "I saw the most wonderful art today at [an illegible word here]. Marvelous."

December 6 she went to the Ice Capades, which was "breathtaking. I enjoyed everything from [the] horse to [the] Blue Danube." And December 14 has only one line: "Boy Christmas!" One more entry, on December 18, noted that Christmas was not far off.

This was her last diary entry. One wonders why Christmas produced no mention. We will never know if it was because the season had been hectic and happy, or too disappointing for words. This would have been the fourth Christmas since her mother died.

Those same teen girls who had a diary also had what was called an autograph book — another clear indicator of gender distinction, since boys did not. Odd, this autograph book, a rectangular, hard-bound book the size of a postcard, with flimsy paper in pastel colours of pink, blue, green, and yellow. The book was passed around to classmates to "autograph," which is to say, write a few lines intended to convey the recipient's feelings toward the autograph-book owner. Typically, "Roses are red, violets are blue" openings ended in couplets slushy and sentimental, corny and comical, or plainly rude, and were signed or unsigned, leaving the autograph-book owner tickled as pink as the pages, or in tears induced by the unsigned cruelties of a nasty boy suspect.

Joyce had one such autograph book, whose first page identified it as hers, at age thirteen in Brock School, the same year as her diary. Inside the potentially full book, only six "autographs" appear. These, too, used the "Roses are red" refrain. One example reads: "Roses are red/Violets are blue/Honey is sweet/and Fraser too. Your friend Smallpox," signed with three X's. As written sentiment was considered a great risk, autograph signers couched their names in code. Joyce received signatures ending with "U R 2 good 2 b true," "Yours till butter flies," and ones that mixed word and symbol, such as "My" followed by a heart drawing, a pair of underpants, and "4 U." (Translation: My heart pants for you.) The following is an example of a "good" insult Joyce received: "Roses are

red/Violets are blue/When it rains it/Reminds me of you. Drip drip drip."

Passing around an autograph book is analogous to entering a popularity contest; you have to get to the finals before you know the winner. Joyce withdrew her book after obtaining only six entries. Does that mean she felt as though she'd "lost"? It is possible that she used her autograph book to put out a feeler to her classmates; and if that was the case, did she expect, *hope and pray*, to gain peer approval? Or was she conducting an opinion poll of herself and couldn't face the results? Although Joyce said she felt different from everybody else, her diary entries at age thirteen convey the activities and feelings of a fairly normal young girl with surrogate-family connections, who baby-sat and went to parties and movies. However, she *was* different from everybody else — in her heart, in her soul.

In later years, Joyce would tell friends how much she appreciated what her sister Joan had done for her, trying to be both a sister and a mom, and what a responsibility this had imposed on Joan.

Family secrets tend to erupt in the heat of the moment and it is quite possible that during such a heated period in Joan exposed the heretofore unrevealed family secret: that their father and mother had not been married. It is not possible to corroborate the exact timing, but what is certain is that Joan told Joyce when Joan may have believed that Joyce was mature enough to handle this information, probably during Joyce's teen years. (Later, when Joyce was about twenty, she told her friend Sheila McCusker that she was a "love child," by which Sheila understood — doubtless as Joyce intended it — that she had been conceived in love, not out of wedlock.)

Joyce was devastated by her sister's revelation. An orphan and now an illegitimate orphan? Joyce must have thought, "What next?" Abandoned by her parents who had died, and by her brother who had gone off to war, and then to be denied a legitimate birthright — what did this make her?

During the 1940s and 1950s, a child born out of wedlock was scorned, called a bastard, ostracized and ridiculed, and, as the growing child would

discover, would be deprived of certain legal rights. Given the moral climate of the times, and Joyce's vulnerability, she suffered greatly from this information, just as she would remain in "eternal mourning," she said, for her mother.

Joyce's defence was one she perfected for the rest of her life — first get mad, then cry, or vice versa; follow this with a joke perhaps, but emphatically, passionately, shake all the heavens and planets to find the courage to forge ahead. Surely she cried, and in trying to be courageous Joyce probably ran away into her private darkness until she could face the world, which she suspected knew all the sordid details. She could also trust her imagination as a retreat. Some years later Joyce described her affinity with her friend Pen Glasser, saying that "at its highest there is a meeting place which is silvery, where our spirits meet, somewhere just above us." Joyce may have been divining that special, bright place during those dark days in her teens.

It will be seen that Joyce romanticized the tragedies of her life in her art, just as she had done by telling Sheila that she was a love child. Although she coped with her multiple abandonments, she never fully recovered.

At age thirteen, we know that Joyce was drawing, which made her de facto an artist — "Made some great masterpieces today," she wrote in her diary — but she imagined herself in fashion. She could not fathom her life in art. However, nothing changed the fact that Joyce's bruised young life was consumed with subsistence. This stalemated her. It left her without resources to prepare herself during her preteen years for the headlong charge toward the gate marked "Artist." The attempt would have been foolhardy in the first place, and second, unreachable. Art? That was something you did last.

Financially, it was out of the question for Joyce to graduate from high school and take another four years at the Ontario College of Art (now known as the Ontario College of Art & Design). As it happened, even enrolling in high school had been iffy. The Kerrs pressed Joyce to quit

school and get a job at the chocolate factory with Joan, but Joan, already having suffered the fate of being forced from high school, would have no part in Joyce's quitting school.

From Brock Street Public School, in 1945 Joyce went to Central Technical School, located at Harbord and Bathurst streets, a short streetcar ride from where she lived. The first technical school in Toronto, opened in 1914, is where Joyce would "learn a trade," a practical notion foisted on 1950s kids who were not university-bound. When Joyce had made her childhood cut-outs and doll clothes she had learned about colour and design, the indispensable handmaidens to art, and at age fifteen and facing her options, she understood that she would ultimately be responsible for her own welfare, and that spelled *job*. With art out of the question, Joyce decided that along with obtaining her high-school diploma she would take dress design at Central Tech. In this field, she expected to find work.

Fashion designer Marilyn Brooks thinks that Joyce would have been a designer "way ahead of her time or from another century because she liked fantasy-type things." Marilyn believes Joyce would have worked in soft fabrics, in watercolour florals, and used beautiful trims and antique laces from another era — "no structured, serious suits. She was eclectic and she would have scoured the market looking for perfect buttons and used no two alike on an outfit," she remarked, as an example of Joyce's love of detail. Marilyn's comments are an apt preview of the personal fashion style Joyce adopted for most of her life.

Though Joyce expected she would never realize her dream of getting a job in art, a promising light in the form of art teacher Doris McCarthy illuminated Joyce's murky hopes.

Among her required classes was drawing, necessary to create fashion sketches, in which one of her instructors was Doris McCarthy, the well-known landscape painter who had discovered in the Ontario College of Art's legendary Saturday-morning classes in the early 1920s that a new style of painting was emerging among the upstart painters known as the

Group of Seven. Doris had been turned down for a teaching position at a Toronto high school because at age twenty, she was too young, but found a job at Central Tech in 1931, the year after Joyce was born.

At their first meeting, Joyce was enthralled by Doris McCarthy. "I never knew anything like her. I never knew a woman artist before," she said. "I can still remember her when I first met her." That was in 1945 and Doris had been teaching for fourteen years. "She was wearing a lavender sweater, hiking boots and she drove a Jeep! I wanted to be like her."

If Doris impressed Joyce, the reverse was also true. "She drew like an angel," Doris said, and she encouraged Joyce to transfer out of fashion and into the art department.

For Joyce, who had felt different from everyone else in grade school, Central Tech miraculously changed everything. The school and the art department granted her instant credibility. She was now an art student and for the first time in her life had an identity that superseded her family background. In this transforming, defining situation, before long Joyce was able to shed some of her feelings of alienation. Though bereft of parents, relatives, a proper home and security, here she connected and felt a sense of belonging she had never before known. Central Tech was as pivotal in Joyce's personal development as it was to her art. The hinge that connected the jollity and pranksterism of Joyce's personality to her intellect — one that had been repressed all these years — finally sprang open.

"We had so much fun," Joyce said. "The other students were all as poor and crazy as I was; we fooled around and acted silly, and at the last minute we'd scramble to finish a drawing because we really loved our teachers."

Joyce thrived on the looseness of the art program, such as Doris McCarthy playing music during class — a radical pedagogical turn, tut-tutted Board of Education sticklers. Head of the art department at that time, Peter Haworth, gave his teachers leeway to create optional subjects for students, with the intent of encouraging individual creativity. Doris had been doing this all along, using music as one way of expanding her students' lives beyond brush and paint.

In addition to Doris McCarthy, others whose instruction enriched Joyce during her years at Central Tech were the renowned sculptor Elizabeth Wynn Wood and painters Virginia Luz, Jocelyn Taylor, and Robert Ross. They were real *artists*. Joyce accorded them her deepest regard.

There is no indication that Joyce endured the typical adolescent anguish during her high-school years. Joyce admitted to Linda Gaylard that she'd been "a bit of a handful" then, but Linda could not remember "hearing about any antics or crazy things she did," just that it was "very hard on Joan having her around when she was a teenager," no doubt concerning Joan as authority figure to her sister. It is understood that Joyce got into petty squabbles with Joan and the Kerr family; one day's diary notes began, "Started out lousy with an argument as usual." Had these years been abnormally disordered there would be some supporting documentation, but none exists. Joyce's high-school years were likely less troubled than the average teenager's inasmuch as adolescent anguish springs largely from parental conflict, which was not applicable here. Obviously, her sister and the Kerrs laid down rules but not to the extent of some parents' harsh, unreasonable, or archaic restrictions (by their offspring's judgment) concerning lights-out, homework, sibling tormenting, dating, clothing, makeup, and hair. In high school, meeting kids as "crazy as I was," loving art classes and her teachers, Joyce began to find herself.

Joyce was not a brilliant student, but she was smart. Research conclusively shows that deprived children do poorly in school; however, emotional or physical deprivation is not exclusively linked to either success or failure. In Joyce's case, her childhood may have affected her marks but it did not thwart her life's achievements. For example, at the halfway term she received a 57 per-cent average. Her art marks were erratic. She attained her highest placement in Creative Drawing at sixth in the class, the same for History of Art, and received her worst marks in Life Drawing. Overall, she placed twenty-fifth in the class, and compared with a class average of 60 per-cent, she received 45 per-cent. Academically, she ranked number one in the class in Health and second in General Science.

She received a 40 per-cent mark in English and 47 in Mathematics.

Life-drawing classes would have involved a live model, male or female, but not a naked one. Models didn't even pose in bathing suits then. Art-college students painted and drew from nude or draped nude models, but not high-school students.

Why Joyce received poor marks in life classes is worth examining. Drawing the human body is difficult — proportionally, technically, aesthetically — the extremities in particular. The Great Masters could call in a studio assistant to paint hands or feet, just as the master painter summoned the "bird" man and the "cloud" man, as the master's deficiencies demanded. It could be that Joyce simply had technical difficulty with the human body; or, as suggested in her diary notations about "dirty dames," and like many teens with a negative body self-image, Joyce felt awkward about the human body — anybody's. She would overcome this reticence and go on to make highly-acclaimed drawings of the nude figure.

Mindful of Joyce's overall cultural development, Doris McCarthy spurred her well beyond the drawing board, urging her to study art history and learn about the world's great artists. With the dual encouragement of her art teacher and her sister, Joyce embarked on making an intimate acquaintance with the Great Masters at the Art Gallery of Toronto (now the Art Gallery of Ontario), and the rich antiquities of the Royal Ontario Museum.

What is more, Joyce's art education, formal and informal, had been under way for years at the movies. From the time Joyce was nine, Joan and Barbara had been taking her to movies, and Joyce's ranking them "swell" and "really good" indicates Joyce's appreciation. She was refining an aesthetic beyond images. Consciously or not, Joyce gobbled up nuances of the stars' costumes, makeup, and manners as voraciously as she downed fish and chips after the movie. Though smitten by silver-screen images, Joyce's artistic sensibilities would also absorb the related cultural worlds of dialogue, set design, art direction, lighting, outdoor landscapes, and musical scores.

Joan had started cultivating Joyce's interest in serious music during her preteens by exposing her to opera on the radio, and later she began taking her to concerts. This constituted a sizable investment in her little sister's "culturification." A top ticket price for a concert at Massey Hall during wartime was five dollars; ten dollars for the two of them would have been far beyond Joan's means, but upper-balcony seats "in the gods" could be sometimes had for a dollar, or fifty cents for the "five o'clocks," short early-evening concerts held at the unlikely University of Toronto football-stadium venue, Varsity Stadium. Add into the event streetcar tickets at five for twenty-five cents and perhaps a bottle of pop, five cents each, and a concert for two would have cost Joan almost half a week's pay. (Comparatively, it still does. At ninety dollars a ticket, an opera at the Humming-bird Centre for the Performing Arts in Toronto, with a couple of glasses of wine, is more than two hundred dollars.)

Joyce's exposure to music, along with movie scores, opera broadcasts, live performances at Massey Hall and the beautiful singing voice of her grade eight teacher, Mr. Eric Tredwell, which Joyce rated "top hole," primed her for the genius that is Mozart. Having made the master's acquaintance in her preteens, Joyce remained everlastingly in Mozartian love. She was heartbroken to learn that the child prodigy who matured to produce one masterpiece after another died a pauper at age thirty-five.

Captivated and enchanted, Joyce developed her first appreciation of artistic genius beyond the visual arts in Mozart and never lost her fascination for the fact that he wrote such a huge body and wide range of symphonies, chamber music, and operas. Like devotees for centuries who appreciated that his was the standard by which music was measured, Joyce signed on for life. She also identified with the young Mozart. She drew pictures before she attended school; Mozart wrote two harpsichord minuets when he was five. At age eight, Joyce achieved artistic success by selling her drawings at school; Mozart, when even younger, was touring European concert halls playing the piano, harpsichord, organ, violin, and on occasion, all of them. Joyce began buying Mozart recordings and never

failed to be enthralled by both his music and his disastrous life.

But it was Doris McCarthy who was her greatest influence as an artist.

In 1990, Joyce put her respect for Doris McCarthy on the record when she, along with painter A. J. Casson and poet Lorna Crozier, provided blurbs for Doris McCarthy's second book, *A Fool in Paradise*. Joyce wrote: "Enchanting and irresistible . . . this is an evocative portrait of a young woman artist's passionate embrace of life." As a fifty-nine-year-old woman then, Joyce had become an authority on the artist's passionate embrace of life.

Doris, who was approaching eighty at the time, reminisces at the end of her book: "I was no longer afraid of being outshone by my own students. Their brilliance was my delight and I knew the excitement of drawing out of them their best work and of watching them go on past me to further fields of achievement." Doris had Joyce in mind in this last phrase. And Joyce, when she read these words, surely must have wept with joy. Doubtless, she would have cast her mind back to herself as that fifteen-year-old hugging to her heart the first instalment on her dream: a teacher who believed that she could be an artist.

While in high school, Joyce had a summer job at a neighbourhood dry cleaners and at the General Electric plant. Whatever paltry sums she earned would have kept her in pin money for the everlasting clothing fads she would have wanted to follow, and to be like the others. Conformity was the standard in apparel — more important than sticking out by being smart — and with the ignominy of her red fox-collared coat still smouldering, Joyce would have wanted to live somewhere on the same fashion planet as the other girls.

Remarkably, as a high school student Joyce got a two-week summer job at the Canadian National Exhibition making charcoal portraits — everyone has seen an artist sketching fidgety children or some man's blushing wife. How Joyce landed this opportunity is open to speculation, except for the fact that her art teachers' works appeared at annual CNE

Art Exhibitions and they surely had the obligatory door-opening contacts to get Joyce the job. Without a networking daddy, without a FOOF (Fine Old Ontario Family), she could not have managed this achievement on her own. What she had going for her was a life force that would emerge with uncommon strength, a fast-developing resourcefulness, an ability to make solid commitments to tasks and people, and a gritty determination to be the best she could be — qualities her teachers would have recognized even then.

Dating from her stint as an apprentice portraitist at the CNE, portraiture would remain a lifelong love of Joyce's and she would make numerous portraits. Unlike other genres, making portraits involves blind faith on the part of both artist and sitter, a give-and-take that can be risky. Joyce echoed the sentiments of many artists' experience in portraiture — that in the process the artist robs something of the sitter. "It's a very strange relationship," Joyce said, one that forms the moment the person agrees to sit for the artist. The artist arrives dangerously close to the sitter's soul. "It's a chance to really look at somebody," she added. "It starts to make you feel weird. You start to see the cells, the blood pumping through the cheeks. You sort of 'osmose' the person, absorbing him so you can put him out again."

For this reason, something changes. The sitter, in an attempt to be "natural" in this quite unnatural situation, talks about him- or herself. Other portraitists encounter the effect that these self-revelatory outpourings have on the painting, and often the sitter dislikes the result. Essentially, he feels that the artist has "robbed" him of a corner of his soul, that he has been too open, that his naked soul is up there in the oil on canvas for all to see. Commonly, the only flattering portrait is one in which the artist paints exactly what the sitter desires: an enhanced — not a realistic or even artistic — image.

Another irresistible attraction of portraiture is human skin. "I saw the Queen once," Joyce said, "and I liked her skin. The skin really says everything — how the light hits it, what comes through. The Queen's skin has

that golden amber tint that comes through wax. Her body is the host of so much history. It has been looked at as much as Marilyn Monroe's — where are all the energies of those looks that went into that body? She was like a little tamed bear that was on display." She mused, "Maybe I'll do the Queen someday."

Joyce's observations on skin reach beyond the mere painterly, where artists examine the Great Master portraits and marvel at their handling of paint to achieve the radiant effects of a girl's English-rose complexion, the alabaster-white throat and cleavage of a countess, the rough, lived-in face of a blacksmith. Joyce's observations about skin were made when she herself was a young woman with a skin that glowed fresh with her vitality and her Englishness. In later years, she would make a self-portrait of a skin that no longer glowed, but more potently rendered a life thoroughly lived.

When the thirteen-year-old Joyce wrote in her diary, "I saw some great art today," it was just the beginning.

In 1946 Joan married Harvey Stewart. Joyce moved out of the Kerrs' home and lived with Joan and Harvey for a brief time in a crowded flat — something of an unspecified communal situation. Harvey's mother, Violet Stewart, felt deep sympathy for parentless Joyce living with the married couple, and she invited Joyce to live with her family. "Through unhappiness, Joyce came to live with us," is how Melita (Mel), the Stewarts' adopted daughter, describes it. The arrangement lasted for about three years.

Joyce was sixteen and Mel was six years older. The two became dear friends. Mel says, "We never bickered. I never had a cross word with Joyce. We had lots of fun and good laughs. And a lot of serious talks, too."

Many of their serious discussions involved the home in which they lived. Mel allowed as how the family was tyrannized by a father — she repeatedly stressed, "not my biological father" — who today would be imprisoned or hospitalized for his maniacal, violent behaviour. Drunk much of the time, he routinely beat his wife and whipped his son Harvey when he was a boy, although he never abused Mel, she said. Speaking

softly, looking down into her hands folded in her lap, Mel spoke of one night, almost three years after Joyce had moved in, when the man's drunken rage grew increasingly violent and reached a crisis point where he began taking life-threatening action against the family.[1] Mel and Joyce ran from the house with only the clothes they were wearing.

(Shortly afterwards, in 1949, Mel married Victor Waterman, the painter she had been dating, and they remained married for fifty-one years, until Vic's death in January 2000.)

Joyce went to stay with a school friend, Mary Karch, for an expected few days, but the Karches welcomed Joyce into their home to live with them. She remained about three years, until the age of twenty-two, and had a kind, caring relationship with the Karches, whom she called her adoptive parents.

From the time she moved in, Joyce felt settled, living in such a calm environment. She began bringing art projects home from school and worked on them at night, and borrowed art books from the library that furthered her self-education in art history. Like that child at a kitchen table, Joyce painted and drew pictures, and indulged herself in the solitary intimacy of her dream of being an artist. At this time she was receiving encouragement from her teachers and was gaining proficiency, even though she lacked the confidence to see it herself. Too much had happened to her. She had yet to create an identity for herself; but she dreamed, yearned, and imagined — "with all her might," as she would have said in her childhood — that this identity meant *artist*.

Chris Karch, Mary's brother, remembers that Joyce "was always painting and drawing" while she lived with them. He recalled that Joyce at age seventeen painted a portrait of him when he was twenty-one, a work he especially liked. He mused, "I don't know what happened to it." In 1951, Chris had bought a couple of tickets to see Frank Sinatra at the Mutual Street Arena, which, when it was not a roller rink, hosted many of the big bands that came to Toronto. "I needed someone to go with," he said, and took Joyce, "even though I was a bit older than her," he added (such

discrepancies were noted then). "But it was great. Joyce really loved it," he said repeatedly.

Graduating from Central Tech's art program in 1948 meant nothing for Joyce regarding a job in art. In Joyce's situation a job meant earning a paycheque.

Joyce looked forward to turning eighteen, the age of majority then, when she could make a life for herself and release her sister Joan, who had brought her up all those years, from any responsibility for her. Linda Gaylard chose her words carefully, respectfully, when she explained, "Joyce felt . . . not obligated to Joan, but she appreciated what Joan had tried to do for her when she was young . . . the way she tried to be a mother, even though she was a big sister." Linda distinctly remembers Joyce being bothered about her sister's sacrifices.

Joyce had to find a paying job. She consigned the prospects of an art job to the world of fantasies that she stored away in the corner of her mind, along with her shaky self-esteem.

For someone without skills, landing a job in the late 1940s was frequently the result of an "inheritance" from a family member working in a factory; when an opening came up, the man's offspring, nephews, and nieces were given preferential treatment. Therefore it is likely through Joan's or Sid's connections that Joyce got her first job at the chocolate factory and worked there for a few months.

At the end of 1948 Joyce got her first "real job" where she did some actual artwork. She was still living with the Karches, when Mary told Joyce about a job opening at her workplace, E.S. & A. Robinson, a company that produced commercial packaging, food containers, shipping cartons, and the like. Package design was also part of the company's services, which necessitated operating a design studio, as well as a silk-screen and lithography print shop.

Joyce was assigned to the design studio. She spoke about creating a label for a sardine tin, describing it only as blue, with big block letters. In

an interview with film critic Lauren Rabinovitz in 1981, Joyce was asked about her inserting words in her films, and she replied, "I had put lettering in my work for years. . . . When I was a kid I'd read just two or three words like a caption under the pictures. And from teachers holding up pictures with words on them. That part of learning to read imprinted very strongly on me. And . . . doing a lot of poster work — commercial art — this [was] where you just had the product and the name. The word juxtaposed with the image was always interesting."

Joyce confided to writer Michele Landsberg that her designs were "too far-out." One could interpret this to mean that they were rejected if her next remark was not a joke: "So I'd end up as the one who washed the brushes."

Regardless, Joyce learned a great deal about the graphic arts. "I saw through the commercialism of advertising art but I liked it. Mind you, I wasn't good at it. But the people I worked for were kind. They kept me around for four-and-a-half years."

She then moved to Planned Sales, a design studio specializing in retail point-of-purchase displays, where she did paste-ups and some pure design work — more than she had previously done. "In those days, nobody made it without getting commercial jobs," Joyce explained. "It was quite respectable — all the successful artists did it."

Joyce was referring to a tradition dating back to Group of Seven artists who worked day jobs in design studios of commercial printing firms. During the early part of the century, painter Tom Thomson worked as a designer at the photo-engraving house, Legge Brothers, then moved to Grip Limited in about 1908. J.E.H. MacDonald was head of the design department at the esteemed Rous and Mann Press and attracted many other artists to this shop, including Thomson in 1912. Similarly, artists in the 1950s worked day jobs in advertising agencies, design studios and as freelance illustrators for consumer magazines and trade journals.

At both E.S. & A. Robinson and Planned Sales, Joyce started meeting fine artists working day jobs in ad agencies after they had graduated from the Ontario College of Art or Central Technical School. One of them was

sculptor Gerald Gladstone, who worked in the design department of an engraving house, Bomac Engravers.

Sheila McCusker, who would later marry Gerald Gladstone, shared her reminiscences of Joyce in a lengthy interview held at her home on Ward's Island, where she has lived for more than twenty years, since her divorce from Gerald.

Sheila was nineteen when she met Joyce. Photographs of Sheila then reveal a classic brunette with the sloe-eyed appeal of the 1940s and 1950s Hollywood beauties, Linda Darnell and Loretta Young. Aiming to be a fashion designer, Sheila worked at an art production house, Purdle and Wylie, "just typing," she says. "I wasn't an artist. The guys just wanted to take me out for drinks."

Chris Yaneff, an artist, designer and later an art dealer, exclaimed, "Oh yeah. All the guys were after Sheila."

Her soon-to-be husband, Gerald Gladstone, said, "She was a knock-out broad."

Sheila describes her boss taking her to a Christmas party. "In those days the Christmas parties put on by the advertising and publishing companies were notorious. Some people actually fell out of windows." This particular party was held in a downtown hotel and Sheila speaks of arriving in a large room "buzzing with music, people, drinking," and relates the unfolding of events. "I had never had a drink in my life before . . . and Bob [not her boss's real name] is pouring whisky into my beer, but I didn't realize this. At some point I looked up and in the door comes this very attractive woman, about my age, all dressed in white — this white angora sweater, I remember. Very glamorous. With jet-black hair down to her shoulders. And she came in with this little guy, very peppy, who everybody seemed to know." It was Gerald Gladstone.

The two of them joined Sheila and her drink-plying boss. "I got talking to this woman, who said her name was Joyce, and we liked each other a lot. She said, 'We're soul mates,' and I had never heard that before but I said, 'Okay, we're soul mates,' and we exchanged phone numbers." (Not

incidentally, says Sheila, "I got totally pissed that night.")

Thereafter, every Sunday for months Joyce and Sheila met at the Gallery of Toronto, and after browsing the gallery they would have tea in the Grange, a restored Georgian brick mansion adjoining the gallery. Built in 1817, the Grange had been a focal point of social and political life in Toronto when it was called York, but its greater glory was in becoming the city's first public art gallery, the Art Museum of Toronto, which was situated in the Grange from 1911 until 1970.

For Joyce, having tea in the Grange was almost as fine as seeing the art. There is every reason to believe that her romanticism received its first stirrings here. Unlike a movie set, this would have been her original, face-to-face encounter with period finery and elegance — the highly polished mahogany tables, porcelains in pine cabinets, and exquisite lace curtains whose work she must surely have examined at close range to compare with her mother's, which until then was her only standard of needlework. Victoriana beguiled Joyce. Years later, these impressions would resonate in her life and art, in theme parties she hosted involving various periods of history, in the Victorian decor of her own home, the lace she adoringly wore, and significantly, in needlework as a genre of her art.

"We just loved going to the Grange," Sheila says. "It was very classy and quiet, very Victorian. And for only a dollar admission you could have tea and cookies."

An image of the two attractive, dressed-up young brunettes sipping tea, gossiping, hushed by the Great Masters they had just seen, artistic dreams stirring within each of them, the candlelit charm of the Grange — is far more than Hallmark could bear.

In her off hours, Joyce continued to paint and draw. One of the benefits at E. S. & A Robinson was the weekly art lessons the company offered to its employees. Joyce attended these classes regularly and considered the program to be her graduate art school. She also enrolled in night classes at her old high school, Central Tech. Joyce's earliest nude drawings were dated 1952 and likely done at this time, during these sessions where there

would have been a class model. Art was becoming more integrated into her life. But Joyce still lacked the confidence to show her work around.

Sheila and Joyce met in 1951, and Sheila invited Joyce to an opening of the Canadian Society of Painters in Water Colour, where Gerald Gladstone had a picture in the exhibition — an achievement "which was really something in those days," Sheila aptly notes. She paused to explain that Gerald's family doctor had bought a house on Bathurst Street in downtown Toronto and Gerald had moved in. Artist George Shane lived in a flat in the house and acted as house manager, and was looking for tenants for two vacant rooms. Gerald told Joyce and Sheila about the two rooms and urged them to move in. The timing was right — for Gerald and George to have two beautiful young women in the house, and for the two women. Sheila lived at home and wanted to shake loose, and Joyce, living with the Karches in the eastern end of the city, at Pape Avenue and O'Connor Drive, jumped at the opportunity to move downtown and exercise some of her pent-up independence. Sheila and Joyce moved in.

George Shane recalls the rent being about eight, possibly ten dollars a week each, a sum both women could afford since they were earning about fifteen to twenty dollars a week. The rooms Gerald and George lived in had a corner set up as a studio and Joyce organized a small work area in her room. In fact Joyce was developing a lifelong habit of incorporating her studio space into her living space. She didn't separate art from her daily living. Sheila, too, created a space for fashion design, exclaiming, "We were ecstatically happy to have a studio. And, of course, the parties started then. It was just marvellous!"

Despite intentions of "working like mad," Sheila confessed that neither she nor Joyce did much work in those early days. "We kept talking about how we must get to work, get to work!"

However, both Gerald and George recall things slightly differently. Gerald says that Joyce was "always painting. She worked in small, pretty things, and was a better painter than a lot of the others." George, too,

remembers Joyce doing quite a lot of work, adding, "We all worked." George did illustrations for Maclean-Hunter trade journals, Gerald had a full-time day job in advertising and designed sculpture at night and on weekends, and an artist named Eric worked at woodcutting. Chris Yaneff, an aspiring illustrator working as an art director at Maclean-Hunter, lived at home with his parents but had a studio in the Bathurst Street house.

"The place was famous for parties," says George Shane. "No drugs, just good-time parties." Guests included mostly artists, some industrial designers, and writers, all of similar age. The drink of choice was cheap wine and the food, bologna sandwiches. Festivities usually got under way in Gerald's room on the ground floor and people would wander around, up and down stairs until they reached Joyce's room on the third floor.

George describes Joyce as "nice and well behaved, a fun-loving young woman."

Chris Yaneff agrees. "She was always nice." He remembers her being "shy and introverted" and "a sweet person who liked dressing in black, trying to be sophisticated or French-looking," he thought. "She was very childlike and cute, with a round French face that was like a coquette's."

Laughing, remembering the hustle and bustle of the place, Chris says, "So many people came and went. You'd see someone in a bedroom for a day or two, if the person renting it was away, and then someone else would come along, just like in the movies." Claiming to be the "odd man out" because he had to go to work wearing a shirt and tie, as soon as Chris got to his studio after work he took off his tie. People in the house would come and "sit on the couch and have a beer. We had no money. We got together but they were not real parties, we just sat around talking and talking — what is an artist, can I really be an artist, who is the greatest artist." They all read the Canadian and American art magazines, and knew the art and artists. "Then Sheila would say something like, you could be an artist the way you pushed a broom across the floor, and then everyone would argue about that. Sheila was very outspoken and she'd say, 'Okay you guys, get the hell out of here.' But Joyce was always a sweet person."

Whatever the comings and goings, every Sunday morning they all got together. "We craved company." As Gerald Gladstone put it, "We all had our backgrounds."

Joyce and Gerald shared certain familial affinities — Joyce as an orphan and Gerald as one who had had to work since age fourteen, who came from a strict kosher home that he wanted to leave and live like a bohemian. When they met, Joyce was eighteen, Gerald a worldly twenty. The woman he would soon marry, Sheila McCusker, described him then as "fast."

There were no sexual liaisons among the roomers, but not for lack of trying on "fast" Gerald's part. He described his one unsuccessful attempt with Joyce: "This one time in her room we were sitting on the floor, propped against her bed or couch and we talked and talked, and then I made a pass, kissing her, trying to take her to bed, and she started to cry. I got so embarrassed. She was very fragile and I was a shy guy. We were just kids." Quietly, he added, "I was really taken with her. She was very dark and gypsy-like, very busty with big hips, my kind of sculptural look. But she was frightened." And despite his reputation, so was Gerald.

Diligently attending her company-paid art classes, Joyce started thinking about making illustrations. She put together a sample of her drawings and packed them off to Chris Yaneff, on the chance that there might be some illustration prospects at one of the Maclean-Hunter magazines. Chris recalled, "She was very good at children's drawings but we had no work for her. And I'd tell her to keep at it, keep running around and knocking on doors. Like we all had to do."

Along with being an art director, Chris was also an illustration and art teacher who taught a life-drawing class in what was called the Asquith Artists' Club and Joyce began going to his classes. "But she was not very good," Chris stated plainly. Chris felt that she was intimidated by some of the others there — George Fanis and Walter Kopcz, who were leading illustrators then. With wonderment still, Chris said, "I never dreamt she would become a famous artist. I knew only her cutesy drawings."

Gerald Gladstone had high regard for her art and mentioned that

Joyce had had a drawing exhibited in one of the early Toronto Art Directors Club[2] shows, around 1952. "I thought she was showing great promise. She was a terrific dame. She was good. She was solid."

Joyce could have gone on a gigantic wingding at this time, letting loose a lifetime of constrictions and restrictions, but she didn't. Gradually, though, as if warmed by the new company she had started keeping, she began to unsnap her protective cold-weather gear and slough off a few of her inhibitions. She was discovering that concealed beneath the barren, staid surface of Toronto, a Rabelaisian underbelly existed for an elite few.

Like any other business community, people in the commercial-art field met one another in their own milieu, the advertising agencies and magazine art departments. A full-page ad, for example, might be designed in the advertising-agency art department but it was "finished" in the art house; which is to say, the art house supplied the illustration and type for the ad, camera ready for the magazine. (This process has long since been replaced by computerized design.) A steady traffic of art directors, artists, and photographers came and went from the art houses to the magazines to ad agencies; certain professional associations, such as the Toronto Art Directors Club and the Copy Directors Club of Toronto, held regular meetings that attracted everyone in the business.

Within a few months of moving into the Bathurst Street house Joyce had evolved from the subdued, awestruck young woman sipping tea at the Grange and the fragile person of Gerald Gladstone's experience to a full-fledged party girl. "Joyce wasn't the kind to sit in a corner and watch other people," Sheila states. "She liked parties. So she'd be much in the centre of things." And she began to exhibit a little brashness. "I think Joyce got a little tipsy now and then, but not raging drunk or anything like that." Sheila assesses Joyce as a combination of "that pre-Revolutionary French frivolity and heavy Germanic/Dutch stuff."

Once, at a party in someone's small apartment in Yorkville where the bathroom was located on the third floor, through which you passed to reach the fire escape where people stepped out to smoke, Joyce created a

bit of a sensation by sitting on the toilet chatting and laughing with people who passed through en route to the fire escape to light up.

It is not known exactly when Joyce became turned on by jazz, but the improvisational nature of jazz is an expression totally compatible with visual artists — especially abstractionists — and of infinite appeal. One responds to its total sexual range, from the quiet noodling of piano and bass, the sustained rhythms, the roaring clashes of horns and not the least, the music's esoteric hipness. Joyce had discovered Louis Armstrong and Duke Ellington, and thereafter became a serious jazz lover. She happened to say to Chris Yaneff one day that she would "give her right arm" to see Louis Armstrong[3], who was appearing at the Brant Inn, a popular big-band dance club and hotel on the shores of Lake Ontario at Burlington. "So I picked up a couple of tickets and took her," Chris said.

"It was a great show," Chris reported. "And at the end Louis Armstrong went mad. We got up really close to the bandstand and Joyce was so excited. She kept hugging me and thanking me." The memory prompted him to add, knowing what he knows today, "She was enthusiastic about everything. I guess it was her way of escaping."

Apart from Sheila as a woman friend, Joyce met Wanda Phillips, an advertising copywriter who had great intellectual curiosity and a love of visual arts, the person who introduced Joyce to a program of physical, cultural, and spiritual enrichment.

During the 1950s, Wanda had discovered Rachel Carson (prior to publication of her famous 1962 treatise, *Silent Spring*), Adelle Davis, Gayelord Hauser, Jane Jacobs, and Peter Ouspensky, to whose philosophies Wanda became an ardent convert. Wanda died prematurely in 1964, leaving Joyce a legacy of nutritional doctrines, ecological warnings, and theories on livable urban environments.

Through Wanda's urgings, Joyce adopted nutrition principles centred on a fibre-rich diet supplemented with B-vitamin pills, wheat germ, and the famed "tiger's milk," one of the numerous food fads that Joyce would

embrace throughout the years. She and Wanda would have dinner at Mary Johns in the Gerrard Street Village, eat thick soup and French bread, and talk the night away.

With Joyce's physical enrichment launched, Wanda then introduced her to the mind/spirit enhancing theories of Ouspensky through his famed work, *In Search of the Miraculous*. Wanda took Joyce along to an Ouspensky study group composed of people who called themselves merely "the group," where, abiding by an established program of discussion and meditation combined with practical exercises in relaxation and breathing, individuals explored Ouspensky's and Georges Gurdjieff's theories on man's emotional, intellectual, and spiritual place in the universe. These studies represented an astonishing new beginning for Joyce. She experienced a conversion of sorts, an enlightenment of her senses. Apart from the Anglican religion she'd known, she began to understand that it was possible for her to use her senses and the powers within her to reach a different, higher level of spirituality. And most positively, she came to expect that if she learned to harness these internal forces, she could then balance the reality of her torturous past life with her dreams for the future. This comprised Joyce's lifetime search for her miraculous.

As part of this early search Joyce accelerated her study of Canada's historical figures and her cultural development. She delved deeper into European art history, went to the Art Gallery and the Royal Ontario Museum, and listened to music — at the time, Frank Sinatra had her in a tailspin, as did another musical acquaintance, Antonio Vivaldi.

These explorations would reach further afield and in time find themselves profoundly, wittily, and on occasion angrily, expressed in her art.

Though employed in an art house, drawing and painting after hours, and taking art classes, Joyce was still not optimistic about making a living as a fine artist. Buyers of art were scarce. The handful of art patrons in the city, indeed in the entire country, practised "safe art" with the Group of Seven, or works of early Canadian life by painters such as Cornelius

Krieghoff or Paul Kane, or the gentle landscapes of Lucius O'Brien, James Wilson Morrice, Horatio Walker, and Homer Watson. Life in Toronto at the end of the 1940s and in the early 1950s was ideal for money making and deadly for art.

When not denigrated as Hogtown, for the city's brisk meat-processing industry, this was Toronto the Good, so named because of its numerous churches, complacency, piety, and stultifying conservatism that had managed, quite successfully, to hold vitality in a lethal hammerlock. The strong temperance movement prevented cocktail bars from opening until 1947. Underpinning the city's righteousness was the Lord's Day Alliance, a powerful lobby. Founded in 1888 and recognized as one of the longest-standing single-subject pressure groups in Europe and Britain, this Christian organization opposed activities undertaken on the Sabbath that did not involve worship and spiritual devotion. Public tennis courts had their nets taken down, swimming pools were closed, swings in playgrounds were padlocked, as were stores, and people got arrested for minor non-essential commercial transactions, such as bill-collecting, until an epic battle fought in Toronto against the federal government's Lord's Day Act (proclaimed in 1906) was won on January 2, 1950, when voters approved Sunday sports.

For the avant-garde, this was prime-time Toronto bashing. Lister Sinclair set the mood with his radio play *We All Hate Toronto*, and *Spring Thaw* gave us annual spirited satire from Dave Broadfoot, Barbara Hamilton, Don Harron, Robert Goulet, and Jane Mallet, among the cast of cut-ups.

At age nineteen, Joyce was impatient, chomping at the bit of her trapped desires in the city that was overwhelmingly "closed." In later reminiscences, she spoke of the year 1950, saying, "I could walk with my girlfriend Mary from Broadview and Danforth to Keele Street [about eight kilometres of a busy commercial street] and we wouldn't see anything. We made suicide pacts. We would say, 'This is life and this is what happens to you so we might as well jump off the bridge' [Toronto's infamous suicide

bridge, the Bloor Viaduct], and we were considering it because there was fuck all! There was an art gallery and a few people, but no feeling."

One activity beyond the reach of the temperance movement and the Lord's Day Alliance, however, was sex.

It soon became apparent to Sheila that Joyce was overtaking her in the sexual race. Sheila recalls a "really handsome Aussie guy, a lettering man in an agency," whom Joyce "ran off with to Niagara Falls." On the pretext of saying she was worried that she hadn't seen Joyce around, Sheila phoned her. "But she didn't tell me anything. She said no, no, we were fine." Sheila says, "I wanted to be like that but I couldn't. So I hung around with someone who was."

Sheila feels that Joyce had a well-balanced sexual sense. "We didn't get into the details but she was certainly more open about sex than I was. She probably had better experiences than me because I was extremely naive." By way of explanation she refers to her ex-husband, saying, "I was just with that one person for thirty years," and she adds, "I remember Joyce using the word *orgasmic* a lot and I wouldn't even have known what it meant then."According to Sheila, the clue to Joyce's sexuality "shows up in her work — those nice pencil drawings and paintings where she was not afraid to express that. I very much suspect that she had a better experience with her body than I had with mine. Maybe she didn't talk to me about it because I wasn't a person who understood that kind of thing."

Social scientists document gender distinctions in sexual development between children who grow up with a father and those without. For boys, a father has always been required to teach a boy how to hurl a spear and catch a fish, but during a male's testosterone-pumped adolescence, sexual behaviour differs very little between boys who grew up fatherless and those who did not. This is not strictly the case with girls. A father does not teach his daughters how to be women as much as he teaches them how to obtain a man's approval.

It is well established that emotionally-deprived women are more dependent on relationships than men are, and patriarchal societies

condition women to seek men's approval as a means of measuring their accomplishments. Joyce received her father's approval for her childhood drawings but by age seven she had lost that paternal-approval structure. A young girl who grows up receiving her father's incidental approvals over the years — "good drawing," "nice cookies," "fine marks," "great piano playing," all of which add up to *good girl* — matures secure in the knowledge that her father still likes her residual childhood accomplishments, and now approves of her as a whole person. Consequently, she doesn't depend on boys to make those assessments, as did Joyce, for example, who without a father may have relied heavily on boys' approval. She had not received much from her brother Sid, who was eleven years older, had gone overseas, then come back and started a family, and through no fault of his own, largely "went missing" to Joyce. When she was eight and the boys at school bought her drawings of naked ladies, the dime they paid was the price of their approval of her. Then at age thirteen, the time of Joyce's first diary entries, things changed swiftly; the peaks can scarcely keep up with the valleys, as biology preordains. She had written about a certain Gerald who said hello to her — "Gosh was I thrilled" — and yet a week later she felt that it was "awful dirty" at the party when "mush began" in the cellar.

Only one reference was found in Joyce's papers — in a journal she kept in 1956 — of her feeling deeply about someone in high school; a situation that may have resulted in her "going all the way," to use the 1950s euphemism. When Joyce attended high school, sex was more fantasized about than practised — heavy necking and petting being the established compromise when not ruling out solitary enjoyments — and Joyce's emotional cravings, united with her newly developed high-spiritedness, may have caused her to succumb earlier than her peers to this most tantalizing of life's engagements. Whenever the event took place, it is reasonable to hypothesize that Joyce submitted her virginity as a supreme quest for male approval, and perhaps no record exists because her experience conformed to the time-honoured response to first-time sex: an occurrence marked more by perplexing disarray than dazed ecstasy.

Whatever social activities engaged Joyce, she continued going to movies. In the early 1950s, her tastes were turning to art films but she complained about the shortage of such films, until she discovered the Toronto Film Society,[4] which originated in Toronto in 1948 as a venue for "alternative" cinema. Founded by Dorothy Burritt Fowler, a filmmaker with the National Film Board of Canada, and her husband Oscar, the couple rightly sensed Toronto's avid film audience-in-waiting. They programmed monthly film screenings on Sunday nights in commercial theatres booked specially for the night or at the Royal Ontario Museum and on occasion at the University of Toronto theatre. Five hundred starved Toronto film buffs soon swelled to a thousand attending these monthly screenings.[4] The going fare included exotic foreign films, along with homegrown silent and experimental films. From time to time, filmmakers made guest appearances at screenings of their films and engaged in lively discussions with the audience afterwards.

Joyce started attending Toronto Film Society screenings in about 1950, and here she was introduced to film greats D. W. Griffith, Fred Niblo, Luis Buñuel, and King Vidor. She would also have seen the hot New York underground films made in the 1930s and 1940s by artists Marcel Duchamp, Man Ray, and Max Ernst, along with established underground filmmakers Hans Richter, Kenneth Anger, Stan Brakhage, and others. Crucial to Joyce's politicization, she encountered the films of the woman called "Hitler's moviemaker" — Leni Riefenstahl — and although she likely did not realize it at the time, she saw works of a filmmaker who would be a major influence, Maya Deren.

Invited to Toronto on several occasions to screen and discuss Deren's early-1940s films and to conduct workshops, film historian John Porter declared that Maya Deren created a "lasting influence on the Canadian film community." It is not known for a fact, but Joyce may have been in attendance when the famed experimental filmmaker came to Toronto in

November 1950 to address an audience of the University of Toronto Film Society. Deren was impressed that Toronto's filmmakers and audiences appreciated her unstructured, technically minimal concept of "poetic film," and her filmic link between camera, choreography and music, defined by Deren as "chorecinema."

Though not a part of the Canadian film community then, Joyce soon would be and she, too, would find in Maya Deren "a lasting influence."

In spring 1951 Sheila McCusker took a trip to England with her parents and on the boat met a Toronto man, Bryan Barney. Coincidentally, back in Toronto that summer she encountered Bryan at a Canadian National Exhibition art show. "I must have invited him to a party at Bathurst [Street] and he started hanging out with us and became part of our crowd," Sheila says — a crowd that began to include ballet dancers from the newly formed National Ballet of Canada and increasingly more artists. It was a time Sheila defines as altogether "very exciting." Especially so for Joyce: She fell in love with Bryan.

Handsome, articulate, sophisticated, Bryan was a writer and seemed to be everything Joyce desired and wished for. He lived in Hamilton, Ontario, a forty-five-minute bus trip from Toronto, and at first the two of them got together on weekends until Bryan quit his job in Hamilton and moved to Toronto, where he worked in several writing/editing capacities on magazines and later, as a scriptwriter for the Canadian Broadcasting Corporation.

The average person did not engage in long-distance telephone relationships then as people do now; long-distance calling was restricted to family emergencies. And because people didn't own cars as they do today, Hamilton-Toronto lovers got together by bus and by mail.

A letter to Joyce from Bryan, undated (likely late fall 1951), neatly handwritten, sent from his address in Hamilton, defines his strengthening feelings for her against the tentativeness of his notions of love.

Dear Jocelyn [as far as is known, no one else called her this],

I've been spending the last few days trying to comprehend the extent of my emotional involvement concerning you. I'm finding it increasingly difficult to reason my way toward any conclusion, yet to place reliance on my feelings. Love is perhaps not the wisest thing to do. I strongly suspect that I'm more than a little in love with you, but [illegible word] nothing of a similar nature has ever happened to me before. I've spent my time bending over backwards searching for other names to call it.

It's left me with a feeling of uncertainty. One can adopt a code of conduct toward most things — work, people, pleasures — even aspirations are usually directly along fairly conventional lines. . . . But this is different. No path is provided, no books are supplied, and no one can give advice. . . .

If from your point of view all this sounds a little forbidding let me assure you that there's no real cause for apprehension. I have strong self control (probably racial) [his Scots background?] which should stop me from doing or saying anything foolish or illogical. And I'm also quite unpossessive. And quite unemphatic about practically everything. I seem to have watered myself down pretty fine there . . . but something that [Edna] St. [Vincent] Millay said — in love, to be serious is to be grotesque — sticks in my mind. . . . [He notes that she might be right.] I'd rather lessen my romantic conception of myself than fall prone to emotional drooling.
I feel confident that within about ten minutes of having mailed this I'll be churning in self disgust at such a display of exhibitionism. Fortunately, there'd be nothing I can do about it then.

I'll permit you a sly chuckle while reading this. Perhaps

two. But anymore than that, and feelings or no feelings, I'll be down there with an AC16 Crestalloy wrench and bash your head in.

Sincerely, Bryan.

Joyce would have found this last line howlingly funny — whether they had an association with a Crestalloy wrench, or because the notion was so bizarrely uncharacteristic of Bryan. She adored his wit, erudition, his elegance, and taste — most commonly he was described by others as "a terrific guy." He was also a good dancer; the two of them went dancing at the Palais Royale on Toronto's waterfront, famed for its crystal-domed ceiling and big bands. At that time, there were two main dancing styles, jive or jitterbug (now called swing), and sexy, slow dancing. Jive was an ideal outlet for Joyce's exuberance — a flared skirt flashing an acceptable leg show, a dance that allowed her to express sexuality in public and reveal to Bryan her feelings. The evening always ended with a slow dance, eternally a publicly-sanctioned prelude to lovemaking, and the two of them would hop a streetcar and hurry back to Joyce's small room on Bathurst Street.

Joyce found the deep personal intimacy she needed with a man; he was someone to whom she could pour out her heart, confide, reveal her lonely past, and trust him with her heartache. Intellectually, Bryan gave Joyce a sounding board for testing out her ever-evolving theories of art and artists, and "meaning of life" questions that had been on her mind since childhood. Bryan obviously comforted Joyce. She loved him, and theirs would later be described as "the best friendship of Joyce's life."

After almost a year living at Bathurst Street, Sheila McCusker and Gerry Gladstone decided to move in together — a scandalous thing to do in 1952. They found a large apartment/studio on Grenville Street, smack in the centre of the 1950s Toronto bohemia.

Quite like first-timers encountering sex, baseball, or argyle socks and

thereafter claiming its invention, those who frequented Yorkville in the 1960s considered it to be Toronto's original bohemia, but the title rightly belongs to the Gerrard Street Village. Located eponymously on Gerrard Street, the area is now subsumed by three of the city's ever-encroaching hospitals combined into the University Health Network, in addition to the Hospital for Sick Children, Women's College Hospital and surrounding nursing residences. (Mount Sinai Hospital was located, as it still is, west of the unofficial University Avenue border of the Gerrard Street Village.)

Artists lived and worked in turn-of-the-century three-storey houses on Gerrard Street and its annexing Grenville Street, cheek by jowl with a collection of certified eccentrics — musicians, poets, jewellery makers, writers, actors, a tea-leaf reader, and the live-ins of a well-known "house not a home." The noted Grenville Street restaurant, Mary Johns Village Inn, was a cheap and cheerful life-saver for nearby interns, nurses, and artists. At Mary Johns, sixty cents bought an adequate lunch of soup and meat loaf; a dollar rated an epicurean chicken pot pie.

Toronto's first boutiques were located in the Gerrard Village. The Unicorn earned a reputation as Toronto's first authentic boutique. Located on Gerrard near Bay Street, it was the magnet to which other boutiques and arty shops were attracted.

Unicorn owners Marilyn and John Brooks smartly incorporated the psychedelic movement in its decor and products — papier-mâché jewellery, scented and coloured soaps, posters, homey mugs, glasses, candles, pillows, and wind chimes available in the hot pink, neon blue, and lime green whose seductiveness zinged direct from eye to wallet. *You had to have this stuff!* Marilyn Brooks designed and produced sassy little minidresses in the back room, thereby launching her as one of the country's name designers, a position she enjoys to this day in her shop located in that other village — the new, upscale Yorkville.

Joyce and Marilyn met when Joyce would drop in to the Unicorn. Later, when Marilyn was one of several designers selected to create an outfit based on a well-known artist's painting — a hugely successful

publicity gambit of the Women's Committee of the Art Gallery of Ontario — Marilyn made a jumpsuit based on one of Joyce's *Time Machine* paintings.[5]

A main gathering place for artists in the 1950s was the studio/house of Albert Franck and his wife, Florence Vale, both traditional artists who held virtual open house to artists and mentored young painters, notably spotting the talent of Kazuo Nakamura while he was still an art student at Joyce's old school, Central Tech. The Francks were among the early buyers of the abstract expressionist paintings of Oscar Cahén and Ray Mead; artists Harold Town and Walter Yarwood became the couple's best friends. Famed were the Francks' annual decades-long tradition of watching the opening game of the World Series and their impromptu musicales featuring Albert on cello, Flory (as she was called) on piano, and anyone who came in with an instrument — all of it dished up with non-stop servings of tea, Albert's scatological puns, and his homemade pickled herring.

When Sheila and Gerald moved to the Gerrard Street Village they began going to the Francks', as did Joyce. Meeting them and the artists who gathered there was a major intellectual and artistic stimulant for Joyce. In welcoming her, the Francks provided her with a crucial door-opener to a select group of Toronto's artists in addition to such actors, performers, and television producers as Ross McLean, "Our Pet" Juliette, Jack Creley, and Joyce Davidson.

Sheila speaks of her and Joyce meeting Robert Varvarende, a Frenchman who had come to Toronto after the Second World War and worked as a laboratory technician at the University of Toronto's Banting Institute. His past wildly intrigued them — he was an ex-prisoner of war who had escaped and joined the Yugoslavian underground — as did his paintings of still lifes and nudes, which Sheila described as "very dark." (A 1961 magazine piece identified twelve Toronto artists, including Michael and Joyce, in a touring art show called *Toronto 61*, which represented "an exciting time in Canadian art. Certainly something unusual and stimulating has happened in Toronto in recent years." Varvarende is defined as "a painter

of ingratiating still-life.") By Sheila's account, "He was a destructive person and quite mad about women but he taught us all a lot, being French, you know. We thought he was quite suave but not very nice."

Varvarende's lasting gift to Joyce and Sheila was an education in fine wining and dining. "Joyce was amazed by him, his intensity, his sophistication," Sheila recalls. "And we all started going out to French restaurants and European restaurants, trying all this exotic stuff." None of them had thought much about food and wine until then. "Food was just something you ate," until "you became a gourmet."

There were only two or three authentically French restaurants in Toronto at that time. The Maison d'Or, an intimate little *boîte* with red-checkered tablecloths and candles guttering in wine bottles, located off Yonge Street at Asquith Avenue, was swallowed up in 1980 by the Metropolitan Toronto Public Library. It was here that many Torontonians were first surprised to discover that the famed *boeuf à la Bourguignon* was beef stew cooked with wine.

More upscale was La Chaumière on Charles Street, where diners on their culinary ascent sampled escargots — once instructed on implement use — and other firsts like *canard à l'orange, boeuf Bourguignon* and *coq au vin*. The place smacked of romanticism, from the crystal sconces, roses in bud vases, white damask tablecloths, and red napkins to the menu written entirely in French — heaven-sent for Joyce. After a few visits you were savvy enough to order your *coqs* and *boeufs* and know exactly what you were getting. And everyone drank Pouilly-Fuissé once they had learned to pronounce it.

It would be another decade before L'Aiglon notched up Toronto's dining out by introducing the style of French food you had previously had to go to France for, and at approximately the same price. Accompanying the *haute cuisine* was handsome Sonny Caulfield, in black tie, playing the gleaming grand piano and crooning lightly swinging arrangements of the best of Cole Porter, Rogers and Hart, Johnny Mercer, Duke Ellington, and Harold Arlen. During the *chateaubriand* and Châteauneuf-du-Pape,

lovers smiled their secrets to Sonny's sultry arrangements of the standards, "You'd Be So Nice To Come Home To," "Night And Day," "Mood Indigo." No cold, cold hearts or lariats here. And up the stairs, the sexiest bar in town — plush sofas and chairs, quiet lighting, men in close contact with women not consistently their wives. The cocktail crowd was greeted at the second-floor landing by a beautiful, bosomy, leggy woman in a black satin *Playboy*-bunny outfit, with flowers in her hair, gliding back and forth in a velvet swing suspended from the ceiling.

By now Joyce was in love with everything French. Having made an acquaintance with the country's art, food and wine, the next French seduction would be its literature. In this pursuit, Joyce raced to the novels of Colette; and just as Mozart's music had captured her, Colette's explorations of the feminine heart struck Joyce with an affinity that was thoroughly intimate and personal. Joyce felt as though she had known Colette (who died in 1954). She would become similarly enamoured of Marie-Antoinette, Madame de Pompadour, and Joséphine Bonaparte, all of whom she would honour in her art.

An undated letter (likely mid-1952) to Joyce from Bryan is an account of him giving notice that morning — "Wilkinson went down . . . sobbing, and soon I was crying too" — and Bryan was persuaded to stay on another week at his Hamilton job before moving to Toronto.

The letter seems to have been prompted by an incident that had occurred, and that he wished to explain:

> After I left you Sunday, I carried with me the strong feeling that I'd fouled things up. Each time I've left you I've sensed in some way that I've failed a little; but this time — with greater cause — more particularly. Several weeks ago I adopted a mental attitude toward one facet of our relationship. It was that at no time should I permit myself to become provoked into any action or gesture that would project us into anything

intricate and harmful. Not so much an ethical decision, or a denial of the strong physical attraction you exert over me, or an attempt to ignore the fact that I am just as much an animal as the next person, but a stand had to be taken about what would be happy or unhappy, wise or unwise. Consequently I was more than a little disgusted with myself. It may seem to you that I'm being pretentious here. Perhaps that is so, but I find myself regarding such an incident as symptomatic, a further illustration of the fact that what I want for myself is still a very long way away from what I've so far attained; especially pertinent now, when only the day before I was blabbing to you about what a prime virtue moral courage was.

He then notes his difficulty with penning thoughts in letters. "If you state something as simply as you can it appears trite yet if you try to do it any other way it becomes mere striving for effect and immediately insincerity creeps in. Therefore, I'm hoping at this moment you know me as well as I think you do."

Bryan sets himself up to save face by poking fun at his feelings. It's difficult to know whether he developed this characteristic from Joyce or vice versa. Together they have perfected the trick of taking a tepid stab at a serious pronouncement, where they venture out only so far, and then backpedal their emotions with a dash of cynicism. Effectively, this gives the expressed feeling a little waffling room — does he mean it? is she serious? (We will see this device used by Joyce in her letters to Bryan.)

Here is Bryan's attempt:

When you spoke the other evening of your uncertainty toward anyone who lacked a two year standing with you, it seemed, to say the least, a little conservative. Now it appears reasonable to such an extent that I wish to present myself for such an apprenticeship — providing you make it retroactive

to Xmas. Even if you don't it won't make too much difference for I've every intention of hanging around till you decide that dry rot has set in — "and as she defiantly snapped her fingers (click!), he smiled a little sadly, turned up his coat collar, and limped quietly out into the rainswept streets," — beautiful.

He mentions a photo of hers he has yet to receive and writes that "if it doesn't arrive tomorrow then I'm writing a letter to the postal authorities. If it has not arrived Wednesday then a formal letter of protest will be dispatched to the mayor, and if not by the day after . . . my God!"

And he ends with, "There are many things I'd like to say, but perhaps I shouldn't. Instead I'll go to bed. See you soon. Yours Bryan."

This letter likely precipitated Bryan's moving in with Joyce at the Bathurst Street house, sometime in mid-1952.

Through meeting increasingly more artists, Joyce became aware of the monumental hurdles abstract expressionist artists faced trying to gain public recognition in the early 1950s, the Dark Ages of Art.

Only a handful of private commercial galleries in the country sold fine art, and their trade comprised three genres — works by nineteenth-century Canadian traditionalists, Group of Seven artists, and anything resembling the "European school of brown cows." Commercial art galleries had no desire to sacrifice their cash and European cows on risky, misunderstood contemporary art. However, the winds shifted in the early 1950s at two commercial galleries: the Laing Gallery, founded in 1931, which sold blue-chip European and Canadian traditional art, and the Picture Loan Society, owned by Douglas Duncan, the only gallery of its kind where you could rent art now and pay later. These two galleries were joined in three or four years by three newcomers who opened galleries strictly to deal in contemporary art: the Gallery of Contemporary Art, the Greenwich Gallery, which would later be known as the Isaacs Gallery, and a picture-frame shop, the Helene Arthur Upstairs Gallery.

Though offering contemporary art for sale, all five galleries ran into the same obdurate wall as they tried to sell misunderstood art created by misfit artists to a highly suspect public.

In the arts, competition for the senses is as vigorously waged by painting as by literature, music, poetry, and the performing arts, all of which are capable of arousing the full range of responses from exhilaration to sputtering outrage. Given that both abstract and traditional art foment this sensual enormity, viewers of abstract art more commonly experience perplexity. Compared with a Turner landscape that may be a lyrical prayer floating to the heavens, an abstract picture is an incomprehensible, hellish fracas. Even sophisticates overflowing with artistic sensibilities feel discomfort when first encountering this art. You could say that its rawness, its rather frightening, violent presence overshoots almost everyone's sensory borders, placing the work outside normal appreciation. At the very least, acceptance of it demands time. American art critic Leo Steinberg pointed out that when abstract expressionist art first appeared on the New York market in the late 1940s it "looked outrageous for a season" and then the public came around — albeit that "season" spanned the better part of a decade.

Canadian contemporary art took an undue length of time to be recognized, in large measure because of the existing art system.

Prior to the 1950s, art societies controlled a living artist's exposure to the public. Oldest among these societies was the Ontario Society of Artists (OSA), founded in 1872, which held annual juried shows at the Canadian National Exhibition Art Gallery in Toronto. Since its inception, the OSA exhibited multidiscipline artists — painters, sculptors, printmakers — including members of the Group of Seven. Other single-discipline art societies followed. The Canadian Society of Painters in Water Colour, founded by Group of Seven members A.J. Casson and Franklin Carmichael, had its inauguration at the Arts and Letters Club in 1925; the Canadian Society of Graphic Arts was formed in 1933 (although its origins date to the Toronto Art Students' League, founded in 1886),

and the Canadian Institute of Painters was launched in 1957.

Lacking a market for their art, contemporary Canadian abstractionists were further disadvantaged by being held hostage by the juries that ran the societies' exhibitions. Should the jury reject an artist for inclusion in an annual exhibition, that artist was shut out until the next year. No wonder that whenever artists got together — at the Francks', in the pubs, at parties — they raged and railed against the art Establishment.

Quebec artists fared marginally better. Paul-Émile Borduas was the senior figure behind *Les Automatistes*, founded in 1947, which included a group of younger surrealist followers, some of them Borduas's students: Marcel Barbeau, Roger Fauteux, Pierre Gauvreau, Fernand Leduc, Jean-Paul Mousseau, Marcelle Ferron, Claude Gauvreau, Françoise Sullivan, Bruno Cormier, and Jean-Paul Riopelle (who had left in 1946 for Paris). In 1948, Borduas published his famed *Refus global*, a collection of essays that was to be known as the painter's art manifesto, which acted to liberate minds and feelings about art, and about how art fitted into contemporary French-Canadian life. Its publication changed attitudes toward culture — some scholars claim it revolutionized contemporary Quebec culture — by calling for the liberation from church and political systems and any other forces that exerted control over the individual. *Les Automatistes* and their fellow abstractionists were accepted by Quebec art collectors much earlier than their counterparts in other areas of the country.

It would be another five years before English-Canadian abstractionists created a similar commotion.

Taking the lead, the Art Gallery of Toronto organized a major exhibition of contemporary paintings and sculpture for its Purchase Fund Sale in 1950, and around this same time the CNE annual art shows, the Royal Academy of Art, and the various art societies began including contemporary art in their exhibitions. But not without howls of protest. In 1951 a sword-slashing demarcation occurred on the Toronto art scene when Oscar Cahén's and Harold Town's abstract oils were included in the annual OSA show. Gasps of outrage spewed from traditionalist OSA

members, who reacted as though everybody's drunken uncle had just arrived at their Christmas dinner. Four OSA members resigned — Archibald Barnes, Kenneth Forbes, Angus A. MacDonald, and Manley MacDonald — and thereafter the Ontario Institute of Painters launched a concerted campaign to wrestle abstract expressionism to the ground for "the restoration of sanity in art."

Albeit, abstract art racked up a major victory in 1952 when Jack Bush was taken on by the Roberts Gallery, Canada's oldest commercial gallery, founded on the solid, safe rock of representational art in 1842. But it can be said that abstraction blasted through the landscape/brown-cow barricades with the formation of Painters Eleven in 1953 (formally disbanded in 1960), a group of eleven abstract painters in Toronto and area who, led by William Ronald, sought to gain attention by banding together and exhibiting their work collectively. They were nine men and two women: Jack Bush, Oscar Cahén, Hortense Gordon, Tom Hodgson, Alexandra Luke, Jock Macdonald, Ray Mead, Kazuo Nakamura, William Ronald, Harold Town, and Walter Yarwood.[6]

Painters Eleven held their first exhibition at the Roberts Gallery in February 1954. Art historian J. Russell Harper noted that the artists "were like a chilling and disquieting storm in a comfortable living room."

This art attracted media attention in a manner that was, until then, unprecedented. No period of art had created such cultural hysteria. Feature-length personality profiles of the artists began appearing in the daily newspapers, art magazines produced glossy spreads of their work, and consumer magazines gushed over where artists lived and worked, what they ate and wore, and sought out their opinions about a new park, an old building, or another Royal Commission.

Toronto's contemporary artists were gaining exposure through the art societies' exhibitions and a lone commercial gallery, the Roberts Gallery, but their legitimization occurred when the public galleries took notice of them. Following the 1950 Art Gallery of Toronto exhibition, the National Gallery of Canada included abstract artists' works in its annual painting

exhibition in 1953 in Ottawa and organized the first Biennial of Canadian Painting in 1955. These exhibitions conferred upon abstract artists a stamp of approval from the art Establishment. And the artists began gaining national exposure when the National Gallery and the Art Gallery of Toronto, along with public galleries in Vancouver, Winnipeg, Windsor, Hamilton, and Montreal, hosted several group exhibitions that toured cities in Canada, the United States, and Mexico, and international cities such as Geneva, Cologne, and Brussels, for the World Fair in 1958.

Once the artists and their abstract works had been endorsed by the public galleries, more private galleries and collectors took note, and abstract art began to penetrate the confines of traditional art in Canada. The struggle — intense, insulting, and lengthy as it was — waged by the early abstract expressionist artists, notably Painters Eleven, paved the way for the next generation of abstract artists — Joyce Wieland, Rita Letendre, Michael Snow, Graham Coughtry, Gordon Rayner, Robert Markle, Robert Hedrick, Richard Gorman, Greg Curnoe, and Dennis Burton — who would make their appearance on the art scene by the end of the 1950s.

While fast learning about artists' struggles, attending art-film screenings, experimenting with wine and food, and luxuriating in her love affair with Bryan, Joyce continued painting and drawing. In 1952 she produced her first lithographic print, *The Kiss*. "At that time we were all fiddling around trying everything," Gerald Gladstone said, and he ventured a guess that a pressman in the print shop at E. S. & A. Robinson encouraged Joyce to try her hand at making a print, and printed it for her.

The first of Joyce's catalogued drawings are dated 1952, made when she was living at the Karches', and only two remain. (Others may have gone missing after Joyce and Mel fled the Stewart household. Joyce said in a 1985 slide lecture that she didn't have slides of early work to show because "most of it's lost or was never photographed.") In 1954 and 1955, she made about a dozen figure studies in a loose style, pen and ink, and of these

early drawings that exist are a portrait of her sister, a woman and her dog, and a picnic. Beginning in 1956 she would create a series of romantic figures, later identified as her *Lovers* drawings.

Still filled with fear that an artistic life was hopelessly beyond her, Joyce grew even more concerned about the contemporary art market as she heard artists' gripes. Should she realize her dream of finally becoming an artist, what good was it if no one wanted the work? There is little doubt that the grumblings she'd been hearing touched off an empathetic anger that would course through much of Joyce's work in rivulets of rage — on occasion fierce, though sometimes spiked with satire and sometimes blunted by whimsy, but appearing nonetheless as an identifying motif.

A little later, probably in the early 1960s, Joyce wrote a definition of what it meant to be an artist:

> What do we care as artists? Nobody cares
> like the women's committee, art collectors and other cunts
> give me a pain in the ass
> dreaming that art is decoration
> leaves them managing directors of bijontries [unknown]
> and, they add,
> if we can't eat our pictures, we'll wear them
> and so they cut up a de Niverville [Louis De Niverville painting]
> and doesn't it make a darling sanitary napkin
> and walk away with bricks stuffed up their asses

Whether in a fury slashing at these words by herself or giggling with a co-conspirator, Joyce probably thought her crude bitterness funny, or satiric. (Her long-term pal, Robert Cowan, said that Joyce swore a lot, but indicated it wasn't offensive.)

The sentiment of the poem would not change, although Joyce's attitude toward the Women's Committee changed as her feminism developed and she began paying a higher regard to all women's work. She came to

appreciate the work of those same committee members she had disparaged for their efforts in organizing costume balls, wine tastings, potato races, and casino nights that raised money to buy Canadian art. Galleries historically have little or zero acquisition art budgets and rely on philanthropists to donate their masterpieces and on fundraising committees to buy art.

As the Women's Committee of the AGO did in 1972, when it raised the purchase funds for Joyce's large quilt, *Canada*.

One could understand if Joyce, acting out of her destitute childhood, would have used every paycheque for living well as the best revenge, like F. Scott Fitzgerald's friends, the Murphys, had splurged on silk pyjamas, jewels, and parties without end; but she didn't. She saved her money for a trip to Europe.

Joyce's friend Wanda Phillips had travelled to Europe in 1949 with a couple of her writer friends, at a time when travel was not all that accessible unless you were moneyed or backpack trekkers. Wanda had a deep affection for the visual arts, and having seen the Great Masters' and impressionists' works, convinced Joyce that such an art tour was a necessity for an artist, not a luxury. Joyce agreed, and she and Mary Karch decided to take the trip together.

Joyce had saved for four years to take a three-month trip — "Imagine that long time saving for such a short period in Europe," she mused, long after the fact — and Joyce and Mary boarded a Cunard liner, bag and baggage. Trunks, actually, George Shane recalls. "They left with an enormous amount of clothes, taking more luggage than you can believe. They had one of those huge trunks and other bags. I don't know how they ever managed with all that luggage," he says with a quizzical smile.

They set sail from Montreal in July 1953. Their first stop was London, then on to Paris, Rome, Venice, and Vienna.

Joyce's wonderment over her travels, her unbounded delight, and the most tender bits of her heart appear in her letters to Bryan Barney. She writes about art and architecture, ruins and restaurants, people she

observes, how much she misses him, and though most is bright and ardent, all too frequently her jealousy, picayune irritations with Mary, her congenital self-doubt, and the aloneness she so fears flicker like eerie shadows through her effervescence.

Her first letter to Bryan is on letterhead bearing a fine script: "Cunard Line R.M.S. 'Ascania'." Joyce would have relished the madly romantic notion of penning a letter at sea, even though they were only on the St. Lawrence River, judging by her first line, "We are almost at Quebec" — likely, her second day onboard. One has a vision of Joyce in a sunny lounge, settled into a chintz-covered armchair, occasionally gazing "out to sea" as she composes lines to her beloved. "Dear Beube," she begins, as she does all her letters to Bryan, using the name for both him and her, and reports that there are a lot of children aboard and not many interesting people to talk to yet. Then, "I feel like a lost sheep without you bunnylion. I don't know [what] to do without you, so I've decided I'll never leave you again."

Joyce writes about her observations of Mary — with many more to come — in a sarcastic, rather nasty tone. She finds it "quite amusing" to see Mary at the bar with two older gents. "It was far from what she ever imagined I guess. These two men were going back to England after sixty years absence. My sweaty body was chuckling all over in amusement (or sobs) at the sight." One has to guess as to whether she meant the sight of Mary and the two men, or simply the situation.

Joyce closes, saying, "I send you my love and a great big lump in the pit of [my] stomach tonight, sweetie. Bye! Bye!"

Another letter to Bryan notes her return address as, "Somewhere in space" — actually in London. "I'm so homesick I could die," she writes, and then vents her displeasure with her travelling companion: "I can't share anything with Mary she annoys me so much. I talk to her only when I have to. It's amazing how little there is in anything without you, beube." And she chastises herself for sounding "terrible to you." We don't know if this refers to her comments about Mary, or a quarrel before she left — an ultimatum perhaps, as Bryan's letter hinted at. Then she relates

her experiences that day at Speaker's Corner in Hyde Park:

> Between the hecklers and the speakers I've never seen such a
> bunch of characters. One speaker (male) ended up by kick-
> ing and slapping a woman heckler. Then she kicked and
> slapped him. There was a little Irish man who was very
> funny. He didn't like doctors or politics and pretended to
> know more than they did. . . . There were at least 20 speakers,
> one South African, communism, peace, Irish Free State, old
> age pensioner, philosophy. One man (about 4 feet tall)
> pinched a big blonde woman's ass. She screamed and clubbed
> him and another man in vengeance. I was so fascinated that
> I didn't want to leave.

On the right day she would have been even more fascinated hearing
the legendary soapbox orator Reverend Lord Soper, a Methodist minister
who weekly expounded his Christian beliefs at Speaker's Corner for more
than seventy years, and standing there she may well have romanticized
herself into a part of the colour and pageantry of England's kings riding
from Westminster to their country hunting fields.

Though Joyce found the grand, beautiful Englishness of Hyde Park as
cool and refreshing as a Pimm's in a sunny garden, downed occasionally
with a shooter of zaniness coming from Speaker's Corner, her friend
apparently had no heart for Hyde Park's shenanigans. "Mary went away
and left me so I had to come home alone without the use of the map,"
which took Joyce two hours to get to the hotel.

To Bryan she inquires, "How is my sweet bun? Do you still love your
silly Beube?" and adds:

> We must never leave each other ever again, only maybe unless
> you wish to. I want to come home and baby my beube kissy
> kissy and huggy bug him and with that the tears pour out of

my eyes and on the bedclothes. What a gushy blubberhead I am. I am just a sentimental old wife. But then my beube is soft too (just a little, not too much to notice). It seems funny when I can't hear you speak anymore. It feels as though life has suddenly come suspended somewhere and that you and I must not breathe for a certain length of time.

Whether the last line had been hastily dashed off or she had seriously collected her thoughts before writing it, one can only guess. If dashed off, the sentiment skirts the edges of a mystical exploration, a stop-and-go journey that Joyce would pursue over the rest of her life, quite like being suspended between her art and her life. If, on the other hand, the words had been thoughtfully composed, Joyce lets loose her romantic soul to rush freely through them, a sentiment that would dominate much of her art.

She mocks her tears and calls herself a sentimental old wife and a gushy blubberhead, employing the same backpedalling device Bryan used in his letter to her. More so than Bryan, Joyce trivializes feelings she suspects might be a trifle too potent for Bryan. Until she met Bryan, Joyce had tucked her unrequited feelings and personal doubts away in her heart, just as she would hide secret mementoes in her art.

One of her letters describes encountering a J. Arthur Rank film being shot in Bloomsbury Square with featured actors Dirk Bogarde and Donald Huston, which Joyce writes "was fun to watch." At the British Museum they saw ancient manuscripts and books "made by the monks. Some of the most exquisite things you could imagine. The Greek section is beyond my wildest expectations. The ancient jewellery a wonderful sight." Although she and Mary spent money only on necessities, Joyce paid about two hundred dollars for a Japanese drawing and a colour print.

The letter continues, dated the following day, with her account of visiting churches by herself, looking at restorations "since the bombings":

Then I went to a beautiful Gothic cathedral and talked to the workmen who were fixing it. The people are proud of their sights and know about the history of them and make willing guides. One workman took me down into the Tombs beneath the church.

Suddenly again I came upon the J. Arthur Rank people, still making their picture, this time outside a hospital. I watched them for an hour and a half, it was quite fascinating. Kay Kendall is the leading lady and she is very beautiful. I was about five feet from the actors all the time and watched the director and the crew take and re-take shots. It seems like a very difficult life.

At this point of her life, in 1953, Joyce at age twenty-two is neither an artist nor a filmmaker and it seems that she regards either course "a very difficult life." She always would. But without her experiences in Europe, her embarkation on both courses would undoubtedly have been postponed. Joyce didn't know how close she was to making these journeys.

The two women had met an anthropologist on the boat who "likes tagging along with us," Joyce writes, and then complains that Mary "monopolizes every conversation with him and they chat for hours about meals and the weather. . . . Mary has turned into the most amazing chatterbox since coming here. I don't know what's got into her."

Joyce reports going to the National Gallery "to see it all over again." Her next sentence, "There are some 'arty' types around there," signifies once more her inability to consider herself an artist or position herself in an artistic context. One can presume that by "arty" types she meant artists seen through her bohemian viewfinder.

"I am glad to leave London (don't know why)," Joyce tells Bryan, and follows this with, "I miss talking to you so much. Mary's conversation range is limited." Closing, she adds:

Don't forget to write me Beube. Don't forget me, deary bun! I love you very very much Beube and when Michele Morgan got kissed tonight in the picture I thought of you again. I will go to bed and pray for you. I feel very holy lately and have taken to praying again. Maybe the city of churches and religious art does this to me or maybe I am lonely. Also poetry reading. I go in the shop where I bought your book and read Yeats and the clerks snicker to one another (they read my inscription [in] the book).

I hope you are doing well enough . . . and are eating properly and sleeping well enough. I am going to sleep too Beube.

Good night my deary-bun. Your Boo.

This particular letter, a blue air-mail letter, is monogrammed with the Royal ER seal and a commemorative stamp of the June 2, 1953, coronation of Queen Elizabeth II. Joyce would have considered this a delightful find. She notes her return address as: "Beube Wieland, Near Soho."

In a letter from France dated September 27, where she and Mary are staying with relatives of Bryan's, she notes that they are "very hospitable" but "Raymonde's husband took a shine to Mary instantly, he hardly takes his eyes off her."

The two women moved eventually into a hotel, described by Joyce as "in the Latin Quarter, full of Arabs and Negroes — we have to watch our step. The whole area is like something out of Puccini's *La Bohème*. Unbelievably Mediterranean."

She likes "the way the people eat and shop and cook here," adding that "there isn't very much to dislike in the French. . . . They smile and sing easily, which is very pleasant indeed. I can't help but compare them with the English." One can imagine her joy in writing, "Guess what just came on TV — a church service coming from the chapel that Matisse designed!"

About her host, she writes: "Pierre was in the Spanish war and met Hemingway and André Malraux. He didn't like Hemingway but admires

Malraux very much. Pierre was also in a concentration camp in the war and has a large bullet wound in his leg from the Gestapo." The nonchalance of this accounting would become understandable in ten years' time, when Joyce acknowledged her deep fascination with disaster and incorporated it into her work.

"We were overwhelmed completely by the Louvre," she writes. "I am afraid to go back." Her using the word *afraid* is thought-provoking. This could merely denote an aberrant use, such as, "I'm afraid I can't go out tonight," although Joyce might have given the word one of her childhood connotations, as in being afraid to desire something you can't have and then get the adored thing and thereafter live in fear of it being taken away. "The *Mona Lisa* is almost a shrine there. It is magnificent, *très* magnificent. It will never be anything less than that." She closes, noting that it won't be long "before I am home with you again Beube doll. I feel a different person already for having come here."

She failed to recount an incident that profoundly stirred her in Paris, one that Sheila McCusker still marvels over. Joyce had had an otherwordly experience when visiting the palace of Versailles that Sheila recalls with eyes wide. "She had this eerie feeling in one of the rooms that she had done the petit point on the chairs: that she and her mother had done them. She was quite sure of it."

This moment at Versailles in the palace of French kings may have lingered in Joyce's subconscious and although she would not attribute it as a source of inspiration, within a few years she would honour her mother and her sister Joan and their fine needlework — and all women's craft work — by creating a series of cloth wall hangings. Whether or not they originate from a mystical, uncanny moment at Versailles, Joyce's cloth works would rank as a career high for her.

A letter dated October 9, 1953, and sent from Naples, has Joyce complaining that their guide "has a terrible crush on Mary. *Really* it's so painful. Mary fascinates every Italian man whom she meets. No one has eyes for me because I have brown hair as everyone in Italy." Joyce

mentions that an Italian wants to marry Mary, and declares, "Woe! is me." Her next sentence perplexes for its hubris. "An American in Paris offered me 80,000 Francs, that's very flattering! I could have had a Christian Dior orig. for that. Oh, well!" Then she adds: "You can't help feeling like a woman in Europe, the men won't let you feel any other way. I have had my bum pinched and my Beube squeezed twice in Paris by the head waiter of a restaurant, evidently it is the custom to stick their finger in your Beube to see if you're a good sport. They didn't do it to Mary, tho. Everyone in the restaurant laughed their heads off! No kidding Beube they all want to get into each other's pants."

She sketched a scowly, fat monk with a lit candle in one hand and a cigar in the other, and captioned it: "This is the monk who took us down to the catacombs in Rome. They smoke very heavily, and [have] very dirty feet, and are continually scratching their bodies and eyeing the girls."

Another paragraph reads:

> We make wonderful jokes about the Priests here in Rome. Our guide says they all have women. One was kneeling at an altar in a dark corner. People said, isn't he devout. I said he's masturbating there so no one can see him. They have secret places for their hands to go in their robes.

The last letter to Bryan found in Joyce's collection is dated October 20, 1953, from Vienna. It differs from all others in tone, and taken singly, would not be considered a love letter at all, signed as it was: "Sincerely, Joyce." She had been away from Bryan now for more than three months; her emotional distance is reflected in this letter, which is less gushy, less breezy. She merely writes of seeing *La Traviata* at the famed Staatsoper, and is expecting to get tickets to *The Magic Flute* and *Die Fledermaus*. She marvelled at concerts and symphonies being "sold out every single night."

On her second day in Vienna, she made a point of locating Mozart's grave. There, Joyce told a friend, she "cried and cried."

Joyce had no job to return to in Toronto, but with the help of the contacts she'd made she obtained freelance assignments, although her earnings were meagre and she looked for a full-time job. Bryan had continued living in the room he and Joyce shared in the Bathurst Street house.

Once back home, Joyce discovered things Canadian beginning to take on a rich, lustrous new sheen. She was surprised by what her country meant to her, as though in her absence the people and the land had prettied up and matured out of their national gawkiness as strikingly as a tomboy flowers with womanly grace. Waves of appreciation swept over her, catching her off guard. Obviously, the country had changed little during the months of Joyce's absence, but she had changed, on levels that proved transformational — psychically, emotionally, and intellectually.

Those who benefit from travel bring back among their souvenir trinkets a trunkful of awakenings that grow more cherished over the years, unlike those who feel shortchanged by their own country after visiting glamorous, far-flung places. The cultural treasures Joyce returned with remained life-lasting, and while the characters she met and places and things she saw did not exist in Canada, back at home she sensed the land in depths deeper and clearer than touristy lake-mountain-seashore admiration. Her heart filled with own-country pride. She began viewing Canadians and Canada through a prized, adoring new lens.

Yet, similar to an object or place whose worth has been reassessed to a higher value, like your Louis XIV chairs or the family cottage, worry is attached to the evaluation certificate. Joyce grew anxious about Canada's resources and things she previously had given only passing thought to. She became concerned about the way Canadians mistreated their land, how little regard was paid to Canadian history, the scant knowledge we possessed of our birds, animals, trees, lakes, and rivers. And our people. Our mistreatment by neglect, especially of Native people and historical figures, troubled Joyce to a degree she had never before experienced. And with growing aversion, Joyce feared the threat of American domination.

In 1954, John Ross and his partner, Jim McKay, opened Graphic Associates, a film production company in Toronto. Jim had worked as a film animator at the National Film Board of Canada (NFB) in Ottawa and resigned early in 1954, moved to Toronto and formed the company, with John Ross's financial backing. Ross and associates ventured to crack Canada's fledgling film industry by becoming a miniature NFB in Toronto. To finance their champagne documentary aims they earned a beer income making television commercials featuring their specialty: animation.

The company's art director, George Dunning, was an experimenter, an artistically curious individual who originated numerous animation techniques. "He was always bringing in early animated films, always showing us something," Joyce said. (Dunning moved to New York in about 1957 to work on *Mr. Magoo* cartoons and subsequently to England, where he directed the Beatles' *Yellow Submarine*, a feature-length movie released in 1968 of Beatles songs set to animation. A celebrated high point is Dunning's treatment of "Lucy in the Sky With Diamonds.")

A devotee of the graphic arts, Dunning followed the Toronto art scene avidly. One art exhibition he attended in 1955 in Hart House at the University of Toronto was the first exhibition of drawings by Michael Snow and Graham Coughtry. Dunning felt that Michael's work, in particular, carried nuances of animation, although this apparently had never occurred to Michael. In a rare stroke of luck for Michael and Graham, George hired the two of them as animators although neither had done animation in their lives.

"It was fantastic," Michael said, who was at loose ends, back from two years of travelling in Europe, without a job and receiving this "incredible offer just out of nowhere." He said that Dunning "saw animation as a fine-art form, not as commercial art," and from this perspective Dunning would teach Michael and Graham, as the esteemed Norman McLaren had trained him at the NFB.[7] Dunning felt that both would have no trou-

ble learning animation, and in addition would bring their fine-art sensibilities to the form.

That same year, Joyce met John Ross at a Toronto Film Society screening, and scattered among the small talk was Ross's discussion of his new company. Like an oyster sucking in a grain of sand, Joyce would culture this moment into a glowing pearl on her strand of lifetime artistic achievements. She asked Ross if he would look at her art samples portfolio; he suggested she show them to George Dunning. "If he likes them, we'll see what happens," Ross told her.

Many a success story begins with a little embroidery trimming the edges of an applicant's credentials, and when hired, the applicant is in for some frenzied flying by the seat of the pants. Joyce's sample work included bits of commercial package design from her days at E. S. & A. Robinson, some illustrative treatments of type fonts and a few drawings. Joyce described how she took her samples to George Dunning and entered the film business:

> Lots of them were lettering with children forming the words. I also did a lot of animals. . . . Dunning liked the work a lot, and hired me freelance.
>
> I was terrified because everyone at Graphic Associates was so impressive to me. The first job Dunning gave me was to animate Niagara Falls. I didn't have any idea how to do that. I tried to ask him, pretending so as not to show how stupid I was. He would try to describe it, but he wasn't very good at showing because he was very much off in his own world; he was a tremendous dreamer. He couldn't help me much and so I went away. For two weeks I worked on this project, and I went into a complete flip-out. I was animating drops of water without knowing how they'd look because I didn't even go in and ask for a flimsy test [also called a pencil test, used to

review the animated action before the animator's drawings are inked and opaqued]. I didn't even know what to ask for or what any of it was. It was disastrous. Well, I think he thought I had forbearance or whatever, and he started hiring me to do different things — paint cels [the sheets of transparent celluloid used in animation work], lettering. . . .

Gradually, I got put on staff, and I met the other people there, including Mike Snow and Graham Coughtry. . . . We all enjoyed working together, and we were doing all kinds of stuff. But we were learning animation, which is amazing to be *paid* to learn.

In Michael's opinion, Joyce was hired because Dunning immediately saw her "really good draftsmanship" in her samples.

After her rank-beginner indoctrination, Joyce moved up to drawing "in-betweens" or "tweens," that is, the dozens of images required to activate action from one sequence to another. For example, if Dunning wanted a teacup to move from position A to B, he would draw the A and B images and Joyce would repeat the images in between, drawing three, four, or fifty drawings of the teacup moving from A to B, so that when Jim McKay transferred the images to film they moved as one smooth action.[8]

There was nothing very creative about drawing in-betweens, but Joyce loved it. She admired Dunning's sophistication almost as much as his good looks. Moreover, she was actually employed as an artist.

At the time Joyce joined the staff at Graphic Associates, Donna Lawson ran the office. She and Joyce remained friends throughout the company's quixotic life, from 1954 to 1957, a time that cemented the women's lifelong friendship.

"Those were crazy days!" Donna said, her memories of forty years ago unleashing a string of giggles. "We were all learning and we made

some terrible mistakes. I remember one television commercial where we couldn't get the tea pouring straight out of the teapot, it was coming out in a jerky stream."

Although producing television commercials was the company's mainstay, occasionally John Ross obtained NFB contracts to make animated segments within documentaries. One of these jobs was for Norman McLaren's Oscar-winning film *Neighbours*, in which two neighbours build fences around their houses, ending with a violent conflict of the men killing each other and their families, a political fable that McLaren made as a protest to the Korean War. Donna described Graphics Associates' animation job as "this picket fence where the pickets were all supposed to fall down like dominoes, but they got flipped out of sequence and went all the wrong way. . . ." Throwing her hands up, Donna sighed, "It was a dreadful mistake. Quite laughable."

In those crazy days, Donna continued, with exaggeration forgivable for its enthusiasm, "We all worked together, ate together, and slept together."

Regarding the latter, Barry Gordon, a freelance director the company hired occasionally, and a teacher of film at Ryerson Polytechnic Institute (now Ryerson Polytechnic University), had bought a house on Sherbourne Street near Wellesley, where he and his wife Doreen lived on the ground floor, and rented rooms on the next two floors. The exigencies of timing, opportunity and desire converge here. Joyce and Bryan's relationship was foundering (more on this later), but one incident attests to its shakiness. Joyce and Bryan were having a drink in a bar one night and they met Donna and George Gingras, who were going out together then. George marked the occasion saying that Joyce came on to him but George resisted; Bryan was a friend and George would not betray a friend. Shortly after this meeting, George who, like Jim McKay, had been a film animator at the NFB, got a job at Graphic Associates and Joyce moved in with Donna and George to the Gordons' — whose house they discovered had formerly been a funeral home.

"It was weird," Donna allowed. Worse than weird was the sleep deprivation the tenants suffered — not because of ghoulish associations with the home's former business but because of their next-door neighbour, a ginger-ale bottling plant. "You could hear those bottles jingling all night long!" Donna cried, wincing at the memory.

Joyce commandeered the top floor of the house, a room with an attached solarium that she used as a studio; and Donna and George lived in singles on the second floor, "dark little holes with no windows," Donna recalled. Seated now on a white leather sofa in her elegant, art-filled condo, a few blocks away from the old funeral home, she smiled, saying they saved on expenses by renting a third room to two out-of-towners who were blissfully ignorant of the building's previous incarnation. Apart from the huge "Funeral — No Parking" sign hung as art in the foyer, the home's past went largely disregarded. "It was a great place for parties," Donna said, smiling rather wickedly.

Chapter Three

With three hundred dollars in his pocket, Michael Snow and his musician friend Bob Hackborne had gone to Paris in 1952 and travelled around Europe and northern Africa for almost two years. In Paris they joined a band of black musicians from the Caribbean — all dentistry students — and played for a few months at three newly established Club Med destinations, then went with another band to Morocco and Spain. Michael played trumpet and Bob, drums. They were paid mainly in lodgings and drinks. "I was a shitty trumpet player," Michael said, laughing, "so I'd play

a couple of numbers, have some drinks and try to get laid." During the day he visited art galleries and drew. He'd left behind a girlfriend, a fashion illustrator studying at the Ontario College of Art, and on his return to Toronto found that she had met someone else and was planning on going to Montreal. Another version of the story is that she wanted to get married but concluded Michael was not her ticket to a posh life, and reportedly saying she "hated this bohemian crap," went to Montreal.

Michael and Graham Coughtry had been working at Graphic Associates a short while before Joyce was hired, and the gang began going out together, socializing much like any other group of people at work. Michael shared a studio with Graham and Robert Hedrick on Spadina Avenue, above Gordon Rayner's studio over a Chinese restaurant, where they had parties. And at this time, early in the group's employment at Graphic Associates, Michael threw a party at his parents' house in Rosedale when they were out of town.

Sheila McCusker described Rosedale, a leafy residential enclave of affluence in Toronto, as if it existed on another planet (which in many minds it does). "Nobody had ever been in Rosedale. I didn't know anyone there. But we all went to Mike's house, this big, elegant, rundown house you see in Rosedale," a place with the genteel decay prized by old money. Sheila reported that Joyce came to the party but didn't leave. "I know she stayed overnight. That was the beginning."

And the end of one phase of Joyce's life.

Donna's previous remark about everyone working, eating, and sleeping together now assumes another dimension.

Joyce had liked Michael from the moment she met him. Simultaneously, she fell for George Gingras. After the party, Joyce's relationship with Michael continued to be a sexual one; George was a lovable buddy, a work pal, a party pal, a rooming-house pal, but not a sleeping-with pal — yet. The two men were a study of opposites: Michael, the self-contained, cool one, at the time more interested in jazz than art, whereas George was a flamboyant, outrageously witty man who drank and partied all night, but

also had a troubled, dark side. He burned a flame for Joyce for decades. George was needy; Michael was not.

A distressing couple of years lay ahead for Joyce. She despaired of feeling more strongly for Michael than he, apparently, felt for her.

And there was still Bryan Barney.

It is not certain exactly when Joyce and Bryan severed their relationship, but after Joyce returned from Europe in 1953, her mind had expanded with a new aesthetic. Her subsequently moving into the Wellesley Street house, getting a job in a film studio — actually working at art with artists — gave her a distinct connection to Toronto's art scene. And as she edged into this faster, wider, headier lane, Bryan did not accompany her. Or would not. He preferred his introspective literary life.

Friends at the Bathurst Street house had expected that Joyce and Bryan would get married, especially after Sheila and Gerry moved in together. Sara Bowser, who married Bryan in 1964, says that Bryan did not discuss with her the circumstances of his and Joyce's breakup. "He never said a word about it," Sara states. "They understood each other. I think it was one of the great friendships in Joyce's life." This indeed remained the case until just prior to Bryan's death in 1997.

Joyce and Bryan's parting related directly to Joyce's infatuation with Michael. Friends said that she wanted a commitment from Michael that he was loath to give and Joyce must have confided something of this to Bryan, based on his letter, undated, typewritten, from Hamilton, which reads:

Dear Joyce,

I'm going to try and write a few things out. When I'm with you now it seems so hard to get anything across. I'm shy. That may sound odd and faintly comical to you but no other word describes quite so accurately my feelings when I'm with you.

You probably feel, as I do, that there is no sound reason for either of us to think that we could ever begin again together. I haven't quite accepted that yet, only because I don't want to.

Maybe you have — you were always more realistic than I, contrary to what you think. If you feel like that then be a good girl and don't read any further because what follows can only have a pathetic sound for you. I'm trying hard to believe that it's over, irretrievably over. I know that if things had worked out better with you and him [an obvious reference to Michael] I would now be almost forgotten, that any feeling you might still have for me exists because things went badly for you, and for no other reason. Believe me, Joyce, that thought alone is almost enough to make me want to clear things up permanently. And that is only part of it. When I think of us being together again I think of the added hazards that would be part of it. Because things couldn't be as they were before. I guess you know what I'm thinking of here.

She must have told Bryan about her night, or more of them, with Michael, for Bryan thinks the "sane, sensible thing to do is to write it off completely," although this "doesn't appeal to me very much, but it's necessary."

Bryan writes that if she really wanted him, "I'd run to you in a minute." He does not care to leave the impression of going through the rest of his life "with a brave heart and a love-sick heart," and he has decided to go to England and "together with my writing will help side-track you out of my mind." As for seeing her before he leaves, he "doesn't think it a good idea but, I think I'll leave that up to you."
He closes with:

Write to me, Joyce. And don't be afraid to say anything you'd like to say. There should be one person before whom we can lay ourselves bare. It helps make us stronger when facing the rest of them.
Love, Bryan.

They met again before Bryan left, which resulted in another letter stating he'd come to a decision. "It's getting so I can't think of you in a more impersonal way all the time. If you ever need me, he promised to "run to you in a minute," but he felt, "it's best that we don't see each other anymore." He would get his books "at some future time." He signed the letter, "Good luck, Bryan."

"I can't guess what went wrong," Sara says,

> because a lot of things went right. Or they wouldn't have gone on being friends. But like a lot of writers, Barney [Sara's only name for him] liked routine, a settled life, dinner at six sharp, in time to get back to the typewriter. He was a very quiet person, reserved, and I think it was all too giddy for him, never knowing when she'd show up, whether dinner would be ten or, you know. And I think it broke up that way. I think. Barney was not a bohemian at all, he was a professional writer. God knows, he got up after breakfast and went straight to the typewriter. I think [Joyce and Bryan's relationship] was wrong in terms of the way they wanted to live.

All Bryan said, Sara declares, was that "he had been looking out the window [of the Bathurst Street house] and noticed Joyce coming home. I gather that not only was she late but she was a bit of a wreck, a mess. She'd been in the rain and was in one of those semi-chaotic states she got into every now and then, and I think he looked at her and said it's too much, too complicated, too irregular. I think it sort of died that way."

Getting a job at Graphic Associates and moving into the old funeral home with Donna and George transformed Joyce in a manner that she could not have perceived during its genesis. Life-altering incidents perversely catch one unawares, until the tidal wave at the source subsides enough to allow

space and time for reflection. Joyce wasn't given nor had she taken this time out. She was in love, she worked in an exciting, creative atmosphere and belonged to a tight group that had good times together. And in the course of the upheaval, subtly, like the scent of spring flowers drifting through the bedroom window into your morning wakefulness, the effect of this stimulating environment that most benefited Joyce was the revitalization of her creativity.

Although Joyce had enjoyed her job at E. S. & A. Robinson, where she had started meeting artists, the creative atmosphere at Graphic Associates, the talent around her, "knocked her out." She greatly admired George Gingras's film-animation skills, John Ross's business acumen, and both men for their style. Sheila McCusker had done some freelance "in-betweens" for the firm and had witnessed some of the daily carryings-on. "George was always wearing Harris-tweed sports jackets and these untied silk foulards that he flung over his shoulder "to keep from dangling into his work," and John Ross "had a drawer full of cashmere sweaters that he threw around to the guys, so embarrassed he was by his money and their poverty."

They did a lot of fooling around and learned animation, but more than anything else at the firm, Joyce was inspired by and impressed with Michael's and Graham's artistic achievements. She saw them as "real artists" who worked as film animators by day to paint during their off hours — and they had already had an exhibition of their work, the one at Hart House.

Joyce itched to do animation and make serious art, like them. (When not going out at night, she worked in her studio but was too inhibited to show her work around the office.) Also, she wanted to party with them. Arriving at the exhilarating situation of being accepted by these clever artists, Joyce compensated for the abandonment she had suffered as an orphan through the socially acceptable means of living it up.

Twenty-three years old when she joined Graphic Associates, Joyce and her confreres revved up their partying to a degree that reduced the Bathurst Street beer parties to sophomoric hijinks. The standard party

routine was to go fellow artists' openings, drink the insipid plonk and wind up at someone's studio for something heavier. Joyce went everywhere and began to gain the reputation of a party girl — one whose high spirits and sense of humour cranked up a party; she liked having a few drinks and dancing. She shed some of her inhibitions.

Drugs were confined to clandestine weed. Surreptitiously at private parties a few joints got passed around, but hard stuff scarcely existed in artists' circles. Joyce's friend Hanni Sager, a dress designer and toy collector, claims there was a better high: "Sure, we had drunken parties and people would fall into the swimming pool, but the Pill was the greatest thing then. Who needed dope when you could have free sex?"

The participants laugh at their innocence, judged by today's standards. At a 1954 art opening at the Here and Now Gallery, for example, Warren Collins did some casual filming. People are seen talking in groups, drinking beer and smoking legal cigarettes. The raciest bit in the clip is a sequence of Gerald Gladstone on a couch nuzzling Sheila (*I saw a man who necked with his wife!*). All the women are wearing dresses, and the men, shirts and ties. Michael is playing the piano.

Warren's camera cuts in and out to Joyce jitterbugging with animator Richard Williams, and they look more like a couple at the prom than at an artist's opening, although Joyce's full skirt swishes to reveal her thighs. If beer bottles were not visible you'd swear the drinks were straight fruit punch. The pronounced air of nicety amused Joyce when she viewed the film years later. She said, "All we wanted to do was get laid."

Until she went to work at Graphic Associates, Joyce's romantic life had been dominated by Bryan Barney but included generic boyfriends at the Bathurst Street house, a couple of impossible dream guys, and the occasional one-night stand, like the handsome Aussie Sheila mentioned — a typical menu of love, sex, and anxiety for a single woman in the 1950s. More than one friend said Joyce was infatuated with Gordon Rayner; another claimed she liked Robert Markle. Dennis Burton was a pal. But

Joyce had fallen for Michael Snow. Friends who speak of Michael and Joyce's early relationship insist, "Joyce was crazy about Mike."

Love's ability to turn its subjects inside out occurs as routinely as winds bestir the autumn leaves, and from the time Joyce paired up with Michael and flew away on her radiant, emotional gale, its turbulence churned up her personal and social life irrevocably.

Mel Stewart talks about how this caused Joyce to drift away from her Bathurst Street friends.

Joyce was sixteen when she and Mel met; the two women remained lifelong friends except for a few years' estrangement when Joyce worked at Graphic Associates. Mel withdrew from Joyce then. "This was the only time I didn't approve of the things Joyce was doing," Mel says quietly.

George Shane, like Mel, saw how Joyce's social life "changed radically" after meeting Michael. George attributes the change primarily to the fact that Joyce was "very easily influenced by trends."

The parties and her exposure to a widening social circle served Joyce's ego lavishly. In her newly minted vivacity, she was sought out by men; they liked being in her company. She flirted, flattered them, and joked with everyone. Joyce's voice was very appealing, soft and giggly, with a girlish singsong lilt that easily soared into high Cs of laughter heard over a party din. The realization that men found her attractive, along with loving Michael and experiencing some mutuality of feeling, boosted Joyce's confidence and freed her to be the person she had kept under awkward wraps. Like that fifteen-year-old girl in her first year at Central Tech who felt a sense of belonging with students who were "as poor and crazy as I was," Joyce felt connected to Donna and the artists at Graphic Associates as well as a lot of new people in the arts. Consequently, she attained a degree of stability that had been missing from her life — even though she'd been in love with Bryan and had had good friendships with everyone at the Bathurst Street house. Perhaps more accurately, whatever stability she possessed was now intensifying; and with it, voraciously, she wanted more of everything she'd been sampling. Joyce had no illusions

about the competitive game she'd entered — and whose rules she had yet to learn — but she rightly determined that she needed a personal polishing-up to compete, to stand out. She would get herself some style.

Sheila and Joyce continued seeing each other even though Sheila was mostly at home having children (eventually a total of six) and making clothes — "My obsession was to become a dress designer. I was totally absorbed in the subject from the time I was fifteen." She and Joyce spent a lot of time discussing clothes. "If you were an artist you weren't supposed to be interested in clothes," recalls Sheila. "As if, how could you be so conceited, when there are so many other important things going on? You didn't fuss over clothes. Well, Joyce and I liked to fuss. We liked the high heels and lipstick and everything, and if that put you in a bourgeois category, we didn't care."

Joyce started wearing bright lipstick and eye makeup that added drama to her teasing brown eyes, and she had her lustrous, dark hair styled into a pageboy. Her appearance became a preoccupation. The figure that would later become plump was then full bosomed and shapely, displayed to advantage in tight sweaters and hip-hugging skirts.

This look, however, was fast becoming extinct in the rush of her and Sheila's fashion madness. Turning the new heads Joyce was meeting required more elegance. The design career Sheila had put on hold found an outlet in clothes she made for Joyce. The first of them were "strappy little things," in Sheila's words, radical by the standards of Toronto fashion then, when "women were wearing little Peter Pan collars and white gloves. So I did the bare spaghetti straps, which are now nothing, but at the time they were something." She speaks of Toronto women at openings who were "serious and severe. They didn't mess around with sexy clothes."

The two of them went "on and on and on" about clothing. They would discuss for hours the great fashion designers of the day — Balenciaga, Givenchy, Chanel. "So we got into a whole philosophy about clothes."

Coco Chanel contributed to Joyce's fascination with the French for her revolutionizing haute couture by simplifying it with her sculptural

lines and all those faux pearls. Joyce adored Chanel clothing as sculpture, but even more infatuating for Joyce was learning that Gabrielle (Coco) Chanel had been raised in an orphanage — this poor orphan woman who single-handedly changed the fashion world — that Picasso and Colette were her friends, and that the designer had refused marriage into royalty because the strings attached would have stipulated her to stop working. In other words, Coco Chanel was a woman who had attained success her way. And when Chanel declared, "I would not go to bed with someone for love. For a marriage of business interests, perhaps," every cell in Joyce's heart of romantic hearts surely thrummed madly, reverently.

The working methods of dress design intrigued Joyce. Innately, artists dwell on design in everything from a dress to cloud formations to salad on a plate, and from her childhood pasttime of playing with cut-outs it is quite likely that Joyce appreciated cut pieces of dress fabric with the same sensibility as she had the paper cut-outs she had folded onto her paper dolls. Both were sculptural forms, each with its own purpose, dimension, colour, and effect when put together, mixed and matched, fitted and adjusted.

Joyce regarded Sheila as an artist of clothes, not as a dressmaker, and she loved watching her cut fabric and arrive at the finished product. On many occasions, making an outfit was a team effort. "I would start without a pattern," Sheila says, "and we'd stand around for hours fussing with things. It was more than a dress. We'd go out looking for fabric and then all the other things, hats and shoes." And of course, jewellery. Joyce loved "little Victorian things, little garnets," which were "too dinky for me," adds the statuesque Sheila.

The two of them went to parties totally coordinated. "If we had a green outfit, we would have shoes dyed green or blue, stockings to match. So we treated the whole thing as art. It wasn't just a couple of chicks dressing up — this was serious with us."

At every opening they wore a different outfit, creating a show that began competing with the art on the wall. Sheila recalls, whispering in imitation of the buzz, "It would be, 'What's Joyce wearing tonight?'"

Thus Joyce charted the course of action she would follow for most of her life: attracting attention to herself.

She began mixing with people she had previously only read about in the gossipy, influential social columns, carried then by all three Toronto daily newspapers, in which being named gave you instant social cachet. Joyce inaugurated a strategic public-relations campaign for herself, going out to be seen, jumping at all opportunities, striving to be "in." Not having the clout to set trends, she gave off mild shocks in the racy talk she developed, the double entendres she played with, and in looking good. A couple of glasses of wine at a party loosened her up to meeting people, especially well-heeled Toronto conservatives who thought most artists exciting, amusing, and rare, like exotic pets you can't keep your distance from. Joyce took a few trendy flyers. Among a select group of artists, smoking dope ranked as fairly stylish and therefore, smoke a little dope Joyce would.

The problem with fast living was that Joyce didn't make the kind of money to support the habit. Sharing digs helped keep expenses to a minimum but Joyce's future as an artist, when she dared worry about it, held little economic promise. She despaired of ever selling a piece of her art, let alone making a living by it, and while the camaraderie of artists and others in similar situations offered solace, it did little to alleviate her straitened circumstances.

Michael struggled like the other artists, although his struggle was concentrated on artistic recognition rather than financial success. His father was a retired military officer and his mother was a devout, convent-raised Francophone with a genteel appreciation of the classics. They had enrolled their son in the prestigious Upper Canada College where he studied music and art. Michael would always be known as the boy who lived in a big Rosedale house, who was in a vastly different league from his fellow working-class artists. Given Joyce's background, Michael's lifestyle was powerfully seductive to her. Until she was in her twenties, Joyce had known only people like herself who lived in working-class neighbourhoods, who struggled and scrimped. It wasn't until she went to

Europe that she made the acquaintance of opulence, albeit through paid admission to castles with roped-off rooms.

She had seen the mansions that wealthy Torontonians lived in and would soon be invited to some of them, but until the party at the Snows' family home in Rosedale, Joyce had been unaware that Michael came from this class; he lived in cheap rooms, as they all did, and always looked as though he didn't have two dimes to rub together. (To this day, he is totally unpretentious about his upper-class background.) Although Joyce derived no direct benefits from Michael's lineage she was dazzled by it — along with him and his refinement, his intelligence and aesthetics. Convinced she had found the man for her, a prince more charming than Bryan, one imagines her as the child who, having had so few of life's treats, gazes up at him with her fingers crossed behind her back, wishing, hoping.

When Joyce and Michael, now identified as a couple, were not attending openings, they and their artist friends went to pubs and clubs that had live music. Gordon Rayner says jazz more than art drew Michael and Joyce together, at first. Michael often played piano in a quartet with artist friends that Joyce later dubbed the Artists Jazz Band, and the name stuck. They included, variously, Graham Coughtry on trombone, Nobuo (Nobby) Kubota on alto saxophone, Robert Markle on tenor, Richard Gorman on bass and Gordon Rayner on drums, playing in his studio "when we were young and had all that energy, once a week all year long," Raynor recalls.

In the 1940s and 1950s, the jazz greats played Toronto to wildly enthusiastic audiences, and top musicians kept returning to the Town Tavern and the Colonial Tavern. Vividly, Rayner remembers those nights. "We heard Miles, Getz, Billie Holiday — I mean, to see her being helped on the stage, that big gardenia in her hair —" He stopped, as though honouring the departed jazz legend with a moment of silence. At that time, Michael Snow was wavering between taking up music or art. Gerald Gladstone recounts the time he was at Michael's apartment and Michael had said he was torn between de Kooning and Miles Davis and he said that night he'd made up his mind to go into art. Gordon Rayner worked

in commercial art and expected to remain commercial. His dream was to knock Norman Rockwell off the cover of the *Saturday Evening Post.* When only fifteen, Gordon applied his artistic skills to forging himself a birth certificate so he could get into the clubs.

He reports, with equal parts bravado and nostalgia, "It was a great time. We all knew what was happening in the New York art scene. We were an aesthetic stock exchange, all trading in ideas about music and art."

They loved jazz, they were hip, this was their moment. They were poised to take the highly uncertain and possibly heroic path to fine art. Joyce, among them, had some catching-up to do.

While Joyce and Sheila had sampled fine French wining and dining, the ordinary night out meant beer drinking at one of two places: the Pilot Tavern or Grossman's Tavern. The all-time famed artists' hangout was the Pilot, located on Yorkville's edge, on Yonge Street,¹ about a beer bottle's toss from where the Isaacs Gallery would soon be located. Here was true grunge. Non-regulars, civilians and square johns conformed to established hierarchies as invisible and potent as jailhouse protocols: flashily-dressed sports returning from the racetrack sat at the bar, tourists and drifters sat in the middle at tables and in booths, and in the rear smoky reaches were the ruling elite, the artists. "It was our place," says Sheila McCusker, as adamantly as though clutching its keys.

Sculptor Gerald Gladstone called the Pilot an art-education centre. "Toronto's art scene got put together there," he stated.

Joyce and Michael were not Pilot regulars to the extent that the others were — Graham Coughtry, Robert Markle, Gordon Rayner, William Ronald, Dennis Burton, Michael Hayden, Chris Yaneff, Gerald Gladstone, Walter Yarwood — primarily because Joyce often went with Michael when he played piano at night — to such popular spots as the Bohemian Embassy, the Anndore Hotel lounge, and later the Westover Hotel (now a place for "couch dancing"). However, Joyce did some time at the Pilot. Artist Barbara Mercer remembered a night when Robert

Varvarende did "something awful" and Joyce threw a glass of beer at him. And then she and Donna were barred for singing Christmas carols during an August heat wave, behaviour that interfered with the artists' higher purposes of ranting about art critics, rival dealers, and rival artists, getting into fights, or making out.

The other attraction for artists in the 1950s — one that remains to this day — was Grossman's Tavern on Spadina Avenue, bordering Toronto's garment-manufacturing district and Chinatown. Grossman's is located among grocery stores, second-hand shops, and small cafés that fan out into the side streets of Kensington Market, a crowded, clamouring, multi-cultural bazaar. The roughness of Grossman's attracts artists as much as its live music — blues, rock-a-billy, honky-tonk — and its location. In the second- and third-storey, paint-peeling, unpretty buildings above the shops are cheap rooms that artists live in and use as studios, handy to a branch of Curry's, a major art-supplies store in business since 1911.

Beer drinking, if not undertaken at the Pilot or Grossman's, was extended to Old Angelo's on Elm Street, where a gang of artists met every Friday afternoon, including Joyce on occasion, and the King Cole Room beer parlour in the Park Plaza Hotel on Bloor Street, a regular, rowdy hangout for Ontario College of Art students.

Of all those at Graphic Associates together, George Dunning made the strongest direct contribution to Joyce's artistic development — the most valuable of her career next to that of Doris McCarthy. And next to McCarthy's was Michael's.

Frequently, Dunning would bring art books to work and discuss them with his artists. Most remarkable for Joyce was an occasion in 1956 when Dunning appeared with a portfolio of one hundred Picasso etchings, known as the Vollard Suite. Famous Parisian art dealer Ambroise Vollard,[2] considered to be one of the leading art dealers and publishers of our time, had given Picasso an exhibition as early as 1901, and in 1930 commissioned the artist to make 100 copper plates that he (Vollard) would

produce as a set of etchings. However, Vollard died in 1939 before he had an opportunity to print the plates. The plates were eventually printed (to Vollard's strict specifications) as a suite of 100 prints of works dating from 1930 to 1937, in a limited edition of 303 portfolios, released in 1950.

By then Picasso had been painting, sculpting and drawing to ever-accelerating acclaim for close to four decades and Joyce, encountering these 100 works, was at that moment artistically and aesthetically changed. Being on intimate terms with sheets of images of unparalleled excellence and printed to the highest art standards, a portfolio handled by the master himself when he'd signed it, had an immense impact on Joyce. To this day, millions of art lovers feel similarly aroused by Picasso's genius. It has been said that Picasso's erotic drawings, combined with Stravinsky's new twelve-tone music, both flowering in the early 1920s, jolted the underpinnings of the art world and set a twentieth-century standard of culture.

The Vollard Suite "influenced us all," Joyce later told Art Gallery of Ontario curator Marie Fleming. Painters working in abstract themes in the twentieth century measured themselves against Picasso, the colossus. And there is no doubt that Joyce and her artist pals at Graphic Associates, consciously or not, made paintings and drawings in Picasso's image, or shadow. Joyce was familiar with Picasso's first masterpiece, *Les Demoiselles d'Avignon*, painted in 1907, for this is the painting that reconceptualized the figure in abstract terms, where it could be subordinated to the total painting. Thereafter, the figure's treatment on canvas or paper changed, where it possessed angles and planes, distortions and abstract compositions of body parts. Art historian H. Harvard Arnason observed, "After this discovery there was only a short step to the realization that a painting could exist, independent of figures, landscape, or still life, as an abstract arrangement of lines and color shapes integrated in various ways on the picture surface."

The images of Picasso's Vollard Suite struck Joyce like a smallish love affair, torturing her consciousness, unabashedly thrilling her. Devoutly as she loved Beatrix Potter's animal drawings and the works of the Great Masters, this infatuation was different. Joyce came to see the human body

anew — freely, as Picasso had seen it. She re-experienced the Picasso nudes the way lovemaking's sensations recur in total body rushes; and in this hapless state of pleasure and expectation, Joyce beat a path to galleries and libraries to luxuriate in more of Picasso's figure drawings. In her studio solarium on the third floor of the former funeral home, Joyce, too, undertook to draw the human figure anew.

Both in competence and subject matter, Joyce's figure drawings from that period are distinctly different from her drawings of the previous three or four years. This can be assumed to have resulted from the combined influences of Dunning's tutorials on Picasso and the figure drawings Graham and Michael were making at that time. In 1956, Joyce began a series of drawings, *Lovers*, that coincide with her self-study of the figure and her sexual relationship with Michael. Although many drawings are undated, a number of them are thought to have been made in 1956 and 1957. This dating is credible, considering Joyce's figure drawings of 1954, which lack the power and the maturity of the later drawings; but the most striking difference between the two groups is the eroticism expressed in the subsequent works.

As thoroughly as figure studies captivated Joyce, her art education would be further expanded through Michael's influence. He claims that his chief influence on Joyce's artistic life was in introducing her to the French artists, notably Marcel Duchamp (who came to America in 1915) and Joan Miró (although Spanish, Miró lived in France for many years). In Miró, Joyce discovered both surrealism and a master twentieth-century painter. Miró's figurative works — his lines, his colours, and overpowering imagery — appealed to Joyce's sense of the glorious absurd; and his abstractions of the 1940s and 1950s had a major impact on the development of Joyce's abstractions. Miró pointed the way for Joyce to be bold with colour, shape, and composition. Duchamp would leave a lasting effect on Joyce through his daring "non-art" sculptural forms. Studying his work, and later that of Louise Nevelson, would lead Joyce in another ten years into a new medium: assemblage.

Again through George Dunning's influence, Joyce found another creative expression.

The talent, innovative dynamism and the remarkably high standard of work produced at Graphic Associates bowled Joyce over. Many at the firm advanced to make distinguished contributions to art and film, along with visual artists Snow, Coughtry, and Joyce herself, who would achieve national and international acclaim. George Dunning would direct the Beatles' animated feature film *Yellow Submarine*. George Gingras continued to do first-rate animation and Richard Williams directed numerous *Mr. Magoo* cartoons and was animation director of the acclaimed animated/live-action feature film, *Who Framed Roger Rabbit*, released in 1988.[3] Warren Collins, Robert Cowan, Graeme Ferguson, and Richard Williams all achieved success in film. Graeme Ferguson teamed up with Roman Kriotor and Robert Kerr and developed the innovative multi-screen hits that were hugely successful at Expo '67, using a technique that evolved into IMAX, and was premiered at Expo '70 in Osaka. The first full-time IMAX theatre opened in Toronto in 1971.[4]

A fortuitous, ecstatic accident that occurred at Graphic Associates during the company's production of a tea commercial (that had given the animators such trouble, Donna remembered), acted as the catalyst for Joyce's filmmaking career. Fooling around one day, Graham Coughtry suggested making a tea-drinking *Hamlet* spoof of the commercial. Warren Collins had a 16-mm Bolex (bought in 1948 and which took a year to pay for, he pointed out), and he purchased some film, loaded the camera and he, Graham, Michael, and Joyce climbed to the roof of the Graphic Associates building and Warren began shooting. On the set — grimy brick chimneys and a mansard roof that look as much like Elsinore as any grotty city rooftop could — Coughtry hams up Hamlet with endearing hokiness. The central dramatic event involves Michael as the ghost climbing through an open window, and after some threatened mimed conflict that never materializes, Hamlet pours the ghost a cup of tea and the two

characters drink with lip-smacking gusto. End of conflict.

"We were all in on it, with everybody contributing ideas," Warren says about this "two-minute little film we called *Hamlet.*"

The group made three more spoofs. *Assault on Grenville Street* and *Tea in the Garden* were each not more than five minutes. Economics rather than aesthetics dictated the length of the films. "Nobody had money to buy film," Warren states. "Two rolls got you seven minutes." For their final effort, Warren relates: "We took a Bolex 8-mm to Craigleigh Gardens in Rosedale and started shooting." Craigleigh Gardens, a lovely gated parkette facing a scenic ravine on one side and Rosedale mansions on the other, became their no-cost set for their four-minute, black and white film, *A Salt in the Park.*

"It was Joyce's idea and her wit that came up with *A Salt in the Park,*" says Warren. "She knew people would question the spelling. And that amused her."

In this parody of a silent-movie cliché, Joyce plays the Lillian Gish-type damsel in distress, Robert Cowan is the trench-coated villain flashing "feelthy" pictures, and Michael, an innocent passer-by becomes the hero. Warren Collins comprises the entire crew.

A rinky-dink piano soundtrack sets the silent-movie tone as the film opens with Joyce strolling in the park, smiling, waving a long-stemmed rose she occasionally sniffs, which causes her to flutter her eyelashes as though rocked by ecstasy. She sits down on a park bench and is soon joined by Robert, the villain. He leers, sidles over, removes a snapshot from his inside coat pocket and flashes it at her. Joyce mimes mortification. Observing the scene is the third character, played by Michael. In pixillated fast action, Michael darts out from behind a bush, streaks across the path in front of them and shimmies up and down a lamppost alongside the park bench. Then the three characters bounce madly back and forth over the park bench and the film abruptly ends with all three of them fleeing down the path, deep into the park.

The last seconds of the film catch a family on the path, stopped dead,

gaping at three people being chased by a man with a camera. Warren squeals, "They thought we were crazy!"

This film would be nothing more than its intended little parody were it not for one last image. While Joyce, Robert, and Michael are running away, Warren pans up to the trees and they wisp softly out of focus, leaving an impressionist image strong enough to hold as a last, dreamlike character. This sweet lingering abstraction manages to dilute the film's satiric heavy-handedness and the viewer is satisfied that art was attempted.

Warren emphasized that the work on all films was done collaboratively. "Plot?" He laughs about *A Salt in the Park*. "There was no plot. We just went into the park with the camera and shot."

He underscored the point that Joyce had a lot of ideas about the final outcome, the look of the film. For her first on-camera performance, Joyce was thinking of Lillian Gish, an actress she thoroughly admired. Joyce once wrote that Lillian Gish "was an artist in a complex sense. She could stand back, outside herself, and draw images with her body, her arms and her face."

Joyce's filmography begins with *Tea in the Garden*, 1958, as a co-production with Collins, and *A Salt in the Park*, 1959, co-produced with Snow. (The dates 1958 and 1959 are misleading in that the films were actually shot in 1953 and 1954, while the group was working at Graphic Associates; however, the films were completed those few years later when soundtracks and titles were added.) Joyce did not list *Hamlet* or *Assault on Grenville Street* as her works.

These "spoofs," as Joyce always dubbed them, launched her on a twenty-year period of filmmaking. And it was these early works, she claimed, that introduced humour as "subject matter" in her work.

Joyce did not set out to make films in a blaze of stardust and klieg-lit fantasies. She said, "We'd often have extra film left in the animation camera, or there would be outdated stock from the documentaries. We would get an idea, go out at noon hour or after work and start making films."

Joyce joked about being fired from Graphic Associates for incompetence

but George Gingras claims she was "let go" in September 1955 because "they could see it coming to an end." And the company folded in early 1956.

Still living at the funeral home on Sherbourne Street with Donna and George, Joyce got a job with an engraving firm doing entry-level lettering and some graphic design.

Through the experience of losing her job, Joyce developed a career coping skill that she would use for the rest of her life: Put on a happy face and be jolly, like the fisherman who returns from a harrowing storm at sea and dares not reveal his terror. Viewed through some eyes, Joyce was on her way. She had landed the perfect job at Graphic Associates, learned animation, and collaborated in filmmaking; she continued to draw and was meeting reputed artists. This was far from everything, however. She didn't have Michael.

Joyce felt that Michael liked her but she acknowledged what her heart had been resisting: that she loved him but this love was unrequited and her yearning to marry him would not be satisfied. Joyce wanted to get married — by her friends' accounts, she *really* wanted to marry Michael.

George Gingras suspects that Joyce and Michael had a falling-out around the time of Graphic Associates' demise. They had all gone in their various directions and Michael did what he always had done — he painted during the day and played piano at night.

George Gingras decided to go to London, England, and Joyce used this opportunity to accompany him and visit her friends in France. Gingras said that Joyce "couldn't bear being in the same city as Michael." She quit her job and set sail for England in May 1956, and then journeyed on to France.

Joyce's hopes of marrying Michael shattered against the shores she left behind. Along with loving him, Joyce yearned for the security and stability of married life. Just as her parents had abandoned her by dying, Michael, too, had abandoned her by not asking her to marry him.

Michael is vague about this time period and its details. He cannot

recall a falling-out with Joyce. He believed that Joyce simply went on a vacation to visit friends in France.

While in France, Joyce kept a journal. In it she penned disturbing feelings about her own shortcomings, re-evaluations of friends, and, most poignantly, her fears and doubts about Michael's feelings for her. But if slogging through the swamp was necessary to find the flowers, Joyce took the trip and came out with a fresh bouquet of realizations about her friends. As for herself and Michael, however, she arrived back empty-handed.

A journal entry dated May 22 describes a letter she received from Mary, a "great letter" that she found very amusing and "a nice piece of writing." Then Joyce gets a little snippy: "I think Mary could write if she possessed a little more poetry in her head. Funny that Mary likes Colette, too."

Joyce and Mary Karch proved to be explicitly good friends. Mary was deeply sympathetic to Joyce's early life's deprivation and her hair-raising escape from the Stewarts', but once the heavy seas of emotional conflict calmed and Joyce settled into the Karch family, the two girls discovered true empathy as teenagers finding themselves. They could share their hearts and minds, rebound unscathed from trifling squabbles, and after they returned from Europe in 1953, Joyce was able to eradicate her silly fits of jealousy over Mary's coquettish blossoming.

Distance had given Joyce an aperture through which she could examine her feelings about Mary, as viewed against the panorama of all her friends. Quite likely this exploration marked the value Joyce began placing on all her women friends, where she tried to analyze her feelings with a respect for theirs, and discard the unimportant clutter of irritant personal habits. Had she evaluated the stable forces in her largely shaky life she would have realized that the loyalty of her women friends — Mel and Mary, from early on, and latterly, Wanda, Sheila, and Donna — was solid and dependable. Most women have some experience with female friends who disappear when men drift in and out of their lives, and Joyce would

be reminded that her small clutch of friends were not drifters; they stayed.

The letter from Mary Joyce refers to is dated May 17, 1956, is neatly typewritten, and begins with the salutation, "Dear Mamselle Hepzibah,"[5] and she acknowledges receiving Joyce's card and letter. Mary writes, "I had visions of a lone, solitary figure, emaciated, tragic, forlorn, standing at the rail, saying a last farewell to the stars, moon, sky, etc., before taking the big jump. But not my Joyce, instead she eats marinated rabbit. Bah! Is there no drama in your soul?"

Mary decides to arrange her news in headlines "so you won't get confused. First and most important," and the heading reads: "M. Snow — Boy Genius — I have heard or seen nothing. . . . Maybe he has more drama in his makeup and is probably sitting in his studio, unshaven, dirty, sad, thinking of one he loves, who is far across the sea, having a marvellous time, making with 'le joie de vivre,' while tears trickle down his face."

The second headline is "The Wedding of the Year." Hers. She and George Shane got married, went to Buffalo, it rained, the food was lousy, the gallery (she likely meant the Albright-Knox Art Gallery) was closed, but, "Married life is nice, Joyce, and we seem to get on very well. So far we haven't got in each other's way yet. I think I would recommend it as a way of life."[6]

Once past criticizing Mary, Joyce writes, "I find myself liking her (Mary) more and more all the time. She is somehow mature with everything. Too realistic? Maybe. But a good heart. A simple girl, an honourable girl. She is willing to talk about everything. I like talking to her about love, men, food, cooking, and fashions. Very feminine topics."

One hopes that Mary, if she ever knew this, would have treasured Joyce's thoughts.

Joyce received a letter from Michael and we experience her nerve endings painfully exposed. She wonders if the letter is "just a kind letter" for her, "Or is he really feeling something?" Admonishing herself, as though she had just walked out the door of her real self, she writes, "I hate always thinking about what this means and what that means. What a

miserable business depending so much on signs, and trying to analyze his handwriting. Reminds me so much of my childhood high school sweetheart Dave. Trying to imagine what he's thinking all the time." (This is the first reference that can be found of Dave, who could have been a fleeting teenage crush; otherwise there would be more information about him.) Joyce thinks Michael's letter "very sweet, very charming. He's so charming. But why do I go on living and keeping this affair going. Why?"

As she records her next thoughts the writing grows increasingly thicker, blacker and bigger, the heaviness of her emotions and overbearing doubts seeming to explode through her pen onto the page.

Marriage burns on Joyce's mind. A woman thinking of marrying a man needs time to untangle herself from the knotted, near-dysfunctional spider's web that love/sex/romance has spun around her before she gets around to thinking of practical matters such as how his family fits into the situation. Because Joyce's family at the time consisted only of siblings, she would place more emphasis on the prospective in-laws than would a woman with parents, grandparents, and other extensions. The marriage offerings, too, become issues. Joyce's dowry comprised only love for her man and a promise of connubial comforts. She couldn't offer in-laws, family connections, generational traditions. What she came with had her wondering the following:

> It would be impossible if I married him. He is still small enough to be a snob. What good is a snob? He's even ashamed of his father.[7] Would he ever accept my sister, her husband? Would he find them coarse, would he not speak to them? I speak to his father. I help him not to be ashamed of his father. I talk and laugh with his father — joke with him. Sometimes Mike looks at me when I do this in a subtle amazement. Why? Doesn't he know his father is human? Sometimes I think his father is much more of a man than he is.
>
> No, I don't think we shall marry.

Joyce notes that someone named Alleyn is expected to visit. The only reason she wants to see him is that "he is so beautiful." She follows this with, "Nevertheless I hope 'he' writes me soon. I depend now on his letters. I hope he writes me a longer letter next time."

She compares the ambition for painting with cruelty: "Those who possess it to a great degree are three-quarters heartless."

Joyce was not a cruel person. In her interpersonal relationships, about the worst things friends said about her was that she was unrealistic, demanding, sometimes churlish and bitchy, but not cruel. Life had been cruel to her as a child; she took care with her adult relationships. "Surely the will to create does not involve cruelty and such immaturity," she writes. "Better never do anything in painting if it means to be like him. His father suffers [by] his hands and even his friends. He must always have things given to him. He would never return dinner invitations even if Robert and Vivian invited him fifty times a year. Why must he be so childish? I must find a few more ideals to look up to. People like Goethe and Katherine Mansfield are the only ones I look up to; what would I do without them?"

She recalls leaving Toronto, boarding the boat:

> If only he needed me, but he obviously doesn't or he would never have let me come away. And when we said goodbye I cried and he didn't. Inside I was gurgling and bubbling and one moment more and I would have passed out or screamed bloody murder. I never came so close to falling apart in my life. Whenever I think of our parting I cry great big fat tears, no matter where I am. Unashamedly. I couldn't bear to feel this way ever again.

Later, virginity is the subject. "It's amazing the number of women who lose their virginity but never their heart. That's just as bad as never losing

their virginity." And Joyce then puts her feet in the fire: "It's so easy I find now to give the body. But the most difficult thing in the world is to have people giving their hearts and bodies together." The one-sidedness of her feelings hits home when she questions, "Why can't love be an equal thing? Why must one always invariably suffer? Why is it that men are never satisfied with one woman for long?"

She assesses her prospects with Michael:

> I think the only thing I can do is not see him again. But my god! what a hard lonely path. I may as well kill myself now as wait five years or more for another love. It's so cruel to expect anyone to go on living without love. I am sick of love already and I haven't been away from him for one whole month yet. . . .
>
> Why can't he at least write me a letter? That bastard.
>
> . . . I say I must never see him again but what's the use? I am fooling myself. Every day I think of him every moment. He's like a constant wound from which I suffer every time I turn, or walk anywhere or worst of all, think. He has become so much a part of me. I adore him. But he's the last person I can say it to. Better to say to him, I hate you, I loathe you. That's the only thing he understands. He's so conceited, so obviously superior. So very talented, so very.
>
> I have never felt so sick in all my life of life itself. It's so beautiful when I'm with him. Why? We see things together. Everything is made especially for us.
>
> It wouldn't be difficult to take my own life but it would affect my sister so much. Her life has been nothing but shit! And I haven't helped it much.

As for Alleyn, Joyce wilfully, vengefully admits to using him and then not hearing from him. "After what I did to him in the moonlight on the

hill in Montmartre, no wonder. I think I did this dirty trick on him as revenge. A kind of return for what he did to that girl in Canada." There are no details, but one surmises a love-her-and-leave-her situation, or worse. "In my mind at that moment on the hill, he became 'M.' I wanted to show him I was master of the situation." And she reprimands herself, "How childish! That's something I would have done five years ago, very successfully. But I didn't carry it off very well the other night."

She decides, "If I feel up to it this summer when we are Provence, I will try in my own way to teach him about making love. I think, like all women who are normal in their attitude, and who have been *awakened*, [her emphasis], that I may be able to teach him something. Joyce like an old prostitute teaching the boy how to appreciate the woman's body." She felt it "sickening" that after "all his talk about Picasso and love and lots of women" that "he should know nothing."

In essay-like style, she writes a full page:

> Isn't it true though, it's the same with men as with women at a young age. Be suspicious of the one surrounded by the opposite sex. More than likely they know nothing of love.
>
> They tease, they don't screw much, if at all, because they really don't like it. They are only interested in making the opposite sex suffer in their hands. Just as I used to be. Anne is still like that. So is Denise.
>
> What a waste of time. They are not interested in finding out what's wrong with them. They said perhaps, 'Oh! I am not lucky in love." Or some such old fashioned philosophic saying.

And the next line reads, "Lydie said that some women in France do it with dogs." Joyce continues:

> I am getting a little better about "M." I think maybe it's just that I am getting a little crazy. I miss everyone at home so

much. I love them all. Joan, Harv, Barb, Sid, kids, Mary, George, Anne, Wally, Arthur, Bryan, Wanda, Isabel, Donna, George, Michael.

Suddenly in the last two days . . . in the back of my mind Alleyn has become someone like Mike, that is, a tender feeling arises when I think of him. Yet I don't like him.

She makes a ten-complaint list, writing that Alleyn is childish, too ambitious, too conceited, doesn't kiss well, his hair is dirty, and by all appearances he is a poor lover. Her last two points are:

He thinks already that he's going to get somewhere with me.
He's not.

Some pages later, writing in a ragged, rushed fashion, which might be propelled by an extra glass of *vin ordinaire*, unlike the previous even-flowing penmanship, Joyce is angrier, less coherent:

It's my ambition to get hold of him. Teach him a lesson. Smash him. Do him dirt. Has he got enough sentiment love and affection in him, to do this? I doubt it. Will he give a little? So that I can get hold of some of his love. Only with a little of his love can I get a stronghold. Then to hang him. It would be a good summer's work. Teach one bad boy a good lesson. It would be tougher going than working on Michael. Mike is capable of a little love. Never again will I show my true feelings to a man. Never again to Mike. He's seen the last of my tears, my sadness. My intricate lacework methods of love traps. No more vicious love traps. I learn a little more every day about love. Too bad I've learned this so late. However I still have time. Never show a man what's in your real heart. Especially a conceited bastard like Mike.

Several days elapse and she writes about jazz, quite as though it is the good drug — safe at any speed — that Michael got her hooked on:

> Every time I hear jazz I feel such a pang shoot through me. I go wild. I realize in myself work, work, work is every part of my existence. Well not every part. . . . But when I hear jazz I am stimulated in every part, my mind is jangling with my body. My sense of living is so heightened, that I am frightened of losing time.
>
> What I feel is this — I must before the time passes, show in my work what it is to love. Love mostly. I want to make joy. I want hope! Optimism in them. Sex . . . every vital thing in life. But the crux — love. To show in my work how glad and good and magical it is to live and feel, smell, think etc.
>
> Painting is so difficult. I don't know what I want to put in painting. I feel and draw what I feel. But I can't make it yet in painting. I wish to God I had one small painting to look at this moment that could possess the qualities of one of my *Lovers* drawings.

On one page of this journal, Joyce fears for her painterly life. Such feelings had not heretofore been expressed: "What I need is to look at more painting and to paint!!! This reading and thinking of books all the time is becoming too much. After [all,] all I do is pretend at painting."

For another thirty years these concerns would alternately wax and wane, largely because of forces unperceived by her, therefore uncontrolled by her. What surprises is Joyce's fear for herself as an artist is as ominous as her fear of Michael's feelings for her. She loves him, and his lack of reciprocity fails to embitter her; she wants the best for him. Quite like a mother who, regardless, wants her tantrum-screaming child to be happy. "No letter from 'M.' A great love affair. Good God he is doing his best it

seems to prove he doesn't care about me. I am on the heavy side of the teeter-totter. Lucky Joyce. Never mind Joyce, somewhere there's a God. This God says you only have to be unhappy for two years and then it's your turn to be happy. By that time it's 'M's turn to be unhappy. Oh! But I couldn't bear to see him unhappy. Tell the God no!!"

A journal page dated "5th or 6th of June" again refers to no letter:

Why? One even writes letters to people one doesn't like, why can't he even send me a note? I feel so sick. I could puke. Mary wrote me a letter. . . . In it she asked me where is my pride? Why do I let the world know how badly I feel about him.

Following this, headlined "7th of June," Joyce writes, "A letter!! Marvellous!! A beautiful affectionate one. He misses me!!!!!" (Five exclamation marks.)

The next few paragraphs are worth quoting in their entirety:

I prayed to God for the letter and it came. I went out for a walk before the postman came. I was afraid to stick around waiting for him again. I was afraid Denise would see my disappointment again. Whenever a letter comes for me she runs to give it to me in hopes that it's from him. So far every letter has been from everyone but him.

Yesterday when the post came and there was no letter for me Denise felt almost as badly as I did. When we drove down to get the rosary in the afternoon I couldn't conceal my unhappiness — I couldn't speak. Denise and Alleyn were joking all the way. My face remained black. When we returned to Le Castelet I was nearly swooning. That horrible black feeling blotted everything from my mind. That feeling is something like walking to the end of a dark corridor and finding no door. There's nothing to cling to.

His letter was so like him, it was almost as good as his presence.

I was trembling, my hands quivered, I could hardly tear at the envelope. When I got it open, it was full of little jokes. Full of kisses and he said in this letter "All my love M." My joy was boundless. I was transformed in minutes. I read it once then twice. After the third time I ran out and explained to Denise what a good letter it was. She laughed and joked with me. She's so philosophic. She said, aren't you glad you didn't write Isabel and say all those cruel things. Naturally, I was glad I hadn't blown off to Isabel. My feeling for Isabel is past now. I don't really care what she may be cooking up for me in her innocent way. . . .

There is no explanation for this blow-up with Isabel.

The letter Joyce received from Michael is dated June 3, 1956, written in pencil on a large sheet of tissue layout paper, the kind artists use for rough drafts. Although it bears no address, the letter must have been written in Toronto and caught up with Joyce in France; she had sent him a postcard from London date-stamped May 25, 1956, addressed to him at his parents' house; it is bereft of sentiment, no doubt because it is a postcard. She wrote entirely cryptically: "London is cold. British Museum better than ever. I bought *Conversations* with Franz Kafka and Goethe with Eckermann[8], both are *good*. Am going to Paris soon. Love to you and your dad."

Michael's letter is for the most part tentative, though well expressed. If one didn't know the writer, it would soon be evident that behind the pencil scrawls is a sensitive soul. A noticeable difference exists between artists' and writers' letters. The artist reveals his or her observations with head-on, unqualified, steamroller candour, different from a writer's feelings, which require consideration before being penned; whereas the artist's dominant creative power is in using words that depict colours and shadings of things and events instinctively but judiciously, quite the way

he or she selects and mixes pigments to express ideas on canvas. For this reason, artists' letters are romantic by happenstance, unlike writers' letters, which can be breathtakingly romantic, obviously, and yet all too often theatricality purples the prose or it is crafted more as if directed to an archival repository than to a lover. None of this pretence emerges in Michael's letter to Joyce. Taken overall, restraint pervades, although periodically his nonchalance is ornamented by a delicate tone as though from a hilltop one hears the sounds of children singing in the valley below. Still, contrasting intrusions appear over the lengthy letter; the writer's supersized ego asserts itself and a patronizing note clangs here and there.

Beyond the first few "hello" lines, Michael writes, "Your letter was so great, such nice little drawings" — *little* drawings — then he immediately relates a few details of Graphic Associates' building being sold and animation equipment bought by the CBC, and he writes about his music. "My modern playing seems to gas everybody although I am very dissatisfied with it," but he notes that he is playing a job a week. Chet Baker had played at the Town Tavern and Michael went to hear Baker three times, and "one night it was so moving it was very hard to keep from crying in the face of this immense warm wailing." He laments the fact that Baker has a problem with his gums and might have to have his teeth removed — for a trumpeter, a technique-limiting condition. Michael mentions Baker's problems with women, referring to one of them as, "You know that dark-haired addict?" as if Joyce did.

He went to "a lousy party last night," he writes. "I played the piano (a very good one) for a long time and played very well. Then I got up and someone sat down and played 'Moon River' in C. So where does it leave you, eh? I guess you don't understand that. Why aren't I for sale? It's raining Sunday dark green. A kiss for you."

He ends the letter with, "I embrace you with fervour inasmuch as it is possible over such a long distance. All my love Mike."

After all my doubts and fears, here was the long awaited

letter. And I had vowed never to answer his next letter. Silly girl! I answered it immediately without hesitation.

I couldn't wait. I filled the letter with flowers and little drawings. I made the letter innocent, charming, mysterious, poetic, and nonsensical. It was such fun. I sent him three poems.

As though Michael's letter inspired a muse of another sort, Joyce wrote numerous lines of poetry, some rewritten two or three times, with words crossed out, whereas others seemed dashed off without revision. She writes about kisses as extravagantly as they are incorporated into her lifetime's drawings, paintings, letters, grocery lists. In one poem, titled "*Poesie pour Juin*," she writes:

Falling in sleep
Trembling knees
and thighs together
winds made from
trees, rise high
beneath the moon
The moon beneath three small trees
floating in pink
in three fields
floating upside down
make
what
his kiss
is.

Numerous mentions are made of "him and his kisses" that are "wrapped in my arms," and that she catches his kisses "in my greedy arms." And, "I carry them in a box."

Michael in his letter had asked her for a photograph — "And he wants

a photograph of me in France!" She and her friend Denise "plotted out how it must be taken. She says next to the swimming pool. I think the hill overlooking Aix. Oh hell. Why must I plot a thing like that. Why can't I just let it happen. Silly girl!!!"

This represents an essential characteristic of Joyce — wanting to be spontaneous, yet plotting her spontaneity; anticipating happenstance, yet planning for it. Too afraid to "let it happen" because she wouldn't be in charge? Too afraid, as in her childhood, of losing something?

The next day Joyce writes about going for a walk just after sunset in the semi-twilight. "Ravishing unbelievably quiet." She sits on a hill for a long time, then lies down. "The clouds were very low. The fields, very dark green, the sun breaking through everywhere." She mentions that her mind wandered "everywhere but finally settled on him":

> I never ask myself what is he doing? Never. It seems irrelevant somehow. He's much too far away for me to ask that. The situation is too unreal. In fact it doesn't exist. It's only here in my mind. It just clings about somehow in my head. He only exists in me.
>
> The "he" that I see and know is only here in myself.
>
> What he has started in me is not completed. Nor will it ever be. He's started something growing in me that will never be born or if it is it will never be satisfied by anything. I am turning lustful, but I don't know what I'm lusting after. The way that he is made, with his mind and personality, he was not made to help me in any way. Only to keep me crazy.

Over the next two weeks Joyce writes of "getting funny in the head from lack of communication"; about being sick, eating too much and getting fat, her friend Denise driving on a very narrow street and nearly killing a little girl, a friend coming to Europe in August. "Her letter was not cheerful. She's afraid to leave [her husband]. What will she miss? . . .

He screws her once a week and has the mind of a fool. She won't miss his intellect much, and the bash she can get elsewhere. She feels sorry for me, just like the others." Then Joyce is remorseful. "I wish I'd never told anyone how I felt. I won't say anything more to anyone. Perhaps it's a little too late to close my mouth, anyway I'll do it."

In the next pages Joyce explores her personal relationship to her drawings. As she had previously done with her paintings, she questions both her motivation to draw and her ability. This has her wondering whether it is possible to draw lovers without their arms around each other, "which is too literal." A drawing of two figures in an embrace makes this point. Her problem with the drawing is that she cannot competently start it and doesn't know when or how to finish it, leaving the image a mishmash of cross-hatching, lines running over each other, totally lacking substance. The search is laboured and crude, and one has no difficulty agreeing with her caption: "This is a terrible thing!"

She tries writing to herself, as if by driving her quandary through the third person she may arrive at the elusive destination she seeks. "In turning lovers upside down in those bad drawings in Paris, you had the best idea. It's the same idea you tried to express in your first drawings (*Lovers*) but at that time you couldn't draw men's figures at all. So if you can try seriously to do it again maybe something will happen."

After admonishing herself for making drawings that were "expressionist," lacking form, that they "[lacked] everything your last drawings back home had," she sets up a question-and-answer session: "What's wrong with you now? Can't you work in this Paradise? No! I feel the lack of love. And you see that's what my drawings have all been about for the last year! Well can't you think about when you were loved? No! It's so far back and I can't remember anything so beautiful."

It's possible Joyce hit upon an explanation — that love had motivated her earlier love drawings. "Okay! that's it, I need love to make love drawings." Or if she was so thoroughly discouraged by her inability to make love drawings equal to those done only a year ago, she sells herself on the notion

that "the lack of love" accounted for her poor draftsmanship. Superficially, then, this afforded her a solution: Get love, make good love drawings.

But Joyce's solutions to her artistic doubts were not simplistic. "My drawing is at a desperate crossroad. In other words I am faced with the fact that my creativity is quite limited." Her struggle is painful to read: "Looking back over the work of the past while I find that the drawings are wordy. Too frivolous. There is no gripping onto essential forms. Forms that make energy. Just my lines alone make energy. There are not enough moving masses — which hold together to punch out a whole. In other words there is no holding together."

Having identified both a technical and an aesthetic deficiency, it seems as though the act of penning her doubts baldly or even exaggerating them will compel her to accept her weakness before she can reach an artistic truth. We don't know if the following sentiments had occurred to her previously and perhaps had been refined, or if they were fresh. There is immediacy to the writing, no hesitations, no strikeouts in it:

> Everything I do is so personal. Personal in the sense that the men and the women I draw are both usually me. . . . This is not good. Everything gets too gummed together. The men are not masculine. Not Phallic. O! and Christ knows how many other things they are lacking.
>
> The women in my drawings are okay. They do what I want. They express the wonder of being a woman. The wonder and joy of having a body. But the men! What I must do — to be able to draw men again is (to have a man around.) I mean that I love, naturally, naturally.

In another four years, Joyce would make love drawings that laid to rest these misgivings; drawings that would outrank by far those she made from 1954 to 1957. She had been right about this thing in herself — that she could not make love drawings without having love.

Joyce returned to Toronto at the end of July 1956. Very shortly afterwards, she and Michael moved in together, into a small flat above a store on College Street.

From the time Donna and Joyce met at Graphic Associates in 1954, their friendship lasted a lifetime despite it "running hot and cold" occasionally, as Donna has stated. At close range Donna had seen the relationship develop between Joyce and Michael, and its culminating union when Joyce returned from France.

Donna recalled that it wasn't long before Joyce "was pressing Michael to get married and he agreed, saying that she would have to make all the arrangements, so she bought the rings and they were married at city hall." Michael recalls their nuptials slightly differently, saying, "We just decided to get married."

This was in September 1956.

Without variation over the next few years, Michael continued to paint by day and play in a band at night. After his first show the previous year at the Isaacs Gallery with Graham Coughtry, Michael appeared in a few other exhibitions. His work was beginning to sell, and he was also making a name for himself.

Both Joyce and Michael worked freelance on commercial art assignments through their connections from Graphic Associates. "Some of the jobs were really strange," Michael reported, one in which they specialized in creating black and white package designs for advertising agencies. "The work was always a rush and we'd sometimes work all night."

Making a living in the perilously insecure field of freelancing began to wear thin and Donna reported that Michael told Joyce she had to "contribute to their costs and so Joyce started giving art classes." Donna, who posed as the life model, has in her collection some of these nudes made by Joyce, quite likely when she, the teacher, worked along with her students.

Although Joyce had no teaching experience, she would have called

upon the techniques her instructors at Central Technical School used that so benefited her, in addition to those of her night-school art teachers. Joyce's vivacity and her belief in the individuality of the creator were her prime pedagogical assets; another was based in her integrity — honouring a tacit contract by giving value after accepting a fee — a characteristic that also would have endeared her to her students.

Joyce may have fancied a teaching career for her later years, carrying on the tradition of countless artists who needed paid work to support their fine art. Albert Franck attracted a number of garment manufacturers as students for a time but Franck, a stickler for propriety, could not break the rag merchants from referring to colours by their trade names, such as beige or navy. "It's ultramarine and ochre," Franck endlessly scowled and corrected. Painter Tom Hodgson, a member of Painters Eleven and an award-winning advertising art director at his day job, also held drawing classes in his third-floor studio at King and Church streets, on the edge of the financial district. For the most part, Hodgson's students were lawyers and businessmen who paid scant attention to proper colour names, focused as they were on the naked models. Tom liked nudity and was notorious for inciting its attendant frolics, which resulted in many of his Sunday painters shedding their three-piecers, belting Scotch and puffing their first joint, and the next morning clawing through their disabled brains for missing portions of the night before.

Some years later, Joyce would teach art with Tom Hodgson — but not quite like these classes.

Meanwhile Joyce conducted her art classes and made drawings that remained representational, although she had begun small constructions in a dadaist style. Her largest output around the time of her marriage and during the two or three years afterwards was in drawing. The reason for this was not so much aesthetic as pragmatic. Joyce didn't have the workspace that painting requires. She worked in a corner of their apartment on her drawings, where her art remained close to the new demands of her life — being a wife, a role she took to her heart and in which she developed

her passion for cooking. Joyce's sincere wifely devotion to feeding her husband well and entertaining friends began in that small apartment and scarcely varied throughout the couple's life. Adhering to Adelle Davis's and Gayelord Hauser's concepts of nutrition, Joyce took — and encouraged Michael to take — a handful of vitamin supplements a day, brewer's yeast, protein-packed "tiger's milk," and an occasional batch of hash brownies. Their apartment was located on the outskirts of Chinatown and there Joyce shopped for fresh fruit and vegetables, meat and fish, and was among the first to try winter melon, thousand-year-old eggs, and exotic herbs and spices like star anise and Chinese Five Spices. And, continuing from Robert Varvarende's indoctrination in elegant French food and her samplings in France during both her trips there, Joyce bought cookbooks and experimented with French and various other cuisines. Baking became an adored pastime. Her repertoire spanned nut/seed/raisin-laden muffins and cookies to butter-cream-layered tortes, all presented in coordinated colours and textures, and ensuring in one way or another that she created a show. Also to become a lifetime habit was her condescending avoidance of canned and packaged foods, along with instant anything. As for wines — she learned, bought carefully and sampled judiciously. She combed specialty shops for the best and freshest coffee beans for her filtered coffee, and loose tea, French baguettes, Greek olives, and Italian prosciutto. Joyce loved preparing food as much as she loved consuming her output.

As for the couple's work habits, for a short while the two of them worked in a second-floor studio above their apartment and then Michael shared a studio with Robert Hedrick near Yonge and Dundas streets, a block north of the Eaton Centre. For most of their married life, Joyce stayed at home and worked in a studio there.

Another of Joyce's lifetime habits developed then — of keeping a cat and other "family pets." Joyce would always have at least one cat, frequently two — as she had in their tiny College Street apartment — along with, over the years, gerbils and turtles.

Her awareness of chemicals in the environment and in foods was

sharpening. To anyone who would listen, Joyce trotted out facts and figures about the damage being done to the food chain with DDT and to people's health through acid rain, harmful workplace pollutants, toxic spills into lakes and rivers; and she fretted over nuclear contaminants. She went to the Metropolitan Public Library, just a couple of blocks from her apartment, and read the journals. And she worried. What was bitingly on her mind appeared in her work, and within a few years her art would carry powerful statements of her environmental concerns.

Michael identified with many of these issues, largely on an intellectual level. He packaged ideas and dealt with them coolly, rationally, and let Joyce kick up a big emotional storm. When he didn't share her opinions or passions, he stood a philosophical distance away and made no objection to her carryings-on. As it is with many contained individuals, Michael's interior self served him well.

Whatever their similarities and differences, Joyce and Michael were united by art. Even though they would never do like-minded work, they forged close links through art and all its happenings and discourses.

Joyce counted herself lucky beyond dreams having Michael — himself along with his mother and father. Taken though she was with Michael's Rosedale, Upper Canada College background, she was equally smitten by Michael's parents, especially his mother, Antoinette Snow, the elegant, refined Francophone whose grace and knowledge of the classics, especially French historical and literary figures, dazzled Joyce. Raised by Ursuline nuns in Massachusetts in the 1920s, Antoinette had wanted to become a concert pianist but her strict, old-fashioned father prohibited her from pursuing a musical career. She submitted to his wishes even though she would later scandalize the family by running off to Toronto and marrying Michael's father in 1925.

Without parents of her own, Joyce regarded Michael's mother and father as a revered adjunct to her life. With a husband she loved and in-laws she admired, Joyce enjoyed the respectability and normality that "wife of" and "daughter-in-law of" confer in society. This probably did a

great deal to remedy Joyce's tainted feelings about her out-of-wedlock birth. She and Antoinette developed their relationship through cultural affinities in the decorative arts — china, porcelains, textiles — and of course, in art and music. When not chatting with her on the phone, Joyce would visit Antoinette and have tea. Quite regularly, the two women went to the Royal Ontario Museum, the Art Gallery of Toronto, commercial art galleries, and fashion shows. There was always a stimulating cultural event that Joyce could attend with Antoinette, who served as a venerable cultural backup to her wingy friends.

With a nostalgic smile, Michael said about those days with Joyce, "Living together then, everything was good."

Chapter Four

During the latter part of the 1950s, abstract expressionist art had begun to gain ground in Toronto, although it lagged significantly behind Quebec, with the whole of Canada trailing well behind New York (excepting a lone Canadian painter, Jean-Paul Riopelle, living in Paris, where his reputation was blossoming). Works by abstract expressionists — the Hell's Angels of art — had never been an easy sell anywhere in the world. Few other art movements suffered such censure, including German expressionism and the non-objective paintings of Wassily Kandinsky and Piet Mondrian in

the early 1900s, as well as the oncoming cubism of Pablo Picasso and Georges Braque. In America, it is well accepted that the famous 1913 Armory Show in New York gave birth to abstract art. The real explosion of awareness and acceptance occurred through the great rocket bursts of Willem de Kooning and Jackson Pollock in the late 1940s, followed by the movement's reaching full maturity in 1951 when the Museum of Modern Art mounted a massive, influential exhibition, *Abstract Painting and Sculpture in America.* Thereafter, despite continuing shrill protests, abstract expressionism lived. New York remained the centre of the realm and in the 1960s was still reigned over by the titans, de Kooning and Pollock (even after Pollock's death in 1956), joined now by Hans Hofmann, Robert Motherwell, Adolph Gottlieb, Franz Kline, Barnett Newman, Mark Rothko, Clyfford Still, Philip Guston, and Ad Reinhardt, among the major figures.

Joyce and Michael kept *au courant* by following the New York scene; de Kooning would become one of Joyce's major influences.

They attended the big-name touring shows at the Art Gallery of Toronto, read the international art magazines and along with numerous other impoverished artists managed to travel to leading out-of-town exhibitions. With gasoline at thirty to thirty-five cents a gallon then, and a draft beer at twenty cents, a carload of artists could see major American and European exhibitions a two-hour drive away at the distinguished Albright-Knox Art Gallery in Buffalo, New York. A drive to New York City from Toronto took perhaps eight hours, but then again the whole trip could be done on the cheap. Joyce and Michael went to New York a couple of times a year and stayed with friends Betty and Graeme Ferguson or with Robert Cowan; a two-night stay allowed plenty of time to tour the exhibitions at the Museum of Modern Art, the Metropolitan Museum of Art, and the Solomon R. Guggenheim Museum, and to catch the commercial galleries showing abstract art.

Artists who didn't have friends to flop with in New York, Detroit, Chicago, or Cleveland could find a motel for twenty dollars a night, stay

at a local YMCA for less, or at no cost, sleep in the car. Roughing it on the road was the code.

The Canada Council, established in 1953, lavishly dispensed grants throughout its first decade to artists, many of whom travelled to Europe on the funds — Spain's sun-drenched, pot-soaked island of Ibiza was the destination of choice for several Toronto artists. Even without a grant, artists worked their way around the United States, Mexico, and Europe, as Michael had done by playing music, and as Joyce managed to do by scraping together three hundred dollars for her second- or third-class Atlantic boat trip and seeing Europe on the legendary five dollars a day.

When first married, Michael played at the Westover Hotel "every night from 1959 to 1961," he said, but there were nights when he and Joyce went to parties at Gordon Raynor's studio, where activities were mainly "listening to jazz, smoking dope, drinking, and laughing." And at some point the artists would decide to play music. Michael admitted to being conceited as a professional musician and called the group's playing silly, but later he realized "miracles happened," and that from a base of "unbelievable wit" they would play over their conversations and the music would take off in great "creative responses." As at any screamingly hilarious occasion, where witticisms come in powerful barrages, puns and friendly insults are hurled the night long, and each crazy voice, bit of body language or zany antic is topped by the next, you are in untranslatable territory. One can make what one will of art dealer Avrom Isaacs's comment, "They laughed themselves to death."

In 1958 Joyce and Michael went on a two-month holiday to Cuba. They rented a house in Oriente province, at the southern tip of the island.

Going to Cuba in 1958? Asked if he hadn't heard about a certain revolution in progress, Michael answered vaguely, "We didn't know there was a war going on. We had this crazy idea we'd go to Cuba, then Haiti." They were not alone in their naïveté; the Cuban revolution did not top Canada's nightly news. Innocently, the pair settled into their quiet little village by the sea and only later learned that Fidel Castro was training his

army in the mountains just outside their town. Communications being unsophisticated, and taking into account the language barrier and Joyce and Michael's understandable, post-marriage preoccupation with themselves, the couple had no notion that the civil resistance movement had been gaining widespread support in Cuba and that bombs were going off in towns and cities as Castro's revolutionaries swept toward Havana. The previous year, in 1957, on June 30 (Joyce's birthday), one hundred explosives had been detonated in Havana, a catastrophe that rates historical reference as "The Night of One Hundred Bombs." Things may have quieted down at the precise time Joyce and Michael were in Cuba in 1958, while negotiations for a truce with dictator Fulgencio Batista were under way. However, the political situation came crashing down dramatically on them one day in Havana as a theatre they had strolled by was bombed. "We missed it by twenty minutes," Michael said. Very shortly after that, they left Cuba.

Michael cannot remember making drawings while in Cuba and he does not recall Joyce doing drawings either — the tropics, the beach, the indulgences of their newly married state perhaps were not conducive to art making — but there is every reason to believe that the trip contributed to some of Joyce's *Lovers* drawings of the late 1950s to 1962. A number of these works came to be exhibited some years later as a suite — *Twilit Record of Romantic Love*, named after the only drawing in the collection that Joyce titled and signed.

The sexuality Joyce expressed in these works had to have emanated from personal experience. Her love/passion for Michael and her ventures into eroticism hurled her artistically upside down, from the innocent drawings of naked ladies she made as an eight-year-old, to truly erotic images. The drawings are sexually explicit, tender, passionate, and amusing; they are love. Auto-eroticism also makes an appearance in *The Way She Feels*. The nude woman takes obvious pleasure in her breasts, using her arms to squeeze them together in fulsome womanly mounds, a view of breasts seen through men's hands filled with them. This drawing presents

the irrefutable notion that the sexual pleasure of a woman's breasts is not for man alone — an evocation not previously seen in Joyce's work.

In style and competence, the early 1950s works are markedly distinguishable from Joyce's more mature drawings of similar erotic subject matter made a few years later. Shockingly, the majority of her drawings made between 1955 and 1962 are unsigned although a few are initialled — an indication that she did not regard them sufficiently to sign and date them. Possibly, she deemed them sketches or studies that she might rework at a later time as oils on canvas.

Lovers with Curly Hair, an ink drawing on tissue paper of a man and a woman, head and shoulders, both topped with swirly curls, might be interpreted as a prelude to love. The man touches the woman's face in a tentative caress. Another work — two heads (undated, untitled) — is softly erotic; the two heads are together, with eyes closed. If the curly-haired couple represents love about to be made, the other carries the impression of pleasurable post-lovemaking serenity.

Morning, dated 1956, is quietly sexual in its suggestibility. The male figure is lying on a bed and the female sits on a straight-backed chair, looking at the sleeping man, perhaps making after-the-fact assessments.

In *The Magic Circle*, a woman holds a diaphragm over her head — hailing its contraceptive powers? tossing it away to make babies? With this drawing, Joyce successfully creates a feminine statement about a woman in control of conception.

Making drawings was not Joyce's sole artistic expression in the late 1950s. Filmmaking had staked its claim on her creative heart and in 1959 she bought her own 16-mm Bolex camera and began experimenting. Mainly, she headed out with her camera and shot random footage, and when the processed film came back from the lab she would examine it for effects of light, colour, composition, and then experiment some more.

Joyce and Warren Collins began a film project about dogs that they titled *Doggerel* or *Dogarama*. Joyce had a friend who ran a dog-grooming

place and Warren said, "We went there and did shots of her clipping dogs. And another friend, Sylvia White, had a white bulldog and we shot that, as well as dogs in the park and some dog-racing thing at the CNE."

It amused Joyce to notice the extent to which people resemble their dogs — an idea that has since been sent up in television commercials and in movie vignettes with comic effects — and although the doggy film was never completed, Joyce shot several hundred feet. Warren makes the point that Joyce was more interested in visual effects than technique, and that much of her film was underexposed because Joyce might have forgotten to open the lens.

"You have to remember, we were all starting out and we got excited and things were happening very fast, so we made mistakes," Warren said, amused by the memory.

Over her lifetime Joyce was known for preserving lasting attachments with her women friends, although a little distance in the late 1950s came between her and three early friends, Mary Karch, Sheila McCusker, and Mel Stewart. Mary had married George Shane and, as George said, Joyce was easily influenced, although not by them and their comparatively low-key lifestyle. Sheila McCusker married Gerald Gladstone and had the first of the couple's six children, and Mel Stewart, married to Victor Water-man, felt disappointed with Joyce for "some of the things she was doing." No disagreements erupted among the women. Their friendships endured; they just did not socialize.

Shortly after Joyce and Michael were married, Joyce met Sara Bowser, who would become a lifelong friend despite their first meeting breaking into "a hell of a fight, a battle royal," reported Sara. "Joyce thought I was rigid, stuffy, and conservative and I thought she was disorganized and raff-ish, *but*," Sara emphasized, "the differences were meaningful. She needed someone around like me and I needed someone around like her. We got along more than we thought." Fondly, Sara added, "Although we still had battles, we were very close," and their friendship survived in spite of the

fact that, as Sara discovered, "Joyce was volatile. Way up and way down."

In one other respect, Sara felt like many who encountered Joyce during the heady first ten years of her and Michael's twenty years together: "She was a circus," said Sara. "I wouldn't have missed knowing her for anything. No one made me laugh the way she did. She told stories — she wasn't a constant raconteur, she only told stories occasionally but when she did they were the funniest stories in the world. You could never say why afterwards — she would just destroy me, I'd roll on the floor. She added a lot of colour to my life."

Donna and Joyce's relationship still ran hot and cold; they bickered but reconciled. One cold period, however, was lengthy and deeply hurtful for them both, and yet Donna and Joyce's mutual devotion held fast for thirty years. They practiced the delicate art — common to true friends — of forgiving and forgetting.

When Donna had been working at Graphic Associates her efficiency was noticed by Office Overload, a firm that supplied temporary office help to businesses, and the company hired Donna. There she met the firm's corporate lawyer, George Montague, scion of a prominent Winnipeg family, and Donna's life changed radically. She and George married in 1959 and moved to the fashionable Bloor-Yorkville district into a Georgian townhouse with a coach house. George Montague was a generous host and the art gang took extreme pleasure in their parties' upward surge from plonk to Scotch, from bologna to pâté. Even more appreciated by the artists, the Montagues exhibited the ultimate hospitality of buying artists' works; they were among both Joyce's and Michael's early purchasers. And they gave Joyce use of the coach house at the rear of their house for a studio.

For the first time in her life Joyce had a real studio, all to herself, away from the kitchen. And for the first time, she began to feel like an actual working artist. With help from Michael and the Montagues, she organized the studio, bought canvas, stretchers, paints, and moved in a large easel. And, befitting an artist with a large studio, she began painting large.

In 1959 and 1960 Joyce produced about a dozen large-size paintings and collages. During this time she created the most purely abstract paintings of her career and with them her first cloth collages — a medium in which she would soon produce singular, stellar works.

Joyce's paintings and collages of this two-year period are manifestly important in that they reveal both an interpretation of abstraction and a depiction of sexuality heretofore unexpressed in her work. What is more, the works represent the first intimation of Joyce's artistic promise.

Not only did Joyce produce in large format — canvases measuring 114 centimetres square, 71 centimetres by 117 centimetres, and 203 centimetres by 270 centimetres — she produced provocative works, many of them by the stain painting method. Phalluses, vaginas, and hearts, rendered both representationally and abstractly, were her dominant subject matter.

Redgasm, dated 1960, clumps oval blue shapes together as though huddled against an approaching penis and testicles. *Time Machine*, also 1959, is composed of a grouping of round and oval shapes totally suggestive of sperm searching ova in the womb, cyclically. *Time Machine Series* 1961 leaves no doubt that the egg has been fertilized and that the unsuccessful sperm depart the image to disappear into bright blue clouds. A very strong image of a dark blue phallus under a bright red heart astonishes and surprises, largely because the heart is bleeding. Joyce called these her "sex poetry."

The works in her series entitled *Summer Blues* are termed collages but they could also be called mixed media in that they use paint, pencil, chalk, crayon, and various materials, such as pieces of cloth, wrapping paper, cardboard, shards of glass, dried flowers, buttons, bits of film strip.

Summer Blues — Walking has three primary images on either side of a curved triangular shape and a wobbly crescent that appear to float on a blue sky delicately wisped with cloud streaks.

Two others in this series are distinctly strong. *Summer Blues — The Island* uses as its central theme cardboard tubes glued onto the canvas and

painted in delicate pastels, while *Summer Blues — Ball* combines varying circular shapes that one reads as vaginas because of the penis shapes heading for them like phallic arrows. *Summer Blues — Do Not* is a subtler work, with graceful ovoid shapes piercing through large square obstacles.

Balling, titled after the slang word for sexual intercourse, is Joyce's salute to heterosexual sex. Overwhelmingly, however, the smallness of the penis grabs all attention. An outline of a circle containing brilliant pink smears surrounding a small oval shape again carries an egg-and-womb suggestion. This central image is bombarded by random paint splatters and drips, suggestive of sperm. Critic Lauren Rabinovitz wrote that the painting refers to a "representation of an orgasmic phallus viewed in extreme close-up."

The diminutive phallus shape prompted this critic also to say that smallness is Joyce's method of mocking mass-media pornographic images of the penis as a powerful weapon, whereas, from a woman's perspective and experiences, the male organ is also delicate and perhaps fragile in its sensuality.

Perhaps more to the point, a woman is free to render the penis abstractly tiny, as men are free to render it large.

No penises appear in *Heart On*, regardless of what one may first think.

Were these works bold, provocative, quick sexual come-ons from a reckless spirit? Or scrupulously serious artworks by a woman painter approaching recognition? Who would create them — a shy, terrified creature or a booming extrovert? These were questions pondered by Joyce Wieland's fans and foes. A debate had always existed about Joyce's shyness. Having known Joyce for thirty years, Donna stated flatly, "Joyce was shy." Joyce later accused herself of being timid for not attacking the art market more aggressively.

Contradictions in both Joyce's behaviour and her art persisted throughout her life. She could be seen in public hooting with laughter and bursting into tears within the same minute, prompting one observer to see a joy-filled party girl and the other, a wretched, broken-hearted soul. Her art, too, gave opposing impressions. *Heart On* exemplifies this point. She tricked up the name but did not want a sexual connotation

taken. The principal images here — hearts amid abstract shapes — were "romantic accidents" on a sheet rendered in menstrual blood, red ink, and red electrical tape and linen cut-out hearts, and the work, Joyce insisted, refers to "birth and blood," at whose centre is a tragedy that "has a lot to do with my mother's death."

If indeed Joyce's timid persona succumbed to her artistic daring and freed her to paint penises, use menstrual blood as a medium, and title a work *Heart On*, the means achieved the result of making highly personal drawings, paintings and collages that attracted to her the attention she so thoroughly craved.

Avrom Isaacs, who was to become one of half-a-dozen dealer/champions of contemporary art in Canada, founded the Greenwich Gallery in 1955 in the heart of Toronto's first bohemia, the Gerrard Street Village.[1]

Born in Winnipeg in 1927, Isaacs came to Toronto in 1941, attended the University of Toronto, and studied political science and economics. After graduating, Isaacs shared a flat with painter Graham Coughtry for two years — an experience that accorded him what he called his post-graduate degree in art.

Not interested in politics, science, or economics, Isaacs made a living from 1951 to 1955 by framing friends' graduation photographs — a fairly substantial business that expanded to general picture-framing. Graham Coughtry worked in the CBC design department after he left Graphic Associates. He, like his confreres, painted in his off hours. Av doesn't remember the exact details of his becoming an art dealer but he's heard the story so many times, he concedes to its veracity: that Michael Snow and Graham Coughtry persuaded him to open a gallery to show their art. Among his earliest shows[1] was a two-person exhibition of Snow and Coughtry. Isaacs moved his gallery in 1961 to a larger space on Yonge Street north of Bloor Street, renamed it the Isaacs Gallery and thereafter assembled himself a stable of contemporary artists largely recommended by Snow and Coughtry. These artists would be known for decades as "the

Isaacs gang," or "Av's boys," or "the Isaacs All-Stars." They included, along with founding members Snow and Coughtry, their contemporaries: Robert Markle, Gordon Rayner, Dennis Burton, and William Ronald. Conspicuous by her absence was Joyce Wieland.

There are several explanations for her exclusion, and among opinions circulating at that time, three of them count — one from Av Isaacs, another from Dorothy Cameron, and of course, there is Joyce's version.

Isaacs began by outlining his artist-dealer relationship and its progression. Generally, the relationship starts when Isaacs places the artist's first showing in a group exhibition, after which, "You give an artist a two-man show and if things work out you give him a one-man show."

In 1959 the gallery had been operating for two years when Isaacs gave Joyce a two-person show with Gordon Rayner. This was actually the second exhibition of Joyce's career; just a few months earlier she had had her first exhibition, a two-person show with Michael at the Westdale Gallery in Hamilton, Ontario. Michael showed exclusively drawings and Joyce showed drawings and a couple of dadaist objects.

In the first professional review of her career, art writer Elizabeth Kilbourn noted that "[Wieland's] witty and amusing drawings at the Westdale Gallery indicate her growing stature as an artist." Joyce was undoubtedly pleased, albeit this was the first of many "wife of " associations she would have as an artist. The review dealt with Michael's drawings and prints at the Westdale (drawings Kilbourn compared with those of Matisse), and Joyce got the last seven lines. For a first review, however, it was positive and promising.

Following Joyce's first Toronto show with Isaacs, he made no offer to represent her. Joyce claimed she did not ask Av to represent her because she wanted to secure her own dealer, independent of Michael.

Isaacs has another version. Chuckling over the memory, he said, "Dorothy Cameron loved to say that she lured Joyce away from me."

At the close of 1959, Joyce had established her bare-minimum professional standing as an artist by having had two two-person shows. Using

this as her calling card, and lacking a commitment from Isaacs, in 1960 Joyce approached Dorothy Cameron at her recently opened Here and Now Gallery (later named the Dorothy Cameron Gallery).

Marjorie Harris, journalist, writer, and latterly gardener of irrepressible passion, worked at the gallery then and she tells her story: "I remember when Joyce first brought her work into the gallery. Dorothy instantly knew it was good." Imitating Dorothy's renowned thousand-watt effervescence, Marjorie flings her arms in the air, widens her eyes and trills, "*Darling! We're going to hang them up on the wall right now!*"

Marjorie adds, "My sense was that Joyce didn't show with Av because Mike was there. It's really hard to believe how retrograde things were then. You didn't show husbands and wives. Or if you did, you were the Bobaks [Molly Lamb and Bruno Bobak]. Or maybe Joyce just thought she should have her own gallery because she didn't want to come in on Mike's coattails. Or maybe Av didn't like the work."

Speaking of Dorothy's influence at that time, Marjorie said, "She knew all these upper-class people. She had great connections. They would come to openings and see artists that they otherwise never would. They were the Roberts crowd, and Dorothy was able to winkle the Roberts crowd downtown, as it were. Which was quite amazing" — considering that "the Roberts crowd" represented the traditional establishment art patron.

Consequently, and through her own initiative, Joyce had the first solo show of her career at the Here and Now Gallery in September 1960.

Titling the show *Paintings and Objects,* Joyce chose six paintings from 1956 to 1960, a dozen drawings, and some of her previously exhibited dadaist objects. A notice appeared in the *Toronto Star* halfway through the exhibition's run that simply announced the show, gave brief biographical details of Joyce, and included abbreviated quotes from the newspaper's art critic, Robert Fulford, writing in another publication about Joyce's show "as having a very welcome personal note . . . her drawings [are] more personal still, [with] a warmth and charm usually lacking in current art. . . ."

The day before the exhibition closed — acute timing for an opening

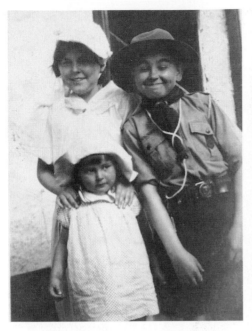

Joyce at age two, with her sister Joan and big brother, Boy Scout Sid. (Courtesy the Joyce Wieland Estate)

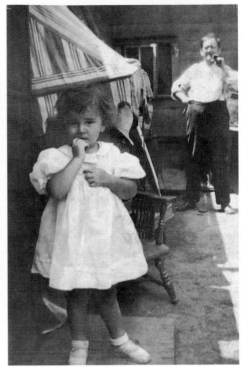

Three-year-old Joyce with her father, the former vaudevillian, who seems to be giving the "apple of his eye" a special performance in their back yard. (Courtesy the Joyce Wieland Estate)

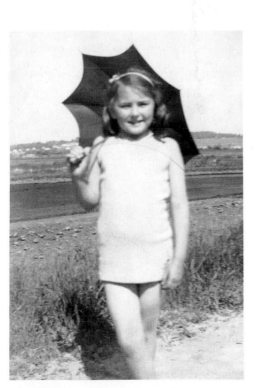

Joyce at about age six, shading herself from the sun at one of several public beaches along Lake Ontario to which countless Toronto families flocked all summer long. (Courtesy the Joyce Wieland Estate)

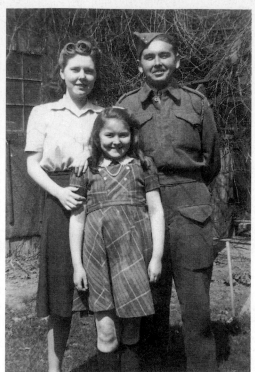

Joyce's mother, Rosetta Amelia Watson Wieland. (Courtesy the Joyce Wieland Estate)

Joyce age 12, Joan 21 and Sid 22, in 1944, when Sid joined the army. The three siblings had been orphaned then for three years, a time Joyce said she went from being a "spoiled brat" to learning how to use a gas stove and cook for her sister and brother. (Courtesy Michael Wieland)

Joyce and her sister Joan in 1944, taken by a street photographer. (Courtesy Joyce's niece Nadine Joyce (Stewart) Schwartz)

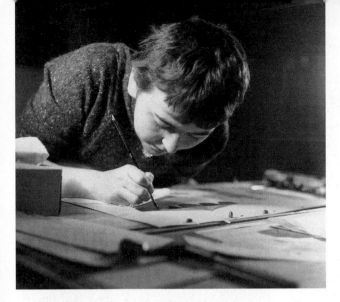

Joyce age 24 at an animation table painting "in betweens" at Graphic Associates, a film animation company, where she met her future husband, Michael Snow. (Courtesy Warren Collins)

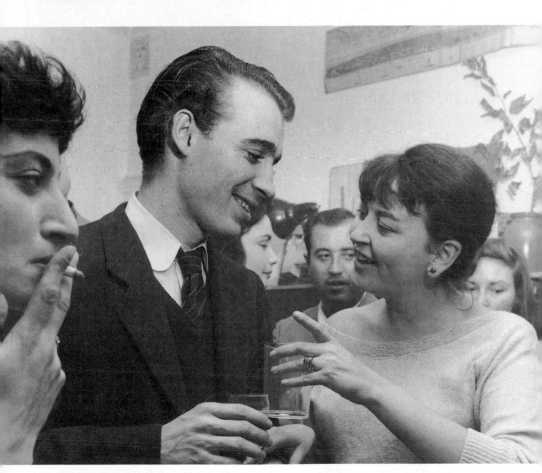

Sweater girl, party girl Joyce in 1956, flirts with Robert Hedrick while Marsha Spiegel Hackborn puffs. (Courtesy Warren Collins)

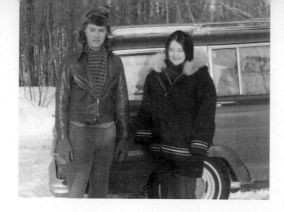

Joyce and Michael Snow, around the time they were married in 1956. Michael said about those days with Joyce, "Living together then, everything was good." (Courtesy the Joyce Wieland Estate)

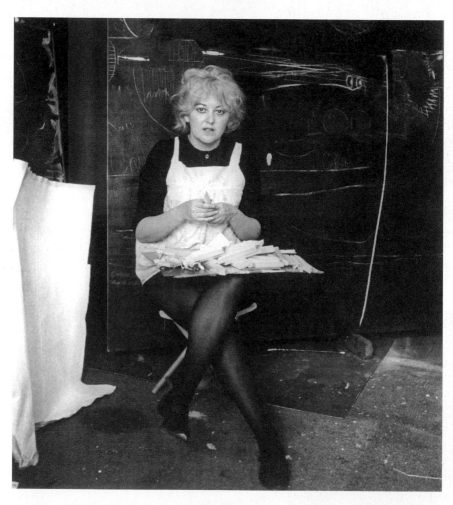

Joyce in her first large studio, the coachhouse of friends George and Donna Montague, where through 1959-1960 she produced a dozen large-size canvasses, the major abstract expressionist paintings of her career. Here she also created her first collages in cloth, a medium she would elevate to a new, definitive art standard. (Courtesy the Art Gallery of Ontario/ Tess Boudreau)

Joyce, the only woman among Toronto's hot shot abstract expressionist artists in 1961: Kazua Nakamura, Jack Bush, Gerald Scott, Robert Varvarande, Gerald Gladstone, Gordon Raynor, Harold Town, Robert Hedrick, Tom Wolfendon, Tom Gibson, Joyce and Michael Snow. (Courtesy the Art Gallery of Ontario/ Tess Taconis)

The blonde Joyce in 1965. (Courtesy the Art Gallery of Ontario/ Michel Lambeth)

Joyce playing a Lillian Gish "damsel in distress" character with "villain" Robert Cowan in A Salt in the Park, produced by Joyce, Warren Collins and Michael Snow, circa 1959. This five-minute "spoof" marked the beginning of Joyce's filmmaking career. (Courtesy Warren Collins)

Joyce in the title role of Warren Collins' film, Fabulous Francesca, 1957. (Courtesy Warren Collins)

Joyce having a tea in her garden, age 27, in the first year of her marriage. (Courtesy Warren Collins)

In 1961 Joyce re-enacted Laura Secord's walk, an event that Joyce believed saved Canada from American domination. It inspired Joyce's first political painting, Laura Secord Saves Upper Canada. (Courtesy the Joyce Wieland Estate)

The New York loft Joyce and Michael lived in, circa 1965. Joyce was truly romanced by the city when they moved there in 1962. But by 1971 Joyce grew frightened of their loft life, felt unsafe in the city and after a dreadful incident that occurred one night the couple returned to Toronto. (Courtesy John Reeves)

1963: With no heat in their loft during the winter, Joyce wore layers upon layers of clothes including tea towels to keep warm. (Courtesy Warren Collins)

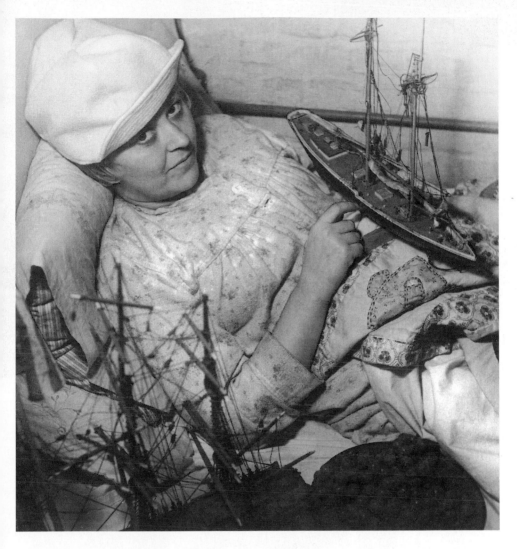

Joyce with boat model, circa 1966. She made a beautiful discovery of scrimshaw, marine photographs and paintings at the South Seaport Museum near their loft, which inspired her "disaster" series. (Courtesy Robert Cowan)

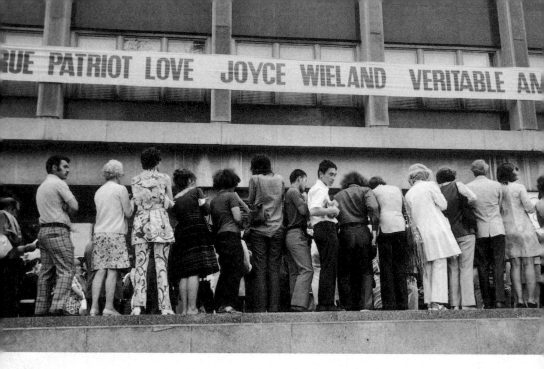

Crowds at the opening of Joyce's retrospective exhibition, "True Patriot Love, veritable amour patriotique," at the National Gallery of Canada in Ottawa, in 1971. Joyce was the first living woman artist to be given a retrospective at the National Gallery. (Courtesy Robert C. Ragsdale, frps)

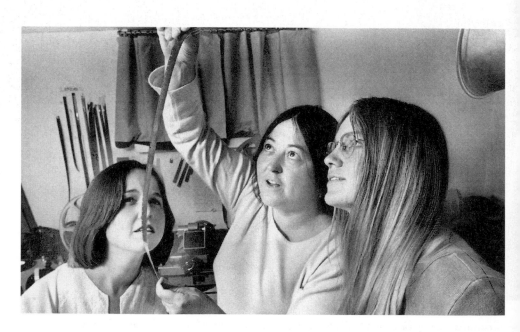

In post-production of Joyce's only feature commercial film, The Far Shore, 1975. Joyce with her co-producer, Judy Steed and an assistant. (Courtesy The Toronto Star/G. Bezant)

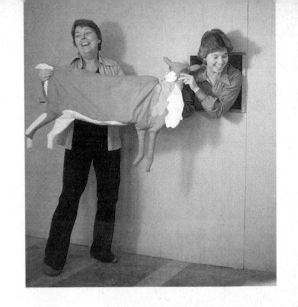

Joyce's niece Nadine helping make Joyce's guilted work, Barren Caribou Ground. Joyce has Nadine push a stuffed caribou figure out of a wall cut-out to her mother, Joan Stewart, which Joyce dubbed the "birth of the caribou." (Courtesy the Joyce Wieland Estate)

Installation of Barren Caribou Ground, commissioned by the Toronto Transit Commission for the Spadina subway station, installed in 1977. (Courtesy The Toronto Star/D. Loek)

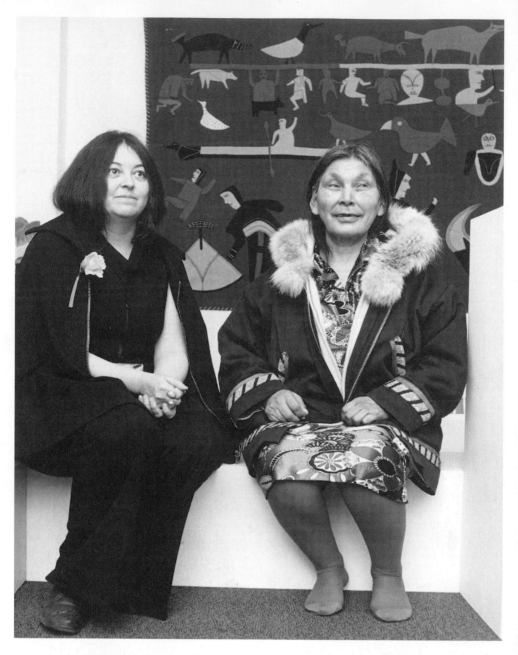

Joyce and well known Baker Lake artist, Jesse Oonark, in 1971. (Courtesy Isaacs Innuit Gallery/Ron Vickers)

The "Bloom of Matter" exhibition at the Isaacs Gallery in 1981. (Courtesy The Globe and Mail/ John Wood)

Joyce in the full bloom of her life, in 1983: setting a goal of "Human Doormat Wants to Break Out," embarking on a bold new direction in her art, and receiving the country's distinguished honour, the Order of Canada. (Courtesy The Globe and Mail/ Barrie Davis)

Glamorous Joyce at the 1987 ceremony having received the Toronto Arts Award, with another award recipient, architect Eberhard Zeidler. That year Joyce also received the YWCA Woman of Distinction award. (Courtesy Art Gallery of Ontario/Brenda Dereniuk)

At Joyce's 1987 Art Gallery of Ontario retrospective. With AGO director William Withrow, board chair Margaret Binhardt, Montreal Museum of Fine Arts director Pierre Théberge, Joyce and Phillip Monk, AGO curator of the retrospective. (Courtesy The Toronto Star/C. McConnell)

Joyce in her beloved dining room, a place described by friend Linda Gaylard as "caravan we were all travelling in" with Joyce on her grand epicurean journeys. (Courtesy The Toronto Star/P. Regan)

Joyce in 1995, her last days living in her home. (Courtesy The Toronto Star)

— the *Toronto Star* covered the show and described the "dominant theme" as "whimsy." After noting, "Unquestionably [Wieland] has talent; her paintings are warm, vibrant and feminine," the writer then expressed the opinion that they are "in the main, thoroughly undisciplined," and that her "technical craftsmanship is almost crude." The dadaist objects are denounced with the question, "But what are we to make of her 'objects'?" And the writer goes on to assert personal opinions that have no bearing on art criticism.

Joyce was a victim of the typical art reportage at that time. Beat reporters often covered art exhibitions, writing with no authority, covering the event as flatly as soup on a plate. Or worse, dashing off another variation on the my-kid-could-do-this theme. A handful of legitimate, scholarly art writers did produce thoughtful pieces, but abstract art was still new to everyone and in the meantime — and to the artists' grave disservice — it would take more time for art writers to catch up, and catch on.

Consoling herself with the fact that other abstract artists were reviewed no better, Joyce put on a brave face. Marjorie Harris says, "When there were bad reviews, Dorothy would get very angry on behalf of her artists but I don't remember Joyce going into any temper tantrums or weeping. If she did, she kept it to herself. Joyce was very stoical. Her attitude was, 'I'll show you fuckers, you wait and see.'" For consolation, there were the unfailingly open arms of Dorothy Cameron's positive reinforcement to fall into. According to Marjorie, "Dorothy would always say, 'Now darling, any publicity is good publicity. As long as they spell the name right,' and she really believed that."

Marjorie fixes Dorothy's historical place in the 1960s gallery scene by stating that Dorothy was one of the first dealers who started showing female artists, and one of them was Joyce. "I think Joyce thought that Dorothy was a woman of means [she was] who was dabbling in art [she was not], and then Joyce learned she was a serious pro. She had won Joyce's respect and Joyce never lost her respect for Dorothy. [More on this arguable point later.] Even though she did end up leaving the gallery."

Joyce left Dorothy Cameron to go to Av Isaacs — a move she did not initiate.

Isaacs said that Michael and another artist (uncertain, he guessed it was Graham Coughtry) approached him and asked him to represent Joyce. "I had nothing against her art," he said, and agreed to take her on and remained her dealer for some twenty years, although Joyce would have only six one-woman shows during that time. "She was not prolific," Isaacs stated. He recognized the special feminine, nationalistic qualities of her work and called her "a great pioneer." He felt that "her greatest quality was her naïveté. She was so far up front in women's rights and was always concerned. She did things a man would never do."

Exemplifying his point, Isaacs refers to a 1961 group dada show[2] that included Joyce, whose exhibit was a small coffin into which she placed a rag-doll figure representing Marie-Antoinette. "But it was too big for the coffin and the legs hung out. She lit candles, had fresh flowers around this coffin and she came into the gallery every other day to change the flowers," Isaacs recalls, with an expression of mystified respect — quite likely an expression he'd worn numerous times through the years at the first sight of some of his artists' works.

As the only woman in the guys-only gallery, Joyce would later confide to close friends that her relationship with the Isaacs Gallery always made her feel like an also-ran; that without Michael as the gallery's standard-bearer Joyce would not have been included. She also said she "put up with" less attention, less admiration, and fewer sales than the men did, thinking at the time, "That's all I deserved."

Michael has a quite different opinion. He defined these years as "a particularly happy time for Joyce. She was at her best. Being part of the Isaacs guys, she belonged to a community."

The environment did not stop Joyce from working. She successfully disguised her innate timidity by producing her *Lovers* drawings and paintings of penises, as well as occasionally behaving brashly in public, but she had no comparable remedy for her low self-esteem. After four years of

marriage to Michael, unquestionably her self-esteem received a boost and in addition she experienced small uplifts from her two exhibitions. Her career held more promise than ever before, and yet she could not a make a distinction between her low opinion of herself and a value her dealer placed on her. Lacking a father figure, she likely expected — *depended on* — her dealer to reinforce her value; this did not and could not happen. Neither the dealer nor the system was able to fill the massive need she had been denied by her parents whose early deaths had left her feeling abandoned. Joyce would soon seize upon a valuable upgrading of her self-worth in her work but until then, she attached no blame to a system that contributed to her low self-esteem.

The contract between artist and dealer is similar to any manufacturer-sales situation; the artist produces the product and the dealer sells it for an agreed-upon commission. And like any for-profit business, marketing is crucial to the contract. In the case of private art galleries, the dealer attracts art buyers, critics, and directors and curators from the public galleries to the artist's work, while devising any number of publicity stunts that will garner widespread national and ultimately international media attention for the artist. The dealer is paid a commission on all works he or she sells. A standard dealer commission in the 1960s ranged from 20 to 30 per cent; it was soon to become 40 per cent and now is commonly 50 per cent of the selling price. Negotiable, though considerable, are expenses; those the artist absorbs — framing, transportation of works to exhibitions, et cetera — and those of the dealer — the opening and costs of printing and mailing invitations, advertising, wine for the opening reception, and so on. The artist and dealer may share these and other expenses — photographing the works, printing an exhibition catalogue and/or poster, shipping works to other galleries, other cities, and the like.

Av Isaacs never had a signed agreement with his artists, other than his statement to them: "When I represent you, whenever a sale takes place I want my commission."

By this, Isaacs is referring to an age-old conflict that can arise between

artists and dealers when an artist sells work from his or her studio without paying the dealer a commission. It is not necessarily the precipitating factor, but artists have monumental battles with dealers who don't work hard enough to sell their work or sell at below-market prices — or worse, at fire-sale prices that assuredly devalue the artist's market. Dealer commissions can become a sore point, too, as the artist gains public acceptance and the work starts to sell briskly, causing prices to escalate; then the artist begins to resent the dealer taking 40 or 50 per cent when, the artist believes, the work is selling itself.

For these and innumerable other reasons that cause any partnership to unravel, artists and dealers leave one and find another. After twenty-eight years, Joyce and Isaacs came to an acrimonious, litigious parting of the ways (more on that later), but in the early days, she was thankful to have a dealer.

Starting in 1959 and 1960, both Av Isaacs and Dorothy Cameron played key roles in introducing Joyce to the art community in Toronto. Isaacs, through their longer association, advanced Joyce's career by giving her the public exposure a serious artist requires — the kind that can only be effected by a reputable, ranking dealer who is able to attract influential art buyers to his or her gallery. The moment a big-name collector appears at an artist's opening, that artist's reputation is on the upswing, so powerful is the collector's presence; and should that collector make a purchase, the artist's reputation is on immediate liftoff. Even more dazzling is the appearance of the country's top curators at openings; excitement crackles through the room. Isaacs and Cameron had the clout to bring the public galleries' directors and curators to their exhibitions, knowing this to be the artist's lifeline. And for the dealers, it meant kudos and commissions.

Handsome, erudite, scholarly, and impeccably tailored Alan Jarvis, director of the National Gallery of Canada from 1955 to 1959, was a vigorous supporter of abstract art. He organized travelling exhibitions (among those noted earlier) and wrote authoritative, lyrical treatises on art. His presence at openings was electrifying. When he swept into a gallery in his camel topcoat and white silk scarf, Dorothy Cameron trilled, "Our hearts

sang!" and when he stood in the gallery and pointed to works on the walls, saying, "I'll take that one, and that one," the euphoria was dizzying.

Joyce's paintings of 1959 to 1961, exhibited in shows at both Dorothy Cameron and Av Isaacs's galleries, resulted in her first major purchases. Corporate and private collectors bought works from this series and other large paintings made from 1959 to 1961.

Time Machine, 1959, was purchased by the Crown Life Insurance Company in the early 1960s; Morden Yolles bought the first of several of Joyce's works at this time, a collage, *Wall,* 1960; and one of the largest works (122 centimetres square), titled *War Memories,* 1960, was purchased by Betty Ferguson.

But most significant was the National Gallery of Canada and the Art Gallery of Ontario would soon buy works from this period.

A public gallery's process of acquisition might consume weeks, months or longer from first seeing the work, depending on budget, the collecting mandate, current policies, and board directives. In 1968, the National Gallery made its first two acquisitions of Joyce's work — the quilt, *Confedspread,* completed in Canada's Centennial year, and her painting, *Balling,* made in 1961 and featuring the much-talked-about orgasmic splashes of ejaculate and the small penis.

Brydon Smith, then assistant curator of Canadian Contemporary Art at the AGO, said that he was introduced to Joyce's work as a student at McMaster University, prior to taking up his position at the gallery in 1964. He recalls that the gallery had a very small acquisition budget (comparatively, this is still true) and relied on the Women's Committee to raise funds to purchase art, and private collectors and foundations to donate artworks to the gallery. (Most major museums of the world are founded on the generosity of collectors bequeathing their masterworks to public institutions. The eminent National Gallery in Washington, D.C., for example, was founded on the private collection of Andrew Mellon). The McLean Foundation purchased Joyce's *Time Machine Series, 1961,* and gifted it to the AGO in 1966.

Smith remembers *Time Machine Series* as the first work of Joyce's that "really engaged me. . . . It was very different from other kinds of abstract art, in its biomorphic forms and the thinness of the paint. It had a real vibrancy. I can still see the colours. There is a lightness about the picture, in the best sense." Quietly, he adds, "It is very fine."

When Joyce and Sheila first attended art openings and created a buzz over their sexy clothes and cheeky talk, they were impressed by the city's social elite. When Joyce was the one having exhibitions, however, the focus shifted. She was suddenly the star the socialites came out to see.

The transition from nonentity to celebrity occurs with radiant speed — in the mere hours between an opening night and the next morning's newspaper coverage of it. Life altering is this time capsule for the rock star, the actress, and the baseball player who zooms from a dirt shack without indoor plumbing to a million-dollar contract, limos, and Rolexes. These instant celebrities, of course, have been perfecting their craft for years but the first starry shower hits overnight, like springtime in the Rockies. Joyce was still so insecure about herself as an artist, she didn't realize that celebrity had graced her, around 1962, after her second solo show at the Isaacs Gallery. She was genuinely thankful for Isaacs, and for the people who turned out at openings and bought pictures, even though the significance of these occurrences failed to make an impression at the time.

Socially, many agree that there was scarcely a better time than the 1960s for artists.

"You would go to the gallery openings and they were wonderful parties!" exclaimed Marjorie Harris. "It was *the* social life. There was an interesting mix of well-to-do people and the collectors *loved* being around artists. And it was very important for them to be around artists. And the artists liked the collectors. There wasn't that kind of cynical, sneery attitude toward anybody with money. It was a lot of fun. The early 1960s? That was the most fascinating, dynamic period." Added to the parties, she pointed out, "There was so much creativity. People were producing a lot

of work — really, really good work. And it holds up!"

Av Isaacs recalled, "At that time there was a fluidness and openness about the relationship with dealers and artists and collectors. The collectors gave parties for artists and invited them into their homes." And the artists keenly accepted invitations — *free food, free booze* — to lavish parties in the Rosedale and Forest Hill mansions of the art lovers of the day: Mrs. John David Eaton, William and Elizabeth Kilbourn, Dr. Percy and Jessica Waxer, Sam and Esther Sarick, Dr. and Mrs. Sydney Wax, Spencer Clark, John C. Parkin, Irving Grossman, Ayala Zacks, Nicholas and Marnie Laidlaw, Michael and Sheila MacKenzie, Morden and Edie Yolles — and any number of corporate collectors, stockbrokers, doctors, and dentists. And Joyce and Michael's friends, the Montagues, generously served food and drink, for no reason at all.

Dorothy Parker's quip, "One more drink and I'll be under the host," could well have applied to some of these parties, like the moneyed couple who hosted a party at their country retreat in which Joyce's highly-visible act of squatting in the middle of an open field to piddle paled mightily alongside the barely-concealed hostess and an artist boffing in the bushes. And the party in Tom Hodgson's studio where the cold buffet was served on a naked model and Tom painted on the girls' breasts; party guests who jumped off a mezzanine in a studio and swung by a rope howling Tarzan-like over the heads of guests; the time an awakened drunk lurched into the kitchen, opened the refrigerator door and pissed inside; a party at an ad agency where girls' bras were hurled out the window at cars below; the painter who projected slides of his paintings on an ethereal naked studio model who was dancing to English madrigals and Miles Davis; the architect's rosewood boardroom table upon which a couple was engaged in more than a meeting of minds; the time Duke Ellington was in town and hosted a small party in his hotel suite at the Royal York, and the Duke. . . . Leave it to American writer Vance Bourjaily who, lamenting the demise of 1950s-style parties, said you knew it was a good party when you woke up the next day and wanted to

change your name, find a new career, and move to a new town.

Despite having had a good time in those fast and heady years, Joyce would later look back at them with a fondness tainted by misgivings — and periodic raging outbursts — about the old boys' club that operated art then and thwarted the progress of women artists.

Joyce had written a diary as a thirteen-year-old, and, like her sister, had a desire to write seriously. At one time, she said she wanted to write a novel, and among her early published pieces is one titled, "The Black Dog." In few words, the childhood that pained Joyce is revisited with grace, sweetness, and the warmest of her warm charm:

> The other day while out for a walk in an old neighbourhood a big black dog began to follow me. He began to walk beside me. I didn't pay too much attention to him, as I was day dreaming. I only noticed his coat was black and shiny and thick.
>
> When I was tired of walking we went into the backyard of the house where I was born and we sat on the back steps. It was winter everywhere just as it used to be. The plants were covered in snow and so was the broken down garage. The black dog and I sat looking at it together. He smiled at everything with his mauve lips exposed. I put my arms around his beautiful neck as I sat there. Around his neck I found a fine chain, attached to which was a little tube. In the small tube I found a dollar bill. It was enough money for us to begin our lives together.

In a questionnaire sent to Joyce of what appears to be a proposed magazine piece entitled, "ME," she is instructed to, "Please keep your reply to two or three short sentences. . . . Be humorous if that's your nature; be serious if you are, but try and be yourself." The last line reads, "Your profile will be published exactly as you write it."

The following are Joyce's responses:

"My job is:"
Taking care of Michael Snow, our two cats Dwight and Grace and our turtle named Ernie and all the fruit flies that live at our house. After that I work on my art objects and films and try to help some kids from the draft (Vietnam War).

"My pet peeve is:"
Freaks who are dull enough to serve you instant coffee instead of freshly ground and filtered French or Italian roast. They contribute to the lowering of our taste.

"My secret fear is:"
That the art market will fall.

"My favourite food is:"
Any food that is organically raised, without DDT and the millions of other dull disinfectants and crap that they are loading on our food. Natural foods simply prepared, delicious salads with safflower oil on them.

"If I had a million dollars, I would:"
Buy a lot of land and let it run wild — keep the developers out.

She makes no comment on two questions, "I reach my boiling point when:" and "My most persistent superstition is." She does answer the last question, "My most unfounded fear is:"

That an airplane might fall on our neighbourhood.

It is not known whether the piece was published, nor is it dated. Guesswork places it in the early 1960s, chiefly by Joyce's references to the art market and the Vietnam War. She was concerned about the art market — she would have preferred to be better served by it, as would everyone else. Vietnam draft dodgers coming to Canada made news and aroused public opprobrium beginning in the late 1950s, and while nothing specific is known about how Joyce helped "some kids," within the coming decade she would be an active Vietnam War protester in New York. That she considered her first line of work "Taking care of Michael Snow" and not "Artist," emphasizes that her self-esteem remained frail.

There is no reason to believe that these comments were facetious. Joyce loved Michael. Friends automatically attached the modifier "mad" to describe Joyce's love for Michael; that she was "mad for Mike," or "madly in love" with him. Taking care of Michael would indeed have been Job One for Joyce in their early years of marriage. While this is natural, normal, and in Joyce's case, genetic, rooted in her mother's doting care of her husband, Joyce may have felt like an artist when painting, and especially in the coach-house studio, but as a life she remains "wife of" and not a working artist.

Recalling her 1956 journal when she wrote that her drawing is "at a desperate crossroad" and that her creativity "is quite limited," one is also reminded of the emotionally fragile condition she was in over not hearing from Michael. If a choice had been put to her then, doubtless she would have chosen Michael over art. Over all.

Married and experiencing a state of full body and mind contentment brought to Joyce a strange exhilaration, like being constantly soaring through pleasures beyond counting. However, while caught in the updraft, conclusively and quite bizarrely, she sacrificed her artistic development for her personal euphoria.

After her 1959 and 1960 exhibitions, when it was crucial for Joyce to gain more exposure, to make news and have more shows, she slumped. Throughout the full years 1957, 1958, and 1959, she had painted only ten

canvases and made only eleven drawings. The works were impressive and revealed promise, but exhibiting such a sparse output over five shows, until 1960, placed the public's interest factor at risk. Instead of painting and drawing, Joyce spent time travelling with Michael. For paid work she picked up a few commercial-art jobs from her colleagues in advertising and the design studios, and she conducted her painting classes. Creatively, she devoted herself to film. She and Warren started shooting their *Doga-rama* film and were plotting numerous other films while the men around her — Michael, Graham, Robert Hedrick, Gerald Gladstone, Robert Markle, Gordon Rayner, Dennis Burton — had exhibitions. (From 1957 to 1960, Michael had had three solo exhibitions.) If Michael's and the others' advancement intimidated Joyce, she looked away and snuggled under the cosy coverlet of her marriage.

Apart from being married and working, another force began to slowly gather around Joyce in these years, one that would empower her, that would endure, and though unfathomable at the time would outrank even her marriage for personal gratification — and this powerhouse force? The women's movement and her growing circle of women friends.

During Joyce's first attempt at teaching art, her competence might have been tenuous but her genuine desire to help others, as she had been helped by her teachers at Central Tech, carried the day. And as a bonus, there was her infectious vivacity, wit, pure devotion to art, and her spontaneous outpouring of high spirits with a little lewdness on the side. Joyce's students loved her. Her women students became her friends. And although Joyce did not appreciate its significance then, her work stood apart. The pioneering feminist themes of her early oils intrinsically bore the royal jelly that defines an artist and honours individuality. She was becoming a role model for a lot of women, and from this time onward Joyce would always have her following.

In her development as an artist, Joyce unfailingly credited Michael as being a major influence on her. And whereas Doris McCarthy influenced

and encouraged Joyce to become an artist, Michael influenced her art. Joyce had studied technique, composition, colour, and mediums from her various art teachers, but to these Michael contributed his opinion. Art, common to all creative expression, is founded first on an idea and next on executing that idea, and concerning those infinite expressions, Joyce and Michael could share and discuss their ideas without them ever arriving at the same destination — Michael taking a cool, intellectual direction and Joyce flying off in her buoyant emotional gale. Both artists made their advancements in the journey, but precisely where and how remains the mystery of creativity.

For this reason, Joyce could never articulate exactly where Michael's influence showed up in her work, and Michael, too, was vague, saying, "I didn't try to direct her but I said what I liked and why."

Artists can scarcely avoid being influenced by other artists. Draftsmanship, colour, and subject matter are powerful attractions, but a pure artist creates his or her imprimatur; amateurs emulate and in some cases slavishly copy others. Though not a copier, Joyce found several artists irresistible, chief among them Giovanni Battista Tiepolo, Pierre Puvis de Chavannes, François Boucher, Picasso, and de Kooning.

The romanticism of Boucher and Puvis de Chavannes are obvious touchstones to Joyce's heart. Puvis de Chavannes, a nineteenth-century French muralist, created monumental decorative works and huge fresco-like canvases that were applied directly to walls. But it was his mythological subject matter, slightly in the abstraction, that captured Joyce and would influence her acclaimed mythological paintings of the mid-1980s, although they bear no similarity to the Frenchman's work.

The Art Gallery of Ontario purchased in 1974 a magnificent Puvis de Chavannes canvas, *Bathers*, of two languid, draped nudes, one seated, one standing, one frontal, and one facing backward — with equal sensuality. Joyce would have gazed upon this painting and smiled lovingly, we can be certain.

Another of Joyce's favourite classical painters was Tiepolo, the most

renowned artist of the early eighteenth-century baroque school. He departed from his sombre, dark early work and created canvases and frescoes of clear, fresh colours, as sunny and gently warming as an Italian piazza in June. Tiepolo worked with a sumptuousness that Joyce adored — "the light, the movement, the power of expression, the glorification of the city itself." Tiepolo's decoration of Venice's Palazzo Labia (given Joyce's fascination for wordplay, the name itself likely stopped her dead in her tracks — *calling that a palace?*) is considered his magnum opus, a work that surely inundated Joyce's senses by its mastery of technique and subject matter. The entire *Gran Salone* is adorned with scenes of the life of Antony and Cleopatra, a favourite theme of Tiepolo's.

Some years later Joyce would pay homage to Jean-Baptiste Siméon Chardin in a suite of drawings — "For Chardin, art was about love," Joyce said — to the sexuality of Jean-Honoré Fragonard in a drawing, and she would have a dress designed in the manner of Jean-Antoine Watteau. She lived in intimacy with her adored Masters.

Picasso, however, remained for Joyce in a class by himself, like Mozart. From the moment George Dunning brought the Vollard Suite to Graphic Associates and Joyce experienced the mastery of his erotic line drawings, she and her fellow artists in the 1960s would be highly influenced by Picasso.

Still more profoundly inspiring to Joyce was the supreme abstract expressionist, Willem de Kooning. Joyce's later works would bear traces of Claes Oldenburg and collagist Joseph Cornell, but de Kooning stayed with her, like a mole on a cheek, throughout her abstract developmental period — although in time she would resent hearing that she remained influenced by de Kooning throughout her career and would make a point of saying she hated his *Woman* paintings. But there was no denying his appeal in those early years, as a haunting, potent master of the genre. Joyce wrote a piece about his painting, *February*, which appeared in *Evidence Magazine* in 1961. Joyce had seen the work two years previously and defined it as possessing "immense, physical presence," an object that was "*something* unto itself. And through this object we experience some-

thing which did not exist before." She ended by addressing the painting's power that "seeks to influence and exert control. This painting has involved the whole personality of its creator, and because of this, it is fundamentally tragic."

In these comments, we see Joyce making attachments to the creator as resolutely as to the work. If the painting is tragic, then so, too is the painter. Joyce romanticized love, painting and music, placing equal emphasis on their creators — the lover, the painter, the composer. One has to wonder, did her discovery of Mozart's pathetic pauper's grave intensify her love for his music? Did she adore Puvis de Chavannes for his love of mythological creatures? Were Watteau's poetic colours a counterpoint to his debilitating melancholy and did Boucher's colossal walls of romantic extravagance at Versailles clarify for her the absolute notion of romance?

Through all Joyce's cultural influences and inspirations she would, in her work in the decade of the 1960s, gather up sufficient bits of courage to express her own deep, intimate views of romance and despair.

However, Joyce had yet to break out of her artistic downturn. Dorothy Cameron, in a letter dated June 6, 1961, takes Joyce to task for her non-productivity; and for its candour and loving concern, the letter merits reproduction. (The letter ends abruptly at the bottom of the first page, indicating that a second page or more was written, although this one page is all that could be located.)

> I am writing you because, frankly, when you told me, last night on the phone, that you have completed no new work since your show in September [1960 at the Isaacs Gallery], I was, for the moment, rendered speechless. I can hardly believe that you have let all these months go by. I understood that while Mike and you were both trying to paint at the apartment, it was very difficult for you, but since Mike has

his own studio now, I fail to understand how you can expect to be taken seriously as a painter, unless you take painting seriously enough to work at it. The only reason I have the nerve to speak this frankly to you is because my interest in you is not superficial. I believe strongly in your potential and I am willing to work and fight for you, but I cannot work alone. You are surrounded by friends who idolize you because you are a great personality and none of them could be this brutal with you, because they are too bewitched by you. I am enchanted by you, too, adorable Joyce, but I care enough about your future as a potentially important Canadian painter to give it to you straight between the eyes. To be an artist of stature requires discipline and hard work. These are clichés, but like all clichés, true. You have no discipline. It's all very well to dissipate your energies in amateur film-making and journalism, for which you have a charming flair, but you are neglecting your real talent. You've got to get off the pot, Joyce, and decide what's important to you. It's all very well to sulk about being turned down by the Biennale, but what did you send them? A new, mature work, expressive of your current development as a painter? No, you sent them a very nice thing but one you painted two and a half years ago. When I asked you what you have to show the Women's Committee you say you have nothing new completed, and mention *Night Interior* which must be at least five years old.

The letter ends.

The above-mentioned Biennale refers to curators of the National Gallery of Canada who survey artists to make selections to represent Canada in the prestigious Venice Biennale, and the Women's Committee refers to the committee of the then Art Gallery of Toronto that raises funds to purchase artworks, the same group Joyce had earlier denounced.

Dorothy likely petitioned both these institutions on Joyce's behalf and would have been understandably disappointed in Joyce for not having anything new to show. Rejection by both institutions amounted to an artistic snub that, at this crucial early stage of her career, likely set Joyce back a decade.

Marjorie Harris knew nothing of the letter and when it was read to her, she gasped at its harshness. "That explains why Joyce never showed again with Dorothy," she said. Marjorie had always wondered why, especially since Dorothy and Joyce had established such a strong initial bond. Informed that the letter was handwritten, Marjorie pointed out that Dorothy penned letters when she "was feeling absolutely passionate about something."

Marjorie deemed the letter "catastrophic," adding, "For Dorothy to say that Joyce was frittering away her energies with amateur filmmaking shows that she just didn't understand Joyce."

In another four years Dorothy Cameron would mount an exhibition entitled *Eros 65*[2] featuring, as the name implies, erotic artworks by artists Dennis Burton, Graham Coughtry, John Gould, Robert Markle, and Harold Town[3] that, put mildly, caused a sensation. The Toronto police swept in and closed the exhibition after seizing certain drawings of Robert Markle's whose subject matter was women behaving erotically with women.[4] Dorothy Cameron was charged with exhibiting "obscene matter, to wit, obscene drawings" and though cleared after a costly and enervating trial, Dorothy closed her gallery permanently and at that time destroyed all her files. Dorothy's husband, painter Ron Bloore, explained that Dorothy did not want any record of her gallery life to remain.[5]

Marjorie said, "I could've killed her. I would have curated her papers." She recognized their contribution to Canadian art history and indeed, Dorothy's personal papers might have revealed information about her writing this letter to Joyce. (Dorothy died in January 2000.)

Whether inspired or challenged — *I'll show her!* — by Dorothy's epistolary rebuke, Joyce got working again. In 1961 she produced eight large

paintings and fourteen collages, and at least twenty-four inventoried drawings — largely a continuation of her 1950s *Lovers* series. In 1961 she numbered works from *Lovers #1* to *Lovers #29*. Some are simply titled *The Lovers*, 1961, or *Lovers II*, 1961, with only two dated 1962. Whether through poor record-keeping or because works were dispersed before the inventory was made, not all drawings appear in numerical sequence on inventory lists; therefore there is no way of determining how many more exist than the itemized twenty-four.

Quite as if she'd received the master's sanction, Joyce freely explored Picasso's terrain, but with a startlingly feminine distinction. If master draftsman Picasso could draw women's vaginas as an image second to big round rumps and bosoms, Joyce would draw tiny, flaccid penises for her lovers, subordinate to their biceps and hairy chests.

When males depict human genitalia in their art, as with Leonardo da Vinci's anatomical drawing of the gaping vagina and the sexual depictions by Aubrey Beardsley and Thomas Rowlandson, and Picasso's and Egon Schiele's vagina-splayed women, male critics confine their assessments to artistic merit, leaving organs aesthetically out of the discussion. Male artists paint their sexual observations of women symbolically and openly and are granted every courtesy to do so, whereas women artists had no such artistic rights or freedoms in the 1960s. Women were supposed to respect male genitals: *leave them alone.* Feminists argue that women artists who dared explore this men-only genitalia domain were taken to task by male critics for portraying the male organ unrealistically, which is to say, small. Artistic evaluation did not rise above considerations of size.

Only time will tell if Joyce's drawings of penises are accorded the *sangfroid* of male artists' vaginal views. Until then, her renderings of the male organ — flaccid or erect, in assorted shapes and sizes, intact or disembodied — will properly represent what Joyce regarded as a few tender, amusing, womanly, totally personal expressions of erotica.

Rendered in pure line, in ink on various papers including newspaper and tissue paper, the subject matter is the nude male and female figure

either solo or *à deux*, seated and standing, entangled in sexual couplings — nude men and women in playful lust. Created by a less gentle hand, the drawings would be dismissed as lacking both draftsmanship and eroticism; however, through Joyce's sensitivity and wit the drawings are a sensual delight. In particular, *The Lovers*, 1961, *Lovers*, 1962, and *Lovers in the Park*, 1962, evoke an immediacy, an "I was there" factor. Not that practice necessarily validates erotic subject matter — just as virgins think, write and paint vivid sexual activity — but in Joyce's drawings the telling details affirm personal erotic experiences. She said, "The sexuality is there the same way the trees are there." In *Lovers in the Park*, one woman's legs are splayed fairly casually near a man's partial torso, great with erect penis, lying alongside one disembodied penis and testicles in the corner of the drawing. Breasts are passionately full, legs wrap around adjoining legs, and a certain confusion of who is doing what to whom amuses and frankly titillates the viewer.

Having garnered comment over her erotic 1959 and 1960 paintings and drawings, Joyce would find her reputation for erotica further aggrandized by these works. A selection of them would appear in the second solo exhibition of her career at the Isaacs Gallery in 1962.

After seeing this exhibition, director of the National Gallery, Alan Jarvis, was overheard leaving the gallery saying that the show should have been titled, "Phallus in Wonderland."

Lack of self-esteem, an affliction from which Joyce had yet to recover since her parents' deaths, received its first boost being in love with Michael, then another after having had a couple of art exhibitions, but the greatest improvement to date could be seen as clearly as the chart of a stock market recovery in Joyce's response to the women's movement. Women were reading *The Second Sex* (published in 1949, released in translation in 1953), by Simone de Beauvoir, who was the precursor of Betty Friedan, Germaine Greer, and Gloria Steinem. Joyce had read de Beauvoir, and strong womanly messaging appeared in her *Lovers* drawings of

the 1950s through auto-eroticism and self-empowerment by abandoning contraception, as in tossing away the diaphragm. In these and in her 1961 and 1962 *Lovers* drawings, Joyce's courage to be herself begins to be seen.

When the drawings appeared in her 1962 exhibition, one reviewer wrote of her subjects "leaping, dancing, flying apart, clinging together," and noted that "the effect is one of whirling, rushing eroticism, and is carried off superbly." These lines would have been immensely uplifting for Joyce. With little or no support from her male colleagues, Joyce exerted a great deal of energy to stay on course. Knowing her insecurity about her draftsmanship, she obviously did not want this impression on the record and would insist, when looking back over these years, that she had never lost sight of what she was trying to accomplish. "Even in the late 1950s I knew there was something legitimate in a female outlook, female expression." To take this a step further, she said, "Mine was a unique expression besides being feminine."

There is more self-confidence in these comments than Joyce likely possessed at the time — although incrementally, Joyce was developing a heightened sense of self-worth by producing art that was uniquely hers. And in this life-affirming development she began to upgrade and redefine herself as a woman, wife, friend, and crucially, as an artist.

Of inestimable importance, the women's movement opened Joyce up, refreshed her and made possible the expansion of her sensibilities.

As a youngster, Joyce's sister Joan had mentored her in music, imparting to her an exquisite, lifelong appreciation of music. Doris McCarthy had inspired her to study the Great Masters, and Michael was contributing to Joyce's development as an artist. While advancing aesthetically through these mentors, Joyce had no mentorship in feminism. It is true that friends from the 1950s, especially Wanda Phillips, had helped form her earliest feminist thinking but she lacked education on the subject. And she did what she had previously done in her independent exploration of the arts and humanities, she embarked on a self-educative, feminist program. This preparation began, she realized, when "I was on my way in

a sense to becoming an artist's-wife-type artist." She does not give a specific time frame for this bald assertion; it is most likely in the early 1960s, after about five years of marriage.

Steadfastly, Joyce acknowledged Michael's artistic influence on her, and he acknowledged her influence on him — "We both influenced each other," Michael said. Joyce also credited Michael with helping her define her own "well-developed outlook, philosophy, and so on" — although, when she suspected that his contribution lacked currency in her pursuit of self, she grew uneasy with the missing link in her evolution as a woman. Recognizing that she was heading toward something unacceptable as "an artist's-wife-type artist" was one thing; how to prevent its occurrence was yet to be addressed. Introduced in her twenties to feminist ideas and theories, in her thirties Joyce was revisiting those concepts of changing feminine roles and witnessing for herself how other women were changing. Her active participation in feminism, however, was immobilized by her marriage. But she knew she wanted to learn more. Her husband — in fact any husband who was well taken care of by a wife — was no source of knowledge for a woman in search of an enhanced concept of womanhood. Michael considered that feminism adopted Joyce, that it was merely superimposed on her work, the implication being that she herself did not adopt feminism. Recognizing that her partner could not help her in this quest, Joyce summoned the resources that had proved valuable in the past: those within herself.

Joyce took up the search for feminist mentors and role models by "looking around for historical female lines of influence." She read the biographies of "many, many women — salonists, diarists, revolutionaries, etc.," and as a result of this study she said, "I started to reinvent myself as an artist." This was her first reinvention. It would not be her last.

As is the natural order of things, during the expansion of Joyce's self-understanding, a diminution of her husband's influence occurred. "I saw that [his] artistic concerns were not mine, although I loved Cézanne, Vermeer, etc. I still had to look into the lives of women who had made

independent statements in their lives." She declared that her husband's "great individuality and talents were a catalyst to my development" as an artist but "eventually women's concerns and my own femininity became my artist's territory."

The reformulation of Joyce's feminism had begun in the late 1950s, and she was making paintings and drawings in the early 1960s that portrayed women's intimate experiences through sexual depictions, among other expressions.

Along with her exploration of feminism, Joyce adopted Canadian history as a serious study and it wasn't long before she saw that our national heroes were few and far between. As well, she encountered the problems the country was facing and this had a major, troubling impact on her, especially environmental concerns and the fear of American economic and cultural encroachment on Canada. The more she learned, the more she questioned what she knew — the critical point in continuing self-education — and she wanted, *needed*, answers to serious questions: What is happening to our country? What is our Canadianism? Are we losing our identity?

Regularly she read *The Canadian Forum*, a publication avowed by some as stodgy, yet the magazine published some of Canada's finest thinkers, and in those pages Joyce made the acquaintance of Melville Watkins, George Grant, among other strong minds. According to Joyce's friend Abraham Rotstein, an economic historian, she "had a good appreciation of the Canadian economic quandaries."

Joyce began a search for ways in which to express her concerns that would separate art from propaganda. An art movement called "point-of-view documentary," "victim art," or "advocacy art," in which art's primary purpose is to raise awareness and/or funds for causes such as the environment, AIDS, breast cancer, and the like, was about to pierce the public consciousness. Like the polarization that so often accompanies newness, this one ignited a serious aesthetic debate in the 1990s, with critics on one side saying that victim art attempts to engender sympathy for a cause and

therefore that intent disqualifies the art for serious art criticism. On the other side, the makers of any art form that advocates for a point of view are legitimate; poetry, music, dance or painting that produces an emotional response stands the possibility of enriching the human spirit, as it has throughout the generations, whether made by Thomas De Quincy, Robert Mapplethorpe, Anne Frank, Fyodor Dostoevsky, Bill T. Jones, Victor Hugo, or Sylvia Plath. And if an artist uses his or her art to draw attention to AIDS, breast cancer, or human-rights abuses, the objective, though blatant and possibly foremost, is no less valid than an artist's still life of geraniums or peaches.

Joyce showed herself to be ahead of this trend in her search to engage her art in a political, economic, and environmental debate. "I wanted an art that could embrace these concerns and also retain beauty, texture, humour, and such," she said in the 1960s. "Then, there was either one or the other — art to raise money for something but never really dealing with the issue." She alluded to friends cajoling their artist and writer friends into designing a poster, writing a brochure, or lending his or her name to their company's multiple-sclerosis campaign as strictly a fundraising endeavour. Joyce would be asked repeatedly, and would oblige — for her causes, on her terms.

In her search for Canadian heroes and a means of expressing political ideas in her art, Joyce discovered Laura Secord. (The name is known to some Canadians as a chocolate maker, in whose products Joyce would often indulge.) The woman's courage touched and astounded Joyce. During the War of 1812, Laura Secord learned that American troops were planning a surprise attack on Canadian forces, and with her cow as a decoy and by telling American sentries she was going to visit her sick brother, Laura Secord walked thirty-two kilometres through enemy lines to warn Canadian officers of the upcoming attack. Prepared and ready, Canadian troops repelled the Americans and thus ended their attempt to take over the Niagara Peninsula.

In Joyce's heart, brave Laura Secord saved Canada from American

domination. This act inspired Joyce's first political painting, and remains one of her most compelling works — *Laura Secord Saves Upper Canada*, painted in 1961.

Joyce would later replicate Laura Secord's courage in person. She dressed herself in period costume, borrowed a cow from a farmer, and walked the walk Laura Secord had taken 150 years earlier to save Canada from the Americans. With this as a starting point, Joyce proceeded to celebrate Canadians and Canadian history, as well as other leading women figures such as Marie-Antoinette and Madame de Pompadour through oil on canvas, with cloth, and in film. And as then future Prime Minister Pierre Trudeau would comment about Canada's proximity to the United States — that it was like sleeping with an elephant — Joyce thereafter used her art to protest against the little Canadian mouse being trampled by the big mastodon stampeding north.

Chapter Five

An ardent Canadian engrossed in studying the country's history and worrying about America's political influence on Canada, Joyce did not make the decision to move to New York. But move she and Michael did. Ten years after they had returned to Toronto, Joyce admitted that she had gone only because Michael wanted to go. "He felt that he would get really good if he went there. He just felt that's where he should be."

During the 1950s and very early 1960s when the two of them had taken numerous trips to New York, they began to see after successive visits

how distanced Toronto was from abstract expressionist art — not so much the artists and their work, as the public acceptance of the genre. Joyce understood Michael's drive and his artistic ambition, which was greater than hers, and she had been persuaded that New York presented more potential for Michael than Toronto did. "I certainly felt that what was going on there was incredible — things were really happening," she said. Even so, she would have preferred to stay in Canada. "It scared me to go because I was comfortable [here], and I wondered what would happen to us there. I was excited but scared."

Omitted from her statement, though preying on her mind, was her fear of Michael's infidelity. She couldn't stay behind in Toronto nor could she go to New York part-time. Married six years, loving Michael "madly," as it was always said, Joyce had no bargaining position. Based on the questionnaire in which she identified her job as "taking care of Michael Snow," she would have followed Michael wherever he wanted to go.

Therefore, in the fall of 1962, Joyce and Michael moved to New York.

They stayed with Betty and Graeme Ferguson,[1] (who had a large apartment — ten rooms, four bathrooms) and began their search for a loft. Joyce made her "tiger's milk" blender drink every morning and Betty said, "She tried to get me to drink it, ugggh!" Joyce loved to rev up ordinary doings; Betty related an example concerning their two-year-old son, Munro, who became a dear little pal of Joyce's and whom she played with and drew pictures for. Betty laughed, saying, "She called him an oracle. He spoke in a strange way, in this odd language that sounded sort of Oriental," that no one understood, and Joyce and Michael would describe the lofts they'd seen to Munro, asking what the oracle thought of this one, that one." The two-year-old soon bestowed upon them his sign of approval, in his own mysterious manner, of a loft.

On one of Joyce's forays in the Lower Village, she headed up the stairs of a charming brick building, two hundred years old, on Greenwich Street. Located near the Battery, the area was famous for its extremes of Wall Street riches contrasted with the huge population of down-and-outers

who lived on the street decades before such sights would become a commonplace urban tragedy. Once inside the building, Joyce followed the sounds of jazz emanating from a loft, and knocked on the door. Living there was poet Paul Haines, a former Montrealer, a man Michael defined as "a committed jazz fan," and his wife, Jo Hayward-Haines. Joyce made a comment about the music and Paul remembers her saying, "My husband plays piano like John Coltrane."[2] As it happened, there was an empty loft next to the Haineses', connected by an adjoining door, and Joyce and Michael moved right in (with Munro's blessing). Underneath them was a vacant floor that they fixed up and used for studios and jam sessions.

Paul described his and Jo's loft as "incredible, with fourteen skylights, only eighty dollars a month." As for the neighbourhood, there was an Italian bar downstairs, and everything, even the bar, closed at five minutes after five every business day. After that, "There was no one down there but us," Paul said, laughing, with one exotic exception: A building across the street contained "floor after floor" of caged wild animals for rent to travelling circuses, zoos, and movies. The only sound heard on the deserted street at night was that of animals screeching and howling. From their lofts the two couples would periodically see a city inspector on the fire escape shining a flashlight in windows at the animals; but everything was allowable then, "with a bribe," said Paul.

At that time, living in lofts was illegal — a city ordinance specified that artists could work in but not live in lofts — but this did not stop artists from setting up housekeeping in them anyway. Numerous warehouses and small manufacturing buildings in the Lower Village fell into disrepair during the 1950s as manufacturers vacated the high-rent city and moved upstate, although owners held on to their buildings for land values. They soon measured out their weight in gold. A whole section of the Lower Village evolved into the mammoth World Trade Center development, starting in 1974. However, until the developers came calling, owners rented space in their abandoned buildings for whatever cash they could negotiate and turned a blind eye to the goings-on, as long as the cash flowed.

Lofts ideally accommodated artists' needs because of their unencumbered layout, high ceilings, low rent, impermanence and grotty windows that let in the perfect work light — soft and diffused. A building with a freight elevator was coveted. Flights of stairs might be agreeable for civilians but not for artists who continually haul materials and large canvases around.

Not surprisingly, the typical loft was filthy, infested, and unheated. If there was water it ran cold. But artists are by nature scroungers and savers, and by virtue of their day jobs as carpenters, house painters, window dressers and labourers, made decrepit lofts habitable and workable. Furtively, ingeniously, artists tapped into nearby power lines and stole electricity for heaters and hot-plate cooking, and rigged up illegal phones. They snagged off the streets or out of trash cans objects that became furniture. And when a chair, a mop, or some pieces of lumber weren't used as household items, they might later appear in an assemblage.

Despite being "excited but scared" about going to New York, once there, Joyce was unabashedly romanced by the city. An artist moving to Manhattan's Lower Village in the early 1960s was like a 1990s computer nerd arriving in Silicon Valley or a rookie congresswoman deplaning in Washington, D.C., in 2001 — *This is it!* "The most endearing thing, the richest thing that happened to me was meeting all those people," she said. "I had never met people who stole their food from grocery stores and lived out of places that were just hovels. . . . One musician who lived in an abandoned loft put up a plastic tent inside, and he put a little hot plate inside the tent. That's how he lived. . . . It was what I believed about what artists should be, what I'd read in history. I was meeting it, and I was becoming part of it."

It took New York for Joyce to truly identify herself as an artist. Here, she and Michael felt like "old-fashioned artists," she said.

Within less than a year of their living on Greenwich Street the World Trade Center expropriation got under way, resulting in Joyce and Michael and the Haineses being forced out of their building. Joyce and Michael

found a loft on Chambers Street in what is now Tribeca, and Paul and Jo moved a few blocks away, to Harrison Street.

The area was less isolated than their former neighbourhood — there were shops and bars — but here, too, everything on the street shut down at night. (Now, it bustles with people going in and out of tony bars, picking up five-star take-aways, sipping lattes at Starbucks and shopping at Banana Republic and The Gap all hours of the night. Chambers Street stands alone as remaining unfashionably undeveloped, in that it's a thoroughfare to the Brooklyn Bridge.)

Joyce and Michael's loft was a broken-down mess. The two of them spent days scrubbing, trashing, and disinfecting to make the place habitable and free of its scampering, furry inhabitants. For the first few months they saved money on electricity; there was none. "We were freezing to death that winter," Joyce said about the nonexistent amenities.

On the third floor, the loft was large enough for separate studios each, a trade-off worth carting everything up three floors, but then they discovered on the floor below a loft "all busted up" that Michael soon made into a studio for himself. Joyce worked upstairs in their living space. During the previous year, Michael had begun his famed *Walking Woman* works, part of which were cut-out painted wooden figures, and in his search for materials he found abandoned wooden crates on the docks by a grocery distribution centre. He used these to build their furniture — a table, some shelves, an art-supplies cupboard. They scouted local trash cans for additional furniture.

In this, Joyce and Michael were among countless artists in the Village who practised what filmmaker Ken Jacobs called "living off the generosity of the streets."

Occasionally, a city inspector came around. Knowing this in advance, via the network of neighbouring loft dwellers, Joyce and Michael contrived a red-alert system by drilling a peephole in the wall so they could see an inspector heading up the stairway. Counting on the laboured climb of a desk-ridden bureaucrat up four flights gave Joyce and Michael

time to convert from a live-in to work-in loft. They pushed furniture into a corner, propped canvases against everything, covered the table with cans of paint, cleared away dishes and food, and successfully concealed evidence of their domesticity.

Leaving aside their actual loft — in time, the place would shatter Joyce's well-being — its surroundings appealed from the very beginning. A few doors away was Sherman's, a health-food store Joyce called "a hotbed of ecology, food and people," and ordinary, neighbourhood stores, a cheese shop, and a hardware store. The only disadvantage, and a principal one, was the seedy hotel next door. Throughout the day and night they could hear fights in the rooms; drunks slept off their previous night's misadventures on the street — frequently in Joyce and Michael's doorway — while women continuously plied their trade.

Joyce accommodated the downside by cherishing her neighbourhood's beauty spots. Visually, she was bowled over — views of the Hudson River, ships sailing through spaces between the skyscrapers, grand historic buildings of white granite, and turn-of-the-century clapboard taverns. City hall was nearby, as was the New York police headquarters. And to Joyce's great gustatory pleasure she was only a few blocks away from a grand old New York landmark, Fulton's Fish Market. She found everything around Fulton's ecstatic — the people, the docks, its fish. She walked street after street, mainlining the life; hot-dog and pretzel vendors, bleating taxi and truck horns, bacon and onion aromas from lunch counters, dresses and T-shirts swishing on racks outside shops. For a breather on hot humid days, Joyce and Jo found a breezy spot in a wind tunnel around the Chase Manhattan Bank tower, and on sticky nights they sometimes chilled off by lying down on the cool marble plaza.

Joyce's quick adaptation to people and places had her, within a very short time, feeling as neighbourly and familiar with sailors rolling off boats and into the saloons as she did with pin-striped Wall Streeters striding to their towers.

Warren Collins, Joyce and Michael's cameraman colleague in Toronto who shot *A Salt in the Park*, visited Joyce and Michael in February 1964, and stayed in their loft. He shivered at the memory. "I nearly froze to death, it was so bloody cold." And when he explained, "They had a stove for cooking and they heated the place with coal!" his eyes widened as though reporting life on an uncharted isle. "There was a fridge, a bed, and a bathroom. And because it was so cold Joyce was always making soups and stews. She wore these Hudson's Bay blankets around her as she cooked." And layers of clothes. Dresses over slacks. Sweaters over sweaters. Warren retains in his mind, as well as in photographs he took of Joyce, the image of Joyce at the stove making soup, wearing tea towels around her shoulders like shawls.

Joyce's personal style was in the throes of a conversion. Transformed from her Toronto days of dressing quasi-straight, she was making a move toward the New York offbeat. Having spent so much time with Sheila McCusker making clothes and thinking about fashion, it was as though loft living had given Joyce a reason to play dress-up decisively. With obvious care, she began effecting a highly distinctive, colourful, exotic style, wearing flowing djellabas long multicoloured skirts, silky pyjama-type pantsuits, shawls, beads and bracelets, and African turbans wound around her head. She would have found this costumerie in multicultural shops all through the Village, at bargain-basement prices.

Living the loft life marked another passage in Joyce's well-cultivated resolve to cope and rise above. Warren's photographs catch merry evidence of Joyce managing to make the best of things. Cooking soup, wearing blankets and tea towels to stay warm — how amusing! How *Bohème!* One can also see two sides to the tea towels — one as symbols of Joyce's pragmatic nature, the other as material for her art.

Warren's photographs also suggest Joyce's ability to cover up, symbolically and intentionally. Just as she retreated from her childhood torments by imagining her dolls as princesses and daydreaming her Woolworth's junk jewellery into diamonds at the ball, surely she would have taken a

similar escape route through her imagination and applied it to their loft. Tea towels on her shoulders? My dear, rare Persian shawls. The cold loft? The interior of a czar's palace, of course. As for her day-to-day New York life, she may well have contrasted her artist's vow of self-imposed impoverishment against her childhood where everything — her surroundings, her second-hand toys, the coat her mother made from one of her own, and the furnace without coal — was de facto impoverished. And when the ache of her childhood memories set in, as it perpetually did, she converted her pain into creative energy. Just as she would cut up pieces of her dresses and panties and stuff them into pockets of collages and constructions for fragmentary bits of beauty, if not nostalgia, it is logical to believe that Joyce conceptualized her linen tea towels into an artwork that she would soon get around to making.

Joyce and Michael made contact in New York with several expatriate Canadians, one of whom was Robert Cowan, another Toronto pal from Graphic Associates who had been living in New York for the previous two years. Joyce and Michael arrived at his loft one night when he wasn't there and the two of them sat on his front stoop until he appeared, which coincided with the sun coming up. Robert took Joyce and Michael to meet well-known underground filmmakers Ken and Flo Jacobs in their loft beneath the Brooklyn Bridge. This is how Joyce and Michael "fell in immediately with the underground film scene."

Michael's studio loft was becoming too crowded for his large *Walking Woman* sculptures and he rented another loft a few blocks away, on Canal Street. ("The quietest street in New York," by Michael's description. Near the docks, "It's the Mafia area and they insist on it.") He had bought a piano from a musician who needed money and like the Greenwich Street studio, the Canal Street loft became a haunt of the "furthest-out jazz musicians in town," according to Michael. Cecil Taylor, Albert Ayler, Archie Shepp, "and all those guys" who had nowhere else to jam, went to Michael's studio.

From the time Joyce began working full-time as an artist, her studio had been crammed into her rented rooms and flats, excluding the period in 1959 and 1960 when she had the Montagues' coach house on Charles Street. After her marriage, Joyce had worked in a studio in their apartment and Michael mostly worked away from home. In a 1981 interview, critic Lauren Rabinovitz asked Joyce if she resented this. "I didn't think I deserved any more," she replied.

This revelatory admission addresses more than Joyce's lack of self-esteem. As a youngster, she made her drawings and comic strips on the kitchen table only after more urgent family activities were accommodated, such as getting by. One could attribute working at home purely to habit were it not for Joyce's lingering doubts about calling herself an artist. And yet, in the mid-1960s when she made this comment, Joyce was producing art and establishing herself as an artist. Still, self-doubt haunted her.

Jo Hayward-Haines, whose relationship with Joyce developed in the early 1960s, was interrupted through the 1970s and resumed in the early 1980s, expressed her understanding of why Joyce worked at home. "In their loft, art was a part of Joyce's life, part of the scene," which was chiefly because "her art was different from masculine art." Jo speaks as both a painter and an art teacher, and out of an understanding of Joyce's deep convictions. "She had very definite ideas that art should be displayed everywhere as part of people's lives. We had this fantasy of setting up art centres all across the country and we used to talk about this, about what it would mean to people's lives." One conclusion, of course, was that art — and artists — would be less elitist, which would be anathema to the male establishment that ran art.

No one would argue, though, that Joyce's and Michael's work spaces stand as a sharp exemplar of their contrasting lives and personalities. Michael's privileged background afforded him the means to freely pursue art and music; he was never without a studio, just as he was not without his own bedroom, his own piano, his own private school. Differing

lifestyles, of course, bear no corresponding relationship to artistic ability — as history's wealthy and destitute artists have proven — but being able to buy unlimited art supplies and have a good studio buys the artist freedom to concentrate on his or her work instead of relinquishing easel time to paid work that provides these necessities. Michael's birthright favoured him in a manner unimaginable to Joyce when she was growing up. Before him, she had known no one who irrevocably obtained whatever he or she wanted.

Working at home in her New York loft suited Joyce — for the time being. She had plenty of space and, as in the past, she could simultaneously work and cook.

Opinion varies about Joyce and Michael's financial situation while in New York. Michael earned money playing in bars and periodically his artwork sold in Toronto, as did Joyce's (although to a lesser extent), and she earned a stipend teaching art to some friends' children. Av Isaacs said that occasionally Michael would call and, rightfully, hound him for money owed. Of that time in New York, Michael said in all seriousness, "You could live pretty well on the poverty level."

Friends referred repeatedly to Michael's tight-fistedness, yet he could pay for two lofts, buy a piano and support the two of them. In conversations about these years Michael himself frequently mentioned, "We couldn't afford [to go out to clubs or restaurants]," for example, and that "we didn't go out that much."

Joyce's nephew, Keith Stewart, lived with the couple when they returned from New York and he said he saw a "blinking suitcase full of American cash" that Michael had brought back with him, earned in jazz joints. But Michael claimed to have played very little in clubs, that he jammed mostly in lofts. Committed to his *Walking Woman* series, he said he had "taken a vow of not playing music anymore," but implied that this had actually not occurred because he was "so amazed" by what he had heard when he started going out in New York and playing in sessions.

Michael admitted that after one "horrible New Year's Eve party" in an American Legion hall, where the patrons "hated the musicians and the

musicians hated each other and fist fights broke out," he stopped playing in clubs.

Joyce and Michael adopted a fairly consistent pattern of work and nightlife. For the most part, they worked during the day, Joyce at home and Michael at his studio on Canal Street. Although there were plenty of cheap Village cafeterias nearby and they lived within ginger-sniffing distance of Chinatown, she and Michael seldom ate out; as Michael said, they couldn't afford it. They dined at home instead on soy-laced blender drinks, Joyce's macrobiotic soups, and stews with a side of herbs, nuts and vitamin pills — served on their dining table that Michael had made of packing crates. After dinner the two of them would go out. More aptly, they were driven out by the wall-thumping, furniture-hurling mayhem committed in rooms next door by the hotel's drunks and prostitutes.

The downside to living in the heart of America's artists' colony was the actual habitat. Originally, its decrepitude had been exciting to Joyce, but after a couple of years of maintaining an upbeat attitude about their seedy loft and the hotel low-lifes next door, she grew nervous. Though not frightened for her life, she did become apprehensive about the denizens of the neighbourhood and the dark, deserted streets at night — concerns that do not enter a man's consciousness. And although their loft had been a source of good times over the years, this would ultimately and grievously end.

In about 1963, urban renewal displaced Flo and Ken Jacobs from their loft under the Brooklyn Bridge to Chambers Street, less than a block away from Joyce and Michael, where the Jacobs still live. The two couples developed a long friendship. Ken, a filmmaker and part-time college lecturer struggling to make ends meet, occasionally invited filmmakers and artists to his loft to view films and charged a small admission fee. Joyce and Michael often attended.

In fact Joyce and Michael found themselves on a growing invitation

list for film and music events, many of them concentrated within a few minutes' walk from their loft.

They walked everywhere. All Villagers did. Not far away were two of Manhattan's finest jazz clubs, the Village Vanguard and the Blue Note, which packed in crowds of New Yorkers with the Eastern Seaboard's finest samplings of live jazz. The clubs were expensive — a hefty cover charge and pricey drinks — a factor that Michael noted precluded them from going there too often, but on the occasions they did, they heard John Coltrane, Sonny Rollins, and a favourite of Michael's, Thelonius Monk, a jazz pianist whose abstract piano compositions unfailingly appeal to abstract artists. They also went with the Haineses to a couple of local lesser-known, less expensive jazz hangouts, the Five Spot and the Jazz Gallery in St. Mark's Place, in the East Village.

On occasion, Joyce and Michael dropped into the Cedar Street Tavern, where the ghosts of de Kooning and Pollock yet lurked and a new generation of artists and a fresh batch of "art tarts" hung out. And on nights with nothing else to do, they settled into one of their neighbourhood bars, as did other Village artists seeking respite from their bleak lofts and resident wildlife. After a couple of shots, even a sleazy bar got to feel downright homey. No matter. They were out, they didn't have far to walk, and ten bucks bought the night's booze.

Former Torontonian artist Les Levine lived in the Bowery district on soon-to-be-expropriated Liberty Street and he often joined the couple at a bar. Though not a drinker or a party man, Les said, "You had to go to bars. It was the only social life available."

Robert Cowan, when between engagements as a filmmaker and film columnist, worked as a projectionist at the Filmmakers' Cinematheque, a New York facility that combined an actors' rehearsal studio with a theatre that was used for weekly underground film screenings by emerging filmmakers. Every Friday night, filmmakers brought in finished or unfinished

bits of film to screen — some high-quality efforts, some not much above clever home movies.

Very shortly after Joyce and Michael arrived in New York, Robert took them to one of the Friday-night screenings. Joyce adored the informality of the place. Cinematheque director, Jonas Mekas, filmmaker and movie critic for the *Village Voice*, allowed screening of everyone's films. Given that democracy invites dissent, not all evenings were polite affairs. Joyce recalled one of those nights in an interview that appeared in *Mademoiselle* magazine, when Ken Jacobs, whom she described as someone with "a slew of good films to his credit," was in the audience. "A particularly bad film came on and he shouted out, 'Crap, bullshit, what kind of film is that!' I felt like yelling those things too but I guess, being Canadian, I'm shy."

Some have implied that screenings at the Cinematheque were an excuse to party; others felt that parties provided an excuse to show their films. Regardless, these gatherings spawned the highly respected New York Anthology Film Archives, a repository of films for circulation founded in 1969, with Mekas as co-director with the chief sponsor, Jerome Hill. (P. Adams Sitney, Peter Kubelka, and Stan Brakhage were also founding members.)

"There was an In-crowd seriousness about these showings," says Robert Cowan. (Having moved to New York in 1954, Robert made twenty avant-garde films before returning to Toronto in 1988.) Films shown at the Cinematheque were chiefly regular 8-mm, super-8-mm, and a few 16-mm formats, but all were highly experimental. "Everybody was trying out everything, one more different than the other," said Robert.

Some nights there was a full house and at other times only the film-maker and two or three friends comprised the audience. "You never knew who would turn up," Robert says, including, on occasion, the police. He smiled. "But nobody brought their mom and dad."

Joyce and Michael went to film screenings, loft parties, openings, artists' haunts, and dives — just as relocating businessmen would go to

Rotary Club meetings and join golf clubs — and although Michael had come to New York originally with the idea of establishing himself as a painter and sculptor, both he and Joyce were beginning to cultivate a taste for the amazing feast that was the city's cinematic smorgasbord.

At one of their early loft parties, Joyce met the twenty-year-old twins George and Mike Kuchar, a meeting Michael described as a "revelatory moment for Joyce"; what she saw was "[the] inspiration of these two young guys making films without any money, that they were just doing it." And more important, that their films satirized the Hollywood films.

Jo Hayward-Haines also remembers how inspired Joyce was by the Kuchar brothers.

Having met the Kuchars, and after her first night at a Cinematheque screening, Joyce went out and purchased a second-hand 8-mm camera.

She took her camera into the streets and shot film of people, shop windows, ships at the nearby docks, waves, Fulton's Fish Market — random, unfinished segments, without a narrative thread. At times she edited and spliced these pieces of film together at the Fergusons', who had an editing room in their apartment (filmmaker Graeme cut and cleaned up early Hollywood films for television, as his paid commercial work). Joyce then dropped around to the Cinematheque with "my bit of film" to show with others' "bits of works-in-progress."

Although she made this sound cool, later she called the experience "scary and wonderful. I'd just be shaking and dripping and freaking out." For the first few times, Joyce brought along her own projector. "I had to drag this projector from the subway, stopping every few feet to put it down."

It was generally acknowledged that a showing at the Cinematheque or in someone's loft could constitute that film's first and last screening. Similarly, the filmmaker's fate.

Betty Ferguson — who juggled the birth of children with working as an assistant film editor doing "dog work" (cutting and splicing) on some of her husband's film projects — and Joyce began "fooling around,"

putting together pieces of scrounged footage.

Joyce did not give thought to narrative line. She shot images from new spatial concepts; there was no school for those ideas. Technique failed to consume her. As *A Salt in the Park* and *Tea in the Garden* reveal, technique runs a distant second to concept, and yet experimentation with technical effects would characterize her work.

"Joyce taught me an awful lot," Betty says. "She taught me not to follow the rules. She always had a million ideas. She would paint right on the film. She looped a lot of stuff. I would worry about the splice marks showing and she'd say, 'Great, let them show.'"

As much as the milieu thrilled Joyce, she kept expecting to meet the real stars of the underground film world. It embarrassed her later to admit that neither she nor her husband appreciated the "treasures we had initially uncovered" in the people they first met. Joyce was not a snob — although she could be uppity about cooking and cats — when you consider that in her lifetime she would entertain Prime Minister Pierre Trudeau in New York and meet leaders of Canada's social and artistic elite, all of whom she held in equal esteem with her immigrant neighbours on Toronto's Queen Street. However, during her early New York days, in her thirties, Joyce had yet to climb some rungs up the artistic ladder. The New York reality was that she and Michael were meeting workshopping filmmakers like themselves. "We kept saying, 'We're meeting these underground filmmakers, but what we really want is to see where the big action is.'"

In this comment can be seen Joyce's accelerating social ambitions. Knowing her modus operandi at Toronto openings of working the room, spotting the "big action," and having emboldened herself sufficiently to approach a stranger at a party and introduce herself, in New York she was disadvantaged in not being able to use her artwork to shout *Look-at-me, dammit!* because she had yet to be taken on by a dealer. Her next-best plan of attack was to get noticed personally.

However, timing was slightly against her.

P. Adams Sitney, editor of *Film Culture* magazine and a chronicler of

avant-garde film, pointed out in a lengthy article on Joyce that when she arrived in New York, the exhibition of avant-garde films was "at its apogee of excitement." Simultaneously, a shift was occurring in the radical film aesthetic.

The term "avant-garde film" was first used in the 1920s to define unconventional, plotless, sometimes actor-less films made by surrealist artists in Germany, France, and the Soviet Union; film was a motion-and-sound medium that offered another expression of these artists' already distorted, surreal visual images. Man Ray made the first of several avant-garde films in 1923, Marcel Duchamp in 1926, and Salvador Dalí collaborated on a film with the noted Spanish filmmaker, Luis Buñuel, and thereafter Dalí made two of his own films, the first in 1929. Alternative film followed, taking its cues from 1940s and 1950s culture, the art of abstract expressionism, surrealism, the atonal music of Igor Stravinsky, and the poetry and literature of the Beat Generation. Coinciding with this movement was the emergence of the foreign commercial art feature films by Buñuel, Federico Fellini, Ingmar Bergman, and Akira Kurosawa — none made in Hollywood.

North American avant-garde films proliferated in the late 1940s. First there were the "visionary" filmmakers: Maya Deren, Kenneth Anger, James Broughton, Sidney Peterson, Stan Brakhage, and Gregory Markopoulos. Their films shared in common the filmmakers' personal revelations. Also at this time, a genre known as radicalized psychodrama emerged, as pioneered by Anger, Brakhage, and Markopoulos, in which the filmmaker acted out his or her highly personal nightmares — films that provoked severe forehead whacking in the conservative heartland. And in the mid-1960s, visionary cinema filmmakers were placing great emphasis on light and its cinematic effects, and on visual perceptions.

However, it was Warhol's Factory decadence films of pale, blasé, nearly-nothing happenings made by a man (more accurately a clique) which knocked the lights out of the underground film culture in the mid-1960s, in particular, Warhol's three-hour epic, *The Chelsea Girls*.

Among the first people Joyce met at the Cinematheque was Dave Shackman, also a budding experimental filmmaker. He had just bought a new 8-mm Bolex and he and Joyce talked about collaborating on a film. (This never materialized; Dave died in 1965.) Joyce and Dave met almost every day and "were always hanging out," Joyce said, at a nearby film-equipment store. Dreamily they coveted lenses costing as much as one's first car. "We would go out [of the store] and think, 'If we could only buy that camera we could slow down the shutter system.' Then I started taking cameras apart and putting them back together. We wanted to get really inside the cameras." Joyce said Ken Jacobs "had done the same thing first."

In short order, the underground film community embraced Joyce, and vice versa. "Filmmakers are nicer than painters," Joyce believed. "They are always willing to lend things and to act in each other's movies. They may be jealous and they may be vain, but underneath there's a warmth and feeling for each other."

Reminiscing with film critic Lauren Rabinovitz about "these fantastic filmmakers," Joyce said, "It was loose. You could make mistakes and mistakes are part of film creation." As though to counteract earlier comments about her and Michael looking for the big action, Joyce admitted, "Finally we realized the absolute brilliance, the bravery, and the courage of what these people were doing."

Not yet actually producing films, Joyce was engaged in filmmaking, and in 1963 her career as a serious independent underground filmmaker burst to life one night — just like in the movies — after attending a midnight screening at the Cinematheque of Jack Smith's *Flaming Creatures*.

"When I saw that film," she said, "something went *pop!*"

For good reason.

Joyce considered herself tuned in, with it, and all the other going terms for open-mindedness (the love drawings she made in the 1950s could only have been created by an innovative, sexual woman), but she soon discovered that Toronto parties that had swung on copious beer and a little nudity were hicksville next to New York's sex-swapping, sado-

masochistic, gender-bending, dope-and-booze bacchanals. That a film-maker dared depict this underbelly of contemporary life is what went *pop!* for Joyce.

Flaming Creatures was shot over summer weekends in 1962 and 1963 on the rooftop of a Manhattan theatre, using army-surplus film stock and costing one hundred dollars to make. So far, it was uncannily similar to Joyce's first filmmaking ventures in Toronto. Joyce and her collaborators had parodied silent films and so had Jack Smith, but with a whopping distinction. He created a daring, hilarious, vicious, pretty, campy, and hugely memorable transvestite orgy. *Flaming Creatures* spoofs the early film techniques and effects of Erich von Stroheim, Josef von Sternberg, Cecil B. DeMille, and Busby Berkeley with grainy, plotless tableaux of actors — four transvestites in inch-thick Pancake and one achingly beau-tiful woman-dancing, fondling their own and nearby genitals, licking, limbs a-jumble, extreme close-ups of mouths, a breast, penises, (forever flaccid) the action unfolding in kaleidoscopic transitions of suggestible sex (no penetrations) to a dervish dance and the final scene, the close-up of a jiggling nipple. The actors sigh and scream to sounds of an earth-quake's roar, and thunder rolls. Add to the soundtrack Deanna Durbin singing "Amapola," a few strains of Béla Bartók's Sonata for Solo Violin, excerpts from the Cuban bolero "Siboney," a little Chinese opera — "China Nights," sung by Yoshiko Yamiguchi — Kitty Wells doing the cowboy lament "It Wasn't God Who Made Honky-Tonk Angels," a rock-ing "Be-Bop A Lula" by the Everly Brothers, and you affirm that Smith achieved his goal of creating a sense of "aesthetic delirium."[3]

The film was banned, reviled and caused riots at screenings. In 1963, Jonas Mekas and Ken Jacobs showed the film at the New York Filmmak-ers' Showcase and they were arrested. Flo Jacobs had been putting up posters and Gerry Sims, also helping with the set-up, claimed that he never even turned around to see the film; he and Flo were not charged, but at trial the following year Ken and Jonas were sentenced to six months "in the workhouse," as defined by Ken, although the sentence was

suspended. On the other hand, *Flaming Creatures* won numerous awards and was hailed a masterpiece by many critics. Susan Sontag, described by writer Jim Hoberman as one "who practically invented public awareness of the camp aesthetic in her discussion of the film," called *Flaming Creatures* "a triumphant example of an aesthetic vision of the world — and such a vision is, at its core, epicene."[4]

Joyce felt "the biggest release" to know "it was possible to make something about yourself in that way." Smith, the outrageous, innovative, crazy man, and his film, "really opened the door for me. My God, it *allowed* me to do this kind of thing. This guy was making very personal, very painful statements about his private life."

Through Jack Smith's freedom in his film, Joyce realized that she, too, could "express anything I wanted to express," and she was on her way to making uncommonly visceral, personal films.

In the lingering heat of *Flaming Creatures*, Joyce made her first serious underground film, *Larry's Recent Behaviour*. An 8-mm, colour, eighteen-minute film, *Larry's Recent Behaviour* is not exactly *charmant*. Using tight close-ups, we see Larry's oversized nose, his large eyes zooming in and out of frame. Larry picks his nose, a woman squeezes her zits, Larry sucks her toes. In certain sequences Larry's out-of-focus face resembles male genitals. Joyce's cat, Dwight (soon to have his starring role in *Catfood*), makes an appearance. There is an American flag. A limp dick swings back and forth. The sound is distorted, continually sped up and then slowed down. The words "funny" and "quirky" commonly define this film.

Betty Ferguson laughs at the mention of the film, saying, "Joyce liked to gross people out."

This opinion is not solely Betty's. Friends Sheila McCusker, Kathy Dain, Sara Bowser, and Mel Waterman all agree that this was Joyce's way of attracting attention to her art. Referring to Joyce's early penis drawings, Mel states, "Joyce said she had to do that kind of work to get in front of the public."

Between her first underground film made in New York, *Larry's Recent Behaviour*, and her previous film, *A Salt in the Park*, made in Toronto, four years had elapsed. The question has been asked many times, what took her so long?

The answer is plain: money.

Underground filmmaking has always been a shoestring operation, untouched by human investor or government grant. The Canada Council awards funding for narrative-driven documentaries and the Canadian government funds the National Film Board, whose members have produced stellar, world-acclaimed documentary films, but the sensory, abstract themes in Joyce's imagination defied classification. How could she write a grant proposal for a poetic synthesis on film? A structureless, non-narrative driven film? Joyce didn't have money, she couldn't afford a good camera; nobody could. It took Warren Collins a year to pay off his 8-mm Bolex in the mid-1950s. And rentals didn't exist in Toronto then. Film was expensive, as was processing. Paying for equipment, sets, actors and post-production was out of the question. Maya Deren, who worked as her own camera operator, director, editor, writer, and sound mixer, said, "I made pictures for what Hollywood spends on lipstick."

When Betty and Joyce's other close friends talk about Joyce grossing people out, they express themselves with total affection and, more aptly, they comment on a truly Canadian trait. Joyce flailed about in the archetypal Canadian identity crisis involving our smallness, meagre cultural heritage and no history that demands we stand and scream wildly so that the giant Americans and culturally-secure Europeans and Asians will take notice. Lacking the capacity to compete against these forces, we present our culture introspectively, through character-based films and books, with Gothic tales of incest and necrophilia or plucky pioneers roughing it in the bush, leaving the Americans to their *Ben-Hur* epics. Joyce would never make, nor want to make, that kind of film. Therefore she had to blast them out of their seats with her small shockers.

It is unlikely that *Larry's Recent Behaviour* will rise to the heights of

Joyce's canon as the films she made following it do, but after one viewing, *Larry* sticks in the chest like a just-hurled spear.

Joyce's next film, *Patriotism,* was a rollicking, boppy, witty sexual romp cum patriotic send-up. Her first animated short (five minutes, colour), it features her pal Dave Shackman in bed, awakened by wieners marching over him. In a combination of both live-action and stop-motion techniques, the wieners dart out from under the blankets, his armpits, between his legs, and in tight drill formation they march to a John Philip Sousa tune. At first the wieners are frolicsome, until they start to slide in and out of buns, masturbating. The film ends with Dave waking up and gazing adoringly, idiotically, at a nosegay of three wieners in his hand, wrapped in an American flag.

Lauren Rabinovitz sees this depiction as "literally linking phallic and patriotic signs as icons of political domination." She explores the pop art influences in Joyce's early films:

> Wieland portrayed the penis as a banal object in much the same way other pop artists used the soup can, billboard, or flag as a means for celebrating and satirizing contemporary culture. But whereas other pop artists employed hard-edged iconography for commenting upon a consumer-oriented society, Wieland's child-like rising and falling cigarettes, airplanes and hot dogs used interchangeably with phalluses symbolically assert contemporary society's dependency on the pursuit of power and its inextricable links to disaster.

Like many artists working on several projects, in several mediums at a time, while making films Joyce was also painting. She brought the neighbourhood phantasmagoria into her studio; the fish, cheese, and fruit she picked up in nearby shops became the still-life subject matter of her first New York paintings.

For two years she painted the hurly-burly of the streets in their

fragments: bottles of soda pop, cafeteria signs, a cigar being chomped by a chap in a fedora, a policeman blowing a whistle, and various dissociated body parts. Rendered in bold, assertive colours, she used speech balloons and stylized lettering in her compositions, as in a 1963 oil, *New Yak City*. Many of these paintings appear rather cartoony and playful, made almost childlike with smatterings of hearts or kisses. Joyce may have suspected that humorous, whimsical paintings are easily passed off as trifles and that she might be nailed for creating personal little pastiches, but she believed strongly enough in her individuality to take that risk.

Intimations of her burgeoning political and feminist consciousness make a distinct showing in a number of paintings done in 1963 and 1964. *Strontium 90 Milk Commercial*, a painting of a domestic still-life, comprises a milk bottle and two glasses that appear in varying actions of milk being poured from the bottle into the glasses, sequentially over twelve frames. And in the last two frames, you interpret the bottle as exploding and disappearing, insinuating that the milk contains deadly chemicals.

In *West 4th*, a tall vertical painting divided in two, the images appear as in film strips and on one side a lit cigarette tumbles through the frames from top to bottom. On the other, the cigarette is held in lips that appear luscious at the top but increasingly they distort through the frames, until in the last frame they are grossly misshapen. Close examination reveals that Joyce has pencilled in the words "causes cancer" above the beautiful lips.

The New Power is twelve frames of a man's hand in different acts of fondling, touching, and playing with objects — either money, a breast, or a penis — and in the last frame the hands are applauding.

Two of her most talked-about works were done during this period. *Penis Wallpaper*, a 1962 oil on canvas, is an array of penises spread full-size — some out of frame — against a polka dot background. *Nature Mixes* uses the film-strip technique — this one, of twelve frames rendered with a hand that gradually metamorphoses into a flower, which in the last frame has become a penis.

During 1963 and 1964, Joyce created about eight neighbourhood

paintings, among her substantial output of forty-one paintings done in this period. Unbeknown to her, though, she was entering a ten-year exhibition drought.

Joyce did not have a dealer in New York at any time during her nine years there. Av Isaacs suspects that she did not exert much energy trying to find one. "She was not aggressive," he said. And Michael believed she had been "too wrapped up in other things," meaning filmmaking, to concentrate on finding a dealer.

Everyone around her had their opinions on the reason she did not have a New York dealer.

Betty Ferguson attributes Joyce's situation to historical timing. "Joyce was in a tough position as an artist and a woman. At that time the New York scene was elitist and snotty. Joyce felt put down by it. The situation was insurmountable, it was just too early for women then." Unlike Joyce's husband. "Michael was selling paintings. He had a green card and he played piano in the clubs in New York and he had a dealer."

Being a woman accounted for only part of the resistance, however. Quite likely, Joyce never suspected how difficult getting a dealer would be, in the queue with throngs of artists trudging their work and slides along from gallery to gallery. Artists do not commonly have agents representing them as actors, writers, and superstar athletes do, and while the self-hustle is bruising and humiliating, the indignity is compounded by the amount of time that is deducted from the artist's studio time making work intended to impress those same dismissive, cavalier dealers. On any given day, artists would be scuttling from dealer to dealer, noses pressed against gallery windows, only to be discharged en masse. They were bothersome pygmies underfoot of the giants de Kooning, Pollock, and the dozen-or-so other leading abstractionists. Though a relatively small group, their powerful works, their gigantic reputations and their renegade, boozy, sexy lives were bona fide terrifying. Joyce's reaction was no different from that of countless other rookie artists coming to the big city from their little 'burbs.

Michael joined this parade, along with the myriad other unknowns. "You'd take your slides in and go down on your knees and they weren't interested. And you went on to the next gallery," he said, groaning. There was no response for month after month. He shuddered at the memory. "It was really horrible."

After more than a year of this seeming futility, Michael was taken on by the Poindexter Gallery and had the first of three exhibitions in 1964, one the following year, and the third exhibition in 1968.

(Av Isaacs said he recommended the Poindexter to Michael, but years after he had severed his relationship with Isaacs, Michael disputes this, saying, "Av had no contacts in New York.")

Michael feels that Joyce, having witnessed his monumental undertaking and the despair it wrought, "didn't want to go through that."

Nor could she have tolerated the barrage of rejections.

Jo Hayward-Haines believes that Joyce "wanted to be recognized and wanted to be an artist, but she didn't want the goddamn business thing of art. Joyce's art came from an intrinsic women's viewpoint," she said, implying that the business of art was incompatible with making art; that it was on some level unseemly. Joyce was developing a growing resentment toward the business associated with art — Andy Warhol said that business is America's art — not because of New York's exclusionary dealer culture, but because an aspect of her creativity was obstructed by that environment.

It would be twenty years before Joyce revealed a brutal truth about the New York art world: "It terrified me," she declared.

From this reflective position of two decades' distance, space enough for her to have examined her fears and found the courage to expose them, Joyce told Lauren Rabinovitz, "Something in me couldn't get it together to make anything for that scene. It turned my juice off. I just took what I could from it without losing sight of something in myself."

Joyce would later qualify this last phrase with a starker revelation: ". . . something [in myself] that would never be developed if I were to become part of a movement."

"Make anything for that scene"? "Become part of a movement"? Nonetheless, Joyce was indeed making things. She was stimulated, productive. Crucially, though, she was also isolated from the scene and the movement — that elite group of men in the early 1960s who ruled abstract expressionist art. And they *were* men. The few exceptions — Helen Frankenthaler, Louise Nevelson, and Mary Bauermeister — had got as far as knocking on the old boys' clubhouse door but were yet to be admitted. So you have this clubby network of male artists represented by male gallery owners — excluding Betty Parsons, Jackson Pollock's dealer — in a tight, locked-down society that was impenetrable to Joyce regardless of the effort she might have put into storming it.

Failing to obtain a New York dealer placed Joyce in the same position as artists throughout history who suffer their thousand cuts of rejection, although in Joyce's case this rejection amounted to yet another abandonment, another snakebite on her soul. How she felt about this would be her best-kept New York secret. Not until she and Michael returned to Toronto in 1971 would she begin to open up. She positioned her explanation in purely feminist terms, telling writer Susan Crean that in New York she kept reinventing herself as an artist. Asked why, Joyce replied:

> Well, I had to. In New York there was that strong male Establishment and once you got in the door it was like joining the biggest bank in the world. You were bankable; you were the item. I recognized how easy it would have been to go along with the aesthetic and even remember a woman asking me, "Why don't you paint like them and then maybe you would get a gallery?" But where would I have been as a woman? I felt I had to remain loyal to myself and to my mother and my female line.

These quotes are dated spring 1987, time enough for Joyce to backdate her feelings twenty-five years. Which is not to discount them, as though

time does not permit old thoughts to be polished up, like the family silver; but whether Joyce held such defined feelings when she was in New York is hard to know. Jo Hayward-Haines said she can't remember Joyce complaining about not having a dealer. Joyce's feminist summation of the scene could have evolved during the intervening years and been refined on her home ground, in Toronto. Remaining loyal to her "female line" implies taking action. If this was the case, she compartmentalized her feminist self into person, artist and wife, and would therefore have attached a hierarchical order to these roles. According to that rationale, the artist is subordinate to her femaleness. Once again, this suggests that Joyce still could not unequivocally place herself as artist first.

Regardless, Joyce's 1963 paintings and drawings reveal the process of reinventing herself — seriously, vehemently. In previous years, penises subordinated the central image, as in *Redgasm* (1960), *Notice Board* (1961), and *Time Machine Series* (1961). Within the next two years, the penis became the central image. Moreover, the case can be posited for penises as confrontation in several works done in 1963. In *The New Power*, the penis is more powerful than money, and in *Flicks Pics #4*, *Hands Film* and *Necktie*, the penis forcefully manipulates hands, disasters at sea, and haberdashery.

Although Joyce's professional art career dates from her first exhibition in 1959, and she had had a reasonable amount of public exposure up to 1963, she was not, however, a household name. Reviews and articles during this period were sparse, uneven. Joyce could not have helped feeling like a tagalong in the crowd with her colleagues William Ronald, Graham Coughtry, Gerald Gladstone, and more emphatically, Michael, all of whom were having exhibitions, receiving favourable reviews, and selling their work. She must have concluded that her best reinvention existed in film.

In effect, she put her visual-arts career on hold by failing to address a major career imperative: that a dealer holds the equation to public recognition.

Just like those who say there is no bad whisky, even a bad dealer is preferable to no dealer — that is, until the artist and his rotgut-whisky existence levitate a notch or two to where the smooth cognac dealers are.

Joseph Duveen, later Lord Duveen, considered to be the most successful art dealer in history, sold — his antagonists prefer *oversold* — the Great Masters to the world's wealthiest and most gullible collectors. Crucial to Duveen's phenomenal success was his manipulating buyers into qualifying for the pleasure of being oversold by him. When a friend informed Duveen that Edsel Ford had begun buying pictures and suggested that he, Duveen, cultivate Ford, the dealer sniffed, "He's not ready for me yet. Let him go on buying. Some day he'll be big enough for me." Betty Parsons, Jackson Pollock's dealer, elevated artists' blood-pressure levels long before their art prices with her attitude: "I never pushed sales very hard. Most dealers love the money. I love the painting." And Douglas Duncan, Toronto's early contemporary-art dealer, in his diabolical clutter called an office where letters went unopened or cheques uncashed for years, could never locate sales records in the boxes and cartons on the floor or papers buried under overflowing ashtrays on his desk. If his artists dared demand an accounting, which few did, so cowed were they in their gratitude for having a dealer, Duncan would "lend" the artist a few dollars until he located said invoices. It is essential to point out, however, that had Joyce managed to land even a poor Manhattan dealer or rate inclusion in a minor group show, a ferocious prey awaited: the New York art critics. It could be that this thought frightened her more than anything else.

Before moving to New York Joyce was aware of the clash of the critical titans Clement Greenberg and Harold Rosenberg that raged throughout the 1950s. Their biases were well established; Greenberg favoured Pollock and Rosenberg was de Kooning's man, and at times hostilities between them achieved a ranking akin to a World Series of art, as passionate as that of the Yankees versus the Dodgers. However, many feel that Rosenberg took the series when Greenberg began making

pronouncements as to who actually rated as an artist and who did not, what in fact was art, and what wasn't. Greenberg's posturing culminated in a visit to de Kooning's studio where he strutted from picture to picture, pontificating, "You can't do this," and, "You can't do that," and went so far as to suggest a new direction for the artist. De Kooning threw him out. One envisages a jubilant Rosenberg camp. At Pollock's untimely death in 1956 de Kooning was crowned king of the abstract expressionists — although this is debated by some — and Greenberg attached himself to the incoming genre, "post-painterly abstraction," a term he coined, also known as colour field painting or minimalism, whose painters Greenberg actively promoted, among them Torontonian Jack Bush. Then came pop art.

This evolution confounded Joyce's situation. The long and the short of it was, her work did not fit the going art fashion. Paradoxically, dealers, critics, and curators prefer adherents of the current art movement, for this saves them a career embarrassment of championing the unknown. By that time, Joyce had shed her abstract expressionist themes, and while traces of pop art are seen in her New York neighbourhood paintings, she never took up minimalism.

Fifteen years later, Joyce was asked when she decided to incorporate pop elements into her work:

> These things were in the air and everybody was tasting them: the ideas of Pop objects or comic strips or whatever. I took that and flavoured it in my own way, because I couldn't do it their way. Basically, the whole movement was male and the 1960s period was dominated by the male establishment and the big money scene. And also it was a very happy period, the Pop movement. So when I did it, I did it my way, and it was kind of sloppy and grungy and it was the way I received it and the way I put it out.

Joyce, by this account, would not give in to the prevailing style; would

not, as had been suggested, "paint like them" to get a dealer. "But you see, it was a very snotty scene after Pop Art. The way it became the 'golden heaven' to which people aspired. To be with Castelli [major contemporary art dealer Leo Castelli] was everything. . . . There was no way I could do things the way they were doing them. It didn't appeal to me. I knew it was good, and I knew it changed the tide of history for a while." And then, like facing a gas spill and holding a match, she treads gingerly. "But you know, big money changed that history. I mean, the big galleries and the big bucks that went into the product. The importance of buying this particular product by these people allowed for them to be made into history." The interviewer commented, "Mythologized, almost," and that was when Joyce flung the lighted match on the gasoline:

> They are the history! Like Pop Art. And there are the leaders of that history, and then the Minimalist period, and so on. There was a lot of other works going on, but those big movements were it. They were the leading edge, and that was sent to Europe, and that brought in billions of dollars. When it was written down, that was the history, the official history. . . . When you have a main line with all that money behind it — huge amounts of money from corporations and individuals buying this stuff — that legitimizes it. What else is it but the history in terms of New York? But there's always so much else going on. I argue and I really am embittered about that kind of history.

Living in the East Village didn't cost much, but nonetheless Michael paid most of their expenses. Without his financial support Joyce might not have remained in New York; likely she would never have moved there in the first place. By the time she had entered her thirties, when in New York, Joyce's energy and her ambition, strengthened in defiance of her fearful past, would see her through, Michael or no Michael.

As for not having a dealer, Joyce was hurt but not felled. If those snooty New York dealers didn't want her, Joyce the consummate improviser would gather her courage around her and *snap!* devise another way, another idea, or make a joke, as she did when plans abruptly changed, be it brushwork, a wrong turn on a country road, not enough jam for toast. Supported by her belief in the psychic value of change, Joyce detoured. She said, "I chose excitement without monetary reward."

Her choice was filmmaking. In this field, she would be acclaimed beyond her most lusted-for imaginings.

Les Levine arrived in New York two years after Joyce and Michael. Robert Cowan introduced them to Les, aware that they had not known one another personally in Toronto, chiefly because Les did not hang out with artists. Working in video sculpture and video installations — a medium defined as the fusion of art and technology — Les was not then and is not now your stereotypical artist. "I don't live like an artist. I don't look like an artist. And I don't act like one," he is quoted as saying. Nor does he consider himself an artist in the traditional sense. "I'm a thinker. I have this feeling for gadgets that work well. I guess I have a naïve inventiveness, if you like."

Neither Joyce nor Michael created much of a ripple on the New York art scene during their first two years, whereas the reverse was true of Les. He fast made waves. "My work never sold in Toronto. It sells here constantly," he said, where Americans embrace the kind of mould-breaking, mind-bending individuality that scares Canadians off. Hot writers and critics of the day — Jill Johnston, Grace Glueck, John Perreault, Jack Burnham, Richard Schickel — took notice of him and reviewed his work in the *New York Times*, the *Village Voice*, and international art journals.

In Ken Jacobs's opinion, Michael was jealous of Les. "Michael was always looking over his shoulder to see what Les was doing." In 1967, after thirty-one shows in Canada and the United States, Les had a solo exhibition at the Museum of Modern Art, the jewel in the crown for any contemporary artist. Michael, however, had started making *Wavelength*, a

film that would garner him international acclaim, as it does to this day.

Despite Michael's feelings about Les, Joyce and Les enjoyed a warm relationship. "I really liked Joyce," Les stated quietly, sincerely.

Discussing Joyce with Les in his New York loft — *chic* New York loft — he wears his cool intelligence as impressively as his black linen blazer and tie, and aubergine silk shirt. He speaks of Joyce's sensitivity to and appreciation of his distinctness, his thinness, his mind, his self-containment. "She was very aware of the idea that artists are not like the rest of society. We're artists and there's the rest of *them*. Most people thought I was one of them, because I was so ordinary. But nevertheless I was doing all these things that were not that ordinary. She would say, 'He's one of us, leave him alone, let him be what he wants to be.'"

Les thought Joyce "intrinsically a very kind person. When we used to go out at night, and we often did go out at night, the three of us, there would be bums on the street lying there and Joyce would take money out of her purse and just slip it beside them, without saying anything." He liked her for her "humanistic concerns, and of course, she was a romantic, too."

By way of example, Les states, "If you imagine what an artist is and you come up with the idea that an artist is a guy who cuts his ear off, or an artist is a guy who throws paint around and drinks himself to death, then you walk around Toronto being half drunk all the time and representing yourself in the manner you think is the manner. Joyce didn't do that. She was a more down-to-earth person. Or she probably would have said something like, 'Oh, poor van Gogh, he cut his ear off because he loved this woman.' Or, 'It's terrible what society did to him.'" He can't resist a chuckle. "She would blame somebody."

In about the middle of 1963 Joyce completed her paintings of the neighbourhood and all its satiric traces in the charge toward the most imposing, enigmatic and, for some, most heart-stopping works of her career. It's quite as though she had to prep herself by poking a little fun at the city, have that done with, and then go for the jugular.

Joyce called this her *Disaster* period.

The subject matter that formed this body of work originated from her wanderings around Fulton's Fish Market and the docks, the sailboats and tugs on the East and North rivers, and locations where she shot footage of the waves, gulls, and bits of marine life that so intrigued her in the "city built on water." These visuals acted as a subtext to her theme, while the subject matter originated out of the South Street Seaport Museum in its scrimshaw, ship's models, seafaring instruments, and memorabilia, and, of devastating fascination to Joyce, the museum's paintings, drawings, and photographs of disasters at sea — boats sinking in gale-whipped storms, fires onboard, sailors going down.

The museum holdings made a direct strike on Joyce's central emotional system. Images of lives lost at sea paralleled her personal losses — the tragedies of her early life that haunted her still. Curator Sandra Paikowsky discussed with Joyce her personal disasters and reported that "her preoccupation with disaster was first based on personal paranoia and the difficulty of dealing with notions of death and loss."

That Joyce had difficulty dealing with death and loss woefully understates her case. In her early thirties when she began her *Disaster* series, she had made very little progress with healing her past, having instead done a fairly good job of warehousing deep inside her the accumulated misfortunes of her life, which over the years had hardened into a gnarly root of sorrow her heart kept tripping over. One wonders if she made a conscious decision to take a butt-head charge at someone else's disasters — in this case, the seamen's — in hopes of ameliorating her own. Unable to beat the devil out of her impoverished preschool years, the death of her parents and the unabating fear of abandonment she had lived with since age nine, she may have thought that a slam-bang confrontation was worth a try. Also a possibility was that she began seeing a psychiatrist in New York in 1964 and may have been encouraged to take this action in her work.

Just as Joyce did not make a public display of her personal disasters, the disasters she painted in this series are thinly obscured by a sense of

calm, like the veil clouding a widow's eyes. A sense of helplessness over forces larger than a human life resonates through these works, leaving an unnerving, frightful impact.

For her subject matter she paints boats sinking and airplanes crashing, plunging to earth on fire, near misses in mid-air. At first, the viewer's attention is concentrated on technique. Some works of boats and planes appear on the canvas in vertical frames like film strips — a device taken from her work in animation and filmmaking. In others, a boat might sail along in a grid of horizontal frames, a technique resembling advertising storyboards. Hinting at the film medium in her painting medium invokes a charming crossover, comparable to Oscar Peterson injecting a little Bach into his jazz or Yo-Yo Ma thrumming a Duke Ellington riff into his Bach, and through the frame-by-frame technique Joyce plots her boat or plane's sequential journey, ending in its demise. The viewer follows the slowness, the calmness of the movements, then gasps at the disaster behind the prettiness — and Joyce achieves her desired shock value, a process that may also have resulted from her therapist's positive reinforcement.

Sailboat Sinking, for example, is rendered in a grid of sixteen frames. A sailboat in the first, top square appears at full sail, picture-perfect against varying colours of blue sea and sky and puffy white clouds. The next frame has no boat. The square is solid blue, the paint laid on thickly and roughly in this ominous square. *What happened to the boat?* The sailboat then reappears frame by frame, except for one frame with a painted circle representing a camera lens focused on a corner of the sail, and in the remaining frames the boat gradually sinks. Grimly, you sense the ship's motion across the water in a delicate, almost-pleasant slide into the sea — contrary to the customary vision of howling gales tearing a ship apart.

Overtly cinematic is the ocean-liner painting titled *Boat (Homage to D. W. Griffith)*, and filmmaking techniques are startling in *Tragedy in the Air or Plane Crash*. A side panel is one beautiful, richly painted blue sky. The remaining canvas is composed of a sixteen-frame sequence, where in eight frames a plane flies among blue skies and softly delineated clouds,

and in another eight frames the plane has caught fire and nose-dives to earth. One is reminded of the earlier questionnaire, in which she responded that her "greatest unfounded fear" was that a plane might fall "on our neighbourhood."

Joyce singled out *Double Crash*, a painting in two panels, the top panel of a plane about to crash land to earth, and in the lower panel a plane on fire is heading into the sea, but the two planes could also be on a collision course, a situation Joyce relates to her earliest personal disasters.. She told curator Joan Murray, director of the Robert McLaughlin Gallery, Oshawa, "Being orphaned at the age of nine was like a double crash. One [parent] one year and one the next, so I think that that kind of thing, where something is very sudden and disastrous, became part of my psyche."

On another occasion, Joyce said the paintings are "about death and loss and coming back. They drown and then they come back. So it's like being orphaned every day. When I was orphaned I was very young, and I always played magic games about finding my parents again." She called the paintings "very playful, but also very serious."

These paintings were exhibited in 1963 at the Isaacs Gallery, the fourth of Joyce's solo shows. Art critic Elizabeth Kilbourn noted that there was "plenty of material from the comics and film strips, and her colors are deliberately raucous, like the blare of advertising." Kilbourn picked up precisely Joyce's sentiment, and continues: "What gives the show its glorious originality is the use of her own very personal images, hearts, flowers, sinking ships, and (because this is a family newspaper[5]), parts of the human anatomy." Kilbourn also wrote that plenty of artists have painted clowns but, "What makes Miss Wieland unique is that she paints as a clown," with each picture seeming "more wildly hilarious, more zany and shocking than the one before, when suddenly there comes the old Pagliacci bit, the wrench at the heartstrings."

She concluded with a line that Joyce, to use her phrase, was surely "blown away" by: "Miss Wieland has found some very personal and original answers to the good old problems of time, space and the picture frame."

Again, "parts of the body" are noted in another review, accompanied by the thought that "one simply doesn't expect to see [them] singled out and painted in such aroused form all over the canvas." Stating that the "redeeming grace" is Joyce's "odd sense of humour" concerning the airplane and boat crashes, the writer then adds that it is a "strange and sick humour but, unlike her preoccupation with the phallus, bearable."

The only response Joyce could have had to this is a big belly laugh.

In *Canadian Art*, however, the show generated a negative review of the worst kind, one that maligned both the work and the artist. Referring to "falling airplanes," the reviewer thinks "she paints a little *less* [the writer's emphasis] well than the average 12-year-old." The works are also called "biographical and didactic, properties common to pop art, and only rarely dramatic, as in *Sinking Liner* or *Sailing on the Bay*, or touched with a real sympathy of perception as in *New Yak City*." Seemingly appreciative of the latter work, the reviewer provides no elaboration.

Some years later, in an overarching interview of Joyce's career, writer Barbara K. Stevenson asked Joyce if she followed what people wrote about her work. Joyce replied that she usually read what was in the papers, and this led to a comment about ambivalent writers: "I don't have to name them, but male ambivalence drives me crazy. They like you in one paragraph, and kick you in the ass in the next."

Not one to soft-pedal herself or her work, Joyce seemed anxious on one documented occasion to cushion the blow of her *Disaster* theme. During a 1965 interview she purposely emphasized her upbeat persona as though to dispel any notion of a pitiable melancholic at the easel: "You know, I'm a happy person . . . but at the same time I'm fascinated by disasters. Here one minute and gone the next. I save pictures of disasters. When they find bodies from a plane crash, they stuff them in white pillow cases." She had made a point of learning this.

Singling out white pillowcases is the kind of telling detail that fascinated Joyce. Actually, it reveals more about Joyce's perception of disaster than disaster itself and helps substantiate the proposition that she concep-

tualized disaster within an emotional/intellectual framework; this allowed her to preserve her personal disaster as the real thing, as opposed to disasters of ships sinking into the sea. Similarly, Joyce could relate intellectually and aesthetically to movie spectacles of bloody swordplay, crashes, and chases; by detaching herself emotionally, she was able to remain enchanted with dramatized disasters. This also applied to art. She compared the energy of a de Kooning painting, for example, with the energy that radiates from events such as "great battles, or death on a winter highway." In her *Disaster* pictures, the material at the South Street Seaport Museum was solidified by New Yorkers and the city, in the grimness enshrouding them — the polluted air, noise, trash, and dirty streets. She was especially impressed by "the American fascination with disasters and grotesque happenings" that appeared daily in the tabloids and on television. She identified "part of the power" of New York with its "tradition of sensationalism and vulgarity" — so compelling that "you assimilate it in your work." As she had done in her neighbourhood paintings.

Curator Sandra Paikowsky, writing in the catalogue of a 1985 exhibition covering a decade of Joyce's painting from 1956 to 1966, must have posited to Joyce a sexual context underlying the sinking boats, for she quotes Joyce as saying that the disasters are "devoid of sexual connotations." The curator then proceeds with her sexual assumption, writing that the ships "have a phallic suggestiveness and perhaps the theme of sinking is actually a clandestine reference to male detumescence. . . . Perhaps, the disasters are sardonic references to the power struggle between men and women."

Of a ten-year retrospective exhibition of Joyce's at the Vancouver Art Gallery in 1968 — the first of her three retrospectives — Marguerite Pinney writes in *artscanada* that four canvases from the *Disaster* period are "the finest works on view." In *Tragedy in the Air or Plane Crash*, "the sexual analogy is apparent" and the writer concludes that the paintings are "comments on the rise of sado-masochistic elements in our society; our casual acceptance of pain, misery, death." Joyce called this "a surface

orientation . . . lacking in depth — lacking in love."

Disparate viewpoints of the same images represent a critical/curatorial aberration that beset Joyce like a terrier that wouldn't let go of her leg. Of course, she is not alone in this regard. A point worth remembering is that Joyce stayed the course she had set ten years before of attracting attention to herself. Her *Disaster* paintings were highly respected by some — art historian Kenneth Green thought them the best works of Joyce's career — and not others. Yet again, Joyce triumphed in attracting personal attention by producing works that generated public discussion.

Heretofore a private matter, Joyce began talking about her marital problems sometime in the early 1960s, possibly around the first time she sought counselling, in 1964. She was becoming increasingly distraught over Michael's womanizing and her acquiescence to it. Though Betty remembers Joyce confiding in her and crying, she can't recall details or incidents beyond Joyce being hurt. Sara Bowser, Linda Gaylard, and Hanni Sager all spoke of Joyce's despair, but they hadn't learned Joyce's account of it until years later. Joyce, however, confided in Les Levine. "From time to time she did talk to me about problems she was having with Mike, that he was seeing other women," he says. "And she was very upset by that. At a certain point, she came to grips with it, as an idea — that she was going to accept the fact that he was going to 'play around.'" (He laughs awkwardly, self-consciously, calling the phrase "old-fashioned," but is unable to provide a substitute.)

Ken Jacobs believes that "Mike's philandering, though it made Joyce unhappy, did not endanger the marriage. One can manage. If it could be accepted and lived with, it was a way of proceeding. You knew what you had a marriage for and you also understood the level to which you could become entwined with other people. Mike had a long sexual practice and could move from person to person with less stickiness than there was for me." Ken had previously alluded to past affairs — in the presence of his wife.

One can manage, yes. Joyce did. She loved Michael, liked being married, liked cooking for him and pleasing him. And they had art. The two of them lived in their films and artwork together and collaborated as only two creative souls in the same discipline can, where a constant exchange of ideas occurs day after day — sympathetically, automatically, from their dual originality and individual creative spirits. They were an art partnership. And if Joyce was tormented over Michael's womanizing, she did what most women in a similar situation do: she rationalized, justified, had crying jags, and she *managed* — expecting, praying that he would, one day, stop.

Les and Ken were right about Joyce's acceptance of Michael's women, at that time; but shortly, both would be proven dead wrong. Les, however, had accurately intuited that Joyce "was taking on a very feminist, strong-woman position."

When confronted some thirty-five years later about his womanizing behaviour, Michael responded with a smiling, "Why isn't it called man-izing?" and quickly moved on to explain that in 1964 he and Joyce were both seeing a psychiatrist whom Michael defined as "a shrink to the artists." They went, he said, "to try to cure ourselves." In another conversation he referred back to the word *womanize*, saying that "it sounds like shredding a woman," and this was not his behaviour. He also offered the reminder, "That was the 1960s."

Joyce's political sensibilities, reasonably well established before her 1962 arrival in New York, gained momentum once she was more or less exiled there. It was as though her Canadian roots had sunk symbolically deeper into her own land the moment she settled on American soil. There is no way of knowing if the heat of her concerns was fanned by being a New York bystander, or if her activism would have inflamed naturally, but proximity surely counted. Having been to New York several times before moving there and experiencing small doses of American "flag-waving," as a resident, Joyce encountered American nationalist fervour in the

extreme. Talking to Americans and hearing about their inflated can-do achievements, their consummate braggadocio, their hero worship, and just "the way they swagger," were some of Joyce's everyday observations of a country proud of its parochialism.

Spending those early, tumultuous 1960s in the United States — it can be said that America *was* the 1960s — Joyce experienced the decade's major phenomena. The nation was wildly enamoured of its Prince Charming, President John F. Kennedy, a lovefest scarred only slightly by "Cuber" and subsequently deified on that fateful 1963 Dallas day. Joyce cried with Americans as she filmed the Kennedy funeral on television. She was there for the hysteria of the Beatles arriving in New York — "Bigger than Jesus" — Martin Luther King's mobilization of black America, student unrest (America's historic first sit-in occurred at Columbia University in 1961, a few blocks from where Joyce and Michael lived), Vietnam War protests, acid rain and acid dropping, pot smoking — the mileposts of an America careening toward violence at the Democratic National Convention in Chicago, at Kent State University in Ohio, and in Watts, California. Then came rapture in 1969 when American Neil Armstrong became the first human to set foot on the moon.

Joyce would make art out of much of this. Meanwhile, it is difficult to single out that which distressed Joyce most, given that her concerns ranged the full political, environmental, economic, and cultural land-scape. Clearly, she felt great torment over the American exploitation of our minds through television, and likely with matching zeal, a burgeon-ing American takeover of our resources.

Canadian culture in the 1960s and 1970s was construed to be the Canadian Broadcasting Company, the National Film Board, the Maple Leafs and Montreal Canadiens, the Group of Seven, Eskimo carvings, and Anne Murray, with a highbrow nod to Glenn Gould and the Stratford Festival. We held these icons dear to our patriotic hearts while regularly consuming American brain candy — Archie Bunker, Mary Tyler Moore, Monday-night football, and, for serious enlightenment, Phil Donahue

and *60 Minutes.* To observers of America's encroachment into Canada, the tidal wave of American culture sweeping the land was obvious, but those same watchdogs were less cognizant of the changing character of the country's natural resources, geographically hidden as they were up north. It is worth remembering that in the 1970s, environmental activists, those wild-eyed tree huggers wearing Birkenstocks, their pockets full of raisins, lacked sympathy apart from like-minded souls; but this did not deter Joyce. She was deeply concerned with environmentalists' public commitment, and she signed on. A cause that would remain closely connected to Joyce's outrage centre was the ecological damage done to northern Canada by American pulp-and-paper and mining companies. "It's the last natural land like that that we have left and I don't want to see it destroyed," she said. In her opinion, a plot to take over Canadian water resources was not far-fetched, prompting her to say that the Americans "would even like to melt the Arctic."

Subtle political content in her work, like quiet diplomacy, no longer suited Joyce.

And so there she was, politically stirred, her feminism snowballing, and her work at a crossroads. She had sold only three paintings in her last exhibition, in 1963, and nothing during the previous two years; reviews were uneven, and she received little recognition for her films beyond warm peer approval. How gravely she assessed her situation cannot be determined, but she took the only valid artistic step: She kept working, she kept personal.

The result was that, in the middle of 1964, a new, bold acerbity entered her films and paintings, and generated a new medium for her: assemblages. In them, she expanded upon her sea and air disasters to incorporate more powerfully her feminist and ecological visions.

As a medium, assemblages — three-dimensional constructions — gained acceptance in the early 1960s through two major New York exhibitions. The first, *The Art of Assemblage,* mounted in late 1961 by the Museum of Modern Art, authenticated and formalized the official name

of this art form, even though it had been around since Picasso's still-life constructions, Kurt Schwitters's junk sculptures and collages, the dadaists and surrealists of the 1940s, and later, with Marcel Duchamp and Louise Nevelson. Organized by art historian William C. Seitz, the show contained a number of two-dimensional objects, from cubist *papier collés* and photographic montages, to dadaist and surrealist objects, junk sculpture, and complete room environments. Seitz described assemblages as "predominantly *assembled* rather than painted, drawn, modelled, or carved," adding, "Entirely or in part, their constituent elements are pre-formed natural or manufactured materials, objects, or fragments not intended as art materials."

A second assemblage exhibition was also held in 1962, at a commercial gallery, the Sidney Janis Gallery, that included assemblages by Marcel Duchamp and Louise Nevelson. Assemblages then entered museology.

In 1960 Nevelson exhibited whole wooden walls on which she attached numerous individual boxes and filled them with painstaking arrangements of dozens, and in some installations, hundreds of found objects — furniture sawed up into fragments, pieces of mouldings and trims from old houses — an entire work might be painted one solid colour, black, or gold. She later created wall assemblages in materials such as clear Lucite and aluminium.

Joyce's art materials for this new medium lay literally at her doorstep.

Trash, the assemblagist's principal material, littered the street outside Joyce's loft. Every morning the sidewalk was piled high with the previous day's discards from the shops — wooden crates and boxes, plastic flowers, light bulbs, broken toys, dishes, packing materials, and so on. Joyce and Michael, like most artists in the Village, had furnished much of their loft from trash. Pieces of life's detritus already a part of their everyday life, one day Joyce scooped up a few items outside her loft, a few more the next, and she got to work on her assemblages.

She talked about scavenging materials off the street: "I need them for my work. I just take them. I don't ask permission. Of course it's daylight

and people see me." And finding it necessary to soften that hard borderline between propriety and necessity, she did admit, "I feel like quite a dope."

Farther afield, near the docks, Joyce found a wooden box with the words "Cooling Room" stencilled on it, and she grabbed it. How she must have pondered the meaning of the words, until she surmised that they designated the chill room of a ship. From this box, its stencilled lettering and the limitless uses it conjured up, she produced her first mixed-media construction in 1964.

Joyce capably used hammer, saw, and power drill, and using the wooden box she found, she built four small wooden boxes for her first assemblage, which she appropriately titled *Cooling Room I*. The basic structure resembles a small wall unit, on whose "shelves" Joyce placed her disasters. Each of four compartments at the top of the work contains an identical plastic tugboat, each differently positioned on a sea of soft, painted plastic. The middle compartment contains a toy airplane crashed and crumpled, and in the lower compartment a hinged door partly obscures objects inside — a plastic chocolate ice cream cone, a pie plate, and some red tubing in the shape of one of Joyce's favourite symbols, a heart.

Much of Joyce's work contains the history of her life that she identifies as, "Pieces of underwear, old dresses, newspapers, I encase them in cotton. Then I paint them." In her construction boxes she placed toys, colourful dime-store doodads, plastic flowers and plants, buttons, photographs, lace doilies, china figurines, dollhouse furniture, and countless objects the street surrendered to her. As far back as 1961 in her wall hanging, *Heart On*, she tucked written notes inside folds of the fabric. "It's good because no one has to know it," she said. "It just might come up some day that these things exist. It's good to have mystery because people want to explain *everything*."

Cooling Room II, also done in 1964, is more emblematic of Joyce's personal iconography — hearts, underwear, penises — and "hidden treasures." In the compartments are: a toy airplane with bent wings, as though it has just crashed; wires with red clothespins pinned to a red

heart hung out to dry, recognizable by its shape as a red satin bra, and stuffed with Joyce's secrets; an ocean liner painted the same scarlet as the heart, the top of a smokestack shaped like the tip of a penis; four lipstick-stained coffee cups are lined up in the lower compartment, and one compartment is bare.

Using boxes for her pigeonholed personal objects, Joyce's assemblages can be said to compare with the boxes and collages of American Joseph Cornell. Not well-known despite his work being exhibited since the early 1930s, this reclusive, cultured, well-read artist is nonetheless revered by a select, devout following. There is every reason to believe that Cornell's collages influenced Joyce, as would have the man himself. Duchamp and Nevelson possess an effete, surreal sophistication that Joyce admired without wholeheartedly liking, whereas she would have established an immediate bond with Cornell, whose numerous wooden-box assemblages were filled with old toys, dolls, photographs, maps, apothecary jars, twigs — authentically representing his dreams and reveries, notions of home, family, childhood, and fragmentary affinities to literature and art. These intensely personal things, the ephemera of an individual's life, Joyce understood.

In interviews Joyce makes no mention of Cornell and there are no references to him in her journals, that can be found. (Cornell himself was a prodigious journal keeper.) However, this omission does not negate the man's probable influence. Joyce's assemblages suggest that she knew Cornell's work, and moreover, she would have loved him and his collages dearly.

The *Disaster* theme of her assemblages — the toy planes and boats that repose in the box statically damaged — first catches the viewer off guard, then evolves into highly personal and feminist themes. At first glance, one is smitten by the tenderness of sweet women's faces, dolls, flowers, doilies, hearts; and then their message strikes as powerfully and authoritatively as an axe whacking through an icy, wintry log.

Young Woman's Blues, 1964, depicts a silver toy airplane mounted on

top of the box, projecting sleek and phallic-like, and in the lower section a woman's face is painted inside a wooden cut-out of a heart. This has been interpreted as the phallus/airplane, having penetrated the woman in the heart/vagina shape, departing into the open skies. Another interpretation is that the phallic airplane is searching above, not finding the woman below, who is hiding in her heart.

Joyce used to walk through the Hispanic neighbourhood on her way to visit the Haineses, and noticed spiritual symbols affixed to houses, one of them a small shrine in a church-supplies store. A conglomeration of these images appears in *Sanctu Spiritus*, a box built like a cupboard, complete with a door and two shelves on which are objects relating to a traditional young woman's life — framed bridal photographs, plants, a ceramic cat, a toy bed, lace doilies — illuminated by a light bulb overhead. These objects are seen as potent feminist symbols of a woman's entrapment in her shrine — the home — complete with a door that could be closed on her — by the husband who "worships" her.

Dad's Dead, haunts. The structural form of boxes and shelves has a number of painted stuffed-cloth objects inside compartments or placed on shelves: hearts, rectangular pouches, a large round ball, and dangling from the top shelf is the most dominant, a softly stuffed shape that suggests a limp phallus. Joyce is vague when she speaks of this work. "There's a baby's dress, although some people think it's a man's shirt. That's for lost childhood, a real regret that it's gone. I put some shapes in a cupboard . . . I don't know what they are. It was a case of a cupboard needing something in it."

The baby's dress is not visible. Joyce may have inserted it into the work when it was exhibited later, in 1965, at a group show at the Isaacs Gallery. She did that sort of thing.

Without guidelines from the artist we are free to interpret the work's enigmatic sexual connotation in a number of ways, the most obvious being her father's final impotence, as in dead. Joyce may also be representing her father's psychic impotence as well as her perception of his

sexual impotence. Although the topic of parental genitals is one of a child's lesser puzzles, we do know that Joyce's father's and mother's genitals were under discussion with a New York psychiatrist mentioned earlier. In a transcript of one session, Joyce said: "I am touching my father's genitals and they are really warm and hot at the bottom. I love touching his penis and I love putting both of my hands on his penis and his cock. I touch my mother's vagina and that really feels good too, because I like the hair and I like the smell, and I like my father's smell too. I sniff them. His seem really hot, hers cooler. He likes to watch me do it. I think she . . . I don't know whether she liked it or not, but she let me satisfy my curiosity. I feel good. I love it."

If there is a secret, it is entirely Joyce's.

Although her assemblages elicit a range of emotions and are artistically daring and personal, they exist on more than an aesthetic level. In Joyce's hands, they glorify small fragments of human life, the shabby and tawdry, the treasured and lovely, to form a highly individualistic, provocative montage, in which something of the meaning of life can be viewed in the eye of every beholder.

In Toronto, David Mirvish, son of the unstoppable theatrical manager/impresario and retailer "Honest Ed" Mirvish, opened an art gallery in 1963 called the Mirvish Gallery. At age twenty-two then, "the kid," as established art dealers not surprisingly called him, looked more like a well-tailored Bay Streeter than a tweedy art dealer.

Young David Mirvish shook the Canadian art scene by showing the first group of the New York and international post-painterly and minimalist artists — Americans Morris Louis, Kenneth Noland, Jules Olitski, Frank Stella, Victor Vasarely, and Andy Warhol, and British sculptor Anthony Caro. Jack Bush was the only Canadian in Mirvish's initial stable of about a dozen artists.

At prices of $5,000 and upward, he sold almost nothing for the first three years. Mirvish, however, could afford to wait. With his father's back-

ing he purchased artists' work, which gave him an advantage over dealers who traditionally carry art on consignment, and by the end of the 1960s the Mirvish Gallery had the market of New York contemporary artists all to itself. The result proved transformational. Introducing these New York artists to Toronto created an upheaval in the Canadian art market, according to collector Dr. Sidney Wax, who was among the first collectors to buy Graham Coughtry, William Ronald, and Harold Town — Coughtry and Ronald represented by the Isaacs Gallery and Town by the Mazelow Gallery. Dealer Arnold Mazelow considered that the appearance of American art turned major buyers away from Canadian contemporary art that didn't have New York approval, that is, minimalist, also known as post-painterly abstraction — art "approved" by the prime mover of this genre, critic Clement Greenberg.

Some art commentators, among them Robert Fulford, felt that Canadian collectors had made their purchases of Canadian abstract expressionists in its first flush, the late 1950s, and did not collect the artists' follow-up periods. Whether they collected initially because they liked the work or were buying the latest art fashion is difficult to know. However, if Canadian artists did not evolve into the "New York-approved" art of the late 1960s and early 1970s — and many did not — collectors began buying the Americans at the Mirvish Gallery. Though few in number — David Mirvish estimated that only eight or ten of his buyers would spend $5,000 on a single picture then — their purchasing clout was significant.

Since arriving in New York and until the end of 1964, Joyce had produced three films, *Larry's Recent Behaviour*, *Patriotism*, and *Patriotism Part II*. And hewing to her normal routine of working on several projects at once, while wrapping up the two *Patriotisms* she began making *Water Sark*. Actually, it could be said that *Water Sark* was her first film. The early spoofs made in Toronto didn't count as serious works, nor could she claim them as solo productions, and *Larry* and the two *Patriotism* films had had

very little exposure in the year or two after they were made, whereas *Water Sark* garnered immediate acclaim when it was released in 1965 and identified Joyce as an upcoming filmmaker. She always said that this was her most personal film. It has also been called "great feminist filmmaking."

During the time Joyce was making *Water Sark*, feminist intimations begin to appear forcefully throughout her work. Like fresh hikers' footsteps on a mossy path in the woods, their shapes leave a distinct impression; but if you look closely you can see, scattered along the same path, earlier traces, earlier footsteps. Until this time, feminist markers were evident only in Joyce's drawings and paintings. The earliest glimmerings showed up in her *Lovers* drawings of 1959, and shortly thereafter they assumed a strikingly bold presence in the penis and womb images of her "sex poetry" works. Men's body parts appeared in certain New York neighbourhood paintings that one curator refers to as a "sly association" between "phallic and sociopolitical power" that Joyce was encountering in New York, which is to say, the old boys' art network. She protested by ignoring the art Establishment when she stated, "The whole thing . . . made me very strong because I left it behind." And this strength hits with its most authoritative force in her assemblages. After working on them for about a year, and having made the conscious and probably angry decision to leave art behind, she unloaded her feminist self in *Water Sark*.

The film is important for its dual purpose of giving depth to Joyce's sexual and domestic views, and expressing a new filmmaking aesthetic. In fact, she had been listing into a changing direction in her filmmaking when both the visual arts and film were in transition. Abstract expressionism was giving way to pop art, jazz was thrown into a twelve-tone tailspin by John Cage and Philip Glass, the dance of Alvin Ailey broke all classical ballet rules, and Allen Ginsberg's *Howl* was muted by the blistering rages of Norman Mailer, Gore Vidal, and James Baldwin — transitions that provoked rethinking, relistening and a reorganization of contemporary thought. The tectonic shift that occurred in avant-garde filmmaking at that time was attributable to two words: Andy Warhol.

Iris Nowell

When Warhol crash-landed into Manhattan's art world in the early 1960s on his Campbell's Soup cans and Coca-Cola bottles, the public had not yet recovered from its befuddlement before this eccentric, kinky colossus of pop art achieved even greater celebrity — accompanied by jeering condemnation, it must be remembered — when he began making films. He shot full rolls of film that concentrated on one subject, and in 1963 released four of them: *Sleep, Kiss, Haircut,* and *Blow Job.* And in 1964 he made *Empire,* a film that generated howling derision in the town it showcased from atop its tallest edifice, the Empire State Building. Who could "understand" a film in which the camera remains stationary for an eight-hour viewing of an entire night and early morning's activities on the street below? Certainly not the millions sitting at home, eyes glued to *The Man from U.N.C.L.E.* Warhol left his fellow underground filmmakers reeling (no pun intended). However, whether Warhol was ridiculed, admired or discounted, his film techniques spawned a new film style that P. Adams Sitney coined "structural film," as contrasted with the previous "unstructured" genre.

Essentially, this new style forced viewers to see images subconsciously. Defining film, a process as jargon-crazed as any found in the world of art, film historian Scott MacDonald described the filmmaker's intent in this genre to be to "exploit black and white and colour flicker as a means of addressing viewers' retinas and the physiological and psychological mechanisms which transform visual stimulation into consciousness." MacDonald calls these films "direct assaults on conventionalized vision."

It has also been called a cinema of "awkward excess."

The genre was finally accepted as "new visionary cinema" and those in it were "structuralists" or "visionary filmmakers." Joyce's films were commonly positioned with the structuralists but like her art, critics were at a loss to pigeonhole her. Certain academicians share the opinion that Joyce's films are unique, largely because they neither deal in pure abstraction nor conform to mainstream traditions.

R. Bruce Elder, critic, teacher in the School of Image Arts at Ryerson Polytechnic University in Toronto, also a filmmaker, and like Joyce and

Michael a major figure in Canada's avant-garde cinema, believes that identifying Joyce with the structuralists is a misconception. "Her film practice has many virtues, but working with preconceived forms that are at once simple in their overall shape but rich both in local variety and in philosophical implications is not among them." In his view, those of her films that "move farthest away from the structural film are her most interesting, and, conversely, that as her forms approach most nearly the paradigm of the structural film, they tend to falter."

Commentators share the dual description of Joyce as a filmmaker who explores herself in her films from a lookout point of her feminist/political views. T. Lianne McLarty, associate dean of Fine Arts and director of the Film Studies Program at the University of Victoria, British Columbia, addresses both points when she writes that Joyce "makes the viewer aware of the filmmaking process in order to sharpen perception for a greater end. Wieland's work is indeed about film, but also considers concrete political issues. It is not a cinema only for itself; it is rather a cinema that is aware of the society that gave it birth."

P. Adams Sitney writes in an article, "There is Only One Joyce," in 1970, that "formerly [referring to films up to *Water Sark*] her films owe allegiance to the Structuralists, yet what is happening on the screen, moment by moment, is quite different." He singles out aspects of Joyce's films that relate to other filmmakers, notably Marie Menken, but adds that Joyce "has a filmic *style* [author's emphasis] that is her signature, quite apart from the differing genres of filmmaking she employs."

Joyce never knew she'd been a part of a movement until she left it. This conforms perfectly to her nature of not adopting the current art fashion. Although she admits to being influenced by certain artist filmmakers — Marie Menken, Leni Riefenstahl, and Shirley Clarke — her feminist and political imprimatur is distinctly her own. Consciously or not, working and living in the epicenter of trends had to have had some influence on her work, just as a sailor is affected by the prevailing winds, whatever the intended destination.

Joyce's motivation for making *Water Sark* was highly personal. By happenstance more than by design the evolving film aesthetic insinuated itself into her film and this *au courant* style, linked to her feminist imperative, accounts for the film's and Joyce's success.

Even before its first screening, *Water Sark* received high praise from Shirley Clarke, a major figure in the world of independent filmmaking, whom Joyce had met at the Filmmakers' Cinematheque. Their friendship developed and Joyce worked with Shirley on one of her best-known films, *The Cool World*, 1963, which takes a gritty, hard look at bored teenagers in Harlem who saw violence as their only way out of the ghetto. *The Cool World* is among Shirley Clarke's three most sensational, talked-about films, one that also created one of the greatest battles in London theatre opening-night history because of its brutality, realism, and four-letter words. (The other two are *The Connection*, concerning addicts waiting for their connection, and *Portrait of Jason*, a film about a black male prostitute, which Ingmar Bergman called "the most fascinating film I've ever seen.")

Shirley Clarke endeared herself to Joyce in this message she sent, after seeing *Water Sark*.

> Bravo camera woMAN! What a beautiful film! An artist's sketch book — a dream — and a lens that is possible to see through the human eye.

Joyce penned a note on this card: "A dream on a tabletop."

Approval from a filmmaker of Shirley Clarke's stature gave Joyce's filmmaking career a worthy boost. "It was a nice send-off," Joyce asserted. "She was so sympathetic and she really was encouraging. I saw her films and I was terribly impressed that she was making features."

Later, Shirley Clarke wrote:

> In the last fifteen years the world cinema has produced a few women filmmakers with important things to say. France has

given us Agnes Varda, the Czechs Vera Chytilova, Latin America Margo Benari, in America Storm de Hirsch, Gunver Nelson, Naomi Levine and myself . . . and now in Canada we have Joyce Wieland whose works are full of warm feminine light. I look forward very much to seeing her film about Canada. [She is referring to *Reason Over Passion*, the film Joyce would begin working on in 1967.]

Water Sark, a 16-mm fourteen-minute colour film, is Joyce's most personal film because "it is just myself as the subject." Surrounded by everyday items placed on what reviewer Lauren Rabinovitz calls the "domestic altar" — a kitchen table — the camera slowly pans over glass tumblers, a blue teapot, flowers, a lamp and ferns, images that appear in dreamy distortions, and then the lens zooms in on a woman's (Joyce's) torso and bare breasts. The soundtrack picks up her voice, running water, waterfalls, a few notes played on a bass. Joyce ends the film by shooting her own image in a mirror with a magnifying glass to exaggerate the shape of her lips, tongue, and eyes, and films herself filming sequences reflecting her self-discovery. Rabinovitz writes that the film "ritualizes self-discovery," by emphasizing "physicality, sensuality, and spirituality," representing another viewpoint of Joyce's "mystical celebration of woman as an introspective subject."

Joyce elaborated on this in another interview:

> I was interested in the idea of the shut-in housewife. In that film, I worked from the premise that a person could not go outside, and had a very restricted area and amount of money. Like the Proustian thing in the room — what can come out of here? This is what I faced as a formal problem for the film. It was domestic art that started on the kitchen table. Even from years ago in my paintings I wanted to touch on subjects that men wouldn't want to be bothered with.

Significantly, her domestic art included her own body as one of its subjects.

Joyce filmed her face out of focus in a soft image that Kay Armatage, filmmaker and professor of cinema at the University of Toronto, described as a "central moment in the film." Like objects on the table, Joyce introduced her body as another item under examination — her naked breasts and shoulders, her face covered in clear plastic wrap — and through a number of cuts she ends the episode with a full shot of the "very warmly tinted flush of her shoulders, hands and breasts." In this, Kay Armatage believes, "the discovery of her own body, the feminine body, has occurred."

Joyce discussed *Water Sark* with filmmaker Hollis Frampton in a 1971 taped conversation six years after she had made the film:

> I wanted to make a self-sufficient film, photographing myself in those mirrors on the table with all that water and prisms, and glasses and cups. In a way I was saying I can do a film that needs no people, no outside world, no glamour, no money, and do it all in the kitchen. In the film I show myself making a film, the same way I make a drawing — just as you see a line revealed by a pencil. It was an extension of my drawings and the feeling of intimacy I had always had with the pencil, I had with the camera, was fluent with my camera.

Hollis remarked that a drawing "is an attempt to see how much you can find out about next to nothing at all, and *Water Sark* . . . is a film that yields cascades of knowledge out of not very much."

Joyce had given thought to the kitchen table's relevance in her work. She regarded the kitchen table as a connector to her innate womanly interests. She seemed awestruck by this commonplace piece of furniture — an inanimate object that transmitted creative power to her as if it were

a trampoline springy with ideas. "*Water Sark* is directly related to all the domestic art which I've been doing. It's connected with art done at the table which I've been doing for twelve years; the table, the kitchen table has been the core of all my art; since I was a child it was at the table I did everything on, made things on, drew things on. I started to make films on just such a table."

Joyce described the first screening of *Water Sark* at the Filmmakers' Cinematheque, saying, "The audience had been yelling [their displeasure] at the last film and then on came *Water Sark*. People about to leave got halfway up the aisle and then went back and sat down."

Critics, too, were similarly compelled. P. Adams Sitney wrote, "Here is the artist improvising freely and joyously with her materials, her camera and herself."

Feminist Lauren Rabinovitz suggested, "Contrary to the vision of a world ruled by the phallus that Wieland depicts elsewhere, here she depicts one corner in which she can operate without such domination." She also noted that the film "ritualizes a woman's cinematic self-discovery" in the way that male filmmakers, such as Stan Brakhage, celebrated male self-identification.

Toronto Star entertainment reporter Peter Goddard, reviewing a retrospective screening of Joyce's films in 1994, singled out *Water Sark* as "certainly one of the gems of *all* Canadian filmmaking." He went on to say, "*Water Sark*'s greatness is that of inspired, intuitive filmmaking, not just great feminist filmmaking."

What was Joyce's opinion of the film? "I liked it because it was a domestic portrait in some way; I felt pleasure in making a film as though I was a shut-in and had to make it on the premises. It had to do with no one but myself. I was recognizing something in myself and my territory, and I honoured it in some way by making it into a film. I loved it. I thought it was a good film."

One very disagreeable incident involving this film occurred in Canada. Joyce took a print of *Water Sark* to the National Film Board,

attempting to gain Canadian distribution, and a few minutes after the screening began, at the sight of the bare breasts, the man to whom Joyce was presenting the film became extremely agitated, demanding, "Are those your breasts?" He kept repeating the question until Joyce shut off the film and left, with him following her down the hall, now yelling, "*Are those your breasts?*" Joyce bounded into the elevator — by this time, crying. (One friend expressed sympathy, saying, "Why didn't you take it to the French section [of the NFB]?")

Joyce had made *Water Sark* on seven separate acid trips.

Sheila McCusker speaks of meeting Joyce after her return from New York and hearing about her drug use. "She told how they would spend three days doing acid and go down the New York streets and the strangest scenes and events from the historical past would come forward and backward in time. I was fascinated with this. I thought, what a breakthrough! She had nothing but good things to say about acid." Sheila's personal experience of the drug culture at that time was nil, but this would change, as her following comments testify. "I can imagine being in New York, wandering the streets for three days on acid in those days when they were getting high-quality stuff." She throws her hands up and her long red fingernails flutter in front of her face as she cries, "*Must have been heaven!*"

Joyce recalled her acid trips with Hollis Frampton in their taped interview. Asked if she thought acid had been important to the film, Joyce replied, "Yes, it was to do very much with acid and light, an old-fashioned thing maybe to young people today."

Hollis pursued the point, asking if acid has "gone on being important."

Again, Joyce said, "Yes," adding, "I think that I wouldn't really have started making the quilts and a lot of plastic pieces without having used those drugs [she refers to acid and pot], although in the last two or three years I haven't been involved with it, but it really was very important."

Asked to be specific, Joyce replied, "I think drugs have very much opened the door to, for me anyway, film. And it has just been a really fantastic thing although I haven't been involved with anything like that

for a long time. They were, ever since the last two or three trips three years ago . . . just about sound and light really."

Hollis returned to the metaphoric door, wondering, "Once they've [drugs] opened the door, who holds the door open, do you?"

Joyce: "It's hard to keep it open."

Hollis: "So that in a way drugs are a way of breaking down some assumptions for you, would you say that? Perhaps you have had assumptions or dead spots in your mind about what things look like?"

Joyce: "Well, the one thing that is real about some drugs is that they can really open your vision, your seeing." (Vision and seeing were distinct, to her.)

The ambiguity and slight incoherence in the foregoing is absent from a later discussion about drugs, a period covering 1967 through to 1969, when Joyce's drug-taking reached its apogee and figured most prominently in her work, particularly in her quiltmaking and in two more films, *Rat Life and Diet in North America* and *Reason Over Passion*.

Picking up her camera and shooting random footage, starting and completing a film, or collaborating with others to make a film, Joyce granted herself the privilege of continuing to go out on a filmic, creative limb.

A rich example occurred when she and Shirley Clarke worked on a film that never got finished. Actually, it didn't really get started.

Shirley had received a commission to make a film documentary on Timothy Leary and Andrei Voznesensky, a poet in the forefront of the Russian poetry renaissance stirring during the early 1960s, and a protegé of Boris Pasternak's. (The commission likely resulted as a consequence of Clarke's sharing an Academy Award as co-director for Best Documentary Feature in 1963 for a film about poet Robert Frost, *A Lover's Quarrel With the World.*) On the first day of the shoot, Joyce and Shirley arrived at the designated location, a wedding at Timothy Leary's home. They waited. And waited. And in the style of New York sportswriters whose coverage of a championship boxing match concerns the hilarious perils en route

that prevent them from ever getting to the fights, Joyce and Shirley spent two-and-a-half days waiting to capture on film the dramatic encounter between Leary and Voznesensky. As Joyce told the story:

> The second day we waited for [Voznesensky] at Timothy Leary's as this was to be a big meeting of the two to be put on film. Andrei never showed, but we worked hard anyway — all three of us shooting fill-in material that might later be useful. [She comments about drawing sketches of the occasion.] I wish I would have done sketches of when we actually filmed Andrei as that was funny too. Particularly the night at the Village Theater when all the major American poets gathered to read and honour Andrei. It was at this gathering that there was so much violence and I was showered with piss and water (all over my new camera, etc.) by an angry messed-up poet.

We know from a later account that the "messed-up poet" is one and the same Voznesensky, who in Joyce's opinion "seemed a bit of a jerk." She never knew what became of the film but Joyce was given the leftover stock and used it to make *1933* two years later.

Joyce told filmmaker Kay Armatage about working with another friend, Mary Mitchell, a Canadian playwright, when they "decided to do a film on Norman Mailer. We have lots of footage of that boring, neurotic existentialist. The best part is a conversation Mary has with Mailer. We got Normie pounding Freedman's head in, in Brooklyn Heights in front of his house — it looks like a typical vignette of U.S. social problems."

While making *Water Sark* in 1965, Joyce had several collaborations on the go. She and Hollis Frampton had started *A & B in Ontario* but didn't finish it — although Joyce would complete the film after Hollis's untimely death in 1984. Joyce started filming *Peggy's Blue Skylight* in 1964 (and finally completed it in 1985). One collaboration, however, was

accomplished and that was with Betty Ferguson when the two of them made *Barbara's Blindness* in 1965, created exclusively from found footage. Basically it's a fairy tale about a little blind girl with long blond ringlets and bandages covering her eyes, whose sight is miraculously restored, and she sees a world she finds very pleasant.

Scenes of little Barbara picking flowers and petting lambs are quick-cut with idiosyncratic images from the found footage: an elephant stampede, rosebuds opening in bloom, a storm at sea, Second World War battle scenes, dancing African warriors, leaves fluttering in the breeze, a motorcycle crash, women wrestlers, a marching Highland pipe band. All the footage carries its original soundtrack, which clangs and bangs and cuts bizarrely into the narrator's storyline. A sort of *Flaming Creatures* without the sex.

Joyce said of the film: "It's very funny."

Betty chuckles, recalling, "We had lots of fun making the film, being silly together. We weren't being profound."

Also in 1965, Joyce worked on a documentary with another friend, Sylvia White. In Joyce's words we see the self-doubts she faced almost every day of her life, but over which she typically triumphed:

> A friend from Toronto, Sylvia White [later Davern], had moved to New York and gotten a job there. The director of her company wanted an all-woman crew to send to this Job Corps Center for girls where half the girls were black. Sylvia asked if I could do the camera. But I was afraid; I didn't feel I could take the responsibility, although I found out later I could have done it.
>
> I wanted to be the second and do all the cutaways. So our friend Jane Bryant became the first camerawoman. She and Sylvia took sound, and I did all the cutaway shots. It turned out that doing cutaways and other background material was more interesting because I did a lot of silent stuff of the girls

typing, girls dancing to the jukebox, the place, and all the tiny little details that made it exciting. The director of photography was doing interviews, just heads and shoulders.

It was very good material and the first woman crew like that ever, I think, except in Japan. We were very proud of what we had done. We made an exact portrayal of all kinds of human things — sadness, loneliness, the humour, the dancing, and all the anger against being taught typing.

Quite a different viewpoint from the folks at Xerox, the client, who had wanted a "study of poor black and white girls at the Job Corps Center brought from rural areas to be 'educated' in typing. . . . The upshot was that when the sponsor saw these young women swearing and talking about their feelings — how could Xerox put that on television? Of course, the whole thing was shelved. " (Joyce was reminded of Toronto filmmaker Ernie Reid, who used all gay men in a Canadian Army recruitment film that, not surprisingly, got axed.) Always a champion of the underdog, Joyce said, "I hardly know whether to laugh or cry about those girls. . . . They were lonely, rebellious, funny, restless, and hopelessly poor. What they were offered in the way of education was humiliating to me, some rooms with typewriters, and a machine that spoke to them as they typed."

However, Joyce was permitted to keep the cutaways. And this would result in *Hand Tinting*, made two years later.

A four-minute silent 16-mm film made with black and white stock, hand tinted, Joyce defines it as "an experience without sound." Vividly the film conveys her empathy with the disadvantaged girls and yet, rather than producing a poor-girl weepie, which might have been irresistible in many other hands, Joyce turns a technical trick on her material.

The girls appear as "displaced creatures" in several situations — at a swimming lesson, sitting at their typewriters, and mostly dancing, which Joyce sees as an expression of "what's happening to themselves through their bodies, their hands, their faces." It's a dance of life that leaves its

smudged images behind. To present this dance, Joyce interrupts the imagery of a joyous present with the girls' unpromising future through innovative, startling techniques. "The sequences are edited rhythmically," she states, "separated by footage of clear leader. The formal distancing of the images is heightened by several sequences of [film] hand-tinted [with] cloth dyes in rose, yellow, blue, or violet."

Kay Armatage explored with Joyce the extent to which form over subject-matter concerned her. Armatage planned showing the film to her class of women and she wanted to know from Joyce in advance how students not necessarily interested in art or film would understand *Hand Tinting*.

Joyce replied, "It could be interesting to them to know that I dyed the film with cloth dyes and punctured it with my sewing needles."

She must have been clutching at feminist straws with that remark; it rankled against her deepening feminism. Yet Joyce nullified the comment with her next statement, a sanguine expression of love, work, and art: "When I first did it, I thought it might not be useful to anyone. It was a poem. There's nothing out of the way in it, it has mystery and rhythm and some repetitive portraits of some beautiful faces. The editing and the girls are the subject of *Hand Tinting*. The editing and the so-called subject matter are equal. You can look at the editing or you can look at the girls. Or just let it happen."

It had been noted earlier that Joyce said filmmakers were more likeable than painters, and she might have added how loose they were and how much fun she had appearing in their films.

Underground filmmakers had no money to pay models or actors — they were often hard-pressed to buy film stock — and their wives, children, and friends played parts, as did their fellow filmmakers. Joyce performed in her first film, as the Lillian Gish-type damsel in *A Salt in the Park*, she filmed her own breasts in *Water Sark*, and she "cast" Dave Shackman asleep with wieners in both *Patriotism* films. She played a nude

scene in the first film Michael made in New York, in 1964, *New York Eye and Ear Control*, and she and Hollis Frampton appeared in Michael's next film, *Snowblind*.

Ken Jacobs used his beautiful wife Flo in his films and Stan Brakhage shot every groaning, moaning, heaving moment of his wife giving birth to each of their five children. Robert Cowan was especially effective in Ken Jacobs's films. So were Joyce and Donna Montague. Donna posed nude for Joyce's art classes and the two of them peeled in Ken Jacobs's *The Sky Socialist*, made from 1964 to 1965.

Ken Jacobs reported Joyce to be "very easy to direct, very natural," and added that his idea of "friends playing roles playfully has a symbolic meaning, that they come in and out of their characters freely." He thought Joyce particularly touching and effective playing a scene in *Sky Socialist* that Ken believes related to Joyce's inability to have a child. She had undergone fertility testing in 1963 that supported her suspicions of being unable to conceive, and Ken recalls Joyce talking to him and Flo about this and he shakes his head in regretful commiseration. (Ken would have more to say about this later.)

A long shot establishes Joyce sitting quietly on a park bench (the actual location is near her treasured haunt, Fulton's Fish Market), with a small rectangular box on her lap — a cigar box appliquéd with a red cloth heart, folded strips of painted cloth in muted green, blue, and red tones, and with a miniature ink drawing of a face on its lid. You're not too sure about this box. As the camera moves in closer, Joyce removes the lid and takes out a folded cloth that you realize is one of her wall hangings, smeared with red blotches, and hand-stitched roughly, obviously by Joyce. You couldn't possibly know that the red blotches are menstrual blood without being acquainted with her 1961 wall hanging, *Heart On*, which is streaked with blood.

Like other of Joyce's wall hangings, this one contains little secret places into which she has tucked items. She slowly unfolds the blood-blotched cloth, slips her fingers into a pocket and removes two red quilted penises

and testes, daintily, her fingers handling them caressingly. She places them in another pocket. Unseen are two more tiny quilted penises, one pink with white testes and the other, red. Carefully, she folds the cloth, returns it to the box and closes the lid.

The work is called *Josephine's Box*, the name lettered across the lid in Joyce's stylish pen script. One is left to ponder: Joséphine, Napoléon, the four baby penises.

About the piece, Ken says, "I thought that was a great work, an intimate work, the most revealing and creative. It was an idiosyncratic work, I mean, nobody was doing anything like that." Familiar with Joyce's *Disaster* assemblages, he loves them and calls them "authentic dreams." He adds, "They come from way down."

Ken speaks of Joyce's personal relationship to the box. "I wanted that box and all the longing it implied or embodied — I wanted that in the work. It's counter to the character. She's clinging. But it is love. Love and longing. A box of love."

The shot is a lingering one, softly lit, and it recedes to a long shot of Joyce on the parkette bench with the closed box on her lap, framed by wispy trees flickering in the fading summer light. Ken said the scene had been considerably longer but he cut it. "It was just too sad."

In wild contrast, Joyce had the high-flying time of her life acting a couple of crazy roles in Kuchar brothers films.

As already noted, she and Michael had met the infamous, off-the-wall underground filmmakers George and Mike Kuchar at a screening in Ken Jacobs's loft where the two brothers were showing one of their films. At its end, George said he needed a crowd for a riot scene in his next film. Speaking with a Bronx accent as thick as pastrami on rye, he reports, "So I asked who wanted to be in the riot and Joyce said okay, *shewwwa*, she'd be in it."

The film was *Lust for Ecstasy*, about which George says, "Joyce plays the Virgin Mary and is in the crowd scene."

The bare sketch he offers of that film is lavishly compensated for in

his description of the next one. It is easy to understand why Joyce had fun with George. He talks the talk of endless characters he has met — as though he himself were an innocent onlooker — of films made and in the making, all of it dashed off with loony self-deprecations, nothing too sacred to be spared interruption by giggles, asides, and non sequiturs. The film under discussion, *The Mammal Palace*, was shot in Joyce and Michael's loft and is based on incidents that happened in an apartment above George when he lived "in the middle of the Bronx, by the Holland River, where this guy, a bus driver, lives with his mother and he comes home and starts throwing furniture around. It was a horrible racket. I used to wake up in the morning and hear his mother squealing like a mouse. Some of the neighbours actually called the police. And my mother used to get on the bus and I'd say, 'Mom, if you ever see that guy, don't get on the bus.' So I just replicated the scene of the domestic squabble and Joyce played the lady. The man and his mother are having this big violent scene, this rough-and-tumble screaming and I dubbed in the sound and it ends when Joyce picks up this hot iron and she brands the bus driver with it. But it's done tastefully." After the laughter, he says, "I mean, it was no splatter picture."

The next Kuchar film Joyce appeared in was *Knocturne*, "which is about strange incidents that were happening when the moon was rising," George explained. Joyce's character was a woman with a "strange obsession" about a doll that is life-sized, that she tried to push into a bathtub and drown but "it wouldn't fit and so she throws it out the window, where it made a big thumpy sound like a body falling. That was nice."

Joyce's acting in this film is highly skilled, controlled. Stealthily climbing the stairs, she *looks* like someone who would throw a body out a window. "I didn't do much directing with her," exclaimed George. "She was having a good time."

Robert Cowan, a man Paul Haines describes as "the genuine article" of the underground film scene, acted in Kuchar brothers films. George refers to one of them, *Color Me Shameless*, in which Bob plays a painter

who can't work and he collects shoes. George had been depressed, "which is nothing new, but the main actor, Bob Cowan, happened to be depressed also and so we had a wonderful time." (Bob said they both had had romantic involvements "that were not working.")

Joyce enjoyed acting in films — whether playing a mute face in the crowd, a crazy lady, or a surreal oddball — as a creative outlet for her many personas. Acting fitted into her everyday make-believe world. For years she had projected her imagined and real selves into her paintings and assemblages, and when facing a camera, she could "come in and out" freely, as Ken Jacobs put it, and express a character different from her nature in a setting where she could let fly. And she would have a jolly good time.

Amused by his thoughts of Joyce in New York, Robert Cowan said, "She was very funny. She swore a lot and was kind of ribald, different from any girl I knew then." And she had a "naïve enthusiasm about things that got her into lots of mischief."

George Kuchar related one occasion when Joyce's mischievousness was not warmly applauded. This occurred at the apartment of a psychiatrist whom Michael had befriended before he and Joyce had arrived in New York. The psychiatrist and his wife entertained elegantly, hosting regular cultural soirées in their spacious, chic apartment, whose invited guests comprised well-heeled, sophisticated New Yorkers. This was where Michael previewed his *Walking Woman* paintings and drawings.

"So Joyce showed her movies in this big West Side apartment," George continued, "with all these socialites sitting around. Once she showed a picture of hers and in one shot she had a man with his pecker hanging out and he was swinging it and dangling it. This devastated the whole party. Like, the people couldn't recover. I remember that moment, how they couldn't handle it. They weren't ready for that." He lets loose a merry laugh. "I got a kick out of it."

George couldn't recall which film caused the damage, but Joyce was likely showing *Larry's Recent Behaviour*.

Though not assuming a direct connection, he says, "Eventually, the

psychiatrist went berserk." And as if to himself, George ponders one of his life's observations — that his eye doctor always wore glasses, the barber was always bald — and adds, "I took it for granted the psychiatrist would be crazy and sure enough he was."

(Not too crazy, however, to certify both Kuchar brothers unsuitable for the Vietnam War draft.)

Much comment has been raised with regard to differing results achieved in film by visual artists and filmmakers. It can be said that avant-garde filmmakers are interested in reinventing cinema, as in the Hollywood cinema, whereas artists make films that are primarily non-filmic.

George Kuchar drew this distinction regarding Joyce, noting that as an artist Joyce's sensibilities were not comparable to those of a pure film-maker, like himself. He describes being at Joyce and Michael's loft one night, saying, "They were watching a movie with this guy Hollis Framp-ton and the three of them were watching these eight-millimetre movies made by scientists of electrical impulses going through frogs' legs. They were sitting there enraptured and I wondered what they saw in it. But it was somehow feeding their artistic natures and they were getting ideas."

Frampton, who without graduating received (as of 1984) the fourth-highest marks in the history of Phillips Academy, in Andover, Massachusetts, is described by Annette Michelson, an influential commentator on the avant-garde art world, as "unquestionably one of the most remarkable talents . . . [in] independently produced cinema in this country," and the "most widely and deeply cultured." Along with his prodigious output of a lifetime's more than sixty films, photography, Xerox prints, paintings, collages, and sculptures, Frampton produced a major body of criticism and poetry, leading Steve Anker to define Framp-ton as one with "an encyclopedic knowledge of many disciplines, including the practices and histories of science, mathematics, literature, poetry, and art."

Joyce learned from Hollis and maintained a deep emotional connec-

tion to him; Michael related to Hollis technically, intellectually.

George Kuchar pointed out that visual artists such as Joyce and Michael — and he undoubtedly included Hollis — develop their filmic ideas in a manner unobtainable to him as a filmmaker; that they absorb and adapt material from sources beyond his experience. Attribution to a heightened aesthetic possessed by visual artists fails to make the case entirely, considering that bona fide "artistic" films have been made by both commercial and avant-garde filmmakers, as well as by artists. A distinction can be made, however, for concept. An underground film-maker who makes a minimalist film and works solo with camera and in production, still requires added elements of sound, lighting, props, loca-tions, and actors. A filmmaker's conceptualization depends on these elements, whereas a visual artist's concept derives from a vision in which images form the technique, colours, effects, and so on, through the concept. Images are predominant for the artist, less so for the filmmaker. It seems obvious that an artist would incorporate images of his or her paintings or drawings into film and transform them into another form and give them another direction. Interestingly, Joyce did not do this — at least, not in the beginning. The reverse can be said, in that she transposed film into her art by using film-strip techniques in her *Disaster* paintings and assemblages.

Frampton perceived Joyce's assemblages cinematically, in that they were about "a series of things [that] go through time." He asked her if she specifically intended this effect and she replied that her assemblages had "actions going on through so that there's always been, since I worked in animation I guess, a very strong thing about film in my work."

On the other hand, Michael's art enters conspicuously into his films. An example is his *Walking Woman* series, the slightly abstract shapes of varying actions of a woman walking that he created in a wide range of mediums — painting, sculpture, photographs. His *Walking Woman* figure appears in his film *Wavelength* over and over, in and out of frame, always changing but remaining identifiably Michael's creation.

Joyce had difficulty with academic discussion of her films. Part of the problem reveals itself in certain comments she made long after she quit filmmaking. Perhaps she needed the distance of years to gel the evanescence of her filmography into concrete terms, especially since she worked almost exclusively in the structureless idiom. Seldom did she know what would result when she picked up a camera and went out to shoot "my bits of film," but she never lost faith in the endeavour. Artistically, she stayed on track. Having said previously that she worked to remain loyal to herself, her mother, and her "female line," through this feminist filter shone her uniqueness, even though she admitted some years later in an interview, "I was very insecure about choosing my subject matter. What I wanted to work with had no future. But because of that, I knew that no one would compete with me for it."

Plainly, without pretension, Joyce frequently said she didn't know why she did what she did; that she just loved doing it. Every moment behind a camera or in front of it gave her immense pleasure. She enjoyed filming objects and scenery, acting in her films and others', nude or clothed, shooting her bared breasts or Dave Shackman clutching a nosegay of wieners, and she loved splicing and editing film. Joyce loved it all. "It was *really* exciting. It didn't matter if you spent twelve hours locked in an editing room putting little pieces of film together. It was wonderful."

From the time Joyce and Michael had worked together on *Tea in the Garden* and *A Salt in the Park* and in New York where they were both making films, they collaborated on each other's projects. As both artists and filmmakers, they shared ideas, concepts, and opinions as logically as physician husbands and wives share diagnoses and broker mates discuss the Dow. Joyce's and Michael's creativity was the lubricant that oiled their daily life; their artistic natures enriched their lives. Over the years, Joyce generously credited Michael with being the greatest influence on her art, and it is safe to say that artistic rivalry and professional jealousy between the two of them scarcely existed. For a time.

After Michael had been in New York for two or three years, his film-making had gained him more accolades than his art. His filmography is characterized as being more experimental than other "experimental" avant-gardists', including Joyce's — and theoretical, which he characterizes as "more like music or poetry." *New York Eye and Ear Control* was hailed for its jazz soundtrack and won the Grand Prize at the Fourth International Experimental Festival in Belgium, the Knokke-Le Zoute, in 1967.

Upon release of *Wavelength* in 1967, Michael and Joyce's life together changed irreparably.

It took ten years after leaving New York before Joyce could publicly express the artistic conflicts that had developed between her and Michael, beginning in the mid-1960s. Ordinary everyday tensions had been manageable; Joyce loved Michael deeply and she accommodated his "significant other" life — music, absences, women. He had a New York dealer, she did not. He sold numerous paintings and she sold very few. Seeing the signs of Michael's artistic reputation outpacing hers, she was sustained by the artistic success of *Water Sark* and took comfort in her growing reputation and the sense of belonging with a group of established filmmakers who accepted her as a peer. If this compensated for being excluded from the visual art scene in New York, we don't know. However, something over which she possessed little control was her self-esteem. Rickety at the best of times, beginning with a childhood that had failed to value her, she amassed in New York a decent portion of what outsiders saw as self-confidence, but this was a facade behind which she still secretly trembled. She didn't need to fake her perseverance, however. She had always persevered. Perseverance — an inner strength she'd been practising as a child hauling her sleigh to get coal, and as a young woman exploring Gurdjieff techniques — accounts hugely for her tolerance of Michael's infidelities. Not persevering would equate to giving up and that would constitute a stupendous failure. Joyce could not impose that on herself. Clouding the issue, too, was the fact that she loved Michael *madly* — the defining word used by her friends — even though love would not save them.

Michael's other women did not jar Joyce out of her wifely complacency as much as did the tension that emerged between them creatively. "I felt there was something inferior — as many, many women artists will say — or missing in me so that I could never be taken seriously or equally. I felt that they were together, all the men, and I could be a part only by being this eccentric or nice little person or something like that. I was there, but when the real discussion about theory and so on —" Here she jumps to another subject, but returns to emphasize that when art discussions became technical, the men had no interest in her opinions.

The stress this caused would have a corrosive effect. Slowly, the situation ate away at the soft, private centre of their marriage that was well concealed by a tough, shiny, public carapace; and once this occurred, Joyce began losing respect for Michael as an artist — a situation far more destructive than losing respect for him as a man, lover, or husband.

Competitiveness among artists runs like bad, black blood from individual to individual, an X factor that uncontrollably infects the national and international artistic scene, and whose only antidote is death, one artist at a time, after which the individual artist's standing is left to the non-competitive, ethereal purity of world art history. There are some resistant souls who do not exchange bad blood and despite associating with carriers, they do not get infected. Vastly in the minority, these artists live their lifetimes with sanguine acceptance that their greatest rewards will be bestowed upon them posthumously. Such piety comes with a few quirks, namely isolation — a situation seen most dramatically in the artist who works in a narrow, confined field of, say, sound sculptures or virtual-reality imaging, who exists quite apart from his or her local art circle in Toronto or Boston or New York but enjoys immense, distant stardom in Berlin or Tokyo or some other international headquarters for that particular art. Such artists dwell obscurely on their local art fringe. They are deemed strange and by their aloofness are highly suspect, unlike their raucous, more brazenly ambitious, vociferous, egocentric counterparts, whose competitiveness is the steely linchpin connected to their artistic temperament.

Given that art is founded on uniqueness, and that creating work in a form and style no one else has done or can do, defines the essence of fine art, its creators earn by many the right to be arrogant, egotistical, and driven by a state of competitiveness that can be socially chaotic.

A rare few artistic unions can survive the day-to-day marriage; art maintains its hold on them. Some couples devise distinctive arrangements, such as painters Mary and Christopher Pratt, who live a married life in separate domiciles. And Frida Kahlo and Diego Rivera, each of whom lived independently in a house connected by a second-storey overhead bridge.

Joyce and Michael's partnership could have done with a bridge.

Scarcely aware she was doing it, for the first time in her life Joyce began competing with Michael. Only her changing feelings alerted her to the occurrence. Michael as life partner had moored her sexually, socially, and artistically, and although the change did not transpire in a grand wallop, over time she discovered that in league with her diminishing respect for him was the motivation to cut herself loose from him.

Later on, when reviewing their life in New York, Michael commented that Joyce was "very moody," and though not a manic-depressive she was in a "kind of depression" because she was afraid of New York.

Presumably, he was unaware that Joyce was also afraid of what was happening to them.

A body of an artist's work comes to a stop for reasons similar to those that originated it: urgency, spontaneity, and the prickly excitement of venturing to a new place. One period ends, a new dawn inexorably begins. After working on her mixed-media installations through 1964 and 1965, Joyce ventured into a new medium — wall hangings made of stuffed, brilliantly coloured plastic bags. As a medium, they are properly identified as plastic hangings or soft sculpture.

Joyce bought an outdated industrial sewing machine in New York's garment district to make her soft sculptures. She began by sewing the

plastic materials into their desired shapes — square, round, rectangular, triangular, oval, large and small, as well as a few shapes in the form of her trademark lips, hearts and penises — after which she stuffed the brightly-coloured opaque shapes with soft, crushed plastic bags to puff them up. She filled transparent plastic bags with shiny little coloured pillows and stuffed both the clear and coloured shapes with bits and pieces of snapshots, pressed flowers, scribblings, cut-outs, fabrics — again, she had found another medium into which she could tuck her treasures. And like the film-strip technique of her early New York paintings, she incorporated a filmic quality into these works by arranging her shapes to be viewed sequentially. Vertical, narrow, and long, for the most part, some works comprise only one or two shapes, plastic-bag pillows; and others three, four, and more bags attached together with coloured plastic strips. Most of them hang suspended, one bag below another.

Joyce said that these works were "stuffed movies," that the narrow shapes were "like pieces of film, but three-dimensional — like a film frame but stuffed." She also called them "home totems," in that "they have things going on around the home, photos of work in progress, photos of people put inside these little bags." The mementoes of her everyday life could then be seen hanging on a wall "in a totem kind of effect."

Stuffed Movie defines this process. Into five transparent bags she stuffed movie memorabilia, one shape containing actual film strips, another a miniature Canadian flag — for Canadian movies? — another a photo of Humphrey Bogart and a lion — for the MGM lion? — and in one bag, a stuffed penis floats.

She titled *D. W. Griffith and his Cameraman Billy Bitzer*, 1966, for the fact that it contains pictures of Griffith and Bitzer. Joyce described *Larry's Recent Behaviour*, 1966, as "made from my film and is three film strips of Larry picking his nose."

Home Art Totem is a work of seven stuffed shapes suspended from plastic strips that documents Joyce's attitudes to self and contemporary 1960s life as no other previous work had. She encapsulates her mythologies into

the hangings much the way native people carve out their tribal histories on totem poles by inserting fragments of her spirituality along with her sexual secrets and her growing outrage over American aggression in Vietnam. Granted, it was not entirely new for Joyce to slide secrets into her work. Years later, soaking in a hot tub at a posh women's club in Toronto, Joyce confessed that when she had visited the writer George Sand's house in Paris, she had pulled a thread out of a curtain and put it in a collage. (Joyce was enthralled by a woman with a man's name, who was as famous for her writing as for her love affairs with such figures as Frédéric Chopin, and who wrote passionately about the need for humanitarian reforms in nineteenth-century France.)

While Joyce's political and sexual themes appeared powerfully in her 1964 assemblages, until she began the plastic wall hangings, in 1966, she had not concentrated such a range of her beliefs and anxieties within a single medium.

Similar to past themes, distinct messages do not strike the viewer all at once.

The works would be artistically valid, likeable, and clever if Joyce had stopped at simply creating wall hangings from brightly-coloured, stuffed plastic bags. But there comes a time during the creation of every work in which the artist faces artistic life or death; the moment when the artist either lays down the brush or pencil and plays it safe by quitting, or brazenly takes one more step and charges toward the precipice. Master artists approach this frightening, vacillating, risky place in every work. Joyce chose risk. She took that next step and elevated her plastic wall hangings to a higher artistic plane. She manipulated shapes and images and positioned her central images on a single bag or several bags, using photographs, film strips, newspaper clippings, or painted images singly or in dizzying montages. Images were affixed to bags, and objects tucked inside them.

Plastic in aesthetic terms pleased Joyce. Its slithery, sensual feel, malleability, sheen, and its spooky opacity appealed as much as its brilliant colours. She valued plastic's ubiquity. "It was all around and it was

in the air. I liked the material; I laminated [with] it, I sewed it, I treated it like a traditional fabric. I started the idea of pocketing, of enclosing stuff in it."

Among the finest of these wall hangings, and one of the earliest, *The Space of the Lama*, 1966, is childless Joyce's dedication to children. It is said that like the young lama, each child born to those who love him or her has been specially chosen by God. The work is dedicated to Munro, the son of Betty and Graeme Ferguson. Arrestingly enigmatic and thoroughly pleasing, the dominant top section is a clear plastic bag that contains a photograph of Munro at about age three, expressing the embodiment of childhood innocence and purity. Four remaining sections contain childhood symbols in the shapes of a ship's wheel, woollen mittens, and bags stuffed with little items. We don't know what they are; they are a small child's secrets.

Joyce had a deep affection for little Munro — the former "oracle" she now called Mun-Mun — and his sister Allison (who would later name her daughter Joyce), and was a major influence on these children.

"Next to my mother, Joyce was the most important woman in my childhood," said Munro, at age thirty-five, in a newspaper interview. "She taught us art, she played with us, she was an inspiration. . . . I got the idea that being an artist was a great thing to be." (Similarly a filmmaker, which Munro would become.)

The Space of the Lama and *Don't Mess With Bill* are sweet and playful; then Joyce moves into political territory. Sardonically, she condemns American imperialism in *Betsy Ross, look what they've done to the flag you made with such care*. A destroyed American flag is set into a mouth, seen as oversized fuchsia lips, with six stars on a blue background, and the rest of the piece is composed of red and white stripes. The first stripe shows how the flag has been desecrated, as though chewed up by the mouth. An actual Band-Aid appears over a wound-like image.

The viewer has to look closely at *N.U.C.*, 1966, to find expression of Joyce's virulent anti-Vietnam War stand. Composed of two shapes, the

round top features a large dollar sign sewn over newspaper photographs of soldiers in battle, an image deceptive at first because the overall effect is pleasing through the use of soft colours of trees and meadows, but then suddenly one realizes that the soldiers are dead or wounded. From this shape a large heart dangles, covered in stars of the American flag, and inside are newspaper clippings — one about a slash-and-burn program of crop killing in Vietnam, and the other about a U.S. Marine charged with murder.

Joyce celebrates the colourful nature of a New York Hispanic neighbourhood in *Puerco de Navidad*, 1967, an arrangement of small, brilliantly coloured pouches that she stuffs with a psychedelic array of articles one would buy in the area — miniature dolls, cosmetics, pieces of a native costume — and (for solidarity perhaps?) part of a Canadian flag.

In many works, the stitching of the bags is crude and the lines are unevenly sewn. "It's never neat," observed one critic, not unkindly, "and the lines and shapes are usually askew. It has a loveable, spilled cosmetic sloppiness to it." That the splice marks show in her films, lines in paintings go unaligned and blemishes stay unconcealed are idiosyncrasies that inherently identify Joyce's work. She never felt that technique should outsmart content.

Joyce cited Claes Oldenburg as an influence in these works. "He was one of the most important artists in my life," Joyce avowed. "The idea [of soft sculpture] was so inspiring. And I had to relate that in my own terms, to make something about my life."

Oldenburg is best known for his pop-art sculpture created in the early 1960s of oversized ordinary objects created in fibreglass, such as the giant hamburger, *Floor Burger*, 1962, a much-maligned purchase made by the Art Gallery of Ontario in 1967), a toilet seat, a drum set, kitchen appliances. On a smaller scale, he created plaster objects such as ice-cream cones, sundaes, and slices of cake, and painted them in a bright, garish parody of the American soda fountain.

Sizable though Joyce's output was during her first four years in New York

— paintings, assemblages, wall hangings, and four films (with a start on a fifth) — at that time she adopted a new medium, quiltmaking.

This interest originated with a patchwork quilt she and Michael had slept under at the Fergusons' in New York. The quilt was made by Betty's great-grandmother, born in 1840. "Joyce adored that quilt," Betty said, about the quilt now hanging in Betty's farmhouse in Puslinch, a one-hour drive west of Toronto, where she has lived since moving back to Canada.

An exquisite composition of irregularly shaped three- and four-sided patches of cotton prints in earth tones of brown, taupe, and beige, the quilt is perfectly preserved through about a hundred years. "Look," said Betty, pointing out the quilt's microfine stitches joining one patch to the next one in a different stitch. "There are hundreds of different stitches," she exclaimed, as though making this discovery for the first time, along with the visitor.

Joyce's admiration for the quilt was such that she finally refused to sleep under it. "It's too beautiful," she told Betty. "It should be hanging on the wall." Betty agreed.

All the while Joyce lay under the quilt, she luxuriated in a psychic intimacy with the quiltmaker, Betty's great-grandmother, conjuring up the woman's spirit and her loving labour of stitchery, pondering how she might make an artistic/spiritual/feminine connection to this woman three generations removed.

Joyce set out to research quilts and quilting. Thorough as she was, she would have discovered that quilts and all-white counterpanes, made from the fourteenth to the twentieth centuries in Europe, India, Persia, Britain, and America, originated as bedcovers when it became evident that two layers of cloth enclosing an inner layer of stuffing provided great warmth. The patchwork quilt, like Betty's great-grandmother's, was a popular Early American style from the mid-eighteenth century and was later fashioned into the Victorian-era "crazy quilt" made by using scraps of material — the lower classes used cotton and gingham, and the upper classes, fine silks and velvets — cut into various shapes and stitched, or appliquéd,

onto the quilt cover.

Quilting is widely identified as a craft and this confronts the lasting argument of what is art, what is craft. Primarily, women make quilts, often collaboratively, which leaves many quiltmakers anonymous, and the participants themselves do not consider that they are creating a work of art. For these reasons, and the fact that quilts are functional, connoisseurs and collectors have long snubbed quilts and most contemporary crafts, but the fact that these craft ragamuffins, barred from the gilded salons of art, have endured for centuries speaks of their lasting appeal.

In mid-nineteenth-century England a growing sophisticated population scorned the quality of manufactured goods, which led to the development of craft schools. Guilds were established and potters and weavers flourished. William Morris created in 1861 a "hand-made industry" in which he designed and produced hand-printed, hand-woven, and hand-dyed textiles, giving rise to fibre art. This aesthetic became a strong design element of the Bauhaus movement in the early twentieth-century, and one of its venerable practitioners, architect Frank Lloyd Wright, incorporated textiles into his total concept of organic architecture and furniture design. In doing so, Wright almost single-handedly elevated textiles to a new aesthetic. Another significant boost occurred in the 1950s from an international movement that sought to raise the appreciation of contemporary crafts through worldwide exhibitions. Viewers admired what they saw and gained a renewed respect for crafts. And though attitudes shifted, certain hidebound sectors preferred that crafts keep their rightful place on the shelf, not on gallery walls — a notion that Joyce would challenge perforce.

Betty's great-grandmother's quilt lingered in Joyce's mind. She wondered how she might use fabrics and textiles as another art form. The magnificent Aubussons she had seen, the Gobelin tapestries at Versailles and the numerous textiles and laces she adored were swept out of her thoughts by that one quilt and the woman who had made it. However, it was another woman who intervened in Joyce's deliberations — her sister, Joan.

While Joyce had been working on her plastic hangings, Joan had been making quilts. As Joyce later explained, "She needed work. She didn't have any money, and I liked what she was doing. I thought maybe I could design a quilt about a person. So I designed one for a friend's son about his character and the things he liked at age five. I cut things out, basted the quilt, and my sister completed it."

That work was *Michael Montague Quilt*, commissioned by the boy's mother, Donna Montague, in about 1964 for Donna and George's first child. A playful covering for the boy's cot, it features Joyce's trademark hearts and lips, and the things Michael liked, a sailboat and balls, and the numbers four and five — Michael was then four going on five.

Michael still has the little quilt. He says, "We hang it up as a piece of art."

After *Michael Montague Quilt*, Joyce made another four quilts that year, in 1966.

While she had been researching quilting in libraries Joyce also scoured second-hand shops and craft centres in New York to look at quilts. In this pursuit, she gained an abiding appreciation of the craftsmanship of quilts and simultaneously she felt wistfully, romantically saddened by the quilters' anonymity, whose recognition was limited to winning ribbons at country fairs. By the time Joyce completed her quilts, like William Morris and Frank Lloyd Wright, she too would have had a hand in the upgrading of textiles, even though initially she took a gigantic career risk in making quilts.

A fine artist who penetrates a genre commonly recognized as craft is aware of the peril. This occurred to Joyce. Evidence of her trepidation is found in her rhetorical questions, "Who could take the quilt seriously in the art world? How could that be art if it had to do with quilt?"

However, Joyce concentrated on the quilt's potential for art as political statement:

> I thought that the only way to work was in things that we knew of as women's areas, and to take the quilt and use it. At

first they were not political statements, but then when I saw what a fantastic thing it was to merge the quilt with the political idea — poetry and women's labour with the political concept — I felt that I really had something.

Joyce cross-referenced her quilts with filmmaking as she had done with her assemblages, calling these quilts "homages to film." This is reflected obviously in two quilts, *The Camera's Eyes* and *Film Mandala*. The former suggests film in a pattern of bright colours that radiates from a central image of two round shapes indicating eyes or lenses, leaving an overall impression of the flickering motion of Technicolor films. *Film Mandala* is subtler, with vertical bands of stitching surrounding a bright red square, blind-stitched in the shape of a film reel. The largest of these works is composed mainly of coloured lines, triangles and squares emblematic of an unidentifiable flag, *Square Mandala*.

Joyce related her quilted mandalas to the Union Jack flag. "It's the flag as a mandala, especially the British flag," a concept taken from the ancient Chinese mandalas adopted by primitive cultures as a woven or painted work containing symbols of sacred doctrines and in some instances, gods. By merely including *mandala* in the title of these two quilts, Joyce accords both the flag and film sacred status, as ancient peoples honoured their deities.

Joyce's magnum opus in this theme is *Confedspread*, a large work, 150 centimetres by 202 centimetres, that is composed of varying shapes representing the Canadian flag and colours of the provincial flags. The year after it was completed, in 1968, the National Gallery of Canada purchased *Confedspread* and immediately mounted it in a group exhibition, *Canada: Art d'aujourd'hui*, organized to tour Europe to showcase young Canadian artists. The first stop was Paris in January 1968, after which the show travelled to Rome, Lausanne, and Brussels.

This distinguished Joyce on two important counts. First, that she had been chosen, which resulted in her first European exposure. Until this

time she had been included in four group exhibitions that travelled outside Canada: in 1962 at the esteemed Albright-Knox Art Gallery in Buffalo and the J.B. Speed Art Museum in Louisville, Kentucky; in 1964 at the Philadelphia Museum of Art; and in 1967, a Centennial exhibition at the Hudsons Galleries in Detroit.

The second factor is that Joyce's selected work was a quilt rather than one of her paintings or drawings. It signified that the National Gallery of Canada placed the quilt, largely ignored or dismissed as "women's work," on a par with drawing and painting as a worthy representative of the country's art.

Quiltmaking offered Joyce a decisive means of ignoring the old boys' network in New York. "Getting into the making of quilts as a woman's work was a conscious move on my part," Joyce is quoted as saying. "There was a highly competitive scene with men artists going on there [in New York]. It polarized my view of life; it made me go right into the whole feminine thing."

Some ten years later Joyce appeared in a discussion about her work in Halifax, where she gave another reason for making quilts. A reporter wrote, "She told the gathering that although she was part of the flourishing, avant garde, and mostly male New York artist's colony, she was never really accepted as a 'peer.' That's when she decided to try a medium that she knew 'men despise and don't give a [a dash here probably replaces Joyce's word, *shit*] about.' That medium was quiltmaking and she raised it to a new level by making it an art form."

Chapter Six

Joyce described *Rat Life and Diet in North America*, 1968, as, "The first film I made that involved Canada as a subject and had any political reference."

Her theme — that the United States holds aggressive power over Canada — is played out by her pet gerbils. They scamper around on dinner plates eating food scraps, presumably leftovers from Joyce's and Michael's meals, scarfing colourful bits of broccoli, cherries, and flowers, and climbing in and out of coffee mugs. The stage is set. And, as in all good stories, conflict soon enough rattles the equanimity — in this

scenario, with the appearance of Joyce's cat, Dwight. Throughout the preceding scenes the action has been interrupted periodically with blank leader flashed with political phrases and single words, and insert shots of crowd protest; a voice-over intones anti-Vietnam, anti-war slogans. We now understand the gerbils to be imprisoned American draft dodgers, and the cat, their captor. Hostility erupts. The gerbils try to start a fight with the cat — what seems a futile attempt since they are enclosed in a glass tank, where they have been incarcerated. But the draft dodger/gerbils eventually do escape, fleeing to Canada where they take up organic gardening. This causes a full-scale conflict between Canada and the United States. The allegory ends with the victorious gerbils, now safe in Canada, feasting at a sumptuous banquet table while a cherry festival is taking place to celebrate them. A sprightly soundtrack of party chatter is accompanied by hurdy-gurdy tunes and rock music.

In what has been called a "beast fable," Joyce films the gerbils eating, staring into the camera with their pinpointy little eyes, and skittering and clawing at the passive cat beyond the glass. Her technique of using close-ups and extreme close-ups, magnifies and exaggerates the animals' behaviour to horrific, murderous proportions. Through clever editing and her use of close-ups Joyce anthropomorphosizes her household-pet actors to successfully portray the oppressed and the oppressor.

It is worth noting that Joyce conveys much the same political message in two different mediums. In the film, American domination is foiled by little gerbils, while similarly she depicts in paint — *Laura Secord Saves Upper Canada* — a lone woman saving Canada from an American military invasion. Joyce would carry other political themes into dual mediums in her upcoming work.

Rat Life and Diet in North America is dedicated not "to" but "against the corporate and military institute of the global village."

We know that Joyce loved her "family animals." From living with them, observing them, it was a logical progression for her to cast them as actors in her films. Earlier in 1968 she had given Dwight his starring role

eating fourteen fish during thirteen flesh-tearing, bone-crunching minutes in *Catfood,* and scarcely had he licked his whiskers clean when she re-engaged him as a cop guarding draft dodgers.

On numerous occasions Joyce was asked why she used her gerbils as political messengers and her explanation was much the same each time. "They'd be there, and I'd get ideas on how to use them. Why not make them actors?"

Joyce believed that Beatrix Potter had made animals "legitimate subject matter" in art, and since the gerbils were a component of Joyce's daily life, just as her art was part of her life, she would unite the two, abiding by the same inclusiveness of her nature that compelled her to use toys, plastic flowers, photographs, and cut-up pieces of her panties in her assemblages.

Delivering political messages through her pets merely because they were there is only part of the explanation. The idea of casting them occurred to Joyce after reading the famed early studies in *Scientific American* about rat behaviour in crowded conditions. She could recreate these experiments first-hand — at home with her pets — and make a corresponding political statement. For six months she filmed the gerbils eating, romping, reacting to light and sound around them, and monitoring their behaviour, but she had yet to conceptualize her theme. Until one defining incident: "When I put them in the sink in an inch of water," she said, "I began to see [it as] a story of revolution and escape."

Speaking of filmmaker Kay Armatage in 1972, four years after the film's release, Joyce explained that having lived "for a long time" with her gerbils, "whose lives were lived inside the glass container," she found their "little family structure very interesting." She noticed their acute reaction to sound, that "their lives were literally ruled by sounds. They were haunted little characters, little prisoners, little victims no matter how nicely they were treated. They were wild creatures . . . and after photographing them for several months, I started to see what the film was about: their escape to freedom."

Rat Life and Diet in North America is important to Joyce's development as a filmmaker in that it served two powerful imperatives; one political, the other aesthetic.

Presenting clear political messages through her furry, long-tailed actors required that Joyce allow their behaviour to formulate her film. The animals forced their plot on her and she wove her political message around their activities. This was unlike any filmmaking she had yet done. Previously, she had maintained full directorial control over her subject matter, whether animation or live action, to convey her political/feminist messages, as in the two *Patriotism* films that satirized American jingoism, and *Hand Tinting*, a social commentary on poor, disadvantaged black and white girls in training for workfare.

In *Water Sark* Joyce selected aesthetics over politics to realize her artistic intent, whereas she employed both in *Rat Life*. Gerbils may not be God's prettiest creatures, but Joyce achieved beautiful cinematic effects filming the light reflections on theirs and Dwight's fur, in her stage-setting and use of props — cherries, flowers, bits of lettuce — capturing the changing light and shadow in the tank, and the superimposed lettering. This was no accidental aesthetic. *Rat Life and Diet in North America* initiated her new exploration of politics and aesthetics.

Jonas Mekas, in a catalogue of film screenings held in 1969 at the Museum of Art, Carnegie Institute, writes of *Rat Life and Diet in North America*:

> It may be about the best (or richest) political movie around. It's all about rebels (enacted by real rats) and police (enacted by real cats). After a long suffering under the cats, the rats break out of the prison (in a full scale rebellion) and escape to Canada. There they take up organic gardening, with no DDT in the grass. It is a parable, a satire, an adventure movie, or you can call it pop art or any art you want. I find it one of the most original films made recently.

A German television network bought *Rat Life*, as did one in the Netherlands. It was shown on the Canadian Broadcasting Corporation network in 1969 and by the British Broadcasting Corporation the following year. Friends and strangers liked the film. Joyce was pleased to report that a truck driver whom she met in the Pilot Tavern in Toronto offered to invest $100,000 in her next film, whatever it was. (Wild things happened at the Pilot. Some panned out, some buzzed only in the next morning's thundering head.)

Joyce defined *Rat Life* as a film that "had a message and a very accessible story." It was as close to a narrative film as Joyce had made, more "understandable" than her unstructured films, and for this reason it garnered some negative criticism. There is no indication Joyce feared that popularity would diminish the film, yet she realized that among her peers, comment went both ways. Writer Hugo McPherson pointed this out, saying the film "became an underground success though some of the New York group may have thought it un-hip."

An avant-gardist *un-hip*? In fact, this is partly true. Joyce, the artist, made hip work but Joyce, the person, never strayed too far from the mainstream (apart from a little substance ingesting), compared with many of those around her, including Michael. In another context, but applicable here, Jo Hayward-Haines (who with her husband Paul counted jazz musicians as their friends) smiled fondly when she said, "Joyce wasn't hip, *we* were hip."

If *Rat Life* was deemed un-hip, Joyce would have dealt with this as she did any negative criticism: She cried, then valiantly moved on. She likely did some deep breathing exercises, meditated an extra hour, or worked on the latest technique that restored her inner harmony. Thus energized, she remained true to her art, not a critic's opinion of it.

The high praises Joyce received for *Rat Life and Diet in North America* boosted her ego, empowering her toward a new strengthening of self. And during this process, synergistically her tolerance of Michael's womanizing

started to erode. For years she had dismissed his peccadilloes, saying, "That's Michael," but now she was having second thoughts. In later accounts, she said she never dreamed of leaving Michael, even though his behaviour had hurt her desperately. She loved him still. She liked being with him. In the past, Joyce had shoved her pain into the dark nightmare cellar and slammed down the door — but now, she faced a new truth.

Although Joyce had the spotlight aimed at her for her films, that illumination did not equal Michael's; he was being acclaimed for both his films and his art. It is quite possible Joyce foresaw the megawattage ahead for Michael and she may have been threatened by it, especially since she had come around to thinking of herself as a bona fide artist. On the good days, when another prize or favourable review came her way, Joyce may have sensed an artistic catch-up with Michael. If so, the shift in stature between the two of them — from master/student, senior artist/junior artist, and even "wife of" — would have diminished her reverence for the master as the playing field levelled, and aroused in her a sense of competition.

As part and parcel of this realization — and fear — Joyce began a campaign to refine and consolidate her personal and artistic aims into an aesthetic unity that was totally, solely hers; a field in which she would stand without competition, where she could define a new creative expression. Joyce's lifelong habit of attracting attention through art that shocked, would now reflect her deepest beliefs.

Her state of mind at this time is revealed in a 1974 *Canadian Forum* article:

> I have been aware of the fact that there is Art and there is Politics, and I have been working on putting them together in aesthetic terms for years. I think I am getting somewhere. I think one can have all the thrill of doing art as well as embedding the political thing in it.
>
> Making a statement in Art that will be political doesn't have to be through any standard way. . . . It is the totality that I am

interested in. I don't want to just harp on politics in my art. I want a really sensitive combination of all areas of our life; Canadian independence, northern mysticism, organic farming, sex. Everything which concerns us must be put together in such a way that one isn't preaching to somebody, or cheating anyone.

Much the way Joyce used gerbils in her film because they were part of her life, just as art was integral to her life, so her political beliefs began expanding in her life and would consequently expand in her art. Joyce stated that *Rat Life and Diet in North America* contained "the seed of something else." Its germination would yield her next film and four quilts.

Joyce's nationalistic feelings — her love of the land that is Canada, its people and purposes — underwent a progressive upheaval as the 1967 Centennial year approached. The official build-up of celebrations began in 1963, when the Centennial Commission was formed to engage Canadians in plans for the country's biggest birthday bash. (Schoolchildren, city mayors, historians, and Canada's creative and performing artists had already been thinking since early in 1960 of ways to toss their celebratory hats in the air.) Enthusiasm and joy swept the country, bringing people together in a cultural embrace from coast to coast. During almost all of 1967, the Centennial Train traversed the country with exhibits and artifacts documenting the past precious one hundred years. Eight tractor-trailers filled with historic exhibits travelled to towns and villages inaccessible by rail. A 3,500 mile canoe race, with competitors from every province and the territories, paddled replicas of canoes used by the early voyageurs. Bobby Gimby's commemorative song "Can-a-da!" was heard all year long. (Who can forget the man himself on television playing his trumpet and leading, Pied Piper-like, his rollicking stream of youngsters singing their hearts out?) Public squares, parks and concert halls packed audiences in with military tattoos, rock bands, Scottish dancers, ballets, and symphony concerts. The

crowning attraction was Expo '67, where Canada proudly showed off its rambunctious, multitalented self to an estimated 50 million visitors who thronged into the city of Montreal from April to October 1967.

As Joyce observed Canada from her New York lookout, the politics of both countries began to affect her seriously. She became angry, she grew frightened, she felt intellectually and culturally endangered by the Americans. Above all, she was implacably at odds with the United States' involvement in the Vietnam War — as were hugely growing numbers of Americans. By 1967, close to five hundred thousand American soldiers were in Vietnam; eighty thousand had been killed, wounded, or were missing in action. President Lyndon Johnson was vilified by his own Congress, a malevolent press and an angry, disillusioned public. Teach-ins, sit-ins, marches, and draft-card burnings dominated the evening news.

Political themes overlapped in Joyce's work from 1962 to 1965, and to the varying degrees that her messages are flagrant, powerful, titillating, wry, and thought-provoking, they are advocates for her protestations. However, not satisfied with static political intimations in her art, Joyce took to the streets.

She and Betty Ferguson joined numerous civil-rights protests. "We were marching in a protest all the time in New York," Betty laconically reported, glancing back thirty-five years on their 1960s zeal. "Up and down in front of the United Nations. Protesting against the atom bomb, the war in Vietnam." Major among their protests was the March on Washington in 1963. Joyce, Michael, Graeme Ferguson, and Dave Shackman drove there to participate with two hundred thousand protestors in the iconic "I Have a Dream" demonstration led by Martin Luther King, Jr., for African-American civil rights. Later, on November 15, 1969, they joined the largest anti-war protest to occur against Vietnam — this, too, in Washington, D.C.

While marching in lockstep dissent with the Americans, Joyce consciously sought the link between Art and Politics. At the mention of Vietnam in an interview some years later, Joyce demanded, "How could

I let that go by me?"

She didn't. Having made a strong anti-war, anti-American statement in *Rat Life and Diet in North America*, Joyce then set out to raise Canada's visibility in the United States. She organized a dozen or so Canadian artists living in New York into a group called *Les Activistes Culturels Canadiens*— no translation necessary — and in December 1970, she and Mary Mitchell arranged their first demonstration, "New Year's Greetings to the Canadian Consulate." It was intended as a salute to their hope for a new year of Canadian cultural independence.

The group hired out-of-work American actor Aaron Grafstein, dressed him in a Mountie uniform complete with scarlet tunic and a too-big Mountie hat that sat on his ears, who led about forty demonstrators along Fifth Avenue to the offices of the Canadian Consulate. At the reception area the "Mountie" flipped into Nelson Eddy and sang "Rose Marie," wildly off-key. Reading from supplied lyrics, he then bellowed "O Canada" in a conspicuous Brooklyn accent; the Canadians spiritedly joined in. The group caused such a commotion, someone called the police. A policeman arrived to encounter a situation little more than a singsong, and he was soon smiling and Joyce was taking pictures of the New York cop with his arm around the Brooklyn Mountie.

Joyce made a life-sized blow-up of the photograph and titled it, *True Patriot Love.*

As for the situation in Canada, Joyce said, "I was in a panic; an ecological, spiritual panic about this country. The whole southern part of Canada is there to this day. But, at that time [1967] and even now [1974], I was thinking about the Group of Seven and that certain artistic records have to be made at certain times." Near rage, she continued, "Just look what has happened to many of the places they sketched. There are old shoes and hamburger buns in those lakes. That country inspired some of the greatest landscapes painted in this world." In her view, Group of Seven painters left as their legacy a reminder of the country's beauty and yet Canadians had no eyes for the splendour surrounding them and no

heart for its preservation. Through insensitivity and/or for commercial gain, Canada's beauty was being desecrated. "The land is a strong Canadian theme. That land which we all count on . . . suddenly we look up and what has happened, it is all churned up, like the James Bay project." (Construction of the James Bay hydroelectric dam in northern Quebec, which threatened to displace the Cree from their land, became an issue that Joyce would actively, vehemently protest against in 1971.)

In a fierce determination to do something passionate for Canada's Centennial year Joyce began an epic journey, literally through the land she loved, figuratively into a powerful aesthetic, and spiritually toward an understanding of who this searching, occasionally drifting and metamorphosing soul was becoming.

The Canadian spirit had undergone a mammoth revitalization when Pierre Elliott Trudeau was campaigning for prime minister, prior to his landslide election in 1968. The man gave the country two soon-to-be overused words: *charisma* and *Trudeaumania*. While previous Canadian leaders snoozed under Hudson's Bay blankets in a sleigh, Trudeau electrified the country as the leather-fringed dude in a Mercedes convertible. Joyce, living in New York, recalled, "My friend Mary Mitchell and I had been reading about Trudeau: the *New York Times*, the Canadian papers, everybody was talking about him. So she suggested that we go to the nomination convention for the Canadian Liberal Party. I would never do anything like that. But we just got on the plane, went up to Ottawa, and did it, and I took my camera."

She shot footage of the convention and returning to New York, Joyce got the idea for a film after reading about Trudeau being quoted as saying, "Reason over passion, that is the theme of all my writings." (Later, during Canada's infamous October Crisis of 1970 when Trudeau defiantly invoked the War Measures Act, claiming that passion is a positive emotion only if it applies to justice. Dramatically, when a reporter asked if he would do such a thing, he snarled his historic, "Just watch me.")

Joyce had her Centennial project and with it, part two of her trilogy.

Begun in 1967 and completed in 1969, Joyce made *Reason Over Passion/La raison avant la passion*, her first feature-length art film.

In 1968 Joyce was given a ten-year retrospective, 1957 to 1967, at the Vancouver Art Gallery, from January 9 to February 4, her first of three retrospective exhibitions and the seventh solo show of her career. She received meagre though complimentary reviews, one from the *Vancouver Sun*, for example: "Like any woman, she has the gift of absorbing minute detail about situations and personalities," nuances that are lost on a man. Commenting on the oil painting, *The Men in Her Life*, the reviewer interprets it as "representing a woman thinking of her past lovers," and as a "humorous spoof upon the file-keeping mind of the female."

Surely this produced a robust laugh from Joyce.

The retrospective offered Joyce a number of personal opportunities beyond the honour of the exhibition itself, which included travelling to Vancouver for the first time and meeting artist Jack Shadbolt and his writer/curator wife, Doris. It also served as a means of completing her film, *Reason Over Passion*.

The intent of her film was to examine Canada from sea to sea. Artistically, she wanted to reveal the Canadian landscape in its numerous seasons, weather and light conditions, as a cinematic equivalent of a surrealist landscape painting. Spiritually, and of greatest importance, Joyce wished to stake her filmic claim on a landscape she felt was fast disappearing to industrialization and environmental degradation, and being destroyed most insidiously of all, by Canadian national ennui.

Starting in Cape Breton, she travelled by both car and train; then she and her friend Wendy Michener used the occasion of Joyce's Vancouver retrospective to continue by train to complete the filming, shooting film out of the train windows as they went. It is apparent that Joyce gave thought to impressionism, likely Monet's *Haystacks*, to create the effects of light on the wheat fields she viewed hour after hour on the train through the prairies, in sunlight and through a scrim of mist, fog and rain. Similarly, she would document the full spectrum of night and day,

from the soft dawn to glaring noon sun to the melancholy shadows of nightfall, as Monet had done in *Poplars on the Epte* and, most poignantly, in the *Rouen Cathedral* paintings.

The trip was Canada for her. "I realized how much I loved it," she said. "It's to do with comparison but it is also to do with living without it." A comparison she immediately used was a grade-school memory of a large map of Canada that the teacher unrolled for discussion in geography class. "This fantastic Board of Education map, which was like . . . beautiful pinks and greens, words such as Keewatin, Hudson Bay, and a tiny point at the bottom, Toronto." She probably never lost the impact of "the unimaginable vastness of this, which seemed even bigger as a child . . . the words 'Dominion of Canada' in a big arc going across . . . and the description of the richness of this expanse —" She stopped there, as though the memory of her cross-Canada journey had knocked the wind out of her.

The film opens with a flickery sequence in which the landscape is barely discernible flashing by. Or, as critic Ross Mendes notes, it is as though you are "seeing everything at extreme speed behind a slatted fence. Or as when you have been running hard for some distance you stop and rest and your vision pulses with your heartbeat."

Flowing scenes of the land are cut with numerous headshots of Trudeau. Writer Barrie Hale describes this as a "phenomenal portrait of Trudeau"; through Joyce's editing and composition "the man is as suggestive and enigmatic as a series of Roman death masks, coloured with both a kind of Renaissance glamour and the peculiar voluptuous smugness of an Edwardian sepiatone; he finally ceases to be that man at all, but a haunting, intense vision of what a man is."

The lettering "reason over passion" is superimposed almost throughout the film. "I wanted to unite the leader to the land and cement it with his words . . . not so much cement as spread them across a continent." She felt that the words would be "metamorphosed into passion through use."

Hollis Frampton animated the lettering in 537 computer permutations.[1] Discussing the film with Kay Armatage, Joyce explained, "I

couldn't afford to use an animation stand. And so he [Hollis] invented a machine-like masking device whereby each permutation was photographed very rapidly on a set-up in his darkroom — perfect and simple." Each time the phrase appears on film it is preceded by an electronic beep, which, Joyce said, is "like a space language or Russian."

As with *Water Sark*, Joyce inserted footage of herself in *Reason Over Passion*, mouthing the words to the national anthem, "O Canada." In both films she used the same idea "of photographing myself — talking, making faces, etc. This idea makes the audience aware of the filmmaker." She goes on to say:

> In *Reason* the self portrait says I predict. I make the film. I am a character in the film. The whole film is a bit of a primer on Canada and my singing lends a quality of a dutiful school child flogging the anthem. And as I carefully sing the words, my camera is beneath my chin photographing, mostly the lower part of my face, and especially the lips. This soundless singing is the overture to the film. Almost announcing the death of the country, which is what this film is partly about — a last look at Canada.

There is more to "as I carefully sing the words" than appears. What Joyce omitted from this account, but later revealed, was that she couldn't remember the words as she filmed herself. Because she was stoned.

Hollis discussed the relationship between drugs and perception "and the arts specifically," and quoted Rimbaud, saying that the only way to make a poem was systematically to derange your senses. He allowed as how drugs "could have the effect of freeing people from those authorities who have told them, in Stan Brakhage's terms, that the sky is blue."

To this, Joyce responded:

> I think that drugs are very useful. I made *Rat Life and Diet*

and all of *Reason Over Passion* using this process. I would edit all day and then I would get high at night and I would review what I had edited, and it was the quickest way to where I was going. It was just like miraculous. I could pick out everything that was wrong and the next day I would just begin again, and that was fine, and at night again I would do it. I did this like for two-and-a-half months with *Reason Over Passion* and it became the most objective and useful tool.

She clarified for Hollis that she was talking about pot, not acid.

He wondered if using "that herb" was similar to detaching yourself, something like a Midwestern habit he "inherited" of "aimlessly driving your car around when you wanted to think," and somehow putting a "distance between yourself and the day's activity in your mind."

Joyce's response to that was, "But let me add one thing. In New York you can't go for a walk, whereas if you were some place where you could go for a long walk that might almost take the place. In New York you have to use a very quick shortcut for many things."

Hollis asked, "If you were working in Canada would you feel differently?"

Joyce replied, "Well, when I'm in Canada I take a two-hour walk and come back."

Without any comparative measure of pot's or acid's contribution, or lack of it, to Joyce's filmmaking, there is no doubt that *Rat Life and Diet in North America* helped Joyce focus on her personal and artistic goals. And *Reason Over Passion* contributed to the improvement of her articulation skills, caused in great part by the media attention the film garnered.

During *Reason*'s two-year production period, Joyce found herself in interviews having to define her films, her technique, her purpose. This was a relatively new exercise. She had exchanged ideas with other filmmakers at the New York Cinematheque, where acceptability ruled the day, but when formal questions were asked of Joyce she was compelled to re-examine

herself in her own creative terms, not those of her colleagues. Or Michael's.

"I have been called a feminine artist. Whatever that is," she is quoted as saying. "It is fine to bring dignity to that term. . . . Naturally as an artist you select images you want and which in my work express a female sensibility. In the way I have worked, I don't know whether a lot of filmmakers work like that — Jesus, how to say that stuff? It is really hard to trust people with information about how you make a film in this way because they think you are making a lot of accidents and then trying to do something with them."

She compared film with abstract expressionist painting: "The thing is being made and sometimes you know what it is afterwards. There is a great deal of subconscious material and individual sense about colour. It is also the fact that no matter what piece of film you pick up you're taking a chance. It is really a very delicate thing to talk about."

In this conversation, dated 1974, significant is her comment about knowing the nature of something after the fact. This could mean either that the work takes on its life only in the completed form, or that others' opinions help shape its identity. Early in her career Joyce put on a brave front of not being affected by opinions of her work, laughing in public and crying at home, but around this time she forced herself to disregard negative comment. (*Rat Life* had been her impetus.) Drawing the comparison between film and abstract expressionist painting is apt. An abstract work computes differently for each pair of eyes viewing it; therein lies its greatest mystery. Critics, curators, art lovers, and Uncle Fred posit meaning in the colours, shapes, brushwork, and even the picture frame, although inherent meaning does not exist in many abstract works, just as there is none in landscape painting. But both can make the heart sing.

Unlike *Rat Life and Diet in North America* — a fully formed political statement that garnered some negative response — *Reason Over Passion* — received widespread, almost-unqualified approval. This was particularly satisfying for Joyce, as the film unambiguously concerned Canada.

Reason Over Passion/La raison avant la passion had its premier at the

National Arts Centre in Ottawa in November 1969, and was screened in New York at Jonas Mekas's New York Christmas Festival at the Elgin Cinema in December 1969. In January 1970, the film was included in the Museum of Modern Art's prestigious film festival, Cineprobe. But Joyce garnered her highest profile as a filmmaker when *Reason Over Passion* was selected for viewing at the Cannes Film Festival in 1970, for the Directors' Fortnight.

P. Adams Sitney called the film Joyce's "major film so far. With its many eccentricities, it is a glyph of her artistic personality: lyric vision tempered by an aggressive form, and a visionary patriotism mixed with ironic self-parody. It is a film to be seen many times."

Jonas Mekas declared: "Ah! The first kinetic Chinese scroll. Made in Canada, by Joyce Wieland!"

Barrie Hale wrote: "Joyce Wieland's movie, like Canada, is as pure and simple as a public monument — too simple and direct to ignore, too complex in its approach to simplicity for anyone to forget for long."

As Manny Farber described it: "*La raison avant la passion* is a clutter of love for Canada, done in the nick of time before it changes completely into a scrubby Buffalo suburb."

Hugh McPherson held that: "Joyce Wieland has given us her most uncompromising and complex quilt — a mosaic of emulsion on acetate which perhaps only the fullest union of passion and reason can contain and comprehend."

Among Joyce's papers are typed outlines of her films prepared in the highly personal manner of why-I-made-this-film. Some outlines are neater and better presented than others; all, however, are informative. Her two-page outline headed "Reason Over Passion," abbreviated, and tidied up only for clarity, reads:

> Like a space language or Russian. Maybe the beep originated from this . . . a space radio . . . a country observed by another intelligence? (Rot you say!) Fuck you!!!! (I just don't know.)

Then came the fantasies of being a government propagandist. When you are editing a film for three months you may have fantasies 12 hours a day. I thought I was Leni Riefenstahl. It was due perhaps to editing Trudeau . . . would he be a good leader? Or just a politician? Irony came wandering in, in the form of applause (in the introduction) for his statement: "Reason Over Passion . . . that is the theme of all my writing."

And it came too in my soundless singing of O Canada. (Dutiful but I mean it, too). But on the other hand this scene is merely a portrait of my Bolex which is under my chin . . . shooting me singing and forgetting the words, because I'm stoned. The film is sewn together with flags, 10 different kinds (different colours, different shootings) meant to complement colour-wise the clear and fogged leader (fogged in different tints) which they tie together.

Flag sewn fogged ends together.

Image to fogged end to flag lumps.

Ribbons and knots.

In the spring of 1968 Americans had been twice plunged into deep mourning by two political assassinations, those of Rev. Martin Luther King, Jr., on April 4, and Senator Robert F. Kennedy, two short months later. These tragedies, followed by later riots at the Democratic National Convention in Chicago and consequent brutal police action, stunned the country.

By contrast, Canada basked in a state of political euphoria. Canadians were in love with their P.E.T., Pierre Elliott Trudeau, who took office as prime minister in April 1968, and people were still enjoying the nationalistic feasts cooked up during the previous year's Centennial celebrations.

Joyce had spent uncountable hours studying and filming the face of Pierre Trudeau for her film *Reason Over Passion*, and the man preoccupied her thoughts in a manner bordering on a sweet little lovesick obsession. Following the film, Joyce created an event that would celebrate her dash-

ing prime minister on yet another level, in another medium.

With love-ins and sit-ins singeing the country's consciousness like a sociological brush fire, Joyce decided to host a quilt-in to honour the prime minister — inimitably, her way. She invited her Canadian women expatriates in New York to her loft on May 21, 1968, to join her to stitch a quilt for Trudeau. Canadian actresses working in films and appearing in plays on Broadway headed her guest list, among them, Zoe Caldwell, who had recently won a Tony Award for her starring role in *The Prime of Miss Jean Brodie*, Kate Reid, who was starring in Arthur Miller's *The Price*, television commentator Joyce Davidson (Suskind), public-relations consultant Valerie Jennings, actress Colleen Dewhurst, ballerina Melissa Hayden, Broadway composer and lyricist Marion Grudeff, and playwrights Jackie Rosenfeld and Mary Mitchell, among others. Friends Betty Ferguson and Sylvia (White) Davern were also there.

Joyce designed the quilt with the stuffed and appliquéd letters *La raison avant la passion*, the French translation of *Reason Over Passion*, made earlier that year and purchased by the National Gallery of Canada. On the reverse of her French version, Joyce made little pockets into which she tucked messages to Trudeau and gave him the quilt. Those messages? Margaret Trudeau may have an answer. The quilt had been hanging in a hallway in the prime minister's official residence, 24 Sussex Drive, and Margaret, prefacing disintegrating incidents of their marriage in her book, *Beyond Reason*, writes, "The colder Pierre became, the more hysterical I got," and concludes a series of examples by outlining an argument the couple was having. She flew into a "frenzied temper" and grabbed at the quilt, wrenched off the letters and hurled them down the stairs at him one by one . . . to put passion before reason just this once."

Joyce's habit of stuffing little surprises, messages and bits of ephemera into her artworks is evident on the back of her quilt, *Man Has Reached Out and Touched the Tranquil Moon*, made two years later, in 1970, where she sewed a pocket and tucked into it a card that reads: "The title, *Man Has Reached Out and Touched the Tranquil Moon*, is from a statement

about the moon shot by Pierre Trudeau."

Trudeau loaned *La raison avant la passion* for an exhibition that opened in December 1970 at the Tel Aviv Museum in the Helena Rubinstein Pavilion. Organized by the National Gallery and the Hadassah-WIZO of Canada, in an effort to forge closer cultural links between Canada and Israel, this was the first art sent by the National Gallery to the Middle East. The exhibition featured thirty-six artworks by eight Canadians, among them Alex Colville, Gershon Iskowitz, Jean-Paul Riopelle, Greg Curnoe, Charles Gagnon, John Meredith, Guido Molinari, and Joyce Wieland, who was distinguished by being the only woman artist in the exhibition.

Around the mid-1960s, Joyce, Michael, and R. Bruce Elder were ranked Canada's top underground filmmakers even though their films were virtually unknown and rarely screened in their home country. Underground filmmakers everywhere suffer similar neglect; the audience for this genre is minuscule. Despite the average moviegoer's knowing nothing of either Joyce or Michael as filmmakers and not having heard of their films, the underground-film community lavished praise on them, especially Michael, who would take the cinematic lead by the end of the 1960s through his film *Wavelength*. Released in 1967, *Wavelength* generated a sensation and within three or four years the film became one of the most discussed of all avant-garde films. It remains by far Michael's best-known film and receives kudos for being Canadian-made. When you think that Canadians readily identify feature films such as *The English Patient* as Canadian because of Michael Ondaatje or *Crash* because of David Cronenberg, in the avant-garde film community, *Wavelength* is as thoroughly analyzed, dissected, and entrail-examined as are *The English Patient* and *Crash* in their culture.

The primary difference between Michael's and Joyce's films is apparent in general terms by their differing personalities — Michael being cool and intellectual, and Joyce, hot and emotional. But the generality cannot be left here. Joyce's early films, made before 1967, have been grouped in the

structuralist genre along with Michael's, but then again, not quite. Puzzling for critics has always been the fact that Joyce did not wholly conform to the new visionary cinema, in chief, because of her feminist/political messaging. She appeared to be classifiable until her distinct persona entered her work and disqualified the classification. Whereas Michael, from the beginning, had been positioned as a visionist filmmaker.

Hollis Frampton's reputation, too, was on its ascent. After making three films since 1967, he produced *Zorns Lemma* in 1970, the film that established him as a "major contributor to alternative cinema."

The two men close to Joyce, with whom she worked in co-productions, were outpacing her but she was not left behind in their dust. As of 1969, she had completed fifteen films (including one unfinished and one co-produced with Michael), two that were particularly highly regarded, *Rat Life and Diet in North America* and *Reason Over Passion*. Since 1963, her films had been shown in festivals, starting at the Isaacs Gallery in Toronto, then in 1967 in the United States with two major shows at the Boston Museum of Contemporary Art and at the Jewish Museum in New York. These were followed by two outings at Manhattan's Museum of Modern Art — one in 1968 and the other in 1969. Like Michael's, Joyce's work appeared in the 1969 Belgium International Festival. Unlike Michael, she did not win a prize.

However, in 1968 Joyce won the first of her art prizes for film at the Vancouver Film Festival, which was an outstanding "first" in that she won two prizes, an Award of Merit and an Honourable Mention. A sweet victory was Joyce's to savour in 1969 when, in competition with her New York peers, she won two prizes again in one festival, the New York Third Independent Filmmakers' Festival, for *Rat Life and Diet in North America*; and *Reason Over Passion* would be screened at the 1970 Cannes Film Festival.

By the end of the 1960s, Joyce was ranked one of New York's top ten filmmakers of the avant-garde cinema. Also included were Michael Snow and Hollis Frampton.

After Joyce's successful quilt-in for Prime Minister Trudeau in May 1968, she had another grander idea — inviting him to a party in their loft. She would also invite Canadian artists, actors and writers living in New York, along with a select group of New Yorkers in the arts.

Michael had not been too keen on the idea, complaining that Joyce had already hosted a party in the prime minister's honour with the quilt-in. But Joyce prevailed, and she and Mary Mitchell extended the invitation to Trudeau's principal secretary Marc Lalonde, who subsequently came to New York to hear what they had in mind. Joyce was overjoyed when Mr. Lalonde called to confirm that Mr. Trudeau would be pleased to accept their invitation and suggested a date when the prime minister planned on being in New York. At that, Michael threw in his full support.

The party, held on November 8, 1969, ranked a Ten even in partied-to-death Manhattan because of its star guest, Reason Over Passion himself, Prime Minister Pierre Trudeau. The buzz started the night before when he deplaned from his prime-ministerial jet in New York to have dinner with a woman he had been dating, Barbra Streisand.

"It was marvellous," the prime minister said, not referring to his date or the party, but to the fact that he could walk down a New York street unobtrusively in his white trench coat — apart from a rear flank of plain-clothesmen from the Royal Canadian Mounted Police, the U.S. State Department and the New York City police force. "I can walk along and do anything — pick my nose if I like," said Canada's leader.

The week before, Trudeau in his first year as prime minister, had made a statement in the House of Commons declaring that he would seek a meeting with U Thant, secretary general of the United Nations, to solicit international co-operation to endorse a convention that was drafted to protect the high seas from pollution. Canada was vulnerable to oil spills or other pollutants caused by ships sunk at sea whose toxic substances could travel under ice and pollute vast square miles of Canadian coastal shorelines, particularly the Canadian Arctic. This set Joyce's ecological

nerve endings into a beautiful delirium; her prime minister taking action to support one of her causes, the protection of Canada's resources. (Trudeau, even with his legendary prescience, could not have foreseen the upcoming *Exxon Valdez* disaster. Or could he?)

On the night of the party, guests assembled in receiving-line formation awaiting the prime minister and when he arrived, Robert Cowan reported that Trudeau "pooh-poohed" the formality, saying, "He just wanted to have a good time."

Robert and Michael had arranged for the music: two saxes, a clarinet, and a drummer — "very wild," by Michael's description. "It started out extra loud and violent and everyone flinched," Michael said, and laughingly added that even Trudeau's security guards "jumped into position."

The breadth of Prime Minister Trudeau's knowledge of the popular and classical arts surprised people who met the man, Michael Snow among them. Michael said that Trudeau was familiar with the New York experimental film scene and knew Jonas Mekas, and as Michael chatted with Trudeau about the quartet that was playing, he described Milford Graves, a flashy drummer known for infusing his drumming with Asian and African rhythms, as "the greatest drummer in jazz." To which Trudeau responded, "What about Max Roach?"

Michael said, "I found that very impressive," that Canada's prime minister would be aware of one of the giants from the bebop era, a drummer who revolutionized jazz drumming with his ferocious drive and technique.[2]

In advance, the prime minister's staff had conferred with Joyce and Mary on routine security protocols — review of the guest list, no publicity, no photos — and Joyce had to confiscate one woman's camera, although guests did not check their politics at the door in that troubled year of 1969 with, in particular, anti-Vietnam War sentiment running high. Canada had recently granted landed-immigrant status to American draft dodgers and deserters, the Cold War chilled still, and the pyrotechnic New York mayoral race featured Norman Mailer seeking office on a

platform of "No More Bullshit." Meanwhile, President Richard Nixon stewed in his juice of resentment over Canada's flamboyant, erudite leader, a man Nixon would soon dub "that asshole."

Joyce served Canadian foods such as Oka cheese, tourtière, and maple-syrup cookies, and she stocked the bar with Canadian rye whisky and Canadian wines. The loft was jam-packed. Among the New York stars to come out that night were poet Robert Lowell, author Mary McCarthy, sculptor Carl Andre, architect Constance Abernathy, composer Lamont Young, filmmakers Jonas Mekas, Ken and Flo Jacobs, and Joyce and Michael's numerous artist and musician friends. Film star Eli Wallach and his wife Anne Jackson had found the prime minister "completely charming," and Wallach is reported as saying he discussed the Vietnam War and anti-ballistic missiles with Trudeau. "He wondered why we can't just sit down with the Russians and work all this out. You know, basically, that it-takes-two-to-tango thing." Given Trudeau's penchant for public cavorting, one expects to hear next that Wallach and Trudeau did, in fact, tango.

Typically, Trudeau's presence was riveting, sexual, dynamic. Women crowded around him, in attendance dateless — unless you count the RCMP — but the big rumour sweeping the party was the prime minister's beyond-casual interest in Joyce's hip, sexy friend, composer Carla Bley. The fever pitch never let up. All through the evening, more than Trudeau's security guards had eyes fixed on their man. One woman said, "There was a steady lineup of ladies standing around waiting to dance with him. I just picked myself up and went outside and cried."

No such behaviour was exhibited by Gloria Steinem, with whom the prime minister reportedly "frequently danced." Not reported was the fact that her dancing became "a little too friendly," a situation that gave the RCMP their only official duty of the night: separating Canada's prime minister from his "overzealous" beautiful blond dancing partner.

Joyce's love of Canada, the land, stimulated her continuing experimentation with nationalist themes in painting, assemblage, quilting, and

film. And yet, regardless of her output and the mediums she used as the 1960s neared their end, Joyce began to sense a missing "something." She couldn't identify the grating, gnawing in her artistic bones, but the irritation persisted.

The vague ideas began a slow transmutation into a shape that eventually became Canada. The land in all its immensity, its beauty and rarity, the goodness of ordinary Canadian people, and the heroes Canadians knew so little about, had been on Joyce's mind most of her adult life. Images far outpaced her ability to execute the entire three-ring circus that filled her head but failed to coalesce into a bold oneness, a thing as big and grand as the visions, words, colours and musings that titillated her. Joyce documented September 1969 as the time she had developed her "something," which took the form of a desire to express her agglomerate ideas about Canada to an audience larger than the one that patronized art galleries and film festivals; and next, she determined that the medium must be a feature film.

Of course, this would be no ordinary film.

Certain imperatives asserted themselves as though preordained: that the film honour a Canadian hero, that it be a love story laced with mystery and intrigue, and that it celebrate Canada's beauty. However, Joyce's film would go that one step beyond and bear her requisite imprimatur of disaster. Assemble these elements together, and you have the life of Canadian painter Tom Thomson.

Thomson's landscape paintings are among Canada's most instantly recognizable art icons, images that generations of schoolchildren know as framed reproductions hanging in the classroom or assembly hall; and kids who grew up lucky enough to see the real, dazzling thing in Canada's art galleries were forever-after Thomson devotees and Group of Seven enthusiasts. These paintings celebrated the land as early Canadian poetry had for Joyce when she had discovered Canada's "superb nature poets." Years later, she realized that art and poetry defined Canadian history but that otherwise, "Our history was nothing," it had been "hidden from us." As a nation

without a history, Joyce bitterly declared, "we're just like black people or women or other criminalized people." Not until you can be responsible for the land you are standing on and relate to it as nature, she felt, can you "start in the most intimate regional way to be responsible for what you are."

Therefore, as an artist, Joyce could assume her responsibility to the land. And while she pondered the life of Tom Thomson and assessed his great contribution to Canada's history, she came closer to her responsibility to Canada — through her movie.

Tom Thomson was everything Joyce's filmic heart desired. A painter, a loner stalking Northern Ontario to impound in paint the land's best trees and streams, its fairyland dawns and sunsets, the seasonal resplendence of snows, spring breakups, summer wildflowers, and autumn leaves, who, with art supplies and a little booze (we now know), paddled his canoe in search of his personal "true north strong and free." Then tragically, at age thirty-nine in 1917, he drowned in an Algonquin Park lake under mysterious circumstances. Suicide? Murder? The only answer is and always has been speculation.

Joyce undertook to learn all she could about Thomson, the man, and to expand her perceptions of Thomson, the painter. Little had been written about Thomson at that time, but it was known that he had lived an uneventful personal life, judging by artistic stereotypes; which is to say, he was not a carousing, brawling sot who juggled wives, exes, and mistresses, lost track of his many-mothered children — no trace of an Augustus John or a fictional Gully Jimson in Thomson. The handful of people he associated with were painters A.Y. Jackson and J.E.H. MacDonald, art patron Dr. James McCallum, and a woman in Northern Ontario with whom he was vaguely linked romantically. A body of great Canadian art binds together a flimsy personal history, while art lovers remain smitten.

The moment Joyce engaged in a serious study of Thomson's paintings, her early appreciation for his work expanded monumentally. Always an admirer, now she was in Thomson's thrall:

I began being interested in Thomson's art when I was young. All his sketches were impressive to me, though my teachers would sometimes point out *The West Wind.* . . . Later at Central Technical School in Toronto, I spent a lot of time in the Toronto Art Gallery. As a budding artist I felt drawn to the freshness and intensity of Thomson's feeling for nature, something close [to] all of us as Canadians.

Later [in her research] I began to understand the contours of Thomson's life, how he liked to travel, and his playful ways. What attracted me to him and made me want to make a film that would deal with his kind of personality was the pioneer spirit in Thomson — going off by himself, and discovering a landscape for the first time.

Starting work on a film, whether on a poolside laptop in Beverly Hills or in a pencil scrawl in a Bombay bar, every discussion, every martini or cup of tea celebrates the filmmaker's dream. Then follows the reality: raising money, casting, refining the idea, scripting, raising money, raising more money. Joyce's underground-film experience compared with Hollywood filmmaking resembled the difference between a lobster lunch at the Polo Lounge and a bran muffin at her kitchen table. She had no resources, no backing. But like all the others, Joyce had her beautiful dream. And right off she had her title: *The Far Shore.*

The largeness and scope of a feature film very soon stymied her. Unlike the speed and deftness with which she could transpose her visual ideas into unstructured film, it surprised her to realize that she could not shape her ideas in this format. But true to her tradition of confronting struggles, Joyce pressed on. She began by writing a script outline. She wrote and rewrote, but the further she progressed, the more she realized that her story was oversimplified. A haze clouded it, like a morning mist over a pond, and yet the images of her film remained crystal clear in her mind. This never changed.

Joyce would spend almost six years working on *The Far Shore*, and throughout the entire time she did not stray from her original intent of making a love story set against the monumental beauty of Canada. The land would appear as a dominant character in her film. Just as waves froth up against miles of sandy beaches in travelogues, alluring and sumptuous with heat and desire, Joyce would characterize her country's lakes and trees and wildflowers as passionately scenic and as captivating as her lovers on film.

The story is about a husband and wife, Ross and Eulalie, who live in a grand old mansion in Toronto next to an artist living in a temporary construction shack who disappears each summer to paint Northern Ontario landscapes — as did Tom Thomson. The couple travel up north and meet the canoe-paddling painter; Eulalie falls in love with him. Their love unfolds against a backdrop of pine trees and lakes, glowing sunsets, naked swimming, lovemaking in the lake, every frame enriched with sweet, sonorous music. Joyce saw in her mind's eye whole scenes. She was tired, she said, of meaningless movies where "we see men playing around, smoking cigars and shooting each other's ears off."

Eulalie's husband is a boorish English-Canadian, a philistine driven by a lust for money-making, whereas Eulalie is a sensitive, cultured Quebec woman, whom Joyce modelled on Michael's mother, Antoinette Snow. ("I think she was pleased about it," Michael said.) As a young woman, Antoinette played the piano but her father prohibited her from taking up a concert career, and this "really, really hurt her," Joyce said. "But she never stopped playing the piano. She just got better."

To Eulalie's intellectual, cultural persona Joyce added elements of Lillian Gish, a star with similar qualities to her mother-in-law's — a fragile beauty in possession of great strength. Joyce's affection for the "first lady of the silent screen" had begun when she first became acquainted with Lillian Gish at Toronto Film Society screenings in the 1950s and intensified when Joyce accidentally tuned in to a television interview with the actress (who was in Toronto), and heard the star compare acting to painting.

"That image really struck me," Joyce said. "I thought of Gish in her films, how she was always watching herself on the screen — seeing outside herself . . . seeing the shapes she was making, the arcs, the stops, the posture." Joyce immediately dashed out of her house and ran to the studio to meet her, "just as she was being escorted into a taxi, just in time to take her hand and say, 'You'll never know what you meant to me. I hope we'll meet again.'"

In 1969, while Joyce was preoccupied with her script for *The Far Shore*, Pierre Théberge, then Curator of Canadian Contemporary Art at the National Gallery of Art (now its director), offered her a retrospective exhibition to be held in 1971.

Joyce was the first living woman artist to be given a retrospective at the country's national gallery.

Describing Joyce as "one of the great artists of the second half of the twentieth century," Théberge felt that "she should get a show." He had admired Joyce's work for several years and had initiated the gallery's purchase of *Balling* and *Confedspread* in 1968.

Théberge said he simply phoned Joyce in New York and made the offer, permitting her to exhibit existing work or make new work especially for the exhibition — her choice.

Joyce's response? "She was a bit overwhelmed," said Théberge. He visited her several times in New York to help her "fulfill her vision" of an exhibition.

For the artist, a retrospective is a dangerous, exciting, pulse-stopping, personal exposé. Its intent is to document the artist's evolution and create a panoramic view of a lifetime's or a stated period's work. It is recognized that whenever a major gallery presents a retrospective exhibition of an artist living or deceased, the gallery is bestowing its highest accolade upon that artist. For the living artist the experience compares favourably to near-death-by-drowning, when up there on all those walls, for all to see, the individual's artistic life flashes before his or her eyes. Exhibiting a dozen paintings in a

solo gallery show, too, can have this similar denuding, life-and-death effect. Painter Tom Hodgson used to say about attending openings of his exhibitions, "I feel like I'm standing around with my pants down."

This much Joyce knew: She would take Pierre Théberge at his word and do exactly what pleased her.

Themes, ideas, images, and concepts tumbled kaleidoscopically through her mind from morning to night. What to select, what to omit, what to make new for the exhibition? Having a fairly substantial body of drawings, paintings, and assemblages to choose from, and two years in which to make new works, Joyce teased herself maddeningly with indecision. Then, employing her time-honoured trick of poking at a predicament until it turned tail and ran off, exposing another view, she stopped thinking of the selection of works and concentrated instead on its theme. She saw her retrospective as grandly Canadian. And once that was established, the title came to her: *True Patriot Love/Véritable amour patriotique*. Her retrospective would embody the spirit of Canada true to the national anthem's phrase "true patriot love," and her art would represent patriotic feelings and emotions as everyday aspects of life, like the events she remembered as a schoolgirl — singing the anthem, respecting the flag, learning geography. Joyce's ideal of art fitting into daily life now had a beautiful adaptation; she would create art in which patriotism appeared naturally. She also saw the opportunity to "spread out . . . with all the elements — ecology, history, politics, the times, women, women's work and the power of all that." These national/political themes would be best incorporated, Joyce decided, in cloth assemblages tailor-made to fit her theme. And to make them, she could count on her sister's help.

There is some question as to whether Joyce would have proceeded in this medium, and in this direction, without her sister's involvement. She could hardly have found a more capable, devoted person than Joan to work with her; also, Joan's needlework skills greatly exceeded basic competence.

The old-fashioned side of Joyce adored embroidery, knitting, crocheting — all the needlecrafts. She would use them for her retrospective. Her

mother had done beautiful needlework, a skill that Joan had picked up, but if Joyce intended to incorporate needlework into cloth wall-hangings and quilts, she would have to find people still working at these crafts. In the meantime, she began designing quilts that incorporated various types of needlework.

In the fall of 1970, Joyce travelled to the Atlantic provinces to scout country fairs, searching for women to do embroidery, knitting, and hooking on her quilts, and she encountered exactly the proficiency she desired. She found Joan McGregor of Halifax to embroider two projects: the words written in the last letters exchanged between two historic figures during the Battle of the Plains of Abraham, General James Wolfe and General Louis-Joseph de Montcalm. Joyce mounted the two embroidered letters side by side in a frame.[3]

The second embroidery work was an outline of Joyce's mouth forming the words of the national anthem.

Joyce contracted champion knitter Valery McMillin of Dartmouth, Nova Scotia, to knit four Canadian flags, each two-and-a-half by six feet.

The Water Quilt, for example, one of the five major quilts she would create, comprises forty-eight small white cotton pillows mounted on a canvas and set into a frame. Over each pillow is a flap, with a delicate, embroidered Canadian wildflower at its centre, and when lifted, the flap reveals a photo reproduction of a page from a book by James Laxer, *The Energy Poker Game*; every page deals with a specific warning about Canada's squandering its natural resources. Producing this work consumed more than a year.

Joyce was asked if using Laxer's book indicated some personal affiliation with the Waffle Movement. (This was a short-lived political group — 1969 to 1972 — composed of ultra-nationalist members of the New Democratic Party, of which James Laxer was a founding member. The name derived from its manifesto that decreed that if the group waffled on any issue, it would "waffle to the left.") Joyce was attracted not to the movement but to the book, saying, "It was a beautiful book because it

dealt with all the facts." The book also proved to be excellent ammunition for her burgeoning environmental activism and her disgust with American ecological bullying. A couple of years later she explained:

> I felt a sense of responsibility which I'd never felt before, about what I could do about the situation in this country, because I'd read about the American ownership and how plans were being drafted in Washington for the Arctic, and how this grid had been made for resources. And so all these plans . . . [described] in *The Energy Poker Game* . . . the water report which the Americans admit had been made something like fifteen years prior to that book coming out, which was simply a drawing on a board saying, "We'll reroute the major waterways to the south." These kinds of things are the things that really got me insane, and made me feel that I should use all my resources for Canadian independence.

Reading that these "mad fantasies" had been given serious consideration by a government that she believed even wanted "to melt the Arctic," Joyce found it doubly disturbing that such information had not created a huge public response. "It infuriated me to think that someone outside could be drawing plans for stuff like that. And that's what inspired *The Water Quilt* — the stuff that he [Laxer] dug up."

Joan Stewart managed the project from beginning to end. Joyce was still living in New York and Joan lived in Halifax. Joyce travelled to Halifax a couple of times and went with Joan to purchase cloth, thread, wool, and necessary hardware fittings, nails, screws, glue, and wood for frames.

At first, Joyce had felt it important that she do all the work herself. However, before long, she discovered her shortcomings.

> I found that there were special qualities with certain stitches; the way my sister did it was exquisite. After three years of

doing work together, I really got to understand what was necessary. . . . So, it was gradually worked out that I did less and less, and she took over.

Joyce made sketches and colour swatches that she photographed and then projected slides of the design and colours on the wall. Working from these images, Joan and the others stitched the quilt.

The energy generated by the craftswomen enchanted Joyce, and she loved seeing her designs unfold in the hands of conscientious, dedicated women. She told one writer, "They are hooking, embroidering, and knitting their asses off."

Productive and energized by two immense projects — her retrospective and the feature film — Joyce thrived. And yet, consistent with her past history, these were precisely the circumstances that invited disaster. It struck in 1970. Joyce suffered a major rejection as a filmmaker when her films were omitted from the newly formed New York Anthology Film Archives, which operated as a repository for films and as a circulating film library. Through the Archives, leading filmmakers were promoted and their films given wider circulation, nationally and internationally, replacing the previous ad-hoc system of screening films by everybody and anybody in lofts and at the Cinematheque. The only means open to a filmmaker for having his or her films included in the Archives was through a selection process by committee. The first committee comprised filmmakers and critics: James Broughton, Ken Kelman, Peter Kubelka, Jonas Mekas, and P. Adams Sitney. They solely determined which films would be archived.

Joyce's films were not among them. Michael's were. As were the films of Joyce's filmmaking collaborator, Hollis Frampton.

At first, Joyce was baffled. She didn't know why she had been excluded. Her reputation as a filmmaker was well established. She was rated among the top ten underground filmmakers in New York, a positioning not lost on selection-committee members.

By 1969, beyond the halfway point in her filmography oeuvre, Joyce had produced fourteen short films and her ninety-minute film, *Reason Over Passion*. And fresh on committee members' minds would have been *Rat Life and Diet in North America*, which had won two prizes in New York that year. Yet they failed to include Joyce in the Archives.

Critic Jonas Mekas explained that the selection process is not based on "predetermined rules of what Film Art is," but on "intuitions of some of the best minds making films and writing on cinema today." When a serious doubt about a film arises and "we get tired or arguing, very often we drop into a deep silence and one of us says: 'OK, is anyone of us willing to defend this film with a real passion?' Or: 'Is there anyone here who is passionately for this film?' And if there is one, we know there is something that we shouldn't dismiss too easily. . . . Although our results are precise and unwavering and almost academic, the way we arrive at them is through a process, and that process defies all rules."

Mekas had reviewed *Rat Life and Diet in North America* and called it "about the best (or richest) political film around" and "one of the most original films made recently." High praise from an Archives selection committee member not "willing to defend this film with real passion."

Joyce regarded her omission from the Archives as a stinging dismissal from her peers. More painful still, this represented yet another rejection for her.

A full ten years later, Joyce's bitterness had not abated; when Lauren Rabinovitz asked Joyce if she had been conscious of being a woman among the New York circle of underground filmmakers, she replied:

> Sure I was. It didn't come up consciously, but even in the late 1950s I knew there was something legitimate in a female outlook, female expression. But to go further than that, the real problem was that mine was a real expression besides being feminine. *Rat Life* is a good example. There was a tendency within the avant-garde in terms of writing and criticism to

underrate my work because I wasn't a theoretician. Many of the men were increasingly interested in film about visual theories. I feel there was a downgrading of my work. It didn't get its proper place, its proper consideration, especially at the Anthology Film Archives, where they secretly judged which films they would select for their Archives.

Convinced she had developed at par with many filmmakers who were included in the Archives, she added, "Then I was left out . . . and I thought, 'Goddam that shit. You could have Maya Deren. And you could have Marie Menken'" — filmmakers no longer living, a prompt for Joyce to charge that "a lot of men appreciate and eulogize women after they're dead rather than deal with them while they're alive." Joyce's friend Shirley Clarke was overlooked, too, "because she wasn't experimental enough, but they thought she was courageous and daring enough when she was raising money for the Film-makers' Distribution Centre" [now called the New York Film Co-Operative]." Shirley Clarke, an heiress whose family lived on Park Avenue, contributed her inherited wealth and worked from 1960 to 1968 founding the distribution organization, which directly benefited those same members of the selection committee who failed to include her in the Archives. Referring to Clarke's violence-driven Harlem teenagers in her film, *The Cool World*, Joyce declared, "If there were Russian subtitles on that, they [the selection committee] would have drooled over it."

Some five years later, Joyce's take on this was, "It really is a wonder that any women filmmakers have managed to survive."

Kass Banning, instructor in cinema studies at the University of Toronto, observed with irony that "the Film Archives was formed to institutionalize and consecrate experimental filmmaking, but in Wieland's case it functioned as an expelling agency."

Interviewed in his New York loft in 1999, Jonas Mekas is asked about Joyce's exclusion: "A lot of people were left out," he stated dispassionately, and closed the subject by saying that if three of five judges "voted

against," then that filmmaker was not included.

Filmmaker Ken Jacobs does not mince words. "They were so stupid. They were arguing and none of them could see what Joyce was doing. It was against their intelligence to value her." He passes them off with a singular inevitability: "They're stuck with who they are."

Ken's wife, Flo, sensitivity pooling in her eyes at the memory, quietly murmurs, "Joyce was hurt."

Speaking to writer Susan Crean about whether or not a female or male art exists, Joyce said that critic Leila Sujir best defined her work when she called it "emotionally based, that there isn't a theory, but there is a language of emotions." Joyce defined female art, saying, "I think it has to do with how much you want to hang on to being a woman. It's an act of, 'Do I want this? Will I take this risk? Will I be true to my feelings?'"

To this Joyce added:

> In New York in the 1960s real art was never about feelings. It had a very patriarchal look. Not only do few women ever get into that world; their aesthetic is ignored. Men's dialogue, on the other hand, is always printed. Articles are written about it; big catalogues are compiled and their aesthetic becomes law, or the criterion that defines what the game is all about. In short, their theory becomes art history.

Joyce knew that her notion of a female aesthetic was not wholeheartedly accepted by her male colleagues, and possibly not by certain females. To emphasize her point, Joyce uses Leni Riefenstahl's 1934 film, *Triumph of the Will*, which was criticized as a major propaganda piece for Hitler. Joyce notes that the famed German filmmaker (alive at age ninety-eight at this writing) uses techniques only a woman would use — numerous flags and banners, prominent in scenes of marching armies and Olympic athletes' parades, as shot through a "female filter." This could mean that a woman's aesthetic appreciation of silk fabrics is just as romantic when

fluttering on poles in a stadium as when swishing around a woman's legs. And the fact that Riefenstahl filmed only the back of Hitler's head as he addressed the masses struck Joyce as signifying that the man was no "more important than other elements in the film." This is a discreet touch that Joyce interprets as purely feminine, lost on a male filmmaker, who would need the frontal moustached face for identification.

"But if we are talking about a female film aesthetic," Joyce stated, definitively, "I feel it consists of putting something in the world which wasn't there before."

Noted New York film critic Andrew Sarris, writing in his regular column on film in the *Village Voice*, took a foray into that very subject, wondering if there exists a "distinctly female point of view on film" in commercial films. He lists women directors (including, esoterically, the names of two women whom he notes in parenthesis are "certified males") both American and European, and comments that Lillian Gish, Leni Riefenstahl, and Shirley Clarke have made "respectable" commercial films, and, "The talented Canadian Joyce Wieland leads the contingent of women film-makers in the experimental, abstract, poetic, avant-garde, underground categories."

A finer accolade would be hard to come by. The problem was, apart from savvy filmgoing New Yorkers and Joyce's colleagues, neither the critic nor the underground film culture had any Canadian standing. And though Joyce savoured the immense praise contained in one sentence of a nearly full-page review, largely she savoured it alone.

Like reviewing yesterday's steamy love affair through today's cool eye, Joyce picked up early warning signals that her feminine film aesthetic lacked widespread approval, but she was too engaged in the thrill of film-making to attack her detractors. Joyce had not been naïve; she just wanted, so badly, to make her kind of films.

The underground film world had changed irrevocably by the end of the 1960s. Artists cum filmmakers from all over America landed in the

Village, circled the wagons, stole the pioneers' ideas, and applied their pure theory to vanquish the emotion of film.

In Joyce's view, the apocalypse was a result of a sudden "invasion of uptown artists, all those guys with very exclusive galleries who came to re-create our cinema. Which is OK I guess; but then the theorists arrived, like flies on shit, and built this bastion. At the same time, it was all very seductive. The films were exhibited and gradually things emerged so that the avant-garde art world could take our work and use it — which is what New York is all about." She added, "With that transition came that *Deutschland über alles* theoretical world. For me it was the end of the road."

This changing film movement, combined with her exclusion from the New York Anthology Film Archives, marked the "turning point" for Joyce. She said, "I simply thought, I'm not going to live or die by their standards of film excellence. I live by my own rules."

After nine years in New York, the city itself contributed to her turning point. She didn't feel the need to adore the place anymore. Her career, her marriage, and her wreck of a loft — "She hated that damned loft," said Donna — were creating frictions, although a misfortune of a graver sort would call an end to Joyce's days in New York.

Joyce arrived home one night at about 9:30 p.m., alone. She and Michael did not always attend the same event on an evening; sometimes Michael worked late or had jam sessions in his studio, or Joyce left a party without him, and while infrequent, it was not unusual for her to come home by herself. Unlocking the factory-type door of the building was a fumbly procedure for Joyce and on this particular night she had just opened the door and was about to enter when a man jumped her, slugged her in the face with his closed fist, pulled her by the hair, and tried to drag her into the vestibule at the foot of the staircase, out of sight from the street.

During the first moments of the attack, Joyce's leg became crushed in the door in her effort to prevent her attacker from getting inside. He tore at her clothes and forced her against the door, clearly intending to rape

her, or worse. With life-or-death strength, she held him off until a passer-by happened along and the would-be rapist fled.

Joyce seldom spoke about this. She told Betty Ferguson, "I thought he was going to kill me." But Flo and Ken Jacobs, who lived across the street and saw Joyce regularly for years, knew nothing of the assault. Nor did Jo Hayward-Haines (although she and her husband had moved to New Mexico by that time). Some of Joyce's closest friends in Toronto were aware of her having had a "bad experience," but they, too, knew little. In one newspaper article she mentions the tragedy as part explanation for her and Michael leaving New York in 1971. She is quoted only as saying, "I was attacked one night, and it was a terrible trauma, which lasted for months."

In a 1976 interview she was speaking about the competitiveness of American artists and related it to the American way of life, in general. Then she added, "And there is the city itself," as her prelude to, "I was attacked twice in New York . . . my assailant pulled out a huge hunk of my hair." She mentioned that they were living in a "warehouse at the time and what a good place for a murder that is. I burned all my clothes [presumably those she was wearing then], even my new shoes, and went to bed for a week. I didn't call the police." (As for being attacked twice, Michael said they had been robbed once and perhaps Joyce combined these in her mind as two attacks.)

"After an experience like that, you feel entirely different about the street: I took cabs," she said, and added, "Reading Susan Brownmiller's book *Against Our Will: Men, Women and Rape* last week, made the whole thing understandable." Without any further comment from Joyce that could be found, one can guess that she possibly obtained from the book a sense of equilibrium in learning something of the many reasons why men rape — which, of course, does nothing to alleviate the rage.

Women victims of sex crimes suffer post-psychoshock symptoms that typically include recurring nightmares, fear of being alone, fear/hatred of men, curtailment of normal activities like walking brief distances, along with other less attributable though just as specific disorders such as abdom-

inal pains, headaches, weight loss, and varying degrees of clinical depression. Contrary to the adage that time heals, for some women the residual symptoms become more destructive over time — especially without support from professional counselling, friends, spouse, and others. Joyce likely sought counselling and Michael probably was supportive, but Joyce was afraid of living in New York. Years later, when explaining why they left New York, Michael said the city was becoming "really frightening."

For nine years Joyce had agonized over trying to reconcile Americans' hot passions for their country — even those emotions she deplored — with Canadians' tepid regard for theirs. This divide was carrying her into a highly defined, potent expression of her love for Canada; for the land, its people, and its safety. She had long feared American domination, and living in New York exacerbated these fears. There is no evidence to suggest that she felt herself to be consorting with the enemy by living there, although the forced intimacy she had shared with her attacker sharpened her senses and put her, the silent eyewitness, on alert. For the entire time Joyce lived in New York she felt she had never left Canada but was linked to another country whose motives she increasingly questioned — a plight similar to hearing testimony in a trial that one suspects has been doctored to endow the rapist with a heart of gold. Fearing for Canada's imminent brutalization by the monster next door, Joyce suspected that given Canada's economic vulnerability, the first attack would be aimed at the country's weakest defence, culture. Four years after returning to Canada, she talked about "going through a lot of political stuff in the States." She was referring to the conflict she experienced over her loyalty to Canada and its quiet conservatism and her de facto participation in the gathering howl of American radicalism. In solidarity with Americans' civil-rights and anti-war protests, she marched and waved placards with them. "It took a while to connect what was going on there to what was going on here," she said. "You couldn't do a goddamn thing about what was happening there, and then I saw what the power structure of that country was doing here and wow! — you sort of run for the fort."

Michael said, "We started asking ourselves, what are we doing? Here we are, foreigners caught up in another country's local interests." He referred specifically to the Vietnam War and the Black Power movement. "And what about our country?" Sensing they were losing touch with what was important, combined with an art scene in New York that Michael now felt was old, whereas Toronto's was new, they decided to return to Canada. (Michael admitted that the attack on Joyce hastened their move.)

The decision to go to New York was chiefly Michael's and it was Joyce's to leave, even though she had misgivings; she felt that Michael was on the way to making it in New York.

Les Levine, however, saw things differently. Speaking in 1999 about that period, he began by declaring that what he was about to say was meant in a "most compassionate way," and then stated, "It was virtually impossible for them to sell any work or do anything here, and if they had stayed any longer it would have started to become a real liability to them. It would have started to look just too hopeless."

Joyce and Michael returned to Toronto in 1971; and true enough, the gossip mill ground overtime about them not making it in New York.

Chapter Seven

When Pierre Théberge extended the invitation to Joyce in 1969 for a retrospective, he could not have known how meaningful this was to Joyce. "He helped me a lot," she said. "He gave me a lot of confidence." This assertion is made in the full understanding that many friends, certain dealers, filmmakers, and collectors held Joyce in high regard personally and professionally, but when Pierre Théberge, a distinguished curator of Canada's leading art institution, singled her out for a retrospective, reassured her and guided her through the myriad details of the exhibition

throughout its two-year gestation period, Joyce was moved. No one had ever taken that much time with her, or had provided her with so much.

A curator's function is, with the support of the director and board, to acquire art, organize exhibitions, and maintain an academic, scholarly art history, within the institution's mandate. Through curators the museum recognizes the worthiness of individual artists by giving them exhibitions, just as a publisher selects writers to publish or a symphony orchestra engages guest soloists. It is an immense honour for an artist to be chosen by the country's national gallery for a retrospective exhibition. Public galleries have the resources to tour the exhibition across the country and farther afield, produce a scholarly catalogue, and through its promotional apparatus, introduce the artist to the public and the art Establishment. Without National Gallery endorsement, by way of exhibitions or purchases, artists' careers may flourish but most likely they will not. There is some question as to whether the Group of Seven artists would have reached their heights of national and international power without the committed, impassioned backing of one individual, Eric Brown, first full-time curator of the National Gallery of Canada in 1910, and its director from 1912 to 1939. He mounted numerous Group of Seven exhibitions and toured them far and wide, generating an unalloyed reputation for Canadian landscape painting by this new breed of painters.[1]

In Joyce's case, the mere fact of having a retrospective exhibition at the National Gallery positioned her as one of Canada's top-ranking artists.

Joyce's retrospective exhibition, *True Patriot Love/Véritable amour patriotique*, opened July 1, 1971, Dominion Day, and continued until August 8, 1971. It surely stands out in the annals of openings.

The nation's most prestigious art gallery was then housed in a grim, cement-block office building in downtown Ottawa (the spectacular Parkin Partnership/Moshe Safdie-designed new gallery opened in 1988) and its façade carried a huge banner reading, "True Patriot Love Joyce Wieland Véritable amour patriotique."

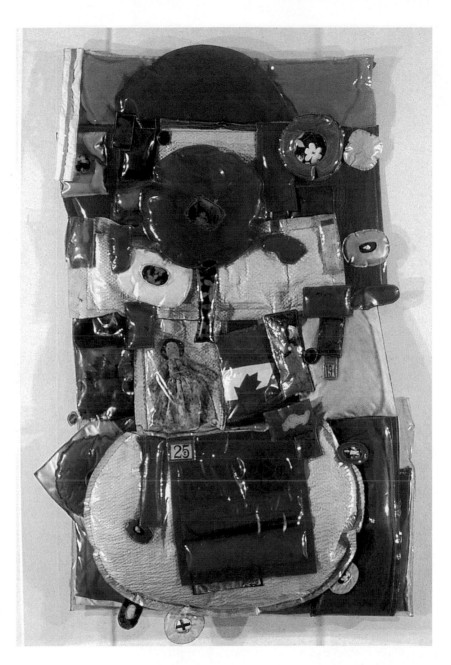

Puerco de Navidad, 1967

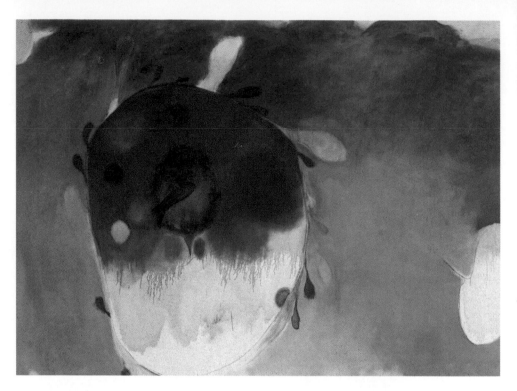

Time Machine Series, 1961

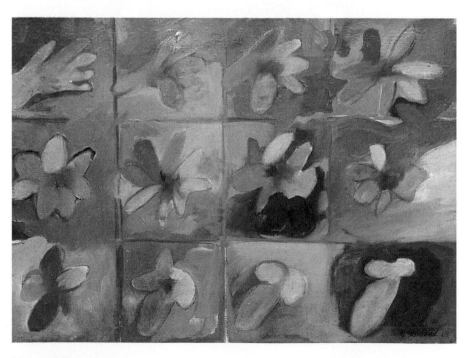

Nature Mixes, 1963

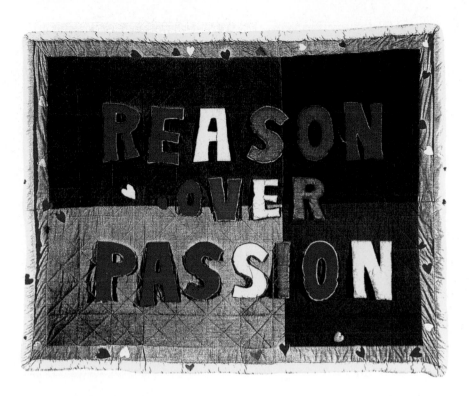

Reason Over Passion, 1968

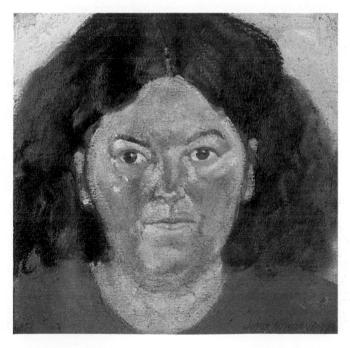

Self Portrait, 1978

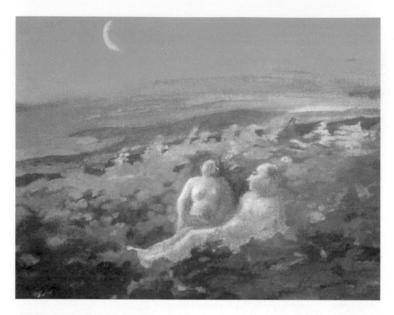

Conversation in the Gaspe, 1980

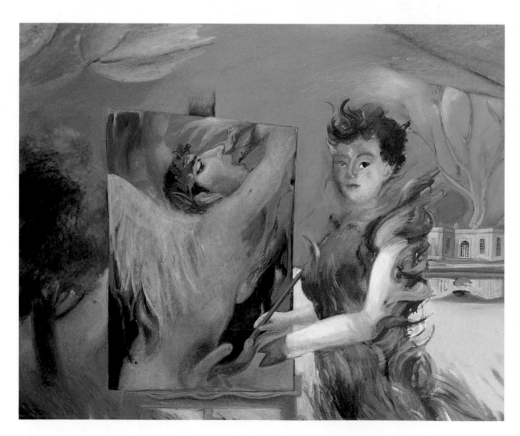

Artist on Fire, 1983

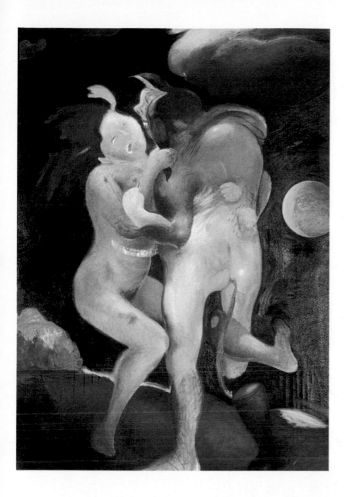

Paint Phantom, 1983-84

Turkish drawing (untitled), 1981

Mother and Child, 1981

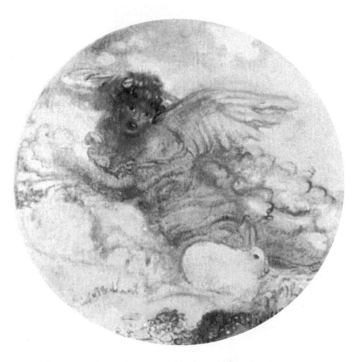

Guardian Angel, 1982

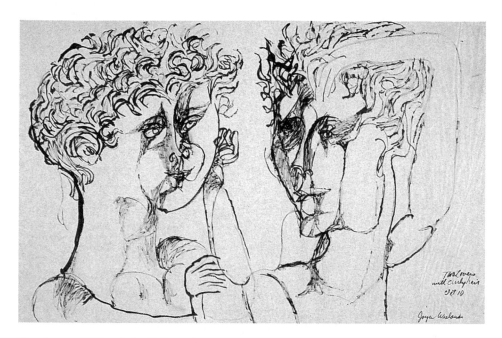

Two Lovers With Curly Hair, n.d.

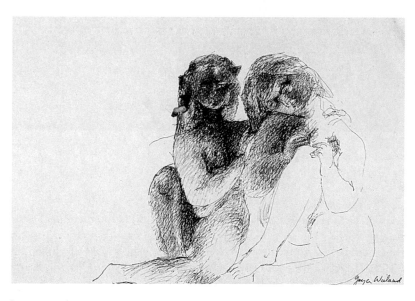

Lovers, n.d.

World Literature Plaque, 1985
Bas relief: "There is no frigate like a book to take us leagues away." Emily Dickinson. (Joyce uses "leagues" whereas Dickinson's word is "lands.")
Collection of Greg Gatenby
Fifty Canadian, American and International authors read at the International Festival of Authors on October 18 – 26, 1985, and all of their signatures appear in the central image shapes of this placque. To name a few: Margaret Atwood, James Baldwin, Julian Barnes, Ann Beattie, E. L. Doctorow, Sheila Fugard, William Golding, Judith Merril, Kenzaburo Oe, Julia O'Faolain and Mordecai Richler.

Joyce's heart hammered with pride at first sight of the banner. Another sight, however, caught her totally off guard, and that was a group of protestors distributing a leaflet titled, "True Patriot Love?" The group demanded the Canada Council stop giving grants to American citizens in Canada and to Canadian expatriates who had settled in the United States — an obvious reference to Joyce Wieland and Michael Snow. The demonstrators were members of the newly formed artists' union, Canadian Artists' Representation (CAR)[2]. Embarrassed and confused, Joyce considered herself a true Canadian and, for an added note of irony, here was Joyce, the protestor, being protested against. (Before long, however, she and Michael were active members of CAR.)

Fortunately for Joyce, the protest was soon overwhelmed by a hundred members of the LaSalle Cadets in full drum-and-bugle regalia playing a fanfare followed by "The Maple Leaf Forever" to herald the 5:00 p.m. opening ceremony.

The image that greeted arriving guests was a gigantic *Arctic Passion Cake*, an edible representation of the shape of Canada as a white landscape with frosting icebergs and fields of snow. At the base of the cake were emblems of each province and its respective flowers, dried, amid sprays of coloured maple leaves. Visitors did not eat the cake but were given petits fours made from the recipe, created by House of Commons pastry chef Jan Van Dierendonck, granting them a symbolic taste of *Arctic Passion*.

Another attraction at the entrance received much comment — a blue plastic kiddie wading pool filled with water, with twenty-four ducklings and four ducks swimming in it.

Joyce had created a perfume especially for the exhibition that she named *Sweet Beaver/Castor doux*. She made it by cooking up a batch of cheap cologne in her kitchen, to which she added flowers, oils, and pine needles, then revised the blend like a chef perfecting a Béarnaise, until she achieved her desired aroma: an intimation of the Canadian wilderness. Joyce described the scent as, "Sweet Beaver perfume: A reminder of a beaver in the woods in Canada. Everyone has a different idea of what that

smell might be. . . . Sweet Beaver is a souvenir of Canada."

A one-dram bottle of *Sweet Beaver* sold for ten dollars.

Lauren Rabinovitz, putting her feminist slant on the perfume, claimed that it "calls up pornographic connotations of women as sensual but passive vaginal objects. Wieland views such an image of women as analogous to Canada's reputation: Canada's history as land raped by England and then by the United States parallels women's history of oppression." In her view, Joyce had engaged in a "Pop art ploy"; that by making *Sweet Beaver* a commercial product, she "played on how the advertising industry participates as a patriarchal tool in selling images of women" and that "her use of the way the advertising industry packages its products articulates a satirical protest."

A Toronto art writer, Kay Kritzwiser, who had followed Joyce's work through the years and who called her "a composite of Joan of Arc, Laura Secord and, occasionally, one of the Belles of St. Trinians,"[3] nonetheless thought Joyce's perfume "ghastly," and wrote that "wherever you go through the exhibition, you get cloying whiffs of Sweet Beaver (Le Castor Doux), the Perfume of Canadian Liberation, which [Joyce] brewed from essences of new-mown hay, Siberian moss and real civet." (Joyce may have romanticized the recipe to the writer; these ingredients do not appear in her notes.)

The exhibition comprised thirty-six works (including the cake and perfume) — four paintings, five drawings, two bronze sculptures, a lithographic print, and some photographs, with the remainder being cloth works and plastic hangings. Joyce used the cloth works to acknowledge the collaboration between the artist and the artisan and to present a linkage from art to craft, and vice versa. "I wanted to elevate and honour craft, to join women together and make them proud of what they had done," Joyce explained.

The works on cloth were much discussed, among them *109 Views*, a quilted cloth assemblage measuring a massive 257 centimeters by 803 centimeters,[4] containing, as its title promises, 109 images, all of which

represent the trip Joyce took to film *Reason Over Passion.* The quilted *109 Views* is a sentiment of the film in another medium.

The 109 images appear in different-sized quilted landscapes painted directly on the cloth in pale, soft colours of rectangles and squares mounted on a backing. Viewed from a distance, the quilt resembles an abstract Canadian landscape of scenic icebergs, mountains, suns, coastlines, and trees far on the horizon or reflected in lakes and rivers. One reviewer called *109 Views* "the largest and most powerful work" of the exhibition.

The Water Quilt, executed in white pillows and pages of ecological writings, is among the major five fabric assemblages in the exhibition. Another, *Arctic Day,* is circular, 213 centimeters in diameter, a composition of 163 round cushions on which Joyce has drawn, using coloured pencils, an Arctic bird, animal, fish, or flower, along with images of the snow and tundra at dawn, in the sunlight, and during a blizzard.

The exhibition catalogue, a hardcover book of 224 pages, is an unconventional work conceived, designed and art-directed by Joyce. It reproduces the complete text of the *Illustrated Flora of the Canadian Arctic Archipelago,* an illustrated botanical survey of Arctic flowers and grasses, including twenty-nine pages of eight maps per page of flora distribution across the country. Throughout, notes are photographed paper-clipped to pages. A tiny silk Canadian flag is glued to the inside front cover. The inside back cover has a pocket containing three inserts: an outline map of Canada; a ten-page program printed on pink paper of the exhibition's thirty-six works, a listing of Joyce's exhibitions, and an essay, "The Films of Joyce Wieland," by Regina Cornwell; and a folded sheet, measuring 56 by 86 centimeters when unfolded, of the text of an interview with Joyce by Pierre Théberge in French, with Michael as translator. In her handwriting on page 219, Joyce acknowledges by name everyone who was involved in the retrospective, including all the needleworkers, the pastry chef, photographers, Pierre Théberge, and Michael, "for all kinds of help." Each name is penned in a freehand border, adorned with tiny hearts.

Ten days after *True Patriot Love* opened, the *Ottawa Journal* published

an op-ed piece on the show, headlined, "The Put-On at the National Gallery." The first paragraph reads:

> It's supposed to be oh-so-clever. Whimsy and humour; fun. Canadian metaphysical; the yoking together of disparate things. The elevation of the commonplace. Fresh insights into our country. Pop Art — the whole genre ingeniously applied to our mythology. But it's a fake, a great put-on that the National Gallery has fallen for in something called "True Patriot Love," Joyce Wieland's exercise in personal therapy now embarrassing the Gallery's first floor.

Admitting that "to mock is to be a philistine," the piece then lays blame at the door of the National Gallery for "allowing itself to be conned. It is lending its prestige to anti-art. It is afraid to say no, because someone might say it's stuffy. . . . The Gallery is boring us stiff, and its director, Jean [Sutherland] Boggs, should know that boredom is just as deadly as irrelevance."

A spate of letters followed, ten-to-two in agreement with the editorial. Among them: "I, for one, am fed up with the appalling 'stuff' Miss Boggs and her friends foist on the general public." Another: "I deplore the use of a public, tax-supported art gallery as a platform for the socio-political propaganda of a select group of artsy-craftsy radicals." And, "The put-on at the National Gallery is not so much that junk show 'True Patriot Love,' as Director Boggs herself, who gets hung up on stuff-called-art regularly, but . . . seems to survive instead of being laughed out of the Lorne Building [the office building housing the National Gallery]."

A man who disagreed wrote, "The Wieland show . . . is a lively exhibition by one of our best artists and I congratulate the Gallery for it," and concludes with lambasting the newspaper: "Perhaps the public would be in a better position to appreciate the exhibition if our newspapers would provide serious reviews of current exhibits by competent art critics."

Jean Sutherland Boggs responded in a rather oblique fashion, writing

that the editorial was "perceptive" in that "Joyce Wieland does laugh at art. But she does not laugh at Canada. Or if she does it is nostalgically, gently, even sentimentally. And occasionally we Canadians should approach Canada without embarrassment, *sans genre.*" Director Boggs then proceeded to note that the gallery is "also full of anti-art that has become established," and cited Juan Gris and Picasso. Not to mention the "established favourites, particularly the Group of Seven, which the Gallery was considered to have been 'flagrantly partisan' to have supported even as late as 1931." Astoundingly, she referred to the Old Masters, "including Rembrandt and Cézanne, who distressed their contemporaries." Next, the director limply declared, "The public may feel put on by Joyce Weiland [sic] but it may change its mind. In any case there is a great deal else to see including superb North West Indian works on the sixth floor which will still be on loan from the closed National Museum of Man through the month of August." (The director may have misspelled Joyce's name, although this could be a newspaper typo.) Most perplexing, though, was her giving Joyce's exhibition short shrift by touting other gallery attractions.

A week later Jean Boggs responded to a reader's complaints about the ducks and the "great quilted billboards" that would "never win a prize in the Canadian National Exhibition's handicrafts display," by giving an enigmatic nod to "waggish" art in general. She left Joyce twisting in the wind with this last paragraph: "The exhibition, we should remember, does not represent a cross-section of Joyce Wieland's work, which is actually much more satiric than it would suggest. It was planned when the gallery was asked to participate in Festival Canada as a genuinely patriotic exhibition to open on Canada Day itself. It is a party, as that decorated cake should surely suggest."

Joyce apparently had no quarrel with the director's comments; she counted Jean Boggs a friend.

What hurt Joyce was being scorned and mocked for her love of country. Twenty years later, discussing the negative criticism, she said, "They

laughed. They thought it was so stupid and unsophisticated. But I have to make what I have to make." And also around that time, Joyce told interviewer Susan Crean, "I have always been on the outside," and that recently she didn't mind that, but "it has meant, however, that I have had to keep proving what I was doing was okay."

The exhibition nonetheless received numerous plaudits, the most lavish a double-page, four-colour spread in *Studio International*, one of the most respected art journals in the English-speaking world. Not a review per se, it served as pure, golden publicity with its description of the show and four reproductions of works, two stills from her films and a photo of Joyce. Not many of her colleagues — artists or filmmakers — could claim similar coverage in this journal.

And Kay Kritzwiser, who in her earlier-noted piece called Joyce a Renaissance woman, concluded, "Who else can draw so surely, sculpt in bronze, paint rough bitter commentaries in oil and, finally, make films which may one day be the summation of all the hard apprenticeship which has led up to this exhibition."

Joyce's artistic reputation suffered some damage from the retrospective, not as one may suspect through criticism of her work or her mediums — although both factors contributed a negative impact — but more injurious was an element entirely of her doing: the catalogue. The problem with the catalogue was, it was not a catalogue. Which is to say, it was not a scholarly review of Joyce's art.

Largely, the catalogue was called "indulgent," "whimsical," and "gimmicky." Art teacher and critic, Ken Carpenter, who among others thought the catalogue whimsical, feels that Joyce failed to get herself treated as a "serious artist," by producing her kind of catalogue. He said, "She did not receive the standard, historical assessment that a serious artist gets with a major exhibition."

Retrospective exhibition catalogues are written to a high academic standard, typically by a scholar with credentials in the particular artist's genre, and, depending on the artist's ranking, the catalogue may be co-

published and issued as a mass-market book. Either way, the catalogue provides an authoritative assessment of the artist's work, a text supported by quality colour reproductions. And of lasting historical importance to scholars and art lovers, a standard museum catalogue includes a list of the artist's exhibitions, a record of major public and private collectors, pertinent biographical material, a bibliography, and notes.

By not providing this academic content, in Ken Carpenter's view, Joyce "marginalized herself."

In the immediate aftermath of her retrospective Joyce hid out. She "cried and cried," she later admitted. But as past injuries had taught her, the resources she'd developed of psychic growth and repair would enable her to emerge with her definition of victory in place. Sequestering herself, hiding out, she augmented her healing regimen with a program of known antidotes, such as listening to Mozart, talking to her cat, reading Katherine Mansfield stories. She had no other choice. The alternative was too dark a place, too far to come back from.

It was beyond Joyce's comprehension that a writer could express a sentiment of endearment and douse it with a cold splash of contempt. "If a critic wants to punish me while giving me one compliment," Joyce said, "I don't need him." One interviewer suggested to Joyce that she was a victim of "critical neglect"; that so often what was written was personal rather than relative to her art. To this, Joyce replied, "I wouldn't want most of the critics writing about me anyway." She emphasized, "I don't want to be written about by creeps."

Joyce could be brutal and sarcastic in her tirades but primarily she railed against forces and entities, fighting major battles on issues with governments and corporate polluters. Courageously, she stood up against the giants and didn't mince her words. Joyce had no illusions about every piece of her work pleasing every critic. She wanted fairness, she hoped for courtesy. If she was in for a hatchet job, she would prefer that a critic stick the knife in and be gone, mean and clean.

After her retrospective, and despite all the comments both kind and not so kind, of great and lasting importance to Joyce was that the retrospective placed her in the national spotlight and gave her historical standing, being the first retrospective awarded a living woman artist in Canada. And by concentrating on showing quilts, soft sculpture, and cloth assemblages, Joyce bestowed artistic credence upon a medium heretofore deemed "women's work." That she had the confidence to present her intimate convictions in fabric art set her apart as a woman with passionate, consequential views on society. She had assumed artistic ownership of feminist, sexual, political, ecological, and nationalist themes, and despite some negative press, Joyce believed that viewers "received things" from the show. "And I had plenty to give, and that's what matters."

Most salutary for women, Joyce's retrospective significantly raised the profile of women artists in Canada, though not overnight and not readily identifiable. Joyce would also remind anyone who listened that a male response to her art was the wrong response; she would give more to her female passions, not less, be more accepting of herself, not less, thus expanding her process of self-empowerment. Feminist psychologist Jean Baker Miller wrote, "It is only because women have begun to change our situation in the world by ourselves that we can now perceive new ways of understanding ourselves and our position in the world."

More than anyone else of her generation, Joyce made a significant contribution toward changing attitudes of 1970s hidebound, misogynistic men who denounced artists like herself for daring to make women's art.

"It's pretty horrendous living in the States," Joyce said.

She voiced this sentiment in 1981, ten years after she and Michael had returned to Toronto. She had suffered too much — her failure to secure a dealer, being excluded from the New York Anthology Film Archives, her growing disillusionment with American politics, being attacked outside their loft. Michael said he "submitted to Joyce's desire to return," although he wanted to stay; his career was taking off

(contrary to Les Levine's earlier prediction).

Returning to Toronto in the winter of 1971, Joyce took delight in saying that the first thing she did was go tobogganing. Following this totally Canadian sporting activity, she thrust herself into Canada's cultural life.

A defining moment occurred for Joyce when she discovered that the Art Gallery of Ontario had given American artist Claes Oldenburg a fee of $10,000 for exhibiting his work at the AGO, while Canadian artist Jack Bush received $400. "It's a scandal," she protested, that Canadian artists were being taken advantage of by their own tax-paying public galleries. Joyce then joined forces with Canadian Artists' Representation (CAR), the same group that picketed her retrospective.

For an intense year she fought for artists' rights, while simultaneously working on completing her retrospective at the National Gallery.

Founded in 1968 by London, Ontario, artist Jack Chambers, CAR was born as a consequence of Chambers getting into a battle with the National Gallery of Canada over the gallery's reproducing a work of his in a catalogue without his permission, and without paying him a reproduction fee. Since no formal artists' organization existed to support his case, he founded CAR. Its mandate was to improve the status of visual artists and to promote the visual arts in Canada. One of the non-profit organization's projects was establishing a scale of fees that artists would be paid whenever their works were reproduced in books, magazines, or catalogues, and a separate fee when their works were exhibited in group shows. Chambers was president of CAR from 1968 to 1975, after which another London artist and another founding member, Greg Curnoe, became president.

There had been other artists' unions in the country — the Artists' Union, which disbanded in 1937, and the Federation of Canadian Artists, a group that would be subsumed by the Massey Commission[5] and its impetus in creating the Canada Council, which was expected to act in artists' best interests.

Joyce embraced the work of CAR from two perspectives: first, to work on the fundamentals of protecting visual artists' rights, and second, an

ancillary objective, to advance visual artists on the belief that government subsidies accruing to one branch of the arts would effect a corresponding return to other areas of the arts, that "money will be returned on a steady basis." Joyce felt convinced that Canadian filmmakers could make significant contributions to Canadian culture if they were endorsed, that is, funded by the government. She had been trying to tap into public granting organizations to make *The Far Shore* on the basis that Canadian films raised the national consciousness by presenting Canadian, not American, stories. It angered Joyce that Canada's filmmakers who did receive government funding went ahead and made imitation American films, and even then they got it wrong. "That is what is most interesting," Joyce stated, "how we get American films wrong when we make them. This is the Canadian esthetic right now." Other Canadian filmmakers did not take kindly to her saying, "It is like a hillbilly trying to get it right, but he can't and produces 'hick art.' I really believe in the idea that we're hicks and we ought to stick with it, cultivate it."

She also complained that the government, namely the Canadian Film Development Corporation, the granting agency, demanded that Canadian filmmakers be competitive internationally, which was construed by Joyce to mean in Hollywood. "For many of us that is a false start. We want to make films for Canadians," she argued. But she was endlessly, tiresomely told that there was no market, no money in making Canadian films. And no distribution system; movie theatres are run by Americans. "What is the use of making a picture that can't be seen in small towns?" she demanded to know. When she first petitioned the CFDC for funding for *The Far Shore* and was told to come back when she had booked a "middling" American star, she refused but received a grant anyway; but that didn't assuage her prickliness over the CFDC's fixation on Hollywood as a standard for films. A strengthened Canadian cinema would result if it wasn't forced to measure up to standards of success determined by money-making, "to run after someone else's formulas — is this a hit, does it have the right ingredients, etc." Joyce's et cetera meant specifically American stars, American

directors, and co-productions with American producers. "We aren't Holly-wood," Joyce insisted, "we are more like Czechoslovakia."

Joyce worked on a CAR funding brief and was one of its presenters at a Canadian Conference of the Arts in Ottawa, in 1971. She must have felt something like the Avon lady at the door who was invited in and received champagne instead of orders for face cream. She said:

> It breaks your neck to go to those things, sit around for two days while they carry on with thousands of dollars. Every table had fifteen pencils and everything was laid on — as long as you go along with it. We broke off, had a radical arm of the conference and prepared another independent brief. . . . We have to keep saying that we are still alive. We are like the Indi-ans in comparison to the Department of Northern Affairs right now. What must happen is greater unity with artists and greater unity with filmmakers. There are independent produc-ers in Quebec now who are helping people produce films. If they can find this independent money and have their own theatres, they can move towards a very healthy thing. . . .
>
> If we didn't have the government intervene at this point, I believe the culture would be completely underground.

Joyce continued her active role in CAR for a year. Av Isaacs permitted members to use his gallery as a meeting place to plan their next protest. (Judy Steed, who would become a film partner of Joyce's, said, "I never knew when Joyce would phone me and I'd have to go out and chain myself to something.") CAR organized members to crash AGO board meet-ings to demand that it "stop being a private club of the rich," Joyce said, and they and members of the Committee to Strengthen Canadian Culture participated in numerous causes involving art institutions, such as the OCA protesting the lack of women teachers, and crossovers with Native artists', athletes' (the Artists-Athletes Coalition) and farmers'

unions, and political and environmental issues affecting culture.

One personal experience confirmed for Joyce that CAR was an essential voice for artists in Canada. She had received an invitation from the Nova Scotia College of Art and Design to teach a drawing class for a three-month semester in the spring of 1971 and she accepted, even though her retrospective would open in July that year and she was still working on *The Far Shore*. The appointment was her first academic teaching post and she welcomed it for both monetary reasons and as an enhancement of her curriculum vitae that she hoped would lead to additional teaching. She may have begun to think of teaching as a reliable, paying, career adjunct. Artists have no pension plans, and worse, no guarantees that their work will sell; and continue to sell. There is another consideration: Because Doris McCarthy had been so influential and had inspired Joyce to believe in herself as an artist, perhaps Joyce felt that, as a recompense to Doris, she (Joyce) might help some other young person realize his or her artistic dreams. Moreover, Joyce's innate sense of noblesse oblige would have motivated her to contribute, as would her helping nature, evident from the time she was six years old, crying over newspaper stories about poor children unable to attend summer camp.

Although Joyce welcomed the teaching post in Nova Scotia, the experience was very unpleasant for her personally, and ultimately, she felt, for the cultural life of the country. While there, Joyce found herself again in another limiting, detestable old boys' network, and some years later she publicly berated the college director for his wholesale denigration of Canadian art and artists. She accused him of being a "snob about the American art scene. He can't open himself to what is lying around him — to the art that is being done in the Maritimes."

Joyce's opinion was not an isolated one. In a 1975 article titled "Fine Art's Finest" that detailed the "powers behind Canadian art" — among them, both Joyce and Michael — the Nova Scotia College of Art and Design was identified as, "Principal national custodian of the notion that there is nothing wrong with Canadian art that a generous application of

American know-how won't fix. American painters, teachers, and graduates of the College dominate the Atlantic section of *Time*'s 'The Canadian Canvas.'" (A travelling exhibition was sponsored by *Time* magazine in 1975.)

That a director of a Canadian art college, which was incidentally founded by a Halifax woman, Anna Leonowens, dismissed Canadian artists as inferior to American artists cut deep into Joyce's nationalist skin. She could not let this go unnoticed. "We have to break away from this one-sided American influence," she said. "It's important that we show ourselves to the world on our terms." That is, as Canadians. She felt that we were still "suffering from a colonialist mentality and it's hard to be ourselves — to make our own history."

In Toronto, her first new work undertaken was a film, *Birds at Sunrise*, which as the name implies is self-explanatory. She and Michael had moved into a house on Summerhill Avenue and Joyce would get up at four in the morning to film birds swooping into the tree outside her kitchen window. She explained, "I sometimes used rolled-up papers to make these strange irises [a film technique of iris-in or iris-out takes an image down into a small circle in the frame or up into a full circle] and I made other irises out of paper and cardboard. I think I put a scratch in some of the originals. It was the life of birds at the window when dawn's coming and the light is changing."

After a filming session with her birds, she would work on the script of *The Far Shore*. "I liked getting up about four or five a.m.," she said. "I developed the script, developed it, developed it, and kept writing, writing, writing. It was a strange thing that I was doing."

No definition is given for "strange." It could mean nothing more than Joyce getting up so early to write rather than to paint. Or that writing a film script — something she had never done in connection with her thirteen films already made — was strange, as in *unfamiliar*.

"Here comes the flag-waver."

Joyce said that was what people thought of her in the 1970s.

She made this remark after saying Lucy Lippard wrote that "people accuse me of having naïve nationalism." Joyce is not quite accurate. Lippard wrote, "Wieland's art has occasionally been criticized for being awkward, sentimental and, above all 'naïve.'" The writer goes on to state that without these elements, Joyce "would not have been able to stretch and flex to accommodate so many different ideas and subjects" — notably, Joyce's patriotism, defined by Lippard as her "born-again Canadianism," resulting from having lived in New York. But Joyce quite accurately observed that Lippard credited these characterizations with what it takes to become a nationalist, adding that Lippard "settled a lot of issues that I've been attacked for in this country," such as being called a flag-waver.

In an interview a few years later, Joyce fumed, as she surely had when first "accused" of being a flag-waver in the derogatory manner often levied against Americans:

> I wondered how they could criticize me when the whole goddam sociology department at Thunder Bay [Lakehead University] had been taken over by Americans teaching Black studies when Indians were lying all over the sidewalk. They didn't have a study program for that [Native studies] because they couldn't get it from Chicago [for published textbooks] soon enough. It's so stupid. I got so furious. I was so angry in those days.

"Those days" were just prior to Joyce's moving back to Canada.

> I wasn't a patriot when I went there [to New York]. . . . Then I learned about that country and I got involved in that country's politics. . . . But being an ex-patriot made me look at where I came from and that's the value of being an ex-patriot.

You actually see where you came from: where it was, what it was, what it means to you and how it stacks up.

One of the most environmentally flagrant plans Joyce encountered when she arrived back in Canada was the project announced by Quebec's young, ambitious, newly-elected Premier Robert Bourassa in April 1970 — his government's proposed James Bay project in northern Quebec, which was to start immediately. The undertaking when completed would be the largest hydroelectric power project in the Western Hemisphere, one that would drain an area of fifty thousand square miles (a space you could plop England into), a $13-billion enterprise with a capacity to supply enough power for four cities the size of Montreal. Constructing it would reroute rivers and ponds, threaten fish, waterfowl, and animal life throughout the entire vast area, but more significantly, it would uproot from their lands an estimated ten thousand Cree Indians[6] and about half as many Inuit and Naskapi who occupied the territory north of the Cree. Since 1950, the Cree had settled into small villages in the James Bay area but "had been there" for five thousand years. Without consultation, without notification, the Cree learned of their fate from radio and newspaper reports detailing the James Bay project.

Following Bourassa's announcement the Cree began mounting a protest, arguing that "if the land was destroyed, the animals would be destroyed — and if you killed the animals, you would kill the Crees." The Sierra Club of Ontario had taken an early leadership role in demanding that the federal government conduct environmental impact studies before starting construction. Admiring the organization's strategies, Joyce allied herself to the Sierra Club and other ecologists. The environmental issues greatly disturbed Joyce, but more troubling was the Native people's plight. According to the James Bay plan, it was clear that floodways, man-made lakes and rivers, canals, new towns, roads, and dams took precedence over the homes the Cree lived in, which would be flooded and gone, as would be the sustainability of their way of life — fishing, trapping, and hunting.

The Cree people needed money to mount a case against the power project and Joyce felt a responsibility to help. She had used her art to direct attention to social, environmental, and women's issues throughout the 1960s, and she would use it now to help the Native cause. Together with several artist members of CAR, the group organized an art event to raise public awareness — and funds — by holding an open house featuring printmaking. The artists rounded up hand presses and booked a theatre in Toronto's St. Lawrence Centre and artists made prints on the spot and sold them as a fundraiser. Several Native people from the affected James Bay area came to the event, along with all manner of environmental activists — Joyce called it "a very huge evening . . . a fantastic night." However, it was a media bust. "Not a word in the paper the next day, not one word," Joyce cried.

(Joyce made a print that night and it likely sold, but there is no record of it and no further mention of the work.)

Environmental protests were not newsworthy then, although we know how quickly this changed. But at that time, despite the activists' attempts, there was insufficient pressure to dissuade the Quebec government from proceeding with Phase I of what Premier Bourassa called "the Project of the Century." The political spin hailed James Bay as the "key to the economic and social progress of Quebec," and why, the utility asked, should the rights of "a few thousand" Indians stand in the way of the greater good of seven million people in Quebec, millions more northern Canadians, and the prime consumers — Americans in northeastern states?

Joyce's disappointment with the media response to the printmaking event soon gave way to hopefulness in the person of Billy Diamond, a twenty-two-year-old chief of the Rupert House Crees (the largest Cree settlement in the James Bay area), who spearheaded the drive to organize other Native bands in Canada to support their cause. The uproar these groups caused was unprecedented, claims Native historian Olive Patricia Dickason. They put on theatrical performances in Ottawa, Montreal, Quebec City, and in any town they could find an audience to raise money

for a legal challenge. The Cree won an injunction in November 1973 to halt the James Bay hydroelectric project. However, one week later, the Quebec Court of Appeals overturned the judgment, ignoring impact studies warning that development would be environmentally damaging and destroy the way of life of the Cree and Inuit.[7]

The last word is left appropriately to Bill Namagoose, chief of the Grand Council of the Crees of Quebec. Joyce would have whistled and cheered and clapped her hands blue had she been in the audience for the speech he made in March 1993 at Tufts University, Massachusetts, as part of his campaign to pressure Americans into cancelling their contract with Hydro-Québec for "cheap power" at the expense of ecology and Native rights. The chief stated, "Anytime there is a great environmental issue, or a huge megaproject to be built, it is always, always on indigenous lands," and mused, "Why is that? . . . People design these [projects] and ask us to accept them in wilderness parts of our land. . . . For us, speaking of land ownership, we can't buy, sell, or own the land, or buy water, or own the air. For a man to say he owns the land is like a flea on a dog trying to say he owns the dog."

Certain of Joyce's friends, looking back at the consequences, hinted that she should have devoted herself full-time to *The Far Shore* and put other projects on hold. Practically speaking, Joyce had little choice. Although she had begun her first screenplay drafts in 1969, the retrospective preoccupied her for much of two years, until 1971, as did her CAR activism. Also in 1971 she took up her teaching post in Nova Scotia and over the following winter and the spring of 1972 she filmed *Birds at Sunrise* (which she completed in 1985) and produced three more films, *Dripping Water*, a 16-mm, ten-minute film co-produced with Michael, *Pierre Vallières*, 16-mm, forty-five minutes, and *Solidarity*, 16-mm, eleven minutes. She also made a series of political cartoons, some of which were published in *Time* and *The Canadian Forum*.

Yet another event would stall *The Far Shore*. Joyce received her first

major public commission and a prestigious one, at that. She and six other artists[8] were commissioned under the federal government's Department of Public Works Fine Art Program (which then allocated a percentage of new building costs for artworks) to create a work of art for the new National Science Library in Ottawa. Regardless of any other work in progress, a major public commission categorically, with gale force, casts all other projects aside.

Such a commission — typically a large-space mural, painting, or sculpture — represents an inherent government endorsement of the artist. Of great significance, the installation is historically long-lasting; it exists for the building's lifetime, unlike art collections in public galleries, which serve more of their history in storage vaults than on walls.

Built in 1974, the National Science Library's entranceway is a spectacular space surrounding two ells of library stacks in what is defined as a "square ring of space." Architects Shore Tilbe Henshed Irwin designed the lobby space for the seven artists to create sculpture and murals, the result of which is a multimedia array of laminated plywood panels, fluorescent lighting in two kinetic wall pieces, a "traditional" sculpture of steel, and a work comprising light panels, fresh plants, and electric sensors.

For Joyce's allotted space, a wall measuring six by twenty-four feet, she created a large cloth assemblage, 193 centimetres by 716 centimetres, titled *Défendez la Terre/Defend the Earth*. Sara Bowser came up with the wording, to represent Joyce's appeal for conservation of the world's natural resources. Once again, Joyce put her sister Joan in charge of the stitching, and she engaged three assistants.

The quilted lettering of the bilingual title appears across the lower portion. Flowers in colours of mauve, periwinkle, ultramarine, orange, carmine red, and fuchsine pink are stuffed and appliquéd on a backing of Egyptian cotton, as though drifting softly through the universe. The manner in which the quilt is made, with the tiniest green stitches holding the appliqués on the cloth, gives the impression that water is softly rippling among the flowers, keeping them afloat like water lilies lilting on

the surface of a pond fed by an underground stream.

The prime location shows the work to beautiful advantage. "It fills the vista effectively and beckons one on, like an intellectual iron fist in a visual velvet glove," according to *artscanada*.

Joyce declared this to be her best work, to date — artistically or politically, we're not certain. Using the word *we* generously, inclusive of those who worked with her on the quilt, Joyce said that it was the "best thing we ever did . . . where the warning is very clear: '*Défendez la Terre.*'"

Dorothy Cameron called the National Science Library installations "the most successful amalgam of art in an architectural setting in a public building in this country, ever."

The year after her retrospective at the National Gallery of Canada, Joyce had a solo exhibition at the University of Guelph, in Guelph, Ontario, a forty-five minute drive west of Toronto. Works included some that had been exhibited at the National Gallery, among them the quilts *Confed-spread, Reason Over Passion,* and *The Water Quilt,* along with the knitted Canadian flags, embroidered works of Montcalm's and Wolfe's last letters and *O Canada Animation,* as well as the bronze sculpture *The Spirit of Canada Suckles the French and English Beavers,* and Joyce's Sweet Beaver perfume. Out of twenty-two works exhibited, two drawings and a print from 1972 were exhibited as part of a commission Joyce received from the Canada Post Office to design a stamp to commemorate World Health Day, in 1972.

The catalogue, written by art critic/historian Ross Mendes, celebrates Joyce and her art in a manner of the highest acclaim, beginning with, "Joyce Wieland's works suggest that she and everyone else is like a collage," which Mendes describes as a collage of memories, parties, friends, and so on, where "every moment of living is a succession of Images. Canada is her iconography, her emotions are her landscape. Images stitched together with light, colour and, there's no other word, love."

Addressing the issue of many critics who make a comparison between

Joyce and the "snap, crackle and pop art of Warhol," Mendes believes that Joyce "always seems to be wrapped in the comic strip of vulgarity." He hastens to clarify "vulgar" as meaning the common people, or in common use. More appropriately, the writer sees Joyce's roots in the abstract expressionism of de Kooning and Claes Oldenburg[9] — an important connection to Joyce's origins in painting.

Mendes concludes with, "Quite simply, I believe Joyce Wieland is one of the most important artists in North America."

The exhibition received no media reviews that can be found. Joyce would have to take her pleasures from the catalogue essay. And like a person pondering wording for his or her epitaph, it is not improbable to imagine Joyce applying serious currency to a quote of hers that appeared on the first page of the catalogue: "The older I get the more I feel it is an honour to be an artist."

The Canadian Film Development Corporation, a government agency that then provided funding for Canadian films in exchange for profit sharing, if any (the guidelines have changed over the years), ran a competition in 1970 for short films worth grants of $15,000. It occurred to Joyce that if she got a grant she could make a five- or ten-minute 16-mm film about *The Far Shore* and use it as a pilot to raise money. She applied for the grant and attached her script as her project outline.

Bizarrely, Joyce confronted a paradox as clichéd as any in a B-movie: She submitted her grant application and so did her husband. Michael received a grant; Joyce did not.

Failing to receive the grant epitomized the long string of setbacks that beleaguered Joyce in making *The Far Shore*. From the moment she flirted with Thomson's life until she produced her dreamed-for, ached-for lovechild film, Joyce endured six years of obsessive/compulsiveness that wreaked upon her the misery of friends' betrayal, a slow descent into depression and ill health, near financial ruin, and finally, at the film's release, criticism that ran the gamut of mild indifference to brutal hostility. Joyce could never

have anticipated the severity of the energy drain she was facing — physically, psychologically, and creatively.

As is expected of an artist, Joyce approached her film in visual terms. The trouble was, she set out doing everything herself: developing the story, conceptualizing the visuals, even creating a soundtrack in her mind's ear. But as the months passed, Joyce accepted what her heart told her — that regardless of her beautiful concepts, her storyline was weak. Her protagonist Eulalie, a sensitive, cultured woman mismatched with a hard-hearted businessman, meets the intriguing painter Tom, falls in love and runs off with him. Eulalie's husband discovers the lovers paddling away in a canoe and he shoots them.

Joyce placed her trust in the film's sensuality. She conceptualized the northern lakes and woods as exterior sets. Interiors, based on her lingering impressions of her first visits to the Grange, would glow with rich, period furniture, fine china, and accessories, and she visualized costumes adorned with handmade lace and velvet ribbons. The magnificent Canadian landscape, exquisite interiors, and a glorious musical soundtrack would provide a backdrop that shared equal billing with the lovers' passions.

Unlike her underground films, which were released with splice lines and scratches evident, Joyce held this film's aesthetics paramount; the story was a mere technical hitch to be overcome. The unfortunate result was that Joyce's diminution of the story at the expense of its images nearly destroyed her film.

After almost a year Joyce had produced at least ten drafts of her script. She sent a twenty-one-page outline to an American film magazine, *Film Culture*, which ran a partial text the following year. "I did this to make myself believe I could actually do the film. It was a dare, in a way," she explained.

Lurking scarcely beneath the surface of these words, especially in the word dare, is the insecurity Joyce had grappled with ever since she was the young teenager who suspected that being an artist was impossibly beyond her reach. And now, at age forty, she put on a fairly good show

of holding her insecurities at bay but was yet to grab and squeeze them in a lethal hammerlock. Many, if not most, creative individuals confront their insecurities as routinely as their morning coffee. The pure artist deals in uniqueness, a creative vacuum that provides no measuring stick for assessing new work, no traditions for comparison; and this no man's land entices creators to seek succour in fawning dealers or agents who pronounce *The greatest! The best!* everything the painter, poet, or composer produces, leaving the creator only the privacy of his or her soul in which to battle artistic uncertainties. Luckily, the creator's ego comes to the rescue. In public, Joyce's bravado more than compensated for any doubts she may have experienced. It had to. Otherwise she could not have summoned the courage to dare to be different.

Another factor of Joyce's personality that influenced her film was innocence. Joyce had spoken of certain of her paintings as having inno-cence "combined with ghastly truth," and others refer to the innocence as playful, whimsical. Av Isaacs, discussing *The Far Shore*, said that Joyce "had a kind of iron-willed innocence. Anyone else would have known that you couldn't raise the money to make that kind of film, and they wouldn't have tried, but Joyce just went ahead and did it."

In early 1972, Joyce reworked her script by creating it into storyboards. (Advertising agencies used storyboards, layout paper of television-screen outlines on which visuals and audio of a proposed television commercial are roughly drawn and lettered, frame after frame — a process now done with computer imaging.) Joyce felt that sketching out key action scenes and putting in the dialogue would clarify her story. But she went further than that. Over three years she drew close to three thousand storyboards in coloured felt pen, coloured pencil, and watercolour, of every scene of her film as she visualized it would appear onscreen.

On some storyboards, in addition to sketching action and lettering-in the dialogue, she noted camera directions and details of light and shadow. In one lake scene with Eulalie and Tom, Joyce appended a camera direc-tion: "Eulalie cuts the film in half by diving in the lake." One can only

imagine how she cherished that vision in her mind.

Finally, however, Joyce realized that her script was not working and called for help from her old friend Bryan Barney, who was writing radio and television dramas for the Canadian Broadcasting Corporation. He agreed to help her write a new script.

Although she and Bryan had been lovers fifteen years prior to this time, Bryan and Joyce's friend, Sara Bowser, had married in 1964 when Joyce and Michael were living in New York. For some friends, true friends, and former lovers, another spouse does not interfere with the friendship and ideally enriches it — a situation that occurred between Michael and Joyce, and Bryan and Sara. The couples kept in touch, visited when either was in New York or Toronto, and after Joyce and Michael moved back to Toronto the couples entertained one another in their homes and went out together. Bryan's work on the script proved to be the best of both personal and professional worlds for Joyce.

Joyce settled down, packed her jitters away in one of her "disaster" boxes, and she and Bryan rewrote the script. As it progressed, they realized they were now dealing with a feature film, hence investors, a lawyer, producer, director, cast, set designer, music composer, and so on.

A lawyer friend suggested, first, that they make a few changes to the Tom Thomson character to indemnify them from potential liability. Chief among them, the painter became "Tom McLeod" and the story was set in 1919, two years after Tom Thomson's actual death. More important, the lawyer advised Joyce to get a producer to do what producers do — raise money.

She found one, in Judy Steed.

Judy, a sometime union organizer and film editor for the Canadian Television Network station in Ottawa, had seen Joyce's retrospective and was fascinated by Joyce's "powerful statements about feminism and Canadian nationalism." She phoned Joyce.

Joyce related her first impression of Judy, saying, "She set up an interview with me, but even before it took place we talked on the phone. I

thought, well, she's about the liveliest person I've met since I've come back from New York. We talked on and on about social issues — feminism, nationalism, unions," and Joyce added a breezy non sequitur, "There was a lot of union activity then. During the Artistic Woodwork strike Judy got arrested for assaulting a policeman."

Judy was working on the television program W-5, and persuaded the producer to do a piece on Joyce. This was done, although Judy thought the interview lacklustre. She purchased the footage from the station and with it made *A Film About Joyce Wieland*. Through this production, the two women established a very strong bond. Joyce then asked Judy to work with her on *The Far Shore*. Judy brought producers Ian Ewing (Judy's brother) and Deanne Judson on board to help raise money. Neither of them was successful, and they both left.

Joyce and Judy decided their only option was to raise the money themselves. Neither of them knew what they were in for. Later, Joyce would wonder if she had squandered her time and talent to a destructive degree on raising money when she should have dedicated herself exclusively to the creative development of the film.

The two women trudged in and out of the office towers on Bay Street, the habitat of venture capitalists, accountants, and lawyers, seeking anyone star-struck enough to invest in films. (Tax incentives then greatly advantaged investors.) Both Judy and Joyce were by pin-striped standards "arty types," and their leftover flower-child appearance may well have elicited some prejudged decisions from these "grey men in grey suits." Joyce said she remembered one occasion of "Judy wearing a long coat that came down to her ankles, eating a doughnut and trailing powdered sugar."

Joyce also had no experience with the time-honoured fundraising tradition of quid pro quo: "You buy a ticket to my multiple-sclerosis dinner and I buy one for your juvenile-diabetes lottery," but when the ante soars to several thousand dollars the field is vastly limited. Joyce tripped headlong into this minefield when she approached close, wealthy friends George and Donna Montague as investors. They said no. Joyce

didn't speak to her dear friend Donna for several years afterwards.

Donna died in early 1998 and George later explained his reasons for not investing in the film, saying that despite knowing Joyce for about twenty years then, he "did not have great confidence" in the film. Furthermore, a personality clash existed between George and "one of the people involved," he said, whom he described as "a very tough nut," and he concluded, "Ultimately, we weren't on the same wavelength as Joyce and Judy," and while he regarded the film a "commendable effort on [Joyce's] part," it was "a jumble, like some of the things she represented."

The Montagues' rejection shocked Joyce. Money did not factor in; George was a man of means, and therefore Joyce deemed the rejection a no-confidence vote in her, artistically. She had counted on their friendship and loyalty. George had bought a collage of Joyce's in 1955 before she had had her first art show, and he and Donna faithfully attended Joyce's shows and bought her work over the years. Like family, Joyce had celebrated the Montagues' first child by making the *Michael Montague Quilt*, but then when Joyce needed them, they failed her.

Reflecting on this and placing her words in their most complimentary manner, Sara Bowser said, "The really amazing thing is that Joyce and Judy could make this film. There was absolutely no reason for anyone to give them a dime."

Chapter Eight

Angry, disillusioned, and exasperated by her and Judy's fruitless fundraising efforts and the bad blood spilled between herself and the Montagues, Joyce dropped *The Far Shore* to work on another project. This action appeared to suggest that Joyce had re-established a pattern of running away as a coping mechanism, starting as a child who escaped into drawing to hide from things that collapsed around her. Indeed, she ran away to Europe when she feared for her prospects with Michael; in New York she ran headlong into filmmaking rather than find a dealer; she went into hiding after her 1971

retrospective, and she plunged into a heavy work schedule as an escape/palliative for Michael's infidelity. It could also be said that she ran away from life's deep disquiet by overeating and gorging on chocolates.

One incident holds a clue as to the meaning of this behaviour and why Joyce carried it into her adult years. When she and Mel Stewart fled the escalating insanity in their house on that traumatic, late night, Joyce had effectively saved herself from certain danger by fleeing — in this case, her survival was at stake. There was no equivocation; the two girls got out and ran. Throughout her later emotional turmoil and adverse life experiences, Joyce learned to be strong and to overcome, but that act that one night may have represented a singular, potent strengthening of Joyce's courage. Running to uncertainty was preferable to remaining behind and facing inevitable harm. Previously, she had relied on instinct, whereas now she had reinforced her courage so that she would act on this strength in the future and with increasing confidence know that leaving a situation constituted regrouping and making a better plan. Contrary to the appearance of running away, she was actually shoring up her courage to come back to what she loved. And Joyce did come back.

This time, Joyce ran away with Judy to make a film on the infamous Canadian terrorist, Pierre Vallières.

A leftist Quebec journalist, Pierre Vallières became leader of the Quebec Liberation Front (FLQ), a separatist organization that during the mid-1960s advocated and used violence, including bombings, as a means of gaining socialist independence for Quebec.[1] Vallières and three associates were arrested in 1966 for their terrorist activities[1] but Vallières managed to flee to New York City, where he was subsequently arrested and deported to Canada in 1967. While serving a four-year prison term, he wrote *White Niggers of America*, a polemic that compared the oppression experienced by Québécois in Canada with that of blacks in the U.S. and South American blacks by their government.

Joyce was drawn to the man by reports appearing in 1971 that Vallières had renounced violence, resumed his career as a journalist and supported

the Parti Québécois, an official opposition party formed to seek Quebec independence.[2]

The romantic Joyce equipoised the terrorist Vallières with his personal struggles. She learned that the man had been born into extreme poverty in Quebec, and Joyce, consummately sympathetic to individual hardship, regarded Pierre Vallières as a person "who tried to do something about his society." That his actions involved terrorism and that the government, "apprehending insurrection," invoked the War Measures Act in 1970, did not capture Joyce's attention to the extent that Vallières's personal tragedy had done — in part, because her politics were evolving into a higher, clearer definition for her. Previously, she had juxtaposed her work on the borderlines of Art and Politics (she invariably capitalized the words) and at this time the lines were converging. Her Art would bear a stronger political element and her Politics would become more personal. Pierre Vallières's story conformed precisely to this convergence. Joyce clarified her Art/Politics intent in making a film about Vallières when she said, "We were aware of the general indifference to Quebec which exists here in English Canada, how extreme radicals considered him a decadent cop-out to [the] Parti-Québécois, etc. We were interested in his writings and struggles to find himself."

Joyce, Judy, and Danielle Corbeil, a friend of Joyce's and director of Extension Services of the National Gallery, who would act as translator, arrived at Vallières's apartment in Mont Laurier, a Laurentian Mountain town north of Montreal, on the appointed morning. The man then sat down in front of the camera and read for more than half an hour non-stop three of his essays on women as an opposed group, social reform, and Quebec independence: "Women's Liberation," "Mont Laurier," and "Quebec History and Race."

During the entire time, Joyce shot only one continuous close-up of Pierre Vallières's mouth as he read.

The thirty-three-minute film is of Pierre Vallières's mouth, full frame, outlined by his lips and dark moustache hairs, centred on the crooked,

stained teeth of a lifetime's poor oral hygiene — "The teeth of a poor man," Joyce said. As his tongue moves in its dark cavern, English subtitles appear over a soundtrack carrying the man's theses that two groups, women and the people of Quebec, are similarly oppressed by the state.

Joyce called the film a "mouthscape," explaining, "What we see on film is the mouth of a revolutionary, extremely close, his lips, his teeth (and calculus), his tongue which rolls so beautifully through his French, and finally the reflections in his teeth of the window behind me." She pointed out, "I liked the idea of concentrating on one small section of his anatomy, because it simplifies things. Here is a close-up hold of his mouth, on and through which you can meditate on the qualities of voice, the French language, revolution, the French Revolution, Géricault's colour, etc. These are some of the things I think about when I see my film."

Film critic Lauren Rabinovitz saw the vagina.

"In its magnified state the large pulsating mouth — two pink, moist lips, coarse, black hair and a graceful tongue — has a physical similarity to female genitalia," she wrote. "If a linkage between mouth/lips and vagina is already symbolically inherent, the particular point of view here makes it visually explicit." She suggested that Joyce individualizes "a single detail," the mouth of Pierre Vallières, as "an emblematic icon for sexual and political power," that the man's mouth becomes "a social poetics about the interconnectedness of three elements: the individual, feminine sexuality, and political power."

American Jonas Mekas admitted in the *Village Voice* that he had never heard of Pierre Vallières but learned from the film that he was a "political writer, among other things. . . . Listening to him, I understood, for the first time, why Quebec is fighting for its liberation."

Mekas also complimented Joyce within the film canon, writing:

I look at this film also as a critique of most of the so-called political documentaries. Their makers seem to think their point will be improved by collecting and collaging all kinds

of documentary footage, usually showing the cruelties, or the miseries, or the blood, to show how bad the capitalists, or the enemy, are. . . . We have learned enough about how such footage can be faked and manipulated. Joyce Wieland doesn't do any such thing. She concentrates on the speaker's voice; she presents Pierre Vallières's voice in close-up, so that nothing is hidden. And the truth of the voice, the sound of the voice, the nuances of the voice, its vibrations, its colors merge so totally with what is being said that no other images are needed to make the point.

In later years Joyce said she hated Mekas (for his part in excluding her from the New York Anthology Film Archives), but despite how she felt about Mekas's ignorance of Canadian politics, she surely would have appreciated his opinion of her film.

However, her euphoria was short-lived. Joyce would need the comfort of this review clasped to her breast while other critics raked her over their red-hot cinematic coals for romanticizing a bomb-throwing, government-bashing terrorist. She admitted, "I have been criticized for making a film about a traitor by some people in the film scene." She then asked, "Where could I take it that he [Vallières] wouldn't be considered one?" If she is suggesting that without the man's criminality, the words he mouthed, the mouth Joyce filmed, she would not have a film, does this justify making her film "by whatever means possible" (to use a black rallying cry)?

Interviewer Barbara K. Stevenson asked Joyce about the contradiction of being sympathetic to the man and yet using his mouth as the "main visual component of the film" when that mouth was not attractive up close.

"It was about dealing with the mouth of a person that was put in jail without trial for three years," Joyce replied, and added that the film defines "what is a mouth. And what is this man, because he is an orator, and very good at it."

However, Joyce did express certain misgivings about Vallières: "I feel

mixed about some of the things he said." But she defended him, and thereby herself, with her declaration: "I think that he's an interesting man and I think *White Niggers of America* was a very important book."

Following *Pierre Vallières*, Joyce lit out to Kitchener, Ontario, to the Dare cookie factory to make another film. Like *Pierre Vallières*, this film, too, served her Art and Politics activism — in addition to forestalling her work on *The Far Shore*.

Workers at the Dare plant, most of them women (275 of 365 employees), had been on strike for a year and in recognition of their plight a rally had been organized just past the one-year mark, in 1972. Five thousand people showed up and marched in solidarity with the workers. Since both Joyce's sister Joan and Joyce herself had worked in a chocolate factory, and Sid had worked at the Orange Crush plant, the conditions of ordinary workers were not new ground for Joyce. Nor would being distanced socially and professionally have diminished her interest in workers' oppression.

Joyce was incensed that the women "worked under medieval conditions" and received less pay than the men did — $2.25 an hour to men's $2.94 an hour. Joyce learned that the company "continually sped up the work line. The temperature in the area where the women worked was always around 130 degrees; they frequently fainted." And, "Women had to raise their hands to signal they wanted to go to the bathroom."

Joyce went to the demonstration with two women from Canadian Artists' Representation (CAR), along with Betty Ferguson, who lived near Kitchener, and Judy Steed.[3] Joyce marched with the women for a time and then began filming. People noticed her Bolex with its long zoom lens mounted on a tripod, pointing only downward, at the marching feet. Someone suggested she film the demonstrators' faces and Joyce replied that it had been done before and she was trying to find another way to tell what was happening. Or, as filmmaker Kay Armatage observed, with Joyce "focussing on the feet . . . you knew that everything was going on outside the frame."

Having just wrapped up a film of only the mouth of Pierre Vallières, Joyce felt that shooting only feet made aesthetic sense. Titling the film *Solidarity*, in empathy for the union workers and their "dare" in the cookie company, Joyce described how these two films stand as examples of her aesthetics applied to political statements:

> There is an intimacy and passion in *Pierre Vallières* that doesn't exist in *Solidarity*. In *Solidarity*, it's more like panning for light around the ground, letting doubts and funny asides in.
>
> The audience laughs at the speech of the woman near the end of the film; they are embarrassed by her passion. The strikers' slogans, "There's a scab in your cookie," and "Scabs out" . . . make the film funny despite its sadness.

Stating that *Solidarity* "is almost invisible to those who have seen it," Joyce wanly admitted she was placated by the notion that "the image in *Pierre Vallières* is not forgotten."

At the end of 1973, with still no money raised for *The Far Shore*, Joyce and Judy appeared before the Canadian Film Development Corporation with Bryan's completed screenplay and a budget, and asked for $100,000, which they pledged to match dollar-for-dollar from private investors.

A speck of good news landed on their barren plates in January 1974 when the CFDC reported that the film script was admirable, the movie deserved a production, and the organization committed $115,000 to the project. Joyce and Judy were almost as pleased as they were crestfallen; that amount of money could not possibly produce a feature film. Originally, they expected to make the film for $100,000, but after reworking costs, Joyce said, "It was scary when the film climbed in budget," to almost $500,000. Off they hustled again to round up more investors, and another producer, whom they found in Toronto lawyer Chalmers Adams.

Turning to casting, Judy contacted Canadian actor Larry Dane to play

the painter. He turned down the part but did them a monumental favour — he persuaded the CFDC to increase their $115,000 to $300,000.

Of all a movie producer's indulgences, casting has to be Fantasy Number One. Poolside, pick the world's hottest hunk or babe, grab the phone, only to discover that Leonardo DiCaprio, Clint Eastwood, Gwyneth Paltrow, and Meryl Streep are ballooning over the Alps, hugging Tibetan trees, or having a baby, and the producer signs a bit player no one ever heard of. Joyce's wish list for the painter character did not include a big American star for her pure Canadian film. However, she had pressure applied: Famous Players offered to invest $25,000 with the string attached of doubling the amount if they signed a middle-range American star for the lead.

"We did our darndest to come up with a star, Rip Torn and Stacey Keach, among others," Joyce said. After reading the script, Stacey Keach turned it down; not his kind of role, he said. And although he had been suggested, Joyce knew the part was not for Anthony Franciosa, then a hot star. "We didn't have our hearts in it because we wanted an all-Canadian cast."

Canadian Donald Sutherland had been approached but couldn't accept because he was booked to film the thriller *Don't Look Now* in Venice with Julie Christie, and Canadian Geneviève Bujold was under consideration to play Eulalie, and although she was interested, she had another film commitment.

As luck would have it, Famous Players came up with the full $50,000 anyway. Then Astral Films, a film distribution company, anted in $25,000.

Joyce felt that the perfect Eulalie, a composite of the beauty of Lillian Gish and the refinement of Antoinette Snow, would be found in Montreal, and there they went, holed themselves up in a hotel room and videotaped "cattle calls" (hopefuls who turn up to read for a part). Their Eulalie appeared in the dewy, exotic beauty of Céline Lomez, a singer and until then best known as the stripper in Denys Arcand's film, *Gina*. Frank Moore was cast as the painter, Tom, and Lawrence Benedict as Ross, Eulalie's husband.

Joyce and Judy's letter and door-knocking campaign ultimately produced close to $100,000, and a few friends made small investments. Still not enough, but fundraising was on the upswing.

Had Joyce known then that she was three years away from finishing the film, and had she been able to avoid what she later called the "dangerous extension" of her energy the project caused her, she might have found a rationale for abandoning it. But returning conformed to her way of dealing with difficulties; she would run away but come back with a stronger resolve to a project whose odds were against her. Furthermore, abandonment happened to Joyce; she did not abandon.

Joyce and Michael still lived in the house on Summerhill Avenue. In 1974 and 1975 Joyce's nephew, Keith Stewart, spent a lot of time with them, fixing up the house; and when Michael bought some property in Port-aux-Basques, Newfoundland, with a cabin on it, Keith went with the couple to work on the place. Keith sensed that those two or three summers were a time of distinct change in Joyce and Michael's relationship.

"More and more she realized she was only around so that Michael had somebody to come home to, to cook and help him with the business," Keith says. "And help him become famous. She did a lot of promotion for him and had a lot of good ideas." He speaks of Michael and Joyce "sitting around, coming up with ideas, like an electronic game of table tennis. That was exactly what she was like. She'd bounce from one thing to another within seconds, then jump up and run here and go there.

"She was getting totally wrapped up in what she wanted to do [with *The Far Shore*], but at the same time she was waiting on Mike hand and foot. Like, here's this feminist doing all this crazy stuff and on the other hand, cooking and cleaning." Describing their mealtimes, Keith casts his eyes to the ceiling. "Like, there was one plate of vitamins and one plate of food. Make them healthier, make them better. Sure." He remembers many times when Joyce "would eat a really healthy meal and then she'd down a pound of chocolates."

Starting in the early 1970s, Michael's career surged nationally and internationally, and with his growing celebrity came invitations to appear at events related to not only his art but also film and music. Back in Toronto, he was away from home sometimes for weeks — at foreign film festivals, teaching residencies — and he played with the Mike White band, and two nights a week for two years with the CCMC (Crushed Cookies Make Crumbs) band.[4]

Joyce grew short-tempered, she worried incessantly, stomach cramps and headaches beset her, and she went on chocolate binges. Keith said Joyce called him at two one morning saying she'd just eaten five pounds of Laura Secord chocolates.

Judy described Joyce's worsening state as, "Joyce always thought she was going to die."

And yet a letter from Michael, dated September 10, 1972, from Italy where he was attending a film festival screening some of his films, contains many tendernesses. He writes, "You are on my mind a lot," that he'll be home soon and he sends "love, love and good morning, afternoon and good night, love, Mike." Those are words a woman clings to, even when angry at her man.

Nonetheless, talk of Michael's extramarital activities continued. With him being increasingly away from home, one friend or another told Joyce they had seen Michael with someone else.

Keith summarized: " What I noticed, progressively, through the 1970s, she got fed up with the whole thing. Mike was always with the band, going places, and all her friends were telling her, Mike is doing this and that, and she'd say, that's Mike. But she started to get ticked."

People's perceptions of the causes of a couple's breakup are as varied as their perceptions of life, and their own marriages. Jo Hayward-Haines attributed her first sign of trouble in the marriage to the raccoons in Joyce and Michael's house. In Jo's view, couples do things together or agree to have things done to keep their home livable — mend the fence, fix the roof, drywall the basement — and basic things that go undone signify a

corresponding deterioration in the marriage. "They had raccoons in the house and didn't do anything about it. And that to me spelled profoundly that something was askew."

Joyce's friend Charles Pachter suggested she look at a house that was for sale on Queen Street East; it was bought as a production house for *The Far Shore*. As the couple's marital troubles intensified, Joyce occasionally packed up and stayed at the Queen Street house.

Two aspects of Joyce's damaged psyche point to reasons why she couldn't make a clean break of her marriage. Staying was safer than leaving. Tolerating Michael's habits was preferable to having no one's habits to tolerate. And if she ran away from her marriage, unlike past "runaways," she probably would have lacked the courage to come back. Crucial to her staying was the fact that she liked married life, liked Michael's family, and whatever strife befell them, Joyce loved Michael. Combined, they had status — as Michael put it, "We were a heavy couple" — they had solid individual reputations as artists, social appeal, close friends, and more; they were bound together by the golden glue of art.

"Joyce and Mike were stars," Sara Bowser said, "enormously venerated, very stimulated by each other." In the artistic sense, "She stole from him and he stole from her. It added to each other's brilliance."

One of the ways that Michael benefited from Joyce was through his sculpture of the flying geese in Toronto's Eaton Centre.

Hanni Sager remembers that Michael "wanted to do something large on the floor." Betty Ferguson recalls this as big rocks, and Joyce said, "No, with all that space you have to do something that floats up there, like birds."

Keith witnessed the work take shape. "That happened in the Summerhill living room when I was sitting there. Mike was thinking, 'What am I going to do with this commission?' and Joyce said, 'Why don't you do birds, Canada geese?' and Mike being the technical guy, working with this material and that material, latched on to it right away and said, 'Yeah, I could make them out of plaster of Paris or something like that, and take

pictures of real birds and put them on.' But it ended up being fibreglass or something."

Keith remembers, "That really burnt her, a few years later when Mike was saying how great it was, blah, blah, blah."

Records reveal that Michael paid Joyce $5,000 for the idea. .

Michael's recollection of the commission is that he decided to "put something in the air at the end" of the mall, "and I thought if it's in the air, why not birds?" He allowed as how Joyce may have suggested he make them Canada geese.

One friend scoffed, "Anyone who knew Joyce and Mike knew that this wasn't his idea."

The strain on Joyce regarding her marriage and the pressure to finish *The Far Shore*, was revealing itself in abdominal pains and headaches. She didn't complain, except to a couple of friends, and one other person.

In New York, Joyce had been in touch with one Donald Kaplan (now deceased), whose name appears on fine personalized letterhead, the kind of social stationery ordered from Tiffany or Birks, bearing only his name, followed by Ph.D., and his address.

Joyce had obviously written to him outlining positive and negative events, exaggerating her well-being. In a reply to her, dated June 3, 1974, he wrote, "I have no comments on your laments, though I do know the misery of appetite (sexual and otherwise)," and he reports his difficulty with quitting smoking, and that her letter "arrived in the midst of my greatest pangs of withdrawal."

His next paragraph reads:

> So you have lost a lot of weight, have gotten some money for your film and are sexually on fire (as you describe). Mixed blessings? All I can say is that I wish you the best on the project and that I implore you to stay with the diet, sex or not sex.

Sexually on fire? Lost a lot of weight? When Joyce was consumed with raising money for *The Far Shore*, when she dashed madly off and made *Pierre Vallières* and *Solidarity*, when her marriage was foundering and she was chocolate bingeing? There is no evidence of another man in Joyce's life, although within a few years, George Gingras would reappear and still later, Joyce would meet some men. But it would be another nine years before she produced her famous painting, *The Artist on Fire*. Her reference to being sexually on fire, at that time, if not hubris is at least a conundrum.

Kaplan continues, writing that New York City "is still here, minus the Yankee Stadium" but it remains "the Big Apple — lots of jazz and handguns." He expresses his sadness over Duke Ellington's death (ten days prior, on May 24, 1974) and ends with, "I'm glad you're okay. Stay with it. Myself, I'm fine."

Six months later, Kaplan writes, "I can't say that I was cheered at the news of your illness," which he likens to a severe strain of flu, and goes on:

> However, what really concerned me were certain perpetuating situations involving your mother-in-law and Michael. I am surprised that you are still paying court to your mother-in-law's regality which she is not entitled to unless, of course, you entitle her. Obviously you have felt trapped and intimidated and then fed up with her ungratefulness. Yourself you go on to represent as a sissy, this at the end of your letter, but I was reminded when I read that self-description of the contrast with your description of your mother-in-law as possessing everything you lack the courage to claim for yourself — including a certain kind of devotion from Michael. It is sometimes true that what we fear are our own repudiated wishes and that we can hold onto our repudiated wishes by investing them in others and then remaining in strong contact with others who now embody a desired part of ourselves. In other words, you may be keeping some of this

monkey-business alive with your mother-in-law so as to experience in her something you want in yourself — regality, privilege, whatever it is you entitle her to. At bottom you may even envy her, if she does embody your own displaced and projected ideals. To envy one's enemy is among the most unsettling experiences. Do you overact, I wonder, for fear that if you didn't you would be as commanding as those who intimidate you?

Joyce and Michael's marriage soon took a fatal dive. One friend says, "Michael was a womanizer, that much was known," but the gossip changed from Michael being seen with women to being seen with one woman.

"Joyce found out about that," Keith says, "but she couldn't bring herself to just cut it off because she had invested so much in the whole thing. And what was she going to do at her age?" No insult was intended. In his late thirties then, Keith was typical of men of that age who did not fantasize about women over forty. And therefore, according to that mindset, Joyce's future did not appear promising.

Joyce and Michael separated in early 1975. She moved into the Queen Street production house and with another year's work to complete on *The Far Shore*, Joyce invited Keith and his wife to move into the house with her.

"She was a wreck," Keith stated.

Joyce's health worsened. Although she would have had to acknowledge that her abdominal aches and pains, menstrual irregularity, and bloating were stress symptoms caused by the film and her foundering marriage, Joyce nonetheless hid behind what she supposed was a normal face and upped her vitamin intake.

She hadn't fooled Judy, though. She forced Joyce to go to the doctor. Judy's timing was eerily apt. Within days, Joyce was admitted to Women's College Hospital and had a hysterectomy.

Her recovery was prolonged and dispiriting, and to her friends, worrisome. A hysterectomy is major surgery, performed under general

anaesthetic, where typically the lower abdomen is cut and the uterus removed, along with one or a combination of other reproductive organs, such as the ovaries, cervix, and Fallopian tubes. For a woman of child-bearing age, the operation can produce severe psychological after-effects with the realization that she is henceforth incapable of bearing children; and more distressing for some, especially younger women, is that the operation can induce menopause. Joyce had known for the past five years or so that she was infertile and now, at age forty-four, this was confirmed.

"It nearly destroyed Joyce when she had the hysterectomy," Hanni Sager believes. "She wanted to have kids but she knew now she wouldn't, that this was the end." Hanni hadn't known about Joyce's fertility testing in New York.

Many of Joyce's friends were likewise misinformed, although unified in their compassion for Joyce's now dashed dreams of motherhood. Certain friends had lived in the faint hope clause of Joyce's eventual motherhood, despite her ticking biological clock, largely because she had left the impression that she longed for children.

Sara Bowser's opinion was quite different. "I never had any faith in Joyce's maternal instincts," she declared, and explained before her meaning was misconstrued, "Theoretically, she wanted children, but I think she would have been a dreadful mother." She paused, then burst into laughter. "She never owned a cat that wasn't crazy." Sara had known Joyce longer than most of her friends, except Mel Stewart, Mary Karch, Donna Montague, and Betty Ferguson; Sara and Joyce remained the kind of non-sycophantic, searingly judgmental friends who could exchange frank words without fear of repercussion. Sara cited a few major faults in Joyce as a mother. "She was not consistent. She would have been a spoiler and a neglecter. She'd bond and then not be around — I mean, motherhood is a boring, hard job and I don't think she liked boring, hard jobs."

Sara referred to what she considered a telling event when Joyce's brother, Sid, died in 1966. "I thought when her brother left all those kids [seven] — there was one she was very fond of and I think maybe

I even said, 'Now's your chance to adopt the baby.' It didn't happen. And I thought she [mustn't] really want that."

There are additional layers in this story. Joyce said Michael vetoed the adoption. And George Montague, in a very forthright, unemotional manner, said that Joyce "put pressure on Donna" to adopt the youngest of the children. The Montagues did adopt the boy when he was twelve years old and he lived with them for about two years.

When this was discussed with Michael, he referred to Joyce's fertility tests conducted in 1963 and their negative results, saying it was "very upsetting" for Joyce and "another thing that hurt her." He believes Joyce would have been a very good mother, but he didn't want kids. The reason, he explained, had to do with being "self-absorbed."

Sara had observed Joyce's associations with children and insisted that Joyce "liked children theoretically and they adored her." She motioned to her daughter, who was visiting from Boston: "This one here was delighted every time Joyce walked in the door. She would catch her up, shower her with attention and tell stories and play little games with her and then *bang!* it was over and she would drop her. That was fun but it was not motherhood. I think she knew in her heart of hearts she was an artist and not a mom."

Another recollection produced a robust laugh from Sara. "Someone once lent her a baby for an afternoon. Joyce returned the baby in the pram and the pram was full of apple cores and candy wrappers and the mom said, 'You didn't give the baby all that stuff, did you?' I don't think they were ever clear in their mind whether Joyce had eaten all the junk or fed it to the kid."

Joyce's love of children included an ability to influence them artistically. For example, she taught Munro Ferguson, when he was six, to draw his self-portrait and a portrait of Michael. As Joyce had done when she was a child, Munro started drawing cartoons. Later he graduated to work as an animator and, obviously influenced by his filmmaker parents, in 1990 he completed his first animated short film. (His next film produc-

tion was in IMAX, the large-screen format developed by his father.)

Ken Jacobs, a man with an impassioned commitment to family, thought it tragic that Joyce had not had children. Using the word *love* frequently when discussing Joyce and her work, Ken also framed love in the context of Joyce's infertility as lost love — that in being barren she had lost the immense love of being a parent. The surgical procedure that removed Joyce's reproductive organs symbolically and emotionally excised a body of dormant love within her. She had written in her journal in 1956, maddened with uncertainty over Michael, that she was learning a little more about love every day and regretted that she had learned so late. And when she added, "Never show a man what's in your real heart. Especially a conceited bastard like Mike," one wonders if those words resounded after her hysterectomy. No question, she would now be forced to accept that despite fertility testing and despite how she may have hoped for a lab error, the operation conclusively annihilated her reproductive function and with it, the lost love of parenthood.

It is difficult to know how Joyce's status as an orphan affected her decision about adoption as well as her true feelings about maternity. Many friends expressed their opinions unaware of Joyce's out-of-wedlock birth. Married to Joyce for more than twenty-five years, Michael said he didn't know.

Joyce had heard it said over and over that her artworks were her children. At some time she may have experienced a familial attachment to her creations, although Joyce snapped the lid on this line of questioning in one interview by declaring, "My artworks are not my children. They are products of passion and imagination. Why don't they say that about men? They say, 'Poor thing, she never had children, but we'll say they are her children. Would they [say to a man], 'You didn't have children. I guess your artworks are your children then?' He'd smack you in the head!"

On the other hand, leave it to Joyce to declare, "I'm a goddess! I've been a mother a thousand times over a million years. Why not believe that?"

Over the space of three years, since Joyce's sentiment appeared in the University of Guelph catalogue in 1972 about her feeling it an honour to be an artist, a growing segment of the public was feeling honoured to have her onside. Her presence had an impact; ethically she carried weight. Increasingly she began receiving appeals to lend her name to causes and speak out against injustices committed by politicians, businessmen, and museum directors, and she was becoming known as a social guardian and agent of change.

She signed petitions, lent work for a poster, put her name on a letterhead, joined frontline marchers and placard carriers. Others did, too, but Joyce went the extra mile.

A case in point is when Joyce and a group that formed the Anti-Reed Campaign (ARC) took on a battle ready-made for artists against the Reed Paper Company in 1976. The company had sponsored an art exhibition at the Art Gallery of Ontario, *Changing Visions — The Canadian Landscape*, which included a painting of Joyce's, along with works by more than forty other Canadian artists.

Since the AGO, not the sponsor, had selected the works, the ARC group wrote to then chief curator Richard Wattenmaker urging him to close the show on the basis of Reed being a major environmental polluter. ARC complained that Reed had been discharging mercury into the English-Wabigoon river system of northwestern Ontario from its pulp-and-paper plant in Dryden, Ontario, which led to some of the highest mercury levels in fish throughout the world and had caused mercury poisoning in northern Native people from eating the mercury-contaminated fish.[5] This public-health hazard was directly attributable to the art show's sponsor, the Reed Paper Company.

Joyce and Michael, and some two-dozen artists, dealers, and CAR members, lined up at the doorway of the AGO on the opening night of the exhibition with posters and pamphlets denouncing the AGO and the paper company. Joyce said, "All the curators and other people were looking out through the windows and the glass doors, and nothing got by." They

disrupted the opening but the AGO did not close the show and did not, as the artists' demanded, remove their works from the exhibition. Joyce trooped her ethical colours by marching into the gallery and taking her picture off the wall.

Av Isaacs said, "Joyce was the only one who took down her picture. The others stood on the sidelines." He added, "Including Michael."

Two years prior to the Reed protest, Toronto artists objected to the AGO's hiring of that same Wattenmaker, an American, as chief curator. Poet Milton Acorn had prepared a statement to the AGO demanding that the Canadian curator be a Canadian, that only a Canadian's eyes could see Canadian art — the implication being that an American would not select appropriate Canadian works for exhibitions abroad.

A group of artists and CAR members barged right into Wattenmaker's office, but it was Joyce who took the definitive step: She chained herself to a filing cabinet in the man's office until the group could speak to him directly. However, he was out of the gallery and the protestors left before he returned. On another occasion, photographer Michel Lambeth and poet Jim Brown chained themselves to a staircase outside Wattenmaker's office.

William Withrow, director of the AGO at the time, stated that the protesters were slightly off the mark in their objection to Wattenmaker, in that he alone did not curate Canadian art; that as chief curator of the gallery "he [Wattenmaker] has overall direction of the collection." Wattenmaker's specialty was the Old Masters and therefore CAR's argument fell short on the issue that Titian could not be seen except through Canadian eyes. Moreover, explained Withrow, "the management board sets the gallery's policy for exhibitions, not the chief curator."

He also made the point that Joyce led the charge and took the bold action. Withrow noted that Michael "stood in the background while the protests were going on, that he did not seem intellectually convinced about the matter."

During Joyce's post-hysterectomy recovery period, Judy Steed urged her

to get into therapy. In New York, Joyce had been seeing a Jungian thera- pist and a psychologist, but for the previous four or five years had not been in formal counselling. When Judy recommended that Joyce see the highly respected feminist psychiatrist, Dr. Mary McEwan, Joyce booked into what would become a profound and beneficial learning experience.

On her first visit, Mary (all her patients called the doctor Mary) rendered the opinion that Joyce was tired of holding her marriage together. "She looked at me in a way no one ever had before," Joyce said. "I completely fell apart. I cried for two hours. It was like being slit open and everything came out."

At first, afraid that her love for Michael was unrequited, falling in love with him hurt Joyce deeply, while marrying him fixed everything that had ever hurt her. Within a few months in 1956, Joyce had gone from being torturously in love to being poetically, classically, dreamily high on the sweet, absurd dementia of love. Everything she'd ever prayed for had come true. But one has learned to beware of answered prayers.[6] Early in the marriage, Joyce acknowledged Michael's infidelities, which manifested a new source of personal torture. When this combined with the disap- pointments and reversals she began to suffer in New York, she sought therapy with a Freudian there. (As had Michael.) After returning to Canada and encountering troubling political and feminist issues, then coping with her hysterectomy and the trials of *The Far Shore*, Michael's perfidy caused her a deeper dimension of pain than ever before, and she admitted she needed help. Joyce had said she'd been in therapy most of her life, which she may have construed to include her various indepen- dent psychological/spiritual explorations. What surprises is how little professional therapy she availed herself of until 1964 in New York.

With feminist therapist Mary McEwan, however, Joyce would gain strength, shed more tears, and come to love Mary as a dear friend. But until then, Joyce had a film to finish.

By spring 1976, Joyce and Judy had raised $480,000, cinematographer

Richard Leiterman and executive producer Pierre Lamy came on board, and pre-production of *The Far Shore* got under way.

Scouting a location for the ideal mansion for their interiors, Joyce and Judy drove around Rosedale and knocked on doors that looked suitable. Door after door was slammed on them until one day, Eugene Kash, musician husband of contralto Maureen Forrester, answered his door and said the perfect place was the Kashes' previous home. It had recently been purchased by Sandy Best (son of Charles Best of the famed insulin-discovering team, Banting and Best), who lived with his wife in one upstairs room while the house was being renovated. As it turned out, Sandy had gone to school with Michael Snow, was a devoted art lover, and his home, with its grand circular staircase and fine architectural details, became Eulalie and Ross's mansion in *The Far Shore*. To replicate such grandeur in a set would have cost, by Judy's estimate, about $300,000.

About to start filming, Joyce and Judy encountered the first of what would become a battle of the sexes. Joyce had been told that directing a feature film was best left to a man, specifically concerning management of the crew. Regardless, Joyce directed her film, although she felt very insecure about the crew. "I thought they'd laugh at me," she said. Senior cameraman, set designers, gaffers, hairstylists, drivers, caterers, and assistant everybodys — a film crew is notoriously, hazardously cool.

Judy Steed uses as an example of the difference between a male and female director, a well-known Canadian male director's approach to rolling film. "He starts with, 'Come on, you fuckers, let's get going,' all very neurotic and emotional."

Having had no experience directing a feature film, Joyce read books on the subject and researched scene marking and splitting up dialogue, but nothing prepared her for the first day on the set. Joyce was terrified. She described how designer Anne Pritchard — designer of *Act of the Heart, Alien Thunder,* and *The Apprenticeship of Duddy Kravitz* — had sustained her. "I'll never forget the look she gave me the first day on location before the first take. I was nervous as hell. I looked around into the

steady gaze of her beautiful eyes. What I saw there was a secret shout of joy and encouragement. It said, 'Go to it, Sister.'"

Determined to maintain control, Joyce also knew she had to get the work out of people her way, amicably; but on the set there were tiffs, spats, and one struggle Joyce called "a big fight" with Chalmers Adams, involving close-ups. Joyce capitulated and called it a learning experience. Her difficulties with making the film were worse than typical because hers was a first feature in Canada made by a woman, and, "The executive producer had absolute tantrums about me directing. There was a show-business lawyer who hired a producer and then let him run around with all the credit cards. He wanted to bring in a Polish director!"

Later, as will be seen, Joyce relates the soul-destroying effect this had on her. But among the film's decay, like Leonard Cohen's flowers and the garbage, beautiful, strong friendships grew around Joyce and the film's key women — Judy Steed, Anne Pritchard, and Sylvia Tyson, who sang the film's title song.

Filmmakers may invite a select few people — friends, investors, fellow filmmakers — to view a cutting copy of a new film, a print the filmmaker uses for final editing. In 1975 Bill Auchterlonie, a graduate from the York University film program, was among those viewers. He reported that the print and sound were poor, "But wow! It really is something," and declared, "*The Far Shore* is one of the most clearly articulated and most beautiful films ever to be made in this country."

Joyce perceived this as a beautiful omen.

The Far Shore had its world premiere on August 5, 1976, as the opener of the Canadian and International Feature Film Festival in Ottawa.

Michele Landsberg wrote in *Chatelaine:*

> It's a woman's film, and that's a jolting new experience, too.
> That "click" of instant recognition, the knowing little thrill of
> secret insights shared, will be irresistible to the macho-weary

female viewer. Here the camera moves at a gentle, dreamy pace, so that we can drink in the pictures so beautifully framed, composed and lapped in light. We can see, for a change, through the clear eyes of the female lead.

Variety, the feared and revered show-business trade paper, opened its critique with, "'The Far Shore' is a very beautiful film . . ." and went on to compare it with *Elvira Madigan*, noting, "This is a far fresher film except visually; they're about equal there. Richard Leiterman's lensing, chiefly around Bon Echo Lodge in this general area, is sometimes breathtaking." (Released in 1967, *Elvira Madigan* has been hailed as one of the prettiest movies ever made, not the least of its charms being the limpid adagio movement of Mozart's Piano Concerto #21 that became popularly known as the "Theme from Elvira Madigan.")

A 1978 piece in *Showbill*, a short-lived film-trade magazine, singled out Joyce's "impeccable eye" for "things Canadian" and her understanding of the "country's visual identity," which was "only to be felled by a TKO from the critics who gleefully panned the final results." Movie reviewer George Anthony pointed out that filming the main character's day-to-day life is a risky technique because "we may get bored before she does" but that Joyce pulled it off "mainly because her film is so physically eye-appealing and her sense of detail so stunning that all the delicate pieces of 'The Far Shore' fit together like a look into another room — a fragile antique jigsaw that none of us could afford at today's prices."

Calling the visual elements gorgeous, Martin Knelman observed, "Wieland has done something we haven't had before; she's evoked the romantic past of Upper Canada's gentry and put it on the screen for us in physical detail." Then he complained, "But dramatically, 'The Far Shore' never gets going," and he described the performers as being "all dressed up with not much of a script to play . . . it may be that her [Wieland's] talents aren't really suited to the narrative form."

However, Joyce surely forgave him after reading the following:

The one unforgettable sequence in the movie is played without dialogue, when Tom and Eulalie, having escaped to an island, make love standing up in the lake. Their bodies are mostly concealed under water, but the scene is highly erotic; it's as if the passion that had been submerged throughout the whole movie finally bursts out.

As for those who "gleefully panned" the film: "The Wieland movie is the genuine Canadian article — conscientious, striving for simplicity and frankly rather dull." Quoted as the article's headline — "*The Far Shore* truly Canadian — rather dull" — would have caused Joyce to burst into tears, we know.

There were other criticisms.

The Canadian Review: "A film must stand or fall by its script. And *The Far Shore* falls, flat on its beautifully photographed face." Leiterman's "dazzling" camerawork, does not "divert attention from the screenplay," which is described as "cumbersome," containing some of the "most (unintentionally) funny lines ever recorded on celluloid."

From the Canadian Press: "The strengths in filming and sets are not enough to pull *The Far Shore* out of its confusing mix of humor and soap into the mature feature it was intended to be."

The *Globe and Mail* ran a headline, "Far Shore beautiful but flat." While the outdoor scenes "glow with vibrance," and the interior sets are "exquisite," the painter is "inarticulate." And the review concludes, "This doesn't work as a concept for a film. A plot is not a sequence of static pictures, no matter how beautiful."

Kathy Dain, a young artist friend of Joyce's, recalled the reviews: "The film got panned but I thought it should be given a serious second look." She thought the film "exquisitely beautiful in terms of the quality of the light, the attention to detail in the sets, down to rosebuds on the lingerie."

Admitting she had "not seen a lot of erotica made by women," Kathy

stated, "But that was the first love scene I've ever seen in film that was timed for women. It went on and on and on." She acknowledged that there is "much more freedom [with] nudity in films now than [when] that was made, but *The Far Shore* was incredibly erotic. . . . And it was woman time. It was not slam, bam, thank you ma'am. Not at all. It was so Joyce. She had this visceral intelligence about what she wanted to say. And she was away ahead of her time."

This view is debated still.

Sara Bowser felt that neither Joyce nor Bryan was too affected by the reviews, which is to say they were not "exceedingly hurt." Endowed with strong egos and both of them being "tough, creative people," Sara claimed they "summarily dismissed the critics." She felt this was especially true for Bryan, who "took his lumps gracefully."

An article that appeared in a suburban newspaper following the film's September 24 opening in Toronto noted, "Both Wieland and Steed are elated by the success of the film," and then we read, "The success is especially sweet because they were warned repeatedly that the film would never make it."

Judy responded, saying, "We knew we had a good script but there were problems getting financial backing because to many businessmen Joyce wasn't suitable as a director."

This was obviously hurtful for Joyce, coming from her co-producer, and moreover that it contained a cold, brutal truth. Joyce was pleased to know that cinematographer Richard Leiterman felt differently. Prior to *The Far Shore*'s release, an interviewer told Joyce that Richard Leiterman was "really excited" about the film. "He said he'd worked for so many directors who really didn't know their ass from page two and who he felt he had to almost direct, and as a camera person that he was really glad to work with you because he knew what you wanted."

Joyce would have more to say about this later.

Historically, Joyce was disadvantaged for undertaking her film during a

demarcation of genres of moviemaking in Canada, when the homegrown feature film had yet to gain cachet in spite of noble products of the late 1960s and early 1970s. Two documentary films, Don Owen's *Nobody Waved Goodbye*, made in 1965, and the 1969 cinéma-vérité film, *A Married Couple*, directed by Allan King, had gained extensive commercial exposure. Added to them were feature films: Paul Almond's *Isabel*, 1968, followed by his 1970 girl-becomes-a-woman film, *Act of the Heart*; *Goin' Down the Road*, made in 1970 by Don Shebib; Claude Jutra's *Mon oncle Antoine*, 1971; in 1973, *Paperback Hero*, directed by Peter Pearson; and in 1974, David Cronenberg's first of his sci-fi/horror films, *The Parasite Murders*. And yet, for all the attributes of these films, which were considerable (*New York Times* critic Clive Barnes called *A Married Couple* "Quite simply one of the best movies I have ever seen"), their faults were thoroughly masticated and spat out by Canadian reviewers half starved on Canada's scrawny film carcass. Independent filmmakers lacked production budgets for technical dazzle, and they suffered by comparison with slick documentaries made courtesy of the National Film Board, from Canada's deep public pockets.

If Kathy Dain is right about Joyce being ahead of her time, *The Far Shore* suffered for appearing while Canada's feature-film industry was in its shaky infancy, caught between respectable small-budget feature films and glossy, mature, NFB documentaries. And yet, only ten years after *The Far Shore*'s release, Canadian filmmakers David Cronenberg and Atom Egoyan were permitted, encouraged, and investor-backed to make daring, edgy films. The films of these two individualistic risk takers became international hits that garnered for them immense critical and box-office success. Cronenberg, for example, called Canada's most innovative filmmaker, manages to straddle the aesthetic edge of shock without resorting to Hollywood chainsaw horror schlock.[7]

Joyce, too, was innovative and her film, also, departed from the Hollywood standard.

Why, then, didn't *The Far Shore* soar?

Women friends of Joyce's believe she was gender-disadvantaged. Men just didn't get it (as men didn't get her art). They didn't recognize Eulalie as a refined woman who seemed frail and subservient alongside her powerful and oafish husband, yet was a woman with an interior life made strong and rich through music, which "gave her an identity," Joyce said. "That's why in a desperate way she clung to it. That's why it gave her the feeling she could talk back, because she had this power . . . that gave her a sense of worthiness."

Attempting to reflect women's ability to exert authority over their circumstances and striving to incorporate her avant-garde filmmaking expertise into a traditional film without compromising herself, surely Joyce's intent for *The Far Shore* sustained her beyond its outcome.

Martin Knelman, in his earlier mentioned review, equates *The Far Shore* with Canada's miserly cultural policy by referring to a line of dialogue in which art dealer Turner is looking at Tom's bold, paint-lashed landscapes and doubting they will sell: "Twenty-seven paintings and not one cow!" In that single instance, Knelman considers *The Far Shore* a parable about the entire Canadian film industry:

> Anyone who has tried to launch a movie in Canada — and Joyce Wieland has had more than her share of obstacles — knows all about the dealers who know what will sell and don't want paintings without cows. Only now they're investors and film industry executives and theatre-owners and government film advisors. Like Turner, they don't want to be caught backing something that won't sell. They're baffled by movies that express what the director cares about, and they take their revenge by pressing for popular entertainment — which usually means imitations of the worst American trash.

Knelman suggests that you can give them what they want, and be a businessman instead of an artist. "Or you can, like Joyce Wieland,

mythologize the Canadian artist as a beautiful martyr — but that's a way of looking forward to your own defeat."

All said and done, Joyce could not satisfy two audiences. Her fans in the underground film culture did not appreciate a narrative-driven film made by a filmmaker appreciated for discarding narrative in her structureless, avant-garde films. The movie-going public rejected *The Far Shore* as being too highbrow. And critics, awarding their thumbs up or down according to Hollywood standards, dismissed *The Far Shore* because of its political sentiment and production flaws.

Three years after *The Far Shore*'s release, Joyce spoke about how much the film had taken out of her. She said, "It nearly killed me."

The huge block of time the film had eaten and its piranha-like, unrelenting pressures — raising money, script difficulties, post-production scrimping because the money had run out, the film's unenthusiastic response — together with her health and marital problems, waged a psychological assault on Joyce. And, like certain shocking incidents, its full impact on Joyce would be seen as a post-traumatic syndrome.

Calling the film a "kind of madness, an obsession," she also said, "After it was over I fell apart. I just sat on the sofa, for months."

Sara's impression of Joyce not being exceedingly damaged in the film's critical undertow may have been the common perception, but this was far from actual fact. Joyce suffered a pain that silenced her by its monumentality. For months she went from room to room crying. She gained weight — eating chocolates. She tried to rest. And yet, true to Joyce's nature, in the film's maelstrom her pride demanded that she paste on a happy public face before going out, and suffer her torment privately, in her lovely Victorian house on Queen Street. Which is why even a dear friend like Sara Bowser was spared Joyce's true feelings.

Joyce suffered a massive meltdown and held the film responsible, saying it used up "a kind of basic energy" in her. Her productivity sank to an all-time low, lasting more than a year. She told one interviewer, "I've

been beaten around by this film. Many reviewers do not know how to handle it because it is different. After a while you start to believe there is some deep imperfection in what you've done. It wears away at you."

Joyce's opinions about the film were not widely published. One reference appeared when interviewer Ardele Lister asked Joyce after the film's release, "So how does it feel now that it's done?"

"I don't even know what it is now," Joyce replied. "If you see footage as much as we've seen that footage you can't tell what it is. You know at the time you made a decision over this, over that, and that decision was the right decision, but then the total thing is now sitting there."

She tried heroically to present a slice of Canada's culture. She admired Quebec filmmakers for making films that adhered to the Québécois culture, whereas English-Canadian films, which are largely made by men (as they are in Quebec), "lack balls because they're mostly just trying to imitate something that they can never achieve and that's some idea of American film." An exception was *Wedding in White* (1972; John Vidette, producer; William Fruet, director), which she thought revealed a "hint" that English-Canadian filmmakers might be changing and producing a unique Canadian sensibility.

Defiantly, Joyce characterized herself as a film revolutionary. And a pioneer. She had bucked the odds, fought the system, raised the money and made her film. "If we aren't going to go through that hell to get the money," she declared, "nothing's going to happen 'cause we've got to go out there and tell the stories to the people that want to hear them. Whoever's capable of telling a story about the country should bloody well tell it, that's all."

Joyce discussed her patient/friend relationship with Dr. Mary McEwan on a television show, a tribute to McEwan after her untimely death in 1985. Among other women patients and friends, Joyce and Judy Steed eulogized the doctor.

The show aired approximately three years after Joyce and Michael had

divorced, and Joyce spoke candidly about her marriage breakdown and Mary's role in her recovery. "I had my husband on a pedestal. I got tired of having him on a pedestal." And she related that as the therapy progressed, "I started seeing him as a person and stopped elevating him. And I started elevating myself. The more I changed my behaviour, the less he liked it. He said I was being very boring."

Through Mary, Joyce uncovered a deep-rooted cause of her behaviour, namely, that she was following the model of her mother's relationship with her husband. Once Joyce made this connection she started working at freeing herself from the stranglehold her mother's example had imposed on her. "My mother hardly saw her father and when she met my father, he was a kind of father figure. She put him on a pedestal, so I saw this as a tiny kid." Joyce recounted the aura of excitement surrounding her father when he came home from work, that he brought brightness into their lives. Her mother "worshipped my father like a god." She fussed over him when he came home, served him tea, bathed his feet, put a blanket around his shoulders and would ask him, "'What does God want now? What is God thinking?' and when he went to work she just sort of fell apart. She wasn't really interested in us. I grew up thinking I don't need anything. I would just plough ahead and not expect a fucking thing." And once Joyce married, she realized, "I did exactly the same thing, treated my husband like a rare commodity — here today but he might be gone tomorrow."

Continually suspecting that Michael might leave her is an admission Joyce had not previously made, accepting as we must her statement at face value. Incidents that caused Joyce to distrust Michael's fidelity had come and gone since the early years of their marriage, and whatever method of reconciliation the couple adopted had been effective for the remaining fifteen-or-so years: That is, they stayed together. Except for confiding in a very few friends, Joyce hung up her feelings in her closet of marital secrecy; but hidden behind those doors, it now appears, was a constant, nagging fear. She feared Michael would leave her if she protested or demanded an accounting, gave him an ultimatum, or hurled at him the

sort of "last straw" threats women use on their cheating husbands. Joyce did none of these things.

A major breakthrough occurred when Joyce told Mary McEwan, "Eventually, I couldn't take it anymore," and she poured her heart out. Joyce was in for a surprise.

Mary could be very stern in that she would not treat alcoholics, or battered women who returned to their batterers. And she was not interested in hearing about women's problems with men. Judy Steed defined Mary's modus operandi: "As long as you were ranting about men, you were missing the point. . . . Work was the really important thing. Getting yourself positioned to become an adult in the world, take responsibility for yourself economically." To this end, "You've got to be ready to move."

Joyce described how she had complained to Mary about Michael, saying, "He did this to me and he did that to me, and she'd just look at me and say, 'Enjoy.' I thought, is she nuts? I'm telling her I'm desperate and she's telling me to enjoy. She had many ways of saying this." Leaving a session, Mary would say, "Enjoy," and Joyce's take on this was, "You'd better enjoy. Get going. Quit wimping around here." Joyce laughed with great glee. "Eventually I got the message: I'd been beating myself up for years, holding onto a marriage that was dead, that was killing me. I started to do things for myself."

Coming around to thinking more about life than just work, Joyce said, "I had lived with[in] the priesthood of art, which is a very closed world." Escaping that, she said, was like a "jailbreak."

Mary's effectiveness as a therapist was in helping her patients to become stronger and more optimistic about themselves. In Judy's words, "It was as if a beam of energy was coming off her." Joyce began absorbing that energy. "I learned you don't depend on one person, your own light and energy comes from you. Mary helped me with this. I thought the sun rose and set on my former husband. It has taken me years to learn that it's in me. I have the power. I don't have to wait for someone to come home or be kind to me. Or be a victim or a doormat."

Among Joyce's papers are "love lorn" letters she wrote to two imaginary advice columnists, Dorothy Dip and Dorothy Whip, with corresponding replies. An example:

Dear Dorothy Whip:

I need your help — 'cause my artist husband is driving me mad. First of all, he drinks all the time now and spends most of the money I make as a salesgirl. He constantly says he doesn't love me any more — and says his shirts aren't white enough. He says it's quieter at his mum's place and threatens to go back to her. He spends most of his time over at his girl friend's apartment, says she's prettier than me and so on. But that's not true. I am still pretty and clean although I'm at times rather haggard. I guess the honeymoon is over — should I go back to mother with the kids? He says it's a good idea and to take the children.

Upset.

Dear Upset:

Certainly not!! Stop feeling sorry for yourself and smarten up. There's too many women of your type these days complaining and trying to escape their duty as wife and mother. Women like you who laughingly up the nation's soaring divorce rate every year. What you want is to be spoiled all the time — to have your husband at your beck and call — this is unreal. His needs are different to yours. You are trying to tie down his independence — clip his wings so to say.

Have you ever thought that you might be a dull marital mate? Why not take a more interesting job — take a course in philosophy at university. Up yourself on the ladder of life!! When is the last time you laughed at one of your mate's jokes? No wonder he seeks comfort in other women — you

are probably driving him away — subconsciously of course.
Why not bring him his slippers and surprise him tonight?

Keith Stewart and his wife lived with Joyce in 1975 and part of 1976; a time of regrouping for Joyce. One bright note occurred when *The Far Shore* was selected to be screened at the 1976 Cannes Film Festival, and she and Judy attended. The following year Joyce went to India for the New Delhi International Film Festival, at which several of her films were screened. She took some time to travel around and went to Nepal. She received a commission from Bata Industries Ltd. in 1977 for the Toronto Eaton Centre and created a giant quilted hanging of a running shoe with the Bata logo on the pant leg — a work that was suspended high over the Centre, at the opposite end of Michael's flying geese.

Also in 1977, Joyce was one of twelve artists[8] commissioned to create an artwork for one of seven subway stations on the new Spadina line, an extension of the Toronto subway system to be opened in January 1978. Each artist was assigned a site in the station; some stations had two or three art sites and some works were mounted outside, at above-ground stations. Artists were given wide latitude as to medium and concept, and the result was an eclectic range of work, among them a three-hundred-foot outdoor mural by Rita Letendre atop a station in the midst of the high-traffic thoroughfare, the Allen Expressway, and a Michael Hayden neon sculpture activated by the motion of passing subway trains. Other installations were oil on canvas, coloured glass, porcelain enamel on steel, and Joyce's work, a cloth wall hanging.

With a budget of more than $500,000 shared by the TTC, Wintario (a provincial lottery corporation that distributed funds to various community projects) and private donors, the twelve artists received fees ranging from $10,000 to $99,000 for their work — Joyce received $32,000.

However, the prospect of placing art in the subway generated such a huge controversy with city councillors that the art barely made it underground.

The project, the first of its kind in Toronto, was also a pioneering venture in North America, although artworks were mounted in subway and train stations throughout Montreal's transit system during the 1968 Olympic Games, giving the packed hordes of riders a balming cerebral aesthetic en route to a joltingly more visceral one at their sports destination.

Three Toronto artists, Joyce, Louis de Niverville, and John MacGregor, were awarded the Spadina station, located in a restored Victorian mansion on Spadina Avenue just north of Bloor Street in the district known as the Annex, an area prized for its faded old residences whose charms for the most part have been lovingly preserved.

Joyce's concept for her site — a horizontal space seven by thirty feet — was a quilted work of fifteen caribou stuffed with light Dacron appliquéd over the breadth of the cloth. Titled *Barren Ground Caribou*, the herd roam over delicately-coloured cotton hills true to Joyce's idea of their natural habitat. She said she tried to capture the spirit of the tundra and the migrating caribou moving in the same direction as the passing trains. She told one interviewer that she saw the work as envisaging a "future where humans, animals and landscape coexist in harmony and respect."

Having designed the quilt in her studio, Joyce needed an actual thirty feet of linear space to produce the work, and she arranged for Joan to take on the needlework, but at the time her sister lived in Chatsworth, about ninety miles north of Toronto. For Joan's convenience the work had to be done where she lived. The two women scouted around town and found the ideal space, a community hall big enough to stretch the cloth over one wall. Joyce rented the place, had a wooden frame made, tacked the cloth to it and mounted it on the wall. Scarcely had Joan got under way with stitching when her marriage ended, disrupting the project. Life had been difficult for Joan, the young girl who never felt loved at home, but happily she had met a kindly man named Roy Proud and moved to his hometown of Deseronto on Ontario's beautiful Bay of Quinte, where she lived in a small apartment with her three girls. The quilt project moved with her, and Joyce found a local church basement that would accommo-

date the work. After a few weeks, however, the rental fees and other rising expenses forced Joyce to give up the church basement. The only alternative was Joan's apartment.

Joan's daughter Nadine laughingly recalls how the quilt dominated their lives, as if it had a life of its own. The quilt got tacked on Joan's bedroom walls. "The whole thing went all around the room in the exact shape and size of the quilt," Nadine says. "There were hundreds of pieces of fabrics all over the place, animals and flowers and trees. Each piece was numbered so that they could all be assembled systematically into place on the quilt."

Off and on, it required a year to make the quilt. Joan worked along with and supervised a crew of a dozen quilters and stitchers at one time, including her daughters Nadine and Alison.

The two girls retain fond memories of their Aunt Joyce's work figuring in their lives throughout their childhood, the caribou quilt being one of the more memorable experiences for Nadine. While helping her mother with stitching in the church basement, she mentioned a serving passageway approximately two feet square in the wall between the kitchen and the main hall through which food was passed at church suppers. In great high spirits, Joyce had Nadine push one of the stuffed caribou through the passageway and she commemorated it as "the birth of the caribou."

Instinctively, Joyce would have felt an obligation to entertain the troops. As creator, she kept the work's image stored totally in her mind and although she appeared on site to supervise its production, she conceptualized the work chiefly one way — as completed. But arriving at that distant place entailed the tedium of third parties stitching thousands of stitches, hour after eye-straining, finger-pricking hour. Joyce realized that the onus was on her to provide a little comic relief, good cheer, and undoubtedly a fine supper and a glass of wine at work's end.

As the deadline for the quilt's installation approached, Joyce worried that it would not be finished on time so she and Joan brought it to Toronto where additional workers could be found. Dress designer Hanni

Sager was one of them, who recalled, "At the last minute everybody was having to work to finish the quilt — Joyce and Joan and a whole team of quilters."

To give the quilt's fifteen caribou a dimensional shape, each one had been stuffed with a light Dacron filler, and on the day before the quilt was scheduled to be installed in the subway, Hanni noticed something alarming — the stuffing in the caribou had shifted. "They all looked like fat, lumpy pregnant caribou, because the stuffing was sagging."

Joyce said, 'No, no, it will be fine. They will be beautiful and flowing."

The following day the sewers assembled for last-minute touch-ups and Joyce arrived, looked at the quilt and screamed, "What is going on?" True to Hanni's warning, the unstable stuffing had sagged down to the caribou bellies.

"Joyce hadn't thought about this thing called gravity," noted Hanni.

The work was being done in a large downtown gallery Michael and his CCMC musician friends used as a rehearsal studio, where they were working on "some kind of experimental music," Hanni reported, and added, "The funniest thing happened!" The quilt was spread out on the floor and everyone was trying to correct the sagging problem and they decided they needed to suspend the quilt to restitch the stuffing. Hanni's eyes lit up with wicked glee. "We found this garden hose and we were all grabbing at it and holding it up so we could hang the quilt over it when Michael came along and gasped and said, 'What are you doing with my instrument?' And I said, 'Instrument? It's just a fucking garden hose, man.' But we found out they used the hose to blow into it for some kind of fart noise." She laughed. "I'll never forget the look on Michael's face when he saw that we were using his *instrument.*"

The subway-art project aroused Toronto philistines who protested in the press about public funds being squandered on art, carping that the estimated $500,000 cost was a waste of taxpayers' money, and so on — commonplace anti-culturalist opposition to publicly-funded artworks.

Long before Joyce had sold one piece of art and during the strongest

selling period of her career, in the 1970s, she bemoaned the lack of support for artists from governments and private buyers. Art was inconsequential to so many lives. She had not been a heavy feeder at the public trough — what she called a "grant artist" — having received only two Canada Council grants up to the time of the subway commission. That artists were historically and cavalierly unpaid, undervalued and could scarcely survive through their art remained one of Joyce's perpetual psychic irritants, a motivating factor for her work with CAR; and when criticism surfaced about the fees paid to artists in the subway project, Joyce was thoroughly disappointed. And then furious. The 1950s Dark Ages of Art lived on. Joyce would not let this go uncontested, and holding fast to her belief that art in public places was meaningful — that there were more supporters than angry letter-writers — Joyce set out to find proof.

She and several other "subway artists" and members of CAR took to the streets with a petition seeking people's support of the subway art project, but the result was disheartening; they received only four thousand signatures. Joyce said, "We kept hearing, 'We don't need anything like that.'"

Joyce attributed the negative public response to the publicity campaign that concentrated on a landmark amount of money going into art for the subway, with little regard for the art or the artists. "The woman conducting the campaign was from Texas, where they talk big money, right? And they forget what they're selling and they're using the artist." By concentrating on economics, Joyce complained, "they never talk about the economics of the artist." People wouldn't take a job away from any other group of people, she argued, but they couldn't regard art as a person's work. "Janitors get paid, everybody gets paid at the Art Gallery but they want the artist to come in like some splendid person and give [their art] to them for nothing."

After insulting the subway project, protestors attacked the artists next. One letter writer complained that Joyce's work could not be seen over people's heads and wasn't vivid enough to "cope with the indifferent light of a subway platform." Not content with letting that stand, this protestor

suggested replacing Joyce's work with one of the early, rejected designs.

Joyce and many others found the negative comment terribly dispirit-ing. "It just about destroyed all of us," Joyce said. But in the end, the artists triumphed. Twenty-three years later, at this writing, the art in the subway today is as beautiful, vibrant, and worthy a public-art project as it was then.[9]

Joyce applied her evolving forthrightness about her art and films to her physical betterment, which led her to nutritionists and naturopaths, a dentist, and an ophthalmologist, along with regular consultations with her gynecologist and at least three counsellors,

In February 1977, she received an "obesity, cellulite fee schedule" that involved an "injection program" of cellulite treatments. A single treat-ment comprised "two injections with one ionization." Cellulite was the new spa buzzword and at this time the market proliferated with "cures" to rid women's hips, buttocks, and thighs of that most unattractive, the ads threatened, orange-peel skin.

A lab report in June of that year reported her high levels of cholesterol and high triglycerides.

A nutritionist recommended a list of forty-six vitamin and mineral supplements to be taken daily, among them vitamin-B complex, rosehips, Kalm Plex (identified as a natural tranquillizer), and a naturopathic supplement called Wobe Mugos, described as "enzymes for retention edema." (Edema is retention of fluid in tissues and Wobe Mugos was developed from "concentrated pancreatic enzymes" in Germany and used in 1949 as an "adjunctive therapy" in the treatment of cancer.)

Joyce subscribed to something called a "Nutritional Health and Activity Probe" in December 1977 that offered a generalized analysis of her lifestyle. Among its findings was: "Your daily intake of 145.3 grams of fat is too high." The report considered her cholesterol and triglyceride levels "desirable," but she was advised, "Improving your health habits, especially exercise and nutrition, would greatly help to better your physical wellbeing." It also

noted, "Cancer history [her mother's indicates] very important to correct faulty health habits," adding that "drugs, such as the ones you take on a regular basis, can have serious side effects, especially when more than one is taken at a time."

A quote from one Henry Butler was found in her files: "Food is your best medicine," and no doubt, Joyce took this personally; it was what she wanted to hear. When the trend for lean cuisine waned, people's search for heartier fare gave rise to "comfort foods" — beef stew, macaroni and cheese, meat pie — a category Joyce never abandoned. She took extreme comfort in food and used chocolates, brownies, and cookies for instant gratification when she went off kilter. In France in 1956, during the time she agonizied looking for a sign that Michael cared, she wrote that she was getting lazy. "What's more, I'm getting fat. I'm eating too much bread and everything else I can find. No love and I begin overeating again."

Starting with "tiger's milk" in the 1950s, Joyce jumped aboard the food-fad train as soon as it rolled into the station, and if she heard that Thai tea had certain beneficial properties, she would scour the specialty markets until she found some and drink nothing but Thai tea. Then she would read reports about ginseng tea, rosehip tea, or green tea. And somewhere she might hear that chrysanthemum soup or black-bean pudding was all the rage, and to Chinatown she scurried.

Food within historical frameworks particularly fascinated her. She learned that Napoleon didn't eat much because he considered lean fare led to longevity. (But he died of stomach cancer, as did nutrition guru Adelle Davis.) Picasso, too, was a light eater, dieting mainly on lettuce and spring water, while Joyce's adored Beatrix Potter considered lettuce a soporific.

Accounts of Joyce's food binges and fads are reported with head-shaking wonder and/or amusement by Sara Bowser, who insisted that Joyce overdid everything. "Brewer's yeast!" she cried. "Remember in the 1960s when everyone was taking brewer's yeast? I took half a teaspoon a day and Joyce would have *two tablespoons* a day! I don't know why she didn't explode!"

Without being funny at all, Sara believes Joyce was addicted to food. For confirmation, she stated, "One of Joyce's favourite foods was a Laura Secord Bordeaux chocolate bar. She told me she knew when every Laura Secord store in town closed."

Sara devised a diet for Joyce called "Bowser on How to Diet," a part of which involved retaining only one indulgence and this was her favourite thing, a Laura Secord chocolate bar. Sara said, "She lost eight pounds on the diet but she soon gained back ten!"

In 1978, after almost two years' absence, Joyce got back into her studio. This proved to be an eminent career turning point, initially revealed in a self-portrait. A small oil on canvas, full-face, head and shoulders, a ring of dark brown curls framing a round face with rouged cheeks, the image takes one aback. At its most startling you see a stony, detached individual, the image of a troubled soul. It's the eyes and mouth. Wide, black-brown eyes and a small mouth, tightly pulled into itself, the effect has the viewer commiserating with the woe scumbling behind the pigment.

That Joyce painted a dolorous portrait of herself is not entirely inappropriate. In the previous year she had been making headway in her therapy with Dr. Mary McEwan, who helped Joyce empower herself to be independent, to dedicate more of herself to herself. With her growing strength as an underpinning, her concentration on self and desire to move forward could have freed Joyce to apply an academic, aesthetic expression to her new personal development. Supposing this to be so, making a self-portrait could logically spring to her mind.

It is worth examining comments Joyce has made over the years about the portraits of the Great Masters. Whenever Joyce discussed portraiture she spoke of the skin — Joyce herself had a lovely skin that was described most complimentarily as "glowing" — and the more she studied oil portraits, the more she was dazzled by the luminosity of skin, especially as painted by Goya, Boucher, Reynolds, and Gainsborough. Quite different, though, was her appreciation of the self-portraits of Rembrandt. In

these works she observed more than painterly virtuosity — she was struck by Rembrandt's pain. She saw in the "intimacy of the self-portraits, the anguish, the truth of his life in his face," and the "greatness of his vulnerability." She also appreciated Rembrandt for portraying what she called "intimate vignettes of life," or, put another way, "entities caught in time." As for his subject matter, Joyce observed, "The only thing that transcends time are the eye beams in his self-portraits."

One might speculate that she wanted her self-portrait's most vital qualities to impart, like Rembrandt's, her anguish and vulnerability. It does that. However, her self-portrait contains none of the disturbing qualities seen in those of that other master portraitist, Vincent van Gogh, who painted numerous self-portraits while he was in a mental institution. Joyce likely saw van Gogh's last self-portrait at the Louvre, done just before he committed suicide in 1890 — "a work that records the frightening intensity of the madman's gaze," writes art historian H. H. Arnason. One imagines Joyce standing at this portrait, shocked silent in condolence.

The question remains: What drove Joyce to paint her pain? One explanation is purely painterly; artists paint self-portraits to expose themselves, as had the Great Masters, to declare: "This is me, as I see me" — and, not inconsequentially, to seek a place in art history's portrait gallery. Another explanation could be that Joyce's improving psychological state demanded that she document her pain to stand as a thing of the past; that an honest, troubling image of herself was shamanistically capable of annihilating her previous period of darkness. The painting may have illuminated a fundamental truth of her life exposed in her eyes, such as she had seen in Rembrandt's self-portraits, suggesting that if she looked her own dark truth in the face, she might find light.

In 1980 she received a prestigious commission to paint the portrait of renowned child psychologist, philanthropist, art lover, and admirer and collector of Joyce's work, Dr. R. G. Nicholas Laidlaw, president of the Laidlaw Foundation. Involving a two-hour session every week, the portrait consumed ten months. Sittings are partly therapeutic on both

sides — the sitter usually talks about his life and the artist attempts to capture it. Having known Laidlaw for twenty years, Joyce learned much about the man — that he loved music, was a poet, a jazz fan (who, Joyce thought, could have been in Duke Ellington's band). "It was really a chance to get the essence of that man."

Not a standard, formal, corporate, or political portrait, Joyce's work represented a more casual, "unofficial" study.

The man was not too pleased. "At first," she said, "he didn't think it was him and then it got shown in a show and he went over and stood beside it." He asked Joyce if she would include the portrait "whenever I'm having a big show and I said yeah and you can stand beside it." Joyce later confided, "He smiles at it . . . and thinks it's his brother. It's very sweet, the relationship he has with the portrait."

In the office, where the portrait was displayed, it is said that Laidlaw relished the thought of being a patron in commissioning the work, but was ambivalent about it — in that he thought his nose was too big — and he always asked people's opinions of the portrait, specifically mentioning his nose.

Joyce had begun searching for the truth in her self-portrait and then extended this search to the Laidlaw portrait. Regardless of others' opinions of these two works, in them Joyce found a new self-assurance. Also during this time, she was working on what would constitute a major upturn of her career; a suite of coloured-pencil drawings whose gentleness and delicateness contrast almost incomprehensibly with her darker, disturbing self-portrait. She would spend the next two-and-a-half years on these drawings, prior to their first exhibition in 1981. Through them, she later said, "I healed myself."

George Gingras came back into Joyce's life during the on-again, off-again separation from Michael that began in about 1975. George and Joyce had been seeing one another during the final times Joyce and Michael were together at their cabin in Newfoundland[10] when their marriage was disin-

tegrating. Joyce expected she might have a life with George. A man figured in her primal desires; the concept of taking care of her husband hadn't changed, though the husband might change. Joyce loved the purely feminine role for herself, cooking daily meals for a man, throwing big parties with a man, going to parties with a man and coming home with him. "I'm really happy with domestic life," she said. "It's nice having someone around who cares." Cautious about being specific, she rather coyly told a writer that a second marriage for her "isn't out of the question."

George stated that he and Joyce began their on-and-off love affair on New Year's Eve, 1958, when Joyce and Michael were married less than two years. (By way of explanation, George said, "Mike was not paying her much attention.") Forty years after the fact, George declared, "Joyce loved me and I loved her."

Although George is surprisingly absent from Joyce's diaries, her commitment to him is evident in a letter he produced that Joyce wrote to him in July 1979, when they resumed their relationship. Though separated from Michael, Joyce had gone with him and Pierre Théberge to the Newfoundland cabin and George was house-sitting Joyce's Queen Street home. Joyce professed, it seemed, two distinct forms of love for George: one, the sincere love of the person that exists outside the partnership, as in how are you doing, has your son arrived yet, did you get the job; and the other, as a love partner wanting to know if she is missed and loved.

Joyce writes to him as "Dear Georgie" and relates an incident of a bear in Newfoundland breaking into their cabin and stealing, "Guess what?" Two dozen "of my homemade walnut cookies with almonds on the top and a whole loaf of raisin bread." The next night the threesome stood at the window watching the returning, foraging bear who was "standing still [on the woodpile] with all the nonchalance in the world." Joyce writes that Pierre said she had waved at the bear, "but I don't remember," and adds that George likely has seen bears "where you come from [Sudbury]. Speaking of you, I really miss you — and think of you every minute — except during bear invasion." She hopes his son will

come back, apparently from camp, "this weekend . . . then I won't feel so sad about being away from you, dear."

She continues:

> I feel anxious about being away from you but not as bad as last summer, believe me.
>
> Do you miss me? I think of the fun we had before I left — going dancing and your great blue shirt and striped tie. That blue shirt and striped tie was so French Canadian. Funny how a sense of taste is handed down. You were adorable that night. Especially dancing — and getting on the floor in the chair — and going for dinner, all the different things we did. I love the way you hold me when we're dancing. [Here, she added an insert] *So firmly!* Who would believe two old crocks like us going dancing. Judy finds it so amusing and touching, that we do that.

She later writes, "Please use the house and be comfortable there. I like to think you are there and having [George's son] there. But then you have to do what suits you, dear."

On the letter's fifth and last page, Joyce's writing changes significantly from the previous four pages, her graceful slanting penmanship abruptly shifting, as does her tone. It is apparent that the letter was finished at a later time, when she was feeling far more poetic and romantic, possibly in the glow of wine or other indulgences. She now addresses him as "my darling man" and writes, "I can't help but mention my feelings of a less spiritual nature but that will have to wait." After this, the writing changes. "Meanwhile I'll burn candles at the altar of love, Sweetie Pie. Wait for me and don't forget me, as I am your Joyce."

Following this, her writing reverts to the first style, as though she had come back to the letter:

Flaccid pasta to you — and joy too, and much meditation and prayer sent on backs of seagulls. You will get the picture when you look up at the gulls over the house — all gulls speak and convey messages from the sea to Lake Ontario.
P.S. Hang onto my pictures.

A letter to Joyce from George, dated, "On a Tuesday night around 11 o'clock. Soon to become the 15th of August in the year of our Lord 1979," begins with the salutation, "My Dearest Jo Jo." He explains that he has just finished reading a biography of Zelda Fitzgerald and "it seems everyone must have a lovable baby name — so that is yours." Noting that the book was set in the 1920s, "where we should have [capered?]" he adds, "I think we can cheat a bit and carry it further another 60 years. Why not, eh?"

He drifts from frolic to crudeness, from fishing and swimming at Manitoulin Island in Northern Ontario with his son. He writes:

It's not fair of you to say I did too much for others and now I'm taking care of myself, it sounds too selfish. I will, given the opportunity, always take care of others.

In a strange way it seems easier to express my love for you in a letter rather than face to face; is it because distance makes the heart grow fonder? *Or* as you will answer, no George — you need therapy.

He refers to himself as "too much the romantic" and says that Zelda Fitzgerald's letters reminded him of Joyce, adding, "But then you can't dance, can you?" Signing off, calling her "dearest," he notes, "You don't sign your letters with love, I won't do that — so all my *love*, Gustave Flaubert, with the assistance of Mr. Science."

Between these occasionally breathtaking lines one reads about a relationship of warts showing through the candlelight and satin sheets. Joyce loved the scoundrel. The charming, exciting, witty, intelligent, sexy scoundrel.

Janis Crystal Lipzin, a filmmaker and director of the filmmaking and photography programs at Antioch College in Yellow Springs, Ohio, spoke of how the state, in 1978, had unaccountably dispensed some extra arts funding and she used her allotment to develop a women's program. Long an admirer of Joyce's films, Janis invited Joyce to Antioch College to discuss her work with students, at a date timed with the United States premiere of *The Far Shore* on March 4, 1978, in Yellow Springs. (To the surprise of all concerned, this amounted to two American "premieres" for the film, the first one held the day before in Chicago at the Midwest Film Center.)

Uninterested at first, Joyce eventually agreed to participate. She stayed as Janis's houseguest for the three-day visit. The two women developed an instant rapport and Janis immediately picked up on Joyce's troubled state of mind. "She was coming off the awful experience of making *The Far Shore* and was in a deep depression. I found it very troubling. It was like a dark cloud had come over her."

The cloud was surely lifted for Joyce, at least momentarily, by the enthusiastic response she received at the college. "The students were very interested in her work," Janis stated. "They were an active group and asked some very provocative questions. They were interested in the political content of Joyce's films and how she successfully reconciles the political with the aesthetic."

American critics responded to *The Far Shore* in both Yellow Springs and Chicago much the way Canadian critics had; they commented favourably on the camerawork and settings, and disparaged the acting and story.

Like Kathy Dain and other women, Janis deemed the slowness of the pace, the elongation of scenes to be a purely feminine aesthetic. In Janis's view, a female filmmaker employs this slowed-down pace out of respect for the audience, which allows viewers to take their time and let their eyes linger on the frame and make their own decisions about what is on the screen. This approach is outside the parameters of contemporary commercial filmmakers, whose principles are embedded in action and

quick cutting. "Their point is, 'I'm going to show you exactly what you need to see.' And the audience doesn't have to think."

We know that Joyce detested the fundraising side of *The Far Shore* as time-consuming and a sacrifice to creativity. "She felt that it was like two hands passing back and forth, where the hand that took the money lost out to the hand making the film," said Janis. When all was said and done, Joyce felt she'd lost the fight between her creative intent and the commercial reality.

Janis also believed that "in her idealistic naïveté," Joyce expected people would respond to the movie "regardless of their arts background. She underestimated an assumption about human beings. And she failed to recognize that not only was there not a big enough audience for her kind of film, but she felt let down that people could not respond to deeply-felt works of art."

In the past, Joyce conceded that differences had arisen on the set, incidents she framed into a learning experience. Pierre Lamy had become executive producer, Joyce related in a 1976 interview, "to push it [the film] through," which she defined as "an interesting combination of English/ French Canadian alliance." In addition, Louise Ranger, a production manager who had worked with Lamy, came in, also with Joyce's approval.

However, Joyce confided to Janis something quite different. She said that a producer informed her that she didn't know how to direct and he would be the director. Joyce had no option. She gave in. Janis had no reason to disbelieve Joyce, particularly since she related the incident so intensely. Janis interpreted Joyce's ceding of control as an act of courage, that "she felt so strongly about her film she was able to relinquish her ideas to someone else." Janis added, with a sad sigh, "But after it was over, she realized how much was truncated."

Cinematographer Richard Leiterman, a gentle, courteous man, was mystified by this account. "I don't know what to think of that," he mused, adding that there was not "anyone else in that position. She was the director." (The credits list only Joyce as director.)

He wondered if questions had been raised about "whether she was able to handle such a production, or if it was thought she was in over her head by not having directed a feature film before. But gosh, her homework was extraordinary." He meant her storyboards. "A work of art in themselves."

Similar to working with other first-time directors, Leiterman remarked, "Sometimes you just say, oh boy, what are we going to do about this," and he went on to define filmmaking as a collaborative effort. "The cinematographer might make a suggestion to the director — that's my job — and Joyce would say, 'That's fine,' or, 'This is what we'll do.' She was absolutely sure of what she wanted. She designed beautiful scenes."

Admitting that Joyce did not have a full grasp of production and she was sometimes floundering, Leiterman said, "She was on the set all the time, *big*. You could feel her there."

Wondering why Joyce claimed she was not the director brings to mind 1955, and her saying she had been fired from Graphic Associates, when this was not accurate; the entire staff had been let go preceding the company's disbanding. Her saying that she did not direct her film is a conundrum. Knowing that a producer had wanted to "fire" her may have aggravated her insecurities and damaged her ego to the extent that her anxiety overcame the reality. Because her directorship had been weak, she may have come to believe, over the following two years, as she told Janis, that she had not actually, really, truly directed the movie, but that the film had got directed through the collaborative forces of the cinematographer, assistant director, producer, costume director, and others. And if one accepted that Joyce's judgment was impaired by the film that "nearly killed" her, she may have devised this story so that she would not be implicated in the film's shortcomings.

One of Joyce's doctors had said, "It doesn't matter what the truth is, Joyce's story is the truth."

While confusion, contradiction, and denial clouded Joyce's feelings about

The Far Shore, in its aftermath one strong assertion begins to develop. She stopped laundering her experiences and began to divulge other painful truths. It is quite possible that her revelations to Janis, real, fabricated, or postpartum-film induced, unsprung strictures that had hobbled her for years. By whatever means, Joyce became more forthright, speaking more intimately about the old boys' club in New York, and as such, she entered a distinct life passage. Her work with CAR helped. She saw that other artists' problems rendered hers far from unique. And it is quite possible that various therapies were having their desired effects of leading Joyce to an understanding of her insecurities and enabling her to address essential self-truths. Significantly, though, she felt that being a woman artist remained relatively unchanged from period of the old boys' club in mid-1960s New York, even though reviews for all women artists were starting to become genderless.

"I felt I couldn't make aesthetic statements in New York anymore," Joyce said, after being back in Canada for a year. "I didn't want to be part of the corporate structure which makes Vietnam."

A short while later she would reveal further intimacies of New York. "There were many things I was embarrassed about in New York. I couldn't really get with the New York scene. I was influenced by it, but I couldn't really show my work. And I couldn't lay down what I felt was my feminine self, to become a disciple or part of a movement." But she could belong to the underground-film movement because, "There was no fame. We were artists together making things. There was an exchange, there was inter-influence. It was very healthy and very exciting."

And later, in 1982, when Joyce was asked if she thought a woman artist "confronts the same kinds of problems you faced in New York," she replied:

> I think it was especially severe in New York in the mid-1960s
> and early 1960s. There weren't very many women artists. The
> ones who were around were working on problems that had

basically been invented by men. I became very frightened; I was afraid I couldn't do it. I couldn't take that step over to becoming a minimalist or whatever. And it was very hard for a woman's dialogue with men to be legitimate, or to be considered. Basically, there was just so much theory. I couldn't handle it. I always felt inferior.

Significantly, Joyce identified and admitted to a major roadblock of hers. "It's basically just timidity. I would have had a lot more success in New York if I could have overcome it." New York failed her, and vice versa, even though "I was very courageous in my work. I really stuck my neck out in my work." But courage, for once in her life, was not enough. "The scene was overwhelming."

She realized — acquiesced, if you will — that the only currency she or other women could have was "to move onto the scene and work on problems that maybe others are working on or inventing." Even so, you needed men's approval to enter into discussions about your work. This began in art school, Joyce maintained, where women students were thought of as objects. "The only way women could get close to the guys was by sleeping with them," and in New York she said the only way she got into discussions with men "was with people who'd seen my films. Carl Andre [the sculptor] wrote a tribute to one of my films. It was only then did I start to understand what it was like for men, to get some feedback, to be appreciated."

Joyce made an effort to establish new friendships and do new things. She joined a group calling themselves "The Loons," composed of "artists, musicians, writers, etc. etc. etc." who lunched downtown, and whose twenty-or-so notable regulars included Margaret Laurence, Harry Somers, John Weinzeig, Earle Birney, Vera Frankel, Murray Schafer, and Joyce, among them. The format, for the most part, involved informal presentations by various members on music, poetry, and theatre. Joyce spoke at one

meeting about the influence of Theosophy on painters, which was noted in the cheery minutes written by Margaret Laurence as "fascinating."

On a more intimate level, Joyce and a few women friends began having dinner together every Wednesday, a practice that lasted for more than ten years. The restaurant changed periodically, but the participants remained much the same — Joyce, Sara, Diane Rotstein, singer Sylvia Tyson, Mary Allodi, a curator at the Royal Ontario Museum, socialite/businesswoman Kristine Wookey, and Rose Richardson, ex-wife of a prominent Winnipeg family member.

Favoured haunts for dinner were the McGill Club, an exclusive women's club Joyce joined (for swimming, exercise, and its excellent dining room), and a casual-but-fine Danish restaurant on Bloor Street that served much-loved open-faced sandwiches.

In a 1997 discussion about this period with Diane Rotstein over a glass of wine in a Yorkville bar/bistro, Diane chuckled throughout her recollections of Joyce and the women's dinner dates. "At one time we were all divorced or going through a divorce," she stated, mirthfully adding, "We ripped men apart and talked about cutting off their penises." We had a great time!"

American-born Diane came to Toronto in the early 1960s and soon met the well-known Canadian economist and historian, Abraham Rotstein. Diane became pregnant at a time, she noted, "when mature women didn't have babies out of wedlock." She languished-in-waiting at Donna and George Montague's place, and married the baby's father after the birth.

An elegant, well-dressed woman, Diane remarked early in the conversation, "You knew I had a brain tumour, didn't you?" She had been a psychologist and cancer researcher, but had developed epilepsy and a brain tumour, which she prefaced by way of explaining, "I don't remember a damned thing." This was not quite the case, although she did have difficulty with dates. "You'll have to ask Sara," she said frequently. Or Donna. Or Sylvia.

The longevity of these dinners hinged on the women's individuality,

and conversations covered almost anything but themselves. Diane said, "Some of us were poor and some were outrageously right-wing or left-wing. We didn't talk about what we were doing — we could find that out by reading the papers. None of us gave a shit about Sylvia being a famous singer. We didn't give a shit about what anyone was doing. That's why it lasted so long. You weren't there for your ego."

One can imagine Joyce joining in enthusiastically and providing her droll repartee on kitchen-table surgery committed on men's organs, but the get-togethers benefited her on a higher level. "I get a lot of stimulation from women," she said. "We talk about art and pursue an idea to its end in a conversation. We can talk about things related to art that are actually mystical." Most important to Joyce was, "The kind of love and care we give each other is invaluable."

Donna Montague went to the dinners only once or twice. Happily married to George, Donna had no interest in a pleasant night out that included trashing men. Diplomatically, she said, "It wasn't something I was interested in."

Beginning in the summer of 1978, after returning from Ohio and as autumn approached, Joyce felt better about herself than she had earlier in the year. Janis and her students had made a significant contribution to her rejuvenation. Joyce took pleasure in her women friends, she enjoyed fixing up her house and she pledged loyalty to her revived health regimen. George Gingras moved back into her life in 1979 and then into her house the following year, and all things considered, Joyce's spirits were decidedly improving.

She had gone to the Newfoundland cabin in 1980 (she and Michael had negotiated a sharing arrangement and Joyce went there occasionally with women friends) and wrote to George noting that in less than two weeks they would see each other. "I can't wait to see you, and your warmth and humour." She describes a drawing she is making of a woman underwater "with a man who she is saving from drowning," and adds:

But since my work is autobiographical, you get the picture. But what nerve I had to think I can save you, when I can't even save myself. I am arrogant, and think I'm better than you. I love you as you are. And I delight in it.

She ends the letter with, "You are very dear to me."

In November of that year (1980) she travelled to Cape Dorset, an outpost on Southeast Baffin Island, to make lithographs at a well-known Inuit printmaking co-operative. The work that resulted from this trip would mark a major career milestone for Joyce.

Of the many sensual stimuli Joyce experienced in the Arctic, she talked to curator Marie Fleming about the effect the Arctic light had on her. "The window where I sat faced the Bay of Cape Dorset [in the Hudson Strait] and I began to notice light more . . . certain kinds of radiances around the edges of objects. And I began to see primary colours, the breakdown, which I had never noticed before."

Later, she is quoted as saying, "Those skies are unphotographable because of the subtleties in colour and light. I realized that it would take years to understand Arctic light."

She felt touched in a manner beyond pure sensory response. Hers was a mystical, spiritual episode that fostered a deep feeling of kinship with Group of Seven painter Lawren Harris.

Harris had travelled to the Arctic in the late 1920s and experienced there a profound affinity for the Arctic through its massive, serene whiteness — light that he said nourished his art. It was then that his painting veered from traditional landscape to the looming, towering shapes of cobalt icebergs, steely black seas, and whale-shaped grey clouds. He was more concerned with rendering the spirituality of landscape than in making his landscapes either representational or abstractions — an intent that dovetailed with his theories of Theosophy, the religion he had adopted. He believed that Canadians were distinctly advantaged being in such proximity to the Arctic (as

opposed to Americans), in that the Arctic could provide Canadian artists with a resource from which to make art "somewhat different from our Southern fellows, an art more spacious, of greater living quiet, perhaps of a more certain conviction of eternal values."

One can picture Joyce falling into a spiritual, aesthetic swoon, as she acquainted herself with Harris's theories.[12]

When Joyce returned from Cape Dorset, she didn't waste a moment before beginning a study of religions obscure and unknown to her. One that caught her attention was anthroposophy, something of a distant cousin to Harris's adopted religion, Theosophy. Simply, sparely put, Theosophy is founded in the notion that the forces at the centre of the universe are perceived to be the Divine Nature, whereas anthroposophy posits that these prime forces centre in the nature of humanity. Common to both is a system of mystical understanding of the significance of light and colour — a prime field of study for an artist, as Lawren Harris had discovered.

At that time, Joyce also took up Pierre Teilhard de Chardin's *Hymn of the Universe*, in which he describes Christ's garments as made of "matter, a bloom of matter, which had spontaneously woven a marvelous stuff out of the inmost depths of its substance."

Again, one imagines Joyce's empathy with this singular thought.

From the period when she pursued the study of Ouspensky and Gurdjieff with her friend Wanda Phillips in the 1950s, Joyce's spirituality had been evolving away from one's reliance on psychic inner forces to acquire harmony with the universe, and leading toward a spirituality that was somewhat removed from the personal. In this ongoing quest, she discerned that the search for spiritual fulfillment is more realizable when approached through the natural world, in which more than one form of life inter-relates. This search was not new, but Joyce's work began to reflect her mystical searches. She had difficulty explaining the direction her art had taken and in one attempt she prefaced this period by discussing her post-*Far Shore* state as having had an obligatory, conditional effect on her work:

A lot happened after *The Far Shore*, and I've told this to many people . . . Like having a complete breakdown and having a hysterectomy during the film and then just falling apart, and trying to get myself — I can hardly talk about it. But I had to mend myself and get psychiatric help. And the breakdown of my marriage, all of these things concurrent.

With her emotional frame of reference established, Joyce goes on to say:

Through that, the coloured drawings came to me. And it was as if they were a gift. [They] don't relate, in a way, to the ones that were made for *The Far Shore*, because I went to the Arctic before the coloured drawings happened and I discovered something about light. . . . And when I came back, I picked up the coloured pencils again, and that's when the whole healing process took place for me: that two-and-a-half years when I did these drawings. I didn't know it then, but I was actually making a bridge to a new link. It was through these beautiful colours, and especially the rose colour, that I healed myself. The themes in those drawings joined together everything that I'd ever been involved with or loved, so they synthesized.

Joyce's nephew Keith had opened up the upstairs studio in her house to let in more light and here, working on her coloured-pencil drawings she re-experienced some of the mystic qualities of light she had observed in Cape Dorset. Asserting that her work had always been spiritual, she said, "Now I feel I'm allowing a certain kind of energy to come into me; the qualities that the painter Lawren Harris talks about that come from the Canadian Arctic." She notes that a "unique light" exists "in every region of Canada. But with the Arctic Light, I'm now able to embrace my subject matter which is animals, people, landscapes and the history of Canada."

Some of the drawings in this suite are confined to only three soft hues — blue, rose, and yellow. Many are round or oval-shaped. Marie Fleming feels that these shapes give the works an "eighteenth-century air." The detailing of her subject matter is immense — humans, animals, cherubim, angels; naked men and women romping with sheep and magnificently antlered deer, over pastures, in clouds, through pale seas.

Joyce evidently is equating one form of life with another, giving equal, loving attention to people and mythological creatures, to water, air, earth, animals, and fish. She also presents her goddesses as protectors: "Every goddess has her region and she collaborates with other regions as protectors." *The Venus of Kapuskasing* is a small drawing, 22 centimeters by 15 centimeters, of a naked goddess astride a settlement of buildings covering a fairly barren landscape, protecting it through her mythological powers. A feeling of oneness links the goddess, the land, and its inhabitants. Describing this drawing, Joyce said, "People are growing underground and animals are growing with people. It's the magic of growth and how energy runs through everything."

This is a telling comment. At the start of these drawings, Joyce had been making a serious attempt to recover — personally, psychically. She had no way of knowing how influential the drawings would be in this quest until after they were completed. "In the meantime," she said, "I was still crying about my marriage. And I was crying and drawing and drawing and crying for a long time." For more than a year.

Symbolically, the drawings marked her next stage of artistic development. The early soft, delicate hues of her colours began to strengthen and with their strength, the women in her pictures became goddesses. "As I gained more confidence [with making changes] my colours increased in intensity," Joyce said. "And at the same time, I was becoming comfortable with the idea of women as superior beings."

She promoted the women in her drawings to goddesses, giving them strength, confidence, and intensity, the same gains Joyce was making in her personal development. Given the times, it can be said that the thunder roll

of the women's movement helped smooth Joyce's advance. Women's societal gains of the 1960s and 1970s were unprecedented. In Canada, the work of such organizations as the National Action Committee on the Status of Women and the Women's Legal and Educational Network Foundation (LEAF), and in the United States, the National Organization for Women (NOW) and the Boston Women's Health Collective, reordered women's rights as everyone's rights. Once the gap began closing between men and women in employment, sex, money and power, and when fair and equal treatment between the sexes established its irreversible momentum, male art reviewers avoided floating the term "women's art" on the undertow of inferiority. Joyce could thank the women's movement for the gender-free reviews she received for her goddess drawings, but it must be remembered that she herself had set the stage, with her 1971 retrospective, for male reviewers to look without bias at women's art.

In March 1981 at the Isaacs Gallery, Joyce had an exhibition of thirty-two coloured-pencil drawings, mystical, allegorical pairings of maidens and deer in floral meadows — works that might be considered pure romanticism were it not for their frolicking, sexy, funny couplings. Pierre Théberge, director of the Montreal Museum of Contemporary Art,[13] on seeing this exhibition, awarded Joyce the greatest accolade of her career when he said, "She did the most beautiful drawings ever done in this country."

Joyce celebrated her love of themes most grand, calling her exhibition *The Bloom of Matter*, in tribute to Teilhard de Chardin. As she had done with *True Patriot Love* at the National Gallery in 1971, Joyce worked on the *Bloom* theme with exquisite attention to detail. She created a space within the Isaacs Gallery enclosed in walls painted rose. Oriental carpets were laid, with potted tulips placed on the floor lining the perimeter. The entranceway to the room was a trellised overhead arch garlanded with daffodils. For the show's opening, a violinist and flautist played Joyce's favourite composer next to Mozart — Vivaldi — featuring "Spring" from *The Four Seasons*. In defining the drawings, Joyce said, "What I'm searching for is the

ecstatic. The kind of feeling you get from listening to Vivaldi." The scent of spring hyacinths perfumed the room. To complete her set design, Joyce wore a flowing, silk floral gown designed by Linda Gaylard. "Joyce idealized the eighteenth-century painters' beautiful gowns," Linda explained, "and although she couldn't go around looking like that, she fantasized herself in this image of how sophisticated and elegant she could look."

There is reason to believe that Joyce created her overtly feminine setting to counterpoint the erotic, pagan themes of certain drawings, such as those depicting interrelationships between naked nymphs and animals, fish nibbling at a swimming goddess's genitals, the mysterious and enigmatic grouping of deer with a mythological figure.

Just when you accustom yourself to the exhibition's paganism, you encounter drawings of limpid delicacy and sensitivity. *Mother and Child*, for one, is a truly disturbing creation of maternal love and melancholy, as though the beautiful mother, with adoring, dreamy eyes, cuddling her infant and surrounded by flowers, ferns, swimming fish, sweetly gazing sheep, and a peach-eating deer, cannot believe her blessed fortune. And in the next instant, one is shocked to wonder, Is the infant in her arms asleep or dead? Or is the mother, if we suspect she represents Joyce, aching for the child she cannot have?

Lynn McDonald, who purchased the drawing, feels it is a drawing about love. "The spirit of it, the sense of colour, I loved it the moment I saw it," she says. Lynn, a former NDP Member of Parliament, noted that Joyce had done some campaigning for her during a 1982 by-election. Living with the *Mother and Child* drawing in her home since about 1985 continually evokes for Lynn the sweet memory of a day at her campaign office when Joyce was helping a group of children paint a mural: "She was exuberant and wonderful with the little ones."

Joyce showed only a few lithographs from her Arctic journey, the most outstanding of them, *Soroseelutu*, 1977, which she made in an edition of fifty prints. (She made another edition in 1979.)

Joyce identified *Shanawdithit*, an oil on canvas, as "the last Boethuk

Indian" of Newfoundland and spiritual leader of the tribe. In a written description of the work, Joyce briefly outlined the heroine's sad history while simultaneously revealing the unbridled depth of her own feelings:

> The tribe had numbered six hundred. These native people of Newfoundland were hunted down and murdered by the white settlers. These settlers wore the bloody scalps tied to their belts as trophies.
>
> It has saddened me to study her [Shanawdithit's] tragic fate. In 1981 I began this painting of Shanawdithit in her country sitting by her canoe, in her last stage before her captivity. The painting shows her as the spiritually powerful young woman that she was. My painting attempts to heal history and I felt that if the work had not been done the spirit of her tribe would never have emerged again.
>
> I would like to see this work placed in a public place, perhaps the government buildings in St. John's.
>
> This work has taken five years to complete and is perhaps my most important painting to date. This painting can help make amends for the annihilation of a spiritual and gentle people.

Joyce may have thought *Shanawdithit* her most important work and although many support her opinion, others attach this superlative to *Guardian Angel,* 1982.

A drawing that inevitably aroused mention is *Death of Love,* a pig's head drawn like a portrait, eerily revealing soft, pliable, human-like skin. The forehead is crushed, as though the animal had been bludgeoned to death, its eyes are closed and in its mouth is a yellow daffodil. Joyce saw the head in a market and brought it home. She said there was no connection to "male chauvinist pig," but, as Fleming writes, "rather an intimation of the pig's sad, trusting expression . . . had so struck her," that she carried the head home to paint it.

Joyce received wholeheartedly complimentary reviews for this show. Carole Corbeil referred to Virginia Woolf's *A Room of One's Own*, using it as a metaphor for women having a place in which to discover their own sensibilities, a place that "not only speaks of what can blossom inside, it also speaks of what can be *kept out* [the writer's emphasis]."

Deer frolic or gaze at the goings-on of the other creatures in many of these drawings, such as *Last Day in the Land of Dreams*, which critic Lisa Balfour Bowen describes as "a riotously naughty work in which a lascivious male is seen tickling the private parts of the giggling goddess."

Joyce had drawn pictures for as long as she could remember, but she held these — which she called her "mature drawings" — most dear to her heart largely because their source derives purely, knowingly from within. Pen Glasser asked Joyce about the figures in the drawings. "More than anything I've done, they were about a kind of contact I've made inside myself," Joyce replied. "It seemed to be a kind of union with certain things, as though I'd brought together all the things I really like, in the form of drawing. . . . It is the heart and centre of myself, in a way. It really is me."

Curator Joan Murray intuited this. For all their pastel prettiness "at first glance," Murray then found them assertive and declared that there was an "urgency about the work, a fierce lust for life." She noted, "This is a middle-aged woman's salute to eroticism and the message is clear, do what you feel is best and be open about sex."

The exhibition, its lavish opening, the critical acclaim, and its sales place *The Bloom of Matter* as one of Joyce's most successful commercial exhibitions. Av Isaacs considered the exhibition stellar for its critical response and sales generated — out of thirty-two works exhibited, twenty-three sold. "That's a very successful show," Isaacs affirmed.

But then, Joyce said, "One day it just left." She had headed to her studio, sat down at her drawing board and nothing happened. "This is it. Just like it was dictated to me." A spirit within had declared, No more. "And I couldn't pick up the pencil again."

In July that same year, 1981, Joyce achieved a similar advancement in both the positive acceptance of herself and her artistic development when millionaire philanthropist Phyllis (Bronfman) Lambert invited Joyce on a cruise to the Greek islands aboard a private yacht.

Pierre Théberge had introduced Joyce to Phyllis Lambert, a powerful force in Montreal's cultural life. An architect by profession, an architectural conservationist, art lover, feminist, and philanthropist — she is a truly cosmopolitan figure.

It appears that Phyllis and Joyce hit it off from the beginning.

Joyce was well aware of Phyllis Lambert's reputation for generosity and a fiery temperament she had inherited, in addition to inestimable millions, from her famous whisky-making father Sam Bronfman. It is well-known and repeatedly told, that Phyllis threatened to disown her father if he proceeded with a "stupid" design for his proposed new office building in New York, and Sam relented, allowing Phyllis to hire the brilliant Bauhaus architect Mies van der Rohe to design the Seagram Building, completed in 1958. And closer to home, Joyce would have known about Phyllis's consultancy role with Mies van der Rohe in his monument to contemporary architecture in Canada, the Toronto-Dominion Bank twin towers, which opened in 1967.

When the two women met, Phyllis would have been planning her magnum opus, the Canadian Centre for Architecture in Montreal, launched in 1989, a $500-million project funded chiefly by her.

Phyllis invited Joyce and two or three American women, whom Joyce referred to as "scholars," on a cruise along the coast of Turkey and the Greek islands. Cruising the Aegean Sea on a private yacht was a pastime enjoyed only by esoteric, vague, affluent "others" or seen with lavish unreality in the movies, and although Joyce felt privileged to be invited — "It was unreal" — she had matured beyond feeling beholden. Joyce knew she brought something to the party, even though she carried in her craw a residue of the 1950s sentiment shared with Mary Karch that socialites need artists to enliven their lives. Not that this applied to Lambert; but

there is regardless a Cinderella quotient for one not to the manor born, despite the artistic/intellectual affinity. The rich, as F. Scott Fitzgerald's observation will eternally remind us, are different from you and me, and indeed, from Joyce.

Her journal begins with the headline, "Visit to Greece and Turkey with Phyllis 6 of July 81." The first entry notes that she had arrived in Athens and before setting sail the group explored ruins in Athens, notably the pillars of the Parthenon, which Joyce defines several times as "amazing," and "huge submerged granite terra-cotta pink near the top — feeling of a natural palace at the top of the mountain." And she ends with, "So tired I can't remember more. Then we went to museum up there — amazing sculpture."

Once onboard, they cruised around the coastal towns and established a routine that remained fairly similar each day, sailing and consulting a map dated 1836 that marked Greek ruins, exploring places that captured the group's imagination, and returning to have meals onboard. Joyce notes in her highest praise, "Gilles' cooking out of sight." He was one of a crew of four.

On their third day the group sailed into the ancient harbour at Cnidus, disembarked, and set out on foot up a steep incline to the temple of Aphrodite. Joyce wrote about the beautiful views and "incredible ruins all the way up, very lovely and many things half dug out, like the theatre," stones and shards underfoot, pieces of pottery scattered about. She notes a comment made by Phyllis when the women came upon a piece of wall covered by stucco and painted pink: "Phyllis said it was Roman and about 1,000 years old."

That she could identify a hunk of wall found by a group of women climbing a mountain to a temple in Greece would have thrilled Joyce's sense of esoterica.

Joyce defined the local residents as "fine and noble in the eyes," and in the next line wrote about carved marble "so moving, the tool marks on the large pediments, very beautiful to have survived. The thorns, the plants, the

herbs, the feeling of what once was, what was done in the amphitheater and the temple of Aphrodite." Notes written aboard the yacht after dinner of that day's outing read, "The food, the company of Phyllis which is so unusual — and wonderful — I can't relax as I feel it can't be true."

Joyce gleaned something about just how splendidly the super-rich live, when you don't have to ask the price of a yacht. (A scrawl among Joyce's papers noted, "yacht rent $8,900," which could refer to this cruise.) More high living was yet to come for Joyce, but after each successive extravagant event she surely felt as she had after this one: "This is something I felt I'd never do, and to do this under such marvelous circumstances is really too much."

Notwithstanding Joyce's progress in healing herself through drawings and her psychic/spiritual quests, she was left with one final improvement to attend to — her weight.

Sometime in 1981 she enrolled in Weight Watchers. She kept a series of foolscap sheets, like report cards, that recorded her weekly weight loss and gain. After she first weighed in at 150 pounds, the cards show that she lost two pounds over one week and gained one-and-a-half the next — the yo-yo dieting syndrome. No more than a dozen cards were found, the last of them showing that she had gained five pounds. She would gain considerably more.

Like Scarlett O'Hara, she may have promised herself she'd worry about her weight tomorrow; in the present, her spiritual and intellectual awakening preoccupied her. This frame of mind generated another series of coloured-pencil drawings that convey a mystical, religious quality Joyce had been contemplating for most of her life but had never previously rendered with the truth and purity that she experienced at this time.

In 1981 Michael announced to Joyce that he had a girlfriend and that she was pregnant. One friend believed that Michael expected Joyce would remain a part of his and his new woman's life, and hence have a relation-

ship with them and their child — a suggestion Michael disavows.

The couple legally separated.

"It was not one incident" that precipitated their breakup, Michael said. "We had come to the agreement that our marriage wasn't working, that it seemed dead."

Hanni Sager recalled, "When Joyce heard about the child, she came to me [Hanni lived a few houses away] and just stood there and said, 'I just found out that Mike and [name omitted] are having a baby.' She was shocked. She said, 'I always wanted to have Mike's child. But art was always first.'"

Hanni continues, "It's one thing if a man leaves you or you break up with a man you have been with for twenty or twenty-five years, but when he's fifty or sixty years old and finds a younger woman and immediately has a kid, when you wanted one for all those years, imagine how you'd feel? It turns your guts inside out. You're dead." Sadness falls over Hanni's face. "I never saw that side of Joyce until then, and I thought, 'My god, she's just like us. She's not a superwoman after all.'"

Hanni, who had had a son in 1962 and raised him alone "when it wasn't as common as it is now," says that Joyce referred to Hanni's life as a single mom, saying, "'I don't think I could have done what you did.' And then she realized she couldn't have a child and never would. I said, 'But Joyce, your art is your baby.' And when I saw how upset she was, it bothered me for years. Many years." (Hanni's not knowing about Joyce's infertility does not devalue her sentiment.)

Sara Bowser begins a discussion of Joyce's marriage breakup by prefacing her comments with a declaration that she always liked Michael and has great respect for him as an artist, after which she says, "But he is a faithless dog if there ever was one." Albeit, she awards him fractional commendation. "He was not a flaunter, he was discreet," and Sara suspects his liaisons were "brief encounters, not long emotional relationships." That established, she then stated, "I think Joyce couldn't take it anymore." Admitting to not knowing a lot about what went on regarding

Michael's infidelities, Sara insists that Michael's girlfriend's pregnancy "was certainly what ended the marriage" for Joyce.

Asked if she thought Joyce was crushed, Sara stops to think for a moment, then gasps a dainty little "Hi, ho!" expletive, and carries on with, "Joyce was not crushable. She could be bashed up and bashed around and she took a pounding, but crushed? No. She kept on working, made a life for herself." Sara thinks back. "Actually, she wasn't crushed, she was *enraged!* It was about the baby." Mimicking Joyce, Sara's voice turns into a recalled cry of her anguish. "She said, 'He's got *everything!*' She was mad as hell. She resented the fact that he'd come up smelling like roses, with the wife, the kid, the respectable reputation. Joyce felt like she'd lost a real battle there."

In addition, Joyce lost Michael's parents.

Her relationship with Michael's mother appeared to be more respectful than warm. (Donald Kaplan had referred to the relationship as "paying court to your mother-in-law's regality.") Joyce said, "I really romanticized a lot about her life," especially the elopement, which during those strict times was the "most radical thing anybody could ever do, to go against their parent's wishes and run away with some English guy to Toronto." And later, there was the mysterious, elderly Cuban millionaire that Mrs. Snow lived with after her husband, Michael's father, died in 1963. According to Sara, "It was too poetic, too romantic for words."

Joyce and Antoinette "shared a common ground," said Sara, remembering as an example an occasion when Antoinette hosted a salon and "this went right to Joyce's heart." Antoinette sent out invitations written in violet ink and invited guests to her home in Rosedale, where she presided wearing a period French white lace gown. "She played the piano and we had little biscuits and liqueurs."

However, when Michael and Joyce separated, "Antoinette dropped Joyce like a hot potato," Sara said. "She went with her boy. And that hurt Joyce."

Michael acknowledged the importance of his family to Joyce, especially

her connection with his mother, but explained the disconnect as a "tribal something" that could not, after their separation, extend the same welcome to Joyce. He recognized that "part of the pleasure [of] marriage" was in Joyce sharing holidays with a family, such as Easter, Thanksgiving, and Christmas. When living in New York, Michael said, "we always came back for Christmas."

One of Joyce's therapists places the marriage separation in a larger context of pain.

Joyce went into a decline immediately following her 1971 retrospective at the National Gallery. The biggest event in her art career, Pierre Théberge's appreciation of her, and the public's acceptance of her acted like a mirror of reflected approval. The therapist explained that children have no self-identity and that parents act as mirrors of their development, which enables children to see how well they are doing and how they are measuring up. Joyce had been without parents to mirror her development and for this reason she never fully developed as an adult person, and when her retrospective show ended, so ended the mirrors of her appreciation. The only response to this situation was a childlike one, which was distress. The huge event was over and now what? Her mirrors had gone. She was afraid for herself.

Then, only a few short years after her retrospective, she split with Michael and she was an orphan all over again.

Although she was now fifty-one years old, Joyce remained egocentric like a child. The problem was not exclusively that Michael had found someone else who would be having his baby; the essential, astonishing problem was Joyce's depreciation of herself.

If a person succeeds in her life, in her terms, then the person can occasionally fail without consequence, said the therapist. He referred to a child's perceptions. "You have a limited ability to tolerate passivity experience. You reason, everything has to do with me. If I don't know shit happens, I have no way of assessing bad things. I just think, what did I

do to make this bad thing happen? The child can't understand that it wasn't intended." Children are unable to get out of "their grandiosity, their egocentric being, and vulnerable people such as Joyce can't get out of themselves. They are traumatized because they are convinced they caused the bad event. They don't have the ability to assess how you can account for this because they do not possess passivity experience."

The therapist spoke of the growing role counsellors are playing at schools where a horrible tragedy occurs and in violent crimes involving adults. Psychiatrists often arrive at the scene before the police. He used a bank robbery as an example, but the same applies to tragic school shootings. The arriving psychiatrist is quick to identify the individuals whose vulnerability has them more traumatized by the event than others and pays them special attention, trying to reassure them that the shooting was not their fault, they just happened to be there when the gun went off.

The watercolours Joyce made on her cruise with Phyllis Lambert, along with a group of mythological drawings and paintings, were shown in an April 1983 exhibition at the Isaacs Gallery. Both drawings and paintings from this show have been widely hailed as major works of Joyce's canon.

Art critic Christopher Hume began his review by describing Joyce as "alone among Canadian artists" and "a searcher for 'the ecstatic.'"

The mythological series inspired Joyce to contemplate life and death — or vice versa? — but either way, at age fifty-three she created a series more congruous to an older artist, works powerful in their otherwordly insinuations. Referring to one painting, *Experiment with Life*, Joyce told Hume it was her attempt "to look Hell in the face" before "moving on." She also said she wanted "to remain in this world a little longer because there are things to figure out."

Joyce's search for the ecstatic had begun.

Hume describes the three elements of the show: one, the goddesses and mythological creatures "teeming with life and illuminated by some great mystical secret"; two, the Turkish watercolours, "tiny jewel-like

watercolours . . . the stuff of romantic afternoons"; and three, the later works "beyond the land of sweet dreams into the underworld of violence and destruction." He states that "no one but Joyce Wieland could have produced a show like this. No one but Joyce Wieland would have dared."

Experiment with Life is a tour de force, a work that has you deliberating with yourself the fundamental meaning of art. You are startled, holding your breath and thinking true meaning might be there before you. In this painting Joyce revisits her early *Disaster* paintings made in New York of burning planes and sinking boats. The shocking difference is that disaster befalls a human. A figure, male, is fleeing a cataclysmic landscape of fiery destruction, running through fire, his feet in flames, and half his hair and grey beard are on fire. Racing up a hillside, with houses burning on the horizon, the figure is glancing back to view the unfolding inferno.

Joyce's handling of the paint is masterful. She applies it in a density of layering against the figures and shapes which effects a radiance like fire or flickering film, and she uses colours that by their boldness have the powerful effect of accelerating the speed of the fleeing figure and simultaneously damning the work with a glowering sense of doom.

Discussing *Experiment with Life* with Marie Fleming, Joyce said, "I started it as a kind of disaster in the suburbs, as though they bombed Scarborough [a suburb prior to Toronto's 1998 amalgamation into the Greater Toronto Area], and then I left it. The figure hadn't appeared, or the flames. It was around for eighteen months. One day I picked it up. I had a very strong feeling [that] I wanted to express something about Vietnam and the thousands of people killed by experiments with chemicals — incredible experiments they did on human life." In her mind surely had been the famous photograph of Vietnam's horrors, twelve-year-old Kim Phuc running naked, screaming down the street engulfed in flames from a napalm attack. "The need was so great [to address Vietnam]," Joyce said, "that it just came out in an hour-and-a-half after waiting eighteen months."

She also said, "This is a painting that kind of bolted out of me."

Artists inject essences of people they know, both admired and other-wise, into their paintings — whether or not this occurs as a conscious realization at the instant paint leaves the brush or pencil strikes paper. Since Joyce was working on highly personal themes during these years and incorporating them into natural disasters of storms and fires, the figures in these paintings could easily be her, Michael, and others. She once said, "I find that people — my friends, myself — emerge in my painting. Something just happens to me." (Although she pointed out that in painting a portrait — which she has described as a landscape of the face — this does not apply.) Showing *The End of Life as She Knew It* in a slide-presentation lecture in Vancouver, she described the male as having the power "to pull things off the earth" and identified him as "sort of my boyfriend at the time but he had this diabolical side." George Gingras asserts that he is the figure in this painting but at the description "diabol-ical," he burst into a laugh, saying, "We had our fights."

Flight into Egypt (After Tiepolo), 1981, pays homage to one of Joyce's favourite classical painters, Giovanni Battista Tiepolo. In Tiepolo, a controlled extravagance exists that Joyce probably pined for, if not envied. Quite likely, Joyce carried around Tiepolo images in her head her whole life long. They charmed her to her bones.

While the subject matter of *Flight into Egypt (After Tiepolo)* is unset-tling, she lays on her paint in a manner that spreads a lush calmness and richness over the work. A winged woman is running behind a trotting donkey, fleeing a male figure hurling thunderbolts at them — three fiery bolts that converge into a cluster of pink clouds. Two tiny angels are speeding overhead, flying on the clouds. The delicate rose, blue, and green colours are laid on like confectionery, without being cloying, in contrast with the painting's urgency.

In the *Globe and Mail*, art critic John Bentley Mays dismisses the first part of the "fey homages to Tiepolo, her little mythological whimsies and invocations of fantastic Cloudcuckoolands," and then writes, "The stronger work, on the other hand, is very strong indeed." Here, Mays is

referring to the 1981 and 1982 watercolours that he describes as "topographic watercolors of the Turkish coast [that] are small, rigorous and virtually flawless. Our vantage point is an anchorage offshore; instead of the picturesque, postcard intimacy of nineteenth-century French pictures of the Levant, we are given a brooding, remote land, locked beyond a brief but uncrossable distance. In the bargain, we get some of the most compelling, contemporary *plein air*[14] pictures I have ever seen."

Interior designer Maureen Milne was attracted to these watercolours by reason of their scale. "I had always seen Joyce as a larger-than-life figure, but these small, delicate drawings were so unlike my notions of her, I had to have one."

As much as Mays acclaimed the watercolours, he adds, "But the newest paintings are the real sensations of this show. In the last few months, Miss Wieland has suddenly stripped away the misty atmospheres and fuzzy delineations of the earlier work, and turned her hand to the creation of stunning personal allegories of crisis, loss and transfiguration." He then states, "It would be hard to find a work with the energy and conviction of *Experiment with Life*, 1983."

Mays regrets that more of the completed paintings in this series were not included, which would "set the so-called 'new' Toronto painting scene on its young, collective ear."

Joyce said that the coloured-pencil drawings were her impetus for these paintings, which started "a whole new phase, a different style of painting than I'd ever done." They are "about nature again, about people, about struggles between men and women, about cataclysms. . . ."

This phase led her to "very, very shamanistic works that were very deep, about my relationship with my father, being, and all kinds of struggles that were going on," which would be another two or three years in development and would become her most celebrated paintings. And among the most daring ever done in Canada.

Just as the renowned violinist's protegé goes on to outperform the master and the law clerk eventually deposes the sitting judge, just as

brilliant youth inexorably assumes dominance over the power elite, Joyce's exhibition of April 1983 evinced a similar power shift in her career.

After Joyce's first solo exhibition at Dorothy Cameron's gallery in 1960 and the rupture that had occurred between them when Dorothy chastised Joyce for wasting her time making films instead of paintings, the two women eventually reconciled. The exact time and the details are unknown, but well-known is the ebullient dealer's unalloyed enthusiasm for Joyce's work. When Dorothy closed her gallery (at the end of the scandalous *Eros 65* trial), she turned her talents to painting and sculpting. Dorothy's work — brightly coloured whimsical figures — bears a slight affinity to Joyce's in its irresistibly fanciful qualities, but her insecurity over her own work, engendered from the excellence of the artists she had known and represented, prohibited her from exhibiting for some years. Nonetheless, she continued working.

After attending Joyce's 1983 exhibition, Dorothy wrote her a note that touchingly bestows supremacy upon Joyce, who formerly had been Dorothy's ingenue. As a respected dealer and a loving, admiring friend, she hails Joyce's artistic achievement and acknowledges its career-turning effect on her:

> You have the capacity to see *totally* [her emphasis] with eyes and heart. I felt your presence in my studio absolutely as a manifestation of the Goddess . . . and at the same time, as the visit of an adorable human being. At last I can accept my work, and my responsibility to it. Because of *you* [again, her emphasis].

No record can be found of Joyce's reaction to the note, but having her stature affirmed by Dorothy must surely have come as a joyous surprise to Joyce. She had begun shedding her previous influences and was in fact growing a little cranky hearing that she had been influenced by such-and-

such artist. This turnabout was timely and appreciated. It coincided with the winds of change that were shifting toward a wider acceptance of Joyce's canvases and works on paper.

Joyce was generous in giving others credit. The craftswomen who embroidered, knitted, and sewed for her were photographed with Joyce in newspaper and magazine stories and mentioned by name, and they knew Joyce respected their talents. "She publicized women's crafts as artistic expressions at a time when North American art centres ignored such work," wrote Lauren Rabinovitz in a 1982 article that examines the feminist aesthetics of Joyce and American artist, Judy Chicago. "By including and claiming domestic crafts as valid artistic activity in 1971, Wieland began raising her audience's consciousness as she showed them what Canadian women were and had been doing for years."

Rabinovitz does not find a similar generosity of spirit in Judy Chicago, whose multimedia installation, *The Dinner Party*, involved the participation of hundreds of workers.

Chicago's installation comprises a massive triangular ceramic table, with sides forty-eight feet long, set with thirty-nine plates — each one explicit with a painted vagina that aroused equal parts controversy and publicity — representing thirty-nine women whose achievements have marked Western civilization. An additional 999 legendary women and goddesses are also commemorated in the work. Taking six years to complete, assisted by some four hundred other artists, craftspeople, and designers who worked under Chicago's direction, as well as fundraisers and organizers, *The Dinner Party* opened in San Francisco in 1979 and appeared in Toronto in 1982.

Rabinovitz assessed Joyce's *True Patriot Love* exhibition as one that examines feminism with "rigorous intellectualism," and while Chicago's *The Dinner Party* has brought more public attention to issues than any other feminist artwork and "its didactic role is its most distinguished," Rabinovitz claims that the work "passively involves the audience," and "employs simplistic themes to achieve its measures." Moreover, she

argues, Chicago's work "provides some disturbing and disappointing resolutions to challenges that Wieland adroitly articulated nine years before" in her retrospective. "*True Patriot Love* is about its own contradictions: *The Dinner Party* lacks awareness of the contradiction it employs. . . . It seems that while Wieland initiated efforts to break down and erase the line between fine arts and crafts, Chicago calls attention to the gap."

When Joyce learned that Chicago had written in her diary, "Stuffed and dimensional fabric work is always so tacky, and I'm not sure we can make it work," she was incensed. Joyce suffered a double blow, reading in *ARTNews* that *The Dinner Party* was "an icon of feminist art" and that the *Village Voice* called it the "first feminist epic artwork."

Just at the time when Joyce was experiencing growing respect for her canvases and works on paper, the pattern repeats itself once again of her being elevated on the one hand and knocked down on the other. She pioneered feminist statements in cloth artworks and now found herself up against a one-trick pony artist who attracted more attention and received credit as an icon; but if Joyce swallowed her resentment for a moment she likely would have given, with utmost generosity, due credit to another woman for advancing a feminine viewpoint in art. A number of women writers noticed that both Joyce and Judy Chicago were subjected to the attitudinal misogyny of male reviewers ready to deny these works and the feminists who created them.

As well as that of the museums that ignored them.

Susan Crean took umbrage with the Art Gallery of Ontario for not using its showing of *The Dinner Party* as an opportunity to mount a complementary exhibition of women's art and therefore promote "a consciousness of what women artists are doing here." And she cited Joyce as an example, declaring her show *True Patriot Love* to be "certainly more daring politically" than Chicago's, and said that Joyce's work "gave encouragement to a generation of artists who were turning to women's culture, and to the subject matter of women's lives for inspiration."

Another writer, Judith Finlayson, observed, "Most of the major media

outlets sent male critics to review *The Dinner Party* and, predictably, most of them either hated it or missed the point. Still, the exhibition has drawn record-breaking crowds of women wherever it's been shown."

Since her 1971 retrospective, Joyce had received little exposure for her paintings and drawings for good reason; apart from her two exhibitions in 1981 and 1983, she had not been terribly prolific. There is reason to suspect that the National Gallery retrospective, while extending a forum for national recognition, failed her by being too narrowly expressed and conceived through her quilts and cloth assemblages, even though the mediums elevated cloth works and made powerful feminist, nationalist, and ecological statements. However, by failing to include more paintings and drawings, Joyce quite probably did herself a disservice as an artist, just as Ken Carpenter believes she marginalized herself by not producing a standard museum catalogue. In the decade following her retrospective, *The Far Shore* film mongoose devoured her art rabbit. And when the decade is examined we see that much of the publicity Joyce garnered tilted in her disfavour, chiefly a result of two events — her retrospective and *The Far Shore*.

That Joyce rebounded speaks coherently of her resilience. Her exhibitions in 1981 and 1983 demonstrated that a re-examination of Joyce as a serious artist could be undertaken.

Joyce as a person, however, still suffered from a sense of isolation wrought by her marriage breakup and from her years of unresolved feelings of isolation. From the time her parents had died, the abandonments kept accumulating like so many broken-down, rusted-out dreams in the backyard of her soul — the latest of them, Michael. Her therapist, Dr. Mary McEwan, wound down her practice in 1982 because of her failing health and Joyce again sought professional help.

Later that year she found a new doctor, with whom she attended "in the aftermath of her divorce, trying to deal with this." Joyce remained in this doctor's care on and off for the next twelve years.

Following her 1983 exhibition at the Isaacs Gallery, Joyce appeared for

an appointment in a highly distraught state. As the doctor described it, "Her show was a great success, there were lots of people and pictures sold. But she said at the end everyone left, left her behind. The main event for that exhibition was that the people left and abandoned her there. She cried when she said this. The tears leaked out of her eyes and ran down her cheeks like a little child's and she didn't bother to mop them up, and she was all squinched up." He gestures by hunching his shoulders as though shutting down his body.

In another session Joyce complained that the art Establishment was grossly remiss in its treatment of women artists by not giving them retrospective exhibitions. "Why do I have to wait until I'm dead?" Joyce demanded, before getting a major show, as had happened with Emily Carr.

The doctor offered his opinion of Joyce's despair: "Joyce said no one wants me. The art Establishment doesn't want me, the Establishment is not going to honour me." She felt this way, he believed, because as an orphan she had no measure of her worth. "Joyce's loss was catastrophic. She always had a problem of identity and was never the same after her parents died. Her development was never completed. And when you are incomplete, you have to keep re-inventing yourself. But she couldn't always do this. And after her show, when the people left the Isaacs Gallery, just as Michael had left her, she is an orphan all over again. No one wants me, she believes. She is one step misplaced from her parents."

Joyce talked about an interview with her therapist, saying, "I was always complaining about the Establishment. One day my shrink told me, 'You are the Establishment,'" and suggested she go to the AGO and ask for a show. She phoned William Withrow [then director of the AGO] and went to see him. "It took about three minutes," Joyce reported. "Withrow was quite surprised. But who's going to ask for it if I don't?"

William Withrow recalls the meeting with Joyce, saying, "She had winning ways, she was very beguiling." He mentioned that as gallery director he did not find it peculiar that Joyce had come to request a show, explaining that artists came to him every week asking for an exhibition —

"not as politely as she did," he pointed out — and then he revealed the AGO's position. A gracious, kindly man, William stated that when Joyce came to see him she was already on the AGO's short list for a retrospective. He confessed, "I allowed her to revel in her story" of talking him into a show. "It gave her pleasure and it didn't hurt me." He repeated that she was on the "deserving short list" and added, chuckling fondly, "So she jumped the queue a little."

A revealing note in Joyce's files is dated 23 December, no year. (It is likely 1983, based on several pages of notes of dreams, poems, and letters dated September and October, 1983, written in the same style, using the same pen. The notes outline visits to the new psychiatrist she was seeing.) Joyce writes:

> Dear Art Angel,
> I'm pregnant — walking around all over the place, have to go to some other place but am abandoned by everyone & Dr. McEwan supposed to get a shot which I need all the time as it's an experiment — the whole thing because I'm too old — but all claim I can do it. However need this shot at moment to have baby. I may die in all this — but no one takes me seriously.

> Sept 6 Night
> Dream of meeting Mike's Baby. I bend over and suddenly see him, he is smiling and knows me — he is dressed in a leather outfit. [after this, a scribble of a small figure wearing a big hat] he is slight narrow faced like a girl I saw in a restaurant getting ice. He is dark, the opposite to what he [Michael] is — which means also he is wise or an intellectual genius of some kind.
> Then later get paint on my dress and they . . .

There is no more.

Chapter Nine

Joyce's retrospective at the Art Gallery of Ontario was scheduled for fall 1987. Its prospects boosted her to a stepped-up level of self-confidence and excitement for having attained another career milestone. With about five years in preparation ahead of her, she could begin choosing existing works to show and start making new work.

Like so many other peaks Joyce had reached, however, again her euphoria would be deflated.

A lawsuit was brought against Joyce and Michael in 1982 in New York regarding an episode that occurred in 1966, about which Joyce maintained

she had acted properly. This aside, the outcome was ignominious.

During the time she and Michael lived in New York, Joyce's filmmaking friend and collaborator Hollis Frampton lived a few streets away in the same loft building as Frank Stella. Hollis and Frank had been classmates at the distinguished Phillips Academy, in Andover, Massachusetts, in the mid-1950s, after which Hollis left to study with Ezra Pound. Meanwhile Stella was in his ascendancy to superstardom, having made his mark in the evolving op-art movement. Dazzling, mesmerizing, his canvases are remarkable for their treatment of colour and shapes that react against the eye in flying, whirling images. He lays sharp, brilliantly-coloured lines on irregular-shaped canvases using vertical, horizontal, and diagonal lines in compositions creating the illusion of colours radiating in and out and up and down the picture in the direction of the lines. These early works, showcased with fanfare at the Museum of Modern Art in 1960, solidly positioned Stella as a major figure in op art, and by the mid-1960s he had added a sumptuous complexity to his work by overlaying his stripes with interrelating circles and semicircles.

Joyce admired Stella but did not know him personally.

There was nothing untoward about Joyce visiting Hollis and, like so many artists who carry the scavenging gene, on leaving the building she might look over the trash and possibly pick up discarded art materials she could use. The building housed several other artists, so the pickings were good. One day in 1966, she noticed in the garbage two large rolled-up canvases, painted on. Presuming they had been trashed, Joyce took them. They were Frank Stella's.

Stella was now suing Joyce and Michael for theft of what he called his "unfinished paintings," and the case came to court in April 1982, heard by a New York State Supreme Court judge who ruled that ownership of the two canvases, valued then at $100,000, be resolved between Joyce and Michael, and Frank Stella.

Joyce and Michael stealing another artist's paintings?

As is common to most disputes, the pure gem of truth glitters only

when the hardened crust of hurt feelings is chipped away, and unfortunately, all too frequently at battle's end the debris that gets exposed at trial is public humiliation, destroyed reputations and egos, and financial burdens. Such was the case of *Stella* v. *Snow and Wieland.*

At issue was the matter of garbage. To an artist, "garbage" is not a dictionary definition of trash — rubbish, refuse, rotting, stinking animal or vegetable matter or contemptible filth — it means, "Can I use this stuff?" The answer to the impoverished artist examining another's discards commonly is, what a find! Trash or treasure, the next matter is ownership. Joyce never denied taking the two canvases in Stella's trash bin, which she defended as: "Everyone has a right to garbage."

Theft, however, became the issue when the two Frank Stella canvases showed up a few years later — framed, for sale, in the window of a New York gallery.

Stella charged that Joyce and Michael had "unlawfully and improperly helped themselves to the paintings." He said the paintings were water-damaged and he had set them aside in his loft in 1966, planning to discard them later.

Preparing for her defence, Joyce had written detailed notes. She described finding the "extraordinary amount of canvas being thrown out," and continued, "We decided on leaving to take the used canvas . . . and see if it could be painted on. On unrolling this on the floor and looking at them for a while we realized that they were complete but neglected paintings. Stella's work is so personal and he is such a great artist that even though these paintings had undoubtedly been decided against for some reason . . . it seemed a shame to paint on the canvas so we decided to keep them intact. They have not been altered in any way."

Michael said he had not looked at the canvases until 1981, in Toronto. Michael and Joyce declared in a written affidavit to the court that they decided to approach a Toronto framer, stating, "We gave permission for this framer to see if he could sell them," and Michael and Joyce would share in the proceeds with the framer.

Michael is quoted as saying in the *Globe and Mail* that he had not heard from the framer, Clifford Duck. The trail of the paintings, now framed and cleaned, progressed to Walter Moos, of the Gallery Moos in Toronto, who tried to sell them in Amsterdam and Paris. Lastly, in March 1982, the two canvases wound up in New York for sale at the Mazoh Gallery.

Michael stated that he was willing to give the paintings back. Joyce was not. She said, "I feel I own them."

Stella threatened to sue the dealer, Stephen Mazoh, for $5 million, claiming that the two unfinished canvases were water-damaged and clawed by his cat, and that offering them for sale was damaging to his reputation.

Certain artists never destroy any piece of their work on the assumption that everything they create has virtue, whereas other artists have a built-in editing, pruning mechanism that prompts them to discard substandard works — slashing and burning in a maddened rage, included. Still others will prudently rack a questionable picture for future consideration, when in a week's or five years' time the piece might reveal heretofore hidden merits. Or alternately, the thing looks worse than ever and is destroyed.

The state of completeness of an artwork does not arouse general discourse, whereas the artist may ponder that precise moment when he or she can say, *Done!* But no reputable artist releases inferior, blemished, or incomplete works for sale, just as the poet laureate would not sully his or her reputation by including sophomoric poems in a current collection. The buying public assumes that the creator has approved every detail, that once an item appears for public consumption it has been ranked a personal best by the originator before the name goes on. An artist of Frank Stella's stature would not risk his reputation by putting unfinished, water-damaged, cat-scratched paintings on the market.

The case was heard in New York and dismissed in June 1982, cited as a "misunderstanding that was easily resolved." Stella released Joyce and Michael from all actions, for the sum of one dollar, and dealer Stephen Mazoh returned the paintings to Stella, whose lawyer concluded that the situation had been "amicably resolved among all the parties."

The years 1983 to 1987 epitomize countless ways in which Joyce lived her life through passion over reason — the marvellous triumphs, her irrational decisions, the unparalleled love and affection she received from an increasingly adoring public, the bilious criticism she endured, and her progress in healing herself that all too suddenly was jeopardized She would travel, accept a visiting professorship in San Francisco, where she tried the latest designer drug, Ecstasy, she worked productively in her studio and received her country's and her city's highest awards, she led headline-making protests and she completed films she had started in the 1960s.

And during these years Joyce completed what many consider to be her most outstanding paintings, second in importance only to those who rank her coloured-pencil works the high point of her career.

At the resolution of the Stella affair, and after Joyce completed her suite of delicate coloured-pencil drawings, her work departs markedly from the calm. She strips away niceties. She exposes deep-seated feelings about her father, she blasts men off their dominating pedestals, re-forms her ideas about mythological figures, and she probes violence and cruelty. Out of this painterly Armageddon Joyce creates a body of works whose strength of femaleness had not previously been seen, and which are considered by many to be the most important of her career. They are by far her most personal, and her starkest.

Two paintings stand out as bearing Joyce's ultimate imprimatur and have been reproduced more than any others.

The Artist on Fire, painted in 1983, likely the only painting in a major public gallery featuring a man with an erection, portrays a woman standing at the easel, flames licking up her back, as fiery red as her short, curly hair. The *Homo erectile* figure on the canvas is torso-sized, naked, with wings, his arms raised to seemingly devour a bird of paradise. A laurel wreath adorns his curls. The artist's paintbrush is tipped with flames, nearing the erect penis. Overhead, a catlike face in the shape of a fish

scowls down upon the couple and in the background, a castle likened to Versailles is reflected in a pond.

(Questions have been raised as to the male figure's identity, an obvious answer being Michael, but George Gingras is the subject — and he makes the point, "imaginary, not posed.")

Joyce said that the male subject had been through four metamorphoses, starting as an angel, but the end result is a quasi-Napoleonic figure, "although he has a laurel wreath on his head, and I left the [angel] wings in."

Joyce told Joan Murray, who bought the painting for her Robert McLaughlin Art Gallery in Oshawa, Ontario, that she was feeling on fire when she made the painting. "I was burning up," she said, with a passion for painting and "painted a sort of hero in a state of sexual arousal." One is reminded that ten years earlier she told her New York counsellor that she was "sexually on fire," and although we cannot locate a specific fire-starter, Joyce identifies the source of the painting's fire when she wrote:

> *The Artist on Fire* wasn't a struggle, it wasn't art. I felt some part of me that had not been involved in making my painting, I just became ignited. It was crazy to get out. The first stage of this painting which was made in 20 minutes was the best. But I couldn't leave it. Because something in me wants to enjoy this new found image. It wasn't enough that I express the fiery feeling of the engagement with myself on the canvas. I had to journey. . . . This is the only way I can see how good or bad I am. Later my face takes on the look of a specific portrait of Madame Pompadour. So that in the painting I've ennobled myself through my identity with Pompadour.
>
> I've flattered and imbued myself with a period of history which I've romanticized and put above me. Now in this painting I dared to take some of these attributes of it for myself. It was like stealing. I dared to take these attributes

even though I wasn't good enough for them. The problem is most of this was unconsciousness [sic] to me until later.

Here, her writing becomes less legible, each line bearing consecutively more strikeouts and rewrites. She digresses to the Bourbons, who "hunted, ate, fucked and snored their way through their history. All these wealthy and powerful Bourbons existed wholly through art, Les jardins, architecture, peinture, sculpture, les costumes, le dresser, la poesie, le theatre, les amours, les scientist, les philosophers."

By using (and misusing) French words — one of her linguistic loves — she may have felt that striking a kinship through the French language gave her the right to castigate. But more potently, lingering in these remarks are traces of Joyce's early resentment of the art Establishment. Despite painting fearless, assertive, deeply-felt works and appearing to be personally strengthened, Joyce still faces the dichotomy of wanting recognition from the art Establishment and yet resenting her participation in it; and, possibly worse, she resents her desire for recognition, the naughty little secret she can't escape.

Art critic Christopher Hume is among those who assessed *The Artist on Fire* as one of Joyce's major works, a "signal painting." He defines it as a self-portrait, one in which "Wieland depicts herself as delicately feminine, in control and on fire. But these flames cleanse and purify rather than burn."

Those not selecting *The Artist on Fire* as a career high for Joyce are likely to choose *Paint Phantom*. Completed over eighteen months, from 1983 to 1984, this painting is like the haunted house on the hill; you see it, you may shy away from it, but you can't get it out of your mind.

A savage, haunting battle occurs on canvas between two mythological creatures, a frightened goddess who struggles to overpower an attacking satyr-like figure with a tail. The two pastel-painted figures are silhouetted, clashing on what seems to be the edge of the earth, under a menacing black night sky, full moon, and enigmatically pretty pink and yellow

clouds. The painting departs vastly from Joyce's earlier depictions of mythological creatures — serene nymphs and goddesses floating and intertwining in rainbow-hued fields of flowers.

The two figures in *Paint Phantom* are engaged in a battle for supremacy — the male, a brutal aggressor overpowering the female, whose naked, blood-streaked body is remarkable for its severed leg flying between the man's legs. She has punched her attacker so fiercely her fist has pierced the creature's body and is sticking out his back. Joyce said that the painting concerns "puncturing phantoms that we make so real." To this she added, "I never really knew my father, and so the father in me turned out to be a monster."

Joyce also said *Paint Phantom* testifies to "what the struggle and the pain of it [the subject matter] was, to be in love with things that were dead, having made them into something more magical than they ever were, and then having to try to destroy them so that one could get on with one's life."

The "things that were dead" could refer to both her marriage and her recent break with George (more on this later). She appears to be peeling off another mask from her phantom. "I had to show this, be naked about it and show the struggle I had with the man I was in love with, but which brought me down to where it was my father, who died when I was little. So the struggle was with two men, and it was for my own survival."

Asked if the struggle was also "with the muse? with creativity?" Joyce responded, "Yes, that's why it's called paint phantom. It digresses over here [she may have been pointing out a sweet face in the moon] to keep you away from the real painfulness of it. I say, 'Oh, the paint's doing it; it's the paint phantom doing it.' But it's just because I'm scared to say that goddamn it, the murderer in me came out!"

Joyce needed some distance to arrive at this explanation. Like one guilty of an indefensible sin within a conglomeration of readily-admissible transgressions, Joyce apparently felt she had sinned by painting her murderous rage and could seek absolution only by condemning her

subconscious accomplice, paint. On that basis, the paint painted the picture and Joyce could then defer to its savagery.

Her sentiments about these two paintings reflect the disorder in Joyce's life, or perhaps more acutely, the disorder she had been concealing. Unlike the paintings themselves, which may or may not be seen as savage by the viewer, Joyce was painfully aware of her feelings when she painted both *The Artist on Fire* and *Paint Phantom*. "It scares me," she said, "because I just don't know where I'm going. I've never had anything as strong as this." A more startling admission followed: "I want to feel safe and do a still life or something!" And then she related her feelings to sales of her work. "It's not good for product. Your product must always look [she does not complete this thought] — but mine never looks the same, so it's hard for people to know. 'Is she losing her oysters or should we invest in this?'"

She expressed a similar view in the 1985 television tribute to Mary McEwan. Joyce is filmed in her studio, at her easel, painting a female figure reclining on a large rock. This is followed by a number of cuts to her latest paintings. She discusses each of them in her soft, musical, little-girl voice, identifying them as works that express "my rage, my murderous feelings."

When Joyce referred to these paintings a few years later, she related an incident in her childhood of extreme rage. After her father died she got into a playground fight with a little boy and almost killed him; she wanted to kill him because she was so angry over what had been done to her. It was a look in the boy's eyes — no doubt terror — that made her stop. She said these paintings are what it's like to express murder.

One painting depicts two men, both with an erection, both pulling at a cringing, screaming woman. In another, a ferocious-looking woman with her tongue hanging out is viciously choking a man. There is blood on his neck. Joyce refers to herself as the female subject in them, pointing out, for example, a delicate, surreal image of a woman in a pretty floral garden petting a deer, while a devil figure leaning on a pitchfork nearby observes the scene. In the McEwan film tribute, Joyce explains, "I have

cast the two people in different roles. He is now the devil and I am the goddess of animals."

About two dancing nude figures, Joyce says, "He is doing the hornpipe and I seem to be floating away. Which I have a tendency to do."

A nude male figure lies supine in a field of flowers, with a flaccid penis, and an arrow stuck in his chest. "He just got hit with the arrow of love, which is very unusual," Joyce announces, and giggles merrily. Alongside the nude man is a splay-legged woman. "She is enjoying love," Joyce says, with a smile. And she starts humming. She hums and smiles as though deep in happy memories.

From the omniscient position of hindsight it can be seen that Joyce's monsters and her murderous rage, in conspiracy with the forces that originated these works, foretell the signs of Joyce's impending doom. No one knew it then, however.

In 1983 Joyce received in the mail a booklet on the Order of Canada, entitled "What the Order of Canada Means," and she immediately tossed it in the garbage.

After thinking this over, she retrieved the booklet and found inside an invitation for her to attend an investiture ceremony at Rideau Hall in Ottawa. The realization slowly swept over her: She had been awarded the Order of Canada.

A jumble of thoughts jammed her mind to a standstill, the way an overloaded elevator causes a stall, and she wondered how she had got it, whom would she tell first, and thought her parents would have been so proud, her sister will be proud, *she* was proud. . . .

"And something just made me feel great. I thought, 'This is real recognition.'" Singled out to be awarded one's country's "highest honour for lifetime achievement" is stellar recognition for anyone, regardless of his or her blasé factor, and wearing the white, gold, and red rosette on a lapel, a ballgown instantly marks the person as a significant builder of Canada's cultural, philanthropic, social, scientific, business, and/or intellectual

house. Since the award's 1967 inauguration, only thirty-five hundred Canadians have been honoured. Michael had received the Order of Canada in 1983.

Monumentally touched by being nominated, Joyce would soon feel even more honoured when she learned how Order of Canada awards are selected. Her response speaks to the goodness of Joyce's soul. Happy that she had been honoured, she was happier to realize with whom she shared the honour.

At the investiture, each honouree is called forward, his or her achievement is read and the Governor General of Canada pins the Order of Canada rosette on the recipient. Joyce later recounted her impression of receiving her honour:

> I found it was a very democratic recognition. From the poorest people — I'm telling you, really amazing — to people who ran the oil companies. It was a big swath, right through. Those were the people who got the award. A man who had led an orchestra in Shawinigan Falls for forty years — it was a youth orchestra. That was his doing, and he came up and he was all bent and he had white curly hair. I forget his name, Monsieur whatever. . . . And a woman who'd taken 400 children into her house during her life, including the retarded. She'd just acted as a public service on her own. And then right up to the very wealthy — all kinds of people. And it was just so moving. I can't tell you. . . . I was very honoured, really. I don't think you'll find many people who were not really honoured. Margaret Laurence felt the same way.

Just as exciting, and complimentary, was the dinner party Jean Sutherland Boggs, chair of the National Gallery of Canada, hosted for Joyce after the investiture, and whose star guest was former Prime Minister Pierre Trudeau. Joyce's guest list included her dear friends from Toronto:

Sara Bowser, Linda and Gerald Robinson, Pen Glasser and Doug MacPherson, David Silcox and his wife, Linda Intaschi, Betty Ferguson, Phyllis Lambert, Nicholas Laidlaw, Av Isaacs, painter Greg Curnoe, and numerous cultural figures, among them Pierre Théberge, William Withrow, and Dennis Reid.

Joyce was among nine Canadian artists,[1] along with Toronto art dealer Ydessa Hendeles and Toronto art journalist Gary Michael Dault, who were invited to Israel for a two-week cultural tour from May 21 to June 4, 1984.

Sponsored by the Canada-Israel Cultural Foundation, the objective was to encourage a cultural exchange between the two countries, in which the artists agreed to make work in Israel that would be exhibited in both countries, and to organize cultural events in Canada, such as music and dance. Journalist Gary Michael Dault would deliver a number of illustrated lectures on contemporary Canadian art and write about the trip for the Canadian media.

The entourage spent the first five days touring the country, visiting historical and modern sites in Jerusalem, Tel Aviv, Jaffa, Ein Hod, the Galilee, as well as the Dead Sea and Masada. An active itinerary included lunches with museum directors, exhibitions and film screenings at the universities of Tel Aviv and Be'er Sheva, and music everywhere. They visited a kibbutz, had dinner in a desert tent with a Bedouin tribe one night, and another night, at Herod's Palace.

The experience moved Joyce "like nothing else." She sampled Israeli life on its essential levels — religious, spiritual, cultural, artistic, and most impressionistically, the country's people and its light and climate.

At the Wailing Wall, Joyce's first observation was the acoustics. "[People] press little prayers into the holes in the walls and. . . . They wail their prayers. There's an effect inside the dome where they pray. The sound was in waves, buzzing in the ceiling. It was absolutely incredible. Celestial, religious music made from praying. The whole thing is so spiritual. . . ."

At a kibbutz they visited, Joyce was entranced by its extremes. Left-

over from the Lebanese war, she saw bomb shelters with art on the walls, a sculpture studio on the enemy line close to machine-gun placements. "All around the kibbutz were flowers. Flowers! Flowers! It's amazing!"

Joyce felt that the Holocaust Museum was a "focal point" for the people's "passion to live, to create." And she saw old tanks from the 1948 war scattered along the roadside on the side of a hill as sculptures, "as monuments to the country's origin."

The group arrived in Israel during an international film festival and here Joyce received a tremendously pleasing compliment — she was known. "It was very unusual to go into a country cold and find they *knew* my work," she said. At the Cinematheque, where the films were shown and the group had lunch, Joyce was asked to sign a dedication book, in which she shared the company of a few other notables — Warren Beatty, John Schlesinger, and Barbra Streisand.

Before leaving for Israel, a friend told her that Jerusalem was a city of light. "It's the whiteness of the light," Joyce discovered. "The stone of the building is kind of creamy. When you see slabs of it polished, it ripples. It has a little pink in it, so when the sun hits it and it glows, *it is* the Holy City."

On her first morning in Jerusalem she heard the sounds of Hebrew spoken by three men in the hotel swimming pool and although she'd heard the language before, this time she exclaimed, "The reverberations! The richness, the sensuality. In the context of their own country." This was like hearing the language for the first time.

These sounds inspired her to finish her film, *Birds at Sunrise*, begun in 1972. Joyce incorporated the Star of David into the film, added Hebrew psalms to the soundtrack and completed the film a year after her trip, in 1985.

She realized that her film, "about birds from the earliest light in the morning until about eight o'clock, in two seasons, spring and winter . . . is very beautiful, but it has a sadness about it because it's about their survival." In the winter there are no berries to eat. "The birds were often

cold and suffering. I became caught up in their frozen world and their ability to survive the bitter cold." And she made the connection: "The struggle for life . . . it's the same with the Jews."

Joyce and Hollis Frampton, while living in New York, had begun work in 1964 on a collaborative film, *A & B in Ontario*. They spent fragmented time shooting in Joyce's neighbourhood, on the streets, in parking lots, on a fire escape, at the docks, and other outside locations, and then the two of them came to Toronto in 1967 for a brief vacation, which resulted in them shooting additional footage at Joyce's friend Wendy Michener's house in Rosedale, and on Ward's Island.

The film is a send-up of the gangster flick. Joyce and Hollis aim hand-held cameras at each other, shooting themselves and the surrounding scenery. The playful diversity of crowded, noisy, dirty New York street scenes is interposed with lyrical sequences of footprints on the Ward's Island beach, waves, birds, trees, and the sound of crickets.

When Joyce and Hollis returned to New York they undertook to finish the film and discussed using a split-screen technique for the final cut, and both Joyce and Hollis took their own footage to edit. Joyce hadn't managed to do much work on the film. Having received word about her retrospective at the National Gallery, she expended her energies there from 1969 to 1971, in addition to working on *The Far Shore*, producing nine more films, and taking the teaching post at the Nova Scotia School of Design. She and Michael returned to Canada in 1971, two years later Hollis moved to Buffalo, where he was a professor at the Center for Media Study at the State University of New York in Buffalo.

Neither Joyce nor Hollis had done additional work on the film. And then in 1984, at age forty-eight, Hollis died of lung cancer. Prior to his death he had been working with Buffalo's famed Albright-Knox Art Gallery planning a retrospective of his photography, art, and selected screenings from among his more-than-sixty films. Curator Susan Krane contacted Joyce in the hope that *A & B in Ontario* could be finished for

inclusion in the exhibition. She deemed the film pivotal, stating, "Frampton's association with Wieland was integral to the development of his compositional format and aesthetics."

Following Joyce's 1981 and 1983 exhibitions and their largely favourable reviews, observers of the art scene could see an elevating opinion of Joyce developing, and along with art dealer Dorothy Cameron's writing that Joyce had inspired her, Joyce's association with Hollis represented the first hard evidence that the tables might be turning; Joyce was receiving credit for influencing a major American filmmaker.

Because *A & B in Ontario* was a co-production between Joyce and Hollis, she vacillated over the prospect of completing their shared work on her own. Chiefly, she was reluctant to make solo decisions on a co-production. This is vintage Joyce — her insecurity stewing in the juice of her ethics about meeting Hollis's high standards. Ready or not, however, the upcoming Albright-Knox retrospective impelled Joyce to complete the film.

She applied for and received an Ontario Arts Council grant to pay post-production costs. In the final cut, dated 1984, seventeen minutes, 16-mm, black and white, Joyce generously cited the film: "By Hollis Frampton and Joyce Wieland."

A & B in Ontario is a neglected film. One explanation could be that some programmers would not include a co-production in an all-Wieland show, just as the film might be excluded from an all-Frampton show.

The film's unpopularity has no relationship to its artistic merit. It was shown in a West Berlin film festival in February 1985, among some six hundred international films screened in competition for the Golden Bear, an award as highly acclaimed in the underground film movement as is the Palme d'Or for feature films at the Cannes Film Festival. Covering the festival for a Toronto newspaper, Gerald Peary wrote that the audience found the film "to be a delightful tongue and cheek, cat and mouse cinema game" of Joyce and Frampton acting like "western gunslingers." He also notes, "*A & B in Ontario* shows Wieland at the top of her form and is a celebration for Canadian filmmaking."

The retrospective, "Hollis Frampton: Recollections/Recreations," opened at the Albright-Knox Art Gallery on September 30, 1984. Joyce was a guest of honour for the opening of the film segment the following week when *A & B in Ontario* was premiered. It was Michael Snow, however, who delivered the opening-night lecture in honour of Hollis. Michael paid an articulate tribute to his filmmaker friend, concluding with:

> Seeing Hollis's exhibition here a month ago, I was moved on many levels, one of them being a reawakening of the sense that through art, as through very few other human endeavors and never with such purity, one places in and leaves in the world for as "forever" as material and conditions will allow, an objectified emanation from the core of one's uniqueness. Could I say that while every individual entity is unique, irreplaceable . . . some are more so than others?

Another film Joyce had begun in 1964 in New York and finished in 1985 is *Peggy's Blue Skylight*,[2] eleven minutes, black and white, the soundtrack featuring Paul Bley on piano.

Some reviewers classify Joyce's films as three-way portraits — people are portrayed in group portraits in *Larry's Recent Behaviour* and *Peggy's Blue Skylight*. Joyce appears as a self-portrait in *Water Sark*, and the land is depicted as portraiture in *The Far Shore* and *Reason Over Passion*. Under this portrait category, *Peggy's Blue Skylight* combines both the group- and self-portrait through the expression of home life as played out by Joyce, Michael, and Dwight, the cat.

Joyce's therapeutic progress had produced a few encouraging blossoms in the untended patch of her gloom, and the whole garden had burst into flower when she began her coloured-pencil drawings that revived her artistically and more — garnered high acclaim.

During this creative flowering, Joyce made a serious effort to improve

her health and latterly, her image. The timing is understandable. A marriage breakdown often activates the injured spouse to undertake a thorough personal inventory in the hopes of determining where the blame lies, and if possible, make some changes. Joyce may well have deemed her physical appearance at fault — as she had suggested to the imaginary Dorothy Whip. Largely, she behaved like countless newly divorced individuals who lose weight, buy sexy, lacy underthings — or black jockey shorts — get new hairdos, new noses, and a resuscitated outlook, readying for the dating roundelay.

It is at this time that Joyce splurged on a new wardrobe, haircut, and makeover, and bought her Volkswagen convertible — the one used in the "theft" of Selma's car. In the film tribute to Mary McEwan, Joyce is wearing a stylish red coat with large black splashes on it (was she confronting and finally annihilating the anguish of her childhood red coat?), and with a sprightly step she gets into her little car, parked in front of her house, and drives off, her smile on high beam.

During her change spree Joyce refurbished her house, after having lived in it for five years. "I went from room to room and I started to do what I wanted to do with this house. Making it my own in every way."

Linda Gaylard and her architect husband, Gerald Robinson, were in charge of the redesign and redecoration. Joyce's bedroom featured a domed ceiling in plush, pleated velvet and a Victorian bed with grand mahogany posts supporting a velvet domed canopy. The dining room, with its oak-beamed ceiling, was covered with a Tudor reproduction wallpaper, and high pine shelves were built above newly built archways to display Joyce's artifacts. These are in themselves quirky, beautiful, rare, and above all, prized by Joyce: a stuffed beaver, a mounted deer's head, stuffed geese, statues of Sappho and the Virgin Mary. Paintings were repositioned all over the room, Joyce's and those of artist friends Greg Curnoe and Vince Sharp — nothing of Michael's.

When Joyce's friends speak of her devotion to food and cooking, the conversations dwell on meals as theatre. Linda described the dining room

as a caravan "we were all travelling in," seated at the long dining-room table, which had previously been a display table in an ancient Eaton's store that Joyce bought at a junk shop in Port Dover, Ontario, and was said to have been made in about 1850.

Joyce would search for special ingredients and experiment with cuisines to lay on grand "theme" dinners. A French theme, for example, featured French cooking and French wine, and Joyce would write out a menu in French and play French music throughout. Similarly, she celebrated an English garden party, or a Turkish or Indian meal.

One of her most spectacular was a Twelfth Night medieval feast she hosted in 1985 that would become an inaugural for an annual tradition (for the next three consecutive years) and was a theme she pursued to grandiose heights. Describing one such feast, she said, "It was magical. We had entertainment between courses, and the food, all medieval in origin, included bean cases, spiced apples stuffed with yams, lamb pie, fennel in cream sauce and English cider."

In 1981, Joyce had taught an art class, "Painting Your Visions," at a collective studio/school known as Arts' Sake Inc.[3] with artists Diane Pugen, Nancy Hazelgrove and Tom Hodgson, and in 1984, she continued the class on her own, as well as giving lessons briefly at the McGill Club. However, Arts' Sake Inc. folded around that time and Joyce asked a few of the students if they wanted to continue classes and share a studio. She located a warehouse space on King Street, not far from her house, and with two and as many as six others, maintained the space as a painting studio from 1984 to 1990. (Joyce used the studio in her house for drawing.) One of the painter/students, Kay Wilson, remained throughout that time and, like one of Joyce's earlier students, Kathy Dain, Kay developed a warm friendship with Joyce.

Kay defined the arrangement as a "self-improvement school for us," explaining that Joyce "could pull out of people what she thought was our best. She was not forthcoming about teaching but was such a wonderful

person, I learned just by being around her."

They did a lot of talking and giggling, Kay said. When Joyce arrived in the studio she would look up to the ceiling "to see if the art angels were there." Kay came to admire Joyce for her ability to "combine the mystery of fine art with decorative flair," and for the way she constantly related ordinary places and people to art, especially her adored eighteenth-century French painters. She brought in art books and discussed the plates with her students. Kay cited as one example: "She had us look at Chardin and Cézanne, and she said, 'Look how much Cézanne owed to him.'" If they were having lunch or dinner together in a restaurant, Kay spoke of Joyce always picking out a face, "And she'd say, 'Look, there's a Delacroix or a Caravaggio sitting there.' She was always looking." As Jo Hayward-Haines pointed out, Joyce instinctively included art in her day-to-day life.

Kay mixed colour for Joyce and cleaned her brushes, and describing Joyce as an "intuitive painter," Kay learned from watching her paint. "She had tiny, tiny hands but they were fast. She worked very quickly. And she loved Belgian linen. That was her favourite canvas. It has a nice spring to it and the brush moves across it like it's moving across skin. And she never lost that vital brushstroke of hers. She did a lot of scumbling and then she'd add glaze over glaze." Painters commonly use linseed oil to mix paint; Joyce used stand oil "because it binds the pigment better," said Kay, adding that Joyce didn't like acrylics. (She never used acrylic paint.) "She loved oil paint," Kay said, with enthusiasm equal to Joyce's when describing one of her adored Mozart symphonies. "Oil has life, a life of its own."

And then Kay's voice quietened to a near whisper, saying, "It was nice working with Joyce."

Jo Hayward-Haines once organized a field trip to Joyce's studio in her house on Queen Street with a class she was teaching at a private school just north of Toronto. "These kids had well-to-do parents," Jo explained, "and they were astonished to see Joyce's modest surroundings, [by their standards,] and they talked about not making much money from selling

paintings. And Joyce very gently, very carefully replied that there are different values in life, that everything couldn't be measured in dollars."

Joyce may not have scorned these youngsters' privileged lives but she surely would have tried to reach one or two of them by pointing out the intrinsic worth they would derive from having art in their lives.

At work in her large studio and through her young students, Joyce sympathized with the struggles women artists were having getting exposure for their work, just as she had, early in her career. With this in mind, in 1988 Joyce founded the Alma Gallery in the Annex at Bloor and Markham, in a building owned by the Mirvishes, next to the former David Mirvish Gallery and now David Mirvish Books/Books on Art.

This was Joyce's contribution to young women artists without studio space; and for anyone who could afford it, she charged a stipend for art classes. Much more than art classes, however, in the Alma Gallery Joyce attempted to establish an art-workshop setting in the Renaissance manner where women could work and exhibit their work. She said, "It's about caring, teaching, and loving. The whole thing all fits together. Artists can become teachers and be creators. Definitely there needs to be a new look at apprenticeship."

Again, the problem was financial. "You see now it's impossible to buy a building," Joyce lamented. "We need to have a building given to us so that we can have a permanent gallery and studios." She lived in hope that through "the group spirit," this would materialize.

Joyce's family history had been documented largely by her sister Joan, beginning in about the 1950s, and Joyce, curious and confused all her life about her ancestry, decided she would pursue a genealogical search of her own. With Joan's help and that of Betty Ferguson, who is very knowledgeable about genealogy, Joyce travelled in 1988 to the place of her parental origins, England. Actually, it wasn't necessary for Joyce to go abroad — there are sources she could have used in Canada — but quite likely Joyce welcomed the investigative nature of her task and the notion

of getting as close as humanly possible to the whole truth by handling documents and speaking to clerks in registry offices and parish churches. She found a treasure trove of information. Numerous "certified copy" records of birth, marriage and death certificates shed light in her formerly dim *Who am I?* tunnel.

Tracing her paternal and maternal roots to the late nineteenth century, Joyce returned with treasured photocopies of theatre programs of Wieland relatives' stage and music-hall careers.

Since her father's "real" marriage was already known to Joyce, finding its documentation likely did not affect her as calamitously as first learning about it and realizing that she had been born out of wedlock — in addition to having siblings she had never met. There is every possibility that gathering the evidence was salutary for her.

Joyce's nephew Michael, one of Sid's sons, remembers Joyce telling him about her father's marriage when she returned from England — news he heard for the first time, unlike Joan's children who had known for some years. Michael said his father didn't talk much about his family. He also said that his father "went through a lot in the war" and grew even more subdued when he returned from overseas, until his death of heart disease (like his father), at age forty-six in 1966.

Michael does not recall Joyce being upset telling him about her father's double life. She didn't speak in any great detail about this with friends and there are no references in her therapy sessions. Her husband had not known. It is safe to conclude that Joyce found peace with this once-humiliating corner of her past.

In 1985 Joyce rose to an entertainment high organizing an extravaganza with Phyllis Lambert and Mimi Cazort, a curator of the National Gallery, in honour of Jean Sutherland Boggs. Retired from the gallery, she had been appointed in 1982 to the Canadian Museums Construction Corporation, responsible for construction of the new National Gallery building. She became embroiled in a controversy over her handling of the contract

and was fired by her board of directors. The party was planned as a show of support for Boggs, who, as Joyce said, "really needed support." It also indicated Joyce's personal loyalty to Boggs, whom she considered a friend regardless of her ambiguous, less-than-supportive responses to negative comments made about Joyce's 1971 retrospective.

Held in Phyllis Lambert's house, in a converted factory in Old Montreal, this sumptuous, theatrical, gala evening would not soon be forgotten.

As an organizer, Joyce was in her element. She designed the invitation on a theme of one of her goddess drawings, and when invited guests read "Dress festive," they did that and more. Sixty members of Montreal's cultural and business elite showed up in period costumes, hairpieces, top hats, and extravagant jewellery, whereas superguest, former Prime Minister Pierre Trudeau, came in a cowboy outfit. Joyce's dress was "after Watteau," designed by Linda Gaylard, a silk print that flowed romantically when Joyce moved, as did the giant green frond she wore in her hair. Many women were presented with wreaths of flowers to wear.

The choreography kicked in when guest of honour Jean Sutherland Boggs arrived. What was patently a Joyce Wieland touch, guests scattered flowers at her feet as she made her way to a garlanded bower, under which she stood to receive guests.

Guests were seated for a performance by three mimes, who presented Boggs with a model of the proposed National Gallery. In Joyce's words: "Then she meets up with the guys with the money — the bureaucrats. She's got a big long roll of paper — the plans — and she makes it shake. The guys wrench it away. But she inspired them to think differently, even though they're bureaucrats. Then they dance and there's silver dust in the air. The guys carry her out in their arms and she carries the model in her hands. It's all about money and bureaucracy. The guests just loved it." Certainly, none more than Joyce.

"You'd think you were at the Petit Théâtre at Versailles," she cried. "Afterward Trudeau asked, 'So you think bureaucrats can change their

minds like that?' I was in seventh heaven about it all."

The festivities continued until four in the morning. For the finale a giant cake in the shape of the National Gallery was wheeled out to send guests luxuriously, indulgently home.

Pierre Théberge later observed, "That evening was an extraordinary creation in itself. It was something that marked our time."

From the outside looking in, many would consider Joyce's life to be full, exciting, enviable. She employed an administrative assistant and a housekeeper, kept company with interesting people, had regular dinners at a posh private club with women achievers like herself, and routinely she dined and wined at trendy restaurants, attended opening nights, and went to movies and concerts. She remained a welcome and regular dinner guest of her two surrogate families, married couples Linda Gaylard and Gerald Robinson, and Sara Bowser and Bryan Barney. Linda described Joyce during this period as "absolutely loving life and getting the most out of it." Like all Joyce's friends who had comforted her through the bad times, they pined for her to love life.

Sara and Bryan occupied an especially meaningful, dependable part of Joyce's life. Joyce adored their daughter Rachel — Joyce had given her a part in *The Far Shore* — and she celebrated Christmas, Easter, and Thanksgiving with them, as family members do. However, Joyce drifted away somewhat when she was unable to tolerate the couple's heavy smoking. Her sister Joan, with health and marital problems of her own, lived out of town with her daughters. She and Joan remained in contact, sent birthday cards back and forth, but did not spend a lot of time together, although Joyce's niece Lois lived with her for a few months in 1980, and Joyce's nephew Keith remained closely in touch. Betty Ferguson lived with her children out of town and did not have everyday contact with Joyce, but they remained dear friends.

Publicly, Joyce presented herself looking her best. Like applying the finishing touches of lipstick and hairspray, she dabbed on her smiley,

dimpled face before leaving the house, and although she largely effected a successful cover-up, certain friends perceived the full extent of her *cri de coeur*. She had written a note that read, "It's uphill to keep one's spirits up and away from down-at-the-mouth people — I want to live — but not in the cellar. All I want is space to paint big and a lovely husband." She grieved like an unrecovering widow. Her husband had departed with another woman and taken with him the priceless valuables of the marriage — his mother and some of his friends.

Losing the companionship of her mother-in-law erected one more barrier between Joyce and a full emotional recovery from her implacable loneliness. For thirty years she had lived with a man — first Bryan and then Michael (and briefly, George Gingras). She was accustomed to the presence of a man. Being alone haunted her. It was like having a deranged relative living upstairs who kept her eerily on edge, as though one day the mad old man would come thumping down the stairs with an axe. Increasingly — unlike the past, when she hid most of her pain — friends began seeing and hearing about Joyce's periods of deep melancholia and tearful outbursts.

Paul Haines took Joyce out a couple of times when he would come to Toronto in the mid-1980s. He remembers how bitter Joyce was. On one occasion they were driving to an event and, "She was crying and crying, saying that on top of everything, all Mike's friends were gone, that they were his, not hers anymore." Another time they were at a restaurant or party — Paul's recall of place is overwhelmed by what happened there — "and Joyce began sobbing so hard we had to leave."

The divorce had been finalized in 1982 but the maelstrom in Joyce's heart was far from over.

Joyce's friend from Ohio, Janis Crystal Lipzin, who had moved to San Francisco in 1978, became chair of the Filmmaking Department at San Francisco Art Institute (SFAI) in 1985. She invited Joyce for a semester as a visiting artist to teach an undergraduate class on filmmaking.

"She was reluctant to take up my offer because of her experience in Nova Scotia," Janis related. "She hated that place, saying it was a very male-dominated school and aesthetically austere. I told her she could be free and open and be herself here, and do what she wanted." Janis explained that the school was dedicated to artists, that all forms of creativity were welcome and students were there "to discover their own personal vision, and when I said Joyce could conduct a course of her own design, she finally accepted." Joyce may have been creatively spurred on by a commission she received earlier that year from Greg Gatenby, artistic director of the Harbourfront Reading Series. Gatenby commissioned Joyce the first artist to create a proposed annual edition of bronze plaques that would carry the inscribed signatures of each year's authors invited to read at Harbourfront, the plaques forming a "wall of fame" to the venues. (Cutbacks and politics precluded further commissions.)

Her design completed and requiring some months at the foundry being fabricated, Joyce had no commitments to keep her in Toronto. She took up the position as artist in residence at SFAI in the spring of 1985 for fifteen weeks, two classes a week, three hours each.

At Janis's farmhouse near Sebastapol, in California's Sonoma wine district, Janis recalled that San Francisco "was slow getting over the 1960s. There was a lot of permissiveness of all kinds of activities and a lot of tolerance for every aberration. And very little interest in the practice of quotidian dailyness of our lives. It was still cheap to live here and people could indulge themselves. There was a sense of, 'I want to try everything.' You've never seen such variety! And in the college there was an expectation of openness and a non-judgmental atmosphere."

This suited Joyce. And as for the dark cloud Janis had noticed accompanying Joyce in Ohio, "It was gone. She was witty and bright, literally the difference between day and night."

Janis connected Joyce with Steve Anker, artistic director of the Cinematheque and a teacher and guest curator in the film program at SFAI. Steve had an extra room in his flat in the Potrero Hill district and Joyce

stayed with him throughout her residency. Born in New York, Steve had become acquainted with Joyce's films there, and in San Francisco on several occasions he screened her films at the Cinematheque. (In 1997, he held a retrospective of Joyce's films.)

Recalling Joyce's first reaction to San Francisco, Steve said, "She thought it a sleepy place with not much going on and I thought, 'We'll see how she responds.' It wasn't even a couple of weeks until she was completely enthralled with the city and became embroiled in all kinds of social activities. She found a new lease on life here and was really quite irrepressible and exuberant."

A young painting major, Jamee Erfurdt, decided to take Joyce's film-making class. "We hit it off right away," Jamee stated, explaining that they were "kindred spirits" who soon became "mutually nurturing" souls. Twenty-five years Joyce's junior, Jamee felt that Joyce wanted to mother her, and Jamee, coming off a love affair, needed someone in her life. She described both herself and Joyce as "lost emotionally," which led them to their "mutual support system."

Jamee introduced Joyce to a few people who were "into healing." One woman had completed some training in Tibet and a man taught psychic healing in his home, where people met regularly to engage in healing practices. They smoked clove cigarettes and some took the latest designer drug, Ecstasy.

Joyce went to one of these sessions and tried the drug. Its effect on her? She thought she'd been thrown off a cliff.

Discussing Jamee's and Joyce's use of the drug, Jamee emphasized that at the time it was legal (the substance was banned in 1988), and just as emphatically she stated that it must be taken in a trusting social situation. She guessed that Joyce took Ecstasy about once a week during her approximately fifteen-week residency. Jamee's total experience was about three dozen times. "I believe it benefits people in the appropriate environment," she stated, which for her and Joyce occurred at psychic healing sessions. "It is beneficial to people who are working out blocks in relationships. It

makes you feel open, more aroused both sexually and verbally, and it helps people who want to speak the truth. At best, you feel pure and loving."

Jamee remembered a session in which she massaged Joyce's feet, and said that Joyce "got emotional, saying how she loved Michael but was devastated by the breakup. She was still having a hard time." On that particular occasion Joyce had been very talkative. "Joyce had suffered so many losses," Jamee said sadly, and added that through Ecstasy, "Joyce got permission to be what she wanted. Once you experience Ecstasy, you want to feel that way all the time. The drawback is, it's a drug. You could do meditation but that takes more work. With Ecstasy, you get close to being what a spiritual master would want."

Ecstasy — chemically MCMA (methylenedioxymethamphetamine) — is also known as MDM, and more recently E, or XTC, the rave drug. It is said to be more refined than LSD (lysergic acid diethylamide) and the amphetamine-grouped drugs, and for most users it is non-hallucinogenic and non-psychedelic. Its proponents claim that it enhances alertness, energy, clear thinking, and communication.

Steve spoke of Joyce returning to his flat "all animated and excited, telling stories about the great time she was having." Steve was not a participant; he and Joyce went out only half-a-dozen times during her entire stay in San Francisco, although the two of them spent time together talking late into the night. Joyce found in Steve a patient, empathetic, and intelligent sounding board, someone she could trust with her feelings. The clear and lasting impression Joyce left on Steve was that she was "in quite a lot of distress about her personal life and seething with anger over being excluded from New York's men's club of the 1960s." He clearly remembered, "She talked about that a lot. She was bitter against Mekas for never taking the pains to embrace her work. She hated him. And she felt ripped off by Mike. His new life was very painful to her." There was no question in Steve's mind that Joyce "felt unappreciated and cast off from what was happening in society," and at the same time he saw that she was gaining a great deal from the "exciting change of being

thrown in with young people" in the film department at SFAI.

During their nocturnal discourses Steve uncovered Joyce's conflicting regard for art and the artist's standing in society. He felt that she was "anti-establishment and anti-institutional, and that she tended to withdraw from institutions." And although she functioned within these institutions, Joyce refused to work in an institutionally-approved fashion. She success-fully made her distinctive feminist/nationalist/ecological art, which in fact had been endorsed by the art Establishment; but at the same time she kept her distance. Steve said, "The irony was, once you understood her work you could see that it reflected that she hadn't been involved."

As a teacher, Joyce's methods raised some academic hackles, according to Janis Crystal Lipzin. Even in a culture that fostered individuality and promoted tolerance, certain faculty members thought Joyce a little too unconventional, and moreover, not all students favoured her informality. Jamee, a fervent exception, tells of a session where Joyce had all members of the class, a dozen or so, lying on the floor, heads together, legs spread out like spokes of a wheel, where they did breathing exercises and willed their bodies into a state of relaxation, starting with the feet, the lower legs, and all up the body — acquainting them with the "higher dimension" of Gurdjieff, no doubt. In another class, Joyce had students pick names out of a hat and make a three-minute film of that person. Jamee drew Christo-pher Coppola (nephew of Francis Ford Coppola, director of *The Godfather* films), and Jamee was pleased that Joyce liked what she produced.

"She was very helpful to me," Jamee declared. She cites Joyce's "warmth and professionalism" as the factors that "allowed us to do things," which in Jamee's view meant "you can be pretty out there." However, the needs of students who expected to learn practical, how-to filmmaking, could not be satisfied in this environment.

In one of Joyce's lecture outlines, she proposed that her students tell a fable about another student's future as a film artist; and that they "demon-strate hope for a future — how to live out a situation which gives hope, to oneself and to others." Also, to "use humour and rhetoric" or speak "aloud

from a dream . . . to re-create this person, their personality and projected future." The final proposal: "Use drama — humour — insanity — madness — anything — but take a risk — risks — a dive."

Joyce also tried to interest her students in using film techniques in paintings, as she had done, "to bring the two disciplines together, to have the students play with the crossover." She admitted, "They didn't know what I was getting at." This may have disappointed her but Joyce learned from her experiences and made a group of *Lesson Drawings* that she showed in a 1989/90 exhibition at the University of Toronto, *Tears in the Rainbow*.

Steve said Joyce's students "thought she was very kooky, outrageous, and totally unorthodox. Not a traditional academic in any way. One thing about her, she almost reflexively challenged conventions. She relished being provocative. She was very critical while at the same time clearly exulting in the light of the essential."

Steve intuited an essential connection between Joyce's work and her spirituality. "Whether painting or teaching or having an experience of being out and meeting new people, she had a powerful interest in things and it was vitally important for her to be connected to her body. She was discovering a new world of sensuality, self-sexuality." Steve made clear that this did not refer to having sex, and as an aside, offered the opinion that he did not think she had had any sex while in San Francisco, "but she was totally excited by being around new people."

Filmmakers George and Mike Kuchar had moved from New York to San Francisco, and Joyce caught up with them. George's opinion of Joyce as a teacher was confined to: "She came to class in these big Granny Goose clothes and brought crayons with her." She and George went on a short, memorable jaunt to Monterey to see the "big Aquarium there," and "did touristy things," as George reported, adding, "She was great, down to earth, bubbling with life," and "a very good travelling companion."

Typically, Joyce wove her adventures into her art, and originating out of this one is a painting, *A Weekend in Monterey*. In the picture, Joyce is holding an unidentifiable monster derived from some film footage a

student of George's had brought back from Guatemala. Screening the film, George noticed a big, strange jungle bird and said, "Play the bird again. And the more he played it, the more interested I became with this cryto-zoological oddity, and I imagined it into some prehistoric monster bird. Joyce commemorated it in her painting."

George commemorated Joyce, too, in a memoir of his life as a film-maker, *Reflections from a Cinematic Cesspool*, published in 1997. He recounts a dinner with Joyce at an Italian restaurant in San Francisco, where

> . . . this robust woman wore a form-fitting dress that hung from her shoulders by thin spaghetti straps. Joyce hit the wine pretty heavily and all of a sudden here was this red-cheeked blossom in full bloom, glowing with life and sensual animation as the spaghetti straps began falling to reveal the meatballs she hid from the hungry. The half-exposed delicacies swayed and heaved in the amber light of the restaurant as she launched into an earthy monologue concerning an old flame that she bedded down with in the Canadian wilderness. Ms. Wieland said that he had a "nice tummy" and then, in a loud voice that boomed from one end of the room to the other, went into scorching detail about the physical manipulations they had engaged in at the forest cabin. It was a delight for me to hear and I think everyone else in the restaurant thought it interesting also. If only some of her students could've been present at the eatery to see the real woman behind the teacher.

The professional therapy Joyce had undergone episodically since 1964 in New York accelerated at this time. After returning from San Francisco, during most of the balance of that year and into the first part of 1986, Joyce attended therapy sessions once a week, and concurrently was seeing a stress consultant and a nutritionist. A sequence of notes in her files,

dated September 1986, are written legibly as though she was clear-minded and penned them fresh after visits with these various practitioners — notes that firmly establish a deep, unresolved conflict originating in the three-way relationship between her, her mother, and her father.

She had been told that this was a central issue of her life, and that her progress toward its resolution would be difficult unless she addressed what she called "some deep past [that] is still an unsolved triangle" that existed when she was six years old "between my parents and I am the outsider rival stimulated by some goings on between them and me." She has had a "lifetime devotion" to this triangle "and for me — feeling dirty and then weird about my involvement." Having lived with this since age six, she "can't give in past a certain point of mild stimulation — [I] stiffen and resist, but not with George and strangely enough not with Mike in the beginning and before the end." Squiggled out, but discernible, are the words "eating all day," which are followed by "must get studio finished soon." This note ends with, "Was my father a womanizer?" And in another pen, as a later add-on, is the word, "Too."

Five days later, she refers again to the "triangle" and she is advised to "supersede this situation" that she describes as the "rivalry with women (mother) plus to grow up and give up father who is engaged with mother, not me."

She seems to believe that loving her father put in her a double bind; that as a consequence of loving him, she is replacing her mother. Troubled by clear sexual overtones, Joyce adds, "Plus, I was a child so couldn't have father (an adult male)."

Her notes describe that she is told to "just give it up." She writes as though directly quoting the therapist: "Look where you have been, he says, with these men who put you second or even less on their list. George with the bottle and his neuroses and Mike with his mother and other women and men in the band."

Describing a different source of anxiety, she reports that lately she feels guilty for just about everything and when asked to be specific, she says,

"For having money and a house, etc. Some friends don't have this."

She is told that she is afraid of being favoured. "'You made this all yourself, the shows, the money, the art, etc.' He [the therapist] said it's about time you decided you wanted to be first with a man, and just like your life you've given yourself."

One has to appreciate that these are Joyce's abbreviated notes, but revealing is the fact that she had for years resisted feelings of a sexual connection to her father. Preschool girls are known to be sexually curious about their fathers — a situation manifested in confused, surreptitious, touchy-feeling explorations, most of which vanish into the larger, more exciting world of discoveries encountered past six or seven years of age, but we learn from Joyce's notes that she did not expurgate these feelings.

There exists a theory that girls' sexual attraction for their fathers is more powerful than it is for lovers — beginning with the notion that Christianity converted paganism into patriarchies, in whose evolution fatherhood was elevated to dominance, giving fathers the right to demand respect from their wives and offspring. It is known that a female baby exhibits love for her father as a pleasure response, different from the love she conveys to her mother, which is based on dependency. As the baby girl matures, her pleasure in her father deepens — provided that he is a lovable father — and combined with the respect that the father has demanded throughout the girl's lifetime, even if unconsciously, father and daughter have forged a potent partnership of pleasure and respect. This leaves the girl attracted only to a man more dominant than her father, who can penetrate the bond she has with him.

Even though Joyce's father died when she was so young, the patriarchal system still existed and she found dominant men. She had lovers, a husband, a father-in-law. But when both her parents died, Joyce said she was always looking for her father and mother, and perhaps she never stopped looking for a father figure. Or as compensation perhaps, she expanded the search for her spiritual self.

Through Joyce's introduction to Ouspensky in the 1950s she would

have investigated Gurdjieff's theories of the "act of believing" and that people live their lives as sleepwalkers, that an individual has the energy within her- or himself to develop a healthy ego. A dedicated study, Joyce may have dropped out after 1964 when Wanda died and without her influence Joyce might have lost some motivation, and while intellectually she cherished the value of "the energy within" as a healing factor, practically its application may have eluded her. In which case, she adopted another search, and another.

Keith observed first-hand some of Joyce's spiritual/philosophical trial runs. "Everything that was new that came out, like crystals, rekai, this or that — she tried anything she thought was spiritual. She had a whole bowl of crystals and she'd say, 'Here, have a crystal and you'll feel better.'" Keith rolls his eyes. "Yeah, sure. And she got into hands-on healing."[4]

This also ties in with Gurdjieff's theory of inner listening, part of a program of therapeutic breathing that works to develop harmony between all the body's organs in an effort to eliminate stress and promote energy.

"She was a healer," Kathy Dain states with emphasis, having experienced Joyce's hands-on healing. She pauses to explain that whenever she is not functioning at top form colour drains from her face — something that Joyce had noticed. "One time in my studio Joyce looked at me and said, 'Your energy's not right.' And she stood behind me and put her hands about there" — Kathy holds her hands about three inches above her shoulders — "and although I couldn't see them I could feel their position. She had been doing rekai and some training in California [in San Francisco in 1985] and I could feel this energy force shooting up and down" — she gestures from her waist to over her head — "it was just *swoosh!*"

Kathy and Joyce had frequently performed massages on one another "for a sore neck and that kind of thing, but this was very real. I could just feel this flow of energy from her directly into my shoulders and right down my body." Softness envelops Kathy's face as though re-experiencing the moment. "I told Joyce how profound this was and she said she

was *on!* That she could feel her way of transmitting this energy was flowing. The colour came right back into my face."

Trying to discern more fully something that she cannot analyze concretely, Kathy settles for, "There is something about that kind of giving of energy where you don't lose your energy to the other person. Joyce was very much a healer."

"It's all bullshit," noted Keith. And he told Joyce as much. "She would say, 'No, I've seen it.'" Likely with Jamee in San Francisco and again with Kathy.

Sara Bowser observed Joyce through many therapeutic meanderings. "She went in for *everything* — Gestalt, est, every fashionable therapy of the twentieth century. She'd go into these things and come out exactly the way she went in. They didn't put a dent in her. They were all phases, and she'd go on to something else."

However, Sara stands to correct herself. Joyce benefited from Mary McEwan's feminist-anchored therapy. "She came out of that improved, and happier."

Jo Hayward-Haines believes that Joyce dealt with the blows of her life through therapy because she hadn't had a classical, formal education, and she felt vulnerable. Therapy then became an education for her, a means of supplying her with information "and to fill in what she was lacking. In therapy she could articulate herself fully." It gave her a "context for her quest and her struggles."

As such, Jo believes, therapy helped Joyce find her way.

Unlike any film she made Joyce saw "The End" come up twice in her life with Michael: the first, when he told her she was boring, and the second, when he told her about the baby. You might say there were three endings if you count the divorce, except that as in many divorces the official paper merely clamps on a legal cauterization to staunch the years of matrimonial bleeding. Before they had reached the five-year mark of their marriage and during its more-than-twenty years, Joyce had acknowledged Michael's

womanizing and braved it out, as soft-hearted, tormented wives do, until the first "End" appeared. Then Joyce called up her self-healing powers.

A review of the period prior to Michael and Joyce's separation is a reminder of the reversals Joyce had endured, such as the trials of making *The Far Shore*, which, she admitted, "nearly killed me," and suffering its barbed reviews, the trauma of her hysterectomy, and the Frank Stella accusation; and through these calamitous circumstances Joyce courageously inched her way upward — with the help of a support team of devoted friends, her sister, nieces, and nephew Keith Stewart, and through Mary McEwan's wise counsel. Tangible progress began to be seen as she loosened the workaholic vise she had trapped herself into for more than thirty years. She made an outright effort to treat herself better — "I gave myself things that I didn't know I wanted" — and the goal she set for herself, "Human Doormat Wants to Break Out," seemed within her grasp.

After her divorce, refurbishing her house, receiving high acclaim for her coloured-pencil drawings, the anticipation of her AGO retrospective ahead of her, Joyce hit a new stride.

In December 1982 George Gingras left after living with Joyce for about a year and a half. Early during this time George had gone on a drinking binge and subsequently attended a few Alcoholics Anonymous meetings, and although the two of them had tender/passionate feelings for each other, their time together had been tumultuous. Significantly, they parted by mutual arrangement, saving Joyce from another abandonment.

"George? — Yessss, George," Keith drawls, in the manner of W. C. Fields, seemingly taking this tone as though the subject matter warranted special treatment. "Man oh man, I was sitting there one day with Joyce and we were shooting the shit and the guy drank for three hours. I would be in Emerg. I mean, literally!"

Keith apparently thinks better of leaving this sole impression of George. "At first, he was doing his best to straighten out a little bit and Joyce was feeding him health-food brownies, but after a while she just got ticked."

Joyce asked Keith about the men around his club. "And I said, 'Why

don't you get a young one?' And she says, 'I don't know, I'm old and fat.'"
Keith sighs heavily. "Give me a break. That's one of the things she used to
freak out about and I used to tease her. I'd say, you're famous, you live in
this nice house and you mean to tell me you can't find anybody? I think
it's just from your lack of looking."

During a session with Mary McEwan when Joyce admitted that she
wanted to meet a man, she was advised to just look around and choose
one, "or more."

Look around? The first principle of looking involves taking action —
to look, to seek, to find — and what would this mean to Joyce? Hanging
out in bars? At age fifty-five? If she hadn't found a man in San Francisco
during a heavily social period of her life, where could she "look around"
in Toronto?

Sara Bowser suggests that Joyce's romanticism disadvantaged her. "An
affair for Joyce had to be candlelit and lacy, and god knows there aren't
many of those kinds of men around."

Keith lobbed a test ball into her court by sending a man from his
martial-arts club to Joyce's to help with jobs around the house, but noth-
ing came of it. Jollying her along, Keith suggested other men. " Like, this
one guy here" — he indicates a framed photo on the wall of a good-look-
ing beefer, black-belt champion — "and she would say, 'Gorgeous! He's
gorgeous!' She thought he was the greatest thing. And she asked if he was
married and I said yeah and" — he imitates her grumbling — "'Are there
any more like him who aren't married?' and I told her she had to look
around." Joyce had heard that before.

At Keith's urging, Joyce went to his club, set up an easel and made
sketches of the men there. Keith said, "I told her, some of these guys think
you're great, you should make an effort, I mean they're in their twenties,
half your age, but who cares, you're still like a child anyways so why don't
you just believe it and do something about it?"

Encountering beautiful men with their beautiful bodies apparently had
a reverse effect on Joyce's self-esteem. Keith says, "Underneath it all, she

was really body-self-conscious, that because of being a little overweight, the guys wouldn't like her, that they wouldn't see her as a sexual being."

Like many a fading beauty, and with such a tenuous hold on her self-esteem at the best of times, Joyce was possibly terrified of not having her ace to play in a prospective new relationship — her looks, her verve, her wingding sass. The weight she kept putting on was fat, not the voluptuousness of her earlier years.

To deal with these feelings of inadequacy, Joyce upped her therapy sessions with her new psychiatrist.

There is no question, Joyce's time in San Francisco produced a wonderfully rejuvenating outcome for her. Especially while there. She gave thought to staying in San Francisco, to the extent of making inquiries about getting a green card and working in California. Steve Anker believes that if Joyce had determinedly wanted to stay, she would have found a way. But surely her Canadian patriotism brought her back, as did her Toronto ties. Having been enriched by meeting new friends and making meaningful self-discoveries, and having taken Ecstasy and benefiting from its effects, one would have thought Joyce was eager to settle back into her beautiful home, connect with her friends and get right to work.

Things did not unfold quite so easily.

Joyce liked being married and waking up with a man who didn't need to leave before dawn. Intellectually, she probably supported feminist Gloria Steinem's decree that a woman without a man is like a fish without a bicycle,[5] but Joyce's preference was for a man. A sexual man. Someone who would live with her. The only man in her life was Keith and although a simpatico, amusing pal/relative and invaluable helpmate, that was all he was.

The following note of Joyce's, dated October 19, no year, is written in a similar style and on the same notepaper on which she made copious notations after sessions with a psychiatrist in 1983 (there is no reason to believe her sentiments changed much over the next couple of years):

This is the hardest part to show my feelings to a man I don't know. I can't rush it with [the] next man — I'm dying with the trying to sleep while feelings of sexual longing drive me mad or nearly. [a few indecipherable words] of such things are harder (especially the little victory last night when he came to the door to ask to go out Fri. with head on one side looking cute, me doing the same — a little discharge of energy and relief. But am terrified to go further — this will take time and I don't have any left. Time is nearly gone. I put a man like that above me when likely things are just as hard for him — but he has sex appeal — would love to ask him to see my etchings — but what if he said no. To be vulnerable now is too painful.

We do not know anything more about this "looking cute" person. There are no further references.

Keith and Joyce had always spoken freely about relationships between men and women, and he saw under her exterior flippancy a serious intention of finding a partner. With their previous approaches yielding no results, a more radical plan was devised. "I helped her write ads for the newspaper. Personal ads." Keith pauses for a moment. "This is the kind of stuff that I'm sensitive about because she was afraid of what people would think." But he continues, admitting, "I did a lot of pushing. I'm going, 'You can do it, I mean, shit, some of my martial-arts guys think you're a real good babe, like you should go for a young guy, get a boy toy. What's the problem?' Especially, I would get her wrecked. She used to like that, smoke a little dope, and she'd freak and go, 'Yeah, great, that's a really great idea,' and she'd start writing the ad."

Did she get results? "Oh, yeah. She met an architect, a couple of professional people, a lawyer. . . ." Keith sighs. "The problem always turned out to be that she was just too wingy for them. Too far-out. She wanted to do the craziest things and it was outside their sphere of refer-

ence." He bursts out laughing. "She called me up one morning and said, 'That guy last night was a lot of fun but boy, is he weird,' and when I asked why and what he did for a living she said, 'He's a *stockbroker!*' 'Okay, Auntie. It's like, you think they're weird . . . ?'"

A response to a personal ad dated December 28, 1986, reads:

> I am an unattached man looking for sincere relationship. I am
> very sensitive and loving with the right person. I am 48, 6' 1"
> — 180 lb. blond hair & hazel eyes. I would be interested in
> learning more about you. I am home weekdays after 5 PM &
> most anytime on weekend. Hope to hear from you soon.

It was signed, "Yours truly, [name deleted]," and he gave his phone number.

A reply so close after Christmas is doubly poignant, for both him and her. Had Joyce's Christmas been so lonely? Had she not received invitations or had she declined them? Or had she anticipated a holiday of such little promise that she was compelled to run the ad during the Christmas week? (Her diary comes to mind — the thirteen-year-old whose Christmas buildup rang out with, "Oh Boy!" entries scattered over several days, then nothing.) This respondent — had he been in a desolate state that Christmas? Or was he another urban lonely guy, without family, home every night and "most anytime on the weekend"? We'll never know.

Joyce's young painter friend, Charles Pachter, suggested she might meet artistic men if she joined the Arts and Letters Club. Founded in 1908, this became a lively cultural meeting place of Group of Seven painters and leading writers of the 1920s and 1930s, and still retains its distinguished, centuries-old appointments — and, some say, its original members propped up in leather armchairs. But Joyce soon realized this club was not for her. The defining moment occurred when a member of the art committee asked Joyce to submit some of her pictures for an

upcoming exhibition. They were rejected. Joyce regaled friends with the story, especially her ending, "And I didn't even get laid!"

As was the case with her 1971 retrospective at the National Gallery of Canada, Joyce was the first living Canadian woman artist to be given a career-long retrospective at the Art Gallery of Ontario, held from April 16 to June 28, 1987. A smaller version toured to the Confederation Centre Art Gallery and Museum in Charlottetown, then to the Beaverbrook Art Gallery in Fredericton, and concluded at the Norman Mackenzie Art Gallery in Regina on March 31, 1988.

The retrospective represented a comprehensive survey of twenty-five years, which included 130 of Joyce's works — 107 paintings, drawings, sculptures, prints, photographs and mixed-media installations, 10 quilts, and a concurrent showing of 13 of her films.

Joyce's retrospective was accorded full museology standards, and the selection of works and preparation of the catalogue got under way about three years prior to the exhibition opening. The catalogue, co-published by the AGO and Key Porter Books, dealt with both Joyce's art and film, documented by three authors: Marie Fleming, a former associate curator of Contemporary Art at the AGO, and two Americans, Lucy Lippard, art critic and social commentator, and Lauren Rabinovitz, professor of film.

David Burnett, the curator of Contemporary Canadian Art at the AGO, had begun preliminary work on the retrospective and appointed Marie Fleming to work on the project with him. Burnett left the gallery in late 1984, after which Fleming took over. She began writing the catalogue but she took sick and soon died. Philip Monk had been appointed curator of Contemporary Canadian Art in late 1984 and he inherited the retrospective.

Philip Monk said that when he came on board he had to pick up the pieces, rather than curate an exhibition that bore his imprimatur. "It was a difficult exhibition to organize," he said, for two specific reasons. He liked to work in collaboration with the artist and although Joyce had had dealings with David Burnett and Marie Fleming, she met with Monk

only once that he could recall. And secondly, Monk said, "Her files and records were in disarray." He spent "a great deal of time looking at work" and found that many works were not in good condition — for example, drawings damaged from hanging in direct sunlight. He singled out as culprits private collectors as well as temporary custodians of works in government offices on loan from the Art Bank. The AGO conservation staff had much restoration work to do.

Following the criticism Joyce received over her National Gallery catalogue, she agreed to a standard scholarly catalogue and approved of the three writers.

Prior to the catalogue going to press, Joyce had expected to see the completed manuscript — not necessarily for text approval, more as a courtesy for her to fact-check and examine the reproductions, titles, and so forth. Instead, she received galleys, the first proofs off the press. When Joyce saw the galleys, Kathy Dain says she was very upset.

Joyce wrote a list of comments covering eighteen pages of large pen scrawls, seemingly hastily written, with many overwrites and cross-outs. Chiefly, she objects to an overemphasis on those who influenced her and "too little emphasis on my strengths & influence on others," claiming that three issues central to "all the work I've done — Ecology, women's issues (women's crafts as a political platform), sexuality . . . barely come through." She stresses that they are "pioneering efforts" and she demands, "How many times do I have to prove myself before I'm given the recognition I deserve?" She writes that she does appreciate "Marie's hard work & serious effort" but she adds, "I simply wish the *truth* about me to be stated as clearly as possible." As for her erotic art, she insists that she was "a pioneer in this area from 1957 onward," declaring that "male erotic art had existed before, but that which the female considers to be erotic had not been portrayed to my knowledge in Western culture."

Having devoted her artistic life to seeking identification with the three themes mentioned above, Joyce wanted this pioneering effort recognized. More important, she fought to shake off any influences of male artists. In

445

another situation, same subject, she demanded, "How long do I have to keep dragging these guys around?"

Some of Joyce's changes were made, but her larger, overarching issues were not. The reasons are twofold: first, that the cost of making other than word changes to page proofs was prohibitive, and the second involved Joyce's expectations. She desired that all adumbrated points be incorporated, but largely they were in opposition to a certain museum prerogative that disregards much personal information where scholarly examination of the work is the prime objective of an exhibition catalogue. And furthermore, a public gallery (operated by public funds) must rigorously refrain from using its position to make evaluations of an artist, or to give any indication that one artist ranks above another. Inevitably, the subject of an exhibition catalogue — or magazine article, for that matter — expects "the best," "the leader," and "the finest" to ring throughout the pages. This appears in paid-for publicity handouts, not in scholarly texts.

"Joyce had a lot of anxiety over the retrospective," said Linda Gaylard, and outlined some of it. Joyce felt the gallery wasn't taking her seriously; she was angry over the budget, the gallery was stinting; and she felt humiliated dealing with such matters. "She didn't have a partner or an agent so she was relying on her circle of friends" — variously Linda, Kathy Dain, and Pen Glasser. Linda noted, "The retrospective was always, always the topic of conversation, but then after she expressed her anger she'd brainstorm with us to see how she could solve the problem. And then make a joke," Linda added. "She always kept her sense of humour."

Even regarding Michael. He had started dropping around now and then with a present for Joyce for her birthday, and at Christmastime. At first, Joyce interpreted this as an attempt at reconciliation and she would get all dressed up and play the flirt, but in time, she recovered and turned to humour. As on the day Selma Lemchak-Frankel arrived at Joyce's and heard that Michael had been there, after a fishing trip in Newfoundland. Laughing, Selma reported Joyce saying, "'And what did he bring me? Stinking fish!'"

However, a pattern was developing, quite as though Joyce would stomp into her war room, chew out the brass, and then return, smiling, to the parlour for the essential business of tea and consultation with friends.

The stress cracks were starting to show.

David Burnett spoke of Joyce being "on and off" during the early planning stages of her retrospective; that she was enthusiastic one time but would do "curious things" at other times. He found her to be "worried about the security of her studio, excessively so." And Marie Fleming would report to Burnett that after some meetings with Joyce things were difficult, or "just fine."

Two days before the opening, when the gallery staff was mounting the exhibition, Joyce dropped by and was very upset about the installation. She called Linda and Pen and they switched works around the way Joyce wanted them. Linda paused to explain Joyce's behaviour by saying that she "never compromised," although Linda allowed as how, from the institution's point of view, making changes to an exhibition on the eve of its opening might have caused the staff some anxiety, too.

Joyce's friends may have considered her behaviour outlandish but artists are generally uncompromising, and never more so than when it concerns the way their work appears before the public in a major retrospective.

"I went through a lot of crap to get this show," Joyce told art critic Christopher Hume, a week before the exhibition opened, and admitted, "It was depressing at first . . . but I think about Emily Carr, who didn't get her retrospective until she was dead." She then added, "I'm not going to let this happen to me." And as we know, she didn't.

She also told him that she was "learning to accept myself and who I am," adding, "I decided to stop beating up on myself."

Obviously taken aback, Hume noted:

> These aren't exactly the kinds of confessions one expects from Canada's senior woman artist. . . . One expects absolute confidence, perhaps a measure of arrogance and narcissism.

Yet it never seems to have dawned on Wieland that *she* is one of the most formidable presences on the Canadian art scene with a permanent place in the chronicles of CanArt.

For the opening, Joyce wore a kimono-style linen outfit designed by Linda Gaylard, who reported that Joyce looked "beautiful and glowing." Soprano Rosemary Landry sang at the opening ceremonies, William Withrow and Philip Monk made highly complimentary speeches, and Linda believed that Joyce was feeling "quite victorious after the struggle to put it on." Friends unanimously declared Joyce to be "thrilled," "very pleased," and "extremely happy," with the way her work showed on the walls — altogether, a dazzling display of twenty-five years of her artistic accomplishments.

Being a Joyce Wieland event, is it any surprise there was a hitch? Joyce discovered that Av Isaacs had arrived at the opening with boxes of her *True Patriot Love* catalogue from the 1971 retrospective to be sold at the AGO. Joyce was furious. She had run out of copies and had been "trying to get some for years," and all that time Isaacs "had been hoarding them."[6]

Joyce had not had an exhibition with the Isaacs Gallery since 1983. The pair's relationship was best described as unravelling; and soon it would be ripped apart.

Meanwhile, the AGO retrospective was her parade and she wasn't going to let anyone rain on it.

Reviews were significantly more enthusiastic than those of her 1971 National Gallery retrospective, and generally more favourable out of town than in jaded, surfeited Toronto, with certain exceptions.

"Wieland retrospective not to be missed," declared a headline in the *Saint John* [New Brunswick] *Evening Times-Globe.*

The *Hamilton Spectator* headlined her as, "Joyce Wieland: First lady of art."

Writing in the *Kitchener-Waterloo Record*, Robert Reid called Joyce a "trail blazer" in a male bastion, but noted, "Wieland's legacy is that she

made it in a man's world not by forfeiting her individuality, but by cele-
brating those qualities that define her sex."

Maclean's magazine noted that Joyce has "achieved something of a
mythic stature in Canada." A feature review detailed the exhibition's
diversity, the films, and certain works are described as having "great
power." The expansive coverage, including five colour reproductions,
compensates for the writer's rather safe, cautious critique.

Writer Susan Crean, in a lengthy analysis of Joyce and women
artists' struggle for recognition in Canada's museum establishment,
reported on the press preview of the retrospective and although ambiva-
lent about attending, she went, deciding that to observe "the art world
paying homage to an artist it has never understood, or tried to, [was]
too rich a moment in our cultural history to pass up." After the formal
greetings, Joyce came to the podium and acknowledged that the day was
something "like a birthday or a bar-mitzvah, a coming together, a
passage." But Crean is dubious about the AGO's motive. "No one would
guess that the struggle for recognition has probably only just begun. For
Wieland's appearance at the AGO, notwithstanding the media hype
attending it, begs the question: is she, once again, the exception to
prove a hoary old rule? Or will women now be allowed to make art
history as well as art?"

Crean was not alone in her opinion. Kass Banning wrote, "It's about
time the AGO granted a female artist the same authorization her brothers
have enjoyed since time immemorial. It is about time that recognition
was bestowed on such a 'deserving' and *living* [writer's emphasis] artist."

Banning also, like others, expressed her "stupefaction" that Americans
Lippard and Rabinovitz had written two of the three essays in the cata-
logue, given Joyce's "once-pervasive anti-American sentiments." Though
acknowledging that they must have been given Joyce's consent — they
were — Banning raises the larger issue of how these American women's
feminism "speak[s] to Wieland's local context." Allowing as how we "have
no indigenous discourse to replace" American feminism, she suggests that

it is time to "articulate the specificity [Joyce] deserves."

The most damning storm of protest was yet to hit.

The *Globe and Mail*'s art critic, John Bentley Mays, opens swinging, noting that the media "wanted to use this show as an occasion to shower bouquets on Wieland as phenomenon — a woman of great personal charm and beauty, an exemplary Canadian patriot, feminist, defender of the earth, survivor of many neglects and troubles — and *not* [his emphasis] as a visual artist."

He wonders what to make of "Wieland's Canadian patriotism of the 1970s?" He dismisses it and "other matters" as "unresolved and sentimental," and he dallies with the notion that Lippard, in "her ham-fisted essay," demands that everybody "cut the carping and simply love the work for its passion, 'hedonism,' femaleness and so forth." He ends the Lippard critique, saying that perhaps she "is on the side of the angels," and if so, "many an art critic, including this one, had better start getting used to the kind of hot, hot weather that exists down below."

In Mays's penultimate summary, he writes, "But perhaps everything that's being complained about here is exactly what's wonderful and welcome in Wieland's art."

Many critics maintain their intellectual balance with the sandwich approach to a review — between the slices of fault-finding they spread a few soft praises — as Mays had done when he wrote, "Her works of enduring punch and presence come in tight clusters, scattered widely throughout the big show." He singled out the "smart, brightly coloured plastic-bagged pieces," her "jewel-like watercolors of the Turkish coast," and her films, "her most outstanding accomplishments."

This particular review is quoted at length for typifying a certain standard that assailed Joyce throughout her career. Her work suffered under a barrage of criticism for being too patriotic, too feministic, and too pretty when not kitschy, incomprehensible, a mishmash, clichéd — all words used in reviews. An analysis of these two polarized kinds of words, the put-downs and those that are praiseworthy, is unlikely to be undertaken.

Such a study would serve no academic purpose despite which side "wins." The useful discussion is about Joyce's response. As one of her psychiatrists had said, what's important is Joyce's story, not the facts.

Joyce's story as it pertained to her retrospective, however, has an all-too-close bearing on the facts of her life.

She cried all day after reading the *Globe and Mail* review.

The following day a sea wave of friends' devotion lapped up on her doorstep, over her phone line and via her assistant, Fran Hill. These friends intuited rightly the nadir of Joyce's despair.

A few days after that, Jane Martin, a developing artist who had attended Joyce's "Painting Your Visions" classes at the Alma Gallery, met with a group of women artists in the studio of Suzy Lake, another student. The no-name group named themselves "The Women of Great Personal Charm and Beauty," and decided to respond to Mays's review with a sizable display advertisement ("For which we had to dig deep into our pockets," Jane said), advertising for a new visual-arts critic, one who would provide informed responses to contemporary work by women artists. The search committee would comprise "The League of Women of Great Personal Charm and Beauty, Exemplary Canadian Patriots, Feminists, Defenders of the Earth, Survivors of Many Neglects and Troubles."

The *Globe and Mail* accepted the women's money and ran the ad, but took no action to replace their art critic.

Undaunted, "The Women of Great Personal Charm . . ." then organized a picnic in Joyce's honour and held it in Grange Park, directly behind the AGO where her retrospective was taking place — satirically, "in the shadow" of the gallery. Although Joyce had been considered to be in the shadow of Michael, in the shadow of abstract expressionism and untold other male shadows, Jane firmly declares, "She was not a shadow, she cast light."

Illustrating her point, Jane recalled an event celebrating twenty-one charter members of the Copyright Collective, and on that especially dull, grey day, Joyce phoned Jane asking if she could bring anything and Jane replied no, "except the sun." When Joyce arrived, she presented Jane

"with a painting of a golden orb inscribed: *The Sun for Jane Martin*. She brought the sun!"

She may have brought the sun to the picnic, but darkness was beginning to descend on Joyce.

During the lead-up time to her AGO retrospective, Joyce's behaviour was becoming erratic, but those who noticed this attributed it to pre-show jitters and shrugged it off. Even after the show, by the end of 1987, however, she increasingly got into fights with people, including her friends. And although Joyce had squabbled with friends in the past, eventually all sides reconciled. Professionally, she began to address problems with angry letters, effectively spending time and energy hosing down little grass fires around the edges of her career while paying no mind, or even noticing, some of the distant flare-ups. She should have foreseen trouble in her relationship with her dealer and paid more attention to planning for her future.

She sent a sharp letter to Philip Monk after receiving a cheque from the AGO to cover exhibition fees — based on one of the CAR policies Joyce herself had so vigorously promoted some fifteen years prior — which she felt was insufficient, and was informed that she had misunderstood CAR's fee structure, and had received the proper fee.

In a 1985 letter to Marion Faller in Buffalo, Joyce complained about not receiving her share of rental fees on *A & B in Ontario* after Hollis Frampton's death and threatened that if "this error" was not rectified within a month, "I will find it my only recourse to initiate litigation."

Also, writing to the National Gallery's curator of film and video, Joyce criticized the gallery's "lack of funding and neglect" of experimental film, noting that Canadian experimental film is "applauded abroad yet our own archives do not possess some works of international importance."

Artists' complaints of treatment by public galleries are perfectly legitimate, not new, and in fact might be worsening as more public galleries eye the bottom line and mount revenue-generating blockbuster shows. Ottawa artist Ted Godwin sought support from artists in the 1970s to

launch a class action to impeach the National Gallery of Canada for ignoring Canadian artists. (When Harold Town, an obstreperous well-known foe of the National Gallery, got the call, he cracked, "Impeach the National Gallery? That's like asking Genghis Khan if he wants to go out for a little rape and pillage.")

Joyce had objected to numerous inequities involving artists for years, but increasingly missing during this period was her drollery.

She even turned against Pierre Trudeau, after an adoration begun in 1968. The change occurred, Joyce said, "when you see the narcissism," and apart from a "wonderful brain . . . the heart is closed over. Then what do you do after you find out that the person's heart is closed and that the War Measures Act could take place?" She stated that her *Reason Over Passion* was saying that it is "really passion over reason" and that she was "making fun of his statements."

This had not been her intent; she expected to film a man who was an intellectual, who "seemed fantastic at the time, a man who seemingly didn't want power." She told Hollis Frampton that while editing the film she felt that she was in a dialogue with Trudeau, that we were "speaking to and working for Canada in some strange way," and she confesses — "a very high far-out fantasy" — that she was "working to the power figure, the father figure."

She then discovered that he wasn't as "concerned and impassioned about Canada as I thought. I'm the one who is."

Frampton noted her "political dilemma" and Joyce responded, saying she came into the film as the third character — next to Trudeau and the land — and had the sense of being a government propagandist like Leni Riefenstahl, and as with her *Triumph of the Will*, Joyce, too, was making a propaganda film. But unlike Riefenstahl — whom Joyce thought really did believe in Hitler — "I got the notion [regarding the two films] . . . it's the same thing . . . reason dominates passion."

Joyce's reversal of earlier affections also applied to her friendship with Judy Steed.

Judy and Joyce had a falling-out around the mid-1980s and although Judy would later understand why, at the time she said, "Joyce was becoming increasingly demanding and would throw temper tantrums. She was actually reverting to a child-like person, a tyrant. I couldn't put up with it. She was hostile and rude on the phone and I said, I'm not going to be talked to like that, and she dropped out of my life."

Taking pains to identify how their relationship changed, Judy outlined that when the two women met, Judy considered Joyce to be her teacher, during a time when Judy was "just a hippie independent filmmaker doing the lowest-ranking job on CTV." She felt "lucky, really lucky" to have met Joyce in 1971 and to have worked on *The Far Shore*, which was "tremendously exciting." Judy stated wholeheartedly, "Joyce was my great teacher. And if you're lucky, you meet a teacher." However, once Judy began achieving status as a journalist and the professional playing field between the two women began to level out, their personal relationship did not.

Like so many of Joyce's friends, colleagues and relatives, especially her nephew Keith, who experienced first-hand Joyce's unhappiness in her marriage, Judy sympathized. She was on Joyce's side. A troubled frown creased Judy's face when she declared, "It's not Mike's fault that Joyce stayed with him."

Joyce spent considerable time at Betty's farm with her and her children. As she had for most of her life, in troubled times she sought a creative outlet and in 1988, after her AGO retrospective, Joyce designed an add-on pavilion to Betty's century-old farmhouse in which she combined an essence of Versailles (one of Joyce's favourite images) and New York's Tavern on the Green in Central Park — a beautiful expanse of chandeliers and glass walls enclosing a swimming pool overlooking the horse stables and a pond.

In this setting that Joyce adored — the country, with her dear friend Betty and her children — she painted a large still life of the lilac bushes

alongside Betty's house, a work quite unlike anything Joyce had ever done, in its delicate, mauve serenity.

Linda Gaylard and her husband had got into the habit of picking up Joyce and taking her to parties and various events, and bringing her home. From the time Joyce started thinking of refurbishing her house and engaged Linda and Gerald to work on it with her, the couple spent a lot of time with Joyce.

Enough to observe Joyce's behavioural changes.

Linda ponders exactly when, but she refers to the period of her AGO retrospective. Specifically, Joyce was becoming forgetful, she needed a lot of reassurance and support, and on occasion the couple noticed that she would go into a minor state of panic if left standing by herself at an event. "Gerald and I suspected something was wrong. We thought it had to do with the metallic paints she had been working with. That was the very first thing that came to our minds." Recent studies have documented artists suffering or in danger of suffering damaging health effects from their work materials — lead paint, aluminum, acrylics, chemical fixatives, rubber cement, varnishes, and various solvents. No one knew the toxicity or carcinogenic effects of these substances then.

Troubling, too, was the fact that Joyce appeared typically herself most of the time; her small aberrations lasted fleetingly and occurred with some people, such as with various AGO staff members involving her retrospective, and not others. Certain friends hadn't noticed anything, and those who observed her lapses of thought or sudden takeoffs into another zone shrugged: "That's Joyce."

Sara Bowser said, "We all thought she was a ditz, so minor eccentricities and behaviour didn't register."

Christine Conley, a women's-studies teacher at York University, was writing her master's thesis on Joyce and Christiane Pflug, and had met Joyce for the first time in November 1988. Christine interviewed her at

home and on that particular day Joyce's face was swollen from having been at the dentist for a root-canal procedure, and she had spent the rest of the day canvassing for the NDP. Joyce complained about the pain of her tooth and repeatedly mentioned being very tired. She seemed distracted — for obvious good reason, Christine believed.

The two women had been sitting in the living room, waiting for the kettle to boil for tea and unbeknownst to Christine, Joyce had turned on the wrong burner and suddenly, with a shattering bang, a glass plate sitting on the burner exploded. If the two of them had been at the kitchen table they could have been seriously injured. Shattered glass had sprayed the whole kitchen.

Unacquainted with Joyce, Christine did not assign anything symptomatic to the afternoon-tea-gone-berserk and instead recalled Joyce being on medication for her tooth. She rationalized, "We all do things like that now and then."

Joyce had been very talkative. She told Christine about her childhood "murderous rage" in wanting to kill the little boy and how this rage emerged in her painting, and about her experience at the National Film Board on the man's fixation on her breasts. Knowing Joyce's love of hearts, Christine had brought Joyce a box of chocolate hearts "but she didn't get the connection," said Christine. After she returned home to Ottawa and began reviewing her notes, she remembered being "dissatisifed with myself," for having a conversation with Joyce rather than conducting a proficient interview.

When Joyce returned to Toronto from San Francisco in 1985, and until her AGO retrospective, she attended to the myriad details of her career of accepting invitations, lending her name to causes, and giving talks. She also spent a great deal of time making an application to the Canada Council for a grant — some twenty pages that included project description and projected expenses, submitted with curriculum vitae and slides of her work — for a massive multimedia installation, *Swan's Cupboard*. She completed a commission she received in 1987 from Cineplex Odeon

for the Pantages movie theatre in downtown Toronto, before it was converted to a mega-musical venue — an oil on canvas, seven by fifteen feet, titled *Celebration.*

Also in 1987, Joyce was offered an exhibition at Canada House in London, located in Trafalgar Square overlooking Buckingham Palace, to be held in July 1988, and she threw herself into its organization.

The following year Joyce's Canada Council grant application was approved, for which she received more than $42,000 to create *Swan's Cupboard,* and she set to work. The installation comprises five life-sized swans surrounding a cupboard with a table in front, on which stands a sculpture of a pleasant woman, "around the time of Millet," Joyce explained, and also contains a representation of a Louis XIV chair, a violin, and a needlepoint stool. The piece is encompassed by a fifteen-foot curved wall, made of century-old siding from Betty Ferguson's barn; the viewer can walk behind the main structure on a make-believe path, as if along a nature trail.

The work depicts Joyce's lifelong loves — music, history, nature — and stands as a powerful celebration of womanhood.

Around this time, Joyce's film career began to thrive, especially internationally. She had gone to Paris in November 1985 to make arrangements for a film retrospective at the Centre Georges Pompidou, which failed to materialize, although she did have a screening at the Ciné-Club de Saint-Charles at the Sorbonne. Also, she went to London, where she had a screening at the London Film Festival. During the two-year period 1985–86, her films were shown in a total of twenty-one film festivals, among them Chicago; Berlin and Oberhausen in Germany; Vienna; Berkeley, California; Ann Arbor, Michigan; New York; Vancouver; and Toronto's Festival of Festivals. The administrative arrangements were labour-intensive for both Joyce and her assistant, Fran Hill.

Involved with everyday matters of managing her career and her work on *Swan's Cupboard,* Joyce had little time to map out future plans. And

yet, a level of society was busily acclaiming her excellence. Just as she had been on the AGO's short list unknowingly and had received the Order of Canada without prior information, the name Joyce Wieland was showing up for serious consideration on various organizations' and institutions' honour rolls. Again, she would have no knowledge of this activity because of the process — one method similar to and as confidentially protected as another, in which names are put forward to committees and boards of directors for awards, honours, commissions, and commendations. The completion time of this process can take months, often years. A number of honours were bestowed on Joyce in the mid-1980s that could have been gestating since her 1981 and 1983 exhibitions, with their resultant media attention, along with the publicity generated by her AGO retrospective. She had been hoisted high in the public eye. She was making an impact. The power elite was taking notice.

In 1987 Joyce received two prestigious honours. She was given the YWCA (Young Women's Christian Association) Women of Distinction Award in May and she received the Toronto Arts Award in September.

The Women of Distinction Award, inaugurated by the YWCA in 1980, celebrates women who have made a "significant difference to the lives and wellbeing of women and girls in their communities." As of the year 2000, more than 130 women have received the award for their contributions in a diverse range of endeavours in the arts, business leadership, social justice, education, community service, health and women's rights, political activism, and so forth.

The awards ceremony takes places at a gala dinner in a luxury hotel, whose program of the evening centres on the honouring of each recipient by a narrated tribute interspersed with filmed clips of the woman and her achievements. Most of Joyce's clips show her in her studio painting, looking earnestly into the camera when speaking in her delicate, girlish voice. She said she "broke all the rules" by "ignoring them" and she had to "stick with going inside. I'm not a coward. Artists are afraid of their own power." Admitting that she "never fit in, never fit in with the male estab-

lishment," she added, "People said I was always a feminist in loyalty to my sister and my mother," at which the narrator says, "Her most influential person in her life was, and is, her sister, Joan Proud." Touchingly, quietly, on film, Joyce seemed to be speaking to her secret of survival when she said, "I wanted to get there. I've been the one who didn't give up." She ends the filmed segment with a comment that originated from Dr. Mary McEwan: "Everything we want is inside us."

The tribute elicited an enormous burst of applause. Joyce walked to the podium looking elegant in a softly flowing, blue-and-grey print silk dress with a matching coat. As she stood at the podium, however, her nervousness was extremely apparent. Unsmiling, following an awkward silence, she began to speak, her light, lilting voice more subdued and more high-pitched than normally. She said only: "I wouldn't be here if it weren't for women, teachers, and my sister," and very quietly added, "I'm very happy to receive this award." And she left the stage clutching her trophy, the Aggie, named after the woman who founded the YWCA, Agnes Blizzard.

Following this award, she received a congratulatory letter from then Prime Minister Brian Mulroney, and on June 12, 1987, the mayor of Toronto, Art Eggleton (now Canada's Minister of National Defence), hosted a reception for Joyce, cited as: "City of Toronto recognizes the achievements of Joyce Wieland."

Eggleton recalls the event with fondness. "Joyce Wieland made a great contribution to the city through her art, and I was delighted to honour her with a party."

That September, Joyce received the Toronto Arts Award, an honour that recognizes Toronto artists from various disciplines. She was among six recipients of the award in its second year.

(Ironies befell ironies in Joyce's life. She had been on the jury of the inaugural Toronto Art Awards the previous year, whose first group of award recipients included Michael Snow. It is not known if Joyce voted for him.)

Joyce took the award in the visual-arts category. The other award winners were: industrial designer Claude Gidman, soprano Lois Marshall,

author Michael Ondaatje, ballerina Veronica Tennant, and in the media-arts category, Moses Znaimer.

Joyce's citation from the Visual Arts Jury reads, in part:

> Joyce Wieland's career has consistently overcome barriers, crossed boundaries and expanded our conception of the possible. She has shown us that art can be not only paintings and sculptures, but also films, quilts, lipstick kisses and more. . . . Through her courage, talent and vision, the feminist art has reached the top of her profession and is still going strong.

Linda Gaylard knew how important it was for Joyce to look good and feel good about herself on the night of the awards. She would be in the company of people she wanted to make an impression on, "not people she wanted to impress. And she wanted to feel beautiful."

The design for Joyce's dress came to Linda when visiting friends at a cottage up north. At dusk one day she paddled out on the lake in a canoe. She was sitting quietly in the middle of the lake when darkness began to fall and the stars came out. As the evening grew progressively blacker she realized Joyce's dress had to be black, and just as dramatic as that starry night. Linda found a "very, very heavy silk satin that you could stand it up and count the seconds until it fell to the floor" — perfect for draping. She stitched tiny black and clear Austrian crystals down the front of the gown, "resembling the Milky Way."

Linda also did Joyce's hair and makeup. "I knew I had to be with Joyce from about four o'clock until midnight," she said, "and make sure she had everything for the evening."

They arrived at the Simpson Gallery on Queen Street West where the honours celebration was held. Joyce looked beautiful and felt beautiful. "She walked with such grace," Linda said with a sigh. Having paid enormous attention to detail in Joyce's appearance, they had overlooked one thing: her acceptance speech.

Nicholas Laidlaw, whose portrait Joyce had painted, introduced Joyce. Differing accounts are given of his remarks but the result was that Joyce found his words terribly unsettling. Apparently aiming for wit, Laidlaw's speech plunged into a garble of confusion — a flash of abnormal behaviour from a normally refined gentleman which could have been attributed to the cocktail hour. Joyce got on the stage, stammered her thanks and quickly exited. But retribution would be hers. Laidlaw had provided Joyce with a chauffeur and limousine for the evening and he was pleasantly surprised when at the reception's end she offered him a ride home. Knowing he would interpret this as an invitation for him to entertain Joyce in his apartment, she unceremoniously dumped him at his door.

Joyce's exhibition in London was held in the building known as Canada House, where a cultural-centre art gallery functions under the aegis of the Canadian High Commission. The office of the High Commission had adopted a policy of exhibiting art by Canadian artists to give them exposure to Britons. During his tenure as Canadian High Commissioner, the Honourable R. Roy McMurtry (now Chief Justice of Ontario) had as his premiere art exhibition a show of drawings by Harold Town in June 1987. Joyce was the second Canadian artist McMurtry honoured. (Michael Snow had had an exhibition at Canada House in 1983.)

Certainly, Joyce had been flattered by the invitation, in particular, since this was the first major exhibition of her artwork in Britain (her films had had fairly strong representation in Britain and Europe). However, during the prolonged months of preparation that such an international exhibition consumed, Joyce found fault. She complained that Canada House was skimping on her catalogue, and on scrawled notes "to Roy McMurtry," she demanded a catalogue as big as Harold Town's, "in same size and number of colour plates." Roy McMurtry does not recall having received the letter and Joyce may have made her thoughts known to the Canada House art curator, Curtis Barlow. In any case, her catalogue is a distinguished one, thirty-two pages with eight colour plates.

The foregoing incidents may seem petty, and indeed repetitive, until you recognize that Joyce was fighting for her life. She emerged once more from the war room where she battled for every piece of art and every film she had made over the past thirty-five years, for the rights she and CAR members had fought for and won, and against male critics who just "didn't get it." She had no intention of acquiescing at this late stage in her life.

Joyce attended this show. She left for London on July 10, 1988, for the opening on July 12. She took a side trip to Ireland, when her show travelled to Dublin and three other Irish centres, Dundalk, Galway, and Limerick. From Ireland, she went to Wales and Scotland, returning from Prestwick to New York on August 19, 1988, after having been away for five weeks.

A month later she was asked where she got her affirmation and optimism. Joyce replied:

> I earned it. I've got it now. I can do anything. Anybody can be anything with empowerment. What I've put together is really healthy, so that people can have the juice out of it right away. I am affirming and positive. I had enough of that other shit.

Joyce was named artist in residence at the University of Toronto School of Architecture and Landscape Design for the year 1988/89. The faculty's artist-in-residence program had been discontinued fifteen years before, but Professor Blanche van Ginkel reinstituted the program and extended an invitation to Joyce.[6]

Joyce welcomed the opportunity of giving painting-and-drawing tutorials to architecture and landscape students, to help them "get in touch with their creativity." She also said, "There should be artists-in-residence all over the country," and being one of them conformed classically to her ideal of incorporating art into everyday life.

The appointment proved to be creatively stimulating and did much to bolster Joyce's ego.

Les Levine, on a trip to Toronto, saw Joyce toward the end of her residency, a period Les identified as "after she'd had time to overcome whatever grief she felt from the death of the relationship [with Michael]." Their get-together was notable for Les because, "She was telling me how she was hitting on some of her male students, younger than her." Repeating that he is not interested in people's personal lives, that what they say "just registers," he chuckled, saying, "I remember that I smiled when she told me. I thought it was sort of amusing. At a certain point she was taking on a very strong feminist position, saying women can do what men do. Joyce must have known that telling me this would mean nothing, because she knows I have no judgment about things like that." In his opinion, "I assumed that the reason she said it to me was to represent herself as complete and whole. That she now has her own life and it's complete in its own way." Though lacking interest, at the same time he seemed pleased that Joyce's personal life had improved, having earlier said that as a consequence of the split-up "she was very devastated, very saddened."

Joyce may have exaggerated the materiality of her sexual aggression, but not its notion. She was obviously attracted to these young men, enjoyed being around them and may have had a teacher-student crush on one or more of them. This situation differed from that of Keith's athletic club, where the men's beautiful bodies intimidated her. At the university, the body was subordinate to the mind and creativity, which placed Joyce on an elevated, respected level that she would have found highly stimulating, a benefit in lieu of an actual sexual outcome.

One of the students had been very helpful to Joyce when she was mounting a show of hers, and Joyce's doctor mentions how thrilled she was to have a young man doing things for her. "She was high on it," the psychiatrist stated, which he interpreted as her response to a distinct representation of someone needing her. Joyce may also have felt that the young man needed her mentorship, her artistic maturity. "And how does she express her appreciation?" the doctor asked, rhetorically. "Like she did with her father; she gave him a picture."

An exhibition held over the winter of 1988 into spring 1989 titled *Tears in the Rainbow*, comprised forty-seven of Joyce's works, the majority of them new, large paintings done in her studio on King Street over the preceding two years. Largely mystical, representing historical figures, women poets, the environment, Joyce's personal relationships, and her artistic struggles, one reviewer described the works as "brilliant colour, pure joy and sexual energy" that come together, specifically in *The Goddess of Folk Art With Her Human Lover.* Joyce told the writer, "It's wonderful to be working at making things of beauty. This work is all about the energy that runs through us, the energy that runs through everything." At this time she had discovered a twelfth-century nun, St. Hildegard of Bingen, whom Joyce defined as "the most incredibly gifted" mentor and even carried around a book about her, "like a crazy person." The saint, abbess, theologian, spiritual counsellor, and physician also seemed interested in ecology, and through these affinities Joyce reaffirmed her belief in herself. Joyce mentioned that her colours were getting "stronger and stronger," quite possibly through this influence. She exclaimed that "it would be *great* if even more colours were invented. In more than just art, everyone's always seeking something stronger."

While her colours were becoming stronger in paint, these works figured just as vitally in Joyce's ouevre as had her delicately hued coloured-pencil drawings. The weight of the colours is potently balanced with the themes. Fetal imagery recurs in *Nursery, Children of the Astral World, Princess Rosebud in the Land of Dreams*, and feminine, sexual forms float hauntingly through *The Goddess Gaia*, described by Joyce as "the original goddess of the earth." (Gaea, in Greek mythology, means Earth.)

Disturbingly, while the colours and images radiate surety and Joyce experienced spiritual empowerment through St. Hildegard, Joyce's judgement was faltering. "I really get scared," she said, surrounded in her studio by several works in progress. "I need other peoples' opinions."

The evolution of Joyce's confidence in her work can be seen as it was expressed in her own words. At age twenty, she was saying, "I didn't know

where I was going, or if I was any good"; at the end of the 1960s she defined herself as becoming "more self-assured"; and prior to her retrospective in 1971 she felt quite objective, "and if I am doing good work I can see it and it gives me great satisfaction." By 1981, Joyce's confidence was superbly realized in her *Bloom of Matter* works and her subsequent goddess series. Then, in the latter part of the 1980s, she appeared to have come full circle to being on shaky ground once more.

In 1989, she had completed a painting of a great female shaman approaching the ocean, and she wondered, "Oh, boy, what have I done?" She called in a couple of artist friends to her studio, asking them to look at it, saying she wasn't sure about the painting, which she had titled *Alma*. "They sat on the floor and looked at it for an hour and said, 'It's great. We think this is really good.'" Joyce said, "I started to cry because I saw that the face was Alma, that's who it was." Alma means fostering, nurturing, giving life. These sentiments frightened Joyce. Not understanding the source of her fear, she transposed it onto her painting.

Over the next two years she would made paintings that were compelling, vivacious, lovely and tender, and she began the most ambitious work of her career, the monumental multimedia installation, *Swan's Cupboard*.

Despite working seriously, her doubts and fears remained.

"Art is a suicidal activity," Joyce said, some twenty years earlier, "one anyone should be able to give up, yet can't."

Joyce had not had an exhibition at the Isaacs Gallery since 1983 when Av Isaacs had earlier stated that his dealer/artist arrangement includes him receiving a commission "whenever a sale takes place." He and Joyce had a dispute that Isaacs called "pretty disturbing," when he uncovered "one incident" of her making a sale. He confronted Joyce, asking for his commission. "She told me, nothing doing," Av said, and he engaged a lawyer.

Isaacs made no public comment but Joyce did. She is quoted as saying, "I'm leaving to be free. To run my own life. I think I'll do my own dealing from now on. I'd never have an exclusive arrangement with a

dealer again." Although she did have another dealer.

Isaacs and Joyce ended their twenty-eight year relationship in 1988. Their negotiated settlement included Isaacs receiving artworks of Joyce's in lieu of his lost commission. Like many legal disputes, it was settled but the scars remained.

Ron Moore, director of the Moore Gallery, defined himself as Joyce's transitional dealer while the legal issue was being settled — a period of about two years — then he acted as her sole dealer. He described Joyce's emotional state at that time as "traumatic," and that she was "spaced right out." Moore believed, "She was such a sensitive person that it hurt her deeper than it might any one else."

A dealer can't do everything and the artist, as a self-employed person, by necessity engages in a second career of self-promotion. Letter writing, submitting proposals, writing grant applications, obligatory party-going and keeping in the news is laborious and often dispiriting — in a letter to a Bay Street financier, Joyce wrote that if the man didn't buy the picture she had recommended he buy, she would have to cut off her ear. Joyce needed more help. She hired another assistant, Linda Abrahams, director of a small women's art gallery, the Women's Art Resource Centre, who along with Donna Montague helped secure an important exhibition of Joyce's love drawings, as will be seen.

Joyce easily poked fun at her foibles, as possessors of wit and high spirits do. She laughed when she found her purse in the fridge, although she laughed less, tearing the place apart looking for cash she eventually found stuffed behind the sofa cushions. And it was no laughing matter when, as Keith reported, "she beat her stove up with a hammer when the oven door wouldn't shut." But next she would laugh, finding her mail in the toaster.

Gerald Robinson, who had known Joyce since 1958 and had always thought her "outrageous, noisy, and passionate," considers the design he created for her house as a "stage set for her life." He observed much of that life as a regular participant in Joyce's theme dinner parties fashioned

from her historical fantasies. Loving her house so much, Joyce kept up her imaginary pageants there.

One night in 1990 Gerald dropped around, unannounced, and found a group of women in the house. "They were having a sewing circle like ladies in a Victorian parlour, and there were baskets of needlework everywhere and they were all crocheting and knitting. It started off as a genteel little party but they each had a bottle of Scotch and they all got wasted."

Joyce and Diane Rotstein continued meeting for lunch. After roughly ten years of dining and wining with women friends at the McGill Club, some members of the original group dispersed to where careers and remarriage had taken them, but Joyce and Diane upheld the tradition.

Diane, recovering from a brain tumour, laughed as she breezily recalled their later lunches. "Joyce was starting to lose it and we could say anything we wanted to each other because we wouldn't remember a thing the next day. And by then, we were so fucking old, who cared?"

Friends heard uproarious one-by-one incidents from Joyce as they always had, and because they weren't aware of their aggregate sum and substance, her behaviour aroused little concern. Friends found no reason to compare notes.

But Joyce's behaviour began to change.

One night Donna Montague received a disturbing phone call from a woman at the McGill Club. "Then Joyce got on the phone," Donna said. "She was sobbing and had been roaming the streets and said she didn't know where she was. She'd got to the McGill Club where she used to meet the ladies."

Donna went to the club and brought her home. "I put her to bed, fed her, and talked to her for two days."

Even then, Donna recalled, "I thought it was just periodic." Based on past experience, Joyce was going through a phase that would soon enough abate.

Sara Bowser concurred. "That's what we all thought. Betty thought she was in a depression."

In November 1989, Joyce's Volkswagen car was stolen and she got a

new 1990 Mazda. Selma Lemchak-Frankel was with her when she bought it. After Joyce had taken a test drive, the car salesman asked Selma, "Is your friend all right?" and Selma didn't know what he meant. He said that Joyce had forgotten which way to turn and seemed "not on top of it." Selma, like the others, passed it off as Joyce always forgetting things. Another misadventure occurred after a dinner at the McGill Club. Donna said, "Joyce phoned saying she'd gone to dinner and lost her car, didn't know where it was. I picked her up and we drove around and there it was on Spadina Avenue." A pattern of hiding and losing things developed. "She started hiding things under the couch and she'd discover she had been sitting on them. And she started to lose money."

Placing her mind back to these situations and analyzing her thoughts of that period, Sara explained, "Joyce had had her bad times. She was not always a bubble of mirth and light. We thought, 'Here's Joyce with another bee in her bonnet.' And it was only when I realized that the problem was intellectual and not emotional that I suspected finally that this was not depression. I mean, she went through emotional phases but when the mechanical things started to break down, when she stopped being able to add two and two — that's an intellectual failure, not an emotional failure. Then it started to register that she was in real trouble." Puffing on her cigarette, closing her eyes, contained in her memories, Sara softly said, "That was a bad, bad time."

Alarm bells were sounding but the "big gongs started going off," Sara said, when Joyce locked herself out of her house "every day for a couple of weeks." Joyce had been through a recent scare when a drunk attempted to break into her house, after which Keith installed a security system and gave Joyce new house keys. Sara and Bryan lived only a dozen or so blocks away and when Joyce couldn't get into her house, Sara said, "She'd come over here and Barney and I would try to find Keith. It was always a colossal mess. And even when we started making her wear the key on a string around her neck, she couldn't remember to put the string on after her shower. "

Other similar incidents took place. "One night she called saying her

house was filled with smoke and she insisted she hadn't lit the fireplace. Barney went rushing over. She *had* lit a fire and the draft was not opened, all the smoke alarms had gone off and she was confused. All she had to do was open the windows —" Sara stopped. "There was a pile-on of that kind of thing. And Joyce admitted to some things that were very peculiar. For instance, she said she couldn't do her banking and she was very upset at the bank. A woman next to her said, 'Can I help you, dear?' and Joyce said she couldn't figure out her account." The woman lived next door to the bank and she invited Joyce to come over, saying she would help her. The woman worked out her deposit and returned to the bank with Joyce, everything in order. "When Joyce told us this, she didn't have a proper sense of how peculiar this really was. So there again, a gong went off. Why, all of a sudden, couldn't she add up her bills and do her accounts?"

Sara and Bryan saw Joyce almost daily and observed her condition worsening. "The evidence piled up at an ever-increasing rate. Things got worse and worse, faster and faster." Finally, Sara became worried.

She phoned Diane Rotstein, a close friend of Joyce's and a psychologist, and the two of them got together. They decided to call Donna. Pausing long and thoughtfully, Sara said, "Donna could be a prickly pear in many ways but she was also very forthright, very tough and *very able*. We called her. And she took Joyce out to lunch and said, 'You have to go to the doctor. Your friends are worried about you, we all think you're sick and I made an appointment on Thursday and we're going.' I mean, just like *that!*"

Later, Sara admitted that if it wasn't for Donna — 'General Montague," she said, smiling — "I don't know what we would have done. We were just milling around."

While Donna was discussing this in 1997, a time when she herself had not been well (she died the following year), memories of her relationship with Joyce flipped back and forth from one time period to another, and she made the point that "things ran hot and cold" between her and Joyce. After George declined to invest in *The Far Shore*, Donna said, "Joyce was

very cold to me." They lost touch for a while, although Donna and George went to Joyce's openings and saw her occasionally. Long periods would elapse between their meetings but these lapses were usually circumstantial. Donna and George kept up their relationship with Michael, as George still does. And when Donna received the call from Sara, she rushed to her old and dear friend without a moment's hesitation.

Donna booked the appointment with a psychiatrist Joyce had been seeing. He recalled that Joyce arrived "really shaken," saying she wanted information about her mental status. Joyce reported that one day she couldn't find her way to her art class and George Montague told her she could no longer drive her car. In the doctor's opinion, Joyce had experienced a sudden loss of her impulses, which is distinct from forgetfulness.

Sara said, in a quiet murmur, "I started to suspect Alzheimer's." She described herself as having a "clinical orientation," saying she had written for medical magazines, that her father had been a doctor and furthermore, she had watched her father's development of Alzheimer's Disease at age ninety.

Joyce's symptoms represented textbook onset of Alzheimer's Disease. With increasing functional degeneration the person forgets recent events such as the show he or she watched on television the night before, or an old friend's name, and like Joyce, where she parked the car. In addition, the individual forgets how to do familiar, simple tasks — again like Joyce, who couldn't master her bank deposit. And because of Joyce's reputation for everyday zaniness, close friends didn't twig, as Sara discovered, until the problem manifested itself as an intellectual failure.

Researchers in the study of memory, such as Dr. Endel Tulving, an internationally respected cognitive psychologist at the Baycrest Centre for Geriatric Care in Toronto, described how over the decades, research has revealed that loss of memory is not a single entity, as previously thought, but that there are several kinds of memory loss. "So that when memory becomes impaired, it is essential to decide what kind becomes impaired and how. Alzheimer's patients differ from other people suffering from

memory disorders in that their impairment is more widespread over different kinds of memory."

When Joyce told her doctor about not finding her way to class, about being told she could no longer drive her car, and the distress this caused her, he suspected she was experiencing early onset of Alzheimer's disease. In November 1991, she was referred to a neurologist, who admitted her to the Toronto General Hospital.

Once there, Joyce treated her stay as a learning, growing experience, and while waiting for test results over a period of some weeks, she spent a lot of time with other patients. Linda Abrahams said, "It's typical of Joyce's courage that she helped patients get up and she walked with them, fed them, and told them stories."

George Montague remembers the day Joyce was discharged from the hospital. "The dear soul. On the way home she bought a lot of flowers and lay down on the couch with the flowers all around her."

Donna may have been mistaken, but she recalled Joyce phoning her from the hospital, sobbing so uncontrollably she could scarcely express herself. The gist of it was, "An anaesthetist told her she had Alzheimer's and to 'go home and get your affairs in order.'"

George and Donna Montague, along with Linda Abrahams, began to help Joyce with her financial situation. Assuming power of attorney, George took Joyce to the bank and he determined that she had "significant" funds "but owed a lot of money," and yet Joyce was interested in buying a country property. As Keith said, "She wanted a place where she could preserve wetlands and watch beavers every day." Having shared properties with Michael, Joyce missed having her out-of-town refuge. "The first thing we did," said George, "was get her out of some investments. We saved her onions there." Donna organized her debts, among them a mysterious three thousand dollars on a credit card for long distance calls to Hong Kong, saying, "We told creditors they would be paid in due course, but not until we could verify the amounts. And we cut up all the cards. Then Joyce went into a tizzy. So we got her a hundred dollars, and the very next day she

didn't know where it was." In a snappish non sequitur, Donna said, "And there was that damn rat in her kitchen." (A pet gerbil Joyce kept in a cage.)

At one point, it became apparent to Donna that Joyce cooked only sweet potatoes in her toaster oven. "That's what she was living on!" Donna started bringing her Meals on Wheels. "When the mail came she couldn't find it, it was in the toaster."

Donna was horrified one day to hear Joyce say, "So-and-so dropped in and bought one of my drawings. "We asked, 'What did she pay,' and Joyce said, 'I don't know.' So we took all her drawings over to Bren Art [an art storage facility] and a lovely lady came to stay with Joyce and made custards, coaxing her to eat."

With Joyce's future security in mind, Donna, George, and Linda Abrahams began making an inventory of her work. And to provide a source of revenue for Joyce's continuing care, George and Donna worked with Ron Moore to effect a significant sale of artwork to Hamilton philanthropist and art collector, Irving Zucker. He bought paintings, drawings, quilts, mixed-media works, and the massive installation, *Swan's Cupboard*, and generously donated it all to the Art Gallery of Hamilton.

Zucker bought the work because, he said, "it is a collection of high quality and Joyce will go down in art history as one of the great Canadian artists. There is no one in Canada who has done this kind of distinctive, feminine, personal work in so many mediums." Zucker was also pleased that his purchase would go toward Joyce's care.

Another private collector bought several works, and Joyce's care was secured.

Joyce tried to ignore the existence of her disease. Only close friends knew about it. With the help of her assistants, variously Frances Patella, Cynthia Lorenz, Fran Hill, and Linda Abrahams, she spent time arranging her papers to be donated to York University and working on her inventory. She attempted to carry on her life as before. Numerous paintings and drawings were left unfinished, although she did complete some works.

The doctor had explained the nature of Alzheimer's disease to the extent it was possible, but Joyce must have thought the strength that had previously pulled her from the jaws of despair and disorder would rescue her once more. While Joyce's diagnosis was made in 1991, for the next two years she functioned reasonably well — some would say, heroically.

Like the six-year-old who made pretty drawings and cut-outs as her father lay dying, she did not lose her capacity to find a ray of light in the grey chambers of her heart.

Friends took Joyce out to dinner frequently. Linda Abrahams, referring to Joyce's deteriorating condition, at the same time citing her cleverness in being able to cover it up, noted that when dining out, occasionally Joyce just sat and stared at her plate when the food arrived. Always very observant of Joyce's behaviour, Linda would place a fork in Joyce's hand and Joyce, having been mentally and physically cued, would then eat her dinner normally.

For many Sundays, Betty Ferguson recalls, Joyce went to the church of her childhood, St. Mathias's, and arranged the flowers before the service. And she took her cat there for the Blessing of the Animals, on St. Francis of Assisi Day.

Kay Wilson spoke of Joyce wanting her and others to go to the neighbourhood of Joyce's birth, so they went to see her house on Claremont Street, and walked around the area. One day, coming home on the Queen streetcar from one of these outings (travelling quite a distance from Queen Street East, where Joyce lived, to the Queen Street West of her childhood), Kay recalled, "It was so poignant. Joyce asked me what I knew about Alzheimer's and I said, 'Joyce, you don't have a broken head, you've got a broken heart,' and her eyes went watery and she stared straight ahead. We sat in silence for quite a few minutes."

Selma would visit Joyce at her house and one day, when everything was in a terrible mess, dishes and food all over, the cat in the sink, she remembered, "I started sweeping up and cleaning out, and Joyce said, 'Leave that, let's go and listen to Mozart.'" The next time Selma came by,

Joyce gave her a drawing she had made of Selma singing (Selma had been an actor and singer), with Mozart accompanying her on the piano, which Joyce had titled, *Selma avec Mozart*. Wistfully, Selma murmured, "She was such a good friend."

Joan sent Joyce a happy-birthday letter in June 1990, which would be Joyce's sixtieth birthday. In part, it reads:

> I always got so annoyed when you drew pictures in my school books. I never dreamed you would become a famous artist . . . despite the male crappers who tried to put you down. I truly admire you. I know that mom and dad are bursting with pride wherever they are.

Joyce's sketchbooks reveal signs of Joyce's developing condition from about 1988 onward. One such book is a phantasmagoria, a frenzied outpouring, a jumble of thoughts, doodles, sketches, poems, self-reminders of tasks to be done and sums to be added, and only occasionally does there appear a small bouquet in this thicket of mounting derangement — drawings of her adored hearts, an entire page of them, and dozens of beautifully decorative figures contained over a page filled with the word, "Le Notre."

One sketch depicts a woman reclining on a sofa, with a dialogue balloon over her containing the word "sad," and off to the side she has written, "What's the use no one for me."

Another sketch is of a similar-looking woman, scribbled over with "marked forever . . . no man wants her."

There are several references to "M," whose initial is repeated, in one page delicately and then blackly over notes about her divorce settlement, and throughout there are people's names, menus, bank balances, small portrait sketches that favour women with massive curls.

Joyce's mental state appears in these notebooks as a pictorial image of higher-function disorganization that could well replicate the evidence of

a scientific brain scan. She scrawled repetitive swirls and squiggles on page after page after page, every line in a notebook, for example, with inverted *m*'s and *w*'s and *s*'s across full lines, full pages, the way a child might have been punished in grade school (in Joyce's day) by having to write a hundred lines of "I will not chew gum in class again," or "giggle," or some such other petty mischief. Another several pages contain only circles. In most cases, after Joyce's few first lines the swirls and doodles become increasingly larger so that after half-a-dozen pages, two or three doodles occupy a full page.

Two sketches chill the heart. In one, a woman with her arms raised high stands over a precipice. It is captioned with three words: "Death Thank God." In the other, a woman sits, with a cat looking back at her, and the title reads, "Famous and comely calling her cat her little husband."

Notes to herself appear to suddenly drop out of Joyce's head, without connection to preceding or following scrawls. Among the scatterings:

Tell Joyce to be careful not to go where there are no angels.

The art world knew nothing of Joyce's condition; she received invitations and commissions, and Joyce herself sent out proposals and acted as a fully operational artist.

Over the years 1990 and 1991 her schedule can certainly be described as daunting, even for a healthy, fit person.

She exhibited a painting, *Menstrual Dance*, at a conference hosted by Women's College Hospital, Regional Women's Health Centre, in a "Celebration of Women's Sexuality," and she attended the keynote speech. She wrote, "A very interesting lecture involving menopause — no ideas about what it means — very fruitful evening."

In February 1990, she gave a lecture at University College, University of Toronto, to a class of seniors in a Later Life Learning session on her "'Views of Contemporary Canadian Art and Architecture' and on the general topic of Joyce Wieland."

Also in February 1990, Joyce received a $10,000 commission from VIA Rail Canada to create an oil-on-canvas mural, 97 centimeters by 183 centimeters, called *The Ocean of Love*, to be mounted in the railway's newly renovated stainless-steel train as one of what had been called the Park Car murals. Completing it in August that year, Joyce was invited to a gala opening of the train murals in the Old Port of Montreal.

Among academic positions offered and sought, in March 1990, Pierre Théberge nominated Joyce to stand for the position of Chair of Fine Arts at the Montreal Museum of Fine Arts, but his nomination was rejected. Joyce applied for, and did not receive, a teaching position at Emily Carr College of Art and Design. She was turned down three times by the Ontario College of Art — until 1982, 87 per cent of the courses were taught by men.

A "Joyce Wieland Week" was held at McMaster University Art Gallery from November 23 to December 9, 1990, which included a film series and Joyce as lecturer over three days. In an interview, the writer noted that Joyce was nervous and not ready for a formal interview, "so we just talked." Concurrently, she attended a group show at the Moore Gallery in Hamilton, which included Joyce's latest works, from 1988 and 1990.

In February 1991, she served as visiting scholar to Queen's University's Department of Art, in a program "primarily as a means of providing students with significant women role models." A follow-up letter noted that "your recent visit was a magnificent success," which "gave inspiration and courage to the students to pursue their work vigorously." Joyce would have been thrilled with the closing, "We are all indebted to you for your warmth and candour, and your enormous generosity of spirit. It will be remembered for a long time in Kingston."

Joyce received fees for these speaking engagements — up to $2,500 for an appearance — as well as exhibition fees for her art.

An honour from Israel was bestowed upon her in June 1991 with her name being chosen to be inscribed in the Book of Life at Hofin Youth Village in Acco.

The following year, as a tribute to "your many years of outstanding service to the arts," Joyce was awarded an Honorary Fellowship by the Ontario College of Art at the college's graduation ceremonies in June. Joyce was presented by filmmaker and professor, Kay Armatage.

Soon, however, it can be seen that Joyce was declining invitations that previously would have "blown my mind," as she was wont to say. Among the rejected was an invitation in December 1991 to teach a week of classes at the Ottawa School of Art the following year. She replied that she was "not accepting any teaching or lecturing positions," that she was devoting the year "entirely to my personal creative endeavours."

Linda Abrahams convinced Joyce to decline invitations for a while so that she could work on her own projects. "This gave Joyce the sense that she could still do things."

In August 1992, Joyce went on what would be one of her last trips, a vacation in Vancouver to visit the Montagues, who had a second home there. A couple of Joyce's friends put her on the plane and she travelled by herself to Vancouver.

Donna Montague wrote an account of the trip, titled "For Joyce," a loving, delicately filigreed account reminiscent of another age, obviously intended for Joyce to read and relive back in Toronto.

Given Joyce's state of mind, not surprisingly the first paragraph outlined that after deplaning she had wandered the terminal looking for the luggage carousel and was the last to retrieve her bag while Donna et al. were pacing the floor in Vancouver. But as instructed, Joyce got a taxi to the Montague's house.

Day One of their travels begins:

> With a host of good intentions the tour headed off to catch the 10:20 ferry to Bowen [Island] but because of some diversions and absolutely necessary shopping (gorgeous tomatoes for gorgeous tomato sandwiches) we managed to make the 11:20 ferry.

A friend "kindly made this lovely house available to us" on Bowen Island, whose "sensational location" is described as having "views of pine covered hills sweeping down to the sea, beaches, coves, and rocky points and the sea itself with the mountain of Vancouver Island in a purple grey backdrop on the horizon."

Throughout the ten days of museum-going, artist-visiting, ferry-taking, sunset-watching, and tomato-sandwich indulgences, there is not a hint of anything less than an upbeat record of friends loving each other's company.

What is likely Joyce's last outing was in July 1993, when her sister Joan died. Betty Ferguson took Joyce to a family memorial gathering at Joan's daughter Alison McComb's home in Williamsford, a small town near Owen Sound, Ontario. Alison and her sister Nadine both felt that Joyce did not quite grasp why she was there. The family knew about Joyce's condition and Nadine remembers, "When Joyce left she thanked Alison for the lovely tea party."

Donna and Linda Abrahams contacted the Agnes Etherington Art Centre at Queen's University in Kingston, Ontario, in 1993, suggesting that curator Jan Allen mount an exhibition of Joyce's erotic drawings that had come to their notice when they were taking inventory of Joyce's work.

Subsequently, from December 1994 to March 1995, an exhibition of four decades of Joyce's erotic drawings was held, titled *Twilit Record of Romantic Love*. In the accompanying catalogue, curator Allen defines the "urgent sensuality" of Joyce's drawings as "reminiscent of Picasso's work, but Wieland's feminine subjects are decidedly less passive."

High praise for an artist, having one's name linked to Picasso, one of Joyce's first and lasting influences. Sadly, at the time of the exhibition, Joyce was not able to understand that she was being compared with Picasso.

Nor did she appreciate that in 1997 she had received the Lifetime Achievement Award from the Toronto Arts Council. Along with the

distinction, the award includes a cash prize of $5,000 for Protegé Honour.

Different from the usual presentation of a hefty, brass-plated statuette, this award allows recipients to play a mentorship role by giving a young artist in the winner's discipline the $5,000 award to create a work of art. Friends acting on Joyce's behalf awarded her protegé award to young painter Kate Brown.

One of Joyce's doctors defined Alzheimer's Disease as a "shrinking down," an incremental decline. Unusual episodes unfold, such as those that happened to Joyce — finding her purse in the oven and losing her car.

The person in early onset of Alzheimer's learns to adjust to these changing erratic patterns of behaviour and memory collapses. The trouble is, the decline begins to take over and "you can't defend against it anymore, and the imbalance takes a sharp downturn, then there's another sequence of happenings. And over a period of time, when the coping runs out, the sudden plunge occurs again," the doctor explained.

Various friends had been attending to Joyce's affairs since the diagnosis was made in 1991, but after Joyce had begun a series of plunges, those friends could see that Joyce needed more than their love.

The last time one of her therapists saw Joyce, he visited her at her home and found her in a highly agitated state. She spoke of there being a lot of people in her house and she fretted over how she could not trust them and she was suspicious of those she depended on — her housekeeper, her secretary. Things were missing and she accused trusted people of stealing from her. "I carefully explained to her how her memory was playing tricks on her and how the disease was the cause of her anxiety. She was very relieved," the man said, as a look of genuine sympathy swept over his face. "Imagine that. She was more relieved that she had dementia than she was about being around people she couldn't trust. She would rather be demented than betrayed."

He made another point. "When she first came to me she said she had a great fear that she would end up a forgotten old lady, in a room with no one

caring for her. It's as though she had to get Alzheimer's to be taken care of."

Another irony derives from Jamee Erfurdt, who said that while Joyce was in San Francisco she "always wanted to forget about her troubles" — an impetus for her taking Ecstasy. But Jamee felt that all Joyce's searches stemmed from one missing link in her life: "She wanted to be mothered." As a patient, now she would be cared for. And having developed Alzheimer's Disease, Jamee observed, "she could forget all about Michael."

Oxford University professor and critic John Bayley wrote a memoir of his wife, celebrated author Iris Murdoch, and their life together when she developed Alzheimer's disease. In *Elegy for Iris*, a tender, loving paean, he describes the woman who wrote seventy-six novels, as "a very nice three-year-old," who needed to be fed, bathed, and clothed. Bayley determined that his wife was "not sailing into the dark" — that voyage was over — and "under the dark escort of Alzheimer's, she has arrived somewhere."

As had Joyce.

Joyce's condition took one of those plunges the doctor referred to, and in mid-1995 she was admitted to a nursing home on Broadview Avenue in Toronto.

She had been a resident at the nursing home for close to two years when Linda Abrahams suggested that I meet with her and pick up Joyce to take her to her house. Friends alternated with this arrangement every weekend, one group calling for her on Saturday, another on Sunday, to bring her home, give her dinner, and take her back to the nursing residence.

I arrived before Linda and went to the designated meeting place, a sunny lounge where a group of about a dozen residents — with blank, unseeing eyes — had been wheeled in after lunch. They were tied in over-sized baby chairs with a tray in front, and wearing bibs. I sat for a moment, then got up and inquired about Joyce's whereabouts. I was told, "She's right there," and was pointed toward a woman with her head bent into her chest, next to where I'd been sitting. I had not recognized Joyce.

Returning to sit beside her quietly, awkwardly, feeling self-conscious

about speaking to someone I knew could not respond, I said, "Hi, Joyce."

I had been told during the course of the recent death of a friend that hearing is the last sense to go. With this in mind, again I said, "Hi, Joyce." I patted her hand. She didn't move. "It's nice to see you," I pressed on. "Linda's coming and we're going to take you home." I continued to utter small comments, feeling obliged to generate a tone Joyce might discern as non-institutional.

Linda came rushing in with a big smile, flowers, and a bag of lunch ingredients to prepare at Joyce's house and she started a routine that continued throughout the entire time, touching, stroking Joyce, talking in cheery, bright tones. "How're you doing, Joyce? Here, let's get you up. Okay?" (To put her in the wheelchair and into my car.) "How's that? Right. Now take a step, right here, okay, little more, that's it. How're you doing? You okay now?"

After a time, any oddity about Linda's one-sided conversation with Joyce, her cheerfulness and incessant smile, vanished and the three of us settled into an occasion perfectly adapted to the circumstances of having lunch. At Joyce's house, in her beloved space, a kitchen, which she had saluted some thirty years before in her film *Water Sark*, Linda placed the flowers in a vase and started frying sausages. She believed that the aroma of frying sausages constituted an olfactory reminder of home for Joyce, and she fed Joyce the sausages in cut-up pieces, gave her sips of ginger ale and then spooned pieces of watermelon into her mouth, just as she would have fed her own little girl, Georgia.

Joyce had not spoken for some months but she retained one word of her vocabulary. On two or three occasions, to Linda's "How're you doing" question, Joyce uttered her only word — a breathy, scarcely audible, "*Excellent!*"

Joyce died on June 27, 1998, three days before her sixty-eighth birthday.

Her funeral was held in the small, beautiful Church of St. George the Martyr, located behind the Grange, where some forty years previously

Joyce and Sheila — vital, beautiful young women then — had spent Sunday afternoons having tea and cookies, exulting over the Great Master works they had seen at the Art Gallery of Toronto.

In attendance was a standing-room-only crowd estimated at five hundred. Joyce's family of nieces and nephews — the children of her sister Joan and her brother Sid — were all there, as were Michael and his mother, many fellow artists, along with Joyce's art dealers Av Isaacs and Ron Moore, the art Establishment comprising curators and directors of public museums and art collectors — the elite group that Joyce both loved and hated — and members of the press. And finally, in huge numbers, Joyce's friends.

A passage from the Book of Revelation was read by the Reverend Canon Elizabeth Kilbourn, an Anglican priest and former art critic who gave Joyce her first professional art review in 1959, marking Joyce's "growing stature as an artist." Leading the mourners in prayer was the Reverend David Brinton, a former priest of St. Matthias's Church, where Joyce had been baptized, and where her mother was also baptized along with all the little girls — a church that been a place of peaceful refuge for Joan.

Following the service, to the tolling of a lone bell, Joyce's ashes were placed in a stone wall in the church yard by one of Joyce's beloved caregivers, then sealed by a mason.[7] A sole piper then led the procession through Grange Park and into the Art Gallery of Ontario to a reception presided over by master of ceremonies Mathew Teitelbaum, director of the AGO. An exhibition of Joyce's work had been quickly mounted in the gallery, curated by Dennis Reid, Curator of Contemporary Canadian Art, who was called to the podium to say a few words. He reflected upon the "long-term contribution to art" of someone he called "a dear friend," and among his touching comments, he said:

> Joyce's art was shaped by the concerns of her daily life. It is urgent, issue-oriented, sensual, immediate. It is an art so deeply informed by and reflective of her ribald sensibility that

those of us who knew Joyce feel we are in conversation with her when we engage one of her pieces. But even at its most personal, its most wittily idiosyncratic, the work resonates with complex meaning, with a breadth of vision. For Joyce was a true visionary. . . .

Dennis Reid's remarks were followed by tributes from Jean Sutherland Boggs, Linda Abrahams, representing Joyce's caregivers, and Charles Pachter, who produced a great outburst of laughter relating the anecdote of Joyce's adventures at the Arts and Letters Club, where not only had her pictures been rejected but, as she had said, "I didn't even get laid!"

Music throughout the reception was provided by soprano Janet Obermeyer, the Grace Church Chamber Choir, and pianist Alexander Kats. Sylvia Tyson sang a tender, moving song, "Piece by Piece," written by Les Smith in commemoration of his loss of a parent to Alzheimer's disease.

Universally, in words from the podium and among groups of people at the reception, the loss of Joyce Wieland was tearfully, nostalgically, and hilariously honoured from three distinct perspectives — as off-the-wall aunt, as beloved friend, and as passionate, celebrated artist.

Throughout her life, as it proved to be in her death, Joyce's generosity of spirit, and her love of family and friends, were the defining hallmarks of her personality. She bequeathed all her unsold art to a total of seventeen members of her family and friends.

Joyce forced viewers of her work to open their sensibilities to issues of the environment, nationalism, and feminism through images she created of cigarettes that burned mouths out, penises that wielded power, hamburger buns that polluted lakes. In film, gerbils presented daring messages about the Vietnam War, her kitchen table became a poetic tableau of a woman's life, and a train travelling from coast to coast evoked a semblance of Canada's reason over passion, and vice versa. Quilts, previously honoured only in country fairs, now adorned art gallery walls.

Through these mediums we have Joyce's heart and her art.

Despite suffering from bouts of timidity, she summoned the courage to render potent images that were sometimes unpalatable to her critics and occasionally mocked. The twenty-year-old who craved attention dared to open an unconventional door and, once beyond its portals, found perfectly conventional angels. They were her private angels, the forces of her unswerving spirituality, the strength that bestowed upon her the will to overcome a blighted childhood, all too many personal and career rejections, and disappointments in love. And yet Joyce experienced profound love — her first love with Bryan Barney, married love with Michael Snow, and at last, true love with George Gingras. In 1983 she wrote a letter to George in Sudbury where he was "taking care of family," as Joyce put it, that contained chatty news about mutual friends, mention of her upcoming trip to Ottawa for her Order of Canada investiture, and she referred to a film she and George had obviously discussed making together. "I think we can have some good times over that, don't you? . . . I'm looking forward to it, dear." She closed with:

> I am saying Hail Marys everywhere. And think of you and that you care about me. That is so inspiring. To be desired by you and to think of God all at the same time is wrong. Especially in your eyes.
>
> But I just want to say that I will always thank you for the warmth and tenderness you've given — since especially it's all I've known since I was a child. I love you George.

Joyce prevailed. Moreover, she managed to have a good laugh at life and its absurdities. She pioneered a new art. She made daring, highly individualistic films. She inspired a generation of women artists to follow her courageous lead.

Joyce Wieland remained a child for most of her life. The setbacks she experienced growing up poor, being orphaned at such a tender age, and the

abandonments that beset her for decades, prevented her from attaining a rightful adult maturity. And yet her work reached full, powerful, glorious maturity. She left a body of work that will continue, as it historically has, to plain amaze us.

The End
Fini
Finis

Endnotes

Chapter 1

1. Now known as the Centre for Addiction and Mental Health.

Chapter 2

1. Mel asked me to omit details.
2. Now called The Advertising & Design Club of Canada.
3. Louis Armstrong appeared at the Brant Inn every season for a period of twenty years, beginning in the late 1930s.
4. Since its founding, lifelong film buffs Ben Viccari and Gerald Pratley, the Toronto Film Society's first president, were instrumental in attracting audiences through their continuing serious film criticism. Both remain fervent fans and film critic/historians, as of this writing.
5. The outfit received national media coverage for both Marilyn Brooks and Joyce when it appeared on the cover and as a feature story in *Weekend Magazine*, in September 1968.
6. Only two are alive at this writing, Tom Hodgson and Kazuo Nakamura.
7. At the time, McLaren was riding the crest of his worldwide popularity, and would go to win more than one hundred international awards. Among them was an Academy Award in 1952 for Best Documentary Short Subject, for *Neighbours*.
8. Predating computer animation, scores of artists would draw hundreds of individual images — tens of thousands of feature-length animated films — to move the action along. The 1999 Oscar-winning documentary for Visual Effects, *What Dreams May Come*, comprised 250,000 images. One second of animated film could require 100 or 200 separate drawings, which could take on animator months to complete, compared with an hour's computer time.

Chapter 3

1. Now moved to Cumberland Street, just two blocks away.
2. Vollard represented many of *les fauves*, the "wild beasts," among them Picasso, Henri Matisse, Raoul Dufy, Georges Rouault, André Derain, Albert Marquet, Othon Friesz, Kees van Dongen, and Maurice de Vlaminck.
3. Richard Williams won an Academy Award — Special Achievement Award — for Animation Direction in 1988 for *Who Framed Roger Rabbit.*
4. With now more than 150 IMAX theatres in twenty-two countries, the film company was sold in 1994 to Richard Gelfond, Brad Wechsler, and Wasserstein Perella Partners.
5. Ma'm'selle Hepzibah is the zany, party-giving character in Walt Kelly's comic strip, *Pogo.*
6. Mary and George would remain in their married way of life, George painting and Mary working for more than twenty years as an executive with the United Steelworkers of America, until her death of cancer at age fifty, in 1982.
7. Michael had said that the two most important factors of his life were that his father had gone blind when he was fifteen and that his mother was an excellent pianist.
8. Johann Peter Eckermann wrote *Conversations with Goethe*, translated by John Oxenford, and Gustav Janouch is author of *Conversations with Kafka*, translated by Goronwy Rees.

Chapter 4

1. Since 1980, Isaacs has been dealing primarily with Inuit art.
2. Dorothy Cameron closed her gallery in October 1965 after the *Eros* show.
3. The other artists were Greg Curnoe, Richard Gorman, Gordon Rayner, and Michael Snow.
4. Because only Markle's drawings were seized, writer Kildare Dobbs reported that Town was suffering from "subpoena envy."

Chapter 5

1. Michael said they stayed with Robert Cowan and though Robert's memory of this is vague, Betty's is not: "No, they stayed with us."
2. Paul Haines interpreted this to mean that Michael played piano like Coltrane played saxophone.
3. It is said that Smith, chief rebel among rebels, has garnered more attention for his wild personal antics than for his films. But his star status as a filmmaker goes unchallenged, as in this blessing from *Film Culture* magazine: "He has shocked us with the sting of mortal beauty. He has struck us with not the mere pity or curiosity of the perverse, but the glory, the pageantry of Transylvestia and the

magic of Fairyland. He has lit up a part of life, although it is a part which most men scorn." (Jack Smith died at age fifty-seven of AIDS in 1987.)

4. In her 1964 "Notes on Camp," Sontag termed the movie more intersexual than homosexual, "akin to the vision in Bosch's paintings of a paradise and a hell of writhing, shameless, ingenious bodies." In an essay in *The Nation*, "Jack Smith's *Flaming Creatures*," she described the film as a "small but valuable work in a particular tradition, the poetic cinema of shock."

5. With remnants, yet in 1963, of Toronto the Good.

Chapter 6

1. R. Bruce Elder explains in *The Films of Joyce Wieland*: "Frampton chose an algorithm that takes the first letter in a given subset of all the permutations and moves it along so it becomes the second, then the third, then the fourth element, and so on, until it becomes the final letter. At that point, a new subset is begun. . . ."

2. Instead of the swing approach of carrying the beat with the bass drum, Max Roach shifted the emphasis to the ride cymbal, which produced a lighter, more flexible texture and enabled greater possibilities throughout the drum kit. This changed technique allowed virtuoso drummers to play at faster speeds.

3. This work was later purchased by the Honorable John P. Robarts, premier of Ontario from 1961 to 1971.

4. In the years since Joyce expressed this opinion (sarcastically or not), safe water has become a major worldwide issue, demonstrating once again Joyce's ecological prescience. A United Nations-backed World Commission on Water for the 21st Century warnedthat a huge investment in global water supplies is urgently needed to address the crisis of unsafe water consumed by billions of people. "Many wars this century were about oil, but the wars of the next century will be about water," predicted the World Bank. Melting the Artic may well be a possibliity, if not a necessity, considering that less than 1 per cent of the earth's water is drinkable, 97 per cent is salty and much of the balance is trapped unerground or stored as polar ice. (Joyce's response would not be too hard to predict, had she heard about a 1998 decision by the Ontario government that granted a company in Sault Ste. Marie a permit to sell tankers of water from Lake Superior to Asia.)

Chapter 7

1. A second person had another important role. J. A. MacCallum, a wealthy Toronto physician, became a Group of Seven patron who supported these artists by buying their works and generously offering them free accommodation in the boathouse of his Georgian Bay cottage, and a boat for their use on painting trips in the Bay islands. MacCallum bequeathed 134 of his works, mostly by Tom

Thomson and members of the Group of Seven, to the National Gallery of Canada in 1948.

2. Now known bilingually as Canadian Artists' Representation/le Front des artistes canadiens (CARFAC).

3. A British cartoon and comedy movie series, originating in 1954, featured hijinks played by bratty teenaged girls on the bumbling staff of a rundown girls' school.

4. *Life* magazine identified it as "what may be the world's largest 'quilt.'"

5. The Canadian government appointed Vincent Massey, later governor general of Canada, to head the Royal Commission on National Development of the Arts, Letters and Sciences in Canada, and its report, known as the Massey Report, was released in 1951. Among two key recommendations were that the government fund grants to universities and fund the development of the arts, humanities, and social sciences. During this time, death duties were applied in force and in 1955 the Canadian government racked up a windfall of close to $100 million in death duties from the estates of two super-tycoons, Sir James Dunn and Izaak Walton Killam. The government used this money in 1957 to establish the Canada Council, at $50 million, and to provide $50 million to universities.

6. Hydro-Québec, the provincially-owned utility, stated that the region "was inhabited by only a few thousand native people, most of them Cree Indians."

7. Joyce never knew the really good news about James Bay. In 1995, the day after hearing a report from federal, provincial, and Aboriginal representatives recommending that Hydro-Québec conduct another environmental-impact study, Jacques Parizeau announced that the project would not go ahead at all.)

8. Douglas Bentham, Michael Hayden, Nobuo Kubota, Glenn Lewis, Robin Mackenzie and Jean Noel.

Chapter 8

1. From 1963 to 1970 there had been more than two hundred bombings in Montreal that targeted individual wealthy Anglophones, politicians, government offices, McGill University, and the Montreal Stock Exchange.

2. In 1980, Pierre Vallières dropped all his political ties, contending that Quebec was doomed to assimilation into Canada, and four years later, after experiencing a revelation, he joined a religious order. He died in 1998 at age sixty.

3. "It's nice to have someone to demonstrate with," Judy said, after meeting Joyce.

4. The original name was Canadian Contemporary Musicians' Collective, but in later years no one like the word "Collective," and it received a number of names.

5. Joyce would be heartened to know that he and her environmental activists's work contributed to a monumental outcome. Canada took a leadership role in convincing the United Nations to sponsor a worldwide initiative to ban the "dirty dozen" of persistent organic polluntants (POPS), among them DDT, PCBS, and dioxins. Such toxic chemicals travel on air currents to the Arctic, and Canadian-conducted

research begun in the 1980s show that Native people and animals in the Arctic have some of the world's highest concentrations of these chemicals in their tissues. A treaty calling for banning the twelve POPs will be signed in early 2001, and it is expected that when fifty countries ratify the agreement, it will be enforced. (A later exemption was granted for DDT, for its use against the lethal mosquito-borne disease, malaria.)

6. Oscar Wilde, in *An Ideal Husband*: "When the gods wish to punish us they answer our prayers."

7. Masters of this genre, beginning in 1963, David F. Friedman and Herschell Gordon Lewis, makers of *Blood Feast* and *Two Thousand Massacres*, do not include Cronenberg in their company. David Friedman said, "David Cronenberg is a thinker. The stuff Herschell and I were doing was just flat-out splatter for the redneck drunks down at the drive-in theatre."

8. The artists: Ted Bieler, Stan Bevington, Claude Breeze, Michael Hayden, Rita Letendre, John MacGregor, Louis De Niverville, Gordon Rayner, James Sutherland, Joyce Wieland, David Wright, and Gerald Zeldin.

9. A similar controversy swirled around a bronze public sculpture in Toronto, Henry Moore's massive *Three Way Piece No. 2: Archer*, commonly known as *The Archer*. Toronto council refused to purchase the piece and the then mayor Philip Givens personally raised $100,000, bought the sculpture and donated it to the city. The sculpture was installed at Toronto's city hall in Nathan Phillips Square in October 1966, but the public outcry over the work is said to have cost Philip Givens his re-election the following month. *The Archer* is now one of Toronto's treasured art showpieces.

10. Over the years, Michael had bought quite a few pieces of property, in the Atlantic provinces, Quebec, and Ontario — "I don't know where I got the money," he said — in an effort to find their "ideal."

11. These conversations predated the infamous case involving Lorena Bobbitt, who actually did cut off her abusive husband's penis.

12. Emily Carr went into a rapture of a similar kind on first seeing Harris's paintings. "I have never felt anything like the power of those canvases . . ." she wrote in her journal. "I longed so to cast off my earthly body and float away through the great pure spaces between the peaks, up the quiet green ravines into the high, pure, clean air. Mr. Harris has painted those very spaces, and my spirit seems able to leave my body and roam among them."

13. Théberge would become director of the Montreal Museum of Fine Arts and would return to the National Gallery of Canada in 1998 to the position of director.

14. A French phrase whose literal translation is "open air," but is a painterly term used to describe painting that truly reflects the quality of the outdoors, as practised by the French impressionists.

Chapter 9

1. The other eight artists were Richard Prince, Vancouver; Ron Moppett, Calgary; John McEwan, Toronto; Stephen Cruise, Toronto; Bill Vazan, Montreal; Irene Whittome, Montreal; Sylvain Cousineau, Montreal and New York; and Molly Lamb Bobak, Fredericton.

2. "Peggy's Blue Skylight" is also the name of a tune written by jazz bassist, composer Charlie Mingus, performed at a historic Town Hall Concert with a big band he had assembled on October 12, 1962, in New York. The concert was recorded and released in 1963. Joyce was a fan of Mingus, had heard him live in Greenwich Village and thought the name "Peggy's Blue Skylight" was amusing, and doubly so, since she had a cat named Peggy. Joyce would hear Paul Haines playing the tune on the piano in his loft next to her and Michael's. It would have amused Joyce greatly to have Paul Bley play the tune "Peggy's Blue Skylight" on the soundtrack of her film, *Peggy's Blue Skylight*. Bley played with Charlie Mingus for several years.

3. An art school founded in 1977 by Toronto painters Dennis Burton, Gordon Rayner, Graham Coughtry, Robert Markle, and others.

4. The "laying-on-of-hands" is based on the ancient theory that energy flows through all living things and that hands are capable of redirecting the body's energy to improve health. Similarly, rekai is a Japanese method that uses hand positions as healing techniques.

5. Steinem's thoughts on this aphorism have been debated since her marriage at age sixty-six in September 2000.

6. Similarly, Isaacs appeared at an exhibition of Joyce's work at the Bau-Xi Gallery in 1996 with the remaining few copies of her 1987 retrospective catalogues to sell.

7. Like numerous other references to Joyce's birth year, it is incorrect on her stone marker as well. The stone is engraved: "Joyce Wieland — 1931–1998." It should be 1930–1998.

Sources

I have relied heavily on certain sources and have used them variously throughout this book, notably: Joyce Wieland's personal papers held at York University, Archives and Special Collections in Toronto; an unpublished Wieland family history written by Joyce's sister Joan (Stewart) Proud; Joyce's numerous friends and colleagues; and the catalogue of Joyce's 1987 retrospective at the Art Gallery of Ontario, Joyce Wieland, *Art Gallery of Ontario/Key Porter Books, 1987*. The catalogue text on Joyce's art is by Marie Fleming with text on films by Lucy Lippard and Lauren Rabinovitz. Quotes by Marie Fleming and Lucy Lippard are from this catalogue while quotes by Lauren Rabinovitz are from the catalogue and other cited sources.

Chapter 1

Many of Joyce's earliest memories are documented in a 73-page transcript of a counseling session with therapist Dr. Achter Hassen in Yonkers, New York in 1987. Childhood memories with other therapists are also recorded in her journals. In addition, Joyce traveled to England in the late 1980s to conduct research on her family background and kept copious records in her files.

Personal interviews with Joyce's nieces Alison McComb, Nadine Schwartz, and Lois Taylor, and her nephew Keith Stewart. Also Betty Ferguson, Linda Gaylard, Selma Lemchak-Frankel, and John Rennie.

Additional sources:

Evert-Green, Robert, "Bold strokes," *Saturday Night*, May 1, 1987.

Freedmen, Adele, "Roughing it with a brush," *Toronto*, April, 1987.

"The Legacy of Mary McEwan," National Film Board of Canada, 1985, A Studio D/PKW Co-Production with Bonnie Fowke and Shelagh Wilkinson, York University, Toronto.

Wieland, Joyce, "Jig & Reels" essay in "Form and Structure in Recent Films at the Vancouver Art Gallery — October 29 – November 5, 1972," Wheeler, Dennis, ed.,

Vancouver Art Gallery/Talonbooks, 1972 (catalogue).
Who's Who in the English Theatre, several editions.

Chapter 2

Certain material on the 1960s in Toronto, its artistic life, art dealers and Painters Eleven derives partially from my memoir *Hot Breakfast For Sparrows: My Life with Harold Town*, Stoddart, 1992, and the late Harold Town's and Walter Yarwood's recollections.

Personal interviews with Joyce's nieces Allison McComb, Nadine Schwartz, and Lois Taylor, and their cousin Michael Wieland. Also Marilyn Brooks, Warren Collins, Kathy Dain, Betty Ferguson, Linda Gaylard, George Gingras, Gerald Gladstone, Penelope Glasser, Chris Karch, Doris McCarthy, Sheila McCusker, Donna Montague, John Rennie, George Shane, Michael Snow, Mel (Melita Stewart) Waterman, and Chris Yaneff.

Additional Sources:

Freedman, Adele, "Portraits from a daring artist," *The Globe and Mail*, January 4, 1983.
——, "Roughing it with a brush," *Toronto*, April, 1987.
Fulford, Robert, "12 artists challenge the country," *The Star Weekly*, March 11, 1980.
Landsberg, Michele, "Joyce Wieland, artist in movieland," *Chatelaine*, October, 1976.
Murray, Joan, typescript of an interview with Joyce, April 25, 1980. Joan Murray Papers, the Robert McLaughlin Gallery, Oshawa.
Naiman, Sandra, "Joyce Wieland is really living!" *Toronto Sun*, March 1, 1981.
Porter, John, "Artists discovering film post-war Toronto," *Vanguard*, Summer, 1984.
Pratley, Gerald, "Maya Deren in Canada addresses Film Society," *The Varsity*, University of Toronto, November 8, 1950.
Rabinovitz, Lauren, "An interview with Joyce Wieland," *Afterimage*, Vol. 8, No. 10, May 1981, from conversations held November 14, 15 and 16, 1979, and March 11, 1980.
University of Lethbridge, typescript of a slide presentation given by Joyce in 1985.
Vicarri, Ben, "Belfast on the Don," *Performing Arts & Entertainment in Canada*, Vol.32, NO.1, 1989 — a tribute to the Toronto Film Society's 50th anniversary.
Ward, Olivia, "Artist Joyce Wieland, blossoming at 50," *Toronto Star*, February 8, 1981.
Web site material on Norman McLaren, "Innovative Film Genius 1914–1987." Also Ouspensky, Gurdjieff and the Summa Foundation.
Wieland, Joyce, "Jig & Reels" essay in "Form and Structure in Recent Films at the Vancouver Art Gallery — October 29 — November 5, 1972," Wheeler, Dennis, ed., *Vancouver Art Gallery/Talonbooks*, 1972 (catalogue).

Chapter 3

Personal interviews with Sara Bowser, Warren Collins, George Gingras, Gerald Gladstone, Barbara Mercer, Donna Montague, Sheila McCusker, Gordon Rayner, Hanni Sager, George Shane, Michael Snow, and Mel (Melita) Stewart.

Additional Sources:

Landsberg, Michele, "Joyce Wieland, artist in movieland," *Chatelaine*, October, 1976.

Tobler, Jim, *Coco et la fin du 20th Siecle*, Nuvo, Autumn 2000.

Vollard Suite material from "Picasso for Vollard," by Pablo Picasso and "Picasso and the Vollard suite," by Jean Sutherland Boggs.

Wieland, Joyce, "Artist Wieland finds maturity," *Sunday Star Toronto*, April 27, 1980.

Chapter 4

Personal interviews with Sara Bowser, Warren Collins, Marjorie Harris, Av Isaacs, Donna Montague, George Montague, Brydon Smith, and Michael Snow. Also, personal interview with the late Dorothy Cameron in 1989 for my memoir of Harold Town.

Additional Sources:

Kilbourn, Elizabeth, "Pianist-painter showing works at Westdale," *Hamilton Spectator*, November 28, 1959.

Paikowsky, Sandra, "Joyce Wieland: A Decade of Painting," Concordia Art Gallery of Concordia University, Montreal, 1985 (catalogue).

Rabinovitz, Lauren, "The development of feminist strategies in the experimental films of Joyce Wieland," *Film Reader*, No. 5, 1982, Northwestern University.

Sones, Derek, "Pictures show talent but those 'objects'," *Toronto Star*, September 24, 1960.

Wieland, Joyce, "The black dog," *Evidence*, Vol. 2, 1960.

——, "February," *Evidence*, Vol.2, Fall, 1961.

"One-Woman show for Joyce Wieland," n.a., *The Toronto Star*, September 19, 1960.

"Wieland faces another historical first," n.a., *Sunday Sun, Toronto*, February 22, 1987.

Chapter 5

Certain descriptions of Joyce's films are derived from her written outlines of them. Films I have screened of Joyce's films and those of her colleagues at the Canadian Film Distribution Centre in Toronto and the Film Distribution Centre, New York. Additional material on *Flaming Creatures* is from Jim Hoberman at the Yeurba Buena Centre in San Francisco in March 2000 where he screened the film, delivered a lecture and distributed printed materials.

Two films have been made about Joyce: *Artist on Fire: The Work of Joyce Wieland*, 1983, directed by Kay Armatage and *A Film About Joyce Wieland*, 1971, directed by Judy Steed.

Personal interviews with Steve Anker, Sara Bowser, Christine Conley, Warren Collins, Robert Cowan, Betty Ferguson, Linda Gaylard, Kenneth Green, Paul Haines, Jo Hayward-Haines, Av Isaacs, Ken Jacobs, Flo Jacobs, George Kuchar, Les Levine, Sheila McCusker, Michael Montague, Hanni Sager, Keith Stewart, and Michael Snow.

Additional Sources:

Armatage, Kay, "Kay Armatage interviews Joyce Wieland," *Take One*, (Montreal), February, 1972.

Crean, Susan, "Notes from the language of emotion, a conversation with Joyce Wieland," *Canadian Art*, Spring 1987.

Donnell, David, "Joyce Wieland at the Isaacs Gallery, Toronto," *Canadian Art*, March–April, 1964.

Elder, Kathryn, ed., "The Films of Joyce Wieland," *Cinematheque Ontario, Toronto International Film Festival Group*, 1999: Quotes are from: Elder, R. Bruce, "Joyce Wieland and the Canadian Experimental Cinema;" and McLarty M. Lianne, "The Experimental Films of Joyce Wieland."

Goddard, Peter, "Screenings focus on Wieland's film," *The Toronto Star*, February 10, 1996.

Green, Robin, item on 1963 exhibition at Isaacs Gallery, *The Globe and Mail*, November 23, 1963.

Hale, Barrie, "The vanguard of vision, notes on Snow and Wieland," *Saturday Night*, June, 1974.

Kirkwood, Leone, "Canadian artist in New York pioneers in nameless art form," *The Globe and Mail*, March 17, 1965.

Kilbourn, Elizabeth, "Art and Artists," *Toronto Star*, November 23, 1963.

Kritzwiser, Kay, "What's so special about New York," *The Globe and Mail*, April 15, 1967.

Landsberg, Michele, "Joyce Wieland, artist in movieland," *Chatelaine*, October, 1976.

Lister, Ardele, "Joyce Wieland, an interview," *Criteria Quarterly*, Vancouver, February 1976.

Malcolmson, Harry, column, *The Toronto Telegram*, March 25, 1967.

McPherson, Hugo, "Wieland, an epiphany of North," *Canadian Art*, Aug./Sept. 1971.

Murray, Joan, typescripts of two interviews, both in Toronto, one dated April 25, 1980, the other dated April 5, 1990.

Paikowski, Sandra, *Joyce Wieland, A Decade of Painting*. Exhibition at Concordia Art Gallery, Concordia University, Montreal, February 20 – March 23, 1985 (catalogue).

Pinney, Marguerite, "Joyce Wieland retrospective, Vancouver Art Gallery," *artscanada*, June 1968.

Rabinovitz, Lauren, "An interview with Joyce Wieland," *Afterimage*, May 1981.

—, "The development of feminist strategies in the experimental films of Joyce Wieland," *Film Reader*, No. 5, 1982, Northwestern University.

Rodgers, Margaret, typescript of an interview with Joyce in Toronto in October 1988. Later appeared in *Gallerie* Magazine.

Ruben, Joan Abelman, "Staking out a new world of film, "*Mademoiselle*, June, 1968.

Sitney, P. Adams, "There Is only one Joyce," *artscanada*, April 1970.

Steed, Judy, "A life of fire and pain," *Toronto Star*, September 8, 1996.

Stevenson, Barbara K., typescript of an interview with Joyce in Toronto, October8, 1986.

Ward, Olivia, "Artist Joyce Wieland, blossoming at 50," *The Toronto Star*, February 8, 1951.

Wieland, Joyce, "Jig & Reels" essay in "Form and Structure in Recent Films at the Vancouver Art Gallery — October 29 – November 5, 1972," Wheeler, Dennis, ed., *Vancouver Art Gallery/Talonbooks*, 1972 (catalogue).

Chapter 6

Personal interviews with Robert Cowan, Jo Hayward-Haines, Flo Jacobs, Ken Jacobs, George Kuchar, Les Levine, Jonas Mekas, Michael Snow, and Pierre Théberge.
Additional Sources:
Armatage, Kay, "Kay Armatage interviews Joyce Wieland," *Take One*, Volume 3, No. 2, 1972.
Banning, Kas, "The Mummification of Mommy, Joyce Wieland as the AGO's First Living Other," *Sightlines, Reading Contemporary Art*, eds. Jessica Bradley and Lesley Johnstone, Artextes, Montreal, 1994.
Blue, Janice, "On film, a woman's vision," *Houston Breakthrough*, Texas, October, no year.
Elder, F. Bruce, "Notes after a conversation between Hollis and Joyce," from "The Films of Joyce Wieland."
Cornwall, Regina, "True Patriot Love, the films of Joyce Wieland," *Artforum*, September, 1971.
Cowan, Bob, "Letter from New York," *Take One*, July 31, 1970.
Crean, Susan, "Notes from the language of emotion, a conversation with Joyce Wieland," *Canadian Art*, Spring. 1987.
Farber, Manny, "Film," *Artforum*, January 1970.
—, "Film," *Artforum*, February 1970.
Fischler, Stan, "Pierre's the star of an arty party in New York loft," *Toronto Star*, November 11, 1969.
Frampton, Hollis, Typescript of a discussion between Hollis and Joyce in New York, Spring 1971.
Hale, Barrie, "A pure new film of a pure land, " *Toronto Daily Star*, July 18, 1969.
—, "The vanguard of vision, notes on Snow and Wieland," *Saturday Night*, June, 1974.
"Intercat '73, the second "International cat film festival" held on April 28, 1973, *Village Voice*, April 26, 1973 (advertisement.)
Jennings, Valerie, "Quilt-In for Prime Minister Pierre Elliott Trudeau," May 10, 1968 (press release).
Landsberg, Michele, "Joyce Wieland, artist in movieland," *Chatelaine*, October, 1976.
Lister, Ardele, "Joyce Wieland, an interview," *Criteria Quarterly*, Vancouver, February 1976.
Magidson, Debbie and Wright, Judy, "True Patriot Love," *Art and Artists*, October 1973.
Malcolmson, Harry, "True patriot love — Joyce Wieland's new show," *The Canadian Forum*, June 19, 1971.
Martindale, Diane, "Wieland: a most unusual artist," *Halifax Chronicle Herald*, March 2, 1978.

McPherson, Hugo, "Wieland, an epiphany of North," *artscanada*, August/ September, 1971.

Mekas, Jonas, "Movie Journal, *Village Voice*, April 3, 1969.

Mendes, Ross, "Light: 24 frames per second," *The Canadian Forum*, September 1969.

Montagnes, Anne, "Myth in many media: Joyce Wieland," *Communique 8*, Winter, 1975.

Museum of Modern Art, Cineprobe Presents First Feature-Length Film of Canadian Artist–Filmmaker Joyce Wieland, flyer and news release, (promoting screening January 20, 1971).

Rabinovitch Lauren, "An interview with Joyce Wieland," *Afterimage*, Vol. 8, No. 10, May 1981.

Sarris, Andrew, "Films in focus," *Village Voice*, March 18, 1971.

Sitney, P. Adams, "There is only one Joyce," *artscanada*, April 1970.

Stevenson, Barbara K., Typescript of an interview with Joyce in Toronto, October 8, 1986.

"The Talk of the Town," n.a., *The New Yorker*, January 3, 1970.

University of Lethbridge, typescript of a slide presentation by Joyce, 1985.

Walker, Kathleen, "The artist as patriot," *The Ottawa Citizen*, October 23, 1976.

Web site, AMG All Music Guide — Milford Graves and Max Roach.

Wheeler, Dennis, "*La Raison Avant La Passion*," essay in "Form and Structure in Recent Films at the Vancouver Art Gallery — October 29 – November 5, 1972," *Vancouver Art Gallery /Talonbooks*, 1972 (catalogue).

Wordsworth, Anne, "An interview with Joyce Wieland," *Descant*, Sring/Summer 1974.

Chapter 7

Letters to the editor of Ottawa papers that followed the opening of Joyce's retrospective in July 1971 are quoted in brief, including responses from the National Gallery of Canada director, Jean Sutherland Boggs.

Personal interviews with Sara Bowser, Ken Carpenter, George Montague, and Pierre Théberge.

Additional Sources:

Benedetti, Paul, "Joyce Wieland, art's wild card," *The Hamilton Spectator*, November 17, 1990.

Cornwall, Regina, "True Patriot Love, the films of Joyce Wieland," *Artforum*, September, 1971.

Crean, Susan, "Notes from the language of emotion, a conversation with Joyce Wieland," *Canadian Art* Spring, 1987.

——, "Forbidden fruit, the erotic nationalism of Joyce Wieland," *This Magazine*, August/September, 1987.

Frampton, Hollis, Typescript of discussion between Hollis and Joyce in New York, Spring, 1971.

Grant, Don, "A gamble that could ruin James Bay's ecology," *The Toronto Telegram*,

October 9, 1971.

Hale, Barrie, "Fine art's finest, the powers behind Canadian art: what they see is what you get," *The Canadian* (supplement of *The Toronto Star*) March 29, 1975.

Kritzwiser, Kay, "Wieland, ardent art for unity's sake," *The Globe and Mail*, July 3, 1971.

Lind, Philip B., Chairman Sierra Club of Ontario, "Should the James Bay hydro project be allowed to succeed?" letter to the editor, *Globe and Mail*, March 1, 1972.

Magidson, Debbie and Wright, Judy, "Debbie Magidson and Judy Write interview Joyce Wieland," *The Canadian Forum, May/June 1974*.

Malcolmson, Harry, "True patriot love — Joyce Wieland's new show," *The Canadian Forum*, June 1971.

Mendes, Ross," Independent Canadian Art Show, University of Guelph, Guelph, Ontario, October 13 – November 2, 1972 (catalogue).

Pierce, Gretchen, "Metro craftsmen needle into national gallery exhibition, *Halifax Mail Star*, May 22, 1971.

Rabinovitch Lauren, "An interview with Joyce Wieland," *Afterimage*, Vol. 8, No. 10, May 1981.

Richardson, Douglas S., "National Science Library, art in architecture," *artscanada*, Autumn 1974.

Stevenson, Barbara K., Typescript of an interview with Joyce in Toronto, October 8, 1986.

Sujir, Leila, "A language of flesh and of roses, a language of love in the film work of Joyce Wieland," *Bulletin, Canada House*, London, England.

" 'True Patriot Love': Joyce Wieland at the National Gallery of Canada," *Studio International*, n.a., July – December, Vol. 182, 1971.

University of Lethbridge, typescript of a slide presentation by Joyce, 1985.

Walker, Kathleen, "The artist as patriot," *The Ottawa Citizen*, October 23, 1976.

Web site material on the James Bay Project:

Deocampo, Daniel M., and Posluns, Michael, "Background on Hydro-Quebec in James Bay."

"Bill Namagoose (of the Cree) speech at Tufts."

Sierra Club Web Site, "Hudson Bay/James Bay Watershed Ecoregion, n.d.

"Feature: Victory Over Hydro-Quebec at James Bay," from *The Planet*, Dec./Jan. 1995.

Wieland, Joyce, "True Patriot Love, *Veritable amour patriotique*," The National Canada of Canada, *Galerie nationale du Canada*, 1971, (catalogue).

Chapter 8

Personal interviews with Sara Bowser, Betty Ferguson, George Gingras, Av Isaacs, Ken Jacobs, George Kuchar, Richard Leiterman, Lynn McDonald, Maureen Milne, Charles Patcher, Janis Crystal Lipzin, John Rennie, Hanni Sager, Nadine Schwartz, Michael Snow, Judy Steed, Keith Stewart, and William Withrow.
Additional Sources:
Armatage, Kay, "Kay Armatage interviews Joyce Wieland," *Take One*, (Montreal),

February, 1972.

Abbate, Gay, "Former mayor loved Toronto, fought hard for municipalities,"Obituary of Philip Givens, *The Globe and Mail*, November 28, 1995.

Anthony, George, "Wieland's Far Shore has appeal with stunning sense of detail," *The Toronto Sun*, September 28 ,1976.

Auchterlonie, Bill, "In Celebration, Joyce Wieland, fillmmaker, The Far Shore In progress," December/January, 1975/1976.

Best, Michael, "Plan for subway art slips in by back door," *Toronto Star*, January 19, 1977.

Blue, Janice, "On film, a woman's vision," *Houston Breakthrough*, Texas, October, 1978.

Balfour Bowen, Lisa, "The joy of sex: In pastel tones," *The Toronto Star*, February 23, 1981.

Brennan, Pat, "Sneak preview, vivid colors inside the new subway," *Toronto Star*, April 22, 1977.

Canadian and International Feature Film Festival, *Canadian and International Feature Film Section*, July 22, 1976 (press release).

Corbeil, Carole, "Joyce Wieland finds room to bloom," *The Globe and Mail*, March 2, 198L.

Crean, Susan, "Guess who wasn't invited to The Dinner Party," *This Magazine*, n.d.

——, "Notes from the language of emotion, a conversation with Joyce Wieland," *Canadian Art*, Spring, 1987.

Dain K, "Patriot Love preceded Chicago," letter to the editor, *The Globe and Mail*, June 10, 1982.

Evert-Green, Robert, "Bold strokes," *Saturday Night*, May 1, 1987.

"'Far North' flows like a soap opera," n.a., *Canadian Press, New Westminster Columbia*, (B. C.), August 9, 1976.

Fear, Joanthan, "Warren wants more subway art and hopes to get public funds," *The Globe and Mail*, January 18, 1977.

Fetherllng, Doug, "Joyce Wieland in movieland," *Canadian Weekly*, January 24, 1976.

——, "Films: Wieland's vision," *Canadian Forum*, May 1976.

Freedman, Adele, "Roughing it with a brush," *Toronto*, April, 1987.

Gard (no other name), movie column, *Variety*, August 18, 1976.

Gerber, Eric, "Stumbling blocks for sure, how to film 'Far Shore?'" *The Houston Post*, September 22, 1978.

Glasser, Penelope, "Problems and visions, Joyce Wieland now," typescript of an interview with Joyce, 1982, published in *Spirale*, winter 1982.

Hume, Christopher, "The search for 'the ecstatic', only Joyce Wieland would dare produce this show," *Toronto Star*, April 30, 1983.

——, "Underground art survives a bumpy ride," *Toronto Star*, June 1, 1997.

Knelman, Martin, "Films," *Toronto Life*, May 1976.

Kostash, Myrna, "Women as filmmakers . . . hey it's happening!" *Miss Chatelaine*, Winter 1973.

"Landsberg, Michele, "Joyce Wieland: artist in movieland, *Chatelaine*, October 1976.

Langlois, Christine, "Joyce Wieland likes her movie," *The Guardian*, (Brampton, Ontario), October 7, 1976.

Lister, Ardele, "Joyce Wieland, an interview," *Criteria Quarterly*, Vancouver, February 1976.

Mays, John Bentley, "Wieland, strong overshadows sweet," *The Globe and Mail*, April 23, 1983.

Mekas, Jonas, "Movie Journal," *Village Voice*, July 13, 1972.

Mittlestaedt, Martin, "UN seeking ban on toxic chemicals," *The Globe and Mail*, December 4, 2000 and Reuters News Agency follow-up, "Delegates agree on UN chemicals treaty, *The Globe and Mail*, December 11, 2000.

"The Legacy of Mary McEwan," National Film Board of Canada, 1985, A Studio D/PKW Co-Production with Bonnie Fowke and Shelagh Wilkinson, York University, Toronto.

Murray, Joan, "A lusty salute to the erotic," *Maclean's*, March 9, 1981.

Olten, Carol, "'Far Shore,' a bittersweet love story," *San Diego Union*, September 19, 1978.

Paddle, Gabriele and Nakonecznyj, Janet, "Wieland on being a 'Canadian' artist," *Breakthrough, a York Feminist Magazine*, York University, Toronto, April 1976.

Price, Michael H., "New films push the taste envelope with sex and violence," *Minneapolis Star Tribune*, April 17, 1997.

R.M. (likely Robert Martin, film critic), "Far Shore beautiful but flat," *The Globe and Mail*, September 25, 1976.

Rabinovitz, Lauren, "Issues of feminist aesthetics, Judy Chicago and Joyce Wieland," *Women's Art Journal*, San Francisco, 1982.

Rogers, Margaret, typescript of an interview with Joyce, October 19, 1988.

Steed, Judy, audio cassette typescript of an interview held at the Isaacs Gallery.

Rasky, Frank, "The painter and film-maker directs a classical romance," *Toronto Star*, Sept. 18, 1976.

Segal, Mike, The Cinema, a column, "The Far Shore," *The Canadian Review*, October, 1976.

Stevenson, Barbara K., typescript of an interview with Joyce in Toronto, October 8, 1986.

Stoddard, Ed, "Delegates agree on UN chemicals treaty," *The Globe and Mail*, December 11, 2000.

Sinclair, Clayton, "Why some strikes drag on," *Financial Times of Canada*, May 29, 1973.

Steed, Judy and Wieland, Joyce, "A talent for friendship: Judy on Joyce, Joyce on Judy," *City Woman, Toronto*, Spring 1985.

"Take the art train," *The Toronto Star*, n.a., January 31, 1978.

Taylor, Noel, "The Far Shore truly Canadian — rather dull," *The Ottawa Citizen*, August 6, 1976.

University of Lethbridge, typescript of a slide presentation by Joyce, 1985.

Ward, Olivia, "Artist Joyce Wieland, blossoming at 50," *Toronto Star*, February 8, 1981.

Wieland, Joyce, "A tribute to Michel Lambeth," *Artfocus/34*, n.d., (likely 1977).

——, "Artist Wieland finds maturity," *Sunday Star Toronto*, April 27, 1980.

"The Far Shore revisited," n.a., *Ottawa Journal Special*, April 6, 1979.

Chapter 9

Personal Interviews with Linda Abrahams, Steve Anker, Sara Boswer, David Burnett, Christine Conley, Kathryn Dain, Art Eggleton, Jamee Erfurdt, Selma Lemchak-Frankel, Linda Gaylard, Jo Hayward-Haines, Paul Haines, Av Isaacs, George Kuchar, Janis Crystal Lipzin, Jane Martin, Roy McMurtry, Philip Monk, Donna Montague, Ron Moore, Charles Patchter, John Rennie, Gerald Robinson, Michael Snow, Judy Steed, Keith Stewart, Michael Wieland, Kay Wilson, and Irving Zucker. Also Endel Tulving in 1990 for my book, *Women Who Give Away Millions, Portraits of Canadian Philanthropists*, Hounslow, 1992.

Additional sources:

Bannon, Anthony: "Film genius Frampton leaves a rich legacy of creativity," *Buffalo News*, April 8, 1984, and other obituaries in Buffalo press.

Canada-Israel Cultural Foundation, press kit on artists Toronto/Israel tour, May 21 – June 9, 1984.

"Canadian artists on 'The Far Shore:' The Art Post interviews Joyce Wieland," n.a., *The Art Post*, Sept/Oct., 1983.

Claus, JoAnne, "Wieland retrospective shouldn't be missed," *Evening Times-Globe/Saint John New Brunswick Daily*, December 31, 1987.

Crean, Susan, "Forbidden fruit, the erotic nationalism of Joyce Wieland," *This Magazine*, August/September, 1987.

Freedman, Adele, "Roughing it with a brush," *Toronto*, April 1987.

Glasser, Penelope, "Problems and visions: Joyce Wieland now," typescript of an interview with Joyce, 1982, published in *Spirale*, winter 1982.

Frampton, Hollis, Typescript of a discussion between Hollis and Joyce in New York, Spring 1971.

Hanna, Deirdre, "Finding strength in colour," *NOW Magazine* Toronto, March 29–April 4, 1990.

Hume, Christopher, "Wieland tells AGO the show must go on," *The Toronto Star*, April 10, 1987.

James, Geoffrey, "The protean vision of Joyce Wieland," *Maclean's*, April 27, 1987.

Inglis, Grace, "Joyce Wieland, first lady of art," *Hamilton Spectator*, May 16, 1987.

Keczan-Ebos, Mary, "Joyce Wieland, re-inventing the artist," SITE Sound, January/February 1991.

Krane, Susan, curator Albright-Knox Gallery, comments on *A & B in Ontario* in Festival of Festivals catalogue.

Lacey, Liam, "Frye, Wieland are among arts awards winners," *The Globe and Mail*,

September 23, 1987.

Landsberg, Michele, "'Old boys' at art school painted a fake equity picture," *Toronto Star*, n.d.

"Making Moves," n.a., *Toronto Star*, March 27, 1989.

Mays, John Bentley, "AGO retrospective enshrines the myth surrounding Wieland," *The Globe and Mail*, April 15, 1987.

Peary, Gerald, "Berlin looks kindly on Canadian content," *The Globe and Mail*, March 2, 1985.

Raphael, Shirley, "An artist's plan for Canada," *Montreal Gazette*, July 10, 1971.

Rodgers, Margaret, typescript of an interview with Joyce in Toronto in October 1988. Later appeared in *Gallerie* Magazine.

Snow, Michael, tribute to Hollis Frampton from "The Collected Writings of Michael Snow."

Toronto Arts Awards Foundation, press material.

Wieland, Joyce, "Wieland and Isaacs part company, letter to the editor, *NOW Magazine*, April 6–12, 1989.

Bibliography

Arnason, H.H., *History of Modern Art*. Henry N. Abrams, Inc.: New York, n.d.

Behrman, S. N., *Duveen*, Random House: New York, 1952.

Blair, Lindsay, *Joseph Cornell's Vision of Spiritual Order*, Reaktion Books, London, 1998.

Carr, Emily, *Hundreds and Thousands: the Journals of Emily Carr*. Clarke Irwin: Toronto, 1966.

Colombo, Robert, *Colombo's Canadian References*. Oxford University Press: Oxford, 1976.

Dickason, Olive Patricia, *Canada's First Nations: A History of Founding Peoples from Earliest Times*. McClelland & Stewart: Toronto, 1992.

Donald Crafton, *Before Mickey, The Animated Film, 1898-1928*. The MIT Press: Cambridge, 1982.

Elder, Kathryn, editor, *The Films of Joyce Wieland*. Cinematheque Ontario Monographs, *Toronto International Film Festival Group*: Toronto, 1999.

Hall, Lee, *Elaine and Bill, Portrait of a Marriage: The Lives of Willem and Elaine De Kooning*. Harper Collins Publishers: New York, 1993.

Harper, J. Russell, *Painting in Canada, A History*, University of Toronto Press: Toronto, 1966.

Herrera, Hayden, *Frida, a Biography of Frida Kahlo*. Harper & Row Publishers: New York, 1983.

Kearns, Doris, *Lyndon Johnson and the American Dream*. Harper & Row: New York, 1976.

Kilbourn, William, *Toronto Remembered, a Celebration of the City*. Stoddart: Toronto, 1984.

___ *Intimate Grandeur: One Hundred Years at Massey Hall*, Stoddart: Toronto, 1993.

Kuchar, George, *Reflections from a Cinematic Cesspool*, Zanja Press, 1997.

Lord, Barry, *The History of Painting in Canada: Toward A People's Art*, NC Press: Toronto, 1974.

Lowenfeld, Viktor, *Creative and Mental Growth, A Textbook on Art Education*, The Macmillan Company: New York, 1947.

MacDonald, Scott, *Avant-Garde Film, Motion Studies*, Cambridge University Press: Cambridge, 1993.

McCarthy, Doris, A Fool in Paradise: An Artist's Early Life. *MacFarlane Walter & Ross.* Toronto, 1990.

—— The Good Wine: An Artist Comes of Age. *MacFarlane Walter & Ross.* Toronto, 1991.

Mellon, Peter, *The Group of Seven.* McClelland and Stewart: Toronto, 1970.

Murray, Joan, *Canadian Art in the Twentieth Century.* Dundurn Press: Toronto, 1999.

Navarro, Jose Canton, *History of Cuba, The Challenge of the Yoke and the Star.* Editorial SI-MAR, S.A.: La Habana, Cuba, 1998.

Ouspensky, P.D., *In Search of the Miraculous, Fragments of an Unknown Teaching.* Harcourt, Brace and Company: New York, 1949.

Robert Russeet and Cecile Starr, *Experimental Animation, An Illustrated Anthology.* Van Nostrand Reinhold Company: New York, 1976.

Schmidt, Johann-Karl, ed., *Les Levine: Art Can* See, Cantz, n.d.

Solomon, Deborah, *Jackson Pollock: A Biography.* Simon and Schuster: New York, 1987.

Steinberg, Leo, *Other Criteria: Confrontations with Twentieth-Century Art*, Oxford University Press: Oxford, 1972.

——, *Encounters with Rauschenberg (A Lavishly Illustrated Lecture.* The Menil Collection, Houston, and The University of Chicago Press: Chicago and London, 2000.

Town, Harold, *Albert Franck: His Life, Times and Work.* McClelland & Stewart: Toronto, 1974.

Town, Harold and Silcox, David P., *Tom Thomson: The Silence and The Storm*, McClelland & Stewart: Toronto, 1977.

Turcotte, Dorothy, Remembering the Grant Inn. *The Boston Mills Press.* Erin, 1990.

Trudeau, Margaret, *Beyond Reason*, Paddington Press: New York, 1979.

Index

ship with George Gingras,
370–373, 380–381, 397, 410, 412,
439–440; tired of hearing about
artistic influences, 399–400;
lawsuit brought against Joyce and
Michael Snow, 405–407; wins the
Order of Canada, 414–416; wins
the Women of Distinction
Award, 458–459; wins the
Toronto Arts Award, 458–461;
travels to Israel, 416–418; general
health, 420–421; founds the Alma
Gallery, 424; artist-in-residence at
the University of Toronto,
462–463; early onset of
Alzheimer's, 455–481; diagnosis,
475–477; death, 481–482

MEDIA

Assemblage, 122, 186, 223–224,
283, 304, 320; Collages, 154–155,
163; Drawings, 92, 122, 134, 140,
150–151, 175–177, 386–388, 474;
Film, 78–79, 103–104, 123–125,
151–152, 169, 173, 190–208,
228–237, 240–241, 246–248 252,
259, 264–265, 270–271, 274–280,
284, 287, 292, 297, 312, 315,
322–337, 376–377, 418–420,
452–453, 457; Lithograph, 386;
Multimedia, 456–457, 465; Paint-
ing, 64, 69, 74, 121, 130, 142–143,

154, 170, 203–204, 215, 218, 271,
275, 387, 395–398, 409–413, 433,
456, 458, 462, 465; Perfume,
303–304, 321; Quilt, 256–260,
276–278, 281, 290–292; Sculp-
ture, 339, 361, 444, 457; Wall
hanging, 99, 242, 251–256, 310

Wieland, Michael, 425
Wieland, Rosetta Amelia (mother),
9–18, 22–25, 29–30, 33–40, 44–47,
54, 56, 58–59, 65
Wieland, Sydney Arthur (father),
6–9, 11–25, 28–37
Wieland, Sydney (brother), 11–15, 27,
32–33, 37, 45–46, 77, 343
Weiland, Zaeo, 7
West 4th (oil on canvas, Wieland),
204
Wilson, Kay, 422–423, 473
Withrow, William (director, AGO),
347, 403–404
Women's movement, 169, 175–178, 385
Wright, Frank Lloyd, 257
Wynn Wood, Elizabeth, 55

Yaneff, Chris, 70–71, 73
Young Woman's Blues (assemblage,
Wieland), 225–226

Zorns Lemma (film, Frampton), 280
Zucker, Irving, 472

Information for Colour Plates
(Dimensions, in centimetres, appear with height preceding width)

Puerco de Navidad, 1967
Mixed media
104.0 X 68.0 cm
Private Collection

Time Machine Series, 1961
Oil on canvas
203.2 X 269.9 cm
Art Gallery of Ontario, Toronto
Gift from the McLean Foundation, 1966

Nature Mixes, 1963
Oil on canvas
30.5 X 40.6 cm
Collection of Catherine Hindson, Hamilton

Reason Over Passion, 1968
Quilted cloth assemblage
256.5 X 302.3 cm
The National Gallery of Canada, Ottawa

Self Portrait, 1978
Oil on canvas
20.6 X 20.3 cm
Collection of Nadine Joyce Schwartz, Owen Sound

Conversation in the Gaspe, 1980
Oil on canvas
20.9 X 25.5 cm
Private Collection

Artist on Fire, 1983
Oil on canvas
106.7 X 129.5 cm
The Robert McLaughlin Gallery, Oshawa

Paint Phantom, 1983-84
Oil on canvas
121.9 X 170.2 cm
The National Gallery of Canada, Ottawa

Turkish drawing (untitled), 1981
Watercolour
9.8 X 13.3 cm
Collection of Maureen E. Milne, photograph by Tom Moore

Mother and Child, 1981
Oil on canvas
42.2 X 41.9 cm
Collection of Lynn McDonald, Toronto

Guardian Angel, 1982
Oil on canvas
22.5 X 25.0 cm
Collection of Julia and Tim Hammell, Toronto

Lovers With Curly Hair, n.d.
Ink on Tissue
28 x 44 cm
Collection of Betty Ferguson

Lovers, (untitled) n.d.
Ink on paper
21.5 X 36 cm (irregular)
Collection of Betty Ferguson

World Literature Plaque, 1985
Bronze
79.5 X 82 cm
Collection of Greg Gatenby, photo by Tom Moore